CASTIGLION DELLA PE...

Siena

CONSTRUCTING THE RENAISSANCE CITY

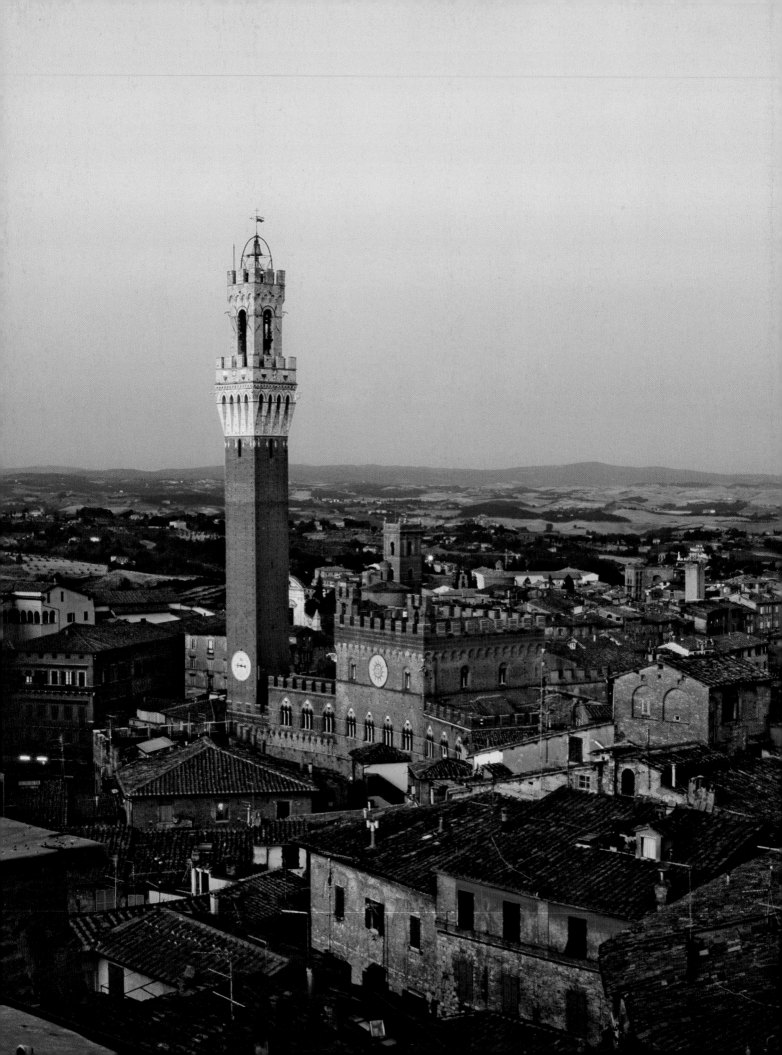

Fabrizio Nevola

SIENA

CONSTRUCTING THE RENAISSANCE CITY

Yale University Press ⚬ New Haven and London

To Clara and Gaia Luce

Designed by Emily Lees

Printed in Singapore

Library of Congress Cataloging-in-Publication Data

Nevola, Fabrizio, 1970–
Siena: constructing the Renaissance city / Fabrizio Nevola.
p. cm.
Includes bibliographical references and index.
ISBN 978-0-300-12678-5 (cl : alk. paper)
1. Architecture–Italy–Siena–15th century. 2. Architecture,
Renaissance–Italy–Siena.
3. Architecture–Political aspects–Italy–Siena. 4. Siena (Italy)–
Buildings, structures, etc.
I. Title.
NA1121.S54N48 2007
720.945'5809024–dc22

2007014686

A catalogue record for this book is available from The British Library

ENDPAPERS Fictive landscape showing Piccolomini dominions,
from an Arnald van Westerhout etching (detail of fig. 103)

HALF TITLE Ambrogio Lorenzetti, *Effects of Peace in the City*. Sala della Pace,
Palazzo Pubblico, Siena (detail of the east wall fresco seen in fig. 5)

FRONTISPIECE View South from the Sala della Pace, Palazzo Pubblico
towards the Monte Amiata (fig. 6)

Contents

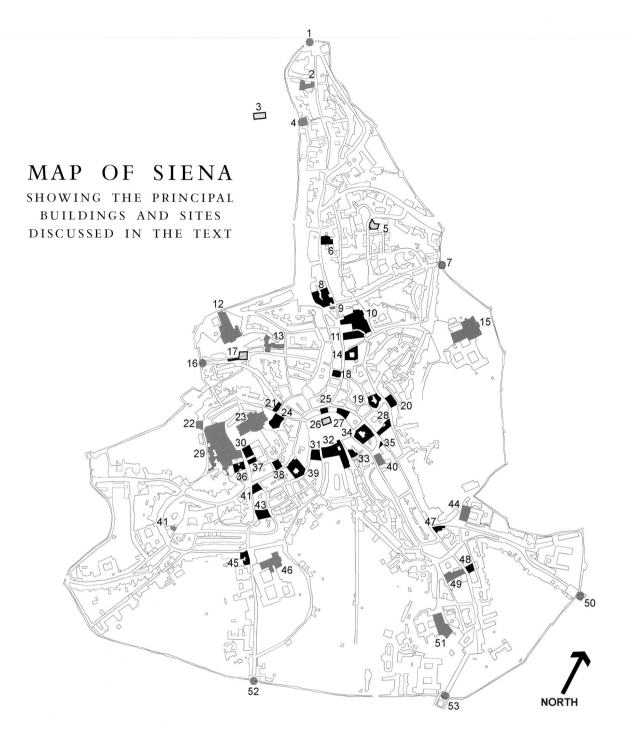

MAP OF SIENA

SHOWING THE PRINCIPAL
BUILDINGS AND SITES
DISCUSSED IN THE TEXT

NORTH

■ PALACES
6 Palazzo del Taia
8 Site of demolished Castellare dei Malavolti
10 Rocca Salimbeni
11 Palazzo Spannocchi
14 Palazzo Bichi-Forteguerri
18 Palazzo Tolomei
19 Castellare degli Ugurgeri
20 Palazzo Bandini-Piccolomini
21 House of Francesco di Giorgio Martini
24 Palazzo 'del Magnifico' Pandolfo Petrucci
25 Loggia della Mercanzia
27 Palazzo Sansedoni
28 Palazzo Piccolomini-Clementini
30 Palazzo Giacoppo Petrucci
31 Palazzo Chigi al Casato
32 Palazzo Pubblico
33 Palazzo del Capitano
34 Palazzo Piccolomini
35 Loggia Piccolomini

36 Palazzo Pecci
37 Palazzo Bichi
38 Palazzo delle Papesse (Caterina Piccolomini)
39 Palazzo Chigi-Saracini (Piccolomini)
42 Palazzo Borghesi
43 Palazzo Bichi-Tegliacci
45 Casa di Santa Marta
47 House of Biagio di Cecco
48 Palazzo San Galgano

■ CHURCHES
2 La Magione
4 Santa Maria in Portico di Fontegiusta
9 Santa Maria delle Nevi
12 San Domenico
13 Santa Caterina in Fontebranda
15 San Francesco
22 San Sebastiano in Vallepiatta
23 Cathedral
29 Santa Maria della Scala

40 San Martino
42 Sant'Ansano in Castelvecchio
44 Santo Spirito
46 Sant'Agostino
49 Santa Maria Maddalena
51 Santa Maria dei Servi

▭ FOUNTAINS
3 Fonte di Pescaia
5 Fonte a Ovile
17 Fontebranda
26 Fonte Gaia

● GATES
1 Camollia
7 Ovile
16 Fontebranda
50 Pispini
52 Tufi
53 Romana

Acknowledgements

A number of institutions and individuals have made this book possible. First of all to the many people who in different ways have commented, criticised, advised and supported my work over the years: Mario Ascheri, Didier Boisseuil, Jill Burke, Peter Burke, Howard Burns, Monika Butzek, Marilena Caciorgna, Joanna Cannon, Giuliano Catoni, Gioachino Chiarini, Giuseppe Chironi, Sam Cohn, Paul Crossley, Jonathan Davies, Barbara Deimling, Nick Eckstein, Caroline Elam, Gabriele Fattorini, Francesco Paolo Fiore, David Friedman, Julian Gardner, Christa Gardner von Teuffel, Richard Goldthwaite, John Henderson, Tom Henry, Machtelt Israëls, Philippa Jackson, John Law, Wolfgang Loseries, Kate Lowe, Michael Mallett, Alick McLean, Gianni Mazzoni, Luca Molà, Sandy Murray, Mauro Mussolin, Diana Norman, Nicholas Oldsberg, John Paoletti, Ludwin Paardekooper, Simon Pepper, Petra Pertici, Brenda Preyer, Guido Rebecchini, Michael Rocke, David Rosenthal, Gervase Rosser, Ingrid Rowland, Pat Rubin, Christine Shaw, Fulvia Sussi, Maurizio Tuliani, Evelyn Welch, Carla Zarrilli. I also thank Graham Wallinger for first teaching me about buildings. The staff of the Archivio di Stato, the Biblioteca Comunale degli Intronati and the Soprintendenza in Siena, and the Courtauld Institute and the Library of the Warburg Institute in London, have all provided invaluable facilities and assistance. My particular thanks go to Yanel de Angel, whose maps and plans communicate information so much more effectively than my earlier rudimentary efforts. Much the same can be said for the photographs that enrich this book, many of which were taken by Matthias Quast and Fabio Lensini; thanks also to Geoffrey Fisher of the Courtauld Institute's Conway Library and Fabio Torchio of the Fototeca at Siena's Soprintendenza. For a grant that assisted with the cost of photographs, I especially thank the generous support of Lila Acheson Wallace – Reader's Digest Publications Subsidy at Villa I Tatti. The community and staff of Villa I Tatti, the Harvard University Centre for Italian Renaissance Studies, provided the ideal context for a year spent (2004–5) completing the manuscript, and I particularly thank Joe Connors for making me so welcome there. Work on this book has spanned my years at the University of Warwick, Villa I Tatti, the Università degli Studi di Siena and will now see the light from Oxford Brookes University. I thank all these institutions for their generous support. Very special thanks go to Toni Clark, Georgia Clarke, Richard Ingersoll and Luke Syson, whose careful reading of different versions of the book have improved it beyond recognition. At Yale University Press, I thank Gillian Malpass for her enthusiastic encouragement of this project, and Emily Lees for her work on the practicalities and impracticalities of putting it together.

VAL DI POZZO, JUNE 2007

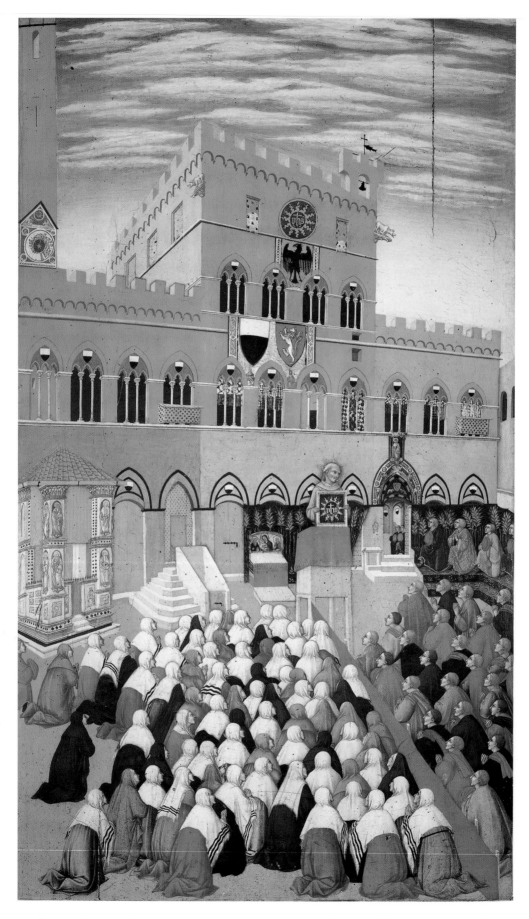

1. Sano di Pietro, *S. Bernardino Preaching on the Campo*, 1444. Museo dell'Opera del Duomo, Siena.

Introduction

The urban environment is constantly changing. Permanent alterations are the result of new buildings going up and others being demolished, streets being widened or straightened, new neighbourhoods being developed. No less significant, however, is the way in which the shared public space of the city is altered on particular occasions, such as for festivals or ceremonies, when temporary effects transform the familiar to underline the significance of given events. This process of temporary and permanent change is true to all cities.[1] Nevertheless, during the fifteenth century in Italy a special attention was paid by city authorities to control and shape the way that urban environments communicated the essence of a city's status and identity to locals and outsiders. While it is not always possible to capture the different phases of urban change, multiple sources can be called on as witnesses of that process.

Three paintings, by Sano di Pietro (*c.* 1445), Neroccio di Bartolomeo de' Landi (*c.* 1468) and Domenico Beccafumi (*c.* 1528), executed over the period of around eighty years, show the same scene of S. Bernardino of Siena preaching on the piazza del Campo, on the occasion of the Lenten sermon cycles he delivered in 1425 and 1427 (figs 1–3).[2] The only possible eye-witness to have experienced the scene was Sano di Pietro (1406–81), although there are clear echoes between one image and the other that indicate the likelihood that Sano's image served as a model to those that followed.[3] The paintings reveal the changes to the urban context over time, and show how these were negotiated by the artists within the otherwise iconic formulation of city–saint imagery.

The scene is clear enough to interpret. The saint stands on a makeshift pulpit erected in front of the city hall, the Palazzo Pubblico, with the open-air chapel of the Cappella di Piazza visible to the left. He holds up the monogram symbol of Christ (IHS), and before him the segregated congregation that fill the piazza kneel in reverence, as do the city governors, raised above the citizens on a dais that is decorated with tapestries. Most of these details can be observed in all the paintings, although it is also evident that there are certain differences in the ways that the artists have arranged the scene, and in the way that they have represented the urban environment of its setting.

In Sano di Pietro's painting, the Palazzo Pubblico is shown in its entirety and in great detail. The large panel

2. Neroccio di Bartolomeo, *S. Bernardino Preaching on the Campo*, *c*.1468. Museo Civico, Palazzo Pubblico, Siena.

forms part of an altarpiece that was intended to support the cause of Bernardino's canonization, and here the city hall, with all the symbols of the polity rally to reinforce that claim; the city is represented by way of the citizens, their rulers and the city hall and central square, all of which function as witnesses to the actions of the preacher. In this respect, the detail with which the scene has been captured corroborates its depiction of the reality of a miraculous episode, since it was above all the mass appeal of his preaching that singled him out for sainthood. In Neroccio's painting, on the other hand, Bernardino appears as a saint with a halo (he had been canonized in 1450), and as such the propagandistic function of the scene is reduced. Having achieved sainthood, the scene of his Sienese sermon cycle joins other stages of his life that form the narrative of the predella. The artist provides a summary of the event, which is circumscribed to a portrayal of the sermon, where the city hall has a more limited purpose as an immediately recognizable backdrop to the congregation and preacher. As in Sano's scene, the Cappella di Piazza appears with its truss beam and tiled roof, and this has led scholars to date the image to before 1468, when that roof was replaced with a sophisticated classicizing, marble-vaulted structure. The chapel's arch and a small part of the frieze can be seen in Beccafumi's predella image, which like

Neroccio's, uses the Palazzo Pubblico to locate the narrative on the piazza del Campo without dedicating too much attention to its accurate representation. In Beccafumi, surplus details, such as the 'porta del sale' that granted access to the salt stores below the city hall, are ignored and the artist has instead ordered the scene around a unifying and harmonious principle of symmetry. Even the congregation is arranged on benches that create a perspectival cone around the preacher, while elegant bystanders fill the sides of the composition.

These three images of S. Bernardino preaching on Siena's piazza del Campo are quite different; stylistic changes are in part responsible for those differences, but it is also true that the limited change to the architectural setting dictate a uniformity of composition that links the three paintings. Bernardino's claim to sanctity was based on his great skills as a preacher, and the context for that activity was largely urban, so that in the paintings the setting acquires a specific purpose in the saint's life. Furthermore, as all three artists were intimately acquainted with the urban context of the piazza del Campo, their portrayal of it changed to reflect alterations to the actual site. As will be shown in the Conclusion, even Beccafumi's stress on symmetry might be informed by plans to regularize the Palazzo Pubblico façade and furnish the piazza with a classicizing portico.

2

Thus Beccafumi's painting in some way corrected the piazza to a vision that was informed by contemporary ideas about how the central square might be improved, and this in turn shaped his composition. Of course, these adaptations distanced the view from the *reality* of the urban setting of the sermon cycle of 1427, but meant that the image was more immediately recognizable to contemporary viewers.[4] Nevertheless, it is also evident that the urban area of the piazza del Campo in front of the Palazzo Pubblico underwent few major changes, and this serves also the justify the essential continuity of forms documented by the three paintings, in which the Sienese saint was shown at the heart of the architectural, social and political life of his home town.

This book proposes a complex chronology of paradigm shifts, rather than the traditional chronology of a succession of styles.[5] The chapters that follow examine the process by which Siena's urban form and patterns of patronage maintained the balance of new and old, of continuity with change, enabling the city to retain a distinctive collective urban image that also marked its distinction from its neighbours. A loose chronological framework has been adopted for the laying out of the chapters, each of which explores the social and built fabric of Siena within a different span of years in order to track parallel phases in the city's history. And yet, the urban process is sequential and protracted; while individual projects may be assessed as isolated phenomena in the city's history, it is not possible to view urban development in an isolated manner.[6] By linking political institutions, patronage systems, urban planning strategies and architectural language, this book outlines a 'complete' (interdisciplinary rather than comprehensive) urban history of Siena's development from the fourteenth century to the mid-sixteenth. In so doing, this book also proposes an alternative means of assessing the sequence of architectural styles, which, through close dialogue between sources and context, are shown to have a specific and subtle political and social significance.

Historical time is marked by both the *longue durée* process and *événementiel* moments.[7] Political events, significant figures and their decisions, and ritual moments are important vectors which locate the 'fractures of history'. The paradigm shifts that mark dramatic turning-points in the evolution of the city and the architectural language employed for its expression are often located around these fractures, that also serve as markers for tracking the urban narrative.[8] Furthermore, these fracture points have a determining effect on chan-

3. Domenico Beccafumi, *S. Bernardino Preaching on the Campo*, c.1528. Fitzwilliam Museum, Cambridge.

ging urban form. Two such fracture points in this period in Siena are identified in this study as occurring around the visit to Siena of Pope Pius II in 1460, and the establishment of the *Novesco* regime in 1487, each of which resulted in major changes in the built form of the city. Lasting change in the built fabric of the city also derives from the urban process, a momentum propelled by response to the evolving needs of citizens, and the antientropic impulse to maintenance and improvement. This latter process was slow, gradual and accretive. Modification to the city fabric was in turn channelled by the institutional and legislative context.

As will be shown in chapter One, Siena's city commune provided a framework for civic patronage, where the urban process and *événements* were carefully mediated by a legislative impulse that controlled and shaped the objectives of urban change well into the 1480s. The dominance of collective interests shaped the patterns of individual patronage towards a common civic goal, as described in chapters Two to Six. On the other hand, as can be seen from chapter Seven onwards, as the political institutions of the city republic were weakened by the growing power of the socio-economic elite – which led to the establishment of the *Novesco* oligarchy and subsequently the Petrucci regime – so too the patronage model for architectural renewal and urban change was also transformed. While the legislative structures remained in place, these were increasingly bypassed, so that urban form came to express the ambitions of a narrow oligarchic group.

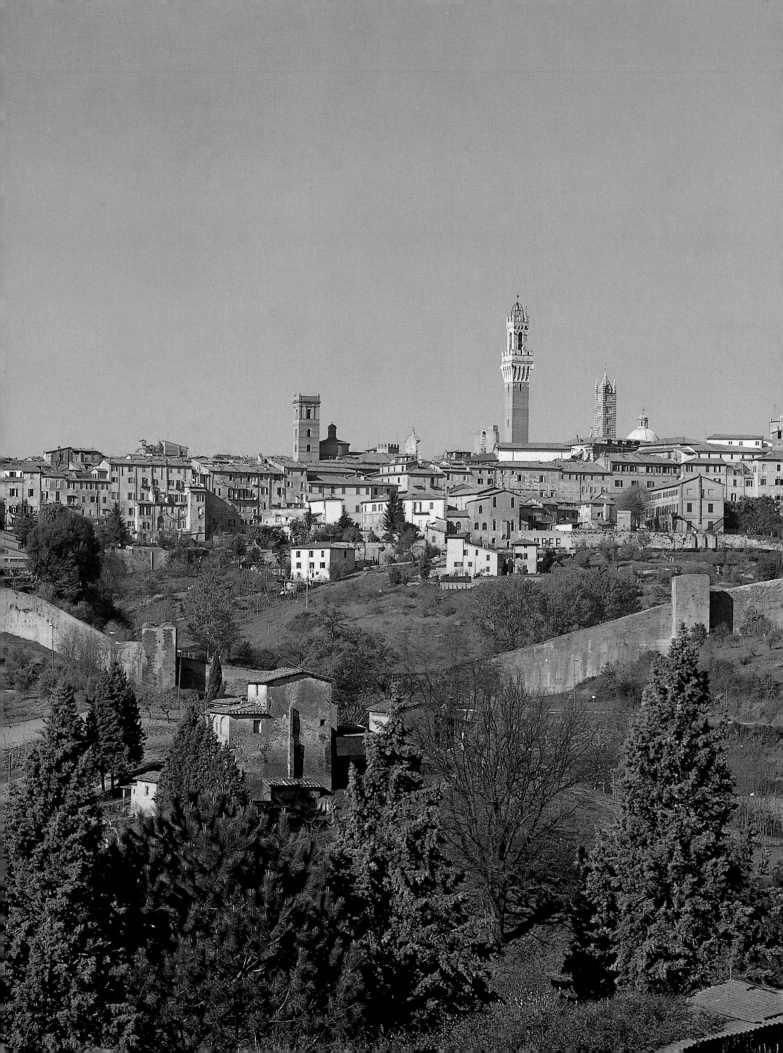

I

'Turn your eyes to behold her'

ARCHITECTURE AND CIVIC IDEOLOGY IN FOURTEENTH-CENTURY SIENA

Turn your eyes to behold her,
you who are governing, who is portrayed here [Justice],
crowned on account of her excellence,
who always renders to everyone his due.
Look how many goods derive from her
and how sweeet and peaceful is that life
of the city where is preserved
this virtue which outshines any other.[1]

In an immensely popular and well-attended Lenten cycle of sermons, held on the Campo in the spring of 1427, Bernardino degli Albizzeschi referred to a cycle of allegorical frescoes inside the government chamber of Siena's Palazzo Pubblico.[2] The painting by Sano di Pietro, now in the Museo dell'Opera in Siena, showing Bernardino preaching on the Campo, records how the sermons were given from a dais in front of the Palazzo Pubblico, on which was erected an altar and a pulpit, as well as seating for government officials (see fig. 1). Thus, when Bernardino mentioned the frescoes, he was standing in front of the building that contained them, and close to the government officials whose role it was to ensure that 'men live in peace and harmony with one another'.[3]

Bernardino was of course referring to the cycle of frescoes painted by Ambrogio Lorenzetti between 1337 and 1339 for the meeting chamber of the Nine, a cycle that fifteenth-century viewers referred to as 'The Allegory of Peace'.[4] The preacher's objective in describing these images was to provide an example that would illustrate the value of peace and civic harmony; thus he said:

How useful a thing is peace! Even the sound of the word is gentle on the lips! Look at her opposite, that is War. It is so rough and so rude a word that it makes the mouth bitter. Oh! – you have it painted upstairs in your Palazzo [Pubblico], where it is a pleasure to see Peace illustrated. And so too it is alarming to see War represented on the other wall [. . .] Oh! my citizens, embrace one another [. . .] and in this way you will show your love for the city.[5]

FACING PAGE 4. View of Siena from the east.

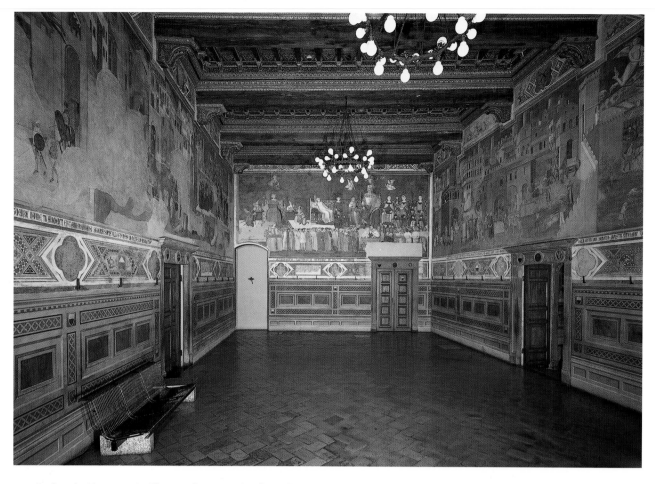

5. Ambrogio Lorenzetti, *Allegory of Peace* and *Effects of Peace in the City and the Countryside*, 1338–40. Sala della Pace, Palazzo Pubblico, Siena.

Like most of his contemporaries, Bernardino identified Lorenzetti's three large frescoes by reference to the major themes they present: war and peace (fig. 5).[6] The frescoes of the Sala dei Nove in the Palazzo Pubblico cover the entirety of three walls of that government chamber with two paired scenes. On the north wall a group of allegorical figures in three hierarchically arranged tiers outline a political ideal of good government or peace, centred around a concept of 'bene comune' figured in the bearded man dressed in black and white; on the east wall a panoramic view of a city scene and landscape reveal the urban and rural ideals of peace-time life; on the west wall the allegorical and panoramic images are reduced in scale to a single wall, revealing a negative allegorical representation of tyrannical rule and the effects of war on the city and countryside.

The theoretical underpinnings of these images, with special reference to the *Allegory of Peace*, have been extensively discussed in relation to mid-fourteenth-century political theory.[7] However, the basic language of the images, and the way that these were understood by contemporary viewers, has received less attention. Furthermore, though it is obvious from even the most cursory observation, these are paintings with a narrative message that is inextricably linked to the architectural context described as their settings.[8]

At the most obvious level, the cycle is based on the relating of theory to practice, or to put it another way, of cause and effect: peaceful civil life as expressed in the panoramic views represents an ideal that is the physical analogue of the political ideal (expressed in the allegorical figures) that renders it a possibility. Panorama and allegorical images are both ideals; they are merely expressed in different terms. The allegory represents the coincidence of public or civic virtues that create the proper conditions for the ideal urban environment to thrive in symbiosis with the outlying rural territory. A natural consequence of the programmatic value of the cycle then, is that the practical consequences of these theoretical statements were not on the walls of the Sala dei Nove at all, but that rather they were to be found

in the decision-making of the officials that gathered in that room. Inspired by the allegories, and aspiring to the reality of the city view, the governors' decisions were thus most tangibly expressed in the social and physical, urban and rural, conditions that surrounded the Palazzo Pubblico: Siena and its *contado*, or territories.

That the images were intended to enter into a dynamic discourse with the people that saw them is manifest in the inscriptions that speak directly to the viewer.[9] Thus, most obviously, an inscription speaks in vulgate Italian from the frame beneath the city at peace to exhort viewers to 'turn your eyes to behold her [Justice], you who are governing' and see 'how sweet and peaceful is that life of the city where is preserved this virtue'.[10] Similar recommendations are scattered throughout the three walls and make the didactic intentions of the images absolutely clear. As such the images performed the ideals of Siena's government at its institutional heart in the Palazzo Pubblico, where the frescoes witnessed and influenced the actions of the city's officials, and communicated them to all viewers.[11]

Again, it is S. Bernardino that most effectively captured the effect of these images on their viewers, when in a sermon of 1425 he declared:

> At times when I have been away from Siena and have preached on war and peace, I have thought that you have it painted here, and that this was certainly a wonderful idea. Turning towards peace, I see business activities taking place, I see dances, I see houses being restored, I see the land and vines being farmed, and sowed, and people going to the baths on horseback, I see maidens getting married, I see flocks of sheep etc. And I see a man hanging from a noose, in order that justice be preserved: and because of all these things, everyone lives in holy peace and concord [. . .].[12]

Bernardino, who had also preached in the Palazzo Pubblico, thus describes the visual experience of unravelling the content and meaning of the fresco of the *Effects of Peace in the City and the Countryside*. The rapid dialogue of reference brings the viewers' eyes from the image to reality and back again in a sequence that intentionally blurs the boundaries between them.

Such a strategy was employed for the frescoes themselves, with the long image of the east wall stretching across the breadth of the Palazzo Pubblico so that the city scene to the left might be said to project allegorically onto the urban fabric it presents an idealized vision of, while the right-hand side of the painting slips easily through the window of the Sala dei Nove to join with the real panorama of south Tuscany (fig. 6). This framing of view-points to the real views from the Palazzo cannot be considered casual, since it is repeated on the west wall.

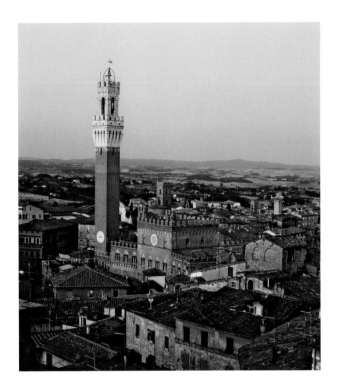

6. Palazzo Pubblico with the view beyond the city walls to the south-east.

Again, it is the inscriptions that help confirm a cause and effect understanding of the cycle, as the *Allegory of Peace* is captioned in the decorative border beneath with a gloss that reminds the viewer that where 'buon comun' reigns, 'every civic result duly follows'.[13] Government policy directly impinges on everyday life in the same way as allegory and landscape are related to one another in the walls of the government chamber.

S. Bernardino's sermon makes it clear that the message conveyed by Lorenzetti in the 1340s was still relevant in the 1420s. Yet the context of the paintings' mid-fourteenth-century production was quite different from that of their reception in the fifteenth century. Lorenzetti's patrons were the government officials called the Nine, elected rulers of a regime that governed Siena from 1287 to 1355.[14] The long period of relative political stability and fiscal and governmental efficiency is often described as Siena's 'Golden Age', and undoubtedly coincided with the flourishing of art and architecture in the city.[15] By contrast, Bernardino preached to a city that had recently been subject to the foreign overlordship of Giangaleazzo Visconti (1401–3), had emerged from a period of massive financial strain generated by engagement in constant mercenary warfare during the later fourteenth century, and where a legacy of political factionalism and conflict had developed in the aftermath of the fall of the Nine in 1355.[16] Beyond

these great differences, however, the linking of visual and political language in Lorenzetti's frescoes continued to convey an important message for Siena's fifteenth-century citizens. That message was not, as has sometimes been argued, predicated on an innate retrospective attitude, which saw the Sienese harking to a bygone heyday.[17] Rather, quite simply, the message and its format continued to be relevant to a society where government, citizens and urban form were bound together in an inextricable manner.

Inheriting and Intepreting *Buon Governo*

Lorenzetti's frescoes of the city at peace captured the essence of the relationship between government authority, urban form and social fabric in the pre-modern city. The image was programmatic, laying down an ideal that was to be striven after, and that to a large extent informed the legislative process of urban regulation and change for two centuries following its execution.[18]

So then, if the visions of peace and war that adorned the government chamber of the Nine can be considered a powerful manifesto that linked the public good of the citizen body to the physical environment of the city, so it becomes appropriate to ask how this policy ideal fared in the centuries that followed its foundation. The survival of this political decorative complex is an indication that its message retained currency for some time at least, ensuring that it was neither replaced nor entirely abandoned to decay. A number of documented restorations were made to the fresco cycle from as early as the 1360s in order to preserve it pristine and legible.[19] Thus, sometime between 1360 and 1385 Andrea Vanni appears to have been enlisted to restore portions of the already damaged frescoes, while it has been shown that in 1492 Pietro di Francesco Orioli was paid for restoration work and the production of a *trompe-l'œuil* perspective to cover the south wall of the room.[20] Again, Girolamo di Benvenuto in 1518 and one Lorenzo di Francesco in 1521 are also noted to have worked on restoration, specifically of the lettering (presumably the inscriptions) and an unidentified face.

A more obvious benchmark for the continued success of the cycle can be seen in the repetition of parts of the composition in civic commissions of later periods. Thus, for example, a number of tax-book covers (the so-called *Biccherne*) repeat parts of Lorenzetti's iconography: the seated bearded figure from the *Allegory of Peace* re-appears in 1344, 1385 and 1474 (figs 7–9).[21] The first of these is attributed to Ambrogio Lorenzetti and repeats in miniature the iconography of the fresco. The 1385 image is sometimes attributed to Andrea Vanni, who also

7. Ambrogio Lorenzetti, *Good Government*, 1344. Biccherna n° 16, Museo delle Biccherne, Archivio di Stato, Siena.

worked on restorations to the cycle; he adopts a number of features from the fresco, most notably the idea of the cord that binds *buon comun* through the shared power of the individuals elected to government.[22] Benvenuto di Giovanni's later image retains the enthroned bearded figure, his clothing in the colours of the Sienese arms (*balzana*) as well as the speech caption 'He who makes good decisions, governs', which recalls the use of text in the originals.[23] The image is updated by a more complex setting of the bearded man in relation to seated government officials to his left and right, shown at work in financial and legislative capacities.

Perhaps most remarkable of all the many evocations of the 'Sala della Pace' images is the 1446 civic commission awarded to Giachetto di Benedetto, a Flemish tapestry master from Arras, to complete three tapestries with 'the design and story that is in the Sala della Pace of that palace [Palazzo Pubblico], resembling the figures and images of that room'.[24] The tapestry commission was part of an exceptionally prestigious and expensive campaign to provide the Palazzo Pubblico with quality hangings: the Commune had asked Giachetto to come to work in Siena in 1442, requesting that in return for tax-exemption privileges and an annual income of 50 florins he set

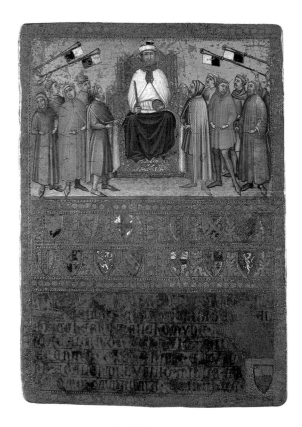

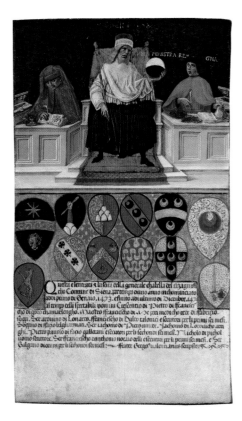

8. Andrea Vanni, *Good Government*, 1385.
Biccherna n° 19, Museo delle Biccherne, Archivio di
Stato, Siena.

9. Benvenuto di Giovanni, *Good
Government*, 1474. Biccherna n° 38, Museo
delle Biccherne, Archivio di Stato, Siena.

up at least two looms and teach his skills in weaving and dyeing to willing apprentices.[25] In the ten years that followed, Giachetto produced a large number of tapestries with the various arms and symbols of the Commune, as well as the three hangings reproducing the *pace* and *ghuerra* frescoes.[26] Giachetto had been hired as 'one of the most famous masters of this art', he was well rewarded for his work and in 1456 petitioned to stay on in the city, reminding his employers that his works for Pope Nicholas v had brought further honour to Siena.[27]

The Giachetto commission provides an interesting case for the city's continued identification with the canonical 'visual text' of Lorenzetti's frescoes, as the decision to have woven replicas of the mid-fourteenth-century originals reveals a considerable financial commitment to these traditional images. However, it is also worth considering what the Commune's intentions might have been for these tapestries and the commission that produced them. On one level, it seems clear that this was considered an effective investment into the diversification of Siena's luxury market production; Giachetto was lured to Siena in the hope that he would establish a tapestry workshop in the city and train apprentice weavers.[28] Seen from a different perspective

it is significant that these replicas were made in tapestry, an expensive but portable medium, which meant that the original images of the 'Sala della Pace' could be transported to varied locations. It is thought that the tapestries were usually displayed in the meeting chamber of the Signoria (the so-called Sala del Concistoro), although it seems likely that they were also used as back-drop hangings when the Signoria appeared in public occasions, on a raised dais in front of the Palazzo, such as when S. Bernardino gave his sermons (see fig. 1).[29] Certainly, such a use of the tapestries in public would have ensured the absolute currency of Lorenzetti's image among the citizens of Siena.

It has been suggested by Deborah Kawsky that the political significance of this conscious revival of 1340s imagery during the 1440s should be viewed through the filter of a specific desire to re-found Siena's commitment to the ideals of *bene comune* at a time of political unrest and impending war.[30] References to the frescoes can be traced in texts and images that span across the century, while restorations to 'Sala della Pace' are not circumscribed to any particular political phase of the city's tormented history. In this sense it seems fair to claim that these three walls of fresco were a visually co-

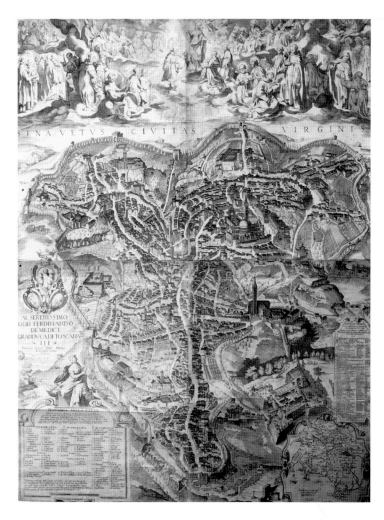

10. Francesco Vanni, *Sena Vetus Civitas Virginis,* etching, c.1595.

dified ideal that represented the political virtues to be fostered among the governing elite, and the expression of these on the city fabric. What these images captured was a way of living in the city in the pre-modern period, where the city and its citizens were one and the same, and where government took a leading part in shaping the urban environment to its own likeness.

After the Black Death of 1348, Siena's population dropped from around 42,000 to about 14,000.[31] In spite of the population decline which affected Siena and all other cities in the fourteenth century, numerous fifteenth-century visitors commented on Siena's new 'molti superbi et degni edificii', as the Venetian diplomat and diarist Marin Sanudo put it towards the end of the century, which flanked the main streets and squares (figs 10–11).[32] This process of urban improvement and renewal continued the policies that had shaped the city under the rule of the Nine, while also updating the rationale and theoretical underpinning of their programme.

Thus, as Nicolai Rubinstein observed half a century ago, Lorenzetti's Palazzo Pubblico cycle was provided with a humanist gloss in the form of Taddeo di Bartolo's frescoes (1413–14) of Roman heroes in the Anticoncistoro (fig. 12).[33] Here, a number of Lorenzetti's seated figures of Virtues were provided with figures from the Roman past that illustrated that quality, while a Pantheon of classical gods framing a portrait of the city of Rome underlined Siena's association with government ideals of Republican Rome. In the adjacent chapel of the *Signori,* Taddeo painted an elaborate narrative of the 'Life of the Virgin', which again renewed Siena's traditional dedication to Mary. Only a few years later, a prime image of civic devotion such as Simone Martini's *Maestà* in the Sala del Mappamondo, was also tempered or fused with the city's new humanist identity, with the addition of an intarsia bench for the priors to sit on in council meetings, produced by Mattia di Nanni, and again showing the Roman hero figures identified in Taddeo's Anticoncistoro frescoes.[34] A similar fusion of continuity of fourteenth-century civic iconography and innovative humanist-inspired imagery was displayed at the monumental fountain on the piazza del Campo, the Fonte Gaia, designed by Jacopo della Quercia (1414–19). Here,

11. Map showing the Republic of Siena in the Quattrocento.

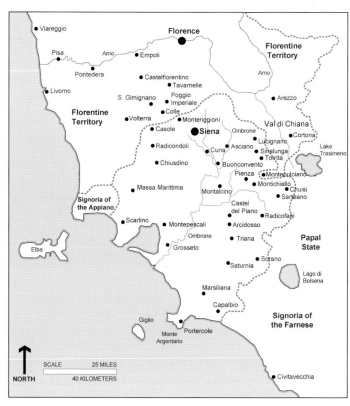

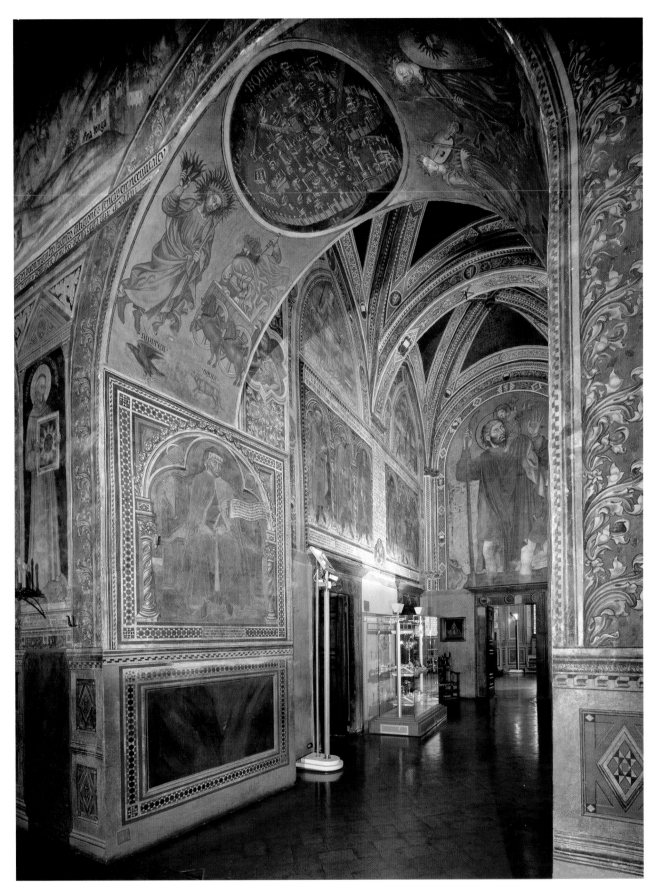

12. General view of the anteconcistoro frescoes by Taddeo di Bartolo, *c.*1414. Palazzo Pubblico, Siena.

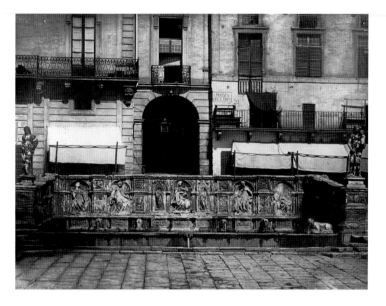

13. Fonte Gaia.

images of religious virtues surrounded the seated figure of the Virgin and Child, while standing full-figure sculptures of Acca Laurentia and Rhea Silvia, the mythical mother and foster-mother of Romulus and Remus, introduced the key figures of Siena's Roman past to the main square (fig. 13).[35]

The Urban Armature of Siena

The development of Siena's built form in the later thirteenth and fourteenth centuries owed much to civic architectural projects financially supported by the government.[36] Lorenzetti's frescoes were but one of a host of civic artistic commissions that ornamented the walls of the government chambers and contributed towards construction of the city's main churches and monumental buildings, as well as city gates, fountains and other amenities.[37] Thus, the symbolic value of the urban scene in the Sala dei Nove frescoes was much greater than merely a representation of a 'well-governed' city, or a 'city at peace'; it was a tangible description of the interaction of the citizen body with the physical fabric of the city itself. This model, which assigned an allegorical or symbolic value to the built form of the city, was at the basis of the civic policy of urban maintenance and beautification. Moreover, as will be shown in the chapters which follow, Lorenzetti's combination of political theory with the architectural expression of the well-governed city, may be seen as the prototype for a number of fifteenth-century Sienese texts that considered urban form to be an integral part of political theoretical discourse.

Lorenzetti's view of the well-governed city reveals an enclosed environment, encircled by city walls that are strong yet permeable, so as to ensure protection and facilitate commerce with the *contado* (see image on p. i). Inside the gates, themselves decorated with civic emblems, citizens and visitors interact on an urban stage made up of the public space of streets and piazzas, where the set is formed by commercial and residential architecture. Inside the government building of the Palazzo Pubblico, the frescoes directly linked to the outside world: to the *contado* in views south, and to the commercial forum of the Campo to the north, beyond which the religious agora of the cathedral precinct could also be glimpsed.[38] The image as it was experienced was at the heart of a building that itself was the heart of Sienese fourteenth-century government, and covered the walls of the chamber in which the nine elected *signori* drew up government policies that would be set up for approval by the city's Great Council in the adjacent Sala del Gran Consiglio (or 'Sala del Mappamondo'). The 'Sala dei Nove' must thus be understood to be the institutional heart of Siena, and the images on its walls amount to its political and architectural 'creed' or programme (see fig. 5). Understanding the fresco thus requires us to understand the city which it epitomizes.

The frescoes in the 'Sala della Pace' lend themselves to being understood as representing the urban context of fourteenth-century Siena, and many scholars have indeed done this (fig. 14).[39] However, just as the figurative allegories cannot be equated straightforwardly to Sienese government and institutions, so too the cityscenes cannot be considered to be documentary representations of Siena before the Black Death. Michael Baxandall has rightly cautioned against the facile interpretation of art as a mirror of society, arguing that rigorous academic method is compromised by the ultimate incompatibility of art and society, which are to be understood as 'analytical concepts from two different kinds of categorization of human experience'.[40] However, as we have seen, viewers from as early as S. Bernardino have made the connection between the images on the walls of the Palazzo Pubblico and the scenes of daily life to be viewed outside that palace. The preacher did not seek to make a stylistic appraisal of Lorenzetti's works, rather he made use of them as a visually effective short hand which illustrated the value of 'peace'.

Similarly, the discussion that follows uses the idealized urban scene in the 'Sala della Pace' as the framework for a survey of the architectural components of the fourteenth-century urban fabric. William MacDonald has described a series of key elements of the urban fabric that underpinned the basic structure of every Ancient Roman city; these elements he described as 'armature'.[41]

So, too, Lorenzetti's painted representation identified the key components, or armature, of Siena's medieval fabric. In fact, this consideration constitutes an important key for the iconography of the composition where, contrary to reality, only one gate, street, piazza, church or bridge can be seen.[42] Following this format, the comments that follow link Lorenzetti's image to the key features of the fourteenth-century city, while also illustrating the way in which these elements were developed during the century that followed.

Siena is often described as the 'daughter of the road', a city which owes its existence to its location on a major trade and pilgrimage path which connected northern Europe to Rome (see fig. 122): the via Francigena, or Romea (after the pilgrims on the way to Rome, the *romei*).[43] The popularity of the via Francigena route had developed through the High Middle Ages, when the coastal Roman consular road, the via Aurelia, became subject to pirate raids, while the other major Roman west-coast axis, the via Cassia, suffered similar problems from brigands.[44] Through the ninth, tenth and eleventh centuries hostels, *pievi* and rest-houses sprang up in the countryside along the Francigena, while towns that already existed benefited from the commercial advantages associated with the road. Since the Francigena was thus both an economic lifeline and an important local artery in Siena's *contado* communications, it is not surprising to find that copious medieval legislation was dedicated to the maintenance and security of the road.[45]

Various issues regarding the construction and maintenance of city and *contado* road networks (i.e. streets, bridges, *fonti* etc.) were initially placed under the control of a single 'street judge' (*judex viarium*), assisted by three 'good men' (*boni homines*), and in 1290 a *Statutum Dominorum Viarium* was drawn up for their use.[46] This statute established two separate offices of 'master of streets inside the walls' (*Viario dentro le mura*), supervising road-works inside the city, and 'master of streets outside the walls' (*Viario fuori le mura*), overseeing works in the *contado*. The *Viarii* were professionals, drawn from the building trade, and as such their office was manual rather than bureaucratic. It was their responsibility to identify damage to the streets and carry out repairs, as also to respond to calls for maintenance made by citizens. Since their role was executive and full-time, the *Viarii* were salaried, and received a certain amount of funding from the Commune for the maintenance work they undertook.[47] As Thomas Szabó has shown, their Statute was consequently practical in nature and was compiled by extracting relevant chapters from the main city Statute: of 434 statutes only fifty discussed the of-

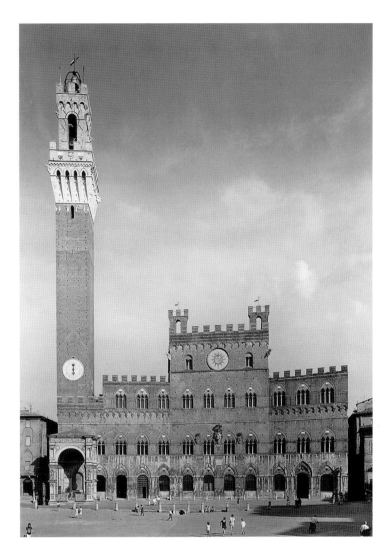

14 Piazza del Campo and the Palazzo Pubblico, with the Torre del Mangia to the left.

fice in general terms, while the rest discussed specific projects to be completed at the time of the Statute's compilation.[48]

While maintenance and improvement of the *contado* road network was a principal concern for the *Viarii*, the safety of travellers was also their responsibility. The death penalty was the ultimate sanction used against highwaymen and other bandits who threatened travellers, damaged the road or bridges, or poisoned the water supplies. It is this legislation that is clearly represented by Lorenzetti in the winged victory figure that hovers above the gate in the *Effects of Peace*; labelled 'SECURITAS', she carries the threatening image of a hanged man, and an explanatory inscription. Beyond her, and the gate, the road winds through the *contado* towards a well-maintained bridge; farmers, merchants, pilgrims, beggars and members of the urban elite travel along the road 'without fear', as the

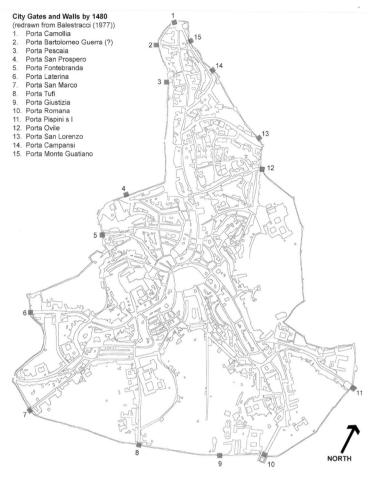

NORTH

15. City gates and walls by 1480.

winged figure announces. The Francigena's facilities and safety continued to be closely protected throughout the fifteenth century, revealing Siena's awareness that the road constituted a major lifeline for the city. Legislation protected travellers along the street and was reinforced in 1469 with the re-issuing of threats of capital punishment for bandits operating along the Francigena.[49] Again, perhaps also to ensure travellers were not deterred from using the road, constant maintenance of bridges is also documented (see fig. 5).[50] In October 1473, as part of the preparations in the lead-up to the Rome Jubilee year of 1475, the city officials petitioned for funds to restore *contado* bridges along the street, 'considering how much utility and honour we derive from this road'.[51] Funds were levied from a forced loan, and Cardinal Francesco Piccolomini, Archbishop of Siena, was asked to petition the pope to allow a tax of 1,000 florins to be levied from churches in the Sienese *contado* in order to cover part of the bridge restoration costs.[52]

Prominently placed at the centre of the *Effects of Peace* are the city's walls and a gate. The city walls formed a

physical and metaphorical boundary to the urban area, pierced only by gates that were placed in relation to roads that entered Siena (fig. 15).[53] The city reached its point of maximum expansion prior to the Black Death of 1348, and the greater part of its walls had been built by this time.[54] Nonetheless, walls continued to be built after 1348, and appear to have received fairly constant attention during the fifteenth century.[55] The most significant portion of new walls was added from 1462, following a request from Pope Pius II that the area between the monasteries of S. Francesco and S. Spirito be enclosed within the walls (fig. 16).[56] The fortification system differed considerably from the early circuit, and resembles the Aurelian Walls of Rome: regularly spaced square turrets and the use of brick as a building material. The Commune imposed a direct tax on all Lombard builders working, and wishing to work, in the city, in order to raise funds for the building programme, and offered public subsidies towards completion of the project in 1471 and 1478 (see fig. 37).[57] To this day, much of the land enclosed by this new section of walls remains agricultural, in contrast to Lorenzetti's image, where the housing stock edges close to the city walls.

In fact, by the fifteenth century quite large areas bordering the city walls were privately owned market gardens (*orti*), so that in 1453 an inventory was drawn up by tax officials, which itemized the relevant size-related tax to be paid by each owner.[58] The taxation of these allotments also served the additional function of identifying owners of property adjacent to the walls, which might be needed for defensive purposes in times of conflict. From as early as the statutes of 1309, it was established that a six-*braccia* (approximately 3.6 metres) belt inside the city walls was to remain public property, for use as a street and safety zone.[59] During the fifteenth century this belt was expanded to ten-*braccia* width, and in 1509 it was established that all trees within ten *braccia* of the walls were to be cut down and that no farming or other activity was to be conducted within twenty *braccia* of the walls.[60] Furthermore, statutes prohibited the erection of lean-to structures against the walls, and doors and windows piercing the walls from houses built adjacent to them were forbidden.[61] Thus, in 1477, it was asserted that in spite of 'the great discomfort to many citizens in a number of different places, and the demolition of numerous houses', such openings should be walled up 'with good strong stone'.[62]

A total of fifteen gates in use during the fourteenth century, through which the Commune was able carefully to regulate entry to Siena, and supervise the image of the city that visitors would experience, have been identified by Duccio Balestracci and Gabriella Piccinni.[63] Of these gates, Nicholas Adams and Simon

16. New portion of the city walls, from S. Francesco to Porta Pispini, constructed during the 1460s.

Pepper have noted stylistic similarities between Siena's main gates, which all had a decorated barbican and were usually oriented towards the major routes into the city from the *contado*.[64] The secondary gates, which gave onto less important routes, also reveal a common typology: scant adornment and no barbican (fig. 18). Most impor-tant of all were the gates through which the via Francigena passed, the Porta Camollia and Porta Romana (or Nuova in the fifteenth century). These gates were decorated with civic images that informed those entering Siena of the ruling regime and the city's symbols and patron saints.[65]

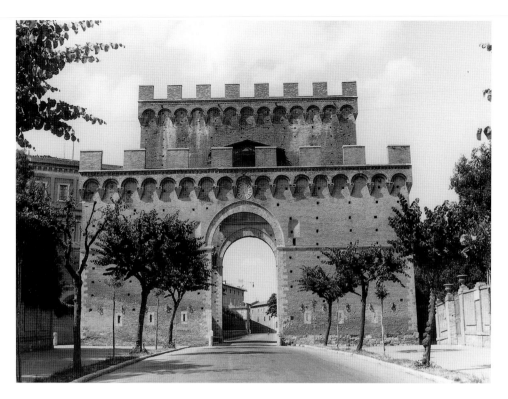

17 Porta Romana.

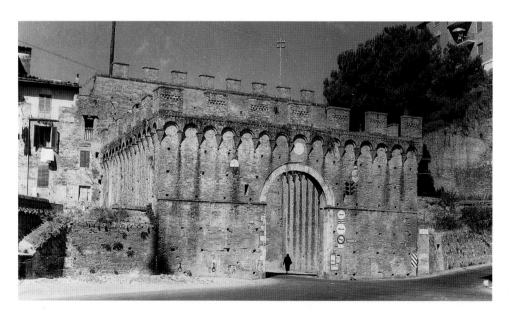

18 Porta Ovile.

It is probable that Lorenzetti modelled his gate on the Porta Romana, begun in 1327 by Agnolo di Ventura (fig. 17).[66] Not only the viewpoint south along the via Cassia towards Rome and the Maremma, where Talamone is also visible, but even the gentle hill rising up to the barbican, resemble the real setting of that gate. Porta Romana is a barbican gate, like that shown in the fresco, with a projecting fortified element (the barbican) and the principal gateway surmounted by a garret. However, Lorenzetti's image differs in decoration from the Porta Romana in at least one respect, for the she-wolf sculptures that flank the main gate were only set in place by Giovanni di Stefano in 1467 (fig. 19).[67] These sculptures completed the fifteenth-century decoration of the de-

19. She-wolf and twins. Porta Romana.

fensive complex, as the 'Coronation of the Virgin' above the gate had been left unfinished at Sassetta's death in 1450, and was completed by Sano di Pietro in 1466.[68] It seems likely then, that in painting the gate, the artist imagined it complete with the civic symbols already in place at Porta Camollia, on the northern approach to the city.[69] The fresco may be considered programmatic, in that it projects an image of the city which only became reality following interventions that were carried out well into the fifteenth century.

Beyond the gates, the via Francigena passed inside the city walls. Since Siena's existence was so dependant on its relationship with the road that led to it, it should come as no surprise to learn that the Francigena's path through the city was also strictly supervised. Just as the *Viarii* remained responsible for the maintenance and safety of the Francigena outside the city, so too the *Viarii dentro le mura* continued to operate under the same general conditions and with similar objectives in the fifteenth century as they had in the past, although communal finances frequently resulted in budget cuts.[70] The number of *Viarii dentro le mura* was reduced from three to one in 1415, although after 1429 this individual was allowed help from *garzoni*, or assistants.[71] Cost efficiency motivated these cuts, although the need for qualified officials was ex-

pressed in the selection of 'valiant and good citizens' as opposed to 'ignorant people who don't know what they are doing'.[72] With this same objective, the term of office for the *Viarii dentro le mura* (or *Viario di città*) was extended from six months to a year in 1415, and in 1466 to two years for the *Viari fuori le mura* in order to ensure greater continuity of policy.[73] A volume of accounts for 1518–24 documents the activity of the *Viario civitatis* through five years, and reveals an even greater degree of continuity in office, with masters Domenico and Beltramo serving intermittently throughout the period.[74]

In spite of the fact that the Statute required that road maintenance costs should be shared between frontagers, that is the owners of properties that faced onto the street under repair, requests for top-up funding were frequently made to the Commune.[75] Indeed, the communal response to direct funding requests may be used as an indicator of the civic priorities in road maintenance, and reveals a special concern for the work of the *Viario di città*. Thus, the curious institution in 1460 of a tax on *bestie da soma* (beasts of burden), is especially relevant as it was paid directly into the *Viarii* accounts, on the basis of the simple logic that these should be taxed because of

> the serious shortcomings of the public streets and roads in the city, which are damaged not only by the continual use by residents, but also by the frequent coming and going of foreigners, and in particular of mules, which pass daily through the city.[76]

From 1460 a tax was thus levied on every animal entering the city, providing a tidy system of road-use tolls that contributed to repairing the damage caused directly by these heavy users.[77] This proved to be an insufficient source of income for the *Viario*, who in 1477 complained that the *cassettina dei muli* (the box containing the mule-tax) did not provide adequate funds on account of a recent bout of plague that had reduced the numbers of visitors and merchants passing through the city.[78] Even so, early sixteenth-century *Viarii* accounts indicate that the mule-tax continued to form a third of the total funding assigned annually to road maintenance, much of which was spent on the Strada Romana itself.[79]

City streets varied in size and importance, ranging from the main city arteries called *strade* to the lesser *vie* and *chiassi*, and were accorded a similarly varied degree of concern by the Commune.[80] By the fourteenth century the majority of *strade* were paved, while the practical desire to keep them clear of dirt brought from unpaved subsidiary *vie* was made clear in the statute of 1309 that 'all the alleys that are on the sides of the street, and give access to it, should be paved'.[81] In addition to paving, streets were increasingly re-ordered by demoli-

tion of overhanging structures and, where possible, by the straightening of façades along the course of the street.[82] Road straightening is documented throughout the fourteenth century through use of the practice of *diritta corda* (straight rope).[83] This practice involved setting out a straight line by means of a rope to link two points along a street; all buildings that invaded the straight line of the new road were demolished.

While the majority of the city's street network was in place by the fifteenth century, occasional improvements appear to have been made in order to rationalize urban space and improve the course of the main city streets.[84] Thus, both the *Viarii* accounts for 1518–24 and occasional documentary references confirm that small alterations were made to streets throughout the Renaissance, and it would seem that the *Viarii* intervened where possible to straighten streets when private or public building campaigns were in progress.[85] An example of the use of *diritta corda* is documented in February 1474 when, coinciding with the grant of a building permit for the construction of Palazzo S. Galgano on the Strada Romana (fig. 20), a land exchange was contracted between the Abbot of S. Galgano and the Commune.[86] The land swap was made in order to straighten the street 'a dritto filo' (along a straight line/thread) under the supervision of the city surveyor, Pietro dell'Abaco.[87] This was done in order to improve the course of the street and the view of the new palace façade, 'because in that place the street and the house façades are not lined up, but they are bent and irregular; it would be just and reasonable to create a straight façade'.[88]

Lorenzetti's image of the *Effects of Peace* does not of course constitute a comprehensive visual record for the arrangement of streets in the fourteenth-century city, but provides, rather, an imagined and idealized urban portrait. As such, it is hazardous to seek direct connections between the painting and the contemporary city; the fresco serves as an index to key issues concerning the connection between urban form and civic identity around the mid-fourteenth century. Thus, for example, the foreground shows a series of buildings, with a variety of commercial activities flourishing in each of the *botteghe* (shop spaces) at street level, conjuring an idea of Siena's economic buoyancy as a thriving commercial centre.[89] This loose connection between real and imagined is all the more marked around the open space in front of these shops, which is filled by a group of dancers whose presence evokes harmony and peace, in a manner that is almost certainly allegorical.[90] Thus, it is the architectural space, social activity and allegorical figures that interact together to form a compound image of the piazza del Campo itself. As such, it seems that the image sought to show the inextricably linked social and built fabric of the city, as viewed from the embracing viewpoint of the Palazzo Pubblico itself. In this way, the image described an inclusive vision of citizenship, which bound the government officials in the 'Sala dei Nove' to the citizens whom they represented, much in the same way as the Campo served as an arena for civic membership that extended outwards from the palace of government.

The piazza del Campo was Siena's main public space; it has rightly been described as the 'civic centrepiece', and has been amply discussed as such.[91] The Campo's setting in the city is almost neutral, as it lies adjacent to the intersection of the three city districts (*Terzi*) and off the main course of the Strada Romana, which skirts around it, and is separated from the piazza by an almost unbroken curtain of buildings (fig. 21). Its location made the piazza a natural market space, and it is as such that it had developed from the earliest documentary refer-

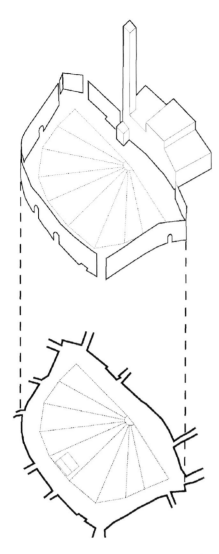

21. Schematic plan of the piazza del Campo and entry pathways onto it.

of the fifteenth century, ensured that the Campo shop-spaces were increasingly only filled by quality retailers such as goldsmiths or cloth merchants, and professionals such as notaries and bankers.[97] The notaries' presence on the Campo, which was marked by an image of the Virgin, known as the 'Madonna dei Banchetti' and painted by Gentile da Fabriano in 1425, was clearly linked to the demand for commercial and official documents in this area, adjacent to the city hall and market areas.[98] Such provisions underlined the fact that commerce was viewed as the mainstay of *bene comune*, and confirmed the Campo as the civic and commercial heart of the city.[99]

Despite the importance of trade and the presence of shops around the piazza, a number of measures established the pre-eminence of the civic authorities over the space, and ensured that decorum was observed in the arrangement of the area. Shop-owners on the Campo were prevented from extending the work-space more than two *braccia* outside their *bottega*; such rules seem to be reflected in Lorenzetti's shop-fronts, which stray very little onto public space.[100] This rule also applied to the narrow lanes and the Costarella, which granted access to the closed bowl of the Campo, thus ensuring an almost theatrical entrance into the civic arena.[101] Restrictions of this sort were thus intended to ensure the dignity of the square while also showcasing the official role of the Palazzo Pubblico and favouring access to it.[102]

The piazza del Campo is dominated by the presence of the government palace – the Palazzo Pubblico – and the civic tower of the Torre del Mangia, which form the natural back-drop to the amphitheatre-like slope of

22. Aerial view of the piazza del Campo in a photograph *c.*1920.

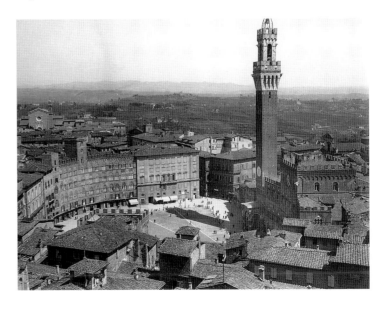

ences to the 'Campus Fori' in the late twelfth century (fig. 22).[92] Already paved by 1262, the piazza was afforded a special dignity in early statutes, which included a number of zoning restrictions.[93] Soon after, in 1297, the city government expressed the intention to create a uniform space, legislating in the city statutes that all buildings on the piazza should have façades that followed the model of that of the Palazzo Pubblico, although by the fifteenth century it seems that such stylistic constraints were no longer applied.[94]

In 1309 various trades and professions had been banned from the central square, including tanners, barbers and the sellers of hay, meat, leather and, perhaps more surprisingly, even saffron.[95] In 1407, grain, flour and poultry markets were transferred from the Campo to the nearby Chiasso dei Pollaioli.[96] These zoning measures, and others like them enforced in the second half

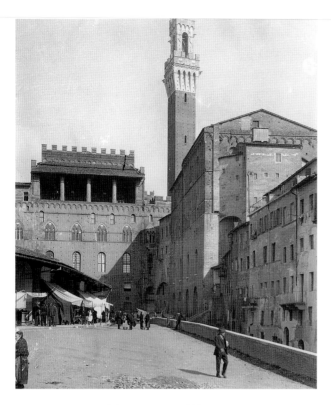

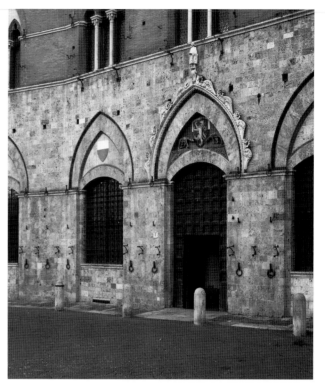

23. Rear view of the Palazzo Pubblico from the piazza del Mercato in a photograph *c.*1920.

25. Ground-floor openings of the façade of the Palazzo Pubblico, with symbols of the Commune over the main entrance.

paved space (see fig. 14).[103] Siena's city hall was the architectural monument most closely associated with the city government of the *Signori*, its patrons and residents, and it is thus not surprising to find that the palace was given a symbolic form as charged as was Lorenzetti's *Allegory of Peace*. For in the Palazzo Pubblico is presented a *summa* of the city's government

24. Plan of the Palazzo Pubblico.

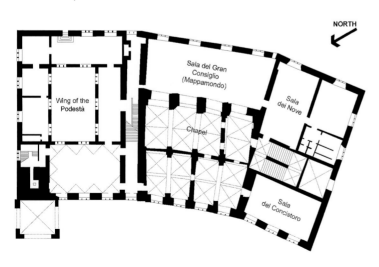

institutions, and their interdependence.[104] Thus, the palace can be divided into horizontal bands: the basement, not visible from the Campo façade, contained warehouses in which the civic monopolies of salt were stored (fig. 23); at ground floor were the administrative offices, first among these the *Biccherna*, the city's formidable tax office (fig. 25); on the first floor were the government chambers of the *Signori* and the Great Council, the decision-making heart of the palace (fig. 26).[105] Such horizontal divisions paralleled a hierarchy of governance, which firmly rested on foundations of primary resources, while an advanced fiscal system brought all citizens into contact with central authority, iconographically legible in the permeability of the arcade-like ground-floor façade (fig. 24).[106]

If the horizontal bands of the palace design transmit the layers of government authority, its vertical divisions separated the different jurisdiction of its constituent parts. Just as in Lorenzetti's fresco the figure of Justice is shown separated from that of the 'Bene Comune', so the Palazzo Pubblico separated the seat of justice from that of government.[107] The residence of the *Podestà*, is housed in the north side of the building and was originally entirely separate from the rest of the palace, as there were no stairs or passages connecting the two

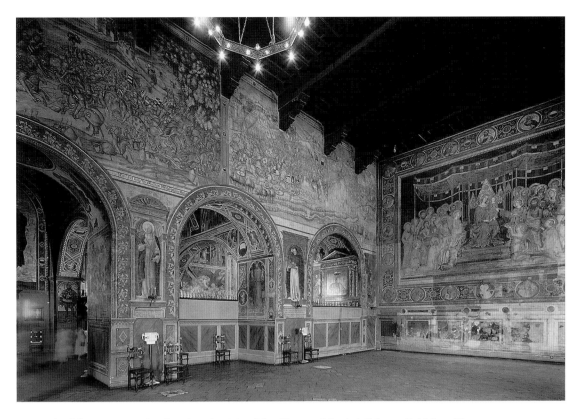

26. Sala del Mappamondo, showing the *Maestà* by Simone Martini. Palazzo Pubblico, Siena.

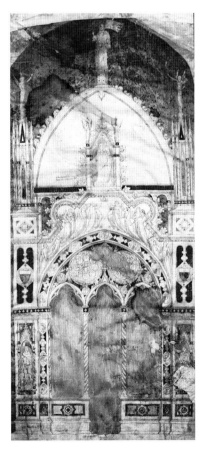

27. Bartolo di Fredi, based on a concept by capomaestro Giovanni di Cecco, a design for the Cappella di Piazza. Archivio dell'Opera Metropolitana di Siena, Siena.

buildings, which were only united on the Campo façade. This architectural division was vital for the separation of the two powers central to the operation of the Republic. In turn, the central block of the building whose vertical prominence mirrors that of the figure of the 'Bene Comune' in the fresco, was accessible to the Great Council, the broadest representative body of the city's government, and consequently the embodiment of its inclusive nature. Finally, to the south side was the residence of the *Signori*, whose inviolability in office was assured by their complete separation from the citizen community for the duration of their mandate.

Of course, the Palazzo Pubblico and piazza del Campo were not merely secular sites of government, but were both invested with sacral functions. Inside the city hall, a lavishly decorated chapel brought the sacred into the place of government, much in the same way as Simone Martini's *Maestà* imposed the presence of the city's heavenly Queen on every Great Council deliberation in the Sala del Mappamondo (fig. 26).[108] Likewise, the civic piazza was sacralized by means of the open-air altar of the Cappella di Piazza, dedicated to the Virgin and erected immediately after the Black Death, as an *ex voto* by its survivors (figs 27–8).[109] The Gothic piers were designed by Giovanni di Cecco with the advice of Bartolo di Fredi from 1374, although this initial design, which is docu-

21

28. Cappella di Piazza in a photograph *c*.1920.

no direct access to a river, and as such the water supply to the heart of the city was of central concern for the Commune. In fact, Siena's water problems were evidently a commonplace, so that even Dante used the citizens' vain search for an underground river (the mythical river *Diana*) as an example to illustrate the sin of pride in Canto XIII of 'Purgatorio', where he refers to 'that vain people which hopes in Talamone (the city's Maremma port) and which will lose more hopes in it than in the finding of the Diana'.[114]

The Sienese did not in fact place their hopes entirely in locating subterranean water-courses; rather, they undertook the extraordinary technological feat of constructing a network of underground aqueducts (the *bottini*), which brought water and removed waste from most of the city.[115] Begun as early as the first half of the thirteenth century, the *bottini* network was made up of over 25 km of tunnels that extended outwards from the city, so as to bring water from rivers and springs to the north in the Chianti hills.[116] The network was largely in place by the mid-fourteenth century, so that by the fifteenth century the principal concern for the civic engineers set in charge of the *bottini* (called *maestri dei bottini*) was to maintain the tunnels, ensure water quality and attempt to increase delivery pressure (fig. 29).[117] Nonetheless, the challenges inherent to the job of the master of the *bottini* seem to have been instrumental in developing the engineering skills of a number of Sienese,

29. View of the *bottini* channels showing the decanting pools that ensured the water was clear at the point of use.

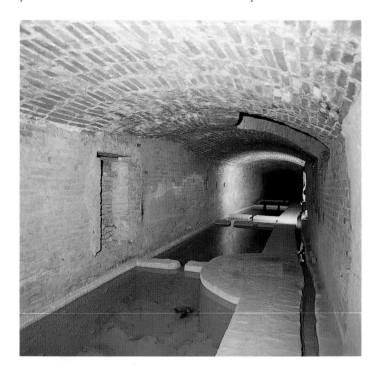

mented in surviving drawings, was left unfinished until 1468.[110] Until that time, a simple wooden roof completed the structure, as can clearly be seen in Sano di Pietro's image of S. Bernardino preaching on the Campo.

Naturally, the great civic, commercial and religious significance assigned to the Campo meant that considerable attention was directed at keeping it clean and clear of building materials.[111] The day-to-day cleaning-up of market refuse was entrusted to a small herd of pigs that would feed on the organic waste left on the piazza; these 'grazing rights' were issued annually as a public contract from as early as 1296.[112] Moreover, the city statutes established that the piazza should be entirely cleaned three times a year, one of which prior to the most important annual religious and civic feast of the Assumption (15 August).[113]

Cleansing public spaces depended heavily on water, which was used to flush waste into the city's sewerage system. However, as is well known, Siena is a city with

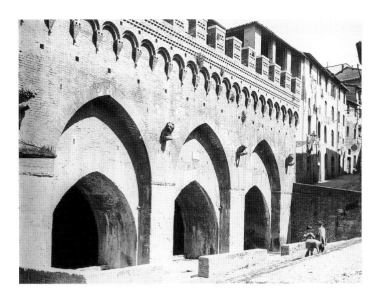

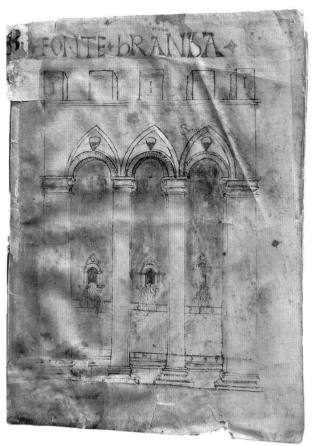

ABOVE 30. Fontebranda, in a photograph *c.*1920.

RIGHT 31. Sketch of the Fontebranda from the cover of an account book (Biccherna 1067) for the maintenance of the city fountains during the fifteenth century. Archivio di Stato di Siena.

most famously 'il Taccola', whose drawings reveal a great interest in hydraulics, and Francesco di Giorgio Martini, who served as *operaio* in 1469 and 1492.[118]

While funding problems appear constantly to have complicated the life of the *operaio*, Siena's *bottini* and the network of fountains (where water was made available to users), was extolled by the local humanist Francesco Patrizi, who in the 1460s wrote of the quantity of water available for all manner of uses, brought to beautiful fountains located throughout the city.[119] Patrizi noted the special attention given to the design of the fountains themselves, which were monumental structures designed to be both functional and a symbol of the city government's role in the provision of water.[120] Fine architectural detailing, sculptural decoration and the use of civic symbols thus gave an outward expression to the otherwise invisible underground infrastructure that provided Siena's community and industries with water.

Thus, for example, the fine fountain at Fontebranda is known to have provided water to the area south-west of the Campo from as early as the twelfth century (fig. 30).[121] Following a series of improvements to the *bottini* that supplied the fountain, a monumental vaulted structure, decorated with stone lions (often attributed to Giovanni Pisano) was constructed around 1246.[122] This was in turn renovated at the beginning of the fourteenth century, when the present fountain was completed; the new fountain reused the thirteenth-century lions, and included them into a three-bay Gothic vaulted struc-

ture, surmounted with a castellated element. Both the brickwork of the crowning level and the arcading that includes the Sienese *balzana* coat of arms closely resemble façade details from the Palazzo Pubblico, under construction in the same years. The cover of a tax register for 1470 in Siena's State Archive shows the fountain as it appeared by the fifteenth century, although it is interesting to note that the draughtsman has altered the rather functional brick and stone piers that support the arches, making them more like classical pilasters, with mouldings at the bases and capitals (fig. 31).

A valuable commodity, water was made available at fountains throughout the city to a hierarchy of uses, beginning with human consumption and progressing to animals, for washing (persons first, then clothes) and for industry, as can still be observed in the arrangement of many city fountains.[123] At Fontebranda water was first made available for drinking, and was then channelled for animals and for industrial use by butchers, tanners and fullers, whose industries were concentrated in the vicinity.[124] It is this arrangement that is documented in Girolamo Macchi's seventeenth-century illustration of Fontebranda, where a sequence of secondary basins, which were filled by the principal fountain, provided for the needs of different users (fig. 32).

23

32. View of the Fontebranda area, from G. Macchi, *Memorie Senesi*, c.1720. MS. D. III, fol. 362 bis, Archivio di Stato di Siena.

A similar arrangement was observed at Fonte Nuova a Ovile, which was built between 1298 and 1303 on a site which had been selected by a committee of artists, including Giovanni Pisano and Duccio da Buoninsegna (fig. 33). Inscriptions record the civic patronage offered for the project, which brought water to an area in which a concentration of butchers and furriers has been documented for the fourteenth century.[125] While by the fifteenth century most industries involved in the processing of animal hide and fur had been transferred to Fontebranda, it is interesting to note that 1463 plans to open a brick kiln in the Fonte Ovile area relied on the ready supply of water.[126]

33. Fonte Nuova a Ovile c.1920.

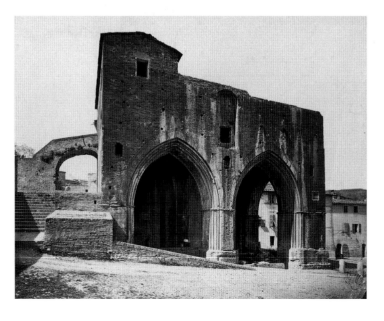

Providing Siena with sufficient water was clearly a major concern for the civic government, although the removal of waste appears instead to have been somewhat overlooked. The only mention made of Siena in Leon Battista Alberti's treatise on architecture reported that

> the sanitation of Siena in Tuscany is poor, because there are no drains. As a result, not only does the whole town stink at the beginning and end of the night watch, when the refuse receptacles are emptied out of the windows, but during the day as well, it is filthy and offensively vaporous.[127]

Alberti's comments may well have been in part motivated by his inbred Florentine antagonism towards Siena, although it is equally true that sanitation was a vexed problem in most urban centres during this period.[128] While legislative measures attempted to limit the unsanitary disposal of waste to night-time, the crude humour of *novella* literature from Boccaccio onwards underlines the inadequacy of legislation in this regard.[129]

For sure, the system of *bottini* brought water into the city, but no comparable infrastructural sewerage system existed. A rudimentary solution appears to have been provided in some areas of the city by open channels of water that ran along the side of streets and evacuated waste thrown from houses, in the manner criticized by Alberti.[130] The system appears to some extent to have been considered as a sewer, so that 1466 plans for a new fountain at Arco Malavolti foresaw the creation of a waste channel (described as a *cloaca*), which exited the city down the steep hill of Vallerozzi.[131] Such a solution took advantage of Siena's hill-top site, so that the downward slopes leading out from the city centre served to remove waste to beyond the city walls. Moreover, the practice of diverting *bottini* water from the streets for private cleaning, condemned by the *Balìa* in 1507, confirms the widespread use of open water-courses along the sides of streets as a public hygiene measure.[132] It also reveals the fact that such channels were supplied by the overflow from the city's fountains, and provides an additional reason for the city's capillary network of fountains, which thus both provided the population with the basic commodity of water, and helped them with the removal of waste.[133]

The virtues of Siena's civic institutions were thus manifest in the monumental infrastructure that provided for the basic needs of the citizen community, but its urban iconography was not limited to these secular monuments alone. As Chiara Frugoni and others have shown, the urban image of Siena was codified from an early date in shorthand representations of the city, which included a number of its most significant monuments.[134] One of the earliest surviving seals of the Sienese Commune, dating to the early thirteenth century, shows a city made up of

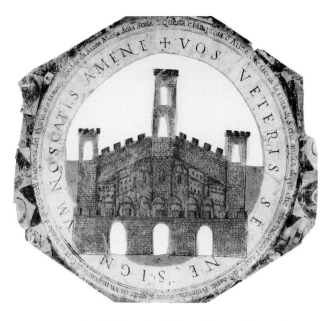

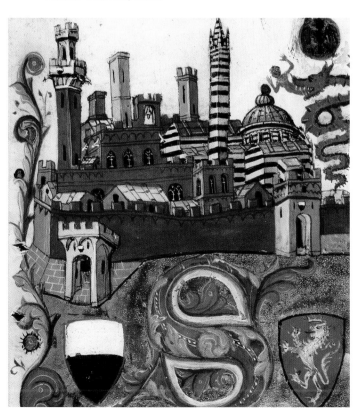

a number of buildings tightly packed within the protective container of the city walls (fig. 34).[135] Although the view is not very detailed, the composition of the cast suggests a hilltop, crowned with a fortified tower, which evokes the oldest settled part of Siena, the highest hill, called the Castelvecchio.[136] The seal defined Siena within its walls, casting an iconographic prototype that was much imitated in the fourteenth and fifteenth centuries. As the monumental form of the urban core came to be defined by civic architectural projects, so too the representation of the city became further defined by inclusion of the city's principal buildings.

Through major and minor artistic commissions from the city's main public offices, as well as religious and charitable institutions, an almost standardized civic

ABOVE 34. Seal of the city of Siena in an eighteenth-century drawing after the early thirteenth-century original (now in the Museo Nazionale del Bargello, Florence). Inv. n° 1691,553, Archivio di Stato di Siena.

BELOW 35. Detail of illuminated letter 's' with city view from the *Liber Censorum*, 1400. Biccherna 746, fol. 10, Archivio di Stato di Siena.

RIGHT 36. Domenico di Niccolò dei Cori, *Siena Offered to the Virgin Mary by the Podestà*. Cappella dei Signori, Palazzo Pubblico, Siena.

iconography of Siena developed. A number of key buildings – what might be described as the 'civic armature' of Siena – were always present in these images: the walls and gates, the Palazzo Pubblico, often the city arms, and usually the Campo and cathedral of S. Maria dell'Assunta. Thus, for example, the *incipit* of a tax register drawn up in 1403, shows the initial 'S' of 'Siena' embroidered around the formulaic representation of the city itself (fig. 35). A few years later Domenico di Niccolò dei Cori executed a similar image as a decorated intarsia panel, perhaps for the choir-stalls of the Cappella dei Signori in the Palazzo Pubblico (fig. 36). These images are somewhat different from the micro-portraits of cities carried by patron saints, such as that in the hands of Blessed Ambrogio Sansedoni in the 'Sala del Mappamondo', for they did not aim at being topographically accurate or comprehensive. Rather, the shorthand rendering of armature evoked the city without recourse to its full rep-

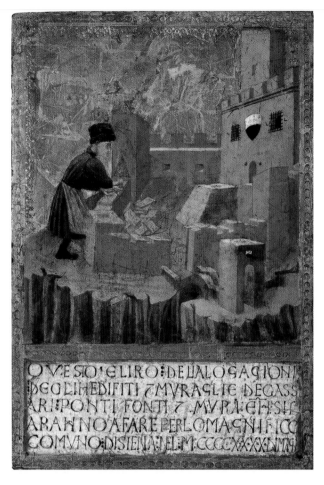

resentation. Thus, once consolidated, the merest hint of the formula was sufficient to evoke the entire image through a process that might be described as a visual synecdoche; so, for example on the cover illustration of a volume listing expenditure for the completion of the city walls and other infrastructure, a gate with the *balzana* coat of arms suffices to summarize the civic import of the enterprise (fig. 37).[137]

A leading role in this civic iconography was also played by the Virgin Mary, Siena's privileged intercessor at the Heavenly court, ever since 1260, when the city had been dedicated to her in the days preceding the famous victory against the Florentines at the battle of Montaperti. Before the battle, on 2 September, the elected military dictator of Siena, Bonagiuda Lucari, led the Sienese in procession through the streets to the Duomo, where a formal pact was made between representatives of the Church and *Comune*, and the city was pledged as a gift to the Virgin (figs 42–3).[138] While the Sienese were by no means unique in their devotion to the Virgin, the extent to which civic patronage was focused on her person in the years that followed Montaperti is exceptional.[139] Such devotion was written into the first rubric of the city statutes, which proclaimed that the city was protected by 'the shield of the most glorious Virgin'.[140] The most important city churches were dedicated to the Virgin: the Duomo, the Spedale of S. Maria della Scala, and its church of ss. Annunziata, as well as the chapels of the Campo and Palazzo Pubblico. Public commissions for images of the Virgin proliferated throughout the later thirteenth and fourteenth centuries, and she could be admired in most rooms in the Palazzo Pubblico, as well as in an extensive narrative cycle of the life of the Virgin on the façade of the important civic hospital and welfare institution, the Spedale della Scala.[141]

The Duomo itself was built on the Castelvecchio, purportedly on the site on the Roman temple of Min-

ABOVE 37. Unknown artist, *Building the City Walls*, 1440. Cover from the register Casseri e Fortezze, 88, Museo delle Biccherne, Archivio di Stato, Siena.

BELOW LEFT 38. Siena cathedral in 1855.

BELOW RIGHT 39. Unknown draughtsman, Piazza Duomo, *c.*1650. Fondo Chigi, P VII 11, fol. 54, Biblioteca Apostolica Vaticana.

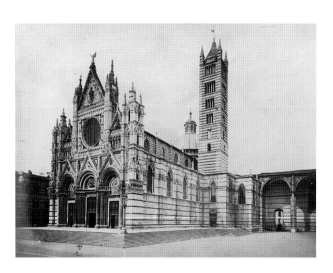

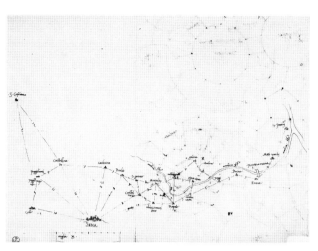

40. Spedale di S. Maria della Scala and hospital church of SS. Annunziata, Piazza del Duomo, 1920.

41. Baldassarre Peruzzi, *Siena and the Valdambra*. Gabinetto dei disegni e stampe, UA 475r, Museo degli Uffizi, Florence.

erva, and was already by 1280 one of the largest churches in Italy; plans for its enlargement, which were abandoned only in 1355, would have made it the largest and one of the most magnificent (figs. 38–9).[142] It remained the central site of civic devotion to the Virgin, as well as containing a large number of guild chapels; active patrons saw to the continuous accretion and modification of the internal organization and decoration of the cathedral space throughout the fifteenth century.[143]

The urban arrangement of the buildings facing the Duomo, around the piazza del Duomo, was also well established by the fifteenth century, articulated on the north side by the Casa dell'Operaio, Duomo and Episcopal Palace, and to the south by the multiple façade of the Spedale di S. Maria della Scala, containing as it did, the church of ss. Annunziata, the Casa del Rettore and various hospital buildings (fig. 40).[144] The Spedale's varied tasks of care, hospitality and assistance were described in frescoes in the main pilgrims' hall by Vecchietta, Priamo

della Quercia and Domenico di Bartolo in 1440–49.[145] These frescoes were shown to most honoured visitors, and were seen by innumerable pilgrim travellers.

In these frescoes, discussed further in chapter Two, the civic emblems of the Commune's coat of arms and images of the Virgin Mary, again highlighted the public patronage of welfare and monumental architecture. Just as the succinct shorthand images of the city described Siena by its major public buildings, so the referencing of those same buildings in larger painted cycles fed into the process of constant affirmation of civic identity. Such a dialogue between built form and painted image remained constant throughout the fifteenth century. Indeed, a remarkable drawing of the northern and eastern part of the Sienese state made by Baldassarre Peruzzi in the 1520s, shows Siena standing out from the smaller towns, on account of the vertical elements of its defining monuments, the Palazzo Pubblico and Torre del Mangia, the Duomo and its bell-tower (fig. 41).[146]

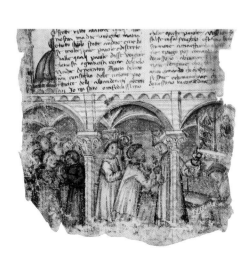

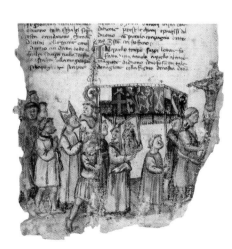

LEFT 42. *The Keys of the City offered to the Virgin Prior to the Battle of Montaperti (1260)*, from Niccolò di Giovanni Ventura, *Chronicle of Montaperti*, 1442. MS. A IV 5, fol. 4v, Biblioteca Comunale degli Intronati, Siena.

RIGHT 43. *City Procession with the Image of the Virgin*, from Niccolò di Giovanni Ventura, *Chronicle of Montaperti*, 1442. MS. A IV 5, fol. 5r, Biblioteca Comunale degli Intronati, Siena.

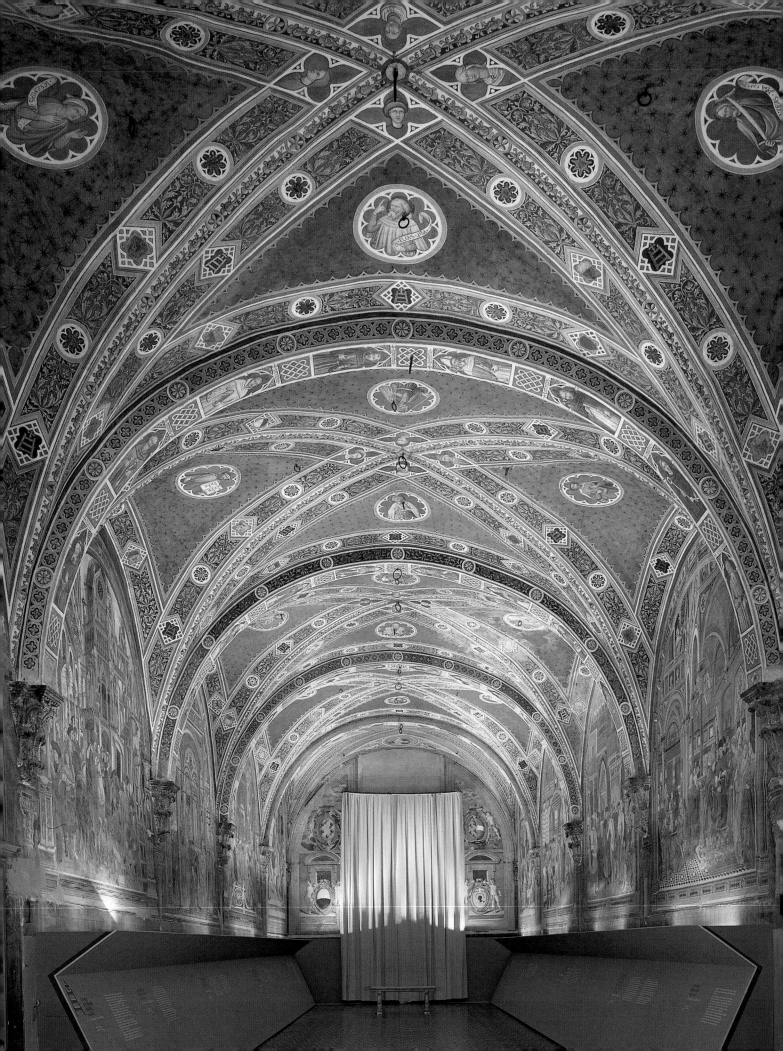

2

The Imperial Visit of Sigismund of Luxemburg

THE URBAN EXPERIENCE OF RITUAL

The Emperour Sigismond enteryng into the town of Scene in
Tuskane, what honours he receiued: is all redy euery wher published.[1]

Ambrogio Lorenzetti's painting, while not a mirror of a historical reality, is nonetheless a product of it (fig. 45).[2] Similarly, Renaissance literary fiction is a product of its time and envirionment, and provides a useful source for urban history.[3] In earlier works of literature and art, such as the *novelle* in Boccaccio's *Decameron* or Simone Martini's 'Blessed Agostino Norello' altarpiece in the Pinacoteca Nazionale in Siena (fig. 46), contemporary urban culture informed and structured the narrative moment, providing loose latrines from which anti-heroes might collapse into slurry pits, or balconies for miraculously cured children to fall from. But the city was also the source for its own narratives, which were most clearly articulated in the displays that accompanied the ritual calendar.[4] On guild or civic feast days, as on the occasion of visits of eminent dignitaries, the city became a stage, and the ordinary and implicit was rearranged to appear explicit and remarkable.

Urban rituals staged the theatre of social interaction in the physical fabric of the city. Urban life and cere-monial events were inextricably linked, as Antonio Averlino, 'il Filarete', commented in his treatise on architecture: 'the city is large, therefore it needs cere-monies'.[5] Rather than describe a setting, as does the painter with a brush or the author with a pen, masters of ceremony created alternative or parallel visions of the city to form the settings for ritual narratives.[6] To this end, ephemeral architecture, with temporary displays and ornaments, enhanced and altered the built envi-ronment. In turn, such ephemera frequently prefigured permanent architectural change, almost as if the ritual moment functioned as a dress rehearsal for actual urban renewal.

Siena's geographical location on the major north–south axis of the via Francigena meant that the city nat-urally constituted a rest-stop for pilgrim travellers and diplomatic envoys as well as princes and rulers bound to and from Rome. During the fifteenth century, Siena received visits from three Holy Roman Emperors, numerous popes, King Charles VIII of France (1494) and

FACING PAGE 44. The Sala del Pellegrinaio, Spedale di S. Maria della Scala.

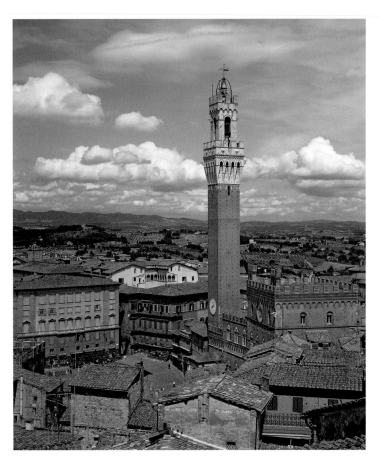

45. General view of the city.

46. Simone Martini, detail showing the miraculous cure of a boy fallen from a balcony, from the altarpiece of the *Blessed Agostino Novello,* 1320s. Pinacoteca Nazionale, Siena.

King Christian I of Denmark (1474).[7] Most of these, and numerous other visits, were preceded by diplomatic exchanges and frenetic preparations, which aimed to present the city in a favourable light. Not all visitors were especially welcomed in political terms; the memory of a coup that had brought an end to the government of the Nine, supported by the presence of Emperor Charles IV in 1355, served as a salutary reminder of the emperor's power to catalyse political faction and opposition.[8] The half-century following the fall of the Nine had been marked by continuous internal conflict and political experimentation involving diverse political groups that came to be known as *Monti.*[9] The *Monti* were groups of varying size and social make-up, formed from the original families associated with the succession of these fourteenth-century governments, the 'Nove' (Nine), 'Dodici' (Twelve), 'Popolo' (People), 'Riformatori' (Reformers), as well as the 'Gentiluomini' (Nobles), who had been excluded from participation in elected city council in 1277 (fig. 47).[10]

47. Election lists to public offices in the city government, showing distribution by Monti. ASS, Consiglio Generale (Elezione e Cerne) 408 (July 1471 – January 1483), fol. 112, Archivio di Stato, Siena.

By the end of the century, Siena's internal divisions led to its easy take-over by the expansionist Duke of Milan, Gian Galeazzo Visconti, whose short rule came to an end with his sudden death in 1402.[11] In the aftermath of this brief period of *signoria,* Siena reverted to a republican government type that brought together the interests of three *Monti,* in what was described a 'governo trinario', a three-party coalition that was exclusive of magnate or noble families.[12] This relatively stable situation lasted through the first half of the fifteenth century, and it is thus perhaps not surprising to find that some government opposition was raised with regard to the visits to the city by Emperor Sigismund

48. Miniatures from Aeneas Silvius Piccolomini's *Historia de duobus amantibus*, taken from the French translation by Octovien de Saint Gelais, in the illuminated 1493 edition printed on vellum, Paris, ed. Antoine Verard. British Library, London.

of Luxemburg in 1432, and the two papal visits of Martin v in 1423 and Eugenius IV in 1443.[13]

This chapter is constructed around the triumphal entry and sojourn in the city of Emperor Sigismund, in 1432 one of the most extraordinary ritual events that marked the second quarter of the fifteenth century in Siena. His *entrata* and visit was widely described in contemporary sources, and was recorded by a remarkable literary text, a Latin *novella* by Aeneas Silvius Piccolomini.[14] The triumphal entry of Sigismund to Siena is described in some detail below, as the topographic progress of the Emperor through the city serves also as the reader's entry point to the built environment of the early fifteenth-century city. The Emperor's long stay in

Siena acted as an important catalyst for urban renewal in the decades that followed, resulting in the enhancement of the built façade of the city. Such visits were inextricably linked with the process of urban renewal.

A Narrative Experience of the City

Piccolomini's *Historia de duobus amantibus*, a romantic bestseller of the fifteenth century which had gone through over thirty editions and numerous translations by 1500, took Siena as the setting for the love story between the German nobleman Eurialus and a Sienese damsel, Lucretia (fig. 48).[15] The events take place in the

streets and palaces of fifteenth-century Siena, beginning with the young wife of an elderly burgher glimpsing a German nobleman as he passes by the window of her home; she falls in love with him, as he does with her.[16] Over the period of a few months, glances, messages and promises are exchanged, the German enters the woman's home by scaling the palace walls while her husband is out of town on his country estates, and they become lovers. The couple often meet, sometimes with the aid of a helpful servant, and repeatedly risk being discovered by the possessive husband, Menelaus, whose namesake is the cuckolded husband of Helen of Troy. Eventually, however, their love is sundered when the unchivalrous hero leaves his fair damsel, returns to his homeland and, on the insistence of his master, marries a local duke's daughter. Like Aeneas who left his Dido to go on to found Rome, and unlike Paris whose love for Helen led to the fall of Troy, Eurialus placed professional duty and the visible marks of chivalric conduct above his affection for Lucretia, abandoning her in Siena while he continued in his professional career, although perhaps with a broken heart.[17]

The tale itself is understood to be a *roman à clef*, with Kaspar von Schlick, an influential nobleman in the entourage of Emperor Sigismund of Luxemburg, taking the role of Eurialus and an unidentified Sienese woman that of Lucretia.[18] The occasion chosen as the setting for the narrative was the Imperial visit of Sigismund to Siena between July 1432 and April 1433, during which time his large court took up residence in the city, prior to going to Rome, where Sigismund received the Imperial crown from Eugenius IV. The reasons for the long stay can be traced in the political conflict between Eugenius and the Emperor, which translated into a Siena–Florence conflict on a more local scale.[19] Thus, the fictional romance was at least in part grounded in the reality of the author's home town, and at a specific moment of contact between the enormously different cultural contexts of Sigismund's court and the communal city. It seems evident that it was the author's intention to make much of this unusual circumstance, and that a dual audience was envisioned for the tale, on either sides of the Alps.[20] Certainly, as two of the dedicatory letters to the text indicate, the original manuscript was sent to two directly interested parties in Siena. The first letter was addressed to a Sienese friend and teacher of Piccolomini's, the jurist Mariano Sozzini, who had lectured at the Sienese *Studium* in the years that Piccolomini attended it around 1430.[21] Sozzini had apparently asked that the story be written, and Piccolomini made much of the inappropriateness of writing such a racy narrative for such an old audience; he was forty, Sozzini over fifty (fig. 49). The second letter was

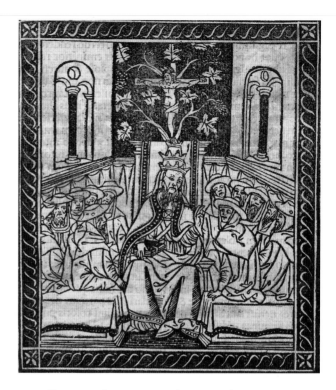

49. Illustration from Aeneas Silvius Piccolomini's *Historia de duobus amantibus*, Venice, Giovanni Battista Sessa, 12 January 1503. British Library, London.

addressed to Kaspar von Schlick, who had been Imperial Chancellor to Sigismund, and in that role was certainly in Siena in 1432–3, which can be proved by the extensive correspondence with the Sienese government in the lead up to the visit, signed in his master's name by Schlick himself.[22] In this dedicatory letter, Piccolomini referred to Siena as a 'city of Venus', and made it quite clear that that the story was based on Schlick's amorous adventures in Siena.[23]

Aeneas Silvius Piccolomini wrote the story and the letters in 1443–4, with the first dedicatory letter to Sigismund Duke of Austria (not the Emperor), dated 13 December 1443 and signed in Graz, indicating that he wrote the tale ten years after the events that they describe.[24] Piccolomini was in Germany, where he had recently taken service as secretary to the Imperial Chancery of the new Emperor, Frederick III; the Imperial Chancellor was none other than Schlick. Not only was Piccolomini in Germany at the time that he wrote the story, but he was also absent from the city when the events took place: from autumn 1431, he was at the Council of Constance, a young humanist in the entourage of Cardinal Domenico Capranica.[25] In spite of his lack of any first-hand knowledge of the events, Piccolomini was clearly well informed regarding the visit and its amorous side-effects in his beloved Siena. He

reported in the opening line of the story that 'all have heard of' Sigismund's visit; we can assume that he was kept appraised of the goings on both through correspondence and later discussion with participants. The fictionalized version of the events thus relied on written and oral accounts, enriched by Piccolomini's own romantic experiences in Siena.[26] Indeed, it is worth reading beyond the love story, to the context of the tale, in order to see what is revealed about Siena, since the city is clearly also a character in the story.

Fact and fiction inevitably elide in Piccolomini's tale, where Siena's physical setting serves as the catalyst for the narrative moment. Significantly, Paolo Viti has noted that the first Italian translation of the tale, made by Alessandro Braccesi for Lorenzo di Pierfrancesco de' Medici in 1478–9, suppressed a number of the references to Siena in order to make the story have a wider appeal to his Florentine patron.[27] Nonetheless, Siena's location on the main route to Rome, as well as its traditional connection with the Empire, made it an ideal setting for a story that revolves around strangers meeting and falling in love.[28] As was discussed in the previous chapter, Siena lay on the via Francigena and as such was an obvious place to stay on the path to Rome. Strangers passing through – students, pilgrims, diplomats and princes – were a common feature of the city's life; a ceremonial existed for dealing with these events, but as the story suggests, there must have been a good deal of social interaction which prescinded from the norms of planned ritual behaviour. Conflict, as much as harmony, was a feature of visits of all sorts, and both legislation and the city's built form were marked by these contingencies. Indeed, the very way in which the fifteenth-century city developed was conditioned and shaped by the city rulers' desire to direct a specific image of Siena to passing travellers and visiting dignitaries alike.

Sigismund in Siena: The Urban Experience

Piccolomini's *Historia de duobus amantibus* is but one of many accounts of Emperor Sigismund's visit to Siena. Given the diplomatic and political significance of the prestigious visitors' arrival and stay in the city, the event is well documented in a variety of published and unpublished sources, ranging from the government deliberations that prepared for his arrival to a number of diaries, as well as iconographic records. Since these narratives all describe the same events, that is the arrival, entry, procession through the city and festivities in honour of Sigismund, these accounts afford the reader a view of Siena that is informed by multiple contemporary viewpoints and interpretations. These accounts, the recorded voices of contemporary viewers, grant us access to the shared and exclusive memories attached to the buildings and streets of Siena at the beginning of the fifteenth century.[29] In approaching the documentary evidence that describes the events of 1432–3, the account that follows privileges narrative description that locates events in a physical context, and applies Kevin Lynch's concept of urban 'imageability' to the urban context of Siena during that time.[30] A compound narrative that collates the evidence provided by these many sources thus allows us to view the city prior to the considerable changes that were to transform its built face over the course of the century. The image of the city that emerges from this study is incomplete and disjointed, but captures the interwoven roles of the urban tissue and the citizen body.[31] Moreover, since Sigismund's visit was rather protracted, it is also possible to view the permanent effects of the stay in the legacy of architectural renewal which coincided with and followed from it, as is shown in the following chapter.[32]

As Richard Trexler has shown, city celebrations were rarely neutral events, and frequently had the propagandistic function of civic self-promotion.[33] Ceremonial rituals offered to official visitors to the city were more complex, in that these needed to balance civic interests with the appropriate respect due to the visitors themselves.[34] Siena's location meant that it was a place of transit for visitors travelling to and from Rome. While the majority of visitors simply passed through, more important travellers could not overlook the political significance of their Sienese stays; their visits, as we have seen, were a cause for both civic pride and for alarm, as powerful visitors posed a possible threat to government stability but were also honoured with magnificent public welcomes.[35] Trexler has said of Florence that on these occasions 'the city celebrated its ability to attract such honourable persons, yet in doing so it admitted how central the visitor was to its own identity'.[36] So too in Siena, visitors were honoured, but in their participating they were themselves used to reinforce and corroborate relevant aspects of the civic image through their involvement in ritual events.

In spite of the benefits of welcoming powerful guests into the city, diplomatic negotiations frequently preceded entries, and attempts were often made to avoid them. The lead up to Sigismund's visit can be traced in both diplomatic correspondence and council deliberations, which both aimed at safeguarding the government's stability as well as the city's honour. On 3 March 1432, three Imperial ambassadors arrived in Siena to negotiate terms for the visit; they were housed at the

50. Unknown artist, perhaps Girolamo di Benvenuto, *Arrival of the Ambassadors*, 1498.
Biccherna n° 46, Museo delle Biccherne, Archivio di Stato, Siena.

Albergo alla Corona and were invited to the Palazzo Pubblico to discuss the length of the stay and possible housing arrangements for the court (fig. 50).[37] The immediate result of this first meeting was that the Sienese declared themselves willing to welcome the Emperor, and letters were sent to invite him to the city. It seems that this first visit was rather expensive for the Commune, as a second delegation of May 1432 was assigned a fixed entertainment budget even though the imminent arrival of the Emperor meant that more concrete business resulted from these meetings.[38] In fact, the Sienese reluctance to spend much on the ambassadors may well have been intended to anticipate their stance as regarded the matter of finances for Sigismund's own stay.

Within a week of the second embassy's arrival, the Signori had decided on a series of provisions on which Sigismund's Sienese visit was to be conditional.[39] The Emperor was required to make Siena a 'Vicario dell' Impero' in perpetuity, and he was requested to pledge

that the current *reggimento* (government) and Statutes would remain unaltered, that the city would be absolved from any extant Imperial *censi* (feudal gifts) and that rebels and exiles named by the Commune should be recognized as such. Clearly, these conditions were intended to assert the city's independence from Imperial power, and to limit the politically destabilizing effects of the Emperor's presence in Siena. Visits by foreign powers, and particularly of the traditional figurehead of Ghibelline authority in Siena, presented a potentially polarizing force for politically disaffected city factions, many of whom were exiled for the duration of the stay, and such provisions were made to prevent possible uprisings.[40] To this end, it was also decided that a permanent guard made up of the city militia would be 'required to be on duty day and night to protect the Emperor and the present government', and the *condottiere* Lodovico Colonna was hired with his company of 200 mercenaries as a further guarantee of protection.[41] Four ambassadors were also named and sent to Sigis-

mund with the unenviable task of informing him of these decisions and of the fact that on account of the city's onerous military expenses, they were going to be unable to support the costs of the visit.[42]

While these decisions made a clear statement of Sienese independence, and reduced the outward marks of respect to the guest by implying that he should pay his own way, a series of internal decisions were made to ensure the magnificent reception and honourable housing of the Emperor and his court. A committee was named to seek out and secure appropriate properties to house the court, it was decided that 'a beautiful gift of a golden chalice' should be presented to him, that 5–6,000 florins would be budgeted for the stay, and that a rota of men, among whom 'at least two will be *literati*', was to be delegated to accompany Sigismund in his movements about the city.[43]

Thus the Emperor would be honourably housed in select buildings in the city, he would be given a valuable piece of (presumably local) craftsmanship, would be treated with appropriate magnificence, and be surrounded by the educated conversation of Siena's intellectuals. As the visit became imminent, so preparations became more frantic. On 8 July, it was decided that silverware and other ornaments from the Palazzo Pubblico would be borrowed for the Imperial apartments.[44] On 9 July, just three days before the court's arrival, it was decided to paint up the Imperial arms on the façade of the Palazzo Pubblico, below the IHS monogram of S. Bernardino, but above the arms of the Commune (fig. 51).[45] The plaster must still have been wet when Sigismund arrived! Nonetheless, the eagle on a gold ground is prominent on the Palazzo Pubblico façade painted in 1444 by Sano di Pietro in his *S. Bernardino Preaching on the Campo*, suggesting that the visit lived on in the collective memory.

Certainly, the remarkably comprehensive accounts kept by the officials 'pro novo adventu Imperatori' reveal the degree to which the momentum and enthusiasm (and consequently expenditure) for the visit grew as the Imperial *cavalcata* came closer to the city.[46] The notebook is prefaced by the names of the six committee members, who record that

> In the name of the Glorious Omnipotent and Eternal One, and his holy mother the Holy Madonna Mary, Ever Virgin, and of the glorious apostles, M.ʳ St Peter and M.ʳ St Paul, and of the glorious saint M.ʳ John the Baptist, and of the evangelists and the glorious martyrs, Ansano, Savino, Crescenzio and Vittore, and generally of the entire celestial court of paradise, to whom with devout prayer we ask to do all the things that will be for glory and praise, and that we will be able to provide

51. Detail showing the Imperial arms on the façade of the Palazzo Pubblico, from fig. 1, Sano di Pietro, *S. Bernardino Preaching on the Campo*.

> with good principles and praiseworthy success for the ordering of the rooms for his Majesty the Emperor, to the honour and estate of the magnificent commune of Siena. And so should God wish it to be.[47]

Though formulaic, this statement reveals the degree to which moments of civic pride were viewed as manifestations of the reflexive relationship which bound Siena to its celestial court. As numerous scholars have shown, the image of the *Maestà* (Virgin in Majesty) had a special significance in Siena, as the Virgin was viewed as the city's divine protectress as well as being the Queen of both heaven and the city.[48] It is specifically such an image that is evoked in the committee members' dedication of their work, to the glory of the city and to the celestial court, with the Virgin as Queen and mother, and the local patron saints (Ansano, Savino, Crescenzio and Vittore) interceding for the polity. Perhaps also, in view of the arrival of the vast Imperial court, the Sienese

52. View of the Porta Camollia area, from G. Macchi, *Memorie delle chiese senesi*, c.1720. MS. D. III, fol. 366, Archivio di Stato di Siena.

invoked inspiration from their own magnificent celestial equivalent. Indeed, evidence suggests that the city governors made a conscious effort to transfer some of this image of courtly splendour to Siena's streets and palaces. Thus, large numbers of payments document the painting of arms, shields and courtly devices to be displayed in public places.[49] Likewise, tapestries were borrowed wholesale from Siena's citizens to decorate the rooms prepared for the Emperor and his courtiers; many of these bore the heraldic symbols of their owners, which must have made for quite a muddle of family symbolism when they were all grouped together at one venue.

The Imperial entry occurred, from Siena's northern gate at the Porta Camollia, on 12 July 1432 (fig. 52–4).

53. Porta Camollia area, detail from F. Vanni, *Sena Vetus Civitas Virginis*, fig. 10.

The Camollia area was made up of a complex sequence of three gates, which provided a succession of defensive barriers, while also granting access to the city by mediating the transition from the *contado* to the urban fabric by literally funnelling travellers onto the central axis of the Strada and exposing them to a sequence of civic imagery.[50] Furthest from the city walls was the so-called Torrione Dipinto, which displayed a large fresco of the 'Assumption of the Virgin'.[51] Inside the Torrione Dipinto was a loosely defined area known as the Prato di Camollia, a non-walled area flanking the Francigena. Bounding the Prato to the south was the Torrione di Mezzo, which was connected by an earthwork to the Porta Camollia itself, creating a protected area outside the city walls known as the 'Castellaccia', densely filled with shops, inns and *spedali* (hostels/hospitals), which had special functions in the care of pilgrims.[52] As is perhaps most clearly shown in a Biccherna cover showing 'The Battle at Porta Camollia' (1526), attributed to Giovanni di Lorenzo, in the Archivio di Stato in Siena, this sequence of gates provided an out-of-town setting suited to defensive functions as well as ritual events, which would be framed by civic symbols, the most powerful of which was the cityscape itself. While unfortunately little is known of the original decoration of the Porta Camollia, Siena's dedication to the Virgin was prominently displayed in frescoes on the Torrione and gate.[53] Moreover, the lost image of the 'Coronation of the Virgin' above the Porta Camollia, painted by Simone Martini with Lippo Memmi before 1345, is thought also to have borne the inscription 'Sena Vetus Civitas Virginis', further confirmation of Siena's divine protection.[54]

It was in the large open space of the Prato di Camollia that the ritual meeting between the Emperor with his court and the civic and religious authorities took place (fig. 55).[55] This amounted to a huge gathering of people, as not only the city authorities but also large crowds of citizens converged on the Prato to meet the court, which the chronicler Tommaso Fecini estimated as numbering upwards of 1,532 people.[56] Banners, standards and flags bearing the arms of the Empire (a black eagle), the Duke of Milan (the Visconti arms), of the Commune of Siena (the *balzana*: the black and white shield) and *popolo* (lion on a red ground) defined the meeting space in heraldic terms. Furthermore, a ceremonial canopy (*baldacchino*) had been prepared for the event, also decorated with the Sienese symbols and those of the visiting guest, in an arrangement that probably resembled the baldachin painted in Simone Martini's *Maestà* in the Palazzo Pubblico.[57] Framed by these permanent and ephemeral symbols of Siena's civic independence, the ceremony of meeting took place, at the

ABOVE 54. Attributed to Giovanni di Lorenzo, *The Battle at Porta Camollia*, 1526. Biccherna n° 49, Archivio di Stato in Siena.

BELOW 55. Lorenzo di Pietro, called 'il Vecchietta' or his workshop, *Sienese Government Officials Receiving an Embassy*, c.1440. The Barnes Foundation, Merion, Pennsylvania.

end of which the Signori offered Sigismund the keys of the city. Sigismund accepted them, kissed them, and returned them to the city governors, saying to them 'You be the protectors of your own city of Siena'.[58] The significance of this gesture was noted by all those present, and was even recorded in the government deliberations, which rarely mentioned events that took place outside the walls of the decision-making halls of the Palazzo Pubblico.[59]

Entry from the Porta Camollia naturally followed the Strada Romana, the section of the via Francigena that cut through the heart of the city, skirting around the Campo and proceeding south to the Porta Romana, towards Rome. The processional route was decorated in honour of the visitors, and Tommaso Fecini reports that shields had been hung on every palace and street corner, displaying the coats of arms of the Empire, the Duke of Milan and of the Commune of Siena.[60] A number of these shields had been commissioned from artists as part of the preparations for the visit, including works by Giovanni di Pietro and other lesser-known painters. Descriptions of later ceremonial entries recount the theatrical nature of these processional progresses, in which citizens viewed events from the sides of the narrow streets and from the balconies and windows of their houses, which were themselves beautified with temporary decorations such as garlands and carpets hung out from windows.[61] The many churches that lined the street would have been open, candles burning at the altars, their altarpieces and relics on display. The size of the Imperial entourage, the large number of horses, knights and other dignitaries, all presumably dressed in splendid and, for the Sienese,

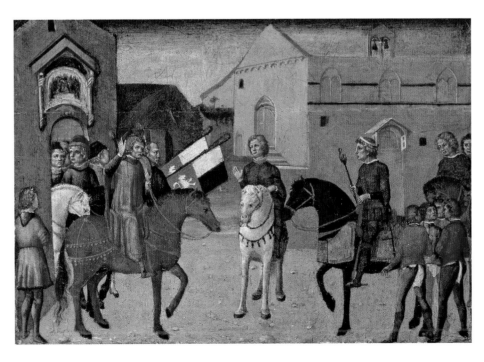

unusual clothes, responded to the civic welcome of display with a courtly show of their own.

While the ritual greeting at the Porta Camollia had brought together the civic and religious authorities, the first official destination of the leading guest was to the Duomo of S. Maria dell'Assunta, where he was to pay his respects to the pantheon of Sienese saints and the Virgin Mary. Having already symbolically returned the keys of the city to the Signori outside Porta Camollia, the Emperor thus also acknowledged the spiritual Queen of Heaven and Siena, thus recognizing the spiritual and secular authorities of the city in the first few hours of his stay. It is significant that it was immediately after this that the ritual moment of hazing occurred, when the ceremonial canopy under which Sigismund had been accompanied through the city's streets to its heart at the Duomo, was seized by a mob of citizens, who destroyed it by ripping it to pieces. This was an act of violence ritually perpetrated on an honoured guest, which both brought him down to the level of other citizens and physically diffused his presence throughout the city as the relic-like scraps of cloth from the canopy were taken back to the citizens' homes.[62]

By this time, Sigismund had reached his appointed residence near the Augustinian convent of S. Agostino, the so-called Palazzetto di S. Marta at Porta Tufi (fig. 56). The palace stood outside the ring of the old city walls of Castelvecchio and the functioning gate of Porta all'Arco, facing the open space of the Prato di S. Agostino; behind was open countryside and gardens as far as the city walls, making it practically a suburban site. It was historically significant as having been originally built as a hospice by the Bishop Donusdeo Malavolti around 1384, and was regularly used as a residence to house Siena's most honoured guests.[63] The palace had been given a thorough, if rapid, overhaul through the month of June, with many artisans employed on the task, including the well-known intarsia master, Domenico di Niccolò dei Cori.[64] A new kitchen was built, presumably to provide the necessary catering for the vast entourage.[65]

Considerable attention had been paid to providing the house with furniture, such as the chests (*cofani*), cupboards (*madie*) and three beds borrowed from Niccolò di Antonio Tolomei, of which one was decorated with paintings and two with wooden intarsia work.[66] Furthermore, the palace had been lavishly decorated with large numbers of tapestries and carpets, which the Commune hired from general citizens, tapestry-sellers and religious institutions alike for the duration of the Emperor's stay. These included 'a large carpet in the French style, in many colours' from the banker Francesco di messer Marco, as well as 'a wall hanging paint

56. Site of Palazzetto di S. Marta, to the west of S. Agostino, as seen in a drawing attributed to Vincenzo Ferrati. MS. S II 1, fol. 68, Biblioteca Comunale di Siena.

ed with many large figures' loaned by the bankers Galgano and Giovanni di Guccio Bichi.[67] Perhaps most remarkable of all was a set of twelve tapestries rented from the presumably very successful shoemaker Meo di Francesco di Mino, among which were one depicting stories of Alexander (the Great) and another of Solomon (and Sheba).[68] These tapestries were evidently so much admired that the Commune did not return them to their owner at the end of the Imperial stay, but instead bought them from him for use in the Palazzo Pubblico.

In the days that followed the court's arrival, a series of audiences were held in the Palazzetto, when the Emperor variously met with the Signori, the Bishop, the Rector of the Spedale of S. Maria della Scala and delegations from the city's major and minor guilds.[69] On 19 July, the Signori presented Sigismund with an ivory chest filled with 4,000 gold florins, while gifts of vast supplies of food were also made, and staples such as wine, fruit and bread were sent daily.[70] Clearly then, in a short time Sigismund's presence in the city became an accepted fact, as did the consequence that the Commune was to pay a high cost for his presence. Records of additional payment of funds to the Emperor are not infrequent, indicating that the initial decision to limit the costs of the stay to 6,000 florins had been completely abandoned. However, there is no sense that the *Signori* resented his presence, rather it seems that high hopes were placed in the possibility that in settling Sigismund's problems with Eugenius IV, Sienese peace with Florence would also be achieved. As if to confirm the unconditional acceptance of Sigismund's presence,

throughout the period of his stay the Great Council deliberations were prefaced with the usual references to the government and religious intercessors, to which was added the phrase, 'during the residence in Siena of the Most Serene Emperor Sigismund' (fig. 57).[71]

So permanent was the court's presence in the city, that we can imagine a courtly topography overlaid on the usual habits of the city.[72] While unfortunately little is known about the housing and provisioning of the courtiers residing outside the Palazzetto di S. Marta, it is nonetheless clear that numerous private homes and institutional structures were given over to receiving these people.[73] Thus, we know that courtiers were housed in guesthouses at the convents of the mendicants, at S. Francesco, S. Domenico, S. Agostino and S. Maria dei Servi as well as with the Umiliati and at S. Donato and S. Spirito. Religious foundations tended to be the largest structures in the city, and many provided facilities for travellers, although perhaps these were not especially well appointed. Much the same can be said for the vast Spedale di S. Maria della Scala, Siena's principal charitable foundation dedicated to the care of the sick, orphans and pilgrims, and the Sapienza, the residential buildings attached to the university, where other members of the court were housed. Finally, numerous private homes, including that of the heirs of Niccolò Tolomei, Antonio Gallerani and the residence of the Operaio of the Duomo were also provided, presumably for the more important courtiers. Tommaso Fecini reports generally that the courtiers were satisfied with their lodgings.[74]

By viewing the lodgings of the Emperor and the court on a map, it becomes clear how the Palazzetto di S. Marta created a new centre of influence in the political geography of the city, as local groups of citizens as well as members of the court attended meetings with the Emperor. The location of the Palazzetto was well-suited to such para-governmental functions; while the via del Casato connected the palace precinct directly with the Campo and city government offices in the Palazzo Pubblico, the perimeter of the twelfth-century city walls and the gate of Porta all'Arco separated the civic authorities from the Imperial court. Although the Sienese government wished to limit the influence of the Emperor in internal politics, they conversely took advantage of the presence of Imperial authority in the city to settle matters of foreign policy. Throughout the summer of 1432, Sigismund was called into Sienese negotiations with Florence and the papacy, and eventually on 27 August, the Emperor was invited to the chamber of the *Consiglio Generale*, where he was given the command of the mercenary army of Piccinino and food supplies for the troops.[75] The process that culmi-

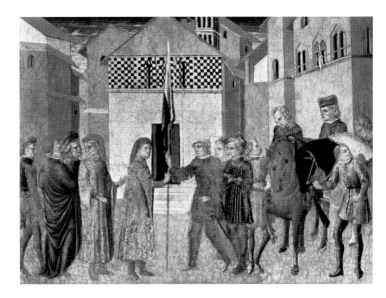

57. Lorenzo di Pietro, called 'il Vecchietta' or his workshop, *Piazza Tolomei and S. Cristoforo*, *c.*1440. Keresztény Múzeum, Esztergom.

nated in the invitation of the Emperor into Siena's council chamber, reveals the degree to which Sigismund and his court were adopted into the city's political life, while a number of examples illustrate the social and cultural exchange between the Sienese and their guests.

The sense in which the court's presence had become a given in the city is well captured in the *Historia de duobus amantibus*, in which Eurialus is described as riding along 'as usual' between his lodgings and those of the Emperor at S. Marta, following a route that passed by the palace of Lucretia.[76] Again, Piccolomini narrates that 'the Emperor frequently went out riding and passed often along that street [where Lucretia lived], noticing that the woman blushed when she saw Eurialus'. The text calls to mind Lorenzetti's image of the city in time of peace, where a wedding procession passes by at street level, while people watch from the balcony above. No documents survive to prove the movement of non-fictional courtiers about the city, but it seems clear that the establishment of the Imperial court at S. Marta, and the focus there of the court's daily life, must have created new paths of movement through the city, underlining the presence of a new source of patronage within Siena's walls. Consequently, it is interesting to observe not only the informal effects of such movement in subverting the social habits of the Sienese, such as in the tale of Eurialus and Lucretia, but also the formal strategies adopted by the government to control the image and authority of the Emperor.

Three weeks after the Emperor's arrival, and following his private meetings with the city's dignitaries, a

staged moment of ritual encounter between Sigismund and Siena's citizens was arranged on the Campo. The occasion is best described by a viewer, Tommaso Fecini:

> On the 3rd of August a wide and beautiful stage was put up from the Porta del Sale to the she-wolf, raised up above the door into the palazzo [Pubblico], and on the stage were made a series of steps, of which one was higher than the others, and on this, at the centre, was made the Imperial seat, which was covered with cloth. And the Emperor came, and he sat on the throne, and then on the first step were seated archbishops and the *signori* of Siena and other Imperial dignitaries according to their rank.[77]

The Campo was thus quite literally arranged like a theatre, much as it appears in paintings of S. Bernardino preaching there (see figs 1–3); as Fecini reports, a stage was erected in front of the Palazzo Pubblico. On this stage, Imperial and Sienese representatives were mingled together in a representation of harmonious coexistence, which drew a cheer of 'Viva l'[I]nperadore' from the assembled citizens in the piazza. While it was the Emperor that was raised up on the highest seat, this occasion was chosen for Sigismund to grant the city the privileges that had been requested in the pre-visit negotiations. Thus, as with the returning of the keys at the ceremony of entry, so too on this occasion the Sienese were able to bask in the reflected splendour of Imperial magnificence, while at the same time asserting their ability to be independent from him. This feel-good factor was to be continued in an open-air ball to which 200 'benissimo ornate' Sienese young women had been invited to entertain the court 'with great honesty'; the event was rained off and took place on the following day.[78]

Neither the chronicler Fecini, nor the public records report any further formal encounters between the city and the Emperor, indicating the degree to which Sigismund's presence came to be recognized as part of the city's everyday reality. The Emperor remained active in Sienese foreign affairs: after he had been granted the use of Piccinino's troops in August 1432, diplomatic missions, which used Imperial and Sienese ambassadors, were sent to Rome and Florence, so that by mid-March 1433 a peace had been settled.[79] Naturally enough, however, during these long months, a relationship developed between the court and the city. On one level, for some the presence of the court in Siena offered the chance for patronage and advancement. Knighthoods and other outward signs of the presence of the court were not infrequent, and are recorded by Fecini as well as being referred to disparagingly by Piccolomini.[80]

A different ambition moved Mariano di Iacomo called 'il Taccola', who in January 1433 dedicated a manuscript to Sigismund with the hope of entering his service.[81] A remarkable engineer–intellectual at the Sienese *Studium*, Taccola (1382–?1458) wrote two treatises (*De ingeneis* and *De machinis*), which were later to exert a great influence on the Sienese artist–architect, Francesco di Giorgio Martini.[82] Although Taccola's offer to Sigismund appears not to have been taken up, the manuscript he prepared of *De ingeneis libri III–IV*, survives and contains a number of written and figural allusions to the close ties between Siena and the Emperor at this time.[83] Particularly evocative is an image of the fully armed Emperor, restraining a lion by treading on its tail: the lion represents Florence (the *marzocco*), while the disembodied celestial head of Christ is shown with a voice caption exhorting Sigismund to help Siena overwhelm their age-old neighbours and rivals.[84] Another illustration of the she-wolf with the suckling twins is glossed with a long caption reminding the reader of the ancient alliance that bound Siena, the city of the Virgin Mary, to the Emperor (figs 58–9).

On a more mundane level, the presence of the court modified neighbourhood behaviour and patronage systems around S. Marta. A small instance of the Emperor taking an interest in a neighbourhood matter can be seen in his intercession on behalf of the nuns of S. Maria Maddalena at Porta Tufi, in order that they might be allowed tax exemptions on consumables.[85] The nunnery stood just outside the city gates, and was thus in the immediate sphere of the Emperor's influence. A detail from Piccolomini's tale throws further light on this small gesture. As part of the habitual scheming that is involved in the adulterous tale typology, a letter was exchanged between Lucretia and a suitor on the road that led out from Porta Tufi (fig. 60). This road passed by both the convent of S. Maria Maddalena and the church of S. Maria in Betlemme. Piccolomini commented:

> Sienese ladies often go out to pray at the church of Santa Maria in Betlem, about a mile outside the city gates [. . .] not far along the way they met two students that easily convinced the girl [Lucretia] to give them the flower, finding the love letter hidden in the stem. Usually this category [students] were much loved by the ladies of our city, but when the Emperor came to Siena with his court, the students came to be derided, ignored and hated, because ladies prefer the sounds of fighting to the subtlety of letters.[86]

This moment in the tale illustrates further the everyday effects of the court on the city, and more specifically on the immediate neighbourhood around S. Marta. As a student in Siena, Aeneas Silvius Piccolomini evidently had personal experience of these places and behaviour. It is also quite likely that the courtiers displaced the stu-

dents quite literally since the buildings of the Sapienza (the university and its lodgings) were being used to house members of the imperial court.

That the court and its members came to be viewed as almost a part of the city and its networks is revealed in one other unusual way. A few days prior to leaving, the Sienese government made the Emperor the remarkable gift of a palace in the via del Capitano, specifying that it would be for his use and for other 'ultramontani' visiting the city (fig. 61).[87] The gift is an unusual gesture for which no precedent can be found in Siena, but it seems to amount to a permanent place being offered to Sigismund in the city. The palace was centrally located, between the Duomo and S. Marta, and made a prominent display of this proposed Imperial residence on one of Siena's main thoroughfares. This was by no means the only physical record of the visit, although its function went beyond commemoration, like a door left open to a guest that might at any moment return. After the habitual salutations and exchange of speeches, Sigismund and his entourage left the city; they were accompanied to Ponte a Tressa by a large party of city officials, before continuing on their path to Rome and coronation with the gold crown of Empire on 31 May 1433. Sigismund did not return to the city on his way back north.

As a record of the Emperor's visit the Sienese commissioned a new panel for the cathedral's elaborate inlayed pavement, showing Sigismund enthroned beneath a monumental architectural baldachin, decorated

TOP 58. Mariano di Iacomo, called 'il Taccola', *Allegory of Siena and Emperor Sigismund Overcoming Florentine Oppression*, from *Liber tertius de ingeneis*, Palatino 766, fol. IV. Biblioteca Nazionale Centrale, Florence.

ABOVE 59. Mariano di Iacomo, called 'il Taccola', *The She-wolf of Siena*, from *Liber tertius de ingeneis*, Palatino 766, fol. 7v. Biblioteca Nazionale Centrale, Florence.

RIGHT 60. *Courting in the streets of Siena*, from Aeneas Silvius Piccolomini, *Storia di Due Amanti*, Milan, 1864.

61. G. Macchi, *Palazzi di Siena e stemmi di famiglie nobili di Siena e dei Luoghi dello Stato*, Palazzo del Capitano and Palazzo Pecci, *c.*1720. MS. D. 106, fol. 52, Archivio di Stato di Siena.

with laurel garland swags (fig. 62).[88] The large marble panel is located in the east transept, between the High Altar and the Porta del Perdono entrance to the cathedral; such a prominent placement commemorated for posterity the special honour that had been assigned to the Emperor during his stay. As has frequently been noted, it is the only scene of the floor cycle to represent a contemporary figure, and it is likewise significant that he was shown in contemporary dress, flanked by *putti* holding shields bearing the Imperial arms. Documentary evidence confirms that the panel was executed to a drawing by Domenico di Bartolo, between October and December 1434, thus indicating that it was conceived as a memorial of the visit, perhaps also commemorating the city's investiture as 'camera imperii'.[89] Domenico di Bartolo employed a sophisticated and innovative architectural design for the throne and baldachin; the former is raised on steps, with the throne set into an arched niche framed between Corinthianesque pilasters, while the canopy is supported by two slender Ionic columns, that are in turn framed by standing figures carrying the symbols of government, the orb and sword. Thus the Imperial visit was commemorated in a manner that connected his status and authority to that of Siena's city rulers.[90]

The *Historia de duobus amantibus* closes with a letter to Kaspar von Schlick, in which Aeneas Silvius Piccolomini gives a clear indication that he identified Eurialus as Schlick himself. The letter ends with the comment that Siena

is the city of Venus. Those that know you say that you burned with a violent passion, and that none strutted more than you [. . .] He who has never felt the fire of love is either a rock or a beast, because it cannot be denied that the fiery spark of love flowed even in the veins of the gods.[91]

Piccolomini here offered another meaning to the tale, which was hidden in the wordplay around 'Civitas Veneri est'. As is well known, Siena was frequently referred to as the city of the Virgin, and with the appellative 'Sena Vetus Civitas Virginis', evoked also in the CSCV acronym that hovers around the head of the seated figure of *ben comun* in Lorenzetti's *Allegory*. By substituting Venus for the Virgin, Siena thus became the object and reason for Schlick's moment of passion.[92]

It was not unusual for Renaissance *novelle* to compress or elide persons and places, so that Eurialus (the foreigner) falls in love with Lucretia (Siena).[93] Such a reading suggests that the love at first sight of the German courtier and the Sienese noblewoman might

62. *The Emperor Sigismund Enthroned*, intarsia floor panel from a drawing by Domenico di Bartolo, 1434. Siena cathedral.

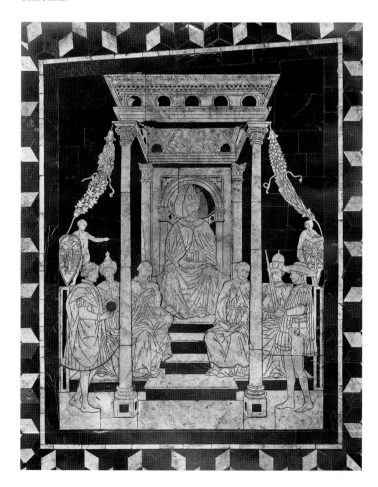

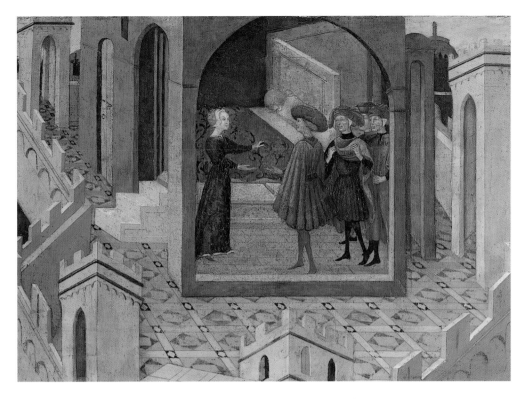

63. Giovanni di Paolo(?), *Lucretia Before her Family*, 1450s. Musée du Petit Palais, Avignon.

also be understood as an expression of the spell cast by Siena on foreign visitors, and conversely of the Sienese pride at winning such exalted guests as visitors at all. The *Historia de duobus amantibus* begins with the Emperor Sigismund being welcomed to Siena by four cultured and beautiful women 'that looked like goddesses, not mortals'; this ceremony actually took place, as Siena was famed for its beautiful and educated noblewomen, although Piccolomini adapted events to make one of the women his heroine, Lucretia (fig. 63).[94] Thus Siena as a woman was formally presented to her guests. When Lucretia was separated from Eurialus for two months, the reader is told, the sense of bereavement was such that 'Siena herself seemed widowed'.[95] The love story between Eurialus and Lucretia lasted the ten-month span of Imperial stay in the city; the lovers were sundered when the Emperor returned to his native land.

The *Historia de duobus amantibus* is fashioned out of supposed fact, Schlick's affair with an unnamed Sienese woman, and Aeneas Silvius Piccolomini's own experiences of Siena. Piccolomini's youthful memories of the city where he lived as a student, are blended with observations and details that bind the narrative to precise places and contexts. Thus, while we may not be able to trace the precise palace in which Lucretia lived, the fact that it had narrow alleys flanking it, make it credible within the context of the architecture of early fifteenth-century Siena (see fig. 212). The narrow alleys, in turn, provided a vital feature for the architecture of the narrative, as Eurialus gains entry to Lucretia's chamber by scaling the walls between neighbouring properties. Furthermore, when Lucretia at last acknowledges her love for Eurialus, and exchanges his amorous declarations, Piccolomini uses a metaphor to describe her change of expression drawn directly from an experience of the medieval fabric of the city. He reports that, 'like a tower that appears strong and solid from the outside even if it is fractured on the inside': once Lucretia gives way to her sentiments, she collapses entirely.[96] The collapse of towers was a not uncommon event in fifteenth-century Siena, since such obsolete structures were rarely maintained adequately.[97] The image of the tower that caves in thus captures admirably the dramatic force of the moment when a virtuous woman gives in to her strongest passions. Such an image might also be applied to the institutional relations between the city government and the visiting potentate.

Like Lucretia, whose appearance and attire flaunted contemporary sumptuary legislation concerning beautiful clothes and elaborate hairstyles, Siena was dressed up for its visitors.[98] In the lead up to, and for the duration of, the Imperial sojourn, Siena was refashioned through permanent and ephemeral changes to the urban fabric and numerous festivities were staged to honour the

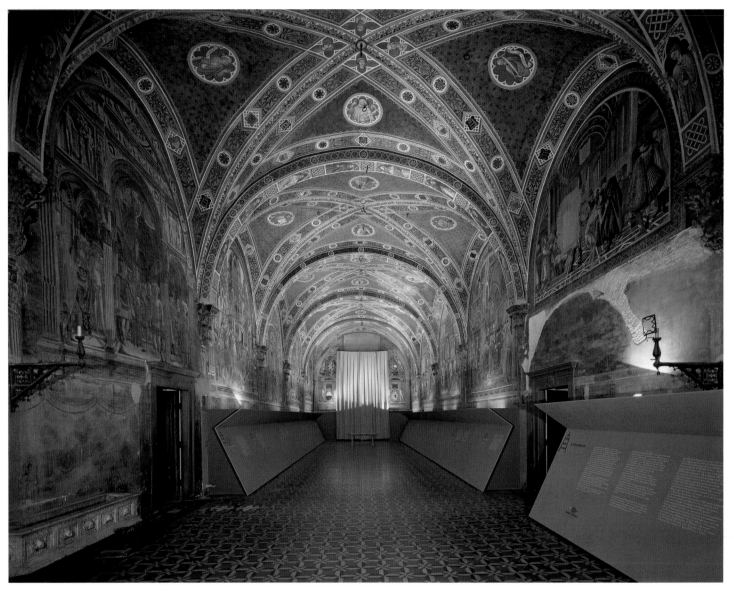

64. General view of the Sala del Pellegrinaio, Spedale di S. Maria della Scala.

Emperor and his court. Moreover, it could even be said that the Sienese government's initial reluctance to host the Emperor, pay for his expenses and provide him with appropriate diplomatic gifts, gave way to overwhelming generosity and lavish expenditure once the guests had arrived; again this resembles Lucretia's love at first sight for Eurialus.[99] To say it with the anonymous English translator of the *Goodli History of the Lady Lucres of Scene [Siena] and of her Lover Eurialus*, they 'neuer sawe nor hearde afore eyther of othere, he a Franconyen, and she a Tuskan, nor in theese busenes they occupied nor theyr tongues: but it was all done with eyene [. . .]'.[100]

As mentioned above, when Sigismund came to Siena, his lodgings were adorned with the heraldic emblems of the empire, but also those of local Sienese families and the Commune. His rooms were decorated with tapestries brought from the homes of the city's richest citizens, a number of which were never returned to their owners, but were acquired for the Palazzo Pubblico, as the *Signori* began an ambitious campaign for the production of tapestries for all its rooms, commissioned from Flemish specialists brought to Siena for that purpose.[101] In turn, his visit was commemorated with works by Domenico di Bartolo, an artist alive to the illusionistic potential of perspective, in designs that displayed both attention to the sumptuous detail of courtly interiors, but also introduced the use of sophisticated *all'antica* architectural settings (figs 64–5). While

44

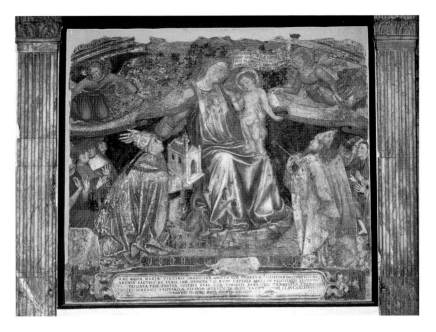

65. Domenico di Bartolo, *Madonna del Manto* (*c.*1444), fragment of the central portion in the Cappella del Chiodo, Spedale di S. Maria della Scala, Siena.

it may not be true to say that Sigismund's visit was the exclusive reason for this growing attention to luxury and splendour – for some 'courtly' cultural manifestations – it is nonetheless the case that the visit precipitated an acceleration of that process. Moreover, it is also interesting to note how at this time the boundaries between civic imagery and private patronage requirements came increasingly to be blurred. In terms of architecture and the improvement of the urban fabric then, the visit marked an important turning-point, as civic identity became associated with the built form of the city's principal streets. This change invested each property owner with an active duty in the promotion of the city's image that was to leave its mark on the patterns of the collective patronage of architecture for the rest of the century.

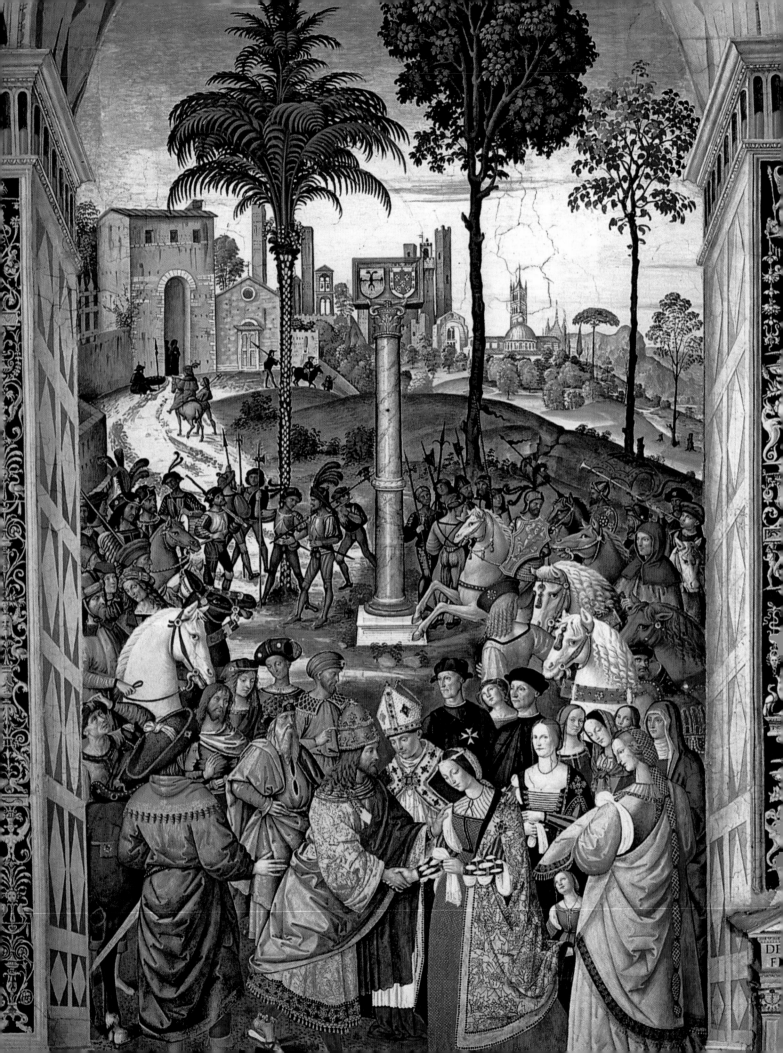

3

Between the Imperial Visits

URBAN RENEWAL AND DOMESTIC ARCHITECTURE

That house cost us four hundred florins, and our dear beloved father built it,
spending over one hundred florins above its market price in order to be close to his kinsmen.[1]

Aeneas Silvius Piccolomini's *Historia de duobus amantibus* is a tale of disappointed love with a domestic setting. While the wider context of the narrative is the city of Siena, Eurialus and Lucrezia's relationship revolves around the family palace and the courtier's successful attempts to gain entry to the closed world of the private home. As the tale makes clear, such access was made difficult by both social conventions and architectural barriers, both of which conspired strictly to define and control women's access to public spaces. It was these formidable barriers separating magnate families from the public space of the street that Eurialus first had to negotiate.

Sienese Magnates and the Fortified Residential *Castellari*

Most of Siena's magnate families had settled in the city during the eleventh and twelfth centuries, re-creating the fortified clan residences of their rural seats in the form of *castellari* (urban castles), a number of which survive to this day. In many instances, these *castellari* included a tower, which served defensive and totemic functions, representing the family within the urban setting.[2] Factional

conflict between noble clans and the growing power of 'newer' merchant families during the thirteenth century had led to the exclusion of *casati* (magnates) from government in 1277.[3] As Daniel Waley observed, fifty-three *casati* were excluded from government office in the ban lists drawn up in 1277, a figure that coincides closely with Giovanni Antonio Pecci's seventeenth-century estimate of fifty-seven towers present within the city in the thirteenth century (fig. 67 and see Appendix, table 1).[4] This suggests a correlation between housing and family types.

The towers attached to *castellari* clan enclaves often had no practical everyday function, for the rooms they contained were small and inconvenient to enter, and were probably only served by ladders and trap-doors.[5] In the majority of surviving cases, Sienese towers were built in stone, usually of a limestone easily available from the nearby quarries of the Montagnola, a material that is often described as 'pietra da torre'.[6] These limestone monoliths are still clearly visible in aerial views of Siena's urban core, where the thick walls, often crowned with roof-top terraces, stand out quite clearly.[7] Many are also discernible at street level, such as that of the Rossi, cut through by the Arco dei Rossi on the Banchi di Sopra, and the Roccabruna tower, which dominates

67. Domenico Beccafumi, view of Siena from the south-west, perhaps from S. Prospero, *c.*1520. British Museum, London.

the Croce del Travaglio, which originally belonged to the Maconi.[8] As can be seen from surviving examples, their only architectural features were a small centred doorway at the base, with narrow windows aligned above (figs 68–9). In fact, the military functions of these towers had largely been lost by the fifteenth century, and so they were either left unused, or were incorporated into residential property. Nonetheless, the retention and repair of towers as part of residential properties suggests that they were architectural features that were seen to represent the family's history and permanence in the city.

Towers, then, were a key element of the urban landscape and skyline, constructed by magnate families as

BELOW 68. Tower of the Malavolti, via dei Montanini.

RIGHT 69. Tower of the Rossi, Banchi di Sopra.

48

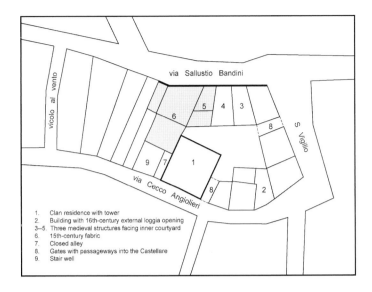

1. Clan residence with tower
2. Building with 16th-century external loggia opening
3–5. Three medieval structures facing inner courtyard
6. 15th-century fabric
7. Closed alley
8. Gates with passageways into the Castellare
9. Stair well

70. Castellare degli Ugurgeri.

visible markers that located their enclaves. It was around these towers that the kinsmen and clients of magnate families gathered to live, within the protective radius of the *castellare*. The Ugurgieri, Malavolti and Salimbeni urban castles provide clear illustration of the markedly defensive, yet monumental residential arrangements common to magnate families by the thirteenth century.

The twelfth-century *castellare* of the Ugurgieri is the best surviving example of these traditional residential enclaves; built around a courtyard and served by a tower and a private well, it reveals a strongly defensive and military design.[9] The courtyard, onto which numerous houses face, could only be reached by two gates that gave onto the street, while the outer walls do not contain any original doorways into the *castellare* (fig. 70–71). The Ugurgieri did not alter the defensive character of their stronghold, although tax records show that by 1453 the family no longer owned all the properties within the closed court.[10] Nevertheless, almost all members of the depleted family continued to live in this enclave into the sixteenth century.[11] In the *castellare* of the Ugurgieri's fortified family enclave, internal protected clan space was separated from the city by architecture with clearly defined defensive functions.

The Rocca Salimbeni, the large fortified enclave of the Salimbeni clan, while heavily modified in the last two centuries is even more monumental, fills a prominent site near the city centre, and still retains its commanding tower (fig. 72). The Salimbeni were one of Siena's oldest and most powerful families, and their massive *castellare* was perhaps the largest private palace of the fourteenth century.[12] Access to the residential complex was through a grand portal cut into one of the enclave's stone towers that gave onto a large hall; around

71. Castellare degli Ugurgeri, gateway entrance.

72. Rocca dei Salimbeni, tower and general view.

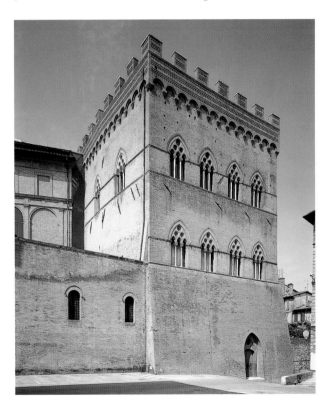

73. Arco dei Malavolti (demolished 1763), from G. Pecci,
*Raccolta Universale di tutte le iscrizioni, arme e altri monumenti
si antichi, come moderni, esistenti nella città di Siena*, MS. D. 6.
fol. 7. Archivio di Stato di Siena.

an internal courtyard area were distributed residential
buildings as well as the 'rocca' itself, a fortified structure,
not dissimilar to the keep of a castle.[13] The site of the
complex, strategically located on the high ground
between the city's main street and the Abbadia di S.
Donato, and the declining fortunes of the family in the
early fifteenth century, meant that much of the prop-
erty passed into the hands of other families during that
later period and was modified to new purposes. Fur-
thermore, extensive restoration of the building in
neo-Gothic style by Giuseppe Partini in the nineteenth
century means that it is difficult to establish the origi-
nal form of the building complex.[14] Commanding views
over the city of Siena, still to be gained from the thir-
teenth-century tower at the heart of the Monte dei
Paschi bank headquarters, give a clear idea of how the
fortified enclave exerted some degree of visual control
over the city as a whole.[15]

Similarly, the Malavolti enclave was developed around
the site now marked by the church of S. Maria delle

Nevi.[16] The 'Arco dei Malavolti', which was only de-
molished in 1763, abutted the fifteenth-century church
and provided a ceremonial and defensive entrance to
what was perhaps the largest of Siena's original urban
castles (fig. 73). The family's repeated conflict with the
city government dictated the eventual demise of the
Malavolti, a number of whom were exiled towards the
end of the fourteenth century to Florence and other
cities.[17]

By the fourteenth century the architectural form of
the family residence defined by a castle-like defensive
exterior and tower was set to change in favour of less
defensive structures, to satisfy the changing needs of
urban living. Perhaps the earliest example for this
change is the Palazzo Tolomei, built around 1270–72 to
replace a palace that had been demolished during the
family's exile after the battle of Montaperti (fig. 74).[18]
It is a free-standing building entirely constructed in
stone with a symmetrical façade, facing onto an open
area in front of the palace, the piazza Tolomei. It has a
high-ceilinged ground-floor loggia that served clan
requirements for gathering the family, as well as having
a probable commercial function as the office for the
family bank.[19] Likewise, the Palazzo Sansedoni on the
Banchi di Sotto was built to be a monumental residence
from 1340, but also incorporated numerous shops in the

74. Palazzo Tolomei.

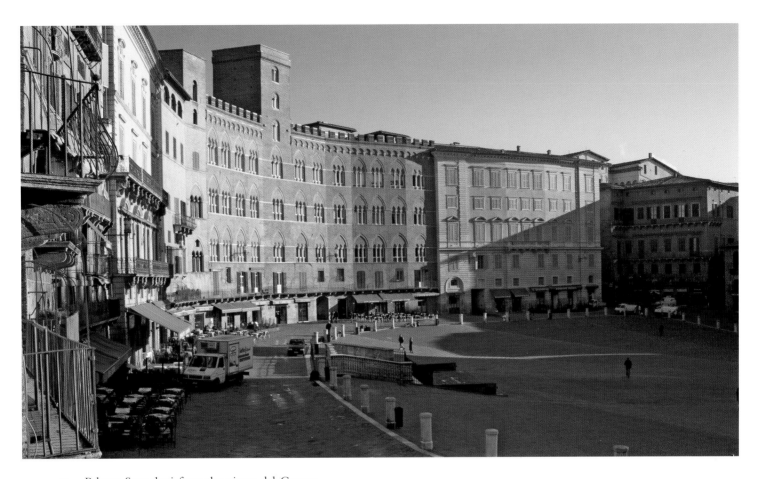

75. Palazzo Sansedoni from the piazza del Campo.

ground floor of both its façade on the piazza del Campo and that on the Strada Romana (fig. 75 and see fig. 120).[20] Like the Palazzo Pubblico that faces it across the Campo, it retained only the crenellations of earlier defensive clan architecture, substituting austere walls with an elaborate façade built of bricks and finished with stone detailing, punctured by numerous ogival *triforium* windows divided by colonnettes.

Palace architecture of this sort articulated a changing relationship between the enclosed precinct of the extended family clan and the public sphere of the street, both through the permeability of their exteriors, and through a growing attention to the façade.[21] As the military functions of the buildings declined, so it became more important for family patrons that their residences should provide family meeting-places like loggias, and sometimes even commercial spaces for the transaction of the family business – banking or trade. In turn, the outer appearance of the palace projected the identity and status of its owner through heraldic symbols, luxury materials and so on. This evolutionary process in the development of the palace type is traced in the chapters that follow.

City Palaces and Urban Renewal before 1450

The city of Siena emerged from the fourteenth century much diminished, in terms of its population, its economic fortunes and in the actual condition of its built fabric.[22] Growing political stability, and the consequent reduced demand of military activity on the public purse, favoured a growing civic investment in policies directed at the improvement of the urban fabric. In the first instance such tasks appear to have been supervised by the office of the *Petroni*, professionals from the building trade that formed an arbitration committee, nominated by the tax officials of the *Biccherna* to adjudicate on land disputes between private citizens, or between the Commune and individuals.[23] As Patrizia Turrini has shown, as early as the 1420s the *Petroni* also supervised the enactment of new legislation for the restoration of derelict properties in the city.[24] In 1423 the church council of Pavia was relocated to Siena, and in order to improve the appearance of the city, the government introduced new policies that attempted to force owners of derelict houses to restore them.[25] Since the situation

had not noticeably improved by 1444, more forceful measures were introduced that included the Commune's right to confiscate unrestored property, which it could then dispose of at will.[26] *Petroni* records list over 200 derelict buildings identified between 1448 and 1500, and report those cases where restoration was eventually undertaken.[27] Nonetheless, the problem of derelict housing was evidently not even solved by the threat of confiscation, and in June 1471 further legislation offered public subsidies for the restoration of derelict buildings.[28] The decision clearly stated that the need to restore properties was required both for the improvement of the city's appearance and to provide housing for people wishing to come to live in Siena. To this end, the considerable sum of 1,000 florins a year was set aside to fund the restoration of expropriated derelict private properties.[29] Once restored, the properties were to be sold, and previous owners were offered the chance to buy back their houses at a fair price.

It is difficult to draw general conclusions regarding the properties selected for restoration in the *Petroni*'s lists. Turrini argued that the first selection of 1423 pinpointed sites in areas that were 'typically working class', such as Abbazia Nuova, Pian d'Ovile and Valdimontone, while the 1448 lists concentrated on the districts in the Terzo di Camollia that she claimed was 'being transformed into a working-class district'.[30] However, it is clearly worth considering these choices from a different perspective. Certainly, the large number of derelict houses in Camollia is an indication of declining investment in the area's housing stock, but it also reveals the Commune's concern that the area be revitalized. The via Camollia is the northern section of the Strada Romana as it enters the city from the Porta Camollia. Clearly it was important that the first experience of the city offered to the incoming visitor was not one of dereliction and abandonment, and indeed further measures were applied in 1471 to curb this situation. The derelict-property policy must then be understood in the terms by which it was described by the city's councillors in 1471, as both functional and aesthetic, for

> considering that in our city there are many derelict houses, and many are becoming ruined, which damages the reputation of the city a great deal, and considering that people that live outside the city may desire to return to live within the walls but cannot find a home, it would be both useful and necessary to reverse this problem.[31]

This of course raises a new concern in the legislative measures applied to the city fabric: aesthetic appearance, an issue that became increasingly important in policy-making from the 1450s, as is discussed in chapter Five.

Attempts to identify the buildings pinpointed for renovation by the *Petroni* have been somewhat inconclusive. Nonetheless, an interesting restoration appears to have been made of a palace belonging to Nanni Marsili on piazza Manetti, a square that backed onto the Duomo Nuovo, and from which properties faced the via di Città, which led up to the cathedral (fig. 76) From as early as 1444 the *Biccherna* officials and *Petroni* demanded that Nanni restore the derelict building on pain of confiscation; he did not comply and the property was duly expropriated in 1452.[32] Seven years later, Nanni Marsili petitioned the government, asking for the building back with the condition that he would restore it; he was granted the property, and its restoration was overseen by a builder often associated with civic commissions, Luca di Bartolo da Bagnocavallo.[33] Extensive late fifteenth-century internal alteration to the palace, as well as heavy nineteenth-century rebuilding, make it impossible to establish the appearance of the palace in the 1460s, although this has not prevented some scholars from identifying it as a late example of 'Gothic'

76. Palazzo Marsili, via di Città.

77. Bichi residential enclave in Castelvecchio district, with the church of S. Agostino at the top, detail from F. Vanni, *Sena Vetus Civitas Virginis,* fig. 10.

domestic architecture.[34] On the contrary, the palace appears to have been developed to a scale and plan that marked it as quite different from earlier residential prototypes in the city, probably making the nearby Palazzo Bichi-Tegliacci the best surviving contemporary comparison.

The Bichi were a prominent Sienese *Novesco* banking family of the fourteenth century, with a documented presence in the city from as early as the mid-thirteenth century.[35] What little is known of initial Bichi settlement shows that from the early 1300s the family was resident in the central district of S. Pietro in Castelvecchio, a fact further corroborated by the construction and patronage in 1439 of a family burial chapel in the nearby church of S. Agostino (fig. 77).[36] By 1453, there were at least four Bichi households living in the district of S. Pietro, with another in Pantaneto.[37] These five households declared a taxable income of 67,300 *lira,* and as such were among the richest families in the city, with Matteo di Galgano Bichi, the wealthiest citizen of Siena, taxed on 37,950 *lire.*[38] In addition to their great wealth, largely derived from banking and the wool trade, the Bichi were highly influential members of Siena's government, particularly in the person of Giovanni di Guccio Bichi.[39] The fortunes and significance of the Bichi family have yet to be properly studied, but it is clear that Giovanni di Guccio was a leading figure in Sienese affairs from the 1430s, and in this capacity had been appointed a Palatine Count by Emperor Sigismund in 1433.[40] Giovanni maintained important business relations with

Naples, was the leading exponent of the pro-Medicean faction, and also an intimate of Aeneas Silvius Piccolomini, later Pope Pius II.[41]

By the mid-fifteenth century the four households living in Castelvecchio were all resident near the palace of Giovanni di Guccio Bichi, the present-day Pinacoteca Nazionale (fig. 78).[42] It is unclear when the palace was begun, but in his 1453 tax return the banker Giovanni referred to the palace as requiring at least 600 florins expenditure to be completed.[43] One year previously, Giovanni di Guccio had received special privileges from Pope Nicholas V to install a portable altar in his home and to celebrate Mass in the chapel of his suburban castle at S. Regina.[44] That Giovanni's two major properties, in central Siena, and immediately outside the walls, contained private family chapels, was in itself a mark of considerable distinction.[45]

The urban palace Giovanni built is unusual in a number of other respects. The façade is frequently cited as displaying Siena's continued preference for the Gothic style in the mid-fifteenth century (figs 79–81).[46] Nonetheless, the façade symmetry, as well as the inclusion of classicizing details such as the Corinthianesque

78. Palazzo Bichi-Tegliacci, now Pinacoteca Nazionale, by an unknown photographer, *c.*1860.

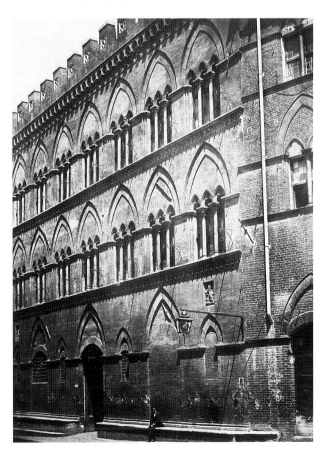

79. Palazzo Bichi-Tegliacci, now Pinacoteca Nazionale, detail of windows.

81. Palazzo Bichi-Tegliacci, now Pinacoteca Nazionale, courtyard.

80. Palazzo Bichi-Tegliacci, now Pinacoteca Nazionale, spiral staircase, known as 'Scala della Pia Tolomei'.

capitals and dentilled string-coursing mark the appearance of *all'antica* taste in Siena by this time. Even more significant in this respect is the palace interior, centred around a regular courtyard, surrounded by a loggia arcade supported by classicizing columns. Somewhat rough and ill-proportioned Ionic capitals and hanging capitals are used throughout the ground floor.[47] It is therefore fair to claim that the Palazzo Bichi was the first building in Siena to adopt *all'antica* elements of palace design, such as a symmetrical façade, regularized plan and the use of orders for the courtyard arcading.[48] It was elements such as these that marked the distinction of the building from previous prototypes, offering new solutions drawn from a vocabulary inspired by some knowledge of Roman architecture.[49] As will be shown in the chapters that follow, architecture in Siena came increasingly to be defined by a refined and 'archaeological' taste, that looked to classical models in Rome as well as nearer to home, to articulate a new architectural language that was quite specific to Siena, while yet engaging in the process of architectural

renewal that affected much of Italy in this period. And while the Palazzo Bichi has often been considered a late example of Siena's 'Gothic' architecture, it is certainly its innovative features that signal its stylistic importance. The fusion of these features with contemporary prototypes also reflects the patron's choices.

Indeed, as Howard Burns and others have argued for the Medici palace, the introduction of *all'antica* elements was conjugated with elements from the local architectural tradition.[50] Thus, at the Palazzo Medici in Florence, the graded rustication *pietra forte* of the exterior echoes the façade of the Palazzo della Signoria, while the round-arched windows and *all'antica* colonnettes update the forms of the Trecento *bifore* windows. Such subtle blending of models and precedents paralleled closely Cosimo de' Medici's political methods of insinuating himself into a position of authority within the established structure of Florentine government.[51] Thus, the Bichi palace façade might be said to follow local models, both of residential buildings and of more imposing sites of power such as the Palazzo Pubblico, adapting these by the inclusion of such elements as classical colonnettes and string-courses.

Such an analogy fits well with Giovanni di Guccio's inextricable connections with Sienese government, which emerge from both public and private sources.[52] Thus, the façade of Giovanni's palace follows closely the model of the Palazzo Pubblico; it is modulated by a sequence of Gothic ground-floor arcades, *trifore* windows on the upper floors, and decorative crenellations topping the building; even the brickwork and use of stone coursing creating horizontal bands across the façade. The façade is also, however, ordered symmetrically around the central portal, the string-courses and colonnette capitals imitate classical forms, and a bench or podium runs along the base of the building; all of these were new elements for a palace in Siena.[53] Inside the building however, just as at the Palazzo Medici, the innovations were far more apparent and revealed the patron's sophisticated taste. Moreover, the palace also housed large cellars and possibly even underground stables, reached from the palace along a spiral stair, and accessed from via del Casato behind. It was facilities such as these that made the Palazzo Bichi one of the most magnificent palaces in Siena by the mid-1450s. So much so that it was twice chosen as a temporary residence in Siena by Cardinal Rodrigo Borgia during visits to the city with Pius II, in spring 1459 and 1460.[54]

The splendour and originality of Giovanni di Guccio Bichi's architectural patronage was not confined to his urban residence, but extended also to the remarkable suburban palace/castle ('palatium sive fortilitium') at S. Regina, the so-called Castello delle Quattro Torri.[55] The castle has attracted surprisingly little scholarly attention, although it is clearly a building of considerable importance, particularly in view of the Bichi's cosmopolitan connections.[56] The castle is designed to a central plan, with a regular courtyard, and square turrets on each of its corners. It is built almost entirely of brick, although the courtyard arcade details such as capitals and column bases are sculpted from stone (figs 82–4). While the castle certainly served some defensive purpose, its visibility from the city, the documented presence of a family chapel there from 1452, as well as its symmetrical plan and the decorative deployment of military architectural features, seem to suggest that it was more a symbol of Bichi's knightly status than a functioning machine of war.[57] Finally, the courtyard of the Palazzo Pubblico served as the model for that at the Castello delle Quattro Torri, particularly in the continuous pilaster strips that bind together the vertical thrust of the ground-floor loggia to the upper level.

It thus seems probable that Giovanni di Guccio Bichi made conscious reference to the architectural prototype of the Palazzo Pubblico when he commissioned his urban and suburban residences, entwining thus in a visible manner his public and private affairs. In fact, so closely bound were his fortunes with those of the city

82. Castello delle Quattro Torri, S. Regina, near Siena, in a photograph by Paolo Lombardi, *c*.1870s.

83. Castello delle Quattro Torri, S. Regina, near Siena.

84. Castello delle Quattro Torri, S. Regina, near Siena, courtyard.

republic, that when in 1456 the coup led by Antonio di Cecco Rosso Petrucci failed, it was Giovanni di Guccio that was sent to Florence as Sienese orator to Cosimo de' Medici, in order to outline the terms for a new alliance between the two cities.[58] A well-known side effect of Bichi's Florentine appeasement was the fact that the sculptor Donatello was lured to Siena, where it was originally thought that he would 'stay for the duration of his life'.[59] Somewhat more surprising was its coincidence with Giovanni di Guccio's sale of his grand new palace and castle to Luigi di Giovanni Tegliacci, a Sienese banking family previously exiled and resident in Florence.[60] The Tegliacci, who were consorts of the Medici, and whose Florentine residence was a prominent and central palace near the Ponte Santa Trinità, evidently reacquired their Sienese citizenship through Bichi's agency, and bought his property as a prominent investment that signalled their return to the city.[61]

Nevertheless, in spite of having sold his urban residence to the Tegliacci, Giovanni di Guccio's activity in the service of the Sienese republic had already been rewarded by the remarkable concession to him of the Palazzetto di S. Marta, on the Prato di S. Agostino, from as early as October 1458.[62] As was shown in the previous chapter, the Palazzetto was a building deputed to house the city's most honoured guests, such as the Emperor Sigismund in 1432 and Emperor Frederick III in 1452; on both occasions the palace had been the

object of publicly funded restorations.[63] As such, its sale to Bichi was an extraordinary act that may have been prompted by his service to civic interests. That this was probably the case may also help to explain another surprising example of a major public building passing into the hands of an influential government figure in these years. For in 1457, the Palazzo del Capitano, the official seat of a principal city magistracy, on the via del Capitano, was sold to Tommaso Pecci, a prominent public figure and leading member of another *Novesco* banking family.[64]

It is again not clear why the palace was sold to Tommaso Pecci, since the officials housed there were forced to move to temporary rented accommodation, an unsatisfactory arrangement that eventually resulted in the construction of a new Palazzo del Capitano, adjacent to the Palazzo Pubblico (fig. 85).[65] Since restoration of the building is only documented from 1476, it is unlikely that the palace was granted to Pecci as a means of avoiding expensive restoration, and so it seems possible that the concession was a reward for services to the public weal.[66] The palace was located in the vicinity of the cathedral, and filled a large site along the via del Capitano, which came to be the centre of a major urban renewal project during the 1490s, as shown in chapter Nine. Moreover, the palace continued to be used on special occasions to house important guests of the city. Thus, for example, when in June 1465, Ferrante of Naples returned from Milan with his new bride Ippolita Sforza, she stayed in Tommaso's palace.[67] The celebrations on that occasion were especially lavish and the chronicler Allegretto Allegretti complained of their high cost, estimating that the extraordinary sum of 24,000 florins had been spent, and affirming that 'more things were thrown away than were actually eaten'.[68]

It is also interesting to note that the palaces of Tommaso Pecci, Giovanni Bichi and the Tegliacci brothers retained a quasi-public function, as they were regularly loaned to honoured guests visiting the city. As a number of very well-documented cases show, the Sienese way of accommodating guests and their high-ranking entourages was to rent the most significant private palaces in the city from their owners, in order to make them available as official residences.[69] Such a practice was by no means unique to Siena, but is worth considering here as a strategy in the projection of civic

85. Palazzo Pecci, via del Capitano.

image.[70] For by distributing guests among the most prominent and magnificent homes of Siena's economic and political elite, a civic value was associated with the private splendour of each individual patron's home. As will become clear in the chapters that follow, this close relationship between prominent citizens and the city government as a whole was articulated on a wider scale and actively promoted by the Sienese authorities, which aimed at the improvement of the collective urban image.

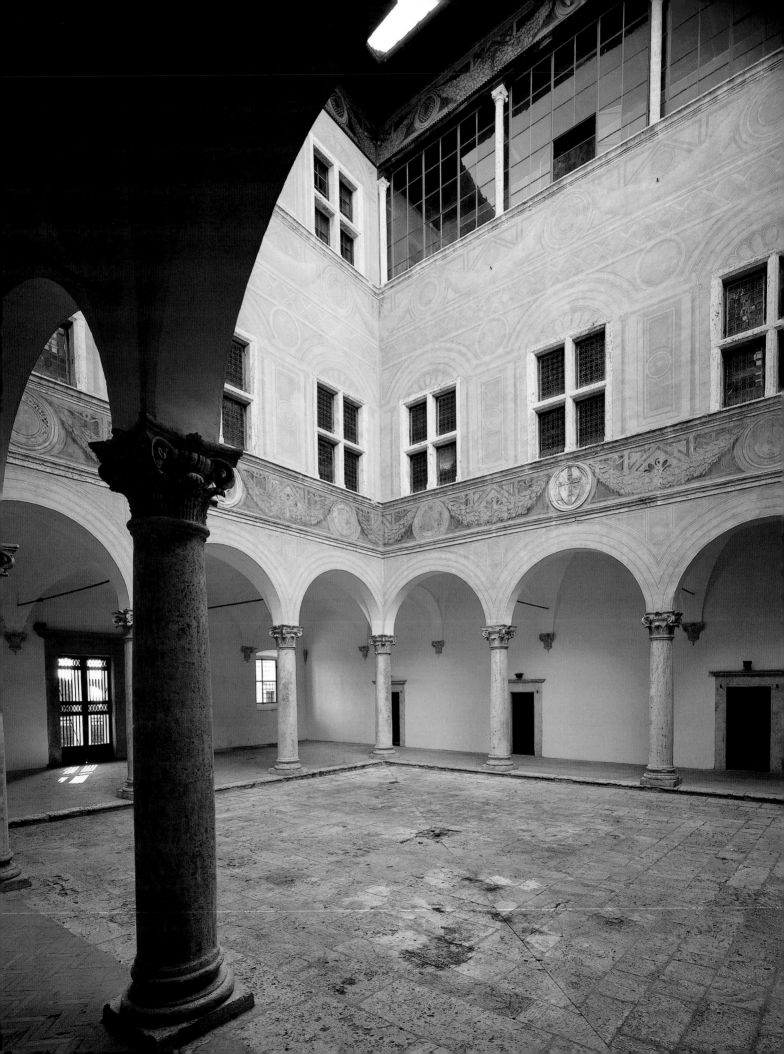

4

Pius II Piccolomini and Architectural Patronage in Siena

PAPAL POWER AND FAMILY IDENTITY

Pius II Pontifex Maximus Gentilibus Suis Piccolomineis.[1]

In 1452, the Holy Roman Emperor elect, Frederick III, entered Siena and made a prolonged stay in the city as he awaited the arrival of his betrothed, Eleonora of Portugal, and for preparations for his coronation in Rome by Pope Nicholas V (fig. 87).[2] The special significance attached to the Siena stage of the Emperor's *adventus* to Rome is to be explained by the mediatory role played in the diplomatic negotiations that prepared his marriage and the planning of the coronation by the Sienese humanist cleric Aeneas Silvius Piccolomini. Piccolomini was born in Corsignano (later Pienza), south of Siena, on 18 October 1405, studied at Siena's *Studium* from the age of eighteen, and subsequently embarked on a successful career as a humanist secretary, most significantly in the service of Frederick III.[3] In 1447 he took Holy Orders and was almost immediately appointed Bishop of Trieste by Eugenius IV; in 1450 he was nominated Bishop of Siena, and was made a cardinal in 1456.[4] As Bishop of Siena, Aeneas Silvius arranged for the meeting of Frederick III with Eleonora of Portugal to occur just outside Siena's city gates, and proceeded with the couple

to Rome, where he assisted at Frederick's Imperial coronation and marriage to Eleonora. If the *Historia de duobus amantibus* can be seen as a narrative forged from the author's personal knowledge of the city of Siena, and members of the Imperial court that visited his native town, the 1452 visit marked the personal reconciliation of his two career paths, and was remembered as such in the commemorative fresco of the event painted in the Libreria Piccolomini of the cathedral in the early sixteenth century.[5]

For the Sienese government, the Imperial visit was not a welcome surprise. The popular faction at the head of Sienese government feared that the Imperial presence might have a destabilizing effect that might be taken advantage of to stage a coup by noble families excluded from government (whom Piccolomini was seen to represent).[6] As a precaution against such contingencies, the government elected a temporary oligarchy (*Balìa*) on 28 October 1451 to govern the city for the period leading up to and during the visit.[7] The Commune subsequently decided to consent to the visit

86. Palazzo Piccolomini, Pienza, courtyard.

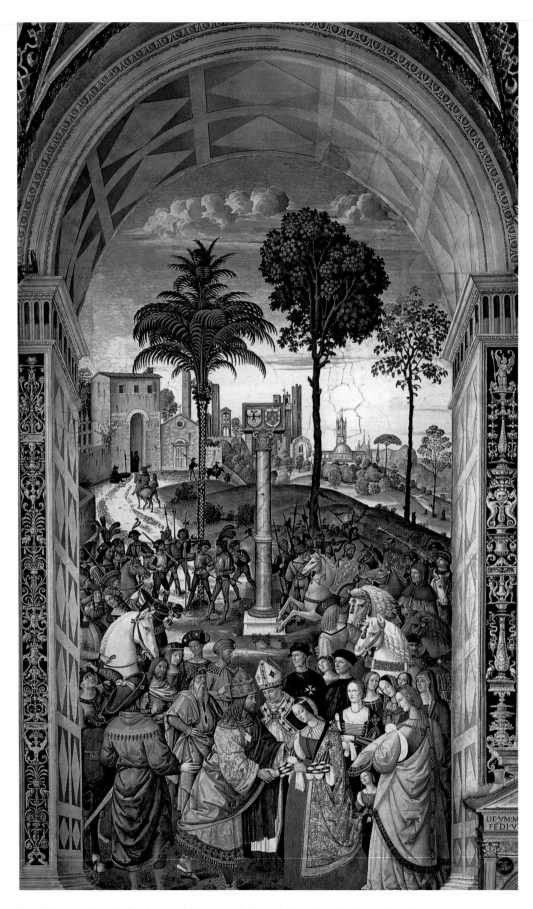

87. Pinturicchio, *Frederick* III *and Eleonora of Portugal Meet Outside Porta Camollia, c.*1506. Piccolomini Library, Siena Cathedral.

with the proviso that chosen members of the traditionally pro-Imperial political party factions of the *Dodici* and *Nobili* be temporarily banished to *contado* towns at least twenty miles from Siena, where they were required to register daily with a local official.[8] Furthermore, on 26 November 1451, five days before the arrival of Frederick's advance guard, the government and *popolo* participated in the annual 'processio devota et admirabilis' commemorating the establishment of the *popolo* regime, which had followed the death of Gian Galeazzo Visconti in 1402.[9] The procession, dedicated to the Virgin and St Peter of Alexandria, re-evoked the protection of Siena's *popolo* regime patron saints on the eve of the Emperor's entry.[10]

In the event, no drastic consequences followed from the visit, although the city government's caution provides some measure of their diffidence towards the successful and well-connected cleric. Nonetheless, the visit was widely reported in contemporary local sources that betray the considerable excitement for the pageant and display surrounding the guests. From these accounts it is possible to gain a clear impression of the buildings and streets that were the stage for the Emperor's stay and sojourn in the city. To a large degree these mirrored those of the 1432 entry of Sigismund, although it seems evident that a number of recent changes to the city and its monuments were showcased by the entry ceremonial. The Imperial visit took place in the coldest months of the year, but accounts of both the entry of Frederick, and the subsequent ceremony prepared on the occasion of the arrival of Eleonora, indicate that the city was displayed at its finest. The short winter days allowed for a glamorous torch-lit entry, rendered all the more spectacular by the placing of candles and torches inside the open churches that lined the processional route, and at the windows and on the rooftops of the houses that were passed by the cavalcade.

Both the first arrival of the Emperor (7 February 1452) and his subsequent meeting with Eleonora (24 February) occurred on the Prato di Camollia, outside the city walls, and the entry cavalcade reached the city centre along the main street, the Strada Romana. The street had been decorated with all manner of plants and garlands, torches and candles lit the route, and crowds of spectators filled the street as well as the balconies and windows of the buildings lining it, many of which were decorated with tapestries and other hangings. The street therefore was a two-way stage, where the city community and urban fabric were viewed by the incoming visitors, who were themselves the objects of the residents' gaze. This spectacle was repeated some days later, when the Emperor and his betrothed were formally presented to the Sienese citizens in a ceremony staged on a elaborately decorated platform raised in front of the Palazzo Pubblico before a massive crowd of citizen onlookers that filled the piazza del Campo.

During events such as the triumphal entry and the presentation of the Imperial couple on the piazza del Campo, the theatrical qualities of Siena's urban space were exploited to the full. Both the Strada Romana, and the central square (the latter in particular) were conceived as civic showcases, and the formal arrangement of the stage before the Palazzo Pubblico made the government palace a part of the display, much as can be perceived in Sano di Pietro's painting, *S. Bernardino Preaching on the Campo* (see fig. 1). However, it is also clear that the guests were shown other major civic monuments; the Emperor was lodged in the Casa di S. Marta as Sigismund had been two decades earlier, and his betrothed in the palace of the Master of the Cathedral Works (*Opera*), next to the Duomo, both of which were well-appointed buildings, improved for the occasion. A special visit was arranged to the Spedale of S. Maria della Scala, an institution they praised a great deal.[11] Particular attention seems to have been given to a visit of the cathedral, and Piccolomini describes the artistic marvels it contained, many of which recently completed, which were much admired by his guests.

The considerable interest with which the Emperor's visit was viewed by Sienese contemporaries can be understood from the copious references made to it in public and private sources. Furthermore, it was also marked for posterity in a unique manner by the erection of a commemorative *all'antica* column bearing a Latin inscription on the site of the meeting of Eleonora and Frederick outside the city gates (fig. 88–9).[12] The column cast the Imperial visit in terms that were explicitly classicizing, while also giving a unifying focus to the open space of the Prato di Camollia that can readily be perceived in Pinturicchio's later fresco (see fig. 87). Remembering those days with the benefit of hindsight, Pius saw a special personal significance in the visit, reporting that as Frederick and he rode south from Siena towards Rome, having reached the top of the hill at Acquapendente, the Emperor turned towards him and foresaw his election to the cardinalate and eventual ascent to the Papacy.[13]

Pius II Piccolomini and Siena

Following his election as Pope Pius II in August 1458, Aeneas Silvius became involved in close diplomatic discourse with the popular regime of the Sienese Commune over the issue of re-admission to Siena of noble families, and the rights of those families to par-

88. Column commemorating the meeting of Frederick III and Eleonora of Portugal on the Prato di Camollia.

avoid issuing a general re-admission for the *Monte dei Gentiluomini*.[17] This decision resulted in the anomalous situation of a branch of one of Siena's most ancient families, who were by rights *Gentiluomini*, becoming one of the most influential voices of the *Popolo*.[18] In April 1459 the *Gentiluomini* were in fact re-admitted, although the Piccolomini remained in the *Monte del Popolo*.[19] Pius then proceeded to request re-admission for the *Dodici* until, in June 1462, the Sienese stated that no further concessions would be made.[20]

While Pius may have resented this decision, contrary to what has sometimes been suggested, he did not withdraw favours from his home town, and continued to visit the city.[21] In 1458 he elevated Siena to the status of archbishopric and canonized Catherine of Siena in June 1461, while he also granted the Sienese *Comune* exclusive rights over the papal territories of Radicofani and Monte Amiata.[22] A number of indulgences were accorded to Sienese churches, and as Nicholas Adams pointed out, the restoration and fortification of Corsignano/Pienza significantly improved the defences of the southern Sienese border.[23] In 1464, on the way to Ancona, where he eventually died, Pius made a gift of the arm of St John the Baptist to the cathedral, leading a civic donation ceremony on 1 May.[24] It was during this same period that the relic of St Andrew's head was brought to Rome, with an elaborate ceremonial entry from the Porta del Popolo to St Peter's in Rome, and it is evident that the donation of the Baptist's arm was also enormously significant.[25] Moreover, the donation of the relic to Siena was both a confirmation

ticipate in city government.[14] Siena's fragile political system was based on a division of the political group into five *Monti*, and following the brief over-lordship of Gian Galeazzo Visconti (1399–1403), the city was governed by a three-party coalition that united the interests of three of the city's five socio-political parties.[15] With the notable exception of an attempted coup by Antonio di Cecco Rosso Petrucci, who tried to install an exclusively *Novesco* regime in 1456, the three-party system survived into the 1480s.[16]

A number of individuals and families associated with Aeneas Silvius had participated in the 1456 plot and had been exiled, while the Piccolomini and other noble families were traditionally excluded from government. As soon as he rose to the pontifical throne, Pius II made the revocation of exiles and the alteration of the antenoble laws a key point of his negotiations with Siena. By September 1458 the Corsignano branch of the Piccolomini had been admitted to the *Monte del Popolo*, a stratagem which allowed the Sienese government to

89. Detail of the inscription tablet from the column commemorating the meeting of Frederick III and Eleonora of Portugal on the Prato di Camollia.

90. General view of the main square at Pienza.

of the Pope's special relationship with the city, and may well have been considered a snub to the Florentines, who themselves had no important relic of the Baptist at this time, in spite of the fact that he was their privileged patron saint.[26] In the pages that follow, it will be shown that Pius II's patronage of architecture in Siena must be viewed as further evidence of the pontiff's conciliatory stance towards the city government.

Piccolomini's sophisticated taste in matters architectural is well known, particularly as documented in the monumental interventions he commissioned for his native village of Corsignano, renamed Pienza in his honour in 1462 (fig. 90).[27] The Pienza redevelopment has been exhaustively discussed in the secondary literature, which has, by contrast, largely ignored the Pope's Sienese building projects. The intimate scale, rapid execution and coherent design of the buildings that surround the central piazza at Pienza, as well as the numerous palaces that line the main street through the small town, have naturally attracted attention, but have more questionably led the small city to be defined as the 'first ideal city of the Renaissance to take visible form'.[28] Pius's plans for Pienza are cast in quite a different light when placed in comparison to his architectural renewal at the heart of Siena, an issue considered later in this chapter.

Siena as the Papal Court of Pius II: Meta-urbanism and Ritual (1459–60)

In as far as the built projects for Siena were only part-funded from the papal purse, and that the buildings in question belonged to the Pope's relatives, these architectural interventions might be described as cases of indirect papal patronage of architecture, and involvement with the changing face of the urban fabric of Siena. Before turning to these then, it is worthwhile to consider the temporary measures that accompanied Pius II's two extended visits to Siena of February to April 1459 and January to September 1460, as the pontiff stayed in the city on his journey north to the Council of Mantua, and on his return the following year.[29] On these occasions, the Pope came to the city with a vast following that included a large part of the papal court and many of the cardinals, each with their own retinue (fig. 91). In essence, the papal court and curia settled in Siena, and, during the time of their sojourn, the practical needs of these high-ranking guests for food and adequate residences, and the requirements of pontifical ceremonial practices, were overlaid onto the everyday life of the city. In this functional and symbolic layering of users on the architectural and social fabric of Siena, a 'meta-urbanism' that goes beyond the everyday or obvious reading of the city and its meaning, can be discerned, and is informative of both the civic authority's plans for the city, and of the alternative significance sought from urban space and ritual by the papal court.

While the Sienese government may have felt threatened by the temporal and spiritual power of a pope who was born from a noble Sienese family, whose interests and alliances were with a faction essentially opposed to the ruling group, they nonetheless rejoiced for the election of a Sienese pope. The papal election of Pius had first been celebrated in Siena when the news came from Rome on 20 August; the information was marked by three days of festivities, bell-ringing, a bonfire on the Campo and a celebratory Mass with candle donations to the cathedral.[30] Significantly though, it was not until 3 September 1458, the very same day as the papal coronation took place in Rome, that a formal celebratory event was staged in Siena.[31]

The event, which is meticulously described in a contemporary account by Francesco Luti, one of the eight *festaiuoli* (party organizers) that supervised the planning of the proceedings, took place on the piazza del Campo.[32] Luti's account makes it clear that the city and Campo had been lavishly decorated, and that the staged event that took place in front of the Palazzo Pubblico saw the papal coronation ceremony recreated, as in a modern-day live relay broadcast, in a spectacular manner

91. Anonymous, Pope Pius II seated between two cardinals, cover of the account book (ASS, Concistoro 2479) kept of the expenses for lodgings of the Pope and his cardinals in Siena, 1460. Archivio di Stato, Siena.

for the crowd of local spectators. Pius's coronation was enacted on the Campo, using a theatrical set and *macchina* that had probably been used for the Assumption, celebrated a month earlier in the same setting.[33] The sixteenth-century chronicler Sigismondo Tizio reported that the Campo was decorated magnificently with triumphal arches erected all around it, and that the space was filled with onlookers.[34] In this triumphal setting a priest representing Pius was seated on a throne raised up on a purpose-built stage, surrounded by actors representing the heavenly throng.[35] From his throne, Pius, seated among angels and city saints, observed a theatrical representation of the Assumption, which took place on the same stage and repeated the *sacra rappresentazione* that had been staged on the Campo a couple of weeks earlier. The image showed the Virgin's ascent accompanied by angels in a cloud of smoke, and was achieved in the words of Francesco Luti 'by a remarkable artifice' as the Virgin was raised to heaven in a cloud of smoke, among a host of angels.[36]

It is likely that the imagery and theatrical machinery used were the same as those for the August feast, with a

QVE STA·E·LENTRATA·DELLVEVERABILE·ANGNIOLO·DIPIET
RO·DIBALDO·THNMARLENGO·ALEI·PO·DESANHVOMINI·FILIP
ODIPIER؟NDI·BANTONIO·DABAGNIAIA·EPERO·DIBARNLOME
ODICHARLO·ETONASSO·DOR BANO·GIOVANNELI·ETONASS
ODIMISEREGIORGIOTONASSI·EANTONIO·DIGIOVANIPINI·EL
OCIODICHELO·DERONDINA·EGIORGIO·DIFRANCIO·DACHA
RIGI·NLOMEI·E DOMENICO·DIVENTVRINO·VENTVRINI·MCCCC6o

92. Lorenzo di Pietro, 'il Vecchietta', *The Coronation of Pope Pius II* (1460). Biccherna n° 49, Museo delle Biccherne, Archivio di Stato, Siena.

variant that substituted the Virgin's gift of the girdle to St Thomas, with the Queen of Heaven personally crowning Pius. Such a theatrical representation fulfilled the idea of divine choice in the selection of Pius as pope. Moreover, the identification of the Divine in the person of the Virgin, rather than God the Father, was significant in the light of the city's special Marian devotion. Thus, while recognizing and rejoicing in the election of a Sienese pope, this show appealed to local pride by perhaps implying that the city was partly responsible for Pius's success, which had been mediated by the Virgin herself. The iconographic subtleties of these dramatic choices are apparent in the beautiful *Biccherna*, usually attributed to Lorenzo di Pietro, 'il Vecchietta', in 1458, *The Coronation of Pius II* (fig. 92).[37] Here, as if to confirm the fact of Sienese agency in the election of Piccolomini, the scene

of his coronation is sandwiched between a city view of Siena (below) and the Virgin Mary (above), who crowns him. The painting thus went to some lengths to transform an event that had a broad significance for the Western Church into a specifically Sienese affair.

Vecchietta's *Biccherna*, like the spectacle on the piazza del Campo, re-signified the papal election, so as to accentuate the honour it brought to the city, successfully achieving an artful shift in emphasis that placed Siena – as opposed to the Piccolomini – in the limelight. Such subtleties go some way in helping the modern reader to understand the ways in which the actual visit of the Pope to Siena was managed, and how the double agenda of civic pride and papal pomp might be negotiated in the streets and squares of the city.

The 1459 papal visit was brief, and Pius mentioned it summarily in the *Commentarii*, where he noted that the entry was preceded by a night in the grange at Cuna, and reports that on 24 February the city was 'splendidly adorned and rejoicing' for his entry.[38] While in Siena, Pius made the donation of the 'golden rose' to the city's rulers in an important ceremonial occasion at which he also sang Mass in the Duomo; he also took the occasion to make extensive criticism of the institutional arrangement of Siena and furthered the cause of the re-admission of the nobles to rule.[39] While the local chronicler Tommaso Fecini noted the Pope's arrival, and departure on 23 April, it is remarkable that he seems to have been more intrigued by the theatrics of a Portuguese tight-rope artist, who in January had impressed citizens by crossing back and forth over the piazza del Campo, suspended on a hemp rope between the Palazzo Pubblico and Casa Saracini![40]

The Pope's return to Siena from Mantua on 31 January 1460 is well described by the local chronicler, Allegretto Allegretti, who reported that

> The entire route was decorated between the Duomo and the Porta Camollia, that is at the painted gate, where a beautiful *apparato* was prepared which imitated a choir of angels, or of Paradise itself. And when Pius reached that place, an angel descended from that angelic host and sang some verses, and then turned from the image of the Virgin Mary to the pope, and commended Her and our city of Siena to him.[41]

Standard ceremonials for the meeting of important guests, such as emperors or popes, often involved the granting of the keys, where city officials gave the keys of the city gates to the guest, who occasionally gave them back.[42] What is perhaps most interesting in the case of Pius II is that this ritual was altered. Again, as in the piazza del Campo 'Paradiso' for Pius's coronation and Vecchietta's *Biccherna*, the Virgin personified the city,

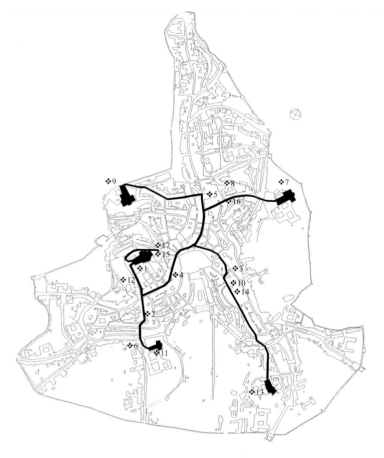

1. Pius II: Palazzo Arcivescovile
2. Cardinal Borgia: Palazzo Bichi
3. Cardinal Bessarion: Palazzo Luti
4. Cardinal Bessarion: Palazzo Marescotti
5. Cardinal Juan de Mila: Palazzo Salimbeni [?]
6. Cardinal Sassoferrato: Casa di Santa Marta
7. Cardinal Scarampo or Orsini: San Francesco
8. Cardinal Colonna: Abbadia San Donato
9. Cardinal de Coëtivy: San Domenico
10. Cardinal Scarampo: Casa di San Martino
11. Cardinal d'Estoutville: San Agostino
12. Cardinal Torqemada: Casa di Giovanni Pecci
13. Cardinal Zamorense: Santa Maria dei Servi
14. Cardinal Barbo: Casa di Tommaso Luti
15. Datario: Casa di Bartolo di Iacopo Petrucci
16. Antonio Robioli: Casa di Bartolomeo Gallerani
17. Giovanni Saracini: Casa di Bartolemeo di Antonio Petrucci

93. Map showing the location of the lodgings of Pope Pius II and the Papal Court in Siena, 1460 (information drawn from Concistoro 2478 and 2480).

paying a great tribute to the Pope, while at the same time reminding him of Siena's divinely sanctioned inviolability. Civic identity as expressed in Siena's devotion to the Virgin was superimposed on papal authority, and reiterated the city's active role in Piccolomini's elevation to the papacy.

Naturally enough, it was not this issue of sovereignty that Pius II recalled in his *Commentarii*, but rather the idea of triumph that was associated with the procession of entry to Siena, which he noted

> was like a triumph and he [Pius] was received with splendid and incredible honours [. . .] Though it was the usual cold February weather, greenery was everywhere. Not a square but was decorated with flowers and fragrant herbs. Everywhere, evergreen trees had been planted, everywhere was heard the singing and shouting of the exultant populace.[43]

There is indeed a sense in which the floral imagery was intended to suggest a re-birth of the city, where spring had arrived early to honour the Pope. To this imagery of rebirth was also added that of the Imperial triumph, evoked perhaps for the first time in Siena by the erection of arches as well as the more usual painted coats of arms of the Commune and of the Pope.[44]

Vecchietta's *Biccherna*, and the staged spectacles that coincided with the Pope's coronation and subsequent Sienese visits superimposed Sienese imagery and civic identity onto the person of the Pope, his family and his office. Pius's two sojourns with the papal court at Siena provide quite a different expression of that dynamic interaction. For if, in the ritual give and take of the entries and other events prepared by the Sienese Commune, the pontiff was shown to owe his good fortunes to his home town, the actual presence of the court in the city might be perceived as a physical takeover of Siena by the Pope. The long-term significance of this possibility can be read in the impact that the papal visit had on choices made in architectural style in the decades that followed, and perhaps more importantly in the programmatic function of legislative measures for urban improvement that accompanied and succeeded the visits.[45]

The papal court in Siena was established in the bishop's palace, adjoining the cathedral on the piazza del Duomo, and various offices vital to the transaction of papal affairs occupied buildings in the environs (fig. 93). Around the papal accommodation were grouped a number of officials in the service of the Pope; this aim was only partially achieved in 1459, when the Papal Depository Ambrogio Spannocchi, who did not yet have a palace in Siena, was lodged on the piazza del Duomo.[46] The policy was taken much further in 1460, when ten properties were hired in addition to the bishop's palace, to house the Pope and his close advisors; while it is not possible to locate all these buildings, four of seven tentatively identified were in the vicinity of the cathedral.[47] Three houses belonging to the Petrucci clan were taken to house the papal equerries, the Datary as well as the papal procurator Giovanni

Saracini; a short distance from the papal court a bakery was hired to supply the daily needs of the palace.[48] The Pope was thus able to recreate his court in the immediate vicinity of the cathedral, the religious centre of the city, on a site well connected to the civic centre, but which also had its own public space in the square facing the bishop's palace and the cathedral.

The court precinct was, of course, also well connected to the residences that city officials had provided for the cardinals, some of which were in the major monastic complexes, and others in private palaces.[49] It seems that a simple governing logic ordered the selection of residences, that they should not be located on either the piazza del Campo, or the main Strada Romana thoroughfare. Rather, the private palaces that were selected lay on the routes that connected the cathedral precinct to the religious foundations of S. Maria dei Servi, S. Francesco, S. Domenico and S. Agostino, roughly distributed to the north, south, east and west of the cathedral (see fig. 93). A conscious attempt appears to have been made to exclude the cardinals from the major commercial street and civic centre, preferring a distribution that gave prominence to secondary pathways through the city. Thus Cardinal d'Estouteville was lodged at S. Agostino; along the route to that priory (via del Capitano and via di S. Pietro) were the palaces assigned to Cardinal Torquemada (Palazzo Pecci), Cardinal Borgia (Palazzo Bichi-Tegliacci) and Cardinal Sassoferrato (Casa di S. Marta). A similarly coherent selection process can be seen in the case of the route to S. Maria dei Servi, where Cardinal Juan de Mella was lodged as a result of the premature death of its planned original guest, the Cardinal of Portugal; along the via del Porrione and piazza Piccolomini route were the residences of Cardinal Bessarion (Palazzo Luti), Cardinal Scarampo (Casa di S. Martino) and Cardinal Barbo (also in a Luti palace).

Such a summary listing indicates that the majority of cardinals were lodged in private residences, many of them belonging to the city's ruling families. It is indeed remarkable that in spite of the fact that monasteries were a more economical means of accommodating religious visitors, a number of the cardinals themselves expressed a personal preference to be lodged in a private home. A rich correspondence records the role of the Sienese ambassadors in Mantua in preparing the 1460 visit, which included negotiating appropriate lodgings for a number of the more exigent cardinals.[50] As the ambassadors Niccolò Severini and Lodovico Petroni noted in September 1459,

Mantua now is honoured by the presence of many prelates and lords, of ambassadors and of numerous courtiers; and it is a beautiful Mantua, and in addition to this large, dignified and beautiful lodgings have been provided. And there is no shortage of anything.[51]

Clearly then, the provision of suitable lodgings was a matter of civic pride, although for some cardinals it was a question of being provided with the style to which they were accustomed. Thus, the Vice-Chancellor Cardinal Rodrigo Borgia requested the Palazzo Bichi-Tegliacci, by which he had evidently been very struck on his first stay, as he stated to the ambassadors his 'great desire to lodge in the palace where he had stayed previously, and that His Holiness had already written to this effect to Luigi Tegliacci, on account of his having recently acquired the palace'.[52] Cardinal Pietro Barbo more bluntly stated that unless he was given better and more spacious accommodation than that of his previous stay, 'he won't stop in Siena on the way back [from Mantua] but will go straight back to Rome'.[53] The Cardinal of S. Prassede went so far as to send an equerry to Siena to 'prepare him the same lodgings and ensure that it was equipped with what was necessary'.[54]

The distribution of the papal court about the city was not simply a question of finding suitable accommodation, but also imposed new processional or ceremonial axes on the public space of the city, as cardinals, ambassadors and other visitors converged towards the papal precinct around the cathedral square.[55] While only temporary, the papal authority marked its presence on Siena's urban fabric through ceremonial functions and visible symbols that jockeyed for position with the long-established civic iconography, thus investing the city with a double identity. The careful balance that saw the city's civic authorities in a commanding role over the local church, defined by many scholars in terms of 'civic devotion', came temporarily to be undermined as the Pope himself officiated at many of the principal religious feasts.[56] Such a decisive presence was established from the first days of the 1460 visit, so that on 2 February, just two days after arriving from Mantua, Pius II officiated at the Mass for the feast of Candlemas in the cathedral and, in the words of Allegretto Allegretti 'personally handed out the candles to every citizen of the city of Siena'.[57] Allegretti was evidently struck by the break from the usual observance of the feast, and his telling observation becomes eloquent when read in conjunction with the near-contemporary papal ceremonial establishing an increased emphasis on the active role of the Pope in the feast of Candlemas, during which the 'pontifex dat candelam'.[58]

In this and numerous other cases, the spiritual presence of the Pope was made tangible for the citizen com-

94. Commemorative inscription and arms of Pope Pius II, from the façade of S. Maria dei Servi.

95. Commemorative inscription and arms of Pope Pius II, from the façade of the Palazzo Bichi-Tegliacci on the piazza S. Pietro in Castelvecchio.

munity, who were brought into direct contact with the Sienese pontiff. The presence of Pius II was also made evident in the physical space of the city, as numerous buildings were marked with the papal and family arms of the Piccolomini. Such a practice may have its precedent on the ephemeral coats of arms, painted on wood or paper, that were prepared to adorn the ceremonial entry route inside the city walls in 1459 and 1460.[59] Certainly, there is no other precedent – other than in the ubiquitous civic symbols of the *balzana* and *popolo* that adorn most of Siena's public buildings – for the widespread use of marble plaques bearing the Piccolomini coats of arms. A large number of these survive, some of them with inscriptions that specifically link them to the papal visit, and it is remarkable that many are affixed to buildings that did not belong to the Pope or his family.

Forty years ago, Iris Origo commented of the IHS monogram popularized by S. Bernardino of Siena and visible on proud public buildings as much as 'on some crumbling farm or castle' that 'this is where San Bernardino came, the emblem tells; this is where he spoke'.[60] Origo's supposition was that many of these plaques were not imposed by outside authorities, but that rather it was a means of popular expression of adherence to devotion to the saint, even where there was no direct record of a visit to be commemorated. There is certainly an element of spontaneity with which the radiant sun monogram was adopted so widely, and was reproduced for private devotional purposes in the form of marble, terracotta and maiolica plaques. By the same token, it would seem that the widespread use of the papal arms of the Piccolomini was only in part promoted by the direct agency of Pius II, or the commemorative impulse of the public authorities, but that in a number of cases it was the individual citizen that chose to affix them to his residence, perhaps as a record of the fact that the building was used by the temporary papal court in Siena. Such is certainly the case for a nice example extant on the façade of the church of S. Maria dei Servi, the Servite twice used as the residence of Cardinal Juan de Mella, that also records the date of the papal coronation (fig. 94). Similarly, the building next to the Palazzo Bichi-Tegliacci, part of the residence of Cardinal Rodrigo Borgia, was marked with the papal arms and an inscription (fig. 95).[61]

In other instances, the papal arms were displayed on buildings that belonged to families with ties of patronage or alliance with the Piccolomini pope. This is the case for the arms supported by *putti*, attributed to the sculptor Urbano di Pietro da Cortona, displayed on the façade of the Palazzo Lolli on the via di Città, a building remodelled in the early 1460s (fig. 96). Goro (Gregorio) di Niccolò Lolli was one of Pius's oldest friends and he

96. Attributed to Urbano di Pietro da Cortona, arms of Pope Pius II, from the entrance of the Palazzo Lolli, via di Città.

97. Coffered wood ceiling from the Palazzo Lolli, showing the Lolli arms at the centre, via di Città.

served as one of his personal secretaries; in recognition of this friendship and service, Pius II granted his family the right to use the Piccolomini name.[62] In tax returns of 1465 Goro declared that he had restored the façade of the palace 'in the happy days [of Pius] in a beautiful manner', and that he needed a further 1,200 florins to complete the internal work, of which a grand *all'antica* courtyard and marvellous coffered ceiling are surviving traces, which record the crossed arms of the Lolli with those of the Piccolomini (fig. 97–8).[63] Built a decade after the death of Pius II, the Palazzo Spannocchi on the Banchi di Sopra, also displayed the Piccolomini arms in honour of the pope that had afforded Ambrogio Spannocchi major advancement in curial financial offices, thus contributing to the construction of the palace.[64]

Such emblems were a powerful means of rooting the memory of the papal visit and sojourn in Siena to the very buildings with which his presence was associated.[65] Comparable spontaneous commemorative marks can also be found on public buildings, in what Luisa Miglio has evocatively described as 'scratches of history', semi-official graffiti on the walls of the Palazzo Pubblico.[66] Here, unknown hands scratched memorial epigraphs of significant events, recording the first papal visit of 24 February 1459, and the Pope's death in Ancona, the night of 14 August 1464.[67] These inscriptions are of particular interest as they appear to bridge the divide between official commemoration in the form of monumental epigraphs that were increasingly common through the second half of the fifteenth century, and the informal subjective record of chronicles or diaries.[68] The public location of the graffiti afforded them a semi-official quality that belied their almost furtive nature. A similar

98. Lolli arms from an Arnald van Westerhout etching after a drawing by Antonio Ruggiero, Piccolomini family tree, 1685. Archivio di Stato, Siena.

99. Inscription commemorating the visit of Pope Pius II to the cathedral works office.

process would explain the inscription 'MCCCC• LVIIII• A DI •5• DI FEBRAIO•PPA•P•II• VENE• I QUESTA• BUTIGA' ('5 February 1459 [1460], Pope Pius II came to this workshop') etched on the walls of the Duomo Nuovo, on the site of the cathedral workshop (fig. 99). The workshop was immediately behind the bishop's palace, deputed as papal residence, and it is interesting to note Pius's visit to it within a week of arriving in the city. The tentatively classicizing capitals lent the inscription an air of *all'antica* formality that contrasts with the use of vernacular, which suggests the spontaneous gesture of the stone-workers to record the papal visit to their work-place.

If the Sienese government's official response to the papal visit is encapsulated in Vecchietta's *Biccherna* image, and the ritual re-enactment of the coronation ceremony on the piazza del Campo, where Siena and the Virgin Mary stepped in to assume a dominant role in Piccolomini's election, the papal visits had quite a different impact on the city as a whole. For two substantial periods of time Siena was taken over by the papal court, whose ceremonial activities and residential requirements were overlaid onto the everyday life of the city, which thus functioned as *alter* Roma.[69] In turn, the strong physical and symbolic presence of the pontiff resulted in numerous permanent marks that recalled the visit, being affixed on public and private buildings, thus etching the memory of the Piccolomini pontificate onto the walls of the city itself. As is argued in the following chapter, the papal visits also accelerated the process of urban renewal of the city's main street, so that it can truly be said that the pontificate of Pius II was the most significant catalyst for the transformation of Siena in the fifteenth century.

Of course, this was also a result of the Pope's active involvement in architectural patronage in Siena and in nearby Pienza. Pius's well-known patronage of architecture at Pienza was matched, and surpassed, in terms of financial outlay in a number of projects undertaken in the centre of Siena, for which the Sienese government offered a series of incentives, tax breaks and concessions that were to serve as an important precedent in the patronage strategies of other Sienese families in the last third of the fifteenth century.[70]

Civic Planning and Private Patronage: The Palazzo delle Papesse

The interaction between Piccolomini patronage and public policies that encouraged the city's architectural renewal can be observed most clearly in the case of the Palazzo delle Papesse, built for Pius's second sister, Caterina, from 1459 (fig. 100). This free-standing palace was built in a conspicuous location called the piazza Manetti, a site facing the via di Città, which was flanked by narrow streets leading up towards the cathedral; however, the site was far from the main Piccolomini family residences, and may well have been chosen to encourage and participate in urban improvement projects around piazza Manetti, since building incentives were offered in April 1459 to 'whoever might like to build on that site [. . .] beautifying that area which is now shameful to the city, especially in view of the imminent visit of the papal court'.[71]

By the time of Pius's accession to the papal throne, Caterina Piccolomini was a widow living in the via del Casato with her stepson Francesco di Bartolomeo Guglielmi.[72] As a widow, Caterina was dependant on her stepson for income, as also was her daughter Antonia, whose marriage dowry to Bartolomeo della Massa was also paid by Francesco; neither Antonia nor Caterina received the full amounts owing to them from Francesco.[73] The election of Caterina's brother to the pontificate in 1458 ended her situation of dependence on her stepson. Caterina reverted to using her father's family name of Piccolomini, which was also transferred to her son-in-law, Bartolomeo dei Piccolomini della Massa, who in turn was appointed Prefect of Spoleto.[74] Papal funds thus helped Caterina reacquire her identity and independence, and were also instrumental in allowing her to become the patron of a large free-standing palace in Siena, where she was to live with her daughter and son-in-law.[75] It comes as no surprise, then, to find that Bartolomeo and Antonia's son was named Aeneas in memory of his munificent great-uncle.

The palace project progressed rapidly for two reasons: on one hand, a steady flow of papal funds from the papal accounts of the *Tesoreria Segreta* covered building costs, while on the other, the creation of an adequate site on which to erect the building was significantly aided by the intercession of the Commune.[76] In October 1459 an anonymous patron petitioned for the concession of the site at piazza Manetti, promising to build rapidly, so that by the Assumption of the following year 'all the front façade [on the via di Città] will be complete'.[77] The petitioner was, of course, Caterina who received part of the palace site in December 1459; she enlarged the site

100. Palace of Caterina di Silvio Piccolomini, known as Palazzo delle Papesse in a late nineteenth-century photograph.

with acquisitions of August 1460, and was granted additional land by the Commune in October 1460.[78] The Sienese government also allowed her the right to take over the side streets adjacent to the new palace so that these could be used for the storage of materials and the placement of scaffolding.[79] Furthermore, tax exemptions were granted on the import of luxury building materials, such as 'travertine marble, *macigno* and any other type of stone needed by her'.[80] As the city council stated, such concessions were in part made in deference to the Pope, but were also intended to help 'make the said house very honourable, and with great expense, to the greater glory of this magnificent city'.[81]

That 'grande spesa' was in turn underwritten directly by papal finances. From as early as January 1459 Caterina was the recipient of a papal income, with regular payments made throughout Pius's reign.[82] While the first payments are for large sums, for which no specific purpose is mentioned, by June 1462, the majority of entries in the treasury accounts specify that the funds were 'for the palace she is having built'.[83] By 8 December 1460, she had received 1,520 ducats, while an additional 2,343 ducats were sent to Caterina over the following four years, paid out in relatively small sums, specifically for the palace project. In addition to these funds, Caterina's son-in-law Bartolomeo della Massa also

101. Palazzo delle Papesse, detail of stone-work.

102. Palazzo delle Papesse, courtyard.

received a considerable salary.[84] Furthermore, the extent to which the rapid construction of the palace was reliant on funding from Rome became explicit after the death of Pius II, when that source of income abruptly dried up and construction came to a halt. As Caterina and her son-in-law declared in a tax report of 1466, 'they were damaged by the death of Pope Pius as they had left 3,000 ducats in Spoleto', so that to continue with construction of the palace for the 'honour and beauty of the city' they had to sell off many of their assets to raise necessary funds.[85] Finishing touches remained incomplete, and completion expenses were estimated at 2,000 florins in tax reports submitted into the early sixteenth century.[86]

By providing funds from the papal *camera*, Pius II greatly assisted his sister with the construction of her palace, thus indirectly supporting Sienese government policies that required the reordering of the piazza Manetti area, and more generally required the improvement of façades along the Strada Romana. In fact, from as early as 1444 the piazza Manetti site had been the object of *petroni* property restoration policies. As was shown in the previous chapter, Nanni Marsili had been required to restore the derelict Palazzo Marsili, which was collapsing, and by April 1459 had commissioned a restoration from Luca di Bartolo da Bagnocavallo.[87] It was, as we have seen, at this time that the *Ornato* set about finding a patron that might develop the site, an offer that was taken up by Caterina, with the financial help of her brother.

Caterina's palace on the via di Città was built quickly on a site that was prominently located but distant from the traditional clan base of the Piccolomini, which was in the district of San Martino, on the south-east side of the Campo. The Palazzo delle Papesse, as Caterina's palace eventually came to be known, served as a residence for Pius II's sister and niece, for Caterina had no male heirs. Indeed, it may be that the building's unusual nickname refers to the fact the palace came to represent a female line which retained the papal surname of Piccolomini (fig. 101–2).[88] The scale of investment and architectural ambition expressed in Pius II's other major family project, which was developed around the piazza Piccolomini, suggests that the Pope expected much of the four sons of his other sister, Laudomia Todeschini Piccolomini.

Family and Memory: Redeveloping Piazza Piccolomini

Aeneas Silvius Piccolomini was born in exile; his grandfather had been banished from Siena in 1368, and his father had been employed first as a courtier and mercenary to Gian-Galeazzo Visconti, and then had maintained his own small estate in Corsignano, where Aeneas

Silvius was born.[89] His branch of the large Piccolomini clan had therefore been discredited in Siena from the fourteenth century, a situation that Pius II appears to have set out consciously to remedy through political intervention and investments in real estate. After so long a period of exile from Siena, his branch of the family no longer owned property in the city, so that their physical and legal presence there had largely been erased.[90]

The Pope's desire to return his lineage to a leading position in Sienese political life, and provide the Piccolomini with an appropriate architectural presence in the city, was channelled through the patronage of Pius's two sisters. In contrast to Caterina, Pius's other sister, Laudomia (who was married to Giovanni Todeschini), had four sons, on whom the Pope bestowed titles and positions: Francesco (Archbishop of Siena and cardinal), Antonio (Duke of Amalfi), Iacomo (*Signore* of Montemarciano) and Andrea (*Signore* of Castiglion della Pescaia and the Isola del Giglio).[91] It was the Todeschini-Piccolomini branch that was admitted into the *Monte del Popolo*, and became active in government offices throughout the second half of the fifteenth century, benefiting from matrimonial alliances with families within and beyond Siena (fig. 103).[92] While Caterina established her lineage in a well-placed palace in the city centre, Laudomia and her sons were the beneficiaries of financial support from the papal *camera*, which led to the creation of a monumental Piccolomini enclave adjacent to the Campo. Thus, Pius's political scheming placed his branch of the family into a dominant position within the powerful *Monte del Popolo*, while his architectural ambitions redefined the Piccolomini clan around the dominant power of the papal nephews (fig. 104).

In a letter sent from Rome in September 1458 by the Sienese ambassador to the Pope, Niccolò Piccolomini reported that Pius had said 'I want to build a palace in the enclave [casa] of the Piccolomini'.[93] The same letter also contained the Pope's formal thanks to the Sienese government for having admitted the Piccolomini family into the ruling group. A connection was thus identified from the very outset between the political, familial and architectural agendas that were encapsulated in the project to redevelop the piazza Piccolomini site.[94]

Piazza Piccolomini was public ground south of the Campo; defined by the space between the Strada Romana and via del Porrione, it was bounded by a series of residential properties and the façade of the *Terzo* church of S. Martino.[95] The high number of Piccolomini residences around the piazza, and well known as the 'pozzo dei Piccolomini', led to the naming of this space 'piazza Piccolomini' from as early as the fourteenth century.[96] In 1453, before Pius's election,

103. Fictive landscape showing Piccolomini dominions, from an Arnald van Westerhout etching after a drawing by Antonio Ruggiero, Piccolomini family tree, 1685. Archivio di Stato, Siena.

sixteen out of nineteen Piccolomini households were taxed in the district of Pantaneto, in the vicinity of piazza Piccolomini.[97] This situation had not dramatically changed by 1481, when fourteen households continued to live in Pantaneto, although by this time eleven households were taxed outside the district.[98] Understandably, it was this area that Pius selected for his major architectural patronage in Siena; it was the heart of clan space, and coincidentally happened to be prominently

104. The Piccolomini enclave in S. Martino, detail from F. Vanni, *Sena Vetus Civitas Virginis*, fig. 10.

105. Loggia Piccolomini.

placed at the centre of the city, adjacent to both the Campo and the Strada Romana.

The redevelopment of the piazza Piccolomini site was achieved by the construction of two major new buildings, a massive palace and a family loggia, which were placed in such a way as to organize the open space of the piazza, which was reoriented towards the path of the Strada. The first phase of this ordering preceded the papal election, as it is known that Aeneas Silvius paid for restoration of the church of S. Martino while he was still Bishop of Siena, since the church was re-consecrated on 10 August 1458.[99] S. Martino was a local parish church, but it gave its name to the district or *Terzo* (third) of the city that spread south-east from the Campo towards the Porta Romana. The Piccolomini were the most powerful family resident in this district, and were frequently involved in its local government.[100] The church was subsequently rebuilt in the sixteenth century, and no traces survive of the fifteenth-century renovation.

While Niccolò Piccolomini reported the Pope's desire to build a palace in the Piccolomini area, progress on that project was preceded by the construction of the magnificent marble Loggia Piccolomini (fig. 105). It seems clear that the church of S. Martino was an integral element in the planned reordering of piazza Piccolomini, as the original plan for the Loggia was that it should be set back from its actual position, so that it would be aligned to the façade of S. Martino.[101] However, to do this would have required a plot of land that was owned by Giovanni di Guccino, a schoolmaster who refused to sell his school to the Piccolomini.[102] Plans were therefore modified and the Loggia was constructed on a site that stands proud of the church. Around 3,000 ducats of papal funds paid between December 1460 and October 1461 were used to acquire a site and perhaps materials for the Loggia, while the building campaign began in earnest with a payment of 600 ducats in late April 1462.[103]

74

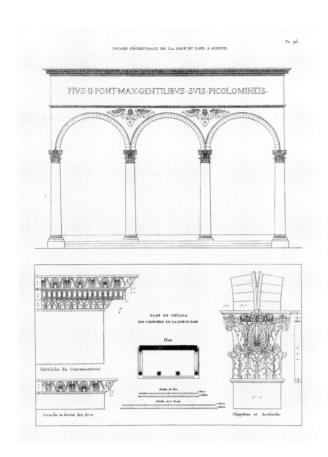

PIVS·II·PONT·MAX·GENTILIBVS·SVIS·PICOLOMINEIS·

PLAN ET DÉTAILS
DES CORNICHES DE LA LOGE DU PAPE

Plan

Corniche du Couronnement

Corniche au dessus des Arcs.

Chapiteau et Archivolte

106. Loggia Piccolomini, from A. H. Victor Grandjean de Montigny and A. P. Sainte-Marie Famin, *Architecture toscane, ou Palais, maisons, et autres Édifices de la Toscane . . . Nouvelle Édition*, Paris, Salmon, 1846, plate 95.

Allegretto Allegretti recorded that the first column of the Loggia was put into place on 18 May 1462, and it is probable that work was complete by September of that same year, when Vecchietta and a stone-mason named Nanni Castori were called to arbitrate on completion costs for the project.[104] Payments made through the papal treasury account for a total expenditure of 3,811 ducats, and may be assumed to be fairly complete, including as they do the payment of 20 *lire* in November 1462 for six pairs of hose bought for the builders 'who have worked on the loggia of the Piccolomini'.[105] This was the last payment made for the Loggia, which was referred to in the past tense, thus suggesting that Pius was able to admire it in its completed form on his brief visit to Siena, on returning from the thermal baths at Bagno di Petriolo, on 31 August of that year.[106]

The Loggia is a large, open three-bay arcade, oriented to face north up the Strada Romana, constructed with marble columns and *all'antica* capitals that support a high attic bearing the Piccolomini papal arms and the inlaid bronze inscription 'PIUS II PONTIFEX MAXIMUS GEN-

TILIBUS SUIS PICCOLOMINEIS' (fig. 106).[107] A simple bench articulated by classicizing pilasters runs around the inside of the Loggia. The exterior of the bench that faces the Strada Romana, and was prominently visible at eye level by all passers-by, was decorated with a series of seven once-painted sculpted Piccolomini coats of arms, which include Pius's, one quartered with the House of Aragon, two topped with a cardinal's hat, another with a bishop's mitre, one with the Imperial eagle and one other (fig. 107). In addition to Pius himself, a number of these evidently referred to his closest relatives, his nephews: Antonio, whose marriage with the illegitimate daughter of King Ferrante of Naples he had arranged in 1458; Francesco, whom he appointed Archbishop of Siena and cardinal in 1460; and Andrea and Iacomo, who had remained resident in Siena.[108] The 'Gentilibus Suis' that Pius associated with his name were particularly the sons of his sister Laudomia, the recipients of his greatest favours, but also, by implication, the rest of the clan resident in the area, whose arms are shown on the corners of the attic, facing the Strada and the piazza.[109]

While Antonio and Francesco were established with careers in the Neapolitan court and Curia respectively, their brothers, Andrea and Iacomo, inherited the Loggia,[110] declaring in 1481 that

> under the Loggia Piccolomini, Messer Iacomo [my brother] and I share two shops and a small warehouse, which are rarely let on account of the great damp that affects them, so that they are usually closed as can be seen at present. And whenever we do get some income from them, we use it for the maintenance of the loggia.[111]

107. Piccolomini Loggia, detail of bench towards Strada Romana, showing the coats of arms of members of the Piccolomini family. Note the shop openings below.

108. Palazzo Todeschini-Piccolomini, view along the Banchi di Sotto, photographed by Paolo Lombardi, *c.*1870.

Andrea and Iacomo therefore owned the property on which the Loggia was built, and the building was maintained at their expense, partially from the income of the shops set into its basement.[112]

They were also the owners of the massive Palazzo Piccolomini, prominently placed between the piazza Piccolomini and the Campo, with a façade that dominates the Strada Romana (fig. 108).[113] As we have seen, the Pope's desire to construct a palace in the heart of the Piccolomini enclave was expressed in his earliest exchanges with the city Commune. Even so, two years elapsed, and three visits to Siena passed, before any action was taken in this direction, during which time Pius's patronage interests were more keenly focused on Pienza and the Loggia project in Siena. The site and construction of the Siena palace were first formalized in a request for tax exemptions on materials made in October 1460 by Pius's agent in Siena, Giovanni Saracini.[114] On that occasion, exemptions were granted

on half the value of property taxes (*gabelle dei contratti*) and the import taxes levied on construction materials, on account of the fact that 'the city will be made more beautiful and magnificent as a result of this marvellous project'.[115] From the outset, the palace project was thus presented as contributing to the improvement of the public image of the city.

Acquisition of the site began in earnest after these exemptions had been granted, with as much as 8,300 ducats expended from the papal purse between January 1461 and October 1463.[116] Of this sum, around 6,000 ducats had been paid out by May 1461, and the remaining part accounts for the acquisition of specific properties required for the completion of the site.[117] Unfortunately, it is not clear whether property continued to be acquired after 1463, but the site must almost wholly have been owned by 1464, since 16,000 ducats that were left to Cardinal Francesco in Pius's will, were earmarked 'to build the palace'.[118] Unfortunately, as Pius's nephews complained in 1466, the will was not observed, and the funds allocated were blocked by the new pope, Paul II, so that 'our palace is on the ground, as can be seen, which for our own honour and that of the city [. . .] not being completed [. . .] will cost us numerous thousands of florins'.[119]

As it stands, the Palazzo Piccolomini remains incomplete, as it should have been free-standing, so as to fill an *insula* bounded by the Campo, the Strada Romana, via del Porrione and piazza Piccolomini, with four façades identical to that which was built (fig. 109).[120] Instead, in 1480, the palace was divided into two parts; one side, which belonged to Iacomo and came to be known as the 'Palazzo Nuovo' (the new palace), faces the Strada Romana and is constructed of travertine in a style similar to that adopted for the palace at Pienza. The other, which belonged to Andrea and is described in documents as the 'Casamento Vecchio' (the old residence), is a more complex structure with a corner on the Campo and a façade on the narrow via del Porrione, made up from a number of buildings extant on site, which were regularized and unified by the insertion of new stone window frames and other architectural details.[121] While Lawrence Jenkens has argued that the division of the palace into two parts, and the distinct architectural language that distinguishes these from one another, is to be ascribed to the differing political ambitions of the two brothers, it seems rather more simply that family matters interfered with completion of the palace according to plan.[122]

In deciding to build at the heart of Piccolomini clan space, Pius II appears to have encountered some opposition from other members of the Piccolomini clan. By seeking to assemble a site large enough for the con-

109. Palazzo Todeschini-Piccolomini, view along the chiasso dei Pollaiuoli.

110. Palazzo Piccolomini Clementini.

111. Palazzo Piccolomini Clementini, courtyard.

struction of a massive palace-cube, Pius's ambitions ran aground, it seems, due to the reluctance of certain members of the clan to sell their property to him. Thus, in the division document that split the palace in two, the 'casamento vecchio' is described as being enclosed on the Porrione-piazza Piccolomini side by a series of properties belonging to other members of the clan.[123] It was these properties that prevented the completion of the palace according to plan. That such was the situation is brought out clearly in an arbitration made by the *Petroni* as late as 1503, in which a property conflict between Andrea Piccolomini and the sons of Giovanni della Piazza, Iacomo and Girolamo, was resolved.[124] The litigation was long-standing, as the disputed property boundary had been mentioned in the 1480 division document, and a builder that had once supervised work on the site was called in to testify on the matter of ownership of a courtyard space that divided the della Piazza property from Andrea's. Such long-standing conflict is surely indicative of the difficulties encountered in other cases in the area.

Indeed, evidence of this sort again confirms that Pius placed the needs and ambitions of his immediate relatives above those of the Piccolomini clan as a whole. In some respects then, Pius's support of shared Piccolomini interests was a foil for the advancement of his branch of the clan; thus no other family members mentioned a fiscal liability for the Loggia, and even though Pius is said to have established a *consorteria* to control common Piccolomini properties, no joint tax return was made for shared property in the city.[125] This of course contrasts with a loggia built in the same period in Florence by the Rucellai, which F. W. Kent has shown was a 'loggia comune', paid for from shared funds and on shared property, in spite of various difficulties.[126]

Nonetheless, while clan members were quick to declare that they had received no benefits from papal munificence in their tax returns, the piazza Piccolomini area is rich with coats of arms, escutcheons, heraldic symbols and other family devices that define familial control of the area and proclaim associations to the papal line.[127] Piccolomini clan space was not limited to

78

112. G. B. Ramaciotti, view of the piazza Piccolomini. Fondo Chigi, P VII 11, fol. 99, Biblioteca Apostolica Vaticana.

the piazza Piccolomini, but extended beyond it, east to via della Staffa, a street that runs parallel to the Strada.[128] In fact, a number of Piccolomini properties faced onto the Strada, and also extended back as far as via della Staffa, linking the two streets across private family space.

The Palazzo Piccolomini-Clementini is one such property. It faces the Loggia Piccolomini, but at ground level a sequence of hallways and courtyards functioned as a covered private street that leads to further Piccolomini properties beyond. The palace was originally constructed around two courtyards of which only the second, towards the rear of the building, survives; here a three-storey loggia articulated on the ground floor by squat travertine columns with *all'antica* capitals bearing the Piccolomini half-moon reveals substantial modifications executed in the later fifteenth century (fig. 110–11).[129] The palace retains a Gothic façade, but was decorated in fresco, fragments of which still survive and show portrait busts of classical heroes.[130] These few surviving remains appear to have been painted in the late fifteenth century and resemble Taddeo di Bartolo's 'Huomini famosi' in the Anticoncistoro of the Palazzo Pubblico.[131] Although the portraits cannot be identified, their purpose may have been that of applying a veneer of classicizing splendour to the façade, which also acquiesced in Pius's project for the piazza by including the papal Piccolomini arms on the façade.[132]

Piccolomini properties, and the family arms – with and without the papal tiara or crossed keys – surround the piazza Piccolomini. While it is not possible to assess what proportion of these buildings underwent modifications in the years around Pius's pontificate, a number of the coats of arms are certainly fifteenth century, and reveal the drive to define clan space by architecture and sculpted symbols. Moreover, as a seventeenth-century drawing in the Chigi collection in the Vatican shows, a prominent medieval family tower faced the palace–loggia complex, binding the new buildings into a cohesive relationship with the historic family architecture of the area (fig. 112).[133] Thus, family arms, associations of place and architectural lineage bound together the large clan, while architectural style and political influence marked out the Todeschini Piccolomini papal nephews as different from their kinsmen.

The Papal Style of Piccolomini Architecture

Architecture served to define the effects of papal patronage both in terms of the scale and cost of the monumental buildings constructed, but also on account of the innovative form chosen for the new Piccolomini buildings in Siena. The Loggia and the two Piccolomini palaces are an important turning-point in the introduction of a new style of *all'antica* architecture to Siena. This distinctive new form marked the Piccolomini out for their connections with papal Rome, and as belonging to the group of sophisticated elite patrons who

113. Palazzo Medici, Florence.

increasingly chose a classical mode for the designs of their palaces.[134] In turn, these ongoing projects served as an important prototype for a number of other Sienese patrons, whose palaces were constructed in the decades following Pius's pontificate.

In spite of their undoubted significance, confusion continues to surround the attribution of these buildings to a specific architect or group of architects. The problem is well illustrated by the conflict that emerged in June 1463 over salaries to be paid by Caterina Piccolomini for the Palazzo delle Papesse; arbitration was sought from 'Magistro Bernardus', usually assumed to be the Florentine architect in charge of the Pienza development, Bernardo Rossellino, for a salary owed to Antonio Federighi.[135] Two years later, Caterina still had an outstanding debt of 400 florins to Federighi.[136] By January 1472, Caterina was subject to further litigation brought through the Mercanzia court by the sculptor and stone-mason Urbano di Pietro da Cortona, for 'marble windows and the price of two Madonnas [. . .]', for which the price-judge, Pietro dell'Abaco, assigned 100 *lire* in reparation to Urbano.[137] The sculptor-architects Rossellino and Federighi, the sculptor-builder Urbano da Cortona and the estimator Pietro dell'Abaco

are all mentioned in association with the building, although none is firmly identified as its designer.

The building itself provides few clues to resolve the issue of authorship. The Palazzo delle Papesse façade finds its closest parallel in the Palazzo Medici in Florence, sharing with it the use of graded stonework, from the massive *bugnati* (rustication) of the ground floor, to channelled ashlar of the upper storeys (fig. 113). Likewise, the slight acute arch of the windows marks a gesture towards local building traditions and neighbouring properties, much in the same way as Howard Burns has described the similarity between the windows of the Palazzo Medici and the Palazzo Vecchio.[138] Again, while the massive round arches that once contained a ground-floor loggia also resemble the Medici model, the nearby thirteenth-century Palazzo Tolomei also contained a symmetrically ordered ground-floor family loggia. Sienese local building traditions are even more marked on the inside of the building; thus, the courtyard, where brick octagonal columns support round arches with pilaster strips connecting up the entire elevation of the building, closely resembles the Cortile del Podestà in the Palazzo Pubblico.[139] So then, while the Florentine model of the Palazzo Medici influenced the palace design, this was significantly adapted to include examples drawn from local tradition.

A series of names have also been connected to the design of the Loggia on piazza Piccolomini: a possible early design, supported by a wooden model, was perhaps submitted for the project by Lorenzo di Pietro, otherwise known as 'il Vecchietta', in March 1460.[140] Both Charles Mack and Ruth Rubinstein proposed that Rossellino was the likely designer of the Loggia, and more recently Jenkens has put forward the name of Leon Battista Alberti as an adviser on the project.[141] A series of documents show that Federighi certainly supervised the Loggia's construction and may have been its principal sculptor; one entry in the papal registers refers unequivocally to 'master Antonio Federighi who is making the loggia in Siena'.[142] Moreover, the similarities with Federighi's rigorously classicizing sculpture, evident in the benches of the Loggia della Mercanzia, where his involvement is also documented, further support the architect-sculptor's prominent role in the Piccolomini Loggia project.

Again, the Palazzo Piccolomini is usually attributed to Rossellino, Pius's chief architect in Pienza, on the basis of stylistic similarities to the Pientine palace (fig. 114 and see fig. 86).[143] However, since Rossellino died in September 1464, that is five years before the palace was actually begun, it has been proposed that a drawing (and possibly a model) was left at his death. The palace was then supposedly built on the basis of these

114. Palazzo Piccolomini, Pienza.

models, in the words of Allegretti, from 1469 by 'Pietro Paolo called "il Porrina" of the de'Porrini from Casole, a Sienese gentleman; and the master builder was master Martino the Lombard'.[144]

In all three of the above cases scholarly debate has focused on the supposed likelihood of Pius's use of a Florentine architect, the same Bernardo Rossellino who oversaw construction of Pienza, to plan the buildings for Siena. According to Pius's account in the *Commentarii*, Rossellino went considerably over budget in the execution of the Pienza project, was disliked by the workforce and local population on account of his being a Florentine, but was much praised for his work by the Pope, who paid a bonus and gave him a rich red robe to display his status as papal architect.[145] Unfortunately, no such praise was reserved for the architect of the Siena project, which

went unmentioned in the *Commentarii*, and doubts remain as regards the attribution of the buildings.

Pius's involvement in Siena aimed to improve the physical presence of his branch of the Piccolomini within their clan territory around San Martino, while also participating in and encouraging public policies directed at urban renewal. By his own admission, Pius would have won little sympathy in Siena if he had employed a Florentine to oversee his projects. Moreover, as at Pienza, it seems likely that Pius II had strong views about the architectural form the buildings that he commissioned should take, and that he would have sought a local expert builder and site supervisor, able to convert his ideas into reality.[146]

Antonio Federighi was *capomaestro* of the cathedral works between 1450 and 1480, and as such was a public

115. S. Francesco, cloister and view to raised roofline of the church.

official. As *capomaestro*, he was involved in some of the most important public projects in Siena around the mid-fifteenth century, including the church of S. Ansano in Castelvecchio, the Loggia della Mercanzia and Cappella di Piazza.[147] Federighi was therefore experienced as an administrator and organizer of large-scale projects and it has even been suggested that he may have served in a similar capacity to Rossellino in Pienza.[148] As a public official in charge of the most prestigious civic commissions, his involvement in Pius's projects in Siena would have been considered a politic and convenient choice, both by the patron and by the city authorities.[149] As mentioned above, Pius visited the *Opera* workshop that Federighi was in charge of within days of his arrival in Siena.

There can be little doubt that Pius favoured Federighi for works commissioned in Siena, hiring him to sculpt his parents' tomb in S. Francesco in 1459 and involving

him at some level with all his architectural projects (fig. 115).[150] Among the earliest recorded payments made from the papal *camera*, 276 cameral florins were given to 'Antonio Federighi master of the Sienese cathedral works office' for restorations made to rooms in S. Francesco to be used 'for the residence of our Holy Father'.[151] Federighi's work displays considerable awareness of classical architecture and sculpture, and he is known to have travelled to Rome for study in 1448 or 1450.[152] Conversely, the fact that both Rossellino and Vecchietta were called on as arbitrators for Piccolomini building projects with which Federighi was involved (the Loggia and the Palazzo delle Papesse), suggests that they were not employed on the projects themselves, while adding further credibility to the fact that Federighi was the supervisor.[153] Federighi would thus have acted as executant architect for several buildings in Siena, although the design for

116. Pienza, general view of the piazza.

these must be understood to be the result of a complex relationship between the patron, site-master and perhaps even an external adviser, such as Rossellino.[154]

The stylistic choices connected the Sienese project to that for Pienza. Architectural style and the planning of buildings on an urban scale certainly unites the two commissions. However, in Siena, Pius was pursuing a different agenda from that which governed his choices for Pienza. That Pius was prepared to invest so much in Caterina's palace away from the piazza Piccolomini suggests that his plans were not exclusive to one area, and that he wished to participate in the Commune's projects for city renewal. By contrast, the purpose of the Loggia and Palazzo Piccolomini was to provide a residence for his immediate relatives, prominently placed in Piccolomini clan space. Throughout, the chosen architectural style marked the buildings, and their owners, as

sophisticated and well-connected individuals within a growing Italian cultural elite. While papal Rome and elite Florence may have provided the models for the architectural design of the palaces and Loggia, Siena's political and urban context shaped the projects in an equal measure.

Architectural Form, Urban Planning and Political Theory

Discussion of the piazza Piccolomini development has often tended to pair this project with Pius's other well-known piazza project at Pienza (fig. 116). In Pienza, a cathedral, a government building, a family palace and a number of other palaces were rebuilt around the piazza Piccolomini and the town's main street over the brief

period of five years.[155] However, Pius II's redevelopment of his birthplace, Corsignano, which was elevated to a bishopric and was renamed Pienza in honour of the Pope, constitutes quite a different case from his architectural patronage in Siena.

Formal similarities can clearly be observed between the Pienza and Siena projects: in both cases a private palace, a church, a loggia and a civic government building were placed in relation to one another around a piazza. Moreover, a common architectural language, and perhaps even the same architect, unites the Piccolomini palaces at Pienza and Siena. But comparisons of this sort miss the vital distinctions made between the two projects; since it is patronage choices that are expressed in such distinctions and details, it is the differences, rather than the surface similarities, that we should dwell on.[156] Patronage conditions in Siena were quite different from those at work in Pienza, while external factors that prevented the rapid completion of the Siena plans means that the built form of the Sienese Palazzo Piccolomini must also be considered in relation to the papal nephews that completed the palace, rather than to their original patron, the Pope.[157]

Corsignano was the home of Aeneas Silvius's parents, a place where the Piccolomini were major landowners, in which it was possible for the new Pope to behave as a feudal lord.[158] While Corsignano lay within the Sienese *contado*, no objections were raised to the re-ordering of the town, since Siena received numerous advantages from the Pope elsewhere in southern Tuscany, and Pienza was also fortified as part of the renewal effort.[159] Piccolomini family power and weak central control from Siena enabled the Pope to reissue the city statutes, which acknowledged the role of the Piccolomini in local government. Moreover, in Corsignano property prices were low, and relocation of dispossessed townspeople was comparatively easy.[160] All these factors contributed to make the realization of Pienza easier and more striking than the Sienese project, while also configuring the papal intervention there in totally different terms from those expressed in Siena.

In the *Commentarii*, Aeneas Silvius made an extensive, justly famous and frequently quoted description of the architecture of Pienza.[161] The description begins with a thorough explanation of the Palazzo Piccolomini, with its many family coats of arms and beautiful views over Mount Amiata and the Val d'Orcia, and continues with a chapter dedicated to the cathedral, with its façade proudly displaying the papal and family arms of Pius II (fig. 117).[162] The other buildings are summarily described, although the Pope underlines the fact that he had ordered the demolition of buildings to make way for the new city hall, which he paid for himself in order to provide a dignified residence for the civic magistracies and to ensure that 'four noble palaces surrounded the piazza'.[163] Having rebuilt the principal buildings that represented the site of civic, religious and familial power, all of which were liberally encrusted with Piccolomini devices, the Pope also participated in reconfiguring urban ritual.

In the chapter immediately following these descriptions comes an account of the celebration of the local feast day of S. Matteo.[164] For the occasion, in order that the civic magistracies might appear more dignified, the Pope had their costumes renewed, while papal funds also paid for the festivities, the prizes for the races and the food provided for all those that attended the fair held on the feast day. A spectator to these events in the company of his cardinals, the Pope conducted the affairs of state, high up on a balcony, above the citizens and their well-dressed officials.[165] No better analogy than that provided by Pius II himself could be offered for the scope and ambitions of the Pienza intervention. The Pope supplied new costumes for the civic authorities, while he brokered real power from a high balcony, an observer of the popular festival that his munificence, as pope and lord, had provided. In the same way, he provided the city with a new statute and a new city hall, while the real centre of power and patronage was located in the Piccolomini palace–cathedral complex.

As has been shown, the situation in Siena was somewhat different. Pius II wielded his influence as pope to give his branch of the Piccolomini a political voice in the city government, while he used papal funds to create a place for his immediate family to live, at the heart of Piccolomini clan space. These two achievements raised Pius's heirs and nephews to eminence within the Piccolomini family, a situation that was expressed in the architecture of piazza Piccolomini and described in documentary sources. For in fact, while numerous Piccolomini lived in the vicinity of the piazza, few of them received direct advancement as a result of his patronage, declaring in their tax returns of 1466 that 'we had no help from Pope Pius nor from anyone else' or that 'at the time of Pope Pius, although we were Piccolomini, we drew no papal advancement from it'.[166] The piazza Piccolomini was thus a family project on two distinct levels; most importantly it gave Pius's nephews a central place in Piccolomini family space, while in more general terms it projected the collective importance of the entire Piccolomini clan through monumental architecture and the inclusive family imagery of the Loggia.

In turn, these projects also provided an example of private magnificence, which contributed to civic urban

117. Pienza, view of the Monte Amiata from the loggia of the Palazzo Piccolomini.

improvement policies described in the chapters that follow. Reporting on Siena's origins and institutions in the *Commentarii*, Pius commented generally on the place of the urban nobility in Siena's past:

> For our part we can assert that in this city there were many nobles and very powerful men who erected

lofty palaces, high towers, and very splendid churches while they administered the state.[167]

His comment implied a direct connection between noble families' private investment in urban architecture and their participation in public office. These remarks precede the account of the Pope's entry to the city in February 1459,

a period in which negotiations for the re-admission of noble families into Siena's government were underway. By referring to the public function of private architecture of the thirteenth century, Pius was perhaps suggesting that the contemporary city fabric would benefit from the re-admission of noble families to office, and their re-investment with a sense of civic duty. The 'nobles' that Pius referred to were ancient Sienese families, such as the Tolomei, Salimbeni and Malavolti, who had indeed constructed 'lofty palaces and high towers', many of which survived into the fifteenth century.[168] Moreover, only a select few of these original magnate families were 'famiglie di loggia', entitled to own an open loggia, where the family could gather to conduct ceremonies and business.[169] It was this prototype that the piazza Piccolomini palace–loggia combination imitated and revived.

That Siena's political life, and the role within it of the Piccolomini and other noble families, was a matter of major concern to the Pope is clear from a reading of the *Commentarii*. Indeed, as Loredana Lanza has rightly pointed out, while Pius made many vivid and insight-filled descriptions of cities in Italy and beyond in the *Commentarii*, all his discussion of Siena revolves around the central issue of politics, and omits any physical description.[170] Some scholars have argued that this, and the fact that he made no mention of the building campaigns embarked upon in Siena, indicate that Pius lost patience with the city, and played down his associations with it in his biography.[171] Factors such as the incomplete nature of the building project, the Pope's death before the manuscript was finished, as well as a conscious emphasis on family history as related to Siena and the political situation there, must also have influenced the omission of the piazza Piccolomini complex from the text.

Furthermore, although Pius II did not leave a written appraisal of the Siena project, a text which he commissioned from his friend, the humanist Francesco Patrizi (1413–94), helps to explain his conception of the intricate connection between architecture, patronage and politics. Patrizi was also Sienese; he and Aeneas Silvius had become friends while they studied together in Siena, and remained in contact with one another while Piccolomini was in Germany.[172] Paola Benetti Bertoldo has shown that Patrizi was a key figure among the group of intellectuals most involved in the development of humanist culture in Siena, arguing that this group was in many respects at odds with the city government.[173] Nevertheless, Patrizi served in public office on numerous occasions, and also acted as Sienese ambassador for events such as the journey of Frederick III to Rome in 1452, as well for visits to the court at Naples and to Federigo da Montefeltro in Urbino in 1453–4.[174] In 1456 Patrizi took part in Antonio di Cecco Rosso

Petrucci's failed plot to take control of the city with the help of the mercenary commander Iacopo Piccinino.[175] As a result of his involvement in the plot, Patrizi was exiled from Siena, and in fact only escaped a capital sentence on account of Aeneas Silvius interceding on his behalf with the Commune. In November 1459 Patrizi was pardoned, and in 1461 his name was officially cleared of the charges brought against him for the events of 1456, again through the direct agency of Pius II. Soon afterwards the Pope nominated him Bishop of Gaeta (March 1461) and Governor of Foligno (May 1461), to which city he moved, bringing with him a large contingent of Sienese assistants to fill various positions in the city's government.[176]

Patrizi was therefore a humanist actively involved in politics, allied with a group of families who desired a government less representative of the popular faction, and was from an early date active in writing texts that defended and defined the interests of that aspiring ruling group (fig. 119). Thus, the short tract *De gerendu magistratu*, written in 1446, celebrated the role of long-established families in the rule of the city.[177] The same theme was to emerge at greater length in the treatise on republican government, the *De Institutione Reipublicae libri novem*, a text that is often dated to the 1470s, but was almost certainly complete by 1464.[178] The work was eventually dedicated to Pope Sixtus IV della Rovere and to the Sienese Commune, although an unpublished letter in the Vatican, written to Cardinal Francesco Todeschini Piccolomini, indicates that Patrizi had originally been moved to write the treatise by Pius II himself (fig. 118).[179] It is thus clear that Patrizi's treatise must be read in the light of Pius II's architectural and urban renewal plans for Pienza and Siena.[180]

118. Francesco Patrizi, *De Institutione Reipublicae libri novem*, Cod. Cassin. 425, Biblioteca del Monastero di Montecassino.

119. Francesco Patrizi, 'Ad Aeneam Pium II pont. max. sanctissimus
q. Francisci Patricii Senensis Poematum liber primus incipit dedicatio
libri', Manoscritto Chigi, J VI 233, fol. 1r, Biblioteca Apostolica
Vaticana.

The specifically Sienese context and significance of the *De Institutione Reipublicae* is evidently a result of the author's personal experience of government in Siena, but also because the volume was prefaced by a letter addressed to the 'Senatum Populumque Senensem', and was thus clearly defined as being relevant to a Sienese audience.[181] Patrizi's text deals with the disposition and government of a city-state Republic, understood in the terms of the contemporary political reality of fifteenth-century Italy, describing and analysing the political, social and economic conditions that prevail in such an urban context.[182] Significantly, the treatise does not confine itself to a theoretical discussion of the city as *locus* of government, but examines the urban fabric itself, giving ample space to a discussion of the role of the architect in planning the city, and the disposition of streets, piazzas and individual buildings, both public and private. Architecture and government are thus bound together, so that a well-governed city will be architecturally well-ordered, and vice versa; the antecedents of such a political and visual discourse in Siena are clearly to be found in Lorenzetti's fresco cycle in the Sala dei Nove, a cycle that was indeed commissioned by the ancestors of the political group (the *Noveschi*) with whom Patrizi was associated.[183]

While, in some respects, the most original feature of Patrizi's treatise is the way in which he links social and political issues of government to the question of urban

form and the role of the architect, the type of government he describes is significant when considered in the light of Piccolomini patronage in Siena, and the promotion of government-excluded factions by Pius II. Patrizi viewed the city-state as the natural resolution of man's need to be a 'social animal', and in Book I he outlines the ways in which urban society should be ordered to maintain equality among citizens.[184] While Book II deals with the varieties of profession that should exist in the city, Book III instead focuses on public offices and the procedures that should be observed in nomination and election. Here, Patrizi dwells at some length on the virtues appropriate to public service; he lists the same qualities that were immortalized by Lorenzetti on the walls of Siena's government chamber in 1338, with a similar stress given to Justice as the principal virtue of government.[185] In describing the types of official needed in the city, Patrizi dedicates chapters to both the secular and religious hierarchies. Following a practice introduced by Pius II for the newly founded bishopric of Pienza, he establishes that the master of the cathedral works ('aedile sacrarum') should be elected by the bishop, a procedure at variance with Sienese practice.[186] In turn, an entire chapter of Book III describes the functions of the officials charged with the maintenance and improvement of the streets and the city's urban fabric ('aedilibus'), an office that was established in Siena during this period, perhaps following the Pope's suggestion.[187]

Patrizi's republic was one in which the political group is drawn from the city's socio-economic elite. In Book II, in the same breath as he lamentes the factional division that wracked Siena, he praises the Venetian republic and the stability of its institutions, and continues to describe the importance of the senatorial or patrician class in stable city government.[188] Indeed, the core three books of the *De Institutione Reipublicae* relate specifically to the family, in its public and private role. While Book IV discusses the function of the family and the *paterfamilias* in the government of private affairs, Books V and VI project the family onto the public scene, so that virtues honed in the family setting are given a public purpose. It is thus in Book V that the public virtues of government, discussed in Book III, are revealed as being an attribute of the patrician class, showing that these families are naturally suited to rule. A clear statement in favour of the ancestral aristocracy's capacity to rule comes in chapter One of Book VI, where Patrizi provides a definition of urban society as being made up of three classes: the ancient nobility, a middle-ranking group of worthy citizens, and a majority suited only to being governed.[189] Connections of this sort are clearly reminiscent of Pius II's comments in the *Commentarii*

regarding the suitability of noble families to public office. It is, moreover, precisely for the re-admission of the socio-economic elite, as represented by the families excluded from Siena's government, that Pius II campaigned throughout his pontificate.

Further confirmation that Pius II's definition of families suited to government coincided with Patrizi's can be found both in the latter's discussion of surnames and ancestry (VI.I and VI.7) and in the description of the public functions of private architecture (VI.3 and VIII.II). Patrizi shows great interest in the significance of surnames and the possibilities that these offered for melding family and urban history. Thus, in chapter One of Book VI he provides an excursus on his own family name, for which he predictably argues a Roman ancestry, which he claims is corroborated in documents and numerous marble inscriptions scattered around Rome.[190] Ancient lineage defined noble families and in turn supported claims to the antiquity of the city as a whole, and indeed Patrizi was later to write a text entitled *De Origine et Antiquitate Urbis Senae* in which family names play a prominent role in establishing the classical origins of Siena.[191] Here, a number of improbable origins are provided for many of Siena's noble families, ranging from the unlikely Ancient Egyptian origins of the Tolomei to the questionable direct descendance of the Piccolomini from Romulus.[192] Whether they were credible, however, the point was to establish an honourable and ancient lineage that endorsed access of these families to government office.

Having thus established which families should be active in government in the central books of the treatise, the last three books turned to the physical form the city should take. Patrizi's observations on urban planning are considered in the following chapter, providing as they do a contemporary theoretical consideration of urban form that serves as a useful measure and guide for the urban renewal policies enacted in Siena during the third quarter of the fifteenth century.[193] However, it is in the last section of the treatise that Patrizi addresses themes relevant to an understanding of Piccolomini architectural patronage in Siena. Specifically, chapter Eleven of Book VIII discusses private architecture in the urban context. Patrizi advises that families in public office should invest in a palace suited to their status, but that this should be 'a beautiful home'. He recommends the use of 'sancta illa mediocritas' (a golden mean), so that a building will display neither the opulence nor the avarice of its owner, but rather that the palace will beautify the collective image of the city.[194] While the examples that Patrizi provides for private patronage in the service of the common weal were all selected from classical sources, a parallel with choices made for the piazza

Piccolomini development and the Palazzo delle Papesse can certainly be noted.

The piazza Piccolomini was developed on a scale unprecedented in fifteenth-century Siena, but for which a number of earlier examples can be provided. The 'beautiful home' that Pius II planned for his sister and his nephews was on a similar scale to that of the thirteenth-century Palazzo Tolomei, a magnificent stone palace with an open ground-floor loggia that faced onto a piazza, and the adjacent church of S. Cristoforo, that had strong familial associations.[195] Likewise, the massive fortified enclave (*castellare*) of the Salimbeni was constructed in a central site in the city, had a dominant stone façade that overlooked a piazza and the city's main street, and was also associated with the nearby parish church of S. Donato.[196] These and other examples of thirteenth- and fourteenth-century magnate architecture provided the Pope with prototypes to be adapted in a contemporary architectural mode. In line with Patrizi's advice regarding 'sancta mediocritas' and Pius's own comments on the architectural patronage of the medieval nobility, the piazza Piccolomini was developed in a manner appropriate for a family with papal ties and in a style that advertised its cosmopolitan connections. Moreover, while the piazza Piccolomini can be said to have improved the city through the beauty of its architecture, the Palazzo delle Papesse actively participated in government-led urban improvement campaigns. Here again, Patrizi's 'aedilibus' (officials in charge of urban maintenance and improvements) intersected with papal patronage strategies and civic policies.

Pius II's patronage of architecture in Siena was certainly intended to benefit his immediate relatives, and more generally the entire Piccolomini clan. However, as the *Commentarii* and Patrizi's treatise seem to indicate, there was a secondary function for the buildings constructed under the aegis of the Pope, which was to provide an example of the benefits of enlightened magnate patronage to the public weal. This example, as chapters Five and Six show, was to have lasting effect on the city and the way in which public policies harnessed private patronage in order to renew the urban core.

5

'La città magnificata'

URBAN MAGNIFICENCE AND CIVIC IMAGE

In order to magnify public honour and rebuild the city in a beautiful way, with appropriate and wonderful works
[...] and especially along the Strada Romana [...] more than in any other location,
because those that visit your city see that street more than any other.[1]

The fourteenth-century storyteller of the *Trecentonovelle*, Franco Sacchetti, tells of one Alberto da Siena, who borrows a nag from a friend in order to go out of the city. The nag had a mind of its own and had no wish to leave the city. When they reach the gate, the horse refuses to go a step further and so Alberto is forced to turn around; the animal then happily trots back to the city centre and to the Campo.[2]

The piazza del Campo was the natural pole of attraction of Siena, and as the heart of civic government, commercial activity and a major site of city devotion, its appearance and maintenance was strictly regulated from the thirteenth century onwards.[3] To be in Siena, for Sacchetti's horse, was to be on the Campo. So too, S. Bernardino of Siena conveyed a similar message in one of his 1427 Lenten sermons, commenting that 'he who should want to come to the Campo from outside the city of Siena, may enter from the gate of Camollia or from the Nuova [Romana] or Fontebranda gates: there are many ways in, but all arrive at the same destination.'[4] The horse without a rider, like the traveller, pilgrim, merchant or honoured visitor, followed a natural pathway that was carved through the dense fabric of the city.[5] Indeed, Sacchetti's image of the urbanite steed fits well with the origins of Siena's well-known horse race, the Palio, which was originally run *alla lunga* along the city's main streets, from the periphery of the gates to the centre.[6] That route, like the processional entries described in chapter One, marked out a privileged axis through the city that directed attention onto its focal centre, the piazza del Duomo and piazza del Campo.

If the city's ritual and civic focus was defined in relation to the piazza del Campo, it is also true that its commercial heart was overlaid on the same shell-shaped piazza. As early as November 1398, the Sienese authorities stated their concern regarding the degradation that had affected the Campo and main city streets, and launched public urban policies to renew those areas.[7] They referred to

the piazza del Campo, which is the most beautiful [piazza] that can be found, and the splendour of the Strada dei Banchi, which begins at piazza Tolomei and reaches as far as Porta Salaria, is unrivalled in Venice or Florence or any other city of Italy.

120. Palazzo Sansedoni, façade from the Banchi di Sotto.

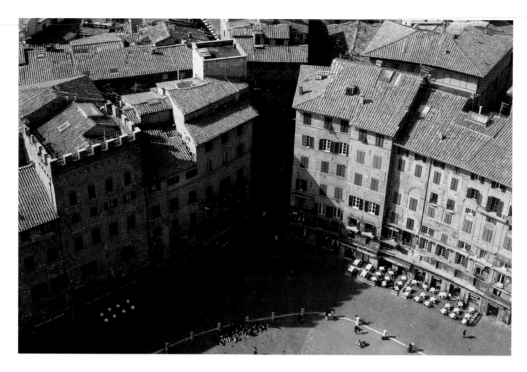

121. Costa dei Barbieri access to Piazza del Campo.

Such a statement makes it quite clear that the Campo and central section of Siena's main street were considered a natural urban showcase, to be viewed by citizens and visitors alike; their maintenance was a matter of public importance. During the century that followed, as this and following chapter show, a concerted campaign brought forward by means of government policies and private patronage, improved the architectural fabric of the Campo and central streets.

Viewed from the shop floor, these changes had a noticeable impact on various businesses. So for example, in 1460 the Sienese barber Ristoro di Meo petitioned the city council, presenting an account of his vicissitudes at the hands of market forces and urban improvement legislation.[8] Until recently, Ristoro had plied his trade in via del Porrione, in a shop that he reported 'I paid a great deal of money to renew'. Thinking that he could make more money from a better location, the barber then moved to the piazza del Campo, where he took a shop under the palace of Giovanni di Misser Agnolo, and again spent large amounts of money to furnish it. Having invested heavily in the new shop, Ristoro began to make the much desired return on his investment, whereupon the city council legislated against barbers operating on the Campo, so that Ristoro was forced to leave the shop and again seek new premises.[9] Having reached the end of this painful peregrination, Ristoro complained that

both for having changed shops and because my new shop is less well placed, and because of the expense of restoring the new shop for the needs of my trade, I have been completely ruined.[10]

The barber's story is clear on the supremacy of location in his business, while confirming that shops needed to be properly furnished; Ristoro renewed three shops in a short period, and had pinned his hopes on a prime location on the Campo.

Barbers of course benefited particularly from being visible on a central location, where potential customers might be drawn in as they undertook other business in the market, or milled about waiting to have access to the Palazzo Pubblico or other services around the Campo (to this day, the main ramp into the piazza is called the Costa dei Barbieri; fig. 121). Indeed, a few years after Ristoro's professional demise, an ingenious barbers' cooperative located in via del Porrione petitioned the city council to be appointed official barbers to the *Signori*, guaranteeing in return that their shop would be properly furnished with hot water, towels, basins and all other implements necessary to their service.[11] Granted the right to wear the same outfit as the *donzelli del palazzo*, the barbers thus promoted their skills through both a good location and an unusual marketing ploy. It might even be that the *Signori* saw a further advantage in the partnership, given the amount of gossip that took place in barbers' shops!

A Conspicuous Economy: The City as Market-place

In 1398 the city officials expressed their concern at the appearance of the public spaces of the Campo and central streets of the Banchi, stating that 'in every good city the adornment and improvement of the city is taken care of'.[12] As is shown in the following chapter, by a combination of individual, institutional and governmental initiatives, which resulted in the construction of new palaces, churches and vistas, as well as through planning changes enforced to improve movement of traffic and processions, the Strada Romana was transformed so as to lend 'great ornament to the entire city and pleasure to all its citizens'.[13] Such a process, however, was not undertaken for the sole benefit of the city's inhabitants, but also for visitors, such as pilgrims, dignitaries or their ambassadors, and merchants. It was these travellers that government officials hoped to attract to Siena, so that they might consequently spend their money in the city's shops and on services. This strategy is most clearly expressed in statute decisions of 1452, which outlined the economic and aesthetic criteria that underpinned city-planning policies:

> it would be much more useful, honourable and beautiful if the more noble and appropriate trades, especially for foreigners, were located in sites which are more public and hallowed in the city, and more frequented by foreigners to the city, particularly those travelling to and from Rome, which are an infinite number [. . .] so that seeing these various wares they may be encouraged to buy, but not seeing them, they do not even think of doing so.[14]

Such economic considerations as these were compounded by another problem; that is the development of alternative north–south routes towards Rome, which privileged Florence to the detriment of Siena. The rise of Florence during the thirteenth and fourteenth centuries encouraged many travellers to adopt routes that followed the Arno valley into the Val di Chiana, thus avoiding the via Francigena which followed the Val d'Elsa and passed by Siena (fig. 122).[15] As late as December 1473, the threat to Siena's trade and prestige from alternative routes was identified by the Sienese diplomat Francesco Luti, who wrote to Lorenzo de' Medici explaining Siena's antagonistic policies towards Florence in conflicts of 1431 and 1473 as originating from Florentine fiscal incentives to users of the Val di Chiana route, which resulted in reduced use of the Strada Romana.[16] As Luti so clearly put it, 'I remember that the wars between your and our Republic also had their origins in the Strada.'[17]

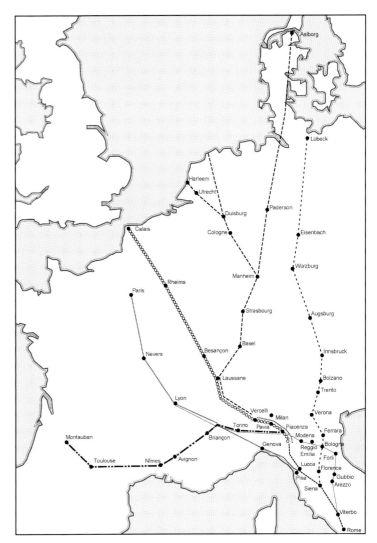

⋙⋙⋙	Sigeric, Bishop of Canterbury (990)
▬·▬·▬	Barthélemy Bonis, merchant of Montauban (1350)
⋯⋯⋯	Eudes Rigaud, Bishop of Rouen (return journey, 1254)
-------	Nicholas Bergthorsson, later abbot of the Icelandic monastery of Thveraa or Munkathvera (1151–54)
·······	Described in the Norse Hauksbók (early 14th-century)
----------	Shared Itinerary
————	Matthew of Paris (mid 13th-century)

122. Map showing pilgrimage routes to Rome through Siena.

Policies that underlined the role of Siena as a market place that would appeal to through-travellers were thus both a counter-response to the challenge of the alternative markets and routes provided by Florence and to the long economic slump that affected Siena in the aftermath of the Black Death of 1348. As William Caferro has argued, the political instability of the late fourteenth century forced the Sienese into massive military expenditure that had a crippling effect on the public purse, and consequently on the citizen tax-payers.[18] Nonetheless, far from collapsing under the

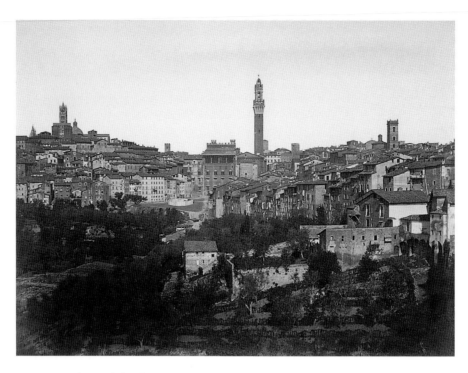

123. Area destined for the Borgo Nuovo di S. Maria, for immigrant housing development, between the Palazzo Pubblico and Porta Giustizia in a late ninteenth-century view.

strain of a dwindling population and various financial pressures, late fourteenth- and early fifteenth-century legislation shows an active concern for bolstering the economy, encouraging immigration to Siena and introducing new luxury industries to the city.[19]

Scholars have usually regarded immigration incentives as indicators of economic decline, although the continuous flow of immigrants to the city constitutes an interesting phenomenon in itself, and suggests quite different conclusions.[20] From the late fourteenth century, tax reductions were offered as incentives to immigrants to Siena, while earlier provisions had only granted citizenship to settlers who built their main residence in the city.[21] In 1398 it was decreed that

> Any foreigner that exercises a trade or is a worker who wishes to come to live in the city or the contado of Siena will be exempt from any expense or communal tax for the period of ten years.[22]

The precedent established by this provision was repeated in Statute compilations observed throughout the fifteenth century, and by 1470, and perhaps as early as 1451, the laws were altered to provide twenty-, rather than ten-year tax exemptions.[23]

The new settlers' citizenship and permanence in the city were physically expressed and guaranteed by the construction of a house within the walls.[24] From 1323,

the Commune had embarked on an ambitious project to create a new district, located below the Palazzo Pubblico and named the Nuovo Borgo di S. Maria, especially for immigrant settlers, described as 'novi cives senenses'.[25] Following the Black Death, the district had been abandoned and become derelict, so that in 1374 it was left to return to agricultural use (fig. 123).[26] Nonetheless, a local historian writing in the 1480s, Bartolomeo Benvoglienti, remarked that foreigners continued to live in the area behind the Palazzo Pubblico, suggesting some survival of the district.[27] New settlers in Siena appear in fact to have taken up residence across the city, favouring the more marginal districts, where property prices were considerably lower than in the centre.[28] In spite of immigration, Siena's population remained fairly constant throughout the fifteenth century at around 14,000, making it the second largest city in Tuscany after Florence (38,000 in 1427), and about twice the size of the next largest city, Pisa (7,300).[29]

Immigration rules existed to define the exchange between the incentives offered by the city to settlers, and the pledge made by the latter to remain permanently in Siena. However, in some cases the Commune was clearly especially interested in the profession exercised by the petitioner, particularly when these were for new or foreign products, and allowed rules to be overlooked in favour of those settling in the city to produce

them.[30] In chapter One, it was shown how tax exemptions were granted to the tapestry-master, Giachetto di Benedetto from Arras, to encourage him to settle in Siena in 1442 and establish a workshop with local apprentices.[31] Giachetto had in fact been preceded in Siena by another weaver from Brussels, Rinaldo di Gualtiero, who had also been given permits to work in the city from 1438.[32] In 1460 the soap manufacturer and perfumer Domenico Pictii was offered personal tax breaks and an exemption on raw material imports of oil and soda to the city, on the condition that 'during the period of his permit he should manufacture in the city of Siena, as much good and retailable white soap as is necessary for the requirements of the city of Siena and the *contado*'.[33] Again, in 1461, Lorenzo Gherardi of Volterra was offered a house free of cost, so that he moved to Siena and established a workshop, from which he produced colour-dyed leather goods.[34]

In addition to these and other case-specific provisions, large numbers of builders and specialist stonemasons from Lombardy and the regions around the lakes of Como and Lugano settled in Siena during the fifteenth century, and were likewise granted tax exemptions and incentives in favour of settlement in the city.[35] It is difficult to quantify the number of Lombards present in Siena and active in the building trade, on account of the fact that many were itinerant workers who did not become city residents. By 1462, however, a vast number of Lombards were working in Siena and its *contado*, and are listed in a volume compiled by the *Ufficiali sopra alle mura* in order to enforce a new tax introduced in August that year, 'against Lombards and other migrant workers'.[36] The summary tables 2 and 3 (see Appendix) show a total of 1,898 non-Sienese individuals listed in the various professional categories connected to the building trade, of which around 70 per cent have names tracing their provenance to the Lake region.

Studies of the Lombard presence in Siena have usually suggested that the brief period of Milanese Visconti rule in Siena (1399–1404) provided the necessary favourable conditions for the immigration of workers south into Tuscany.[37] There is no reason to believe this to have been the case since, as Giovanni Cecchini first pointed out, the presence of Lombard workers on Sienese building sites can be noted from as early as the thirteenth century.[38] Moreover, recent studies confirm earlier findings, which traced Lombard builders in most cities in Italy, as well as in most countries in Europe (including Russia), without resorting to political or diplomatic motivation to explain their migratory habits.[39]

The immigration of Lombard builders to cities throughout Europe was obviously a result of their specialist skills, combined with a shortage of work on local sites and higher salaries available outside their home regions.[40] As early as 1396 the *Opera* of Milan Cathedral expressed its fears regarding the migration of labour away from Milan to larger, and more financially attractive, work-sites in central Italy.[41] Thus, as the work of Ennio Poleggi has shown for fifteenth- and sixteenth-century Genoese architecture, the Lombard *Maestri Antelami* communities had an important hold on the construction industry and were granted privileged taxation and working conditions.[42] Likewise, scholars have noted that in Venice, special laws were passed to allow Lombard workers to participate in the construction of the Doge's palace, while the presence of the Lombardo sculpture workshop (i.e. Pietro and his sons Tullio and Antonio) is but a minor indication of the significance of 'imported' artists in Venice's architectural and sculptural tradition.[43] So too, the conspicuous presence of Lombard builders has been noted in the same period in Rome, where the sculptural architecture of Andrea Bregno represents perhaps the most sophisticated stonework of the last decades of the century. Unfortunately, however, while scholars have identified the role of Lombards in these and other Italian cities, their particular contribution to local architectural traditions has largely been ignored, and no common features have been assembled to describe a 'Lombard mode'.[44]

Fifteenth-century immigration to Siena by Lombards probably occurred in the form of small groups of workers, headed perhaps by a financially independent master; they could either be seasonal or more long-term.[45] Evidence from tax returns filed during the second half of the fifteenth century shows that Lombards were poor, and few had families with them. At least two declarants claimed tax exemption since 'we still have 11 years exemption, given we came to live here 14 years ago', indicating that a twenty-five-year tax exemption had been offered to them for settling to work in Siena.[46] Furthermore, in April 1472 a group of 'men, and particularly Lombards', appealed to the city authorities, that they might take over a number of derelict properties in the city, itemized as

> piazzas, small houses, derelict properties, and other houses that are in a ruined condition in your city, in order to build and restore those houses and improve those sites. And they would pay tax in your city and contribute to the lira (tax office) as other citizens do.[47]

Appropriately, the petitioners proposed to put their professional qualities in the service of both the Commune and themselves, restoring derelict properties for the public good and for their own residences, in return for citizenship.

Perhaps on account of their number and skills, the large contingent of Lombards who came to work and live in Siena resulted in a trade dispute that ended with the break-up of the building guild of the *Arte del Legname* during the mid-fifteenth century, and the formation of a largely Lombard *Arte dei Muratori* in 1488.[48] Almost all the members of the new-formed *Arte dei Muratori* had names referring to provenance from north of the Apennines, and the signatories on the new statute stated that 'two thirds of the masters are living and permanently resident in the city of Siena', confirming large-scale long-term immigration of Lombard workers to the city.[49] The very formation of the new guild of the *Muratori* had been dependent on this group of permanent settlers in Siena.[50] Nonetheless, once the Lombards had definitively seceded from the local building guild, the latter repeatedly complained that the Lombards were parasites, earning money to send back to their families in northern Italy, rather than spending it in Siena.[51]

The presence of so large a workforce of builders in and around Siena suggests considerable demand for labour, which in turn indicates that the city's economy was able to support construction on a large scale. While the impact of these specialized workers on Siena's local building tradition will be assessed towards the end of this chapter, immigration on such a scale underlines the value of government incentives in favouring the city's economy and expanding the labour market.

Cases such as these reveal that the city government actively pursued policies intended to bolster the city's economy through the introduction of new trades, as well as encouraging fresh industries designed to supply the needs of local markets. Such objectives were also expressed through legislative measures that specifically called for the establishment of new businesses.[52] Thus, in May 1451 a series of provisions were introduced to encourage the production of silk and velvet in the city, coinciding also with the raising of import taxes levied on imports of these luxury goods to Siena.[53] In July of the same year, the wool guild was reformed, production of cloth was increased, and the import of luxury cloths was banned.[54] A more comprehensive decision of October 1459, in which the Commune nominated a committee to supervise the reordering of the guilds and encourage economic revival was prefaced 'it is known that the guilds and trades are what make the city rich, populated and beautiful', and suggested a series of policies to this end.[55]

Incentives for luxury production industries continued to be granted throughout the second half of the fifteenth century, and received further legislative attention in the early sixteenth century. The silk industry continued to be favoured by incentives, although in 1466 a series of complaints were filed against silk workers who took advantage of financial incentives and loans offered to them for settling and establishing a business in Siena, only to leave with the money.[56] Specialist workers continued to come, however, so that in July 1477 one Antonio di Girolamo from Venice successfully petitioned for a safe conduct to settle in Siena and establish a workshop, on the grounds that 'it is well known that your city has a serious shortage of masters that exercise the trade perfectly'.[57] The following year, further provisions were made in favour of the wool and silk industries, on account of both the income made from the trade in these goods and the employment opportunities offered by the industries.[58] Other industries were also encouraged: for example, in 1477 limits were placed on the import of ceramic ware to Siena, on account of the damage this did to local production, although in this instance it was specified that glazed maiolica ware could be imported.[59] In the years that followed, provisions were made in favour of the leather industry and shoemakers, while in 1481 the cloth-merchant Nello di Francesco was granted incentives to establish a rope-making workshop in the city.[60]

Many of these economic policies aimed at increasing the production of luxury goods that were to be made prominently available to visitors and citizens in shops lining the Campo and Strada Romana.[61] The 1398 ruling had already expressed such an objective through attempts to establish strict zoning for the Strada, stating that 'they should order [the street] so that the bankers are together on one side, and that the cloth-merchants be somewhere else, and so too the goldsmiths, fur-sellers and the armourers'.[62] While such restrictions do not appear to have been fully enforced, they reveal a concern that the street should act as a showpiece shop-front for the city's luxury industries.[63] That it was luxury retail that was to be encouraged is partly confirmed in a government decision of 1451 that,

> For the good of the common weal and private individuals, they decided and ruled that from January 1452 onwards, no smithy of iron or copper, with the only exception of goldsmiths, be allowed to exercise their trade under any account, from the Croce del Travaglio as far as the Cantina di San Giorgio, under pain of a fine of 100 gold florins.[64]

This positive encouragement of goldsmiths operating along the southern portion of the Strada contrasts sharply with the succession of rulings against butchers, cobblers, smiths and linen-makers operating in the same areas.[65]

Zoning measures implemented from the mid-fifteenth century were increasingly defined in terms of

urban aesthetics and the beneficial effect of such an enhanced environment to the retail potential of shops selling luxury products. The legislative foundations for zoning procedures are again to be found in the fourteenth-century statutes, such as the 1309 laws regarding the Campo, which sought to create a civic showpiece onto which the Palazzo Pubblico faced.[66] Industrial clustering of water-intensive primary industries such as tanners and fullers around the major fountains of Fontebranda and Ovile also dated to the fourteenth century, but was need-specific rather than policy-driven.[67] From the fifteenth century, however, increased application of zoning restrictions was largely dependent on a developing sense of urban aesthetics, since the majority of zoning provisions refer to 'ornamento della città' (beautification and improvement of the city) as the motive for the transfer of certain professions to peripheral areas.[68]

In July 1459 the city council passed another law against cobblers, shoemakers, tanners, butchers, barbers, carpenters, smiths, pan-makers and other professions that used fire in the production process, banning them from working on the Campo and other centrally located streets.[69] These trades were to relocate to other areas and were granted special rights to abandon lease contracts without paying penalties, in order to enforce the decision speedily; targeted shopkeepers who had recently moved into new premises on the Campo were even allowed to re-acquire their old shops at a fair market price. Such decisions were not always popular, as was shown by the case of the barber, Ristoro di Meo who had moved from a shop on via del Porrione to the Campo because 'I was successful in my trade [. . .] and thought that I might do better I left my old shop in favour of a shop on the Campo, below the residence of the jesters'.[70]

That it was the image projected by the city's main piazza and streets that was at the heart of these new zoning restrictions is made abundantly clear in a decree of 25 October 1459:

> it would be a good and honourable thing, particularly on account of the imminent visit of the Papal court [. . .] that it were decided and ruled that blacksmiths should on no account have their workshops along the Strada Romana from San Donato a Montanini as far as the Duomo and the piazza Piccolomini.[71]

By removing the noisy and dirty blacksmiths' workshops from the main city streets, a clear relationship was established between zoning restrictions and urban improvements, with the specific intention of creating a suitable setting to receive the papal court of Pius II.[72] A similar attitude was adopted in relation to the city's butchers, who were forced to relocate their businesses from the city centre to the bottom of the hill of Fontebranda.[73]

The 'putrid' smell produced by tanners and fullers had, in the fourteenth century, been singled out by residents of the district of Fontebranda, in an unsuccessful petition that sought to have these industries relocated to the lower slopes of that district.[74] By the mid-fifteenth century, however, zoning measures were applied in spite of the possible negative economic consequences to individual workers or the industry as a whole. By the late 1450s, a series of government decisions document the bid to ban butchers from exercising their trade on the main city streets.[75] Again, the adverse comments of visitors to the city seem to have acted as a spur to government policies: the butchers were required to move specifically because 'our city is much criticized by courtiers and other foreigners who are in the city [. . .] because they [the butchers] are in the main streets'.[76] The Commune was concerned that Siena was being compared unfavourably with other 'well-governed cities', and thus a general ban was issued on butchers pursuing their trade on the main streets.[77]

The butchers immediately reacted to the decision, with a guild petition addressed to the *Concistoro*, dated 13 May 1460, which claimed that

> your predecessors instituted and commanded that the shops of our guild members should be on the streets and in those places where they are now [. . .] so that shops have been handed down from father to son, and it would be very difficult to leave them.[78]

The guild also claimed that the cost of the required moves would be so high as to put many out of business; the petition was read out in council but was rejected. Indeed, the *Comune* increased its sanctions in August 1463, and established that all butchers were to be confined to work in the vicinity of Fontebranda without exception.[79] The government stated that the butchers' habit of bringing livestock through the city and across the Campo and main streets was inappropriate to the city's decorum, and that it constituted a health risk. They thus banned all butchers from locations anywhere else in the city, and offered to provide land at a fair price for the construction of new slaughterhouses.[80]

Opposition to these sanctions was understandably widespread among the butchers and resulted in 'bridging-policy' that allowed them to continue working in old shops for a year if they owned a refuse well ('pozzo cupo') at least 15 *braccia* deep, into which they could tip blood and viscera.[81] Nonetheless, the butchers were still expected to move to Fontebranda, to the area

124. Fontebranda development of shops for the relocated butchers.

down the slope from Ghiaccetto. In order to ease the move, government officials were charged with oversee-ing the adjudication of fair prices to be charged for land for houses and slaughterhouses for the relocated butch-ers.[82] The absence of further documents and petitions on this matter suggests that the policy was successfully enforced, as does the fact the city slaughterhouses remained in Fontebranda until a decade ago.[83] Recent restorations in the Fontebranda area have revealed not only a sixteenth-century shared slaughterhouse facility facing the Fontebranda fountain, but also a range of shops that appear to have been built in the third quarter of the fifteenth century (fig. 124). A sculpted coat of arms of the Arte dei Carnaioli, dated 1484, survives in the vicinity, and confirms the fact that the guild had moved to the district definitively by this time.

What is interesting about the zoning of the butchers is that in spite of widespread opposition to the move, which was communicated to the government by the guild as a whole, economic arguments against relocation were defeated by urban aesthetic criteria. With the pre-viously described zoning measures and immigration incentives, examples such as these reveal how legislative measures combined the economic targets of industrial and commercial regeneration with the conscious objec-tive of creating a privileged showcase for the city's luxury products. The commercial centre of the city was defined by such rulings as being the Campo and the streets that radiated out from it, north towards the Porta Camollia, south-east to Porta Romana and south-west to the Duomo precinct. It is this definition of the city centre that was also at the basis of Sienese policies for architectural renewal and urban beautification.

Policy Strategies for Urban Beautification

The Strada Romana was the principal axis cutting through Siena, following a sinuous route that clung to the high ground of the city's northern and south-eastern districts. The urban section of the via Francigena, the Strada Romana entered Siena from the complex of gates and fortifications at Porta Camollia in the north and left the city, southbound, at Porta Romana. As the city's main thoroughfare, the Strada Romana, or 'strada maestra' (main street), had been afforded a special treat-ment from the earliest legislation of the thirteenth century, and was maintained by the *Viarii*, whose work was discussed in the Introduction.

Civic concern for the maintenance and surveillance of the Strada was further reinforced by the work of *Petroni*, whose task it was to regulate property issues and guar-antee the public nature of the street itself. If the *Viarii* could be said to have been in charge of the road surface, their counterparts, the *Petroni*, were concerned with the road's boundaries and legal definition in property and law.[84] Moreover, as was shown in chapter One, the *Petroni* were also instrumental in supervising and enacting leg-islation that had as its objective the restoration of derelict properties within the city, many of which lay on Siena's principal thoroughfares. The methods of enforcement of these objectives changed over the length of the fifteenth century, so that while from the 1420s to the 1440s the problem was identified and solutions were sought by leg-islative and coercive means, from 1448 a more effective solution was achieved by means of incentive-driven mea-sures, which were further renewed in 1471, in part to resolve earthquake damage caused in 1467–8.[85]

This, of course, raises a new concern in the legisla-tive measures applied to the city fabric: aesthetic appear-ance harnessed to civic image. It is within the wider context of this concerted effort to improve the built façade of the city that the founding of the new office of the *Ufficiali sopra l'ornato* in 1458 must therefore be understood.[86]

The *sopra l'ornato* was an office of nine men whose main purpose was to enforce policies for the improve-ment of the urban fabric and in particular to encour-age (and to some extent oblige) private property owners to renew their properties following certain criteria of *ornato*.[87] The very term 'ornato' defies an easy transla-tion, for it coincides with both an aesthetic value of beauty and decorum, but also a collective qualitative judgement defined by the ideal of the well ordered and dignified city, where beauty is a civic value that over-comes the shame of squalor and disrepair. This complex objective is well described in a decision issued by the office in December 1465 that stated how the officials

work incessantly and oblige all citizens without exception to improve the civic image (*honore publico*) and renew the city's appearance by appropriate and beautiful works, and especially by removal of overhangs from the most prominent sites. This is particularly the case in the street of Camollia, because visitors to the city see that street more than any other. And it is already clear how beautiful the street has become from the demolition of many of these overhangs.[88]

While Petra Pertici's extensive transcription of *Ornato* records has made available much material relating to the officers' activities, little is known about their foundation or their specific functions.[89] Most informative is a statute issued in October 1458, which established that *Ornato* officers be nominated annually; they had no executive powers to assign funds or land or give permission for demolitions, nor did they receive any salary.[90] Best explained as an office of aesthetic adjudicators, charged with formulating and implementing urban improvement policies that involved restoration of private buildings, they had special authority to plead on the owners' behalf to the city magistracies for funding, which (if granted) was usually made in the form of a salaried post as a public official.[91]

This specifically founded body of officials, dedicated to the maintenance and improvement of the city's main open spaces, streets and buildings, as well as the considerable financial investments made to this end, reveals how important Siena's appearance was to the Commune.[92] Of course, the very title of the office, as well as the ubiquitous use of terms such as 'ornato' and 'bello' in relation to the effects of policy application, confirm the aesthetic ambitions of the government initiative.[93] While the foundations for this concern were clearly laid in the late thirteenth and fourteenth centuries, the growing public sensibility to such issues during the fifteenth century is corroborated by considerable surviving documentation. As we have seen, already in 1398 the Sienese proudly considered the Campo to be the 'most beautiful [piazza] . . . in Italy', in itself betraying a competitive conception of urban form, which implied that Siena and the Sienese viewed themselves and their city in direct comparison to other centres.[94] Competitive motivation for urban renewal had probably played a significant part in launching the *Petroni*-mediated restoration polices of 1423, given that in that year, the re-location of the Council of Pavia to Siena resulted in the arrival of Pope Martin v and large numbers of religious and secular dignitaries.[95] More eloquently, Sienese diplomatic reports from Mantua, on the eve of Pius ii's visit to Siena in early 1460, exhorted the city rulers to make all necessary preparations so that Siena would not lose face by comparison to the ducal city.[96]

In addition to implementing zoning restrictions that favoured the formation of a commercial centre around the Campo and main streets, the *Ornato* were concerned with the overall beautification of the urban fabric. The majority of *Ornato*-mediated interventions were aimed at the removal of *ballatoi*, cantilevered balconies that projected from buildings and invaded the open space of the street, reducing ease of movement along it, access of light and the general decorum of public space (fig. 125).[97] In fact, the very founding of the *Ornato*, and the pre-eminently aesthetic prerogatives assigned to them, may well owe more to the papal visit of Pius ii than seems at first sight. Pertici has rightly pointed out a connection between the Commune's growing concern for urban aesthetics as expressed in *Ornato* activity, and the papal visits of 1459, 1460 and 1464.[98] Naturally, the government desired that the city be seen at its best on these occasions, but it seems likely that the Pope may have influenced the adoption of new policies to this end. In fact, urban renewal policies introduced in the Papal State, and specifically at Viterbo, overlap closely with those implemented by the *Ornato* in Siena.

125. An overhanging structure (*ballatoio*) on a house in via dell'Oro.

Pius was an active proponent of *ballatoio* demolitions in Viterbo in the lead-up to the magnificent processions that were arranged for the feast day of Corpus Domini in 1462.[99] On that occasion, demolitions were carried out along the ceremonial route, and surviving papal accounts reveal that the demolition work was subsidized with funds from the cameral purse.[100] As Pius himself wrote of the occasion in the *Commentarii*:

> he [Pius] gave orders first of all that the street leading from the citadel through the city to the cathedral, which was cluttered with balconies and galleries and disfigured with wooden porticoes, should be cleared and restored to its original splendour. Everything that jutted out and obstructed the view of the next house was removed and everywhere the proper width of the street was restored. Whatever was removed was paid for from the public funds.[101]

Unfortunately, no reasons, examples or models were provided when, on 30 June 1463, the Sienese *ballatoio* demolition legislation, which launched the *Ornato* campaign in earnest, was set in place.[102] The council deliberation provides the terms of the decision, which required the removal of all specified overhangs by the middle of the following September, setting a steep fine of 100 ducats for non-observance.[103] While similarities can therefore be seen between the demolition of overhangs in Viterbo in 1462 and Siena from 1463, no direct evidence links the two cases.

On 6 May 1464 Pius was in Siena, where he led the procession and festivities surrounding his donation of the arm of St John the Baptist to the cathedral, when he would have experienced the initial improvements consequent to the 1463 *Ornato* rulings.[104] In fact, almost all the demolitions that predate the 1464 procession were made for overhangs that invaded 'the road that goes to the Duomo', suggesting that it was precisely the processional route to the cathedral that was the first to be improved by the *Ornato*.[105] Moreover, as the previous chapter showed, the architectural patronage of Pius II not only benefited from the legislative measures implemented by the *Ornato*, but actively participated in the urban renewal process that the government officials directed at pinpointed areas of the city. As was shown in the previous chapter, the Palazzo delle Papesse, built for the Pope's sister Caterina, was constructed on the derelict piazza Manetti site that was provided at no cost on the understanding it would be developed for the construction of a 'very honourable' palace.[106] The palace was thus built in a central city location near the cathedral and on the via di Città, a site that both the *Petroni* and *Ornato* officials had been seeking to have redeveloped from the 1450s, while the surrounding area was itself improved by *ballatoio* demolitions.

Pius II and the Piccolomini thus benefited from government policies enacted by the *Ornato*, but may also have been instrumental in having those policies put into place. For sure, a close analogy to the office and tasks of the *Ornato* can be read in Book III of Francesco Patrizi's *De Institutione Reipublicae*, where 'aediles' are discussed.[107] Patrizi noted the classical precedents for such a group of officials and catalogued the practical tasks they were set to oversee, such as the maintenance of roads, bridges, sewers and aqueducts, while also listing their role as arbiters of urban improvement and beautification.[108] Patrizi observed the instrumental role of the 'aediles' in the ancient city, and suggested that such an office should be adopted in modern times to guarantee maintenance of the urban fabric, but also so that they might exert their authority on citizens, so that they too would contribute to the process of urban renewal. Furthermore, while Patrizi advised the use of porticoes in damp climates, he stressed the fact that streets and piazzas should be open to the sky, and that light should not be impeded by overhanging structures.[109]

Pier Nicola Pagliara has suggested that Patrizi's knowledge and interest in architecture was largely informed by Vitruvius, whose *De re aedificatoria* Patrizi consulted in 1461, when he borrowed a manuscript of it from the Bishop of Ferrara, Lorenzo Roverella.[110] However, as was shown in the previous chapter, Patrizi's political model for the ideal republic described in the *De Institutione Reipublicae* was in part derived from classical sources, but was also heavily dependant on his personal experience of government in Siena and the reformist ideas he shared with Pius II. Much the same may be said for Patrizi's knowledge and advice on matters architectural: Vitruvius and a number of other texts underpin his comments, which are in turn principally informed by Sienese experience.[111] In a book dominated by classical examples, Siena is the only contemporary city to be mentioned as a model: not only does Patrizi raise up the Campo as a model for the central piazza, he also extols the benefits of a cathedral standing on high ground and visible from outside the city gates.[112] It would seem then, that Patrizi's treatise, a work that expressed many opinions shared by Pius II, described the task of 'aediles' and made a conscious connection between these and the Sienese *Ufficiali sopra l'ornato*.[113]

Final evidence in favour of the close connection between the office of the *Ornato* and the motivating agency in their creation being Pius II comes from the work of the officials themselves. Surviving documentation for the *Ornato* indicates some activity before the visit of the papal court in 1459, but there is a noticeable upsurge in the officers' work in the years immediately

following Pius II's papal appointment. While the first civic reaction to the impending visits of the Pope and his court where channelled through legislative measures that required widespread observance, such as zoning restrictions, from 1463 an increasing portion of interventions were person specific, and involved the removal of overhangs and the construction of new façades (see Appendix, table 4).[114] The *Ornato* thus mediated petitions for public funding, presented by private individuals charged with improving their properties on the city's main streets, which were the major thoroughfares used by travellers and visitors to Siena. In the early 1460s, the main pretext for such improvement policies was the intermittent presence of the papal court in the city, although after the death of Pius II in 1464, there is no sign of decline in the number of *Ornato*-mediated improvements. Indeed, the statistics for the five years following the Piccolomini pontificate are marked by an intensification of the civic-sponsored urban renewal process.[115]

Clearly then, it would seem that the growing power of the *Ornato* in matters pertaining to the process of urban renewal and beautification was heavily motivated by papal influence and the presence of the court in the city. However, it is equally important to note that while that presence served as a catalyst for renewal legislation, *Ornato* activity outlasted papal influence and became instrumental in shaping Siena's urban form during the second half of the fifteenth century. Furthermore, not only do the years following 1464 show a rise in *Ornato*-mediated interventions, but a growing number of subsidies, tax exemptions and land concessions were awarded to patrons, a fact that indicates increasing civic incentives provided towards the renewal process.

A Shared Façade: Renewing the Strada Romana

Like the zoning restrictions and the incentives offered to foreign artisans settling in Siena discussed above, the *Ornato*'s activity appears to have been principally directed at the city's main arteries and the central square. The effect of *ballatoio* demolitions should not be underestimated: removal of these balconies, that often extended over more than one floor of a building, usually resulted in the integral replacement of the entire façade. By mapping identifiable locations of *Ornato* involvement it becomes clear that the Strada Romana was especially favoured by their intercessionary powers (fig. 126 and see Appendix, table 4). Of 108 identifiable sites for which *Ornato*-mediated interventions are documented between 1444 and 1479, no less than 54 are on the Strada Romana, 14 are on the via di Città and via dei Pellegrini which lead to the Duomo, and 16 are on the Campo itself.[116] This means that of all identifiable *Ornato* operations, 77 per cent were directed at the main city arteries, and 50 per cent at the Strada itself.

Some general conclusions can be drawn from the mass of evidence that individual cases of *ballatoio* demolitions provide.[117] In the first instance it should be noted that the process of change they inaugurated was gradual and accretive, rather than imposed and immediate, reflecting an ideal of cooperative participation of public and private interests.[118] Clearly, *Ornato*-led *ballatoio* demolitions peaked in the second half of the 1460s, coinciding with a rise in subsidies and tax exemptions to individuals involved in renovation. In turn, the petitions' wording indicates that the policies increasingly relied on a sense of civic duty, encouraged by public legislative measures and financial incentives. Once the policy was underway, evidence suggests that *ballatoio* demolitions became so common that peer and government pressure encouraged all to participate, as the work was perceived as being for the good of the city and its citizens.[119] So,

126. Map showing *Maestri sopra all'ornato* interventions (1431–80); each block represents a building affected by Ornato interventions documented in ASS, Concistoro 2125.

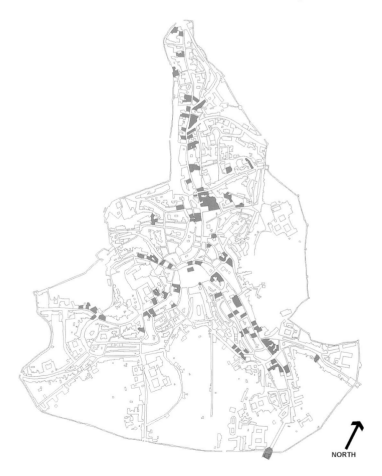

NORTH

127. Giovanni di Agostino, design for the Palazzo Sansedoni, Strada Romana façade, 1340. Collezione Banca Monte dei Paschi di Siena.

in November 1463, Agostino di Iacomo turned to the Commune in order to attempt to force Bishop Giovanni Cinughi to share the costs involved in demolishing a shared *ballatoio*, the only one left in the area where he lived, and for which 'he practically does nothing but apologize all day' to his neighbours for not removing it.[120] Again, in April 1469, Pietro and Agnolo di Pietro Buonagiunti stated that 'having been the first to begin [to rebuild their façade], many others have followed so that, as can be seen, what was previously the ugliest part of the Strada, is now considered the most beautiful'.[121]

The demolition of structures that encroached on public space was required because 'the city becomes more beautiful as a result of their removal', but the *Ornato* do not appear to have been stylistically prescriptive regarding what was to be put in the place of demolished façades.[122] Thus, when in January 1466 Tofo di Cecco Sansedoni was requested by the *Ornato* to complete the façade of the Palazzo Sansedoni, 'considering [. . .] how beautiful it will be when it is finished, particularly as it is on the public street', no stylistic requirements were stated.[123] The *Ornato*'s objection to the

magnificent Palazzo Sansedoni, which stood on the Strada south of the Croce del Travaglio, was that it had remained incomplete since the fourteenth century, so that its windows 'as can be seen, seem like palace doorways' (fig. 127 and see fig. 120); public funds were thus provided as an incentive for Tofo to place the needed colonnettes in the Gothic *bifore* (mullioned) windows of his palace.[124]

What was clearly at issue for the *Ornato* was not the style adopted by the Sansedoni in the design and construction of their palace, but the fact that its incomplete front onto the Strada detracted from the collective splendour of the street façade in so central a city location. Individual patronage choices or stylistic decisions were thus subsumed into a broader aesthetic principle of urban beautification, which concentrated on collective decorum rather than the specific characteristics of individual façades.[125] In this respect, the funding of Sansedoni's colonnettes was no different from the numerous, more modest subsidies for lesser houseowners to improve façades through *ballatoio* demolition; either way, public subsidies were offered in the name of the general principle of 'ornato della città', irrespective of the social or political standing of the petitioner or the architectural merit of the project.[126]

In this regard, the house of the paper-merchant Biagio di Cecco presents an interesting case of a private project, outside the city centre, that adopted a distinctive style and commanded considerable public funding.[127] Biagio di Cecco's house (built 1469–73) is one of the clearest examples of a late fifteenth-century use of Gothic domestic architectural forms in a prominent location on the Strada Romana.[128] The building as it stands today is much altered from its original form, and retains only three bays of Gothic arches on the two upper storeys, with the suggestion of further extension both to the right and left (fig. 128).

Biagio was a merchant of moderate financial standing, and it is perhaps surprising to find him involved in a sizeable project, one that involved the construction of a new palace and the reordering of an entire property block around the building.[129] He moved to this site, on the south end of the Strada, from the more central district of S. Cristoforo; communal incentives may well have been offered for the redevelopment of the site, which backed onto the piazza S. Spirito, and was bounded by the thirteenth-century city walls. An *Ornato* petition survives to document Biagio's account of the site and his plans to develop it on a lavish scale, which was to be integrated with urban improvement plans for the area.[130] Indeed, in November 1470, Biagio declared to the city government that the friars at S. Spirito were repeatedly asking him to tidy up the site

128. Detail of upper floors of the house of Biagio di Cecco.

behind his house, the piazza in front of the monastic complex.[131]

The long petition that describes Biagio's plans for the area, and the fact that public funds were assigned to the project in the form of the profitable castellanship of Grosseto from July 1470 to April 1473, indicate that Biagio's private concerns and those of the Commune and friars at S. Spirito coincided sufficiently for the project to be funded to its completion.[132] As the petition indicates, Biagio was granted property rights over the public space bordering his land on the side of piazza S. Spirito, which he was required to wall around 'in order to remove the great ugliness which is there'.[133] The government authorities specified that the curtain-wall was to contain architectural details that would imply the presence of a building behind the wall, thus suggesting a unified façade along the Strada and onto piazza S. Spirito.[134] An unpublished seventeenth-century plan of the area (now in the Chigi collection in the Vatican) records how Biagio's property was connected up to the public space behind it, in order to rationalize the piazza facing the church of S. Spirito.[135]

Surviving fragments of the façade of the new house that Biagio di Cecco constructed, following negotiations with the city authorities, show the patron's selection of a Gothic style, constructed of brick and adopting acute arches, *bifore* windows with marble colonnettes and waterleaf capitals. Unlike the palaces of the Marsili and Bichi discussed in chapter Three, which were constructed before the widespread introduction to Siena of *all'antica* style in palace architecture, the house of Biagio di Cecco is evidently *retardataire*. It may be

that Biagio's stylistic choices were conditioned by the semi-public role assumed by the project, as the Commune appears in part to have controlled the building's design, and specified a number of architectural details to be used.[136] Indeed, many of the features of the house can also be found in the contemporary public commission of the Palazzo del Capitano (discussed below), which closely imitated the architecture of the fourteenth-century Palazzo Pubblico.[137] Certainly, by demanding that certain features be employed in Biagio's new house, the *Ornato* were able to harness public policies to private interests, and it may be that the stylistic choices adopted underlined the collaborative nature of the project.

Nonetheless, the house of Biagio di Cecco cannot be considered representative of the usual *Ornato* procedure for promoting architectural regeneration, nor of the effects of the *ballatoio* demolition policies. Popular housing abounded along the extremities of the Strada, inside the city gates, where buildings were lower and less ornamented. Widespread use of plaster originally unified the general appearance of these façades, obscuring the many phases of restoration and renovation that affected these humble dwellings.[138] In the absence of accurate surveys of evolving wall surfaces, which trace the phases of construction and modification of individual buildings, it is nonetheless possible to make some observations regarding fifteenth-century vernacular façade solutions.[139] Replacement of Gothic window and door openings with round arches or frames, and the application of simple moulded terracotta *all'antica* cornices, with egg-and-dart or dentilled

129. House in via di S. Pietro.

130. House on via dei Servi, 3.

cornices, may well have coincided with building work related to *ballatoio* removal. Such minor modifications significantly altered the appearance of façades by the introduction of round and not acute arched windows, a contemporary hallmark of the 'ancient manner of building'.[140]

Providing an alternative to the acute Gothic arch, and equally easily built in brick, round arches were increasingly used in all fifteenth-century buildings, such as the new façade built – following the demolition of a *ballatoio* – on a house facing the Palazzo Bichi-Tegliacci, in via di S. Pietro in September 1468 (fig. 129).[141] Another fine example of such choices is a house on the corner of via dei Servi and via delle Cantine, where a symmetrical distribution of numerous ground-floor entrances, and their diminishing size along via dei Servi, suggest the architect's perspectival awareness even for a building destined as popular housing for multiple owners/tenants.[142] A similar arrangement was used in the nearby house on the Ponte di S. Maurizio, where an egg-and-dart and dentilled narrow classicizing cornice crowned the building, as in the house on via dei Servi (fig. 130). That these designs were considered clas-

sicizing is indicated in a rare example of a patron seemingly defining the style of his house: Bernardo di Pietro Bernardelli, resident in an unspecified location in the district of S. Stefano, stated that he had 'facta all'anticha che è la faccia di fuori murata [. . .] a terre', which indicates that some classicizing brick-work moulded elements were used in the new façade.[143]

The *Ornato*'s policies might even be viewed as socially levelling, and indeed were critically viewed as such by magnate patrons, such as Bonaventura di Agostino Borghesi, who forcefully argued in December 1464 that

> considering how much [the palace I wish to build] will add beauty to Your city, and that Your Republic is so generous with citizens demolishing even the merest overhang, which is evidently a cheap job,

so much more should they be happy to support the construction of a 'very beautiful palace which will add greatly to the ornament of the city'.[144]

While the *Ornato*'s financial incentives appear to have been introduced to ensure that the economically disadvantaged would participate in the city's improvement, incentives to build were also provided for the city's

wealthier potential patrons of palaces and churches. So then, the 'building boom' of the second half of the fifteenth century that Pertici has aptly described, re-using Richard Goldthwaite's term, was in part supported by policies that encouraged architectural patrons.[145] Assistance from the Commune took a variety of guises, with incentives in the form of land concessions, tax exemptions on materials or direct financial assistance, while a citizen's own private residence remained untaxed throughout the fifteenth century, regardless of size (see Appendix, tables 5 and 6).[146] Thus private patronage itself was favoured by public policy because it participated in the objective 'to magnify public honour and rebuild the city in a beautiful way, with appropriate and wonderful works' (1464).[147]

Increasingly, it would seem, from around 1460, property owners along the Strada were not only receiving assistance to build new palaces, but were being expected to rebuild by public authorities and neighbours alike (see Appendix, table 4). Thus, while in 1464 Bonaventura Borghesi had received funding for his palace at Postierla, so too, in 1491, Guglielmo di Goro di Cristofano del Taia recorded in his tax declaration that he had spent a large amount of money to build a splendid palace on the Strada:

> So far I have built a façade as everyone knows, and so as to make it as splendid as I was encouraged to by many citizens, I have spent a good deal of money, and I still need to spend about 250 florins to finish it. The house has aged me ten years both for its expense and for the worry it has caused me, and I remind Your Excellencies how it is customary and right that whoever builds such buildings should be commended and assisted.[148]

Instances such as this suggest that pressure to participate in the Ornato's renewal campaign was applied both through official decrees and social pressure on a local level. Guglielmo del Taia's melodramatic complaints were directed at the government as well as at his neighbours and peers, just as the request that he renew his palace façade had been made by Ornato demands and neighbourhood requests.

Unsurprisingly, in their petitions for public funding, both Bonaventura Borghesi and Guglielmo del Taia stressed the civic value of their private palaces: they employed an almost formulaic argument that bound the expression of private intentions, taste and achievement through architecture to civic magnificence, as expressed in the collective renewal of the streetscape.[149] Such a ploy was pushed so far as to make patrons appear coy in describing personal advantages of palace building or façade construction so that Borghesi mentioned merely

that the new palace would be 'useful' to him, while del Taia claimed that the 'splendid' façade was built to satisfy neighbours rather than himself (fig. 131).[150] While these subsidy hungry petitions distort the personal significance of the palaces that were being constructed, these documents remind us of the vital incentive that the Ornato policies provided to individual patrons to build in the first place. As such, the construction of many of the palaces discussed in the following chapter were directly motivated by the legislation the Ornato applied.

The process of change that affected the Strada was gradual and accretive, rather than imposed and immediate, reflecting an ideal of cooperative participation of public and private interests.[151] Public and private architecture in Siena were a civic concern; while building

131. Palazzo del Taia.

always reflected personal intentions, taste and achievement, it also combined to create and renew the collective image of the city. It seems therefore, that an enduring dynamic in Siena's Republican system linked public good to private interests, 'to increase the honour of the polity and make the city beautiful by appropriate and well ordered works'.[152] Moreover, the range of interventions that contributed to the overall renewal of the built façade of the street was inclusive rather than exclusive, since financial incentives enabled citizens with no surplus income to invest in the renovation of the façades of their houses.

Variety: Defining a Civic Style through the Public Patronage of Architecture

Government policies implemented by legislative measures and dedicated offices were key factors in the urban renewal of Siena during the third quarter of the fifteenth century. In the chapter that follows, it will be shown to what degree *Ornato* policies and other building incentives encouraged private patronage of architecture, which contributed towards the large-scale renovation of Siena's urban core. By promoting architectural renewal, the civic authorities shaped the development of the city while also actively participating in that process through public commissions. Such public works were pursued following a variety of strategies, ranging from the direct commission of new buildings to participation in neighbourhood projects, as well as cosmetic – but nonetheless highly visible – additions to the architectural furniture and sculptural decoration of the city centre.

The built form of the Palazzo Pubblico, the city's principal government building, was fixed in the fourteenth century.[153] Furthermore, the intention to create a uniform space, articulated by façades imitative of the Palazzo Pubblico, had been famously expressed in statute form as early as 1297, although by the fifteenth century it is unclear whether such stylistic constraints continued to be applied. Nonetheless, a number of significant projects, executed during the 1460s and early 1470s, reordered the public space of the Campo, while zoning provisions also helped to render it more decorous. This piazza formed the natural setting for civic events, where the formal meetings with foreign dignitaries were staged on the dais in front of the palace, which served as a back-drop for these ceremonies. The Palazzo Pubblico thus stood as a representation of the civic authorities housed within it, and perhaps the fact that its external façade remained largely unaltered was intended to be symbolic of the stability of the city's

government within. This is not to say that the palace and piazza remained unchanged. As was discussed in the Introduction, a series of commissions dating to the first quarter of the fifteenth century expressed Siena's putative Roman origins on the urban stage of the Campo. Thus, Jacopo della Quercia's classicizing Fonte Gaia (1414–19) brought together imagery of the Virgin Mary with the she-wolf foundation legend of ancient Rome, while Giovanni Turrini's gilded bronze *lupa* sculpture was placed by the entrance to the Palazzo Pubblico in 1427 (fig. 132).[154]

Inside the Palazzo Pubblico, Taddeo di Bartolo's cycle of frescoes portraying Roman Heroes (1413–14), as well as a set of intarsia benches by Mattia di Nanni (1420s) showing similar subjects went further to establish Siena's political and historical links with Republican Rome.[155] Attention was also paid to the internal architectural detailing of the Palazzo Pubblico, so that in 1446 Bernardo Rossellino was invited to sculpt an *all'antica* doorway for the Commune, some thirty years before the Florentine Commune commissioned Benedetto da Maiano to replace the door-frames for the Sala dei Gigli in the Palazzo della Signoria.[156] Rossellino's contract

132. Giovanni Turrini, *She-wolf and Twins*, 1427, in a nineteenth-century photograph showing its original location outside the Palazzo Pubblico. Museo Civico, Siena.

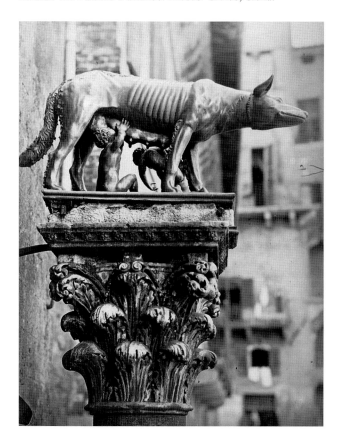

133. Door to the Sala del Concistoro, Palazzo Pubblico.

that use of stone for façades was exclusive to patrons antagonistic to the city government.[159] In the words of Duccio Balestracci, stone-built private palaces were 'architectural experiments undertaken by the aristocracy [. . .] where the use of stone [. . .] underscores the nearly total absence of a Sienese Renaissance architecture'.[160] Such a reductive statement raises a number of problems, since surviving visual evidence suggests quite different conclusions regarding both patrons' stylistic choices and, more generally, Siena's architectural response to humanist concerns with classical antiquity. Primarily, Balestracci's contention, that the dominant architectural mode during the fifteenth to early sixteenth centuries was 'Gothic' and that breaks from this model marked political dissociation from the political regime cannot be corroborated by surviving buildings and documentation. Indeed, the architectural choices made by the Commune of Siena show the adoption of both innovative *all'antica* style and traditional 'Gothic' forms. Catholic

134. Standard *all'antica* door in the Palazzo Pubblico, viewed from the Sala della Pace to the Sala del Mappamondo, with Simone Martini's *Maestà* visible in the background.

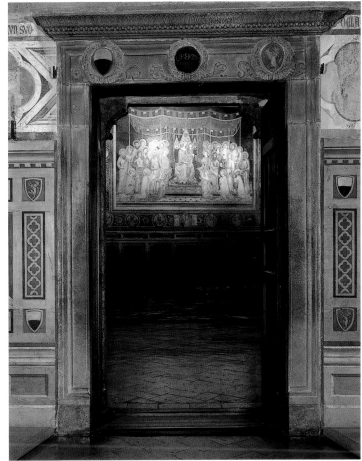

specified that he was to create a monumental doorway from a single block of clean, polished Carrara marble, and was also to include four sculptures of the cardinal virtues above the cornice.[157] The extant portal was indeed sculpted from marble and is decorated with fluted columns with *all'antica* capitals and motifs, including cherubs bearing the arms of the Commune (fig. 133). Rossellino's design led to the subsequent substitution of a number of Palazzo Pubblico doorways with simplified designs with *pietra serena* classicising architraves, which also bear the arms of the Commune (fig. 134).[158]

These various sculpted and painted works, introduced a new humanist-inspired classicizing vein into the repertory of Siena's civic imagery, which were to gain growing circulation in the 1460s and after. Nonetheless, the relative stylistic unity of the Campo and the buildings facing onto it during the fifteenth century has been used as the basis for an argument that the Sienese Commune preferred Gothic brick-built architecture and

stylistic tastes of this sort challenge commonly held pre-conceptions regarding the nature of 'Renaissance style' and reveal the need for a more subtle and complex approach to the issue of stylistic choice.[161]

Continuity in Siena's government institutions certainly contributed towards the survival of the architectural language adopted in the Trecento for public buildings. The main civic institutions were housed in buildings that dated from the Trecento: the Palazzo Pubblico, the Spedale della Scala, the cathedral and baptistry in addition to the bishop and *Operaio*'s palaces, and the city's numerous fountains were all largely built during that century.[162] These buildings were the seats of governmental offices, most of which remained unchanged over the fifteenth century, although increased bureaucracy and other practical needs resulted in the acquisition of buildings to house officials and provide warehouse space. Thus, part of the Palazzo Tolomei ground floor was used for customs offices in the fifteenth century, and the Commune attempted to buy the whole palace at a bargain price in 1430, when the Tolomei bank was in difficulty, in order to use it as a grain store.[163] Moreover, during the fifteenth century the practice of expropriating property from exiled families proved a cheap method for acquiring palaces; the main body of the Castellare Salimbeni was taken over by the Commune in 1403, and, as documents show, was first adapted for use as the Dogana del Sale (a salt store) and a grain store, and was subsequently developed as the new Monte di Pietà in 1474.[164] Both the Tolomei and Salimbeni palaces were prestigious medieval buildings linked to prominent noble families, but their selection to house communal offices cannot really be interpreted as expressing a stylistic preference. The maintenance of their Gothic appearance might have been respectful of Gothic public building precedents, but was quite simply also cheaper than rebuilding the palaces from scratch.[165] Their architectural form was imposed by default, rather than being the result of a conscious institutional preference for Gothic style.

The selection of master Luca di Bartolo da Bagnocavallo to head the construction of the Palazzo del Capitano di Giustizia in via di Salicotto is therefore far more significant on account of the stylistic choices displayed in the design (1466–74).[166] This new public building was built on a site just off the Campo, facing the side of the Palazzo Pubblico as a result of the sale of the original Palazzo del Capitano, on the via del Capitano, to Tommaso Pecci in 1457.[167] Subsequent to the 1457 sale, the Capitano and his assistants had occupied expensive rented premises, and eventually the Commune decided to construct a new palace to house them.[168] The new building is articulated by four bays of Gothic arches on three storeys, while

inside the modern-day shops, polygonal brick columns can still be observed (figs 135–6).[169] In this case, form, materials and details were consciously chosen, and respected Trecento architectural precedents, most obviously those of the neighbouring Palazzo Pubblico.

A surviving full contract for the building describes a number of the buildings' details, specifying dimensions, required rooms and exactly what materials were to be used for the façade.[170] The opening part of the contract described in detail the 'main façade [. . .] made of new bricks [. . .] with two storeys of four windows per storey, constructed with colonnettes made of finely worked stone', which clearly corresponds to the surviving brick façade with travertine colonnettes and string-courses.[171] These specifications neither mentioned what we might understand as stylistic features (such as acute arches, biforium windows etc.), nor made

135. Palazzo del Capitano.

136. Palazzo del Capitano, façade detail.

direct reference to the adjacent Palazzo Pubblico, which, on the basis of clear similarities, was probably used as a model. Just like the Palazzo Pubblico, the top of the Palazzo del Capitano was castellated with corbelling below the crenellations, which are embellished with bands of decorative brickwork. Both palaces have travertine double string-courses along the window bases and at impost level, and travertine colonnettes in triforium windows.[172] Moreover, at ground floor, acute arched portals appear in each bay, which also bear the sculpted arms of the Commune, placed in the spaces between the acute and segmental arches, just as in the city hall's Campo façade.[173]

The Palazzo del Capitano was one of the most significant public commissions of the 1460–70s, and the acquisition of its site, and its slow construction, cost the Commune over 2,500 florins.[174] The choice of a Gothic design in the second half of the fifteenth century was surely more than coincidental, as it was also for the house of Biagio di Cecco *cartaio*, and may have constituted a stylistic choice on the part of the patrons. Such a choice evidently created stylistic unity among the

buildings associated with the practice of government around the Campo.[175] However, while the Palazzo del Capitano might be understood in the light of the government's preference for continuity of architectural forms, a number of civic projects underway in the same area, and in these same years, challenge this interpretation of the Commune's patronage strategies.

In the first instance, plans for a second tower for the Palazzo Pubblico, which would have provided a symmetrically placed companion to the Torre del Mangia, were approved in November 1463.[176] It was decided that 13,500 *lira* would be spent on the new tower over the period of eight years. It was never built, as in March 1464 lightning struck the Torre del Mangia, and all funds were diverted to the Torre's restoration.[177] It is significant, however, that the first visual representation of a twin-tower solution for the Palazzo Pubblico appears in a drawing made by Baldassarre Peruzzi half a century after these initial plans were put forward by the civic authorities (see fig. 264).[178] Peruzzi's drawings, and other plans for the symmetrical ordering of the piazza del Campo in the sixteenth century, reveal a continued desire to bring order to the public square and the government palace facing onto it. The failed plans for the 'Nuova Torre' thus reveal the desire to provide a symmetrical façade for the Palazzo Pubblico, which would have transformed the 'Gothic' asymmetry of the government palace.[179]

While the planned second tower for the Palazzo Pubblico indicates a desire to impose symmetry onto the façade layout of the city hall, the completion of the Cappella di Piazza introduced sophisticated *all'antica* architectural sculpture onto the Campo. The original chapel had been erected as an ex-voto by survivors of the Black Death of 1348, and the original Gothic piers, designed with the help of the artist Bartolo di Fredi from 1374, were topped until 1468 by a simple wooden roof, clearly visible in painted views of the Campo.[180] Between 1468 and 1470, the Cappella di Piazza was completed by the sculptor and architect Antonio Federighi, with an elaborate cornice and frieze, which used an *all'antica* griffin motif, probably derived from the example of the Temple of Antoninus and Faustina in Rome (fig. 137).[181]

The crowning portion of the Cappella di Piazza adopted an explicitly classicizing design, both through the frieze and the fine architectural detailing of the cornice, arches and piers.[182] However, it is also interesting to note that the architect remained faithful to the model and forms laid down by the pre-existing structure. The Gothic piers and foliated capitals form the base for the arcades, while the piers actually continue through to the cornice and frieze, in the manner of the pilaster strips

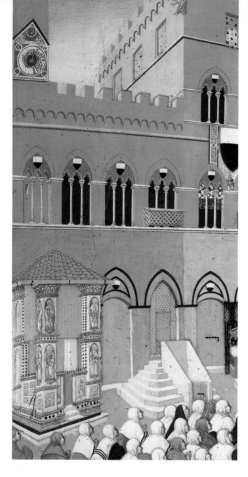

137. Detail showing the Cappella di Piazza with the Torre del Mangia behind, from fig. 1, Sano di Pietro, *S. Bernardino Preaching on the Campo.*

cathedral works, Federighi would doubtless have had access to it. Rather than complete the chapel with an obviously Marian reference, he and his patrons chose instead to complete the chapel with a classicizing frieze, below which the arms of the Commune are prominently displayed in the spandrels, while the image of the Virgin was portrayed in a fresco behind the altar.[185] Thus, the Cappella reframed civic dedication to the Virgin in a more contemporary representation of the city's cultural identity, which married its classical past to its more recent history and devotion. Such choices made of the Cappella a 'complex amalgam of elements from several traditions', as Ralph Lieberman has said of the Arsenale gate in Venice, representing varied strands of the city's past.[186]

Certainly, planned and constructed projects such as those for the Palazzo del Capitano and the Cappella di Piazza indicate that it is difficult to provide a single interpretative key to explain the stylistic choices made by Siena's civic authorities during the 1460s. However, the broad stylistic range of these buildings raises the question of how far stylistic choices were a matter for debate at all in the patronage process. After all, as was shown above, the *Ornato* themselves were far from being prescriptive in their demands for façade renovation. Furthermore, the search for normative models in religious and secular (civic or private) architecture during these middle years of the century is also elusive. With rare

138. Cappella di Piazza.

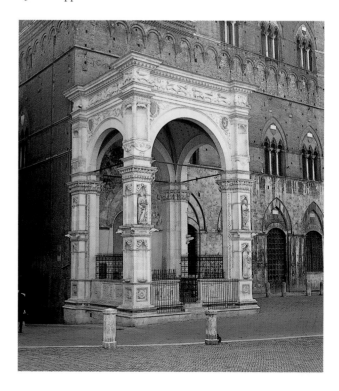

that unify the fourteenth-century façade of the nearby courtyard of the Palazzo Pubblico.[183] In turn, the new piers contain niches, which resemble those of the Gothic structure in size, and even echo the form of ogival arches through use of an *all'antica* shell motif. It might even be argued that the high round arches were based on fourteenth-century models in the courtyard of the Palazzo Pubblico and the Duomo Nuovo.

A series of architectural precedents for the completion of the Cappella di Piazza can be identified in local Sienese architecture, but Federighi provided an *all'antica* interpretation of those models (fig. 138–40). Moreover, it is also evident that the original plans for the Cappella, recorded in a drawing of 1374, were abandoned in the final design.[184] The drawing, recently attributed to Bartolo di Fredi, shows a sculptural upper storey representing the Virgin of the Assumption, to whom the chapel was dedicated. The drawing survives in the Museo dell'Opera, and as master-mason of the

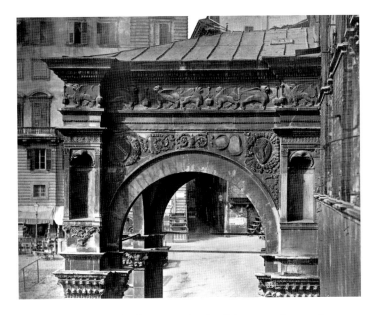

139. Cappella di Piazza, detail of the crowning section, as seen in a late nineteenth-century photograph by Paolo Lombardi.

140. Temple of Antoninus and Faustina, Forum, Rome. Note the decorative frieze.

exceptions, such as might be the role of Antonio Federighi in Pius II's architectural plans for Siena (discussed in the previous chapter), it is equally difficult to identify architects, or individuals to whom a coherent body of works may be attributed.

Thus, for example, the brilliant painter and sculptor, Lorenzo di Pietro, called Vecchietta, has often been identified as having had a career as an architect, in the wake of Piero Sanpaolesi's suggestion that he had been involved in the design for Pienza.[187] Following a formative collaboration with Masolino, around 1439, in the decoration of Cardinal Branda's chapel at Castiglione Olona in northern Italy, Vecchietta certainly developed a distinctive painting style in which *all'antica* architecture played an important background role.[188] Indeed, it is the very confidence with which Vecchietta created fictive *all'antica* spaces in his paintings that offers some grounds for considering his practical involvement in architecture (fig. 141). Furthermore, the artist's long-standing association with the Spedale di S. Maria della Scala, where he also painted the remarkable *Dream of the Blessed Sorore*, set in a symmetrically ordered classicizing temple, may also be the viewed as a point of contact with a master-mason working within that same institution, Guidoccio di Andrea. Guidoccio was involved in renovation of the hospital from around 1466, including the redecoration of various rooms, which were rebuilt using classicizing details in *pietra serena*, and together with Vecchietta he went on a tour of inspection of fortifications of the Sienese *contado*

towns in 1467.[189] As we have seen in the previous chapter, Vecchietta was also called as arbitrator to assess the construction costs of the Loggia Piccolomini, although such tasks were not reserved exclusively for professionals from the building trade.[190] Nevertheless, there are no firm documentary grounds that support the hypothesis of Vecchietta's involvement in architectural design, and such a possibility must remain a conjecture for the present.[191]

Whether Vecchietta was an architect or not, it is true to say that the disciplinary or professional boundaries that defined that profession were far more permeable at this time than in later periods.[192] It is well known that numerous artists and sculptors worked as architects in the fifteenth century. Moreover, within the building trade, engineer-professionals such as *maestri d'abaco* and *estimatori*, had the specific task of assessing quality and quantifying and costing work, and in some cases this practical experience resulted in their being called on to advise on designs.[193] Nicholas Adams has shown that Pietro dell'Abaco, a city surveyor, was involved in designing bridges, city walls and a dam.[194] Adams documented Pietro's participation in extra-urban projects, although it is evident that he was also active in Siena, as an estimator and town-planner; he is recorded as costing many of the restorations made before the visits of Pius II in the 1460s, while in 1473 he assessed a minutely itemized construction project, and in 1474 oversaw the straightening of the Strada Romana in the environs of the Palazzo di S. Galgano.[195] Individuals such

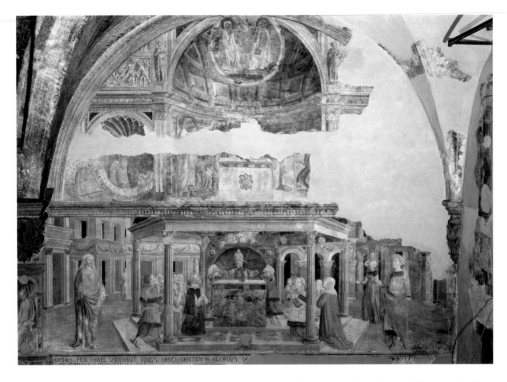

141. Lorenzo di Pietro, 'Il Vecchietta', detail showing *Solomon and the Glory of the Temple of Jerusalem*, 1446–9, from the fresco cycle in the Sacristy or Cappella del Chiodo, S. Maria della Scala, Siena.

as Pietro thus developed architectural skills by combining practical experience with an ability in applied mathematics.[196]

In this regard, it is worth returning to the Lombard master-masons and builders, whose large-scale immigration to Siena during the fifteenth century was discussed earlier in this chapter. The presence of such a large community of building professionals in Siena, and the occurrence of their names among the salaried workers on major city projects, suggests that this group is central to a better understanding of the process that produced Siena's Renaissance buildings. However, Vasari's well-known tale of a labour dispute on the dome project for S. Maria del Fiore serves as a valid admonition against assuming that named builders are necessarily supervising masters, or even architects: Brunelleschi's sacking of a hostile local labour force, and replacement of it by a skilled group of ten Lombards 'who learned everything they needed to in a day', is a reminder of the important distinction between worker and master.[197]

The practical skill of Lombard masters is nonetheless well attested for Siena; some parallels with the Brunelleschi case can be seen in the documented enlargement of the monastic church of S. Francesco in the 1470s, which the local chronicler Allegretto Allegretti claimed was 'the invention of our [Sienese] citizen Fran-

cesco di Giorgio Martini', but was executed in his absence by Antonio Lombardo and Giovanni da Bologna.[198] So, too, the magnificent Palazzo Piccolomini dei Papeschi in the Banchi di Sotto was overseen by a veritable hierarchy of site-supervisors, as Allegretti commented in September 1469, when Cardinal Francesco Todeschini Piccolomini laid the foundation stone and placed commemorative classicizing medals into the foundations.[199] Here, a sophisticated and ambitious humanist patron officiated at the foundation ceremony of a palace whose supervision was entrusted to a local gentleman with some skill in the field of architecture (Porrina had supervised works at Pienza and was *operaio* (clerk of works) at S. Domenico), and on-site control was given to a Lombard master.[200]

The Piccolomini case illustrates the complexities of patronage choices that all too frequently involve a dynamic yet hard-to-trace interaction between patron, architect (if there is one), patron's mediators and site-masters. In the scholar's haste to identify the architectural personalities of 'architects' as 'inventors' of designs, there is a great risk of losing the vital ingredients of the patron's direct involvement in the design process and the master's interpretational skills in the transmission of design into practice in the buildings of fifteenth-century Italy. Moreover, the very difficulty of suggesting any styl-

istic unity among buildings in which Lombards had a hand, and the relative lack of biographical data necessary for the creation of an 'artistic personality' for individual Lombard builders active in Siena, may actually constitute a major clue for understanding their skill and working patterns. The stylistic diversity of buildings erected within years of one another, such as the Palazzo del Capitano and Oratory of S. Caterina in Fontebranda for example (both of the 1460s), suggest that Lombards were employed not because they utilized a particular style, but because they were able to execute patrons' requests.[201]

Rather than search for a unity of style for the civic, religious and privately commissioned buildings of Siena between 1460 and 1480, it seems more sensible to recognize that variety was its defining feature, largely as a result of patronage choice. Far from being 'unreceptive' to Florentine models – as traditional scholarship tends to describe the adoption, or not, of *all'antica* style architecture following in the foot-steps of Brunelleschi – Sienese patrons appear to have acted in relative autonomy when planning their new buildings. As John Pope-Hennessy so perceptively affirmed in 1947, writing of 'Sienese Quattrocento Painting', 'it is no longer the duty of the art critic to bludgeon the artist of the past for failing to live up to a sense of mission with which they were invested by posterity', so we may also say of architecture in this period.[202] On the contrary, having reviewed the complex web of legislature, tradition and innovation that the civic government wove to create the ideal context for the urban regeneration of the Strada Romana, it is fair to claim that variety was not a casual effect of patronage, but the consciously chosen stylistic mode of Siena's republican government.

6

The Word on the Street

THE STRADA ROMANA AND ITS USERS

Siena then is the second-most city of Tuscany for power and wealth [...]
at the present time it can be considered among the other modern cities of Italy,
because there are no signs of dilapidation, but instead all has suitably been renewed.[1]

The fourteenth-century Florentine geographer–poet Fazio degli Uberti described Siena in his *Dittamondo* (first published in 1474) recording his arrival in the city:

> Along that road that was the straightest
> We reached the city of Siena
> Which is built in a safe and healthy location.
> It is a charming place with beautiful customs
> Filled with graceful women and courtly gentlemen,
> Its air is sweet, bright and pure.[2]

Fazio went on to mention a selection of the city's major monuments – the Campo, the fountain at Fontebranda, the city gate of Camollia, as well as the hospital of S. Maria della Scala and the cathedral of S. Maria dell'Assunta.[3] His unusual rhymed account confirms the important role of the via Francigena as the principal route leading to the city, while the reference to Porta Camollia presents that gate as the virtual frontispiece to Siena, through which the visitor was granted access to the main landmarks within the walls.

While, as we have seen, visiting dignitaries were afforded special attention when they visited Siena, with processions, ephemeral architecture and various displays scheduled to mark the occasion of their visits, the accounts of other travellers signal what was deemed remarkable about the city's permanent fabric.[4] Numerous accounts record what stood out as being worthy of comment by late fifteenth-century viewers, and it is noticeable that a degree of coherence emerges in what was reported. Perhaps most comprehensively, Jacopo Foresti of Bergamo described Siena in his *World Chronicle* of 1483 as a city

> spread out over a hill in the manner of a peninsula, as steep banks surround it almost on all sides; however, in the higher part there is much land which is adorned with beautiful gardens. In the city there are famous and splendid buildings, among them a wonderful university, a central piazza, a portico and regal palaces; and an immensely wealthy hospital, which is governed in a pious manner. The city is, moreover, large and free, has towers and fortifications and is endowed with good customs.[5]

Like Fazio, Foresti mentioned the city's principal institutions and the monumental architecture that housed

FACING PAGE 142. Via dei Pellegrini.

143. Jacopo Foresti, *Supplementum Chronicarum* (Venice, 1490), fol. 76v, from a copy embellished with colour wash. Bodleian Library, Oxford (Auc.2 Q inf. 2 38).

them, while he also noted how, on the crest of hills on which Siena was built, there clustered prominent palaces and gardens, which were deemed 'splendid' and even 'regal' (fig. 143). The stylized view of 'Saena Ethrurie Civitas', which accompanies the text description of the city from the 1486 edition, shows a city surrounded by hills, encircled by walls, within which can be seen churches and secular buildings, which may be supposed to evoke the cathedral, city hall and private palaces. The view, however, is generic and was indeed used within the same volume to illustrate the city of Edessa![6]

Ten years after Foresti, in 1494, the Venetian diarist Marin Sanudo reported on his visit to Siena in the entourage of Charles VIII of France, and commented that in the 'upper part of the city there are [. . .] magnificent and noble buildings [. . .] and a dignified piazza with palaces of the *Signori* and other private palaces which are most proud [*superbissimi*]'.[7] While it is possible that Sanudo's account may in part have been shaped by Foresti's and other descriptions, it is also clear that he saw the city and noted the new buildings that had recently been constructed. Thus he considered that 'Siena can now be numbered among the other modern cities [of Italy], because there are no signs of dilapidation, but instead all has suitably been renewed'.[8]

That much construction was underway in Siena during the second half of the fifteenth century appears not to be in any doubt. In the same years as Foresti

described Siena for his *Supplementum Chronicarum*, the Sienese humanist writer Bartolomeo Benvoglienti praised the 'very new additions' to the city's architecture, and concluded that 'Siena completa est'.[9] Benvoglienti's account, which is examined in greater detail in the following chapter, concentrated for the most part on antique remains within the city fabric, in order to create an argument, grounded in archaeological evidence, which supported the city's Roman foundation legend. However, the long description of Siena made by Leandro Alberti in his *Description of Italy* of the mid-sixteenth century underlined the role of private patronage of palace architecture in the definition of the city's distinctive characteristics.[10] Thus, as well as reiterating Foresti's description of the city's setting, and mentioning the principal religious and civic structures, he recorded that 'you can also see the proud palace built in cut stone for Pope Pius II, as well as many other noble buildings and beautiful palaces, that would take too long to describe'.[11]

Many of these palaces were the product of the policy-driven building activity that resulted from the *Ornato's* urban renewal policies, enforced in the quarter-century after 1460. In turn, as Leandro Alberti's comment seems almost to suggest, it was the exemplary lead of the papal-funded Piccolomini architectural developments that provided a model for palace patrons.[12] However, with rare exceptions, the city descriptions written by visitors to Siena did not dwell on specific private buildings, but rather they identified both public and private buildings worthy of discussion, and judged the appearance of the city in terms of their combined effect. In this respect, the descriptions capture that paradoxical tension between the characteristics of individual buildings and the formation of a sense of a place conveyed by the collection of all the buildings that made up the city. This combination between policy and patronage, which made individual buildings into part of a wider collective urban renewal project, is perhaps best understood in the redevelopment of the Strada Romana.

Collective Patronage: Private Patrons and Public Space

On 30 January 1476, the Sienese banker Piero Turamini wrote to the Florentine Benedetto Dei that

> Ambrogio Spannocchi has built a notable palace with a marvellous façade on the Strada Romana, next to the Palazzo Salimbeni. It has been designed by a Florentine, and work on it is still underway. It is considered a beautiful thing and is said to have cost him more than 15,000 florins.[13]

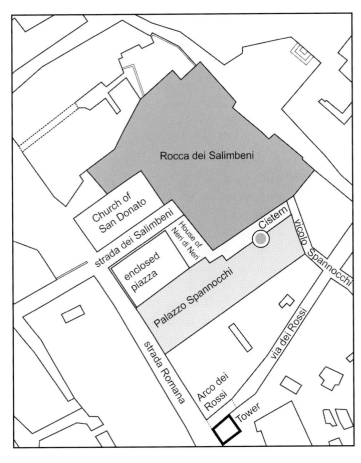

144. Map showing the site created for the Palazzo Spannocchi, 1464–76.

It is clear from these comments that a number of factors were significant in the patronage choices made by Ambrogio Spannocchi when he set about acquiring the necessary land to 'build a beautiful house' in Siena in the late 1460s.[14] Turamini singled out for comment the quality of the building, its location and proximity to a magnate palace, the fact that it was designed by a Florentine architect (a fact that would have interested Dei), and that it cost the patron a good deal of money. All these elements indicate the patron's desire for conspicuous display.

Palazzo Spannocchi was built on a large site acquired over a period of around five years (1468–73), in a central area of the Strada Romana (Banchi di Sopra) between the Arco dei Rossi and the large fortified medieval enclave of the Salimbeni (fig. 144).[15] Ambrogio Spannocchi was Sienese by birth, but had made his considerable fortune through banking in Rome, Naples and Valencia, where he enjoyed privileged commercial contacts with the Aragonese kings, but especially the papacy.[16] Married to the Sienese Cassandra Trecerchi in 1460, for family reasons his visits to Siena became increasingly frequent, and probably on account of the

fact that he had relatives living in the S. Donato a Montanini area, he chose a nearby site for his own palace.[17] By 1468, Ambrogio was in his fifties, and evidently wished to display his cosmopolitan entrepreneurial success in his home town; this is indeed more or less what he declared when, in October 1473, he applied for a building permit to the Commune, saying that 'having returned to Your [the Commune] city, and by the grace of God having earned some money, he decided to build a beautiful house for the glory of the city and of himself, in spite of his age'.[18]

Ambrogio Spannocchi's palace satisfied the highest specifications for elite residential architecture, with an *all'antica* design, rich materials, a broad and magnificent façade and central location, as well as lavish interior furnishings (figs 145–7). The palace was, moreover, designed by a renowned architect, Giuliano da Maiano, and was constructed on a site with marked associations of nobility through its long ownership by the Salimbeni clan.[19] As numerous sources confirm, Giuliano da Maiano began construction of the palace on 15 March 1473; his design focused on improving the palace site by various visual strategies.[20] The palace façade is gently angled towards the north, so as to present its 'face' to oncoming travellers from both north and south along the Strada; just as Leon Battista Alberti advised, 'it is no trifle that visitors at every step meet yet another façade, and that the entrance to and view from every house should face directly onto the street'.[21] The façade dressing itself folds around the northern corner just enough to imply full cladding in stone to the northern view, from which the palace corner could be seen, framed

145. Leonardo de Vegni and Vincenzo Rust, *Palazzo Spannocchi*, etching, 1755 (printmaker Pazzini Carli).

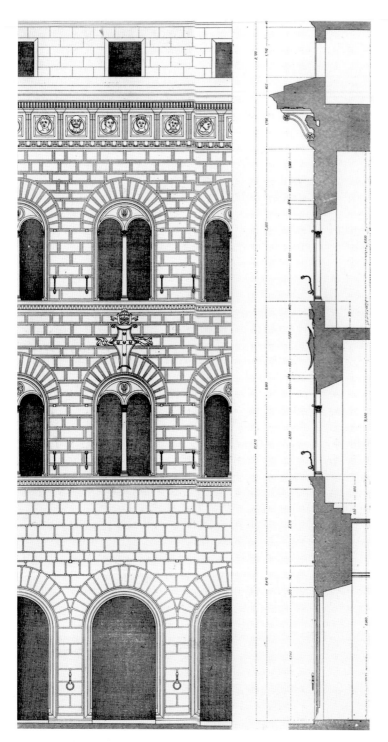

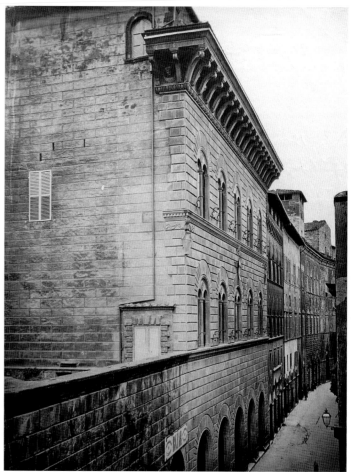

LEFT 146. Palazzo Spannocchi, elevation drawing, from C. von Stegmann and H. von Geymueller, *The Architecture of the Renaissance in Tuscany: Illustrating the most important churches, palaces, villas and monuments* (New York, 1885).

ABOVE 147. *Palazzo Spannocchi Viewed from the North*, by Paolo Lombardi, *c.*1870.

through the Roman arch of 'Severo e Valeriano', discussed later in this chapter.[22] The palace was also made prominent through the use of an unusual, heavily projecting entablature in which three-dimensional busts were framed by modillions – a unique feature on a palace in Siena (fig. 148).[23] Finally, and perhaps most ambitiously, Ambrogio sought not only to create a palace built to a regular symmetrical plan distributed around a central courtyard, but he also seems to have

set out to furnish it with a private piazza on its northern side, a project that was only partially completed at the time of his death in 1478.[24]

In August 1475 Cardinal Giacomo Ammannati Piccolomini wrote to his friend Cardinal Francesco Gonzaga, describing the 'Ambrosianae domus' as being so 'wide, large and magnificent that it outstrips both yours and mine. Its outer appearance is that of a royal palace; the interior is richly appointed and so spacious that it is in no way different from a royal palace'.[25] It was the site of the palace, as much as its design, that gave it the prominence that so much impressed Ammannati, and indeed his experience of the building was enhanced by its very location, since he had been a guest there as a spectator for a horse-race (*palio*) that passed directly in front of it, along the Strada Romana.

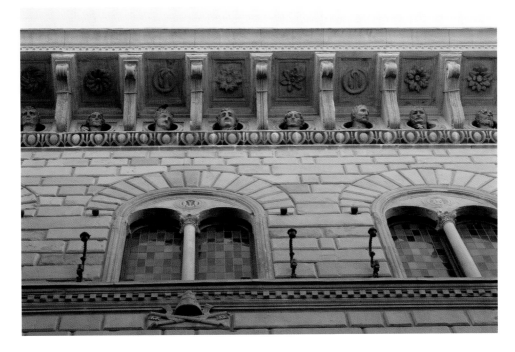

148. Palazzo Spannocchi, *all'antica* cornice with portrait busts of emperors and Ambrogio Spannocchi.

Spannocchi had appealed to the shared sense of civic pride that underpinned the urban renewal policies enforced by the *Ufficiali sopra l'ornato* in order to secure a series of concessions and privileges required to acquire the site, and build his palace. Much the same ploy had been adopted by other wealthy patrons, such as the Borghesi and del Taia, who were also desirous of securing public funding to partially underwrite the cost of their new palaces. In May 1468 Francesco di Goro di Cristofano del Taia petitioned the *Ufficiali sopra l'ornato* for funding assistance towards the reconstruction of his palace since, as a result of implementing *ballatoio* regulations, the original palace 'began to collapse and it became necessary to rebuild it from the foundations'.[26] As was shown in the previous chapter, in 1491 Francesco's brother Guglielmo complained that the palace still required finishing touches, and requested a tax-break towards the cost of its completion.[27] The palace fills a massive site, between the Strada Romana and the narrow via della Stufa Secca behind; to the rear of the palace numerous service entries and warehouse space filled the ground floor, while large windows and possibly a loggia faced the Chianti countryside from the *piano nobile*. The Palazzo del Taia façade can still be seen on the via Montanini; its design is unusual for its use of *pietra serena* framed windows surmounted by oculi, an *all'antica* cornice and a grandiose portal bearing the family arms (see fig. 131).[28] These stylistic choices as well

as the ostentatious and unusual contrast of travertine for the façade and *pietra serena* for details, drew attention to the broad palace façade.

Very little is known about the del Taia brothers; Guglielmo appears to have been a merchant and owned a valuable shop on the Campo, and was probably active with his brother in the wool business.[29] The new family palace did much to affirm their status in an area that was dominated by the presence of the Malavolti clan, whose large 'urban castle' (*castellare*) was located across the street (fig. 149).[30] While much of the Malavolti property was demolished in the nineteenth century in order to create the new piazza delle Poste development, surviving fragments of the Malavolti palace on via del Cavallerizzo suggest what might be called chromatic competition between the Malavolti and del Taia palaces. For the palace of the Malavolti is built of a dramatically contrasting brick and limestone *opus mixtum* that both singled out the building for its 'markings', but also suggested the antiquity of the family through the use of limestone 'pietra da torre', commonly used in medieval magnate tower houses.[31]

These are not unique instances of polychrome façades in Siena. Obviously, a number of major churches, such as the Duomo, Baptistry and S. Francesco, had façades that used white marble and other more local coloured stone, while the Palazzo Pubblico façade was built of limestone and brick. The privately commissioned

149. Malavolti enclave (demolished in a nineteenth-century reordering for the piazza delle Poste), detail from F. Vanni, *Sena Vetus Civitas Virginis*, fig. 10.

oratory of S. Maria delle Nevi (from 1470), discussed below, was built in brick, but its façade was oriented towards the Strada Romana and was built of travertine, with *pietra serena* architectural detailing, such as fluted pilasters that support an elaborate cornice, and a fine moulded doorway. A similar arrangement was used for the neighbourhood church of S. Caterina in Fontebranda (*c.* 1465–74), which has a brick façade articulated by *pietra serena* detailing, rather similar to that at S. Maria delle Nevi (figs 150–1).[32] A comparable treatment of materials was adopted for the Palazzo Bandini-Piccolomini, a palace that stood near the monastic complex of S. Vigilio, a street back from the Strada Romana within the Piccolomini enclave.

A good deal of confusion has surrounded this palace, which displays the Piccolomini arms both in the pedimented portal and in the entrance hall (fig. 152–4).[33] Cardinal Francesco Todeschini Piccolomini, Archbishop of Siena, was also abbot of the Camaldolese monastery of S. Vigilio that was adjacent to the palace; his will

150. Church of S. Caterina in Fontebranda.

151. Church of S. Maria delle Nevi.

152. Palazzo Bandini-Piccolomini.

reports a number of properties in the S.Vigilio area, and the Palazzo Bandini-Piccolomini almost certainly belonged to him.[34] The palace is remarkable both for its façade arrangement and the innovative asymmetrical placement of the doorway, which is not centred to the palace façade, but rather to the street that connects the palace to the Strada Romana, thus giving the illusion of symmetry to the oncoming visitor. The façade itself is also interesting. The palace is constructed of smooth bricks joined by slender layers of mortar, in itself an *all'antica* practice, while the elevation is modulated by a series of horizontal *pietra serena* bands at street level, where the horse-stays are fixed, below the window-sills and at the cornice.[35] The door is framed by elegant *pietra serena* composed of fluted pilasters, which support a frieze decorated with dolphins, and is topped with a pediment displaying the Piccolomini escutcheon.[36] Refined iron-work horse-stays, which continue the

dolphin motif, adorn the ground floor, whose wall surface is pierced by a series of high square windows and two oculi around the door pediment. In turn, the windows are framed by a simple moulding and are topped with a pediment, decorated with garlands.

Following Piero Sanpaolesi, Francesco Paolo Fiore has suggested that the palace was probably designed by Vecchietta, and has argued that like the churches of S. Maria delle Nevi and S. Caterina, it cannot be considered part of the *œuvre* of Antonio Federighi, to whom others have attributed all or some of these buildings.[37] However, while it is true that these buildings utilize architectural detailing in a painterly way that recalls many Vecchietta scenes, by literally applying architectural detail in a contrasting colour to the wall surface, it is also clear that their sculptural elements resemble closely Federighi's known works, such as the Cappella di Piazza. Moreover, Federighi was head of the cathedral works throughout

153. Palazzo Bandini-Piccolomini, detail of portal.

154. Palazzo Bandini-Piccolomini, horse-stay.

this period, while Cardinal Francesco was archbishop, and is documented as having supplied some sculpted elements for the church of S. Caterina.[38] Thus, while documentary evidence that links Federighi to the Palazzo Bandini-Piccolomini is still to be found, it seems reasonable to believe that the Piccolomini's favoured Sienese sculptor–architect was also involved in this project.

The use of expensive or unusual materials was clearly a way in which palaces (and buildings in general) could be made more visible; brick or simple plaster façades were probably the norm in the fifteenth-century city, so that stone immediately served as a mark of distinction.[39] Such a ploy was long-established for palace architecture, as early magnate residences frequently made use of a locally available limestone known as 'pietra da torre', a practice that carried over into the fourteenth-century palace designs of the Tolomei and Salimbeni, to name but two examples. Stone denoted prestige, and perhaps even nobility, and it is certainly for these reasons that expensive and non-local travertine and marble were preferred for the Piccolomini projects discussed in the previous chapter. So too, the Palazzo del Vecchio that stands next door to the Palazzo Tolomei on the central stretch of the Strada Romana also adopted a channelled ashlar travertine

façade with design features derived in part from the ongoing Palazzo Piccolomini project. The palace was designed for Sano di Agnolo del Vecchio, and the fact that the diarist Allegretto Allegretti noted that it was begun on 28 May 1472, using 'smooth cut stone', indicates that these materials were considered exceptional (fig. 155).[40] Sano del Vecchio was, like his father, a shopkeeper of some success, and already lived in the district; it seems reasonable to assume therefore, that work on the palace was largely confined to the application of an all'antica veneer to the main façade, perhaps as a display of status and wealth, more than of any cultural and political alliance with the Piccolomini faction, as has sometimes been proposed.[41] Indeed, the absence of any antagonism with regard to the Commune is confirmed by the fact that in December 1473 del Vecchio successfully appealed to the Ornato for financial assistance to 'finish furnishing the façade of his house on piazza Tolomei'.[42]

While in this and other cases a stone façade was sufficient to denote prestige, the Palazzo delle Papesse went a step further in the conspicuous consumption of materials, by adopting a façade design of graded masonry, similar to that designed by Michelozzo for the Palazzo Medici in Florence. The use of ground-floor massive rustication has

155. Palazzo del Vecchio.

156. Palazzo Bichi-Ruspoli, Banchi di Sopra.

the effect of drawing the attention of the viewer to an otherwise unprepossessing site on the inside of a curve. Opposite, the medieval Palazzo Mares-cotti (now Chigi Saracini) vied for visibility both by means of its stone façade and the high tower that marks the curve in the via di Città. Palazzo Marescotti was in fact also a Piccolomini residence for much of the second half of the fifteenth century, as Iacomo Piccolomini acquired the palace as his home while he awaited completion of his palace near the Campo.[43]

Both the Palazzo Marescotti and the Palazzo delle Papesse acquired visibility through visual strategies that imposed the building on the viewer, either by alignment of key features to the visual trajectory of the street or by impinging on that visual axis.[44] This practice could only really be employed by such patrons as had palaces at significant turning-points of the Strada, which nonetheless was a street that conformed to Alberti's ideal, expressed in Book IV of *De re aedificatoria*:

Within the town itself it is better if the roads are not straight, but meandering gently like a river flowing now here, now there, from one bank to the other [. . .] and it is no trifle that visitors at every step meet

yet another façade, or that the entrance to and view from every house should face directly onto the street.[45]

His comments were those of a pragmatist, as it was rarely possible to create straight streets in the centre of the tight-knit fabric of medieval cities. Nonetheless, it underlines the importance of visibility of buildings, for owners, viewers and the community as a whole. Such considerations were obviously foremost in Pius II's mind when he planned the site for the new Loggia and Palazzo Piccolomini, which are both best viewed from along the Strada Romana.[46]

Many palaces along the central portion of the Strada Romana employed such strategies. Thus, from the Palazzo Spannocchi onwards, the viewer can perceive the civic 'goal' of the street, with the Torre del Mangia, a marker for the Campo and Palazzo Pubblico, visible over the rooftops of the palaces. Along the street, palaces jostle to be seen, using a variety of materials, styles and decorative features. Among these, the Palazzo dei Rossi (later Bichi-Ruspoli) is one of the more impressive: the ancestral home of the magnate Rossi, it was bought in 1518 by the wealthy banker, Alessandro Bichi (fig. 156).[47] It seems that the new owner left the core of the orig-

157. Loggia della Mercanzia.

inal fourteenth-century residence of the Rossi substantially unmodified, since a three-bay, ogival-arched, ground-floor loggia remains intact, while the upper storeys were probably only modified in the seventeenth century to make way for rectangular framed windows in the place of the original acute *bifore*.[48] The sandstone façade, massive architectural features and flanking limestone towers gave the palace a dominant place in this central portion of the street.

158. Loggia della Mercanzia, detail of bench with arms of the Comune and she-wolf.

Beyond, the Croce del Travaglio, the city's most important crossroad was marked by the monumental Loggia della Mercanzia, a structure that had occupied this vital site at the city centre from as early as 1194 (figs 157–8). The Loggia was rebuilt from 1417, probably as Judith Hook and Sabine Hansen have both argued, from 'a desire to foster trade', since 'on account of the main street, all foreigners come past this place, from wherever they come to Siena'.[49] It served as meeting place for the corporation of Sienese guilds, and was rebuilt using Commune funds and the *Opera del Duomo* workshop: a public commission intended to express in a highly visible and prominent manner the buoyancy of Siena's economy.[50] Viewed in the light of the zoning and immigration measures discussed in the previous chapter, the Loggia can be considered the visible centrepiece of governmental policies that intended to make the Strada a commercial, as well as an architectural, civic show-piece. Significantly, the Commune and *Opera* arms are more prominent and numerous on the bench backs that flank onto the Loggia's access alleys to the Campo than those of the Arte del Cambio and Mercanzia themselves, which the Loggia was intended to represent.[51] Likewise, the Loggia della Mercanzia statues show the city's patron saints (Ansano, Vittore and Savino), as well as the two patrons of the Mercanzia church, over which the Loggia was built, Peter and Paul.[52] Moreover, the statues themselves are oriented towards users of the Strada coming from the north, as they all face up the Banchi di Sopra.[53]

Commerce and the Street

The Strada Romana was not simply Siena's most prestigious residential street, it was also that most densely filled with commercial properties, which plied their trade with the city's residents and the many pilgrim travellers passing through (fig. 159). The mixed commercial and residential composition of the street meant that it was naturally a major place for interaction between locals and outsiders, as well as between elite palace owners and other members of the urban community.

The steady, and sometimes heavy, flow of pilgrims and travellers along the Strada meant that Siena needed to provide facilities for these visitors, both in the form of religious hostels and privately run hotels and inns.[54] Sigismondo Tizio's assertion that over 4,000 pilgrims on their way to and from Rome stayed in the city's hotels and hostels every night over the Jubilee year of 1450 is probably exaggerated, but nonetheless offers an indication of the large numbers of visitors to the city.[55]

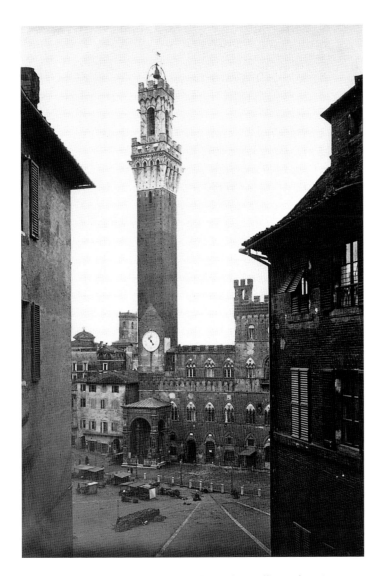

159. Piazza del Campo with market stalls in place in a photograph by Paolo Lombardi, *c*.1860.

Maurizio Tuliani has examined the social and economic history of inn-keeping in Siena during the fourteenth and early fifteenth centuries, revealing the large number of hotels operating within the walls and along the main roads of the *contado*. It seems that for security reasons, hotels and inns were confined to the main city streets, which also made them more readily identifiable to their potential customers.[56]

Tax evidence suggests that inns and hotels were often owned by wealthy property owners, but managed by hired inn-keepers, which indicates that such businesses were considered a worthwhile investment. In 1453, for example, Giovanni Pecci owned an inn called 'I Galli' and a hotel in Camollia called 'L'Oca', which was still in his son's hands in 1481, when Bartolomeo reported that it earned him a high rent income of 240 *lire* a year.[57]

It is also interesting to note that as well as bankers such as Ambrogio di Iacomo Spannocchi, who in 1453 declared ownership of two hotels, the knight Dino Marzi did not shy from income earned from his hotel at Pian Galluzzi.[58]

Siena's red-light district was also centrally located, as brothels and gambling joints operated in the area behind piazza Tolomei and the church S. Cristoforo, while the 'publico postribulo' (public brothel) was situated behind the Campo and continued to thrive into the sixteenth century in spite of S. Bernardino's call for its closure.[59] Of course, inn-keeping was subject to a number of variables, of which none was greater than damage wrought by soldiers; thus in 1481, Onesta the widow of Paolo di Filippo from Montalcino, who owned the Albergo della Staffa in S. Vigilio complained that she earned no income from it as it was filled with soldiers.[60] The situation was not substantially different in 1509, when Chimento di Vanni complained of damage done to his hotel by the troops of Valentino (Cesare) Borgia, while entrepreneur-owners such as Giovan Battista Guglielmini and Leonardo Mannucci owned hotels at the baths of S. Filippo, in the district of Pantaneto and at Ponte a Merse, as part of large property portfolios.[61]

If owning a hotel was a possible source of income, the ownership of rentable shop-space was a far more widespread investment among Siena's wealthier taxpayers. As was shown in the previous chapter, government policy in fifteenth-century Siena tended to favour retail activities, and particularly the concentration of luxury outlets along the Strada Romana. By applying zoning laws that encouraged the concentration of bankers, goldsmiths or cloth-merchants exercising their trades along the Strada, the *Comune* provided ideal conditions for foreigners to the city to buy precious Sienese wares.[62] Naturally enough, since the city's main street and the piazza del Campo were the principal retail areas in Siena, the *botteghe* there commanded much higher values and rent incomes than elsewhere in the city.[63] Thus, real-estate investors tended to favour shops in those locations, while those in the periphery tended to remain in the hands of local residents.

Among countless examples, that of Ghino di Lorenzo di Ghino, a resident in the Casato di Sotto, is particularly informative, since in 1481 he owned a large portfolio of shops that were all located in areas of prime retail real estate that were collectively valued at 4,180 *lire*, and produced a considerable annual rent income.[64] In 1509 Ghino's heirs still owned the properties and continued to derive income from them.[65] A similar attachment to rent-producing *botteghe* is expressed by Niccolò di Minoccio, who declared ownership of five shops in the central via del Porrione, 'with a house

above them'; it is evident from his tax return that it was the shops that produced income, and that the house was a far less valuable asset.[66] It is also interesting to note that since centrally placed shops produced high rents, the Commune itself was not averse to generating some income from selling valuable properties. Thus, Andrea di Francio del Malizia had a shop under the Torre del Mangia that he must have bought from the Commune, while Andrea di Mino Bargagli paid rent on a similarly placed shop to the confraternity of S. Onofrio.[67] Perhaps even more surprisingly, Iacoma, the widow of Galgano Cenni, owned a 'shop in the ground floor of the new palace of the Captain of Justice', which she had received as part of her dowry restitution on her husband's death.[68] It seems likely then that part of the plan for the new administrative palace (discussed in chapter Five) included shops for immediate sale, which may have defrayed some of the construction costs as a form of public–private partnership.

Considering the matter from a different perspective, it is significant that Pius II provided the new cathedral and bishopric of Pienza with an income in part derived from an endowment of numerous rent-producing shops in Siena. Payments made through the Pope's procurator in Siena, Giovanni Saracini, between 1462 and 1463, document large expenditures made to this end, and specify that the properties bought should produce an annual rent of at least 20 florins each.[69] Even more specific were the requirements contained in Andrea di Nanni Piccolomini's will of 1507, which specified that 150 florins of botteghe were to be bought to endow the cathedral church of S. Maria di Pienza.[70] Not content with leaving the choice of properties to his executors, Andrea specified that

> the shops should be located from the Piazza Tolomei, along the Strada towards Piazza Piccolomini, turning from that piazza [Piccolomini] towards S. Martino, and entering into [via del] Porrione, and along it towards the piazza del Campo, and anywhere on the Campo, so rising to Porta Salaria and following the Strada to the Croce del Travaglio.[71]

Even more than Ghino di Lorenzo's property portfolio, Andrea Piccolomini's testamentary requirements defined the 'golden triangle' of Siena's prime real estate, between piazza Tolomei, the Loggia Piccolomini and the lower end of via di Città. Quantatively analysed, tax evidence from the *Lira* between 1453 and 1509 would certainly confirm Piccolomini's assessment.[72]

With this in mind it is natural to ask to what degree palace design reflected this situation; were palaces and houses in this central part of the city more likely to contain shops than elsewhere? And to what degree were

domestic arrangements altered to guarantee rent income from ground-floor *botteghe*? The ownership of shops seems to have been an almost endemic feature of urban life in fifteenth- and sixteenth-century Siena, so that centrally located residential buildings were not simply divided into apartments reserved for separate households, but ground-floor *botteghe* as well as less valuable stables, sheds and even gardens might all be owned by different individuals. This fragmentation of property often makes it difficult to reconstruct the 'ownership' of even the more monumental palaces of the city centre. For example, in 1481, Nastoccio Saracini owned three *botteghe* in the ground floor of the Tricerchi palace, while Minoccio di Niccolò Tricerchi – part-owner of the residential portion of the palace – owned a further three (fig. 160).[73] Other residents of the Palazzo Tricerchi, located at the strategic intersection of the Croce del Travaglio, were Alessandro di Pietro Tricerchi, as well as Minoccio's brother.[74]

Palazzo Tricerchi contained six shops on the ground floor, which suggests that the design of the palace

160. Palazzo Tricerchi at the Croce del Travaglio, showing also the shop openings at ground floor.

161. Unknown draughtsman, Palazzo Chigi, Campo façade with shop openings, c.1650. Fondo Chigi, P VII II, fol. 101, Biblioteca Apostolica Vaticana.

that filled the two façades of the palace, on the piazza del Campo and the Banchi di Sotto.[79] Moreover, not all shops were owned by family members, so that in 1481 Francesca, widow of Francesco del Cotone, owned shops under the palace, on both the Banchi di Sotto and the Campo sides.[80] In order to understand quite to what extent the palazzo Sansedoni was crammed with shops, it is useful to look at a drawing in the Chigi collection of the Vatican, which shows the design for the neighbouring seventeenth-century Palazzo Chigi-Zondadari (fig. 161–2).[81] As with the Sansedoni site, the Chigi-Zondadari had façades on the Campo and Banchi di Sotto, and the design for the new palace made ample provision for shops throughout the ground floor.

Clearly then, it must be the case that palaces built in fifteenth-century Siena also included shops, and that these were intended to generate income, either through immediate resale or (more commonly) from rent paid

accommodated as many retail outlets as was possible within the space available. When compared with the Palazzo Tolomei, a magnificent late thirteenth-century palace built for a family deeply involved in banking activity, it is evident that different criteria governed the design in that period. Palazzo Tolomei has a vast open ground-floor loggia, which was probably used for family occasions as well as the family's banking business, but it is surely no surprise that in 1481 none of the twelve Tolomei households declared *botteghe* in the family palazzo.[75] As David Friedman has also noted, residential properties in medieval Siena and other cities, tended to take the form of tall and narrow houses that contained *fondachi* (warehouses) or a shop at ground floor, presumably for the exclusive use of the owner–resident.[76] Clearly then, at some point after the thirteenth century, a conscious design choice that may have been driven by market forces was made in favour of wider palaces with more ground-floor shops.

While, within the Florentine context, scholars have tended to indicate that the Renaissance palace type eschewed the inclusion of *botteghe* in favour of more dignified façade arrangements, Sienese patrons seem to have been more pragmatic.[77] A building that may well have marked the turning-point for palace design in Siena is the fourteenth-century Palazzo Sansedoni, a building that both survives and whose design is richly documented in the form of a long written contract and an elevation drawing.[78] By 1453 the residential upper storeys of the palace were divided between three households that owned private apartments, while each declared liability for different parts of the many shops

162. Unknown draughtsman, Palazzo Chigi, Strada Romana façade with shop openings, c.1650. Fondo Chigi, P VII II, fol. 102, Biblioteca Apostolica Vaticana.

163. Palazzo Piccolomini-Todeschini, shop openings and mezzanine window.

chapter Five) was built in horizontal phases, so that Iacomo was able to benefit from rent income well before the palace was complete.

Clearly, the Piccolomini development on the Strada Romana was intended to capitalize on potential rent income from shops, with as many as twenty shops planned, while the rent from two shops and a warehouse under the Loggia Piccolomini sufficed to pay for its maintenance.[85] Moreover, the surviving architectural evidence indicates that the Piccolomini patrons had planned self-contained units, which not only provided a large open shop-floor or workshop space, but were connected by internal stairs to a mezzanine warehouse or perhaps even residential rooms above. Such a solution appears to derive directly from fourteenth-century precedents, such as the Palazzo Sansedoni, a near neighbour along the street.

Ritual, Devotion and Pilgrimage: Religious Architecture along the Strada

The urban fabric of Siena was not merely a secular showcase for private magnificence, commerce and civic display but as is clearly suggested by the sermons of S. Bernardino, it was a city with a sacred topography intimately bound up with the pilgrimage route to Rome. The friar located the religious examples created for the Sienese audience of his sermons within the fabric of their city, much in the same way as local rhymesters or *novellatori* used similarly well-known settings for their poems and tales. Naturally, quite different objectives were pursued by the creativity of the authors involved; these reflect the range of experiences of urban life, which spanned from devout religious observance to revelling in ribald humour.[86] S. Bernardino's sermons frequently used the allegorical image of travel as a way of describing the right *path* to God, and illustrated such allegories with examples that brought his message directly into the everyday lives of his listeners. A good instance comes in the Lenten sermon cycle of 1427:

Take the example of someone who wishes to go to Rome, standing there at Camollia; wishing to go to Rome he takes to the road that leads towards the Porta Nuova [Romana], following the correct road that will lead him to Rome. Don't do as so many do, that say:

'I want go to Rome.'

And they go to Porta Camollia, and go out from it, heading off in the wrong direction. And people ask them:

by tenants. So, then, in 1481 Cino Cinughi, Rector of S. Maria della Scala, owned four shops under the recently built Palazzo Cinughi on the Banchi di Sotto.[82] Numerous other examples of the sort can be documented: in 1488 the heirs of Ambrogio Spannocchi earned 20 florins from the shops in their palace, although it is unclear how many of the four possible spaces were rented out.[83] On the other hand, Andrea di Nanni Piccolomini stated that he earned as much as 200 florins in rent from the many shops in the ground floor of his palace, which faced the Campo and the via del Porrione, while his brother Iacomo owned ten shops in the ground floor of the new Palazzo Piccolomini that adjoined it, which faced the Strada Romana and via dei Pollaiuoli (fig. 163).[84] Iacomo complained that not all shops were yet filled, but that he too received rent of 20 florins a year for each *bottega*. It is also significant that the new Palazzo Piccolomini (discussed further in

'Where are you going?'

'I'm going to Rome.'

'You're going the wrong way!'

And nonetheless he goes that way. He goes to Fontebecci; feel free, go there. He goes to Florence; feel free, go there. And when he is again asked:

'Where are you going?', he replies:

'I would like to go to Rome.'

'Where have you come from?'

'I have come from Siena.'

'Oh, but you are going the wrong way; you are going in the opposite direction, oh wicked one. You have lost your way [. . .].'[87]

It is amusing to note that, for the Sienese preacher, the path towards wickedness led directly to Florence. S. Bernardino's image was clear to all his audience, as Siena had a longstanding vocation as a city on one of the three principal pilgrimage routes of the Middle Ages, the via Francigena to Rome.[88] The Strada Romana, as has been said, was the portion of the Francigena within the city walls, and constituted a clearly identified path for the visitor to the city to follow. The high palace façades, dark and narrow side alleys, steep hills falling away from the Strada that held the city's high-ground, all contributed to funnelling the movement of travellers along this privileged axis. In this respect, Siena's Strada Romana creates a kinetic dynamic that cuts through the city in a manner that resembles the route of the Grand Canal in Venice; here too, but for the initiate, the city offers an ordered yet impenetrable façade, which controls movement and articulates resting points.[89] As Joseph Rykwert has written, a 'street is human movement institutionalized', channelled by boundaries of private property and propelled by anticipation; conversely, streets also provoke rests, stops and emotional reactions from their users.[90]

Siena was well equipped to cope with pilgrim travellers, both spiritually and logistically, with religious and secular facilities within and beyond the walls. Practical needs were satisfied by a multitude of religious-run hostels (spedali) as well as privately managed hotels and inns. Siena's northern gate, which faced towards Florence, was the most heavily fortified; beyond the Torrione Dipinto, the furthest north of a three-gate defensive structure, was a group of permanent buildings. Among these, the Spedale di S. Croce functioned as a hospice; it abutted the city walls and was restored in 1454.[91] Next to it was the oratory of S. Sepolcro, constructed in 1459 by the Neapolitan Alessandro Mirabilli, one of Pius II's bankers and a partner of Ambrogio Spannocchi.[92] Little is known about this small religious complex, which was destroyed in 1554 for strategic

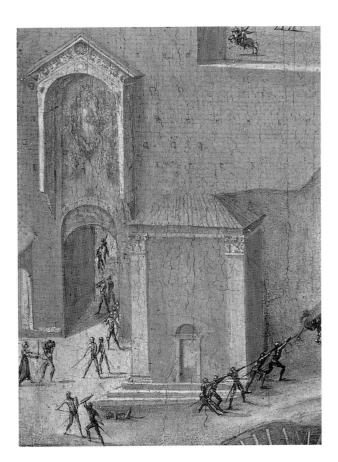

164. Detail of the chapel of the S. Sepolcro, from fig. 54, attributed to Giovanni di Lorenzo, *The Battle at Porta Camollia*.

reasons, although it can be seen in numerous views of the Porta Camollia, and especially in a *Biccherna* cover of 1498 (fig. 164).[93]

Within the Torrione Dipinto was a loosely defined area known as the Prato di Camollia, an unwalled area flanking the Francigena, and beyond it to the south was the now-demolished Torrione di Mezzo, which was connected by an earthwork to the Porta Camollia. This created a protected area outside the city walls known as the 'Castellaccia', densely filled with shops, inns and *ospedali*, which had special functions in the care of pilgrims.[94] The arrangement must have been practical for travellers arriving after the inner gates were closed, although the large number of hotels and inns within the city walls, and especially along the Strada, indicate that foreigners were not confined outside the city gates for security reasons.[95] As with the Porta Camollia, so too the Porta Romana was surrounded by permanent and impermanent structures, many of them for the use of travellers and pilgrims.[96] The monasteries of S. Barnaba and S. Caterina delle Ruote clustered around the gate itself, although repeated attempts were made through-

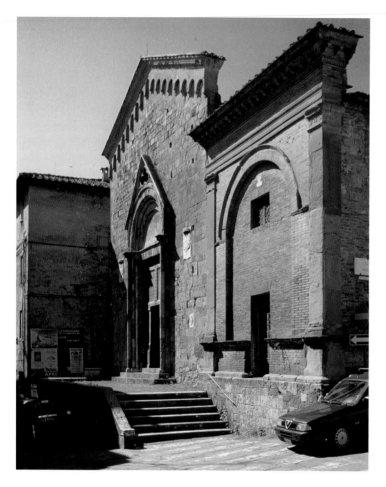

165. Church of La Magione with Spedale around the open courtyard to the rear. Note the ramp of stairs oriented towards the nearby northern access to the city from Porta Camollia.

argued that Andrea Vanni's painting for the High Altar of the church of S. Stefano alla Lizza (1400) included the figure of St James the Great, patron of pilgrims, specifically because of the numerous pilgrims coming to the church to view the relic of St Stephen, preserved in the church.[99] Similarly, at S. Andrea Apostolo, which was originally connected to a hostel, the High Altar of the church was visible from the Strada, and the iridescent gold ground of the *Coronation of the Virgin*, painted by Giovanni di Paolo in 1445, coaxed visitors into the church.[100] That the display of relics was enhanced by altarpieces and the architectural framing of church façades and doorways is made especially clear in descriptions of the nocturnal entry of Eleonora of Portugal to Siena in 1452, when all relics were on show on the altars of churches that faced the Strada, lit up by candles and torches.[101]

Indeed, the combination of relics with a hospice was particularly successful at attracting pilgrim travellers, and is exemplified most monumentally in the Spedale di S. Maria della Scala (fig. 166–8). While many pilgrims and travellers surely stayed in the *spedali* inside and outside the city gates, many would have continued into the centre of town. Once inside the city walls, travellers often proceeded to the Duomo, Siena's largest and most important religious building, which was reached along extensions of the Strada Romana, the via di Città and via dei Pellegrini, which underwent similar urban improvement campaigns as the main Strada. The main public focus of Siena's religious life, the cathedral faced the hospital of S. Maria della Scala, a public institution dedicated to the care of the sick, orphans, poor and travellers.[102] The intimate relationship between Spedale,

out the fifteenth century to remove all, or parts, of these on aesthetic grounds.[97]

Inside the city walls a number churches that faced onto the Strada Romana were attached to *spedali*, whose main concern was directed at the care of pilgrim travellers through Siena. Thus, for example, the first church inside the gate at Camollia was S. Pietro della Magione, originally founded by the Templars in the twelfth century, and subsequently taken over by the Knights of Malta.[98] The church had a clearly defined vocation as a hospice: it is oriented to face north, and a ramp of stairs ascends to the portal also from the north, the direction of entry of travellers coming from the Porta Camollia (fig. 165). La Magione functioned as a *spedale* for pilgrims, who were lodged in the porticoed structure behind the church, which was clearly visible from the Strada itself. Henk van Os has suggested that pilgrim-viewers were considered as part of the audience for a number of Sienese altarpieces; he has

166. Spedale di S. Maria della Scala, from G. Macchi, *L'Ospedale di S. Maria della Scala e le grancie*, c.1720. MS. D. 108, fol. 69, Archivio di Stato di Siena.

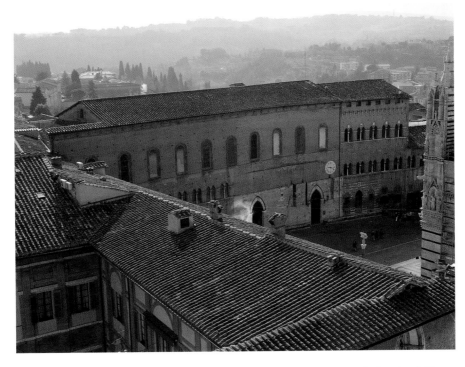

167. S. Maria della Scala, with the rector's residence and the hospital church of SS. Annunziata.

Duomo and citizens was again captured by S. Bernardino, in an anthropomorphic simile:

> I remind you that it [the Spedale di Santa Maria della Scala] is one of the eyes of your city, and the other is the Episcopate, while the left eye is the hospital. Look how the piazza in between is sort of long, like a nose. Hear me! Citizens, give charitably to the hospital![103]

In 1497 a German visitor to Siena, Arnold von Harff from Cologne, reported that 'in front of the cathedral is a superb hospital, which we were shown around by the city's leaders'.[104] Von Harff was one of many visitors to have been shown around the hospital, as indeed it appears to have been an institution of which the Commune was especially proud.[105] The *Comune's* involvement in the running of the Spedale was clearly manifest in the prominent display of the city arms on the façade facing onto the Piazza Duomo. S. Maria della Scala continued to expand in the second part of the fifteenth century, with the enlargement of the church of SS. Annunziata and the vertical expansion of the Palazzo del Rettore.[106] Work on the new church has been convincingly attributed to the Spedale 'maestro di casa', Guidoccio di Andrea, as payments for his work to make the church 'beautiful, honourable and magnificent' continued through 1466–72, and were probably completed by 1480.[107] Enlargement of the Palazzo del Rettore, and the completion of the roofs which bind together the façade, are documented to 1479–80.[108]

In spite of the financial difficulties faced by the hospital in other areas at this time, its role as a pilgrim hostel seems to have been invested in quite heavily.[109] Van Os has argued that the increased acquisition of relics for the Spedale from 1359, and again under the Rector Giovanni Buzzichelli (1434–44) 'stimulated [the] reli-

168. Spedale di S. Maria della Scala, church of SS. Annunziata, detail of windows and cornice.

gious tourism' of travellers staying in or visiting the hospital on their way to and from Rome.[110] Buzzichelli was also the initial patron for the internal decoration of the hospital's rooms, and in particular of the public rooms visited by pilgrim travellers. Frescoes were commissioned for the Pellegrinaio, the main hall room in which pilgrims were lodged, on which Vecchietta and later Domenico di Bartolo and Priamo della Quercia worked from 1440 to 1449, producing a cycle representing the welfare role of the hospital and stories of its foundation.[111] Likewise, the sacristy to the hospital church or Cappella del Chiodo, where a nail from the cross of Christ, one of the hospital's most sacred relics, was kept and was decorated with a remarkable cycle of frescoes by Vecchietta, an artist closely associated with the Spedale (1446–9).[112]

Such a process of renewal of the internal decoration and external façade of the Spedale improved its visible standing as one of Siena's most important public institutions, projecting the city's munificence onto the public stage of the piazza, which separated it from the cathedral. Moreover, the images of the Pellegrinaio not only contained frequent references to the Commune through the display of arms, but also made a tangible link between ideal views of hospital life and the urban environment of Siena, by portraying the open doors of the Spedale and the Duomo and bishop's palace beyond (see fig. 64). The visitors that filled the large wards, for use by the sick as well as the numerous pilgrims that came to rest and pray in proximity of the rich relic collec-

169. Arrangement of the Palazzo S. Galgano, hospital church complex of S. Maria Maddalena and adjoining properties, detail from F. Vanni, *Sena Vetus Civitas Virginis*, fig. 10.

tion, were in turn the means by which the fame of the Spedale spread abroad. Indeed, it is well known that S. Maria della Scala was an important model, to which Francesco Sforza of Milan sent his advisers to seek information, inspiration and advice for the planning of the Ospedale Maggiore, built from 1456.[113]

It was indeed perhaps the very success of S. Maria della Scala as a repository of relics that lay behind the development of one of the more remarkable new hospitals of fifteenth-century Siena, the Cistercian complex of S. Maria Maddalena and the Palazzo S. Galgano, located in the vicinity of Porta Romana (fig. 169). In February 1474 Giovanni di Niccolò, Abbot of S. Galgano, approached the Sienese Commune for a building permit for a palace to be built opposite the Spedale of S. Maria Maddalena near Porta Romana, which was run by his community.[114] The Abbot also contracted for a land exchange with the Commune in order to straighten the course of the street and improve the view of the new palace along it, proposing that the façade of the new building be aligned with neighbouring properties, under the supervision of a public official, Pietro dell'Abaco.[115] The request was approved, and on completion of the palace nearly two years later, a significant decision was approved, whereby

> having seen the beautiful palace which the Abbot of San Galgano is having built near the Maddalena in our city, we have decided that if the neighbours were to demolish any overhangs [*ballatoi*] and create an even façade as shown in the drawing, this would add great beauty to our city along the Strada Romana.[116]

The new palace was thus to be given a central place in a redeveloped section of the Strada Romana, with demolition subsidies to poor neighbours provided in order to 'make the façades as beautiful as that of the Abbot, and as honourable as those across the street'.[117] Combining the construction of a palace with the restoration of the Spedale and monastic church, the S. Galgano community effectively created a new hospital complex inside the city, one attractive to travellers and pilgrims as well as to the citizen community (fig. 170).

The S. Galgano community had their main monastery at Chiusure, nearly 30 kilometres from Siena.[118] The monastery traced its origins to Galgano Guidotti, a knight who underwent a conversion and planted his sword in a rock on the hill of Montesiepi in 1180, creating the cross that came to represent the symbol of the newly founded Cistercian community. Throughout the Middle Ages, monks of that community had served as neutral financial officials and chancellors of the Sienese Commune, and it is for this reason that their monks' white habits and representations of the S. Galgano

round-arched *bifora* windows supported by *all'antica* colonettes, owes much to the near-contemporary Palazzo Spannocchi, which the Abbot himself referred to as a model in his 1474 petition for government subsidies.[122] These similarities, have led some scholars to make a stylistic attribution of the building to Giuliano da Maiano, although this cannot be confirmed from the documents.[123] However, there are marked differences in the two designs: the S. Galgano palace has a six-bay design that does not have a central axis of entry, and the proportions of the two built storeys are unusual, since the upper floor appears to be of equal height to the ground floor. Furthermore, the stonework detailing is somewhat less refined than that of the Palazzo Spannocchi, and lacks an elaborate moulded *all'antica* cornice.

On the façade, the arms of the S. Galgano community are represented not by shields, but in two rectangular low-relief panels, which illustrate scenes from Galgano's life, as well as in the prominent sword-shaped iron horse-stays on the ground storey (figs 171–2). The use of such figurative panels that represented the foundation narrative of the monastic community that commissioned the building is in itself unusual, and may have

170. Palazzo di S. Galgano.

171. Palazzo di S. Galgano, detail of relief panel on façade.

legend frequently appear on *Biccherna* covers.[119] It still remains unclear why the Abbot of rural S. Galgano became the patron of a stone-built *all'antica* palace, which may have been intended to serve as abbatial lodgings, but it seems likely that behind the move there lay an attempt to revive the flagging financial fortunes of the formerly immensely wealthy monastic institution, by appealing to an urban 'pilgrim market'.[120]

This aim was followed through a number of commissions of art and architecture, the most expensive of which was the large, six-bay palace, built of sandstone and elaborately decorated with the arms of the monastery.[121] While sixteenth-century restorations to the building added a second-storey loggia and probably altered the internal arrangement of rooms around a courtyard, the magnificent stone façade survives in its original form. Its design of coursed masonry and

172. Sword-in-the-stone motif on the Palazzo S. Galgano horse-stays.

a precedent in the Della Robbia maiolica relief panels for the Ospedale del Ceppo in Pistoia.[124] As in these cases, the choice of a narrative rather than symbolic image was intended to catch the attention of the viewer, using an illustration that placed the building into direct relation with the adjoining hospice, and the story of the relic that it contained.

173. Church of S. Maria Maddalena, from G. Macchi, *Memorie Senesi*, *c.*1720. MS. D. 107, fol. 127, Archivio di Stato di Siena.

The palace was constructed opposite the pre-existing hospital–church of S. Maria Maddalena, which had recently been taken over by the monks (fig. 173).[125] Palace and church connected visually across the street, and it might be that the palace's proportions and prominent narrative panels were intended to compensate for the fact that the church stood on a slight hill, by putting the *piano nobile* on a level with the church. The church, which has since been demolished and is documented only in small and inaccurate early seventeenth-century ink sketches by Macchi, was extensively restored in 1474 to coincide with the palace's construction.[126] Macchi's sketch of the church suggests that the staircase may have been framed by pilasters, rising and converging towards a simple façade, articulated by a pedimented portal. The church was given a new sacristy, as well as a new façade and staircase up to it from the Strada, all of which were constructed at considerable expense.[127] Beyond the church, as can be seen in a detail from Vanni's 1599 map of Siena, was located the hospital complex, which was also swallowed up by the seventeenth-century Palazzo Bianchi-Bandinelli that now fills the site.

It seems clear that Abbot Giovanni's (and his successor Bartolomeo's) plans for the church–palace complex on the Strada Romana aimed to revive the monastery's fortunes through the cult of S. Galgano himself.[128] At the same time as these major building projects were underway, the monks also improved the church's attractions for pilgrim travellers by permanently moving their most important relic, the head of S. Galgano, into the city from their *contado* monastery.[129] The relic of S. Galgano was well known in Siena; it was housed in a magnificent late thirteenth-century reliquary, and had been carried in Easter processions led by S. Bernardino in April 1425, when it was the most important relic carried by members of the Terzo di S. Martino.[130] Central to the church project was the construction of 'a beautiful tabernacle for that holy relic [. . .] in a protected place within the church, furnished with an iron gate', which was to be stored inside the church.[131] The tabernacle itself survives on the outer wall of the Palazzo Bianchi Bandinelli garden, and is a fine piece of sculpture by Giovanni di Stefano, bearing the sword-in-the-stone symbol of the S. Galgano community (fig. 174).[132] It seems probable that the reliquary casket was to be shown inside the tabernacle, protected by the extant iron grate.

Part of the Commune's conditions for subsidizing the new tabernacle required that the relic should play a more active part in the city's ceremonial and religious calendar, and to this end it was decided that the relic should be borne in procession on the feasts of Pentecost, the Assumption and S. Galgano (3 December).[133]

174. Giovanni di Stefano, reliquary tabernacle for the Head of S. Galgano, from the demolished church of S. Maria Maddalena, now on via Roma.

The permanent transfer of the relic from Chiusure to Siena may thus be understood as a means of making the most of local devotion to the saint's relic, as well as that of pilgrim travellers along the Strada. Finally, it has recently been suggested that the Abbot was also patron of a new altarpiece, which included the saints Galgano and Mary Magdalene, commissioned from Giovanni di Paolo for the High Altar at S. Maria Maddalena around 1470.[134] The painting thus wove together the rural and urban dedications of the Sienese Cistercians, and adorned the altar of the restored church, a destination for local and visiting faithful.

Not all churches or religious institutions owned large collections of relics, but this did not stop them from developing strategies for attracting believers within their doors. Among these, the most obvious was that of providing a widening in the street, which could be used for ritual purposes and as community meeting spaces, and naturally encouraged visitors to slow down or stop and admire the building that faced them. Siena is a city with very few piazzas, and it is remarkable that almost all the widenings along the Strada Romana coincide with a church. As has been mentioned, such widenings were formed with the expedient of creating wide stair ramps to La Magione and S. Maria Maddalena, while more ordered piazzas existed in front of the churches of S. Cristoforo (at piazza Tolomei) and S. Giorgio (in Pantaneto).[135]

Bolder projection solutions were reserved for sites where acquisitions allowed greater flexibility. Thus the Bishop of Pienza, Giovanni Cinughi's oratory of S. Maria delle Nevi, begun around 1470, filled a complex site on the northern edge of the Banchi di Sopra.[136] Cinughi put in a bid for the site, arguing that it was appropriate that a church dedicated to the Virgin be built there, because 'in this city which is called the city of the Virgin, only the Cathedral is dedicated to her name'.[137] The church was built on the Poggio Malavolti, an empty space on the Strada, previously covered by a then-derelict loggia owned by the Malavolti family, flanked to the south by the Arco Malavolti, which granted access to that family's enclave, and beyond this an arch that was believed to be Roman, because of the inscription 'SEVERO ET VALERIANO' that it bore.[138] Neither arch survives, but by recreating the layout of the site it becomes evident that the church was placed in direct relation to these arches, the latter of which was described in 1466 as 'the most beautiful gate in all Tuscany' (fig. 175–7).[139]

The Oratory's classicizing façade, dressed in travertine and framed with *all'antica* fluted pilasters supporting a *pietra serena* pediment, created a splendid setting for the display of the patron's arms, prominently positioned in marble roundels below the pediment. Moreover, the church's design clearly reveals how the building was intended to interact with the street: while the structure is built entirely of brick, the façade onto the Strada

175. Church of S. Maria delle Nevi, from G. Macchi, *Memorie delle chiese di Siena*, c.1720. MS. D. III, fol. 301, Archivio di Stato di Siena.

176. Roman arch at Poggio Malavolti, traces of demolished arch.

177. Roman arch at Poggio Malavolti, from G. Pecci, *Raccolta Universale di tutte le iscrizioni, arme e altri monumenti si antichi, come moderni, esistenti nella città di Siena*, MS. D. 6. fol. 6v, Archivio di Stato di Siena.

Pispini was rebuilt from 1498 on a site that faced onto a narrow side street which branched off the Strada.[142] It is surely not coincidental that just as the *Balìa* elected officials to oversee the project in 1499, so in April 1501 the *Balìa* also decreed 'that the *Viarii* may demolish the small gate [*porticciuola*] leading to Santo Spirito and make a beautiful new street leading to the Strada'.[143] A new axis was thus created, aligning the church façade with the Strada Romana.

178. The site of S. Maria in Portico di Fontegiusta, detail from F. Vanni, *Sena Vetus Civitas Virginis*, fig. 10.

alone is richly ornamented with *all'antica* style architecture and expensive materials, revealing the importance of display in the design (see fig. 151). This is further underlined by the slightly tilted angle of the façade, which gives prominence to views of the church to users of the Strada coming from the north by creating a slight widening in a very narrow portion of the street. Moreover, Bartolomeo Benvoglienti's comment that 'banners are lowered' around the Roman arch suggests a probable ceremonial stop on processional routes, which would have given further prominence to Cinughi's church.[140]

Even churches that did not face directly onto the Strada, and were indeed located some distance from it, developed means of projecting their façades in such a way as to be visible from that street. *Ornato*-supported demolitions and subsidies led to the creation of a direct visual axis onto the Strada for the monastery church of S. Tommaso degli Umiliati in 1463–5.[141] Similar alterations to the city fabric were made when the monastic church of the Observant Dominicans of S. Spirito ai

179. Axial alignment of the façade of S. Maria in Portico di Fontegiusta to Strada Romana.

Perhaps the most successful example of a church developed on an unpromising site, through the creation of a street and visual axis to the much-used Strada Romana, is provided by S. Maria in Portico di Fontegiusta (fig. 179). The church, dismissed by Manfredo Tafuri as 'archaic', is nonetheless an unusual structure that might be described as an *all'antica* interpretation of a hall–church, with a centralized, three-by-three bay design.[144] The church was constructed around the site of a miracle-working street-shrine image of the Virgin, whose religious 'activity' is documented from the 1430s in the vicinity of one of the city's secondary gates, at Pescaia and the fountain of Malizia (fig. 178); however, it was not until 1478 that a confraternity that had developed around the cult

received permission from Pope Sixtus IV to construct a church around the image.[145] In 1479 construction of a chapel began for which the *Comune* granted special leaning rights onto the city walls, as well as offering public land for the new church, 'considering how many miracles God makes through that image'.[146]

Three months later, the Sienese army beat that of the Florentines in a battle at Poggio Imperiale, and a victorious procession was made to Fontegiusta to thank the Virgin for her intercession at the battle.[147] Indeed, the anonymous Sienese author of an unpublished sixteenth-century diary wrote of the special significance accorded to the Fontegiusta Madonna for the Poggio Imperiale victory, reporting that

The next day [after the battle] on the feast day of the Nativity of the Virgin Mary, the *signori* with all the clergy and all the city officials went in a devout procession with an honourable offering to the Madonna of that devotion. There, they attended a solemn Mass and left hanging in the church a number of the spoils taken from the enemy in the victorious battle the day before. The place is in [the district of] Camollia, near to the city walls, at a place where a few years before the said Lady had begun to perform many miracles at the Lord's behest. Pope Sixtus had benefited believers with numerous spiritual gifts, and it is called the Madonna of Fontegiusta, and has been honoured with a noble temple by the Sienese. And in memory of that day, a pledge was made that is still observed, that the civic magistracies will go each year on that day and make an offering at the church.[148]

A number of benefits were accorded the miracle-working Madonna shrine of Fontegiusta in the years that followed. In 1482 Giovan Battista Cibo, Cardinal of S. Cecilia, granted special indulgences to visitors to the church, and the following year a number of other cardinals approved indulgences to those 'that contribute to its construction and maintenance, as well as to those that visit the church'.[149] The first stage of construction probably led to the erection of a two-by-two bay chapel along the side of the city walls, with no façade towards the Strada.[150] This can be confirmed from a break in the masonry and scaffolding holes in line with this smaller church on the exterior, and an inscription that dated the completion of this initial phase to 1482 above the present side entrance to the church.[151] The inscription specifies that 'Master Francesco di Cristoforo Fedeli from Como' made the building (*opus fecit*), leaving no doubt as to the fact that the Lombard master was designer and master-mason of the initial project (fig. 181).

Moreover, the enormous devotional interest afforded the shrine in the years following 1482 ensured a considerable increase in the confraternity revenues, so that in 1484 they were able to consider expanding the church further 'to improve that work and increase the decorum of the church by enlarging the chapel'.[152] Again, as the contract specifies, 'they hired to work, to build anew, construct and make good, master Francesco di Cristoforo Fedeli from Como in Lombardy, a permanent resident in Siena, and master Giacomo di Giovanni of Lake Como'.[153] The same master as had built the first part of the church was approached to execute its expansion, in association with another Lombard; they were required to build three new façades 'similar in all aspects to the walls that have already been constructed, with windows also similar to those that

have already been built'.[154] Moreover, the new main façade, which projected towards the city's main street, was to be adorned 'with an oculus above the door similar to the oculus on the church of the Osservanza outside the gates of Siena'.[155]

The design for the expanded church created a main façade towards the Strada, which was adorned with an oculus and a marble-framed doorway, bearing an inscription that described the miracle-working powers of the image and papal indulgences offered to devotees.[156] The façade itself is a simple three-bay brick structure articulated by pilaster strips that run into the entablature, which in turn supports a pediment, a design element adopted from both the façades of the cathedral at Pienza and the nearby Osservanza (built from 1476), cited in the contract as a model for detailing (fig. 180).[157] The church of Fontegiusta combines refined but economical *all'antica* detailing of external moulded brick-work with internal splendour of free-standing travertine columns with classicizing capitals. Its plan is unusual for the use of a three-by-three bay design with nave and side aisles of equal height; this might be understood either as an interpretation of the Austrian hall–church type experimented with twenty years earlier at Pienza, or may be a centralized solution appropriate to Marian shrines.

It is also interesting to note that funds for completion of the church came with an unusual decision from the newly established *Novesco* government, in 1488,

180. Pienza cathedral.

181. General view of the interior of S. Maria in Portico di Fontegiusta. Visible in the arch of
the foreground vault is the inscription recording the intervention of Cristoforo Fedeli.

which established that any bequests made to churches outside Siena and her *contado* should be re-directed to Fontegiusta which 'will be built for the great honour of the city'.[158] Such a provision indicates the continued devotion at Fontegiusta across the political wranglings of the 1480s. Again, in 1489, confessional rights were accorded to the church by Innocent VIII through the mediation of Cardinal Francesco Piccolomini, which guaranteed increased attendance of the church on numerous feast days throughout the religious year.[159]

The church at Fontegiusta was a site venerated for its civic as well as its miraculous significance, and a centralized design was developed to aid pilgrims and pro-cessions flow through the shrine, which was adjacent to the city walls and in the proximity of the city's main street. Civic and private patronage united to complete a grand new church, an example that serves to remind us that the devotion to particular shrines could operate on multiple levels. Moreover, processions of the sort that were annually made to Fontegiusta traced oft-repeated ceremonial routes on the city fabric, reinforcing and reiterating the sacred topography of the city. Machtelt Israëls' recent reconstruction of the Corpus Domini feast, as well as other published ceremonial rules, indicate that while the destinations of such processions varied, the Campo and Strada Romana were vital urban

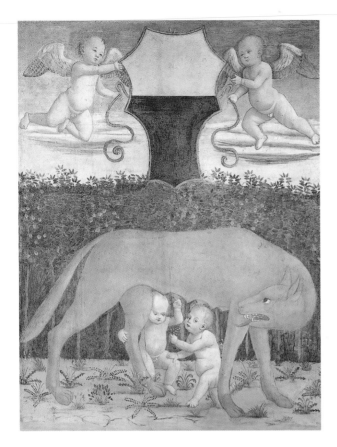

182. Bernardino Fungai, *She-wolf Bearing the Arms of the Commune of Siena*, 1510–15. Collection of the Monte dei Paschi di Siena, Siena.

components of almost all ceremonial routes.[160] On such ritual occasions, when processional routes would be marked by canopies, floral displays as well as churches being left open with their relics on show, the numerous religious buildings and institutions were united to create a devotional city: the city of the Virgin.

Sena Vetus, Civitas Virginis

The closing section of the previous chapter argued that the *Ornato*'s promotion of urban renewal did not impose stylistic unity on the city, but rather that both in government-sponsored direct commissions for buildings, and through the collective process of individual patronage, Sienese architecture of the third quarter of the fifteenth century was characterized by stylistic diversity and variety. Nonetheless, it is also true to say that the same process was instrumental to the introduction and development of the new *all'antica* style to the city fabric, and that Siena's putative classical origins provided a powerful narrative that brought together private and institutional interventions to suggest a co-herent project.

The most effective means by which the Commune harnessed private architecture to public interests was by providing clear interpretative markers along the Strada Romana that informed its users of the public nature of the street itself. Around the city gates and along the street's sinuous route, public arms and symbols were prominently displayed.[161] Siena's special devotion to the Virgin Mary, manifest in her frequent visual representation throughout the city, dated at least from the thirteenth century, and was expressed in public, private and institutionally managed street-shrines and images.[162] By contrast, images of the Capitoline she-wolf suckling twins, 'which (in 1467) have been, or are being, erected in a number of sites throughout the city', were more specifically linked to the Commune's classicizing imagery as developed during the fifteenth century (fig. 182).[163] A number of these sculpted symbols were erected on gates and columns in the city centre, and created a strong visual reference to Siena's foundation myth, which claimed the city's descent from Senio and Aschio, the sons of Remus.[164] Significantly, however, rather than develop a new image to represent this city myth, Rome's Romulus and Remus symbol was adopted and adapted

183. Map showing the location of she-wolf sculptures.

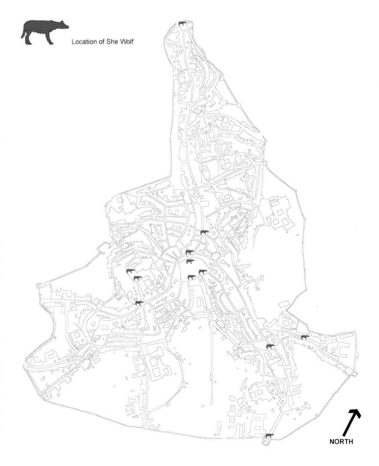

Location of She Wolf

NORTH

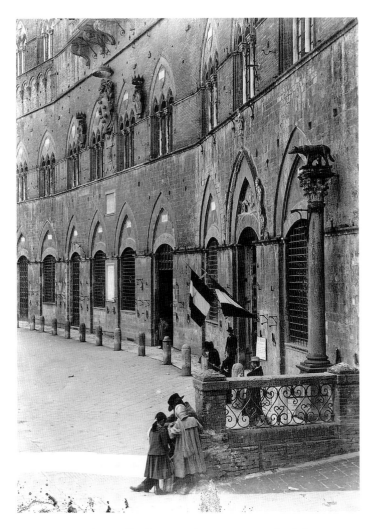

184. She-wolf column at the entrance to the Palazzo Pubblico on the piazza del Campo in a view of *c*.1910.

to Siena's local requirements, creating a visual conflation of myths that associated Siena directly with Rome, the destination of so many travellers through Siena.

The communal adoption of the she-wolf with the twins as a symbol and image of the city's ancient and classical past dated from the fourteenth century, but it was increasingly used during the second half of the fifteenth century, and coincided with growing humanist interest in Siena's Roman foundation myth (fig. 183).[165] Probably the first of these three-dimensional sculptures was Giovanni Turrini's *all'antica* wolf, originally placed on an antique Roman column brought from the coast near Orbetello and placed outside the Palazzo Pubblico in 1427 (fig. 184).[166] Sculptures at Porta Camollia and Porta Romana followed in 1467 and 1470, and by 1468 the symbol was sufficiently associated with the Sienese Commune to be painted on government buildings in the *contado*, as part of Siena's official symbols.[167] Again, in a

1467 petition for funding for a fountain presented to the *Ornato* by the southern city district of Abbadia Nuova, the petitioners explained that they had 'made a column with a golden wolf, which they hope to erect by this fountain', as part of a facility which would be 'beautiful and useful'.[168] The petitioners clearly hoped to win public funding by providing a prominently placed civic symbol on what was otherwise a privately subsidized infrastructure project.

An ever-increasing number of classicizing she-wolves were erected on columns in prominent city sites. Two columns with finely worked *all'antica* capitals survive in front of the cathedral, one of which is attributed to Urbano di Pietro da Cortona and dated to the second half of the fifteenth century (fig. 185).[169] Near the Abbadia Nuova fountain a stone wolf was already in place on a column by 1467, on the site of the horse-market at the Ponte di S. Maurizio, supported on a classicizing capital decorated with the Commune's arms, while another marks the central piazza Tolomei

185. One of the she-wolf columns flanking the entrance to the cathedral.

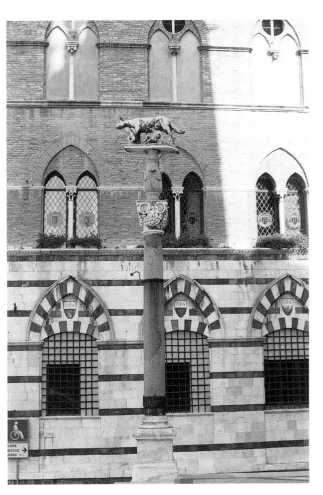

186. Column at Postierla, from G. Macchi, *Memorie Senesi*, *c.*1720. MS. D. 107, fol. 439, Archivio di Stato di Siena.

(fig. 186).[170] In April 1487 piazza Postierla was reordered under the supervision of Gasparre di Gasparre di Giovannello with the construction of a 'stone bench with a standing column', which was also topped with a she-wolf.[171] The choice of sites adopted for these columns was not accidental, since they marked piazzas or turning-points in the street, prominent sites where both visitors and citizens were compelled to notice them. Viewed on a map, the repetitive representation of the she-wolf along the main city arteries and the Strada, suggests that the intention was not only to mark redeveloped areas, but more explicitly constantly to remind travellers and citizens alike of Siena's ancient origins and Republican civic identity, as associated with the symbols of the ancient Roman republic's foundation myth.[172]

Siena's foundation legend, and the manner by which it was developed during the 1460s and 1470s in the sophisticated humanist circle of Cardinal Francesco Todeschini Piccolomini, is examined in chapter Seven. The narrative that underpinned these legends, and was given tangible form in the she-wolf sculptures, connected Siena directly with Rome, focusing the city's fortunes towards the south and the Papal State. In so doing, the dominant urban iconography that bound the city to its principal intercessor, the Virgin Mary, was flanked by one whose humanist legend updated the civic pantheon with powerful and iconic Romanizing intercessors, in the form of the founders of Rome itself.

It is not coincidental that the she-wolf imagery, and its *all'antica* form, was brought to Siena from Rome. It

is tempting to seek a cultural nexus with Florence for the development of a classical vocabulary in the architecture of Siena during this period. However, it is not at all clear that this was the favoured path for the translation of ideas and forms.[173] A core group of buildings considered in this chapter have nonetheless been discussed in recent studies as marking a point of contact and experimentation with Florentine models of palace architecture.[174] Following from the two Piccolomini palaces, through the Spannocchi project, to the derivative designs for the del Vecchio and S. Galgano palaces, a series of patrons of the 1470s have been described as having sought Florentine inspiration for the design of their palaces. While the connection of these and other buildings is evident with such Florentine-born architects as Bernardo Rossellino and Giuliano da Maiano, it is nonetheless essential to note that the translation of their designs to Siena was mediated through other centres.[175]

Thus, it is evident that by the time Rossellino may have been called to work on the design of the Palazzo delle Papesse and Palazzo Piccolomini, he was firmly established as papal architect through his work at Pienza and his earlier involvement in Nicholas v's Rome.[176] The Piccolomini palaces brought the monumental scale of the cardinal's residences in Rome to Siena and Pienza, employing such elements as cross-mullioned windows to underline their pedigree. Similarly, the selection of Giuliano da Maiano as architect for the Spannocchi palace also stressed Ambrogio Spannocchi's commercial activity outside the city. As Francesco Quinterio has convincingly argued, the web of interests that tied the da Maiano architect–sculptors to Ambrogio from as early as 1466 was one of commercial contacts that passed through Rome and Naples, not Florence.[177] Thus, Ambrogio's choice of Giuliano da Maiano, and his brother Benedetto, to work on the palace and the Cappella Maggiore of S. Domenico in Siena, confirmed the banker's Neapolitan contacts, and introduced the sophisticated style of elite palace architecture to his native city.[178]

Palaces such as these introduced a series of new architectural features to Siena: symmetrical plans centred round courtyards, the use of classically inspired capitals and columns for decoration and details, a preference for round arches and the use of stone, itself a material associated with *all'antica* design.[179] Such features are frequently associated with the development of domestic architecture in Florence during this period, but had rapidly become characteristic of elite domestic architecture throughout central Italy.[180] Private palaces and their design by well-known architects were increasingly a means for the ostentation and display of personal fortunes, usually irrespective of the geo-political prove-

187. Duomo Nuovo, detail of coffering in the 'facciatone'.

nance of the architects themselves.[181] As urban palaces were representative of the cultural and economic elite, these sometimes provided a model for less affluent members of the urban community to imitate. Thus, the Palazzo del Vecchio looked to the Piccolomini palaces to create a façade veneer that sits uncomfortably on the building beneath, perhaps because pre-existing floors dictated the placement of windows, especially in the over-sized mezzanine. However, the imported new styles and architectural features introduced by elite patrons of the 1460s and 1470s, came to represent Siena's cosmopolitan contacts during that period, and were adopted, adapted and ultimately abandoned in the 1490s and the century that followed.

Instead, it was the façade typology of the Palazzo Bandini-Piccolomini that was to have a more lasting impact on the development of palace architecture. The chromatic potential of using various materials for the façade composition were there exploited to the full, with the smooth surface of bricks juxtaposed with fine sculpted detailing in *pietra serena*, much in the same way as brick and travertine is frequently employed in earlier Sienese architecture. As in fourteenth-century palaces, strong horizontal bands mark the elevation, with a *pietra serena* course at the level of the horse-stays, and another separating the two storeys and marking the base for the windows. However, these characteristics were updated and transformed by the *all'antica* pedimented door and window frames that were among the earliest examples of such features to be used in Siena.[182] It is perhaps on

account of the fact that the design revealed such a degree of engagement with local traditions and precedents – and consequently was more easily executed by local professionals – that it was to emerge in the 1480s as the most widely adopted formula for Siena's palace façades.

Furthermore, the classicizing language of architecture developed in Siena from the 1460s did not necessarily require direct experience of Roman or *all'antica* models elsewhere in Italy, for sources could often be found close to home. The almost 'archaeological' remains of the failed Duomo Nuovo project, details of which were themselves inspired by antiquities, used coffering similar to that of a Roman triumphal arch, was almost certainly imitated for the ceiling of the church of SS. Annunziata, across the piazza (figs 187–8).[183] The round-arched arcades of the Duomo and Duomo Nuovo may likewise have provided the source for round-arched loggias such as those of the Mercanzia and Piccolomini, as well as for the Cappella di Piazza (fig. 189). Similarly exemplary was the fourteenth-century courtyard of the Palazzo Pubblico, where octagonal columns support round arches with pilaster strips connecting up the entire elevation (fig. 190), a solution also adopted for the Cappella di Piazza and the courtyards of private palaces such as the Palazzo delle Papesse. As a number of scholars have noted, this combination of pilaster strip and simplified entablature was to become an integral part of Francesco di Giorgio's vocabulary, as was the use of string-courses, which he described as 'recinti' in his treatises.[184]

143

ABOVE 188. SS. Annunziata, church of Spedale di S. Maria della Scala, coffered ceiling.

BELOW 189. Siena cathedral façade, detail of triple arch portal.

RIGHT 190. Cortile del Podestà, Palazzo Pubblico.

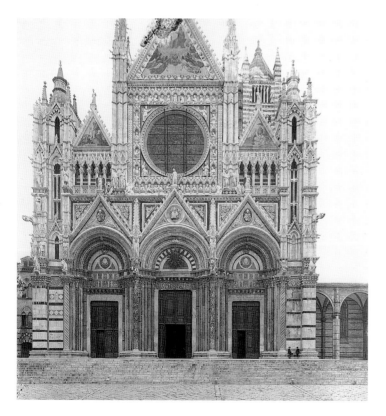

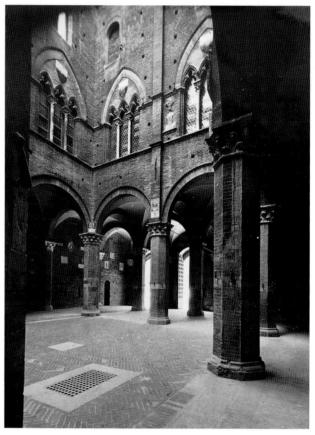

What emerges then, is a picture of the stylistic development of architecture in Siena that updated local traditions without definitively abandoning their models, an argument that has been quite widely accepted for stylistic changes in painting through the fifteenth century.[185] The trajectory that transferred architectural ideas developed in Rome, through Pienza, to Siena can also be noted in religious architecture, and is well illustrated by the case of the church of S. Maria in Fontegiusta, whose unusual central plan and hall–church internal elevation have their closest parallel in the

cathedral of Pienza. At Fontegiusta, as was noted above, it is clear that the design process was laid down in written and verbal communications with the master-builder, the Lombard Francesco di Cristoforo Fedeli, that specified precedents and models to be imitated. A similar design control was exercised through the contract drawn up with the same master in 1482 for the completion of the church of S. Maria degli Angeli in Valli, although the principal model there was the newly completed church of S. Bernardino dell'Osservanza (figs 191–3).[186] The Osservanza was central to the development of church design in Siena during the last quarter of the fifteenth century, introducing such widely imitated elements as the drum dome internally supported

LEFT 191. Church of S. Maria degli Angeli in Valli, façade.

ABOVE 192. Unfinished fragment of the Siena cathedral expansion project, in a late nineteenth-century photograph by Paolo Lombardi.

BELOW 193. Church of S. Bernardino dell'Osservanza (La Capriola).

on pendentives and pilaster strips that run straight into the entablature frieze.[187] Both features can be traced to local precedents. The exterior brick drum dome follows the remarkable Romanesque dome (although not on pendentives) of the chapel of S. Galgano at Montesiepi, outside Siena, while the use of pilaster strips imitates the example of the Cortile del Podestà of Palazzo Pubblico, mentioned above.[188]

In conclusion, in the two decades following Pius II's visits to Siena, the city was transformed by the construction of numerous new buildings, and the careful placement of civic imagery that altered the urban iconography, previously almost uniquely associated with the Madonna, to include clear symbols of the city's classical origins. The process was accretive, as new information was added to the urban fabric, enriching the city's narrative rather than rewriting it altogether. Thus, the ineluctable action of the sedimentation of history overlaid a sequence of architectural 'presents', rarely erasing one in favour of another, but rather negotiating a constantly updated definition of the 'contemporary' city. The urban process, for this is the most accurate term for describing the evolution of urban form, speaks inevitably of a city's relationship with its own past.[189] So, then, while the city fabric survived through time, the ebb and flow of urban narratives invested its buildings with new and varied meanings.

194. Titus Livy, *Ab urbe condita libri I–X*, illuminations attributed to Pseudo-Michele da Carrara, 1463. MS. Plut. 63.1, frontispiece (showing detail of Romulus and Remus), Florence, Biblioteca Medicea Laurenziana.

7

Rewriting the City's Pasts in Stone

HUMANISTS, ANTIQUARIANS AND THE BUILT FABRIC

This is ancient Siena: this is the city of the Virgin.[1]

In the year 4483 after Adam, the twin orphaned sons of Remus, the unlucky brother of Romulus, mythical founder of Rome, recognized that their lives were also in danger from their fratricidal uncle and made good their escape from Rome. Senio and Aschio, for these were their names, set forth from the recently founded *urbs* of Rome, moments before hired killers came for them. They escaped on foot, bringing with them the altar to the *lupa*, dedicated to the legendary she-wolf that had suckled their father and uncle. Under the protection of Apollo, Senio and Aschio eluded the man-hunt sent out after them by Romulus, and were provided with two horses, one white and one black, on which they were able to travel north from Rome into the valley of the Tressa in Tuscany (fig. 194).

Ensconced on the high ground in the vicinity of the Tressa river, the brothers set up a temple to Apollo on the highest hill, and re-established the altar to the *lupa* on a site near it. A community soon gathered to live under the protection of the twins, which proved useful when Romulus's scouts traced their location and brought an army to besiege the fledgling town. Romulus's generals, Montonio and Camellio, laid siege to the town from the slopes to the north and east of the high ground colonized by Senio and Aschio, and

after a long period of combat a treaty was signed that left the town independent. Senio and Aschio thus erected a temple to Mars on the hill they had so successfully defended, and built two towers, named 'of the fortunate' and 'of the victorious'.[2]

Siena's foundation myth was written under the pseudonym of Tisbo Colonnese, sometime around the mid-fifteenth century.[3] The identity of its author remains a mystery, although the text is thought to have been written in the erudite humanist circle of Cardinal Francesco Todeschini Piccolomini, Archbishop of Siena, by either Agostino Patrizi or his uncle Francesco Patrizi.[4] The date of writing of the Tisbo Colonnese foundation myth is uncertain, although it is thought to have been written sometime during the 1460s, and may also have been produced in the orbit of the cardinal.[5] A number of manuscripts that include the text attribute it to the otherwise unknown Patrizio Patrizi, which has led to the identification of the author as Francesco Patrizi, or his nephew, Agostino.[6] Neither candidate seems likely, however, as both challenged the Senio and Aschio foundation legend in texts that they certainly wrote in the following decades, discussed below.

Tisbo's foundation legend is constructed with the benefit of hindsight, and perhaps the most distinguish-

ing mark of its being a 'forgery' is the fact that it continually provides philological and topographical explanations from the pre-Roman past for the names and sites of the contemporary city. Thus, the arms of the Sienese Commune (the *balzana*) are explained by the twin's black and white horses, the *castrum veteris* is described as the area first colonized by Senio and Aschio, while the northern and south-eastern portions of the city received their names from the besieging generals, whose names remain embedded in the districts of Camollia and Valdimontone. In turn, the architectural choices made by the founders are shown to survive into the present-day, so that the site of the cathedral corresponds to the sacred area of the temples of Mars and Apollo, while a number of stone towers are also given classical origins. Finally, of course, and most importantly, an explanation is provided for Siena's unusual mimicry of Rome's symbol of the she-wolf, and the place name of the city itself is neatly linked to the name of one of its founding fathers.

Foundation myths providing classical ancestry for cities are a common literary type of the fifteenth century, and Tisbo Colonnese's narrative is neither unusual for the extent of its basis in fiction, nor for its topographical determinism.[7] The phases by which the writing of city myths and urban histories developed through the fifteenth century have been outlined in previous chapters. The aspirations to Roman ancestry in early fifteenth century humanist terms is well illustrated by Taddeo di Bartolo's 'Uomini Famosi' cycle in the Palazzo Pubblico (1413–14), where a series of portraits of classical heroes is used to link Siena's Republican government ideal to its classical roots.[8] Long inscriptions accompany each image, and beneath the figure of Furius Camillus the author of these short texts declared that 'thus, from our name, derives the name of Camollia, the third part of your city of Siena'.[9] In this case, the fortuitous intersection of the hero's name with that of the northern district of Siena led to the identification of that link; however, no similar connections are drawn in the other captions.

Numerous civic artistic commissions carried out throughout the fifteenth century led to the widespread representation of images that made tangible the supposed link between Siena and Rome, perhaps most effectively achieved by means of a series of sculpted she-wolves placed on top of columns in strategic locations around the city centre.[10] These she-wolves, but also the public display of antique *spolia*, the iconographic type of the classical 'Uomini Famosi', and more generally the increasingly widespread adoption of *all'antica* architectural style, projected Siena's claims to Roman ancestry onto the urban fabric. By so doing,

these works served as a visual counter to the allegations made by the famous humanist Flavio Biondo in his *Italia Illustrata*, that Siena was post-antique, and that 'nullis in veteris monumentis reperiat'.[11] Biondo's polemic was indeed forcefully contested by Siena's home-bred humanists, a number of whom appear to have been commissioned to write texts that supported the Roman foundation hypothesis by the Archbishop of Siena, Cardinal Francesco Todeschini Piccolomini (fig. 195).[12]

It is not at all clear what form this presumed commission took, but a family of texts by different authors all of which deal with different aspects of Siena's ancient origins has a copying tradition that links them with the cardinal.[13] As was discussed in chapter Four, Cardinal Francesco, an educated humanist scholar in his own right, may have inherited this historiographic project from his uncle; Francesco Patrizi stated in an unpublished letter to him that it was thanks to the encouragement of Pius II that he had originally been inspired to write the *De Institutione Reipublicae*.[14] Pius II had evidently also been interested in the history and classical origins of his home town; in the *Historia de duobus amantibus*, for example, the link between the temple of Venus and the cathedral of the Virgin is alluded to, while the heroine's husband is a descendent of the same Camilli that supposedly – according to Tisbo – gave their name to Porta Camollia.[15] So too, one of Pius's secretaries, Leonardo di Pietro Dati, forged an Etruscan foundation story for the city that traced its origins to the days of Porsenna, and identified one Bacco Piccolomini as one of the city's founding fathers; the text was naturally dedicated to Pius II.[16]

Cardinal Francesco appears to have written his own history of Siena for the period 1200 to 1400 in around 1466, a work that was followed by others that addressed the more remote past.[17] Thus, around 1480, Francesco Patrizi wrote *De origine et vetustate urbis Senae*, a work that was donated in manuscript form to the Commune of Siena in 1481.[18] No fifteenth-century manuscript of the text is known, and most known later copies are bound with other works of the same period and provenance.[19] Patrizi's text follows two principal agendas. On the one hand he addresses the issue of Siena's Roman origins, refuting the Tisbo Colonnese foundation legend (and Biondo's), and proposing instead a foundation in the 4th century BC, following Marcus Furius Camillus' successful defence of the site from incursions by the Gallic tribe of Senones.[20] On the other hand, Patrizi painstakingly outlined etymologies for the surnames of Siena's leading families.

This process provided further evidence for the city's antiquity, as it was claimed that direct lines of descen-

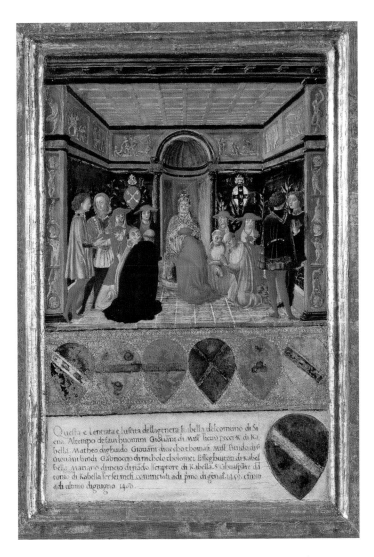

195. Francesco di Giorgio Martini, *Francesco Piccolomini Crowned Cardinal in Siena by Pius II*, 1462. Biccherna n° 33, Museo delle Biccherne, Archivio di Stato, Siena.

dance linked Siena's families to specifically named Roman families, the senatorial class, Gallic tribes and Holy Roman Emperors, even to Romulus himself in one case, and to an ancient Egyptian dynasty in another.[21] Interspersed within the discussion of these names a few topographical references to ancient sites within the city are mentioned, often as corroborative evidence for the etymologies offered. Thus the Camilli, in truth hardly known as a name in Siena although it is Menelaus' surname in the *Historia de duobus amantibus*, are used as the excuse for a digression on the district of Camollia, supposedly named after Furius Camillus, as well as a purportedly Roman gate in the area.[22] Similarly, a somewhat spurious identification of the Piccolomini as descendants of Romulus, makes way for an equally improbable identification of the church

of S. Quirico in Castelvecchio as the original site of a temple dedicated to Romulus, 'who was also known as Quirinus'.[23]

In the *De origine et vetustate urbis Senae*, Francesco Patrizi displayed his erudition and scholarship by numerous citations and references to classical authors that supported his etymological derivations, as well as the topographical observations and the foundation history he proposed.[24] In this sense Siena's antiquity was shown to be embedded in the history of the families that lived there, and corroborated by the firm authority of ancient authors. A similar strategy for linking the city's past with the present was pursued by the Bishop of Pienza, Francesco Patrizi's nephew, Agostino, when in 1488 he wrote another work dedicated to Cardinal Francesco Piccolomini, *De antiquitate civitatis Senarum*.[25] Agostino's short treatise appears to summarize much of the far longer text by Francesco, while also turning to the humanist's armoury of textual references in order to prove the city's antiquity.[26] Biondo is extensively quoted, it seems, only as a foil for the trite consideration that it is human to make mistakes, and a subsequent review of all the good reasons for accepting the city's pre-Roman foundation date.[27]

Quite a different text of these same years, the *De urbis Senae origine et incremento*, was written by a provost of Siena cathedral chapter, Bartolomeo Benvoglienti, between 1484 and 1486 (fig. 196).[28] Rather than use a basis of ancient written sources, Benvoglienti, whose book was published in Siena in 1506, used topographical and archeological evidence from the contemporary urban fabric to trace Siena's history from antiquity to the present day. In this respect he used both a humanist viewpoint, which looked to the classical past for authority and examples, and method, which drew conclusions from the comparison of the present with evidence from the past. His objective in writing was similar to that of Agostino and Francesco Patrizi, namely to offer a credible alternative to Flavio Biondo's unacceptable suggestion that Siena was a post-antique city.[29] As a member of the cathedral chapter, Benvoglienti was also connected to Cardinal Francesco Piccolomini, whom he mentions in the Preface, and thus his work joined the common front 'Contra Blondum', as a rubric in one of the margins of the work states.[30] Biondo's account and rationale for the city's late foundation was primarily based on textual evidence, but also on the observation that 'no antiquities can be found there'.[31] Thus, if the Patrizi texts can be said to have refuted the written evidence, Benvoglienti was principally engaged in challenging the physical evidence.

Benvoglienti described the city's development, taking the reader on a tour of sites in the city where antique

197. 'VERO ET VALE' inscription on the former site of a 'Roman' arch at the beginning of via Montanini.

196. Bartolomeo Benvoglienti, *De urbis Senae origine et incremento* (Siena, 1506), fol. 5.

remains and traditions could be identified, using architecture as the main thread that linked Siena's Roman past to the present. The book aimed not only to establish Siena's Roman origins but also rehearsed the direct topographical descent of urban sites from their use in Roman times: thus the site of the Duomo was linked to a Temple of Minerva, the original settlement around Castelvecchio was identified as a Roman military camp, and Postierla as a gate into it, while the by now familiar derivation from the Roman names Camillus or Camelius was proposed for Porta Camollia.[32] Benvoglienti's evidence, however, was not restricted to that evinced from etymological tricks or local traditions of usage. Instead, he highlighted sites where antique remains were still extant. Thus, for example, he recorded the presence of the remains of the classical arch in the vicinity of the church of S. Maria delle Nevi, recording the fragments of an inscription 'VERO ET VALE'.[33] The arch, which Benvoglienti believed had been a mile-marker set 200 miles from Rome by the consuls Severius and Valerianus, had recently been demolished, an act that Benvoglienti condemned (figs

197–8). Elsewhere, he mentioned an antique entablature that was used as the base for a column at S. Domenico, which had been erected to display *palii* on feast-days (fig. 199).[34]

Furthermore, Benvoglienti's aim was not simply to make an account of Siena's antique origins and remains, but also to reveal how archaeological evidence survived from after the Roman period, and proved the city's continuous existence, right down to the present. A good example of the agile use the author made of written and visual sources comes in a discussion of the Prato di Camollia, the area outside the city's northern gate. He related a story heard as a child, about a German Emperor (perhaps, he thought, Otto I) who made a camp outside Porta Camollia, and actually built a palace there; to corroborate the story, Benvoglienti cited recent road works that revealed the ancient foundations of the palace.[35] Bringing the reader closer to the contemporary city, he discussed land use in the medieval city, describing the way in which the narrow streets with few squares developed from the defensive needs of private properties, which only left a low-lying open space for the market square, or 'Campus fori'.[36]

His description of the city's urban development was apologetic of Siena's lack of open spaces, which he evidently perceived as a normal part of Roman cities, explaining the shortcoming in terms of recent history. As if to add authenticity to this claim he suggested a connection between the Sienese Campo and the Campus Martius in Rome, which he identified specifically, and erroneously, as the Campo de' Fiori.[37] Later in the book his description of the city became more involved with the present, mentioning numerous family clan areas and new buildings, including the church of S. Maria delle Nevi and the palace of Cardinal Ammannati at Porta Tufi.[38] By describing these buildings and the 'novissime additiones' made to the church of S. Spirito, Benvoglienti's narrative reveals how architectural monuments could be used to show the city's

198. 'VERO ET VALE' inscription recorded in G. Pecci, *Raccolta Universale di tutte le iscrizioni, arme e altri monumenti si antichi, come moderni, esistenti nella città di Siena*, MS. D. 6. fol. 6. Archivio di Stato di Siena.

199. Column at S. Domenico, from G. Macchi, *Memorie Senesi*, c.1720. MS. D. 107, fol. 434, Archivio di Stato di Siena.

continuous development, almost a hereditary chain that linked the modern city to its Roman past.

Benvoglienti and the two Patrizi argued forcefully for the classical origins of Siena, demonstrating this by weaving together diverse strands of evidence, which was intended to create a critical mass sufficient to topple the rival claims of Flavio Biondo. However, it is also clear that the city's claims to antiquity were not simply constructed in written treatises, they were also expressed in buildings, the designs for which were as subtle and agile in their manipulation of evidence as were the arguments of the humanist authors. Thus, for example, the Cappella di Piazza described in chapter Five, was completed in an *all'antica* style that overlaid classical architectural elements on Gothic foundations; a kind of reverse sedimentation. Many other examples trace the gradual introduction of classicizing architecture to Siena, so that there is a sense that *all'antica* buildings and monuments were perceived to be akin to 'genuine' antiquities.

In this regard, perhaps the most intriguing and manipulative use of *all'antica* architecture around the middle of the century is the case of a chapel dedicated to S. Ansano, erected in the central district of Castelvecchio. Benvoglienti's narrative of Siena's development naturally began with the Castelvecchio, a site which many considered to have formed the nucleus of a Roman garrison town, the *castrum veteris*.[39] Having established this fact, the author proceeded to a close analysis of the fortifications that encircled this original camp and identified traces of these in the wall surfaces of buildings extant on the site.[40] He further indicated that three gates originally opened out from these walls, and identified their location; the most important of these, the praetorian gate, he located in a tower that had recently been transformed into a chapel dedicated to S. Ansano.[41]

S. Ansanus (in Italian Ansano, in Siena also Sano) was venerated as an early Christian martyr, and was believed to have been beheaded outside Siena, in the vicinity of Montaperti, on 1 December 303.[42] As the fifteenth-century iconography reveals, Ansano had baptized people in Siena, had been arrested and jailed by the Romans, and having foiled his captors' attempts to boil him in oil, had been beheaded (fig. 200).[43] Subsequently, in February 1107, Ansano's body was translated to Siena, where it was honoured in both the Baptistry and a chapel in the Duomo.[44] Ansano's pedigree as an early Christian martyr–baptizer of the Sienese helped him become one of the four patron saints of the city, and he appears in civic religious images, such as Duccio's *Maestà*, in the company of Crescenzio, Vittore and Savino.[45] Moreover, the fact that Ansano brought Chris-

200. Giovanni di Paolo, *S. Ansano Conducted to Prison*, 1440s. Pinacoteca Nazionale, Siena.

tianity to Siena was considered as further evidence of the presence of a town there in Roman times, so that as well as being an evangelist, the saint was also drawn into the debate on the city's antiquity. Thus Agostino Patrizi described Ansano's martyrdom outside the city gates, in the vicinity of Montaperti, while Benvoglienti outlined his martyrdom story and the construction of an oratory consecrated to his name.[46]

The S. Ansano oratory was a civic commission approved in 1441, and financed through the *Opera del Duomo* throughout the 1440s (figs 201–2).[47] From its

201. Church of S. Ansano in Castelvecchio, from G. Macchi, *Memorie delle chiese di Siena*, c.1720. MS. D. III, fol. 282, Archivio di Stato di Siena.

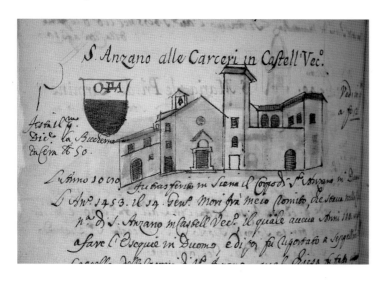

inception, the chapel project aimed at reclaiming the site of Ansano's incarceration, identified as being the Castelvecchio tower, in order to convert it into a shrine in his honour. To this end, in August 1441 a feasibility study was made for the conversion of the Castelvecchio tower into a chapel; the committee ascertained that it would need to buy certain properties from one Urbano di Francesco del Bicchieraio in order to create the oratory, since the tower was too small to serve as a chapel on its own.[48] The Oratorio di S. Ansano in Castelvecchio did indeed include the tower into its structure, clearly visible both from the plan, where the massive walls of the tower form the walls of a small chapel, and in the external elevation, where the tower stands out for both its materials and form.[49] The design of the oratory is rather simple and seems to have unified the pre-existing tower to another building (presumably the house of Urbano di Francesco), the main body of the oratory. As is clear from the elevation, the building is composed of more than one storey, and it is likely that the upper rooms served as confraternal meeting rooms. Late sixteenth-century alterations to the oratory mean that only a *pietra serena* door frame survives from the original internal architectural detailing, although the exterior presents greater elements of interest.[50] The gabled brick oratory façade abuts the tower on the right and the sixteenth-century Palazzo Celsi Pollini on the left; it is sparsely decorated, and the elements that are most prominent are the tower itself and a set of *pietra serena* moulded window frames.

The internal reordering of the building to make the oratory was undertaken by Luca di Bartolo da Bagnocavallo and a carpenter named Pietro Paolo.[51] The conservative design of Luca di Bartolo's known works in Siena, such as the Palazzo del Capitano near the Palazzo Pubblico and the remodelling of the Palazzo Marsili, suggest a different authorship for the oratory's window frames, which are all different but adopt an *all'antica* pilaster-framed design and details, unprecedented in Siena at this time (figs 203–4). Documents published by John Paoletti indicate that Antonio Federighi was involved in the S. Ansano project from 1444; while his actual role in the project is still not clear, stylistic similarities between the window frames and his other known works suggest that it was he that sculpted them.[52]

Leaving aside these issues of attribution and dating, the civic magistracies' original wish had been to 'make the chapel of Saint Ansano [. . .] in Castelvecchio, in the tower where he was incarcerated for his Christian faith until the moment of his martyrdom', and confirm that the oratory's patrons intended that the Torre di Castelvecchio be viewed as the original Roman tower.[53]

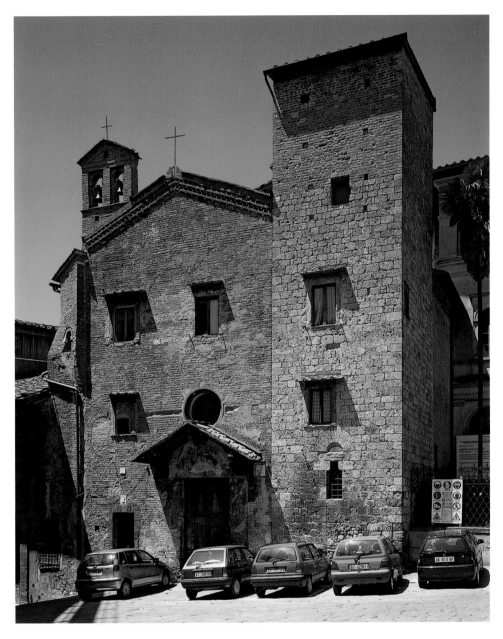

202. Church of S. Ansano in Castelvecchio.

As early as 1444 Eugenius IV granted a special indulgence to visitors to the chapel, which must have increased the number of pious visitors.[54] This indeed may have motivated the decision to give the chapel special prominence within the city fabric in 1449, when a piazza was created in front of the building, which served both to make it more visible and to accommodate the public on ritual occasions.[55]

It seems that following this first phase of development of the tower–chapel site, a second intervention altered the façade in the decade following 1465, probably as a result of Cardinal Francesco Todeschini Piccolomini's

patronage. The cardinal's particular devotion to S. Ansano is documented in the fact that he added a dedication to the saint at S. Saba, his first benefice in Rome, sometime after 1463.[56] It was in these same years that Giovanni di Meuccio Contadini sculpted a low-relief frieze for the chapel of S. Ansano in the Duomo at Siena, which housed Simone Martini's *Annunciation* of 1333.[57] While the patron of the frieze is unidentified, it is interesting to note that the saint is shown in what is evidently intended to be classical dress, a clear break from previous iconography, which showed him in a more generic robe. The emphasis on such a classicizing

203. Church of S. Ansano in Castelvecchio, detail of windows.

interpretation of Ansano's life appears in a similar portrait in a stained-glass window added to the oratory façade in around 1470, in which the arms of Cardinal Francesco are also shown (fig. 205).[58]

It might thus be supposed that just as the rose window on the façade of S. Ansano was commissioned by the cardinal, so too the window frames might best be dated to this phase of alterations to the oratory. Cer-

204. Church of S. Ansano in Castelvecchio, detail of windows.

tainly, the elaborately sculpted *pietra serena* rectangular-framed windows can better be understood within the context of architectural production of Siena during the 1470s than that of the 1440s. Indeed, Giovanni di Meuccio's S. Ansano low relief is a useful measure for comparison: it too is sculpted from *pietra serena*, and each panel is separated by a simple channelled pilaster, similar to the stone-work detailing of the *all'antica* window frames on the oratory. Perhaps the most convincing argument for a later dating of the window frames is Cardinal Francesco's devotion to the saint and his interest in Siena's ancient history.[59] In the texts that have been discussed, which are all closely linked to the patronage of the cardinal, Ansano emerges as an important figure in the early history of Christianity in Siena. It is thus that he is also remembered in the sixteenth-century treatise by Cesare Orlandi, the *De Urbis Senae Eiusque Episcopatus Antiquitate*, which is in turn heavily reliant on the fifteenth-century humanists' studies.[60]

Modifications to the iconography of the saint – who became more obviously 'Roman' – and to the built appearance of the oratory of S. Ansano, which was restored *all'antica*, emphasized Ansano's antique origins. As Benvoglienti in turn shows, by 1475 a considerable effort had been made to confirm the Torre di Castelvecchio's putative Roman origins, and its association with the site of Ansano's fourth-century incarceration.[61] Thus it seems that the Roman aspects of the saint's story were given greater prominence in the 1470s, and that the tower came to be identified as the interface between past and present, a relic in itself.

What is so interesting about both Benvoglienti's text and the Oratorio di S. Ansano is the way in which both manipulated non-contemporary architecture to reinforce historical claims. Thus, in Benvoglienti's narrative, an architectural monument of the medieval past enabled the author to construct a built genealogy that linked Siena's Roman past to the present.[62] That modern archeologists have only recently documented a Roman settlement in Siena, and that the S. Ansano tower is almost certainly an eleventh- or twelfth-century construction, only serves to confirm the degree to which myths could be created, and physical evidence could be accumulated to lend them credibility.[63]

Benvoglienti's discussion was based on the perceived equivalence of contemporary architecture with that of antique remains, with which he was familiar both from Sienese examples and probably from a visit to Rome.[64] The success of his argument relied on the real changes that had been made to the urban fabric during the third quarter of the fifteenth century by both public and private patrons, which formed the basis for a favourable comparison between Siena's Roman past and present.

Benvoglienti did not define a break from the medieval past; rather, he suggested that contemporary advances in city architecture had restored the city to its former glory.[65]

While the example of the oratory of S. Ansano reveals the degree of sophistication that humanist writers and architectural patrons might achieve in the pursuit of particular agendas, it is by no means the only instance in which buildings were assigned new meanings and significance in the contemporary city. Indeed, the phenomenon of change and re-signification that affected much of Siena's elite medieval housing stock towards the end of the fifteenth century, reinvested the buildings of the city's recent past with meanings whose significance pertained to the changing political circumstances of the last decade of the fifteenth century. In this way *all'antica* style was endowed with a political significance, while at the same time the architectural choices of Siena's elite patrons came to coalesce in a language that was both derived from local medieval precedents and from the example of antiquity.

205. Oculus from the oratory of S. Ansano in Castelvecchio.

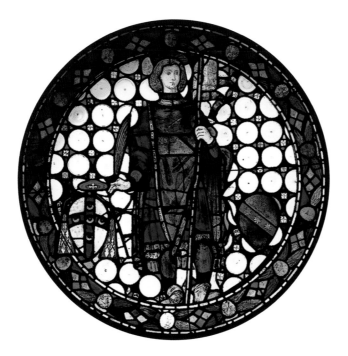

8

Palaces, Politics and History

THE ARCHITECTURE OF THE *NOVESCO* OLIGARCHY

Siena of the tall, proud towers and of the much-renowned palaces.[1]

Throughout the fifteenth century, dynamism and conflict were central components of Siena's constitutional make-up, which rested upon a broadly based political group, drawn from a coalition of citizens from three of the city's socio-political parties (the so-called *Monti*).[2] Political turmoil and internal conflict was caused by the desire to keep a broad political elite, which was represented and institutionalized in the party and factional divisions of citizens into *Monti*.[3] As we have seen in earlier chapters, with some hitches – notably the failed coup by Antonio di Cecco Rosso Petrucci who attempted to install an exclusively *Novesco* regime in 1456 and Pope Pius II's demands to have the *Gentiluomini* admitted to government offices during the 1460s – this system survived into the 1480s.[4]

Although Siena's internal political situation was rather complex, towards the end of the century the city's fortunes seem to have become increasingly controlled by swings in foreign policy. Recent studies of Siena's political history, and relationship with Florence, have underlined a strong anti-Florentine position prevalent in Sienese foreign and economic policy until 1456, the date of the failed coup.[5] In spite of a temporary lull in hostilities, anti-Medicean and Florentine feelings continued from 1474, and became overt with Siena's alignment

with the Papal–Neapolitan axis in the Pazzi war of 1478.[6] During the late 1470s, Siena had acted as the Tuscan base for the Papal–Neapolitan alliance during the Pazzi war, becoming home to the leader of the alliance, Duke Alfonso of Calabria. In April 1480 the Duke was given the Palazzetto di S. Marta, where he took up residence and established his court, much as the Emperor Sigismund had done half a century earlier.[7] Duke Alfonso had become virtual lord of the city by early 1480, a situation that was only ended by the Turkish sack of Otranto in August of the same year, which led to the Duke leaving Siena.[8] Following the departure of Alfonso, the *Monte del Popolo* assumed greater power in the city's government, marked in 1483 by the large-scale exile of the *Novesco* supporters of the Duke of Calabria.[9] Continued attempts were made between 1480 and 1487 to create a pact between rival factions that might guarantee internal stability; numerous constitutional reforms, as well as peace-making rituals were enacted to establish order, largely to no avail.[10]

While Siena's foreign relations changed frequently over the fifteenth century, a natural axis seems to have emerged with Rome and Naples. Siena's connection with Rome was strengthened particularly between 1458

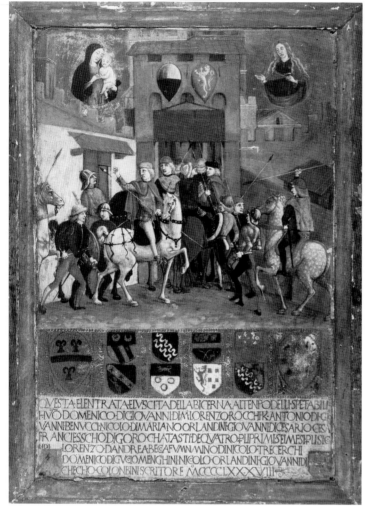

207. Guidoccio Cozzarelli(?), *The Return of the Nove to Siena*, 1488. British Library, London, Davis 768.

and 1464, during the pontificate of the Sienese Pope Pius II, whose nepotistic nominations provided Siena with a young cardinal archbishop, Francesco Todeschini Piccolomini, as well as a vast number of jobs at all levels of papal administration (see fig. 195).[11] Although there was a backlash against Pius's nepotism by his successor, Paul II, connections with Rome remained strong; especially through the papal finances, where more than one generation of bankers, such as Ambrogio Spannocchi and Agostino Chigi, made their fortunes through administration of the papal purse.[12] Siena was a smaller and less powerful city-state than Florence, and its bankers presented advantages over their Florentine counterparts, in that their political influence was less extensive. In turn, as Christine Shaw has also shown, these strong Sienese ties with Rome and Naples were indirectly reinforced by the political wrangles that distinguished much of the fifteenth century and resulted

in the frequent application of the sanction of exile, which led in turn to the establishment of dissident communities of Sienese citizens in both cities, particularly in the lead-up to the return of the *Nove* in 1487.[13]

The popular government was deposed by the *Nove* on 22 July 1487, when they dramatically re-entered the city at dawn and established a new coalition with the *Popolo* (fig. 207).[14] During the 1490s Pandolfo Petrucci gradually emerged as a leader among the *Noveschi*; he achieved this by personal control of the military, financial strength and personal alliances with a narrow elite of supporters, plus direct personal contact with foreign powers and the ruthless elimination of a number of his opponents, such as Niccolò Borghesi.[15] By 1503, Pandolfo was virtual *signore* of the city, and was able to pass on his power to his son Borghese on his death in 1512, and in spite of the latter's lack of government skills, power remained in the hands of the Petrucci family up to 1525.[16]

The main instrument of *Novesco* authority, and the government office through which they hastened their decision-making power, was the *Balìa*.[17] The *Balìa* had originally operated as small short-term commissions instituted to resolve particular problems, usually of a military or fiscal nature; following the return to the city of the *Noveschi* in July 1487, the *Balìa* was effectively established as a permanent institution and used as a constitutionally acceptable means of imposing oligarchic control on the Republican system, through the appointment of members from a tight circle of regime sympathizers.[18] The *Balìa* made a dramatic step towards limiting popular involvement in government affairs, and was used carefully by Pandolfo Petrucci to shape internal and foreign policy, virtually guaranteeing his control of power by the use of a narrow group of electable members. Thus, a remarkable political upheaval transformed the constituency of the Sienese ruling elite, which came to be controlled by members of the *Monte dei Nove* and a number of other powerful families associated with that 'party'.[19]

It is clear that the turmoil of the 1480s made way for major transformations in favour of oligarchic government controlled by a limited group of families. This political process was one that had already been unsuccessfully attempted in the lead up to Antonio di Cecco Rosso Petrucci's *Novesco* coup of 1456. Indeed, as I have argued in chapter Four, it was this political programme that had inspired Francesco Patrizi's *De Institutione Reipublicae* and Pius II's ambitions for institutional reform for Siena during his pontificate. The political model espoused by the *De Institutione Reipublicae* substantially opposed the broad-based *popolo* Republican regime in power in Siena, and favoured instead the

interests of the alliance between *Noveschi* and nobles that had made a bid for power in the Petrucci plot of 1456. It is then not surprising that Patrizi's text was to acquire renewed significance in the late fifteenth century, when the Petrucci indeed did return the *Noveschi* to power. If the *De Institutione Reipublicae* might be said to be Pius II's political, architectural and urban manifesto, its instructions found their closest parallel in the real changes that followed on the establishment of the new *Novesco* government in 1487.

Telling Tall Stories: Family History and Family Palaces

Pandolfo Petrucci's profound impact on the development of the Siena's urban form, and the role of the architect Francesco di Giorgio Martini in that process, are examined in the next two chapters. However, prior to Pandolfo's emergence as first citizen on Siena's political scene, the new *Novesco* oligarchy marked the urban fabric by diverse strategies, which overturned a civic tradition of patronage that had been in place for nearly two centuries.

As was shown in the previous chapter, in his *De origine et vetustate urbis Senae* Francesco Patrizi had paid special attention to the lineage and antiquity of the city's major families, providing a long discussion of family names that served as corroborative evidence of the city's ancient roots.[20] This is symptomatic of both the growing use of surnames and of a gradual increase in the importance attached to noble birth by the later fifteenth century.[21] It is significant to note that in the long list of families discussed in the text, an overwhelming proportion of those assigned antique origins correspond to the families of the late fifteenth-century oligarchic group, while a number of the *casato* nobility of the 1277 ban lists are identified as having names of more recent origin.[22] It is likely therefore that Patrizi consciously associated the contemporary urban elite with the city's antique past, while at the same time using their more ancient lineage as a means to helping them surpass the *casato* nobility. As we have already seen, opportunistic juggling with history and myth was not limited to texts alone, so that the oratory of S. Ansano was built on a site adjacent to a tower that had been adapted so that it would appear antique, and evoke more effectively a site of the patron saint's life. It seems that a similar process was employed by a number of families from the new *Novesco* oligarchy, who made use of medieval tower-houses, as a means of 'reconstructing' their identity, lineage and history.

In his treatise on the origins of Siena, Bartolomeo Benvoglienti commented on the process by which the city had developed in more modern times, as residences had spread out from the Castelvecchio 'like children huddling by their mother', to colonise the high ground near the main streets, where 'houses, palaces and towers' were constructed.[23] A large number of Siena's magnate families that had settled in the city during the eleventh and twelfth centuries had indeed constructed monumental fortified residences called *castellari*, which were frequently connected to a tall limestone tower.[24] A useful map of building materials used in Siena helps to identify these towers, which stand out for their thick wall mass and regular square footprint, locating them around the Campo and Castelvecchio areas, and adjacent to the main city streets (fig. 208). Certainly, while Siena's present-day skyline is dominated by the civic Torre del Mangia and the bell-tower of the Duomo, earlier visual sources, such as Pinturicchio's panorama of the city in the 1506 frescoes of the Libreria Piccolomini, suggest a scene rather more crowded with high-rise buildings (fig. 209).

208. Map showing the location of medieval towers in the city fabric, with identification of those belonging to prominent magnate families.

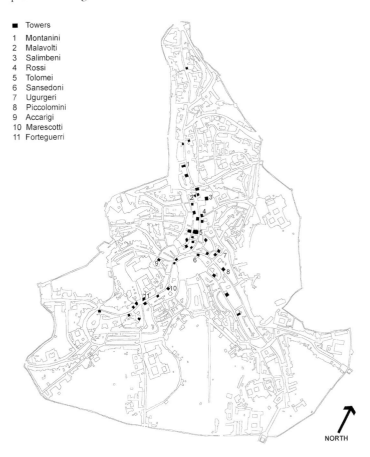

■ Towers
1 Montanini
2 Malavolti
3 Salimbeni
4 Rossi
5 Tolomei
6 Sansedoni
7 Ugurgeri
8 Piccolomini
9 Accarigi
10 Marescotti
11 Forteguerri

NORTH

209. Detail showing the city skyline with many towers, from fig. 87, Pinturicchio, *Frederick III and Eleanor of Portugal Meet Outside Porta Camollia.*

A brief survey of the monumental private domestic architecture of the century before 1400 suggests that lineage and family identity were closely associated with clan residential space, which was afforded easy visibility by the vertical markers of their defensive towers.[25] As we have seen, *castellari* developed through the twelfth century as fortified urban enclaves that brought together lineage residences, marking out parts of the city for individual families and their clientage network. These urban castles usually included a tall tower, built to improve the military capabilities of the residences, but whose height also made the presence of the family visible on the city skyline as well as at street level.[26] Even as palace architecture altered during the following century, abandoning such visible military characteristics, the grouping of families around specific areas or clan neighbourhoods continued to be a common practice. Since *castellari* were a housing type associated with the urban nobility, it is possible to assess clan cohesion around a specific family enclave by analysing individual residence patterns in relation to the *castellari* themselves. Table 1 (see Appendix) shows a sample of family names appearing in the anti-magnate laws of 1277, which can be traced in Siena's tax books for the period 1453–1509.[27]

As they stand, the figures in table 1 suggest that a number of *casato* families continued to live together, and in the same areas as they had inhabited in previous centuries. This permanence in a given district can often be explained by the continued use of clan residential space, as expressed architecturally by towers, *castellari* and

shared palaces. The low incidence of households living outside their clan area confirms these conclusions, especially in view of the fact that in many cases, apparent moves can be explained by declarations made from neighbouring districts. Thus, of the two Saracini households living outside S. Pellegrino in 1453, and away from the family palace that faced onto the Campo, one was in neighbouring Vallepiatta, and the other in Porta all'Arco.[28] By 1509, however, although there were still four households in neighbouring districts, six were scattered in other parts of the city.[29] The consistently high number of family members declaring tax from S. Pellegrino between 1453 and 1509 confirms the continued significance of their family palace.[30]

The extraordinary force of clan cohesion is again revealed by the Tolomei, whose active political engagement from the thirteenth century onwards, laid them open to exile and expropriation. The present Palazzo Tolomei had been built around 1270–72 to replace an earlier palace, which had been demolished during the family's exile, after the battle of Montaperti in 1260.[31] Like most old Sienese families, the Tolomei continued to keep hold of their ancestral property, even when this led to 'testamentary fragmentation'; by 1318 they had allegedly divided their palace into 182 parts.[32] Each heir claimed their part of the 'casamento Vecchio' despite the fact that the small spaces allocated rendered them virtually useless; so small were the individual portions that by the mid-fifteenth century the ground floor was let to the *Comune*, although the low income resulted in a joint *consorteria* complaint that rent from the property 'is scarcely enough for maintenance of the roofs'.[33] Nonetheless, ownership of part of the palace was equated with membership of the clan, and was manifest in a shared tax declaration, in which the palace 'as taxed all in one piece'.[34] In fact, while some family members may still have been able to live in the original palace, most had their main residence nearby, or connected to it; of sixteen Tolomei householders assessed for tax in 1453, all but two were resident in the district of S. Cristoforo, where their ancient palace was.[35] Furthermore, despite the political unrest and exiles that affected the family in 1481, by 1509 almost all had returned to live in the environs of piazza Tolomei in the district of S. Cristoforo.[36]

Ancient lineage and permanence in Siena was given prominence through the continued use of old buildings, as families continued to be associated with specific sites in the city. However, as the population of the city changed through the centuries, so new families rose to prominence and a number of the magnate *casati* disappeared into obscurity. Nevertheless, the sites and many of the old buildings, which had belonged to eclipsed

families, continued to be used by emergent members of the new urban elite that replaced earlier residents and recycled their memory-laden homes.

Issues of site were crucial for patrons whose desire was often to be connected to family spaces. Thus, Pius II's development of the piazza Piccolomini enclave consciously sought to reposition his branch of the family at the centre of clan affairs, much as Niccolò di Iacomo Bichi went out of his way in 1453 to spend 'more than 100 florins over the market value for a house, in order to be near my family', specifically, close to the new palace of the powerful banker–politician Giovanni di Guccio Bichi.[37] The choice of a site, and the ancestral memories that this represented, must therefore be understood to be an essential factor in the design process.[38]

Furthermore, just as a site could have connotations of prestige and lineage that might be harnessed to various ends by Siena's patrons, so too the architectural remains of *casato* family properties could also serve a number of interesting purposes. What might be described as 'domestic *spolia*', such as towers, *opus mixtum* walls, coats of arms and even acute-arched door and window openings, survive in a number of instances in the residences of Siena's noble families. Thus, for example the *opus mixtum* tower on the corner of the piazza di S. Pellegrino marked the ancient residence of the Saracini, adjacent to the Campo and Croce del Travaglio. So too, the Sansedoni palace that faces the Palazzo Pubblico and has a secondary façade on the Strada Romana also featured a tower.[39] By the fifteenth century, the palace itself was divided into *abituri* (apartments), so that three Sansedoni tax assessments for 1453 all came from residents in the palace, each of whom owned a share of the building, the shops underneath and the family tower facing the Campo.[40] While modifications to the palace are reported in this period, neither Campo nor Strada façade was changed, and it is clear that the tower was retained as a significant feature of the building.

However, not all towers remained the property of the *casato* families that had built them, and the towers' declining military functions meant that diverse solutions for their reuse were found in the evolving city fabric. The reuse of magnate towers might be said to have occurred for the first time in the twelfth century, when the cathedral bell-tower was erected on top of a tower that had formerly belonged to the Forteguerri.[41] In this instance it seems that the solution was adopted simply as means of erecting a tall bell-tower without having to construct a structure *ex-novo*. More often, towers were simply annexed into new palaces. Thus, the prominent Palazzo Chigi-Saracini on the via di Città is marked by a massive tower that fills the curve of the street and acts

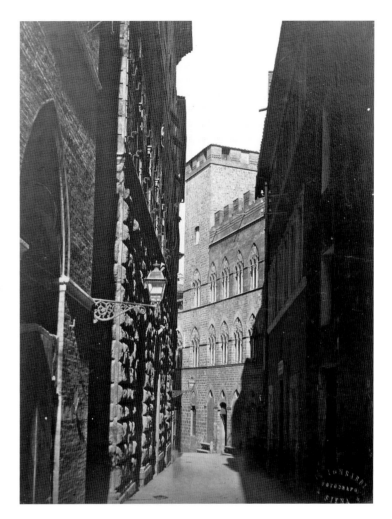

210. Torre dei Marescotti, part of present Palazzo Chigi-Saracini in a photograph by Paolo Lombardi, c.1870.

as a visual focus for oncoming travellers (fig. 210). Originally the property of the Marescotti, by 1481 the palace was rented by Iacomo Piccolomini (brother of the Cardinal Archbishop of Siena, Francesco), who evidently chose it as a suitable residence while his new palace was under construction on the Banchi di Sotto.[42] As Iacomo's tax declaration shows, the ancient lineage of the Marescotti gave its name to the whole area, and the prominently placed tower reinforced the family presence on this important thoroughfare.[43] While Iacomo Piccolomini may only casually have come to reside in a palace with a magnate tower, and certainly had no need to share the Marescotti's lineage as the Piccolomini were also magnates, there are a number of instances where quite a different dynamic seems to have been at work.

Much in the same way as sites of magnate family residences might be reused to appropriate an aura of ancient lineage by less established families, so too

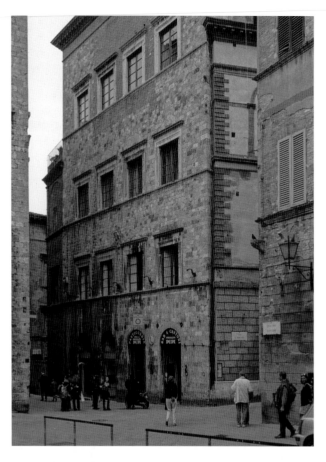

211. Palazzo Borghesi alla Postierla.

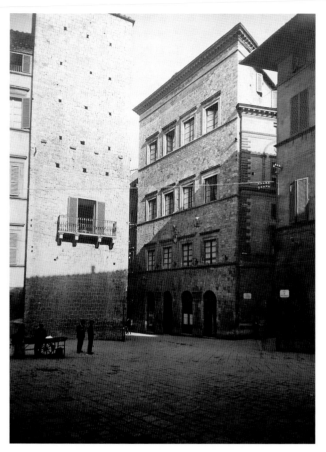

212. Torre dei Forteguerri (Palazzo Bardi) and Palazzo Borghesi, Piazza Postierla, in a photograph by Paolo Lombardi, *c.*1870.

'domestic *spolia*' appear to have been adopted by a number of non-*casato* families as façade features that would apply a veneer or patina of history to their homes. Thus, for example, the major crossroad of piazza Postierla, between the via di Città and the via del Capitano, which leads to the Duomo precinct, was redeveloped at the beginning of the sixteenth century around two medieval towers. The end of via di Città was framed by two tall towers, which had originally belonged to the Forteguerri, and were probably connected together by an arch and walkway.[44] By the end of the fifteenth century, however, part of the Forteguerri properties were in the hands of the *Opera del Duomo*, while the Borghesi family had also become property owners at Postierla (figs 211–12).[45] In 1509 the Heirs of Conte Forteguerri declared the sale of a house to Girolamo di Bonaventura Borghesi, and it is likely that this formed part of the large palace site that was developed by Girolamo and his cousins, Battista and Pier Francesco di Iacomo Borghesi, when the latter were granted long-term leases on two properties belonging to the *Opera del Duomo*.[46] Following extensive renovations, the young

Domenico Beccafumi was commissioned to decorate the façade with an elaborate design of *all'antica* architectural frescoes, partially recorded in a drawing now in the British Museum (fig. 213).[47]

While the modern-day viewer can easily perceive the medieval stonework of the magnate tower-house on account of the total loss of Beccafumi's frescoes, this would not have been so in 1513. Nonetheless, a number of important considerations should warn against a hasty conclusion that the tower was lost behind the fresco façade. The palace maintained the proportions of the earlier medieval building, with its tall upper storeys, separated by simple stone courses, a factor that Beccafumi, as Panofsky observed, accounted for in his design.[48] It is also probable that the travertine of the tower remained uncovered on the sides of the palace, which were clearly visible on both corners, where brackets that originally supported the Borghesi coats of arms survive. Moreover, the historical memory of the site's long association with the Forteguerri name survived the visual loss of the tower itself, in local place names such as 'canto [corner] dei Forteguerri', much as the Marescotti name was asso-

ciated with a palace lived in by the wealthy and influential Iacomo Piccolomini.[49] Finally, it could be argued that the Borghesi used their palace as a fortified residence and a focus for clan cohesion, thus reviving the functions of the medieval tower-palace. The Borghesi were key members of the oligarchy that emerged to rule Siena in the late fifteenth century, which was largely drawn from the political group called the *Monte dei Nove*. The rapidly growing Borghesi clan clearly developed Postierla as their family neighbourhood, as by 1509 twenty out of twenty-eight members of their family declared residence in the vicinity of Postierla as opposed to four out of nine in 1453.[50] Moreover, as key members of the new regime, *Novesco* military and festive gatherings often met at Postierla and in the palace.

Across the road from the Borghesi palace stood that of the Bardi family, who were also allies of the new ruling elite. Their palace was remodelled from another part of the Forteguerri enclave, and the frescoed façade that Vasari reports was executed by Sodoma, also covered an imposing medieval tower.[51] Unlike the Borghesi, however, the Bardi palace retained the military characteristics of the medieval tower, as only a balcony and a window were cut into the original tower, which still has the corbels and holes originally intended to support wooden structures such as jetties and walkways. Moreover, the tower stands out from the rest of the fabric as the surrounding buildings are set back from its stone walls, and it is also considerably higher than the palace itself.

The Bardi and Borghesi were far from being alone in connecting their residence to a tower associated with the memory of the pre-1277 noble elite, as it seems to have become almost a fad among the members of the new oligarchy that took command of Siena's government from 1487. It is not clear whether there was also a conscious agenda on the part of the oligarchy to replace or revive the architectural memory of the *Nove*, whose long-lasting government (1287–1355) marked a period of stability and fortune for the city, to whom the *Monte dei Nove* faction's name harked back to. Nevertheless, there can be little doubt that the reuse of the medieval towers of Siena's original noble families by Siena's late fifteenth-century political and financial elite subtly adjusted the urban core and assimilated the associations of ancestry and nobility of the original magnates whom they replaced.

Thus the massive Palazzo del Magnifico, built in the early sixteenth century for the aspiring *signore* of Siena, Pandolfo Petrucci, and examined in greater detail in the following chapter, made use of family-owned property on the via dei Pellegrini, but enlarged the site with a series of acquisitions from the neighbouring Accarigi,

213. Domenico Beccafumi, design for decoration of the façade of Palazzo Borghesi alla Postierla. British Museum, London (inv. 1900-7-17-30).

which gave Pandolfo the ownership of the entire property block as far as piazza del Duomo.[52] It is clear that Pandolfo acquired properties from the Accarigi that included a tower as well as a considerable part of the Accarigi property block on the corner of the Baptistry square, by November 1504.[53] The tower was not only incorporated into the palace, but actively featured in the internal arrangement of rooms. The palace portal onto

214. Sixteenth-century additions to the Palazzo Bichi-Forteguerri along the via dei Rossi.

the via dei Pellegrini cuts into the tower itself, which stands out for the massive width of its walls, also legible from the floor plans of the palace's three storeys; Pandolfo's famous 'camera bella', decorated with a cycle of frescoes by various artists, is frequently mentioned in documents as the 'camera della torre'.[54]

A rather later, but interesting, example of such reuse of towers can be seen in the palace of Alessandro Bichi, which has recently been discussed by Matthias Quast (fig. 214).[55] Moving from his family's neighbourhood of S. Pietro in Castelvecchio to a palace on the Strada Romana in 1518, Alessandro chose to acquire and restore a series of properties that were bounded by medieval towers on either end; these acquisitions effectively an-

nexed the arch and Torre dei Rossi into the palace façade, thus insinuating the Bichi into the site of one of Siena's *casati*.[56] Observation of the palace suggests that Bichi confined façade renovations to the side and rear of the building, where rectangular and cross-mullioned windows can be observed, while leaving the main façade intact with its acute-arched doorways and windows (replaced only in the seventeenth century). Quast has gone as far as to suggest that the Rossi coats of arms in the portals are original, and that Bichi chose to retain the insignia of his predecessors on the site, although this seems highly unlikely and it seems more probable that the arms were altered in one of many nineteenth-century restorations to Siena's Gothic façades. Nonetheless, Bichi undoubtedly capitalized on the associations of ancestry evoked by the architecture and site of his new palace, which was of course also prominently placed on Siena's main thoroughfare.[57]

In 1522 the sixteenth-century historian Sigismondo Tizio considered medieval towers of the sort reused in the palaces of leading members of the turn-of-the-century Sienese elite an asset to the city's appearance and bemoaned the demolition of a number of these as a result of ill repair and lightning damage.[58] Around that date, two towers had indeed been razed, one called the Torre di S. Angelo in Montone, whose materials were reused in the rebuilding of the church of S. Maria dei Servi, and the another called the Torre del Pulcino, because its imminent collapse threatened a nearby house.[59] It seems, however, that more often towers were absorbed into the fabric of palaces, even though their thick walls and small rooms often rendered them scarcely habitable. Thus, for example, recent research suggests that when in 1516, Girolamo di Biagio Turchi came to renovate the Palazzo Diavoli outside the Porta Camollia, he chose to incorporate an existing tower, which both indicated the age of the building and conveniently paralleled the architecture of the family's rural castle of 'La Chiocciola'.[60] Like the Borghesi, and Bichi, discussed above, the Turchi were political allies of the Petrucci and members of the oligarchy that emerged to rule Siena from the 1490s. It seems also that they shared the same approach to the architecture of Siena's medieval past.

That the towers were viewed favourably as an important element of the city skyline, and a testament to its recent past, is confirmed by contemporary visual evidence. While the urban portraits discussed in chapter One included a number of the city's prominent monuments, little attention was paid to the numerous private towers. Pinturicchio's city view of 1506 in the Libreria Piccolomini, and also an intarsia panel by Giovanni da Verona (*c.* 1503–5) from the Duomo choir, show a city

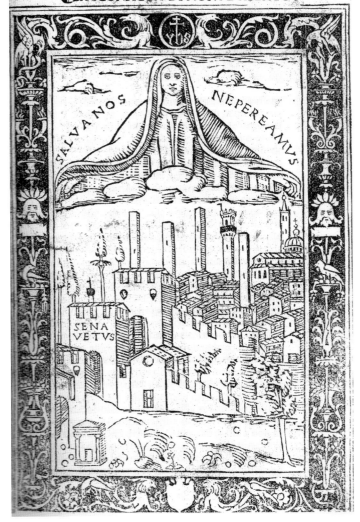

215. Lancelotto Politi, *La Sconfitta di Monteaperto*, Siena, 1502.

view that also includes towers.[61] Even more significantly, the 1502 woodcut frontispiece to Lancelotto Politi's *Sconfitta di Monteaperto* shows a view of the city under the protection of the Virgin in which countless towers can be seen. Politi's text re-evoked the heroic victory of the Sienese over the Florentines at the battle of Montaperti in 1260, renewing the city's civic memory of that event (fig. 215). The author poetically referred to the city as 'Siena of the high and proud towers and splendid palaces', a description that applied as much to contemporary Siena as it did to the city in 1260.[62] The work was dedicated to Pandolfo Petrucci, and evoked the same bygone era of noble knights that was also conjured up by the medieval towers annexed into the residences of the city's new ruling group as archaicizing features for their *all'antica* residences.

A Tale of Two Cities: The Changing Face of Palace Patronage

While the reuse of the medieval towers in the residential architecture of numerous members of the oligarchy indicates that group's common desire to distinguish itself within the city fabric, individual choices made by patrons in relation to their residences also illustrate the remarkable changes that affected Siena in these years. Domestic palaces were not simply markers of a patron's wealth and social status, but through style, location and magnificence they expressed the private individual's most tangible and powerful political statement within the public sphere of the city. While the pairing of architecture and power is well established, it is, however, important to exercise caution in interpreting the meaning of architectural choices, for their subtleties are often elusive to modern critics and scholars.[63] The historical period that has been briefly outlined above was one of rapid and dramatic changes that saw a succession of government types, with the consequence that the ruling group was replaced in a short period of time. Such realignments were felt on a large scale in the urban fabric as a whole, as is shown in the next chapter, but also left their mark on residential strategies of individual patrons.

An eloquent example of the way in which political change affected the housing choices of one elite family is to be seen in the case of the Bichi (see fig. 77). As was shown in chapter Three, the Bichi family's enclave in Siena was in the district of S. Pietro di Castelvecchio, the high ground to the south-east of the cathedral, where the magnificent Palazzo Bichi-Tegliacci had been built during the 1440s for Giovanni di Guccio Bichi, a leading banker and political figure. In the aftermath of the failed 1456 *Novesco* coup, and as part of a broader policy of Florentine appeasement, Giovanni had sold his palace to the Tegliacci, who returned to Siena from Florence, where they had been exiled. Giovanni in turn moved to the Palazzetto di S. Marta, opposite the monastery of S. Agostino, a residence that was given to him by the Commune in 1458, probably as a reward for his civic loyalty. Twenty years later, in 1480, the Palazzetto was donated to Alfonso, Duke of Calabria, during his brief quasi-lordship over the city, and Giovanni Bichi's son Antonio moved from it to rented accommodation.[64] The following year, after the return to power of the *Monte del Popolo* in June 1482, Antonio was exiled from Siena on account of his support for the Duke of Calabria. He was not to return to the city until 1487, after which he settled in the district of S. Giovanni, where – as is shown in the next chapter – he built a new palace next door to that of his political ally, Giacoppo Petrucci.[65]

216. Antonio Piccolomini's castle at Celano, Abruzzo.

The case of Giovanni di Guccio and his son Antonio is remarkable, as it traces the political fortunes of an ambitious family through their ownership of a succession of palaces, where each move can be linked directly to a change in their political circumstances and position in the city. The Bichi never moved far from the church of S. Agostino, where their family chapel was located, but during the space of thirty years they owned four different palaces, two of which they had constructed themselves. While Giovanni and his son did not totally abandon their clan's traditional enclave, it is also true that their prestigious residence was not maintained in the family as the focus of lineage identity, nor was the magnificence encapsulated by each palace the sole purpose for its construction.[66] Instead, the case of the Bichi illustrates the political value of owning prestigious property, and suggests some of the ways that this political capital could be shifted and realigned to changing circumstances.

A similar set of issues must be confronted when considering the completion of the Palazzo Todeschini Piccolomini on the Banchi di Sotto, discussed in chapter Five. Before Pius II died on 14 August 1464, he planned to leave a large sum to his nephews so that they might pay for construction of the palace.[67] By the time of the Pope's death, much of the site for the new palace had been assembled, and was in the hands of Laudomia and her husband, Giovanni Todeschini Piccolomini. They complained in their tax return of 1466 that these properties were in part derelict and ruined, and that a new palace needed to be built at great expense to preserve their own honour and that of the city.[68]

Pius II invested a good deal of money and diplomatic effort into his four nephews as a means of establishing a dynasty that would extend well outside the walls of Siena.[69] Such an objective was pursued through the provision of land and titles to each, and the construction of monumental architecture that marked the Piccolomini presence in numerous localities. The most ambitious of the Pope's plans were reserved for Antonio, for whom he arranged a marriage with Maria d'Aragona, the illegitimate daughter of King Ferrante of Naples, in 1458.[70] Antonio was a soldier and was nominated keeper of Castel Sant'Angelo in Rome, but his fortunes were to be bound to those of the King of Naples, whose patronage and support he won helping to suppress the Barons Revolt (1459–62). Antonio had acquired the title of Duke of Amalfi with his marriage, and his loyalty and service won him titles and large territories in the Abruzzo, where he was made Count of Celano and Gagliano from 1463. While Antonio's palaces in Amalfi and Naples do not survive, a network of numerous impressive castles marked the boundaries of his large territories in the Abruzzo, protecting the sheep-grazing (*transumanza*) routes and marking Piccolomini's presence and ownership (figs 216–17).[71]

217. Antonio Piccolomini's castle at Ortucchio, Abruzzo.

For Francesco, on the other hand, Pius II had reserved a clerical career: he was appointed Archbishop of Siena at the young age of 23, and was almost immediately elevated to the cardinalate in 1460.[72] Francesco was titular cardinal of S. Eustachio in Rome, and from 1461 he set about building a palace in the vicinity of Campo dei Fiori, while from 1463 he also controlled the church of S. Saba on the Aventine, which he extensively renovated (fig. 218).[73] In Siena, Francesco was Abbot *in commendam* of the Camaldolese monastery of S. Vigilio, and had his residence in the archbishop's palace as well as his newly built palace adjacent to S.

218. Detail showing the inscription over the gate to Antonio Piccolomini's castle at Ortucchio, Abruzzo.

Vigilio, the Palazzo Bandini-Piccolomini, discussed in chapter Six.[74] In addition to his clerical business, Francesco played an important part in maintaining relations between Siena and Rome through the 1470s and 1480s, and his Roman palace served as an occasional meeting place for the Sienese community in Rome.[75] Following the return to Siena of the *Nove*, the Piccolominis' political fortunes continued successfully, and it was about this time that Cardinal Francesco proba-

219. Cardinal Francesco Piccolomini's palace in via della Staffa.

bly set about extending his S. Vigilio palace with another building, which extends the palace façade south, along the via della Staffa (fig. 219).[76]

The new portion of the cardinal's palace is built in the same elegant and simple style of many Sienese palaces around the turn of the sixteenth century, with a brick façade and *pietra serena* architectural details.[77] There is a striking continuity between it and the earlier Bandini-Piccolomini façade, both for the brick–stone contrast of the design, and for the linking element of the *pietra serena* string-course that links the two buildings together on the

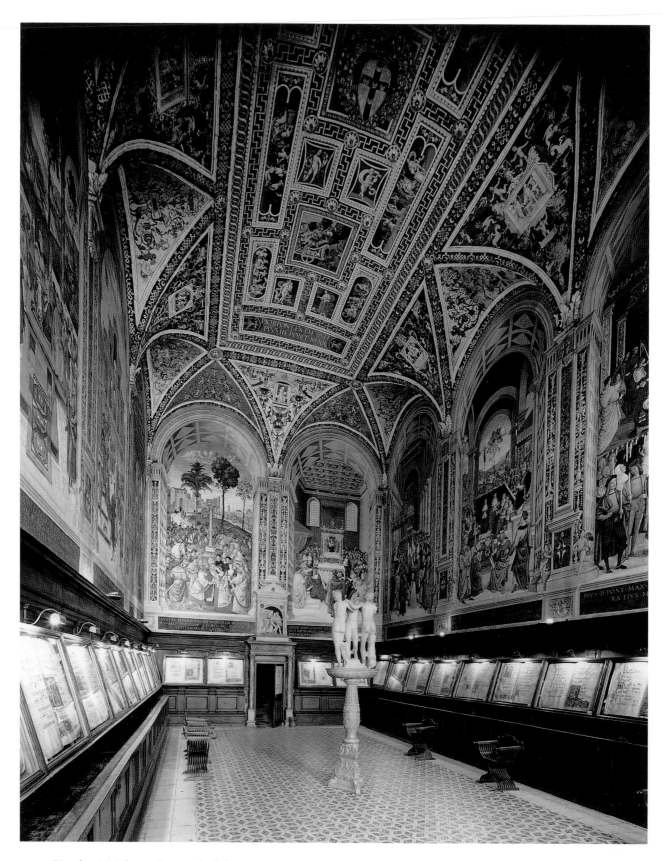

220. Piccolomini Library, Siena cathedral.

ground floor. Cardinal Francesco's patronage in Siena was by no means limited to the via della Staffa palace. In 1481 the cardinal took over the guild chapel of the shoemakers in the cathedral and transformed it into a family chapel, inviting Andrea Bregno from Rome to execute the altar, which was completed with four sculptures commissioned from Michelangelo in 1501.[78] He also paid for the construction of the Piccolomini Library in the cathedral, which was decorated by Pinturicchio between 1492 and 1507 with images that exalted the life of his uncle Pius II (fig. 220).[79] Cardinal Francesco was himself elected pope on 22 September 1503 with the name Pius III, and left most of his properties in Rome, Siena and elsewhere to be divided between his two brothers, Andrea and Iacomo, when he died less than a month later (18 October 1503).[80] His brothers in their turn celebrated his brief pontificate with a large fresco, also by Pinturicchio, painted above the entrance to the Library in the main church, which recorded the ceremony of his election as pope.

The fortunes of Andrea and Iacomo had remained more closely bound to Siena, although both had been endowed with considerable estates. Of the two, Iacomo was the wealthier, and as well as large land-holdings in southern Tuscany, was Lord of Montemarciano, an estate on the coast of the Marche, north of Ancona.[81] Andrea was the youngest of the four brothers, received the least privileges, and in fact acquired the Lordship of Castiglion della Pescaia and the Isola del Giglio through his brother Antonio.[82] Both Iacomo and Andrea continued to invest heavily in real estate throughout their lives, particularly in the Sienese *contado*, and by the beginning of the sixteenth century they were among the city's wealthiest citizens.[83] Furthermore, the brothers' dominions on the southern edge of the Sienese state were consolidated by marriage alliances into the south Tuscan and Roman aristocracy, as Iacomo married Cristofora Colonna, and Andrea married Agnese Farnese.[84] It was in Siena, however, that the brothers had their homes, developed on the site acquired for the construction of a grand new palace by their uncle, Pius II.

Construction of the palace followed a foundation ceremony officiated by Cardinal Francesco on 12 September 1469.[85] In late October 1469, Andrea and Iacomo appealed to the *Ornato*, requesting that public land on the Campo required to complete the site for their new palace might be granted so that 'this marvellous project that will be a great ornament to the city [. . .] will have a square plan'.[86] The public authorities wished to encourage the project and made the necessary concessions, although progress on the palace was evidently slow. By June 1471, the 'base on the level of the street' was in place, but there is no further record of

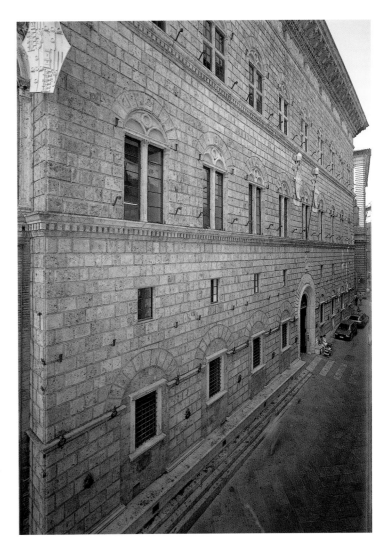

221. Palazzo Todeschini-Piccolomini, view from Banchi di Sotto.

the building campaign that decade (fig. 221–2).[87] By October 1480, Iacomo and Andrea decided to split the property, with Iacomo taking the portion along the Strada Romana and his brother that along via del Porrione.[88] The division document drawn up between them only sheds some light on the state of advancement of construction by 1480, as its principal concern was with defining the boundaries that divided the two sites, and the division of building materials stored on the courtyard space at the centre of the building. Nonetheless, the half of the building that was taken by Iacomo was called the 'Palazzo Nuovo' and described as having been 'nuovo murato' (newly built), while Andrea's portion was called the 'Casamento Vecchio' (the old building).[89] Evidently some construction work had been done on the corner of the palace that flanks the Strada Romana and Chiasso dei Setaiuoli before the division occurred.[90]

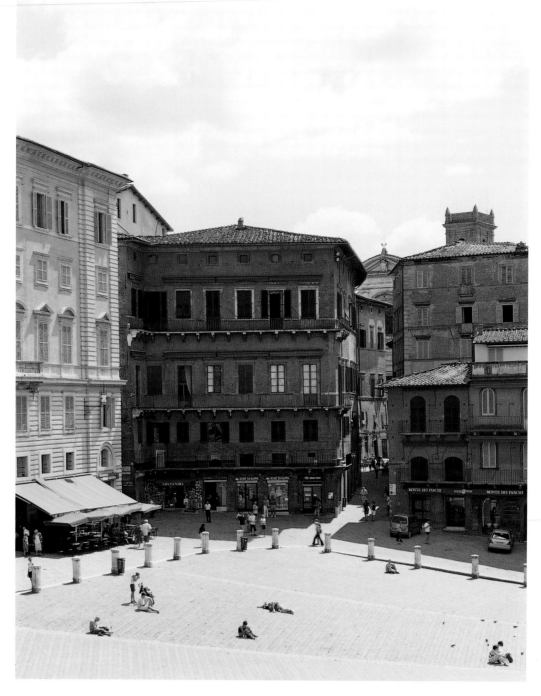

222. Palazzo Todeschini-Piccolomini, view from the piazza del Campo.

By 1481 Iacomo declared partial income from ten shops 'beneath said palace', which indicates that the slow construction campaign proceeded by horizontal bands rather than vertical blocks; it can be assumed that this was done in order to capitalize from the rent income from the ground-floor shops as soon as possible.[91] Iacomo's tax returns indicate that he continued to derive income from the shops throughout the building cam-paign, but also reveal his concerns for the high costs he was committed to in completing the building to plan.[92] Meanwhile, Andrea had decided not to rebuild the portion of the property that he owned, but rather to make use of the building as it stood, providing it with a new entrance on the via del Porrione.[93] The two dis-tinct decisions made by Andrea and Iacomo for their portions of the property, and the consequences of these

in the architectural design of the two parts of the building, have given rise to some debate as to the motives for those choices.

It has recently been suggested by Lawrence Jenkens that the brothers' decision to divide the property, and Andrea's supposed reluctance to build on the grand scale adopted by Iacomo, is to be understood as a reflection of the brothers' differing political ambitions.[94] This interpretation rests on two premises that are themselves questionable; the first is the suggestion that Andrea was significantly more involved in Sienese politics than his brother, while the second supposes that the Palazzo Nuovo was more magnificent than the Casamento Vecchio. We shall consider these two problems in turn. Both Andrea and Iacomo had an active role in Sienese politics until at least 1494, which would imply that the choice Andrea made in 1480 was not exclusively political.[95] Iacomo and Andrea served as *Capitano del Popolo* in 1480 and 1489 respectively, and they remained active defenders of the *Monte del popolo*'s participation in government until 1494, with the support of their brother, Cardinal Francesco.[96] In 1480 Andrea also served a term as *Gonfaloniere* (standard bearer) of the *Terzo* of S. Martino, indicating his involvement in local interests, as well as central government.[97] As late as August 1497, Iacomo was a member of a committee of three, with Pandolfo Petrucci and Antonio Bichi, responsible for the plans that led to the removal of Duccio's *Maestà* on the High Altar of the cathedral, while Andrea stood on the committee for the construction of the new church of S. Sebastiano in Vallepiatta.[98] Clearly then, with such evidence of Iacomo's close association with two of the most powerful political figures in Siena, it cannot be argued that he was absent from Siena's political scene.[99]

If the brothers' political engagement cannot stand to explain the differences in the two halves of the palace, then some other motive might be proposed that would also resolve the issue of their stylistic divergence and comparative magnificence. Closer observation of the brothers' property division document of October 1480 offers some reasons for the decision to abandon completion of the palace to plan that are principally to do with neighbouring property. On the one side of Andrea's site stood the piazza del Campo, the public space most closely associated with Siena's civic identity, on the other were numerous family members, who were reluctant to abandon their homes for the sake of the grandiose project.[100] In spite of the 1469 concession agreement, which would have allowed the palace to invade the Campo, the executed design was carefully carved to maintain what must be assumed to have been the original property boundary with the piazza.[101] To

the south of his site, Andrea had a number of neighbours, and documentary evidence shows that he gradually bought many of these out so as to gain total control of the property block along the via del Porrione.[102] However, it is also interesting to note that the properties bought between 1492 and 1499 all included ground-floor shops, and that two of these were specifically on the corner of the Campo and Chiasso dei Pollaiuoli.

These property transactions raise some interesting problems. In the first instance, the fact that Andrea bought property on the corner of the Campo suggests that the Piccolomini had not yet secured all the land required to create the original 'palace-cube' project, and thus that the 1469 public land concession had little value, since there were private properties in the way of its execution.[103] In the second place, these acquisitions show Andrea's desire to assemble a portfolio of retail properties in the immediate vicinity of his palace that would also provide him with rent income. Such a suggestion is leant further force when considered in conjunction with Andrea's will of 1507, discussed in chapter Six, in which he laid down that 150 florins of retail property should be bought in the high-rental central district, in the vicinity of his residence.[104] The Loggia Piccolomini, a building jointly owned by Andrea and Iacomo, was also maintained by rent income.[105] Indeed, it is noteworthy that Iacomo reported in his will the fact that he was forbidden from alienating the Loggia or the palace, and there are good grounds for suggesting that the retail property owned by both brothers was assembled to ensure the necessary income for maintenance of their properties.[106]

The 1480 division certainly marks a watershed in the history of the Palazzo Piccolomini, as it seems to have sealed the decision not to pursue the acquisition campaign begun by Pius II that would secure all property in the *insula* between piazza Piccolomini and piazza del Campo for the two brothers. Iacomo, the elder and wealthier of the two, inherited the portion of the palace that was most onerous, in view of the ongoing construction work, and decided to live in a palace rented from the Marescotti on the via di Città while awaiting its completion (see fig. 210).[107] Seeing the slow progress of construction, in 1479 Iacomo had actually bought half of the Palazzo Marescotti, and by 1509 his family were sole owners of the property, which they had also restored.[108]

Construction of the Palazzo Nuovo was characterized by its slow pace. Begun in 1469 to a design that was perhaps already a decade old, its façade is dependent on the model of the Piccolomini palace at Pienza. Architectural details such as the *pietra serena* Piccolomini shield rosettes set into the shop vaults and

223. Palazzo Todeschini-Piccolomini, *all'antica* hanging capitals from the second piano nobile.

hanging capitals at ground-floor level can be dated to this first construction phase. Nonetheless, attempts were made to update the design as it progressed, for example by providing the façade with a massive classicizing cornice above an attic storey.[109] It is probable that Cardinal Francesco Piccolomini's papal election in 1503 resulted in increased expenditure on the project around that time, and the sculptural commission given to Lorenzo Marrina for work on the family chapel in S. Francesco in 1504 led to his being hired to work at the palazzo, a fact that is confirmed in Iacomo Piccolomini's will of September 1507 (fig. 223).[110] The highly worked *all'antica* hanging capitals of the two *piani nobili* can certainly be compared to Marrina's other known works, such as the near-contemporary architectural sculpture of the façade of the Piccolomini library in the cathedral.[111] Iacomo's heirs, Enea and Sylvio, still complained in 1509 that their palace, 'as can be seen is being built at great expense', by which time, the palace had been under construction for forty years and planned for fifty.[112] Designed as the lasting monument

to the renewed fortunes of Pius II's branch of the Piccolomini family, it was planned that 'it will provide dignity to the piazza [del Campo] and to our city'.[113] In fact, the palace as it was built had neither a façade onto the Campo nor onto piazza Piccolomini, although the massive façade onto the Strada, and the numerous Piccolomini arms displayed, had the effect of extending the piazza Piccolomini space along the street (fig. 225).

In contrast to Iacomo, Andrea lived in the portion of the Piccolomini property on via del Porrione that had not been demolished, and where his mother also had an apartment.[114] Nonetheless, Andrea also had to invest heavily in maintenance and renovation of his residence, which he described in 1481 as being in part derelict.[115] The building's façade on the piazza del Campo and via del Porrione was largely rebuilt, and furnished with rectangular framed windows with travertine mouldings, and balconies onto the piazza (fig. 224). These were quite possibly in place by 1508, when Andrea drew up his will, dividing the property between his sons, Pierfrancesco and Alessandro, as there is no mention of construction work in the will.[116] The document describes a luxurious residence, divided into more than one apartment, one of which was reserved as the residence of Andrea's wife, Agnese Farnese.[117] Fresco fragments surviving in a number of rooms of the Casamento indicate that the palace was decorated around the turn of the sixteenth century using elegant and fashionable *all'antica* grotesque motifs, similar to those employed by Pinturicchio in the cathedral library.[118]

It is interesting to note that the 1508 will created two unequal portions of the palace, and arbiters were called in to assess the financial compensation to be offered

224. Palazzo Todeschini-Piccolomini, simple rectangular-framed moulding of windows on via del Porrione façade.

225. Palazzo Todeschini-Piccolomini, belvedere loggia.

by Pierfrancesco to Alessandro for receiving the larger property block; the architects Domenico di Matteo and Ventura Turapilli were summoned to make the cost assessment, which they valued at 600 florins.[119] By 1508, Ventura Turapilli was master-mason of the cathedral works, and in that capacity was a key figure, as he himself attested later in his life, in the introduction of *all'antica* style and motifs to Siena.[120] It is not of course possible to suggest Turapilli's involvement in the Casamento project, although it is nonetheless clear that the Piccolomini brothers' close involvement with the family patronage of the cathedral library, as well as Iacomo's participation in the committee for the High Altar renovation, put them in contact with some of the most significant local and foreign artists active in Siena around 1490–1510. While Iacomo was only able to transfer this experience to the internal architectural details of his palace, Andrea's Casamento Vecchio was much more directly influenced by the innovations in painting and architecture of those years. His palace was in line with contemporary taste, and can usefully be compared with a number of residential properties of Siena's political and economic elite, discussed in detail in the following chapter.

In conclusion, it is fair to say that Pius II had planned a magnificent residence for his sister and nephews when he set about buying land for a centrally located palace in Siena. As was shown in chapter Four, that palace was designed to express not only the newly acquired status of the Pope's branch of the family, but also the cosmopolitan and specifically papal identity of its indirect patron, an objective achieved through both architectural style and prominent inscriptions. However, the slow progress of the palace's construction meant that the two nephews were able to follow different strategies for their parts of the building. Iacomo, the wealthier and elder brother, was obliged to follow through the initial plans, thus paying homage to his powerful uncle, the effective re-founder of Piccolomini dynasticism. In some respects the palace was consciously *retardataire*, evoking the memory and times of Pius II. By contrast, Andrea was not committed to the same agenda, and was able to undertake a less financially onerous renovation project that conformed much more closely to the patterns of patronage of his peers in the new post-1487 oligarchy. Time and expediency, rather than diverging political ambitions, thus underlie the different faces of the Palazzo Piccolomini.[121]

9

The Stratified City

OLIGARCHY AND URBAN FORM

And this happens particularly in the birth-place of scientists,
because no prophet is well received in his fatherland,
in spite of the fact that my compatriots have not fallen into this sin of ingratitude.[1]

In the aftermath of the dramatic return of the *Noveschi* to Siena on 22 July 1487, not only were the institutions of the city's government altered, but a remarkable change in the social composition of the ruling elite occurred, which in turn was to have a lasting effect on the urban fabric. The late fifteenth- and early sixteenth-century city was no longer controlled by policy-driven patronage that figured the institutional reality of its republican government; in its place came elite-driven projects which tended towards the creation of a socially stratified urban core, where stylistic and patronage choices served to define the ruling hierarchy. Furthermore, this dramatic change in patronage patterns and the architectural language employed for buildings commissioned by this new ruling elite are closely bound to the growing influence of Francesco di Giorgio Martini (1439–1501) in Siena during the last decade of the century.[2]

It is indeed within the context of the return to Siena of the *Nove* and their allies that we should consider the career of Francesco di Giorgio, without any doubt the most influential artistic figure to have emerged in the second half of the fifteenth century in Siena.[3] Fol-

lowing an early involvement in engineering works for Siena's underground water conducts (the *bottini*) and the Bruna dam, from 1477 Francesco is documented as active abroad, in Urbino and Naples, after which time, with a letter of recommendation from Federico da Montefeltro, he returned to Siena in July 1480 to take up office in the Consiglio del Popolo.[4] During the years of the Duke of Calabria's presence in Siena (1480–82), Francesco was active in the city, primarily on fortifications along the Florentine border. In 1481 the architect still declared residence in Siena, although by September 1483 he was writing from Urbino to defend himself from the accusation of treason, for having designed fortifications for Siena's enemies.[5] That same year, Giacomo Cozzarelli, perhaps Francesco's closest assistant, filed a tax return in Siena, in which he recorded his absence from the city for work reasons, stating that he was with Francesco di Giorgio in Urbino.[6]

In July 1483, after a year of political unrest following the departure of the Duke of Calabria, numerous *Novesco* families had been exiled, only to return in 1487; while Francesco was not a *Novesco*, he appears to have been grouped with them, as documentary evidence

226. General view of the city.

shows that his personal possessions and property worth about 1,000 *lire* were confiscated, and were only returned to him after July 1487.[7] In spite of this, the Sienese authorities evidently set greater store by the architect's skill than his political affiliation, and on 19 December 1485, the General Council of the Sienese Commune voted 174 to 41 to re-admit Francesco di Giorgio as a citizen, and a week later appointed him city architect. He was offered handsome remuneration for the post, and for relocating his family to Siena, in the form of property to a value of 800–1,000 florins, but did not take up the invitation. The offer was again repeated in October 1486, while in May 1487 he was awarded the prestigious and valuable post of *podestà* to Porto Ercole, for which Guidobaldo da Montefeltro pleaded on Francesco's behalf that he might send a substitute as he had so much work to supervise in the Marche.[8] It would seem, therefore, that although the Sienese authorities were anxious for the permanent return of Francesco to his native city, they were unable to achieve this, and had to settle for his occasional advice on projects such as the reconstruction of a bridge at Macereto, often transmitted through the agency of one of his assistants.[9]

It seems therefore fair to conclude that Francesco di Giorgio was reluctant to settle back in Siena during the years between the departure of Alfonso, Duke of Calabria, from Siena in 1482 and the regime change of 22 July 1487.[10] Conversely, within ten days of the *Nove*'s return Francesco was contacted also to return to Siena, and is documented as present on a number of sites before the close of the year.[11] In January 1488, Francesco di Giorgio was offered a financial incentive of 1,000 florins, on condition that he return to Siena with his family, and that same year he reappeared on the city's tax records, this time as an 'ingegniere'.[12] Francesco was not only resident in Siena, but was active in local government, finance (through various business partnerships) and diplomacy.[13] Thus, if during the years 1482–7 correspondence repeatedly confirms that Francesco was based in Urbino, from the late summer of 1487 his frequent visits to oversee or advise on projects throughout Italy witness him setting off from Siena. It is therefore plausible to suggest that Francesco's interests closely coincided with those of the *Nove*, and that his return to Siena was motivated by the favourable political and patronage situation resulting from the regime change of 1487.

Following his return to Siena, Francesco was given special privileges that allowed him to hold government office, suggesting his close connection to the new regime.[14] This is confirmed in a partnership agreement drawn up in February 1489 between Pandolfo Petrucci,

227. House of Francesco di Giorgio Martini on the piazza del Battistero.

Paolo Salvetti, Francesco di Giorgio, Paolo Vannoccio Biringucci and others for the foundry and armaments industry, in which Francesco offered professional advice on the harnessing of hydraulic energy to industrial production.[15] In Siena, Francesco lived opposite Pandolfo Petrucci on the piazza S. Giovanni, and he is named a number of times as 'Francesco di Giorgio architettore' in public documents involving the Petrucci (fig. 227).[16] In the years that followed, Francesco provided reports to the *Nove* on troop movements around Perugia, and accepted invitations to provide architectural advice to the King of Naples, the Dukes of Urbino, Calabria and Milan, as well as to Gentile Virginio Orsini and Lorenzo de' Medici.[17] The manner in which his frequent trips are documented – with a formal letter of invitation from the host to the *Balìa*, a reply from the latter and letters of thanks on the return of Francesco to Siena – suggest that his architectural skills were treated as a commodity to be used for diplomatic ends. Indeed, in at least one case, a committee of *Noveschi* was specially elected to encourage Francesco to go on such a mission.[18] Such a possibility is unsurprising when viewed in the light of Lorenzo de' Medici's oft-cited cultural diplomacy of the previous decade.[19]

Francesco's work as an architect outside Siena during the last fifteen years of his life is well established, al-

though many questions still remain as to his activity in this capacity in his home town.[20] While later discussion will return to this issue, it is instead his work as an architectural and urban theorist that should be considered within the context of Sienese architectural patronage during these years. A prolific writer, he is known to have written two treatises on architecture that were widely circulated and copied in the late fifteenth and sixteenth centuries.[21] While there is some debate as to the precise dating of the two versions of the *Trattati*, it is generally agreed that the first version predates 1487, while the second was laid down in the last decade of the century.[22] Again, while the first *Trattato* and other works were almost certainly intended to reinforce Francesco's ties of patronage with Duke Federico da Montefeltro, the second version of the treatise is less closely bound to any one patron.[23]

The second version of the *Trattati* is more rationally ordered than the first, and gives considerable attention to the planning and positioning of cities, as well as to the design of secular buildings, such as palaces and houses. Although the references to specific projects and places are rare in both versions of the treatises, presumably since this would have detracted from their universal didactic functions, it is noticeable that in the second version, preserved in manuscripts in Siena and Florence, there are a number of references to Siena and its *contado*.[24] Thus, for example, in the first book, a section describing building materials makes frequent reference to stone available in the Siena area; in the following book the author describes the use of underground grain stores, introduced to Siena as a result of the advice of Pius II; in the same book, Francesco discusses the risk of noxious gaseous vapours exhaling from new wells, and illustrates the problem with a Sienese example 'that I saw in my home city'.[25] It is again significant that in the attack on 'plagiarists' that opens the seventh book, Francesco cites the common *topos* of the prophet despised in his homeland, but qualifies this with the comment 'in spite of the fact that my compatriots have not fallen into this vice'.[26] Corrado Maltese rightly took this comment as evidence for the fact that Francesco's relations with Siena were good at the time of writing the Magliabecchiano manuscript of the *Trattato*, a situation that applied to the architect's relations to his home town from 1487 until his death in 1501.[27]

It is surely no coincidence that the second *Trattato*, which is otherwise more succinct and rationally ordered than the first, includes such references to Siena, as the period in which it was written was one in which Francesco di Giorgio enjoyed a prominent place in the city as a contractor of art, architecture and various engineering projects, as well as serving in government office.

Moreover, the theoretical content of the work also owed some debt to the architect's knowledge and experience of his native city and the changes that were being made to the urban fabric in those very years, particularly in the wake of the return of the *Nove* in 1487.

As was shown in the previous chapter, and will emerge more clearly from the discussion that follows, the *Nove* actively pursued an urban and architectural strategy that sought to distinguish the new regime from its predecessors. This process is most clearly legible in policies and patronage choices that favoured urban stratification, that saw the concentration of elite residences in oligarchic enclaves quite separate from the more inclusive residential and commercial streets, such as the Strada Romana.[28] A theoretical interest in social stratification in palace types and urban layout can be identified in architectural and political treatises circulating in Siena during the late fifteenth century. On the one hand, Francesco Patrizi's *De Institutione Reipublicae*, examined in detail in chapter Four, provides a number of insights into the socio-political context of palace architecture and its significance within the urban scene. On the other, Francesco di Giorgio's *Trattati* throw interesting light on stylistic and urbanistic aspects of the question. Patrizi was a close friend of Pius II, and his treatise was written on his behest; however, by completion the Piccolomini pope was dead and the author dedicated it both to Pope Sixtus IV and the 'Senatum Populumque Senensem'.[29] As was argued in an earlier chapter, the treatise is vital for a proper understanding of Piccolomini patronage in Siena and Pienza during the 1460s, but it also appears to have had considerable relevance for the late fifteenth-century city. After all, Patrizi himself had been a close associate of Antonio di Cecco Rosso Petrucci, a member of his *Novesco* coup of 1456, and certainly identified his ideal republic with the rule of the urban elite.[30]

Patrizi stressed social stratification in the well-planned city of his elite-governed republic, and following various classical examples (most obviously Plato) indicated a tripartite hierarchy between patricians, artisans and rustics.[31] In discussing domestic arrangements Patrizi stressed that houses or palaces should be appropriate in size and magnificence to their owners.[32] Perhaps even more tellingly, he proposed that residential streets should be arranged according to precepts of regularity, with palaces of equal heights, no overhanging structures and that an ideal quality of 'mediocritas' should be observed.[33] The appearance of the well-governed city should, moreover, be overseen by an architect who would have a special concern for the layout and rational ordering of streets.[34] While no explicit mention is made of zoning and the distribution of professions or

social groups in distinct areas of the city (as was later expressed by sixteenth-century theorists), this would be the natural conclusion of the argument.[35]

Patrizi placed a high value on architects in his well-governed city, discussing their essential role in defining urban form and determining the design and layout of public and private buildings in Book VIII of his treatise.[36] Francesco di Giorgio might well be viewed in the light of Patrizi's comments: his prominent role in late fifteenth-century Sienese affairs and a number of comments regarding palace architecture and street design in the second version of the *Trattati* appear directly relevant to his practical experience of *Novesco* Siena. Thus, in the second book, Francesco states:

> There are five types of private house, between which it is important to distinguish. There are the houses of rustics, others of artisans, others for scholars, notaries, lawyers and doctors or physicians, and generally of all other *scienzia*. The fourth type is for merchants, and finally there are the houses of nobles, whose worldly pursuit is to live with honour and without too many worries.[37]

He also discussed the ordered layout of streets and professions, and in twenty-two precepts on town planning he declared that 'all the professions that are beautiful to see (*in se hanno bellezza e decoro*) should be on the main streets and public places', while also proposing the professional clustering of major guild industries and professions.[38] Like Patrizi, Francesco di Giorgio did not directly link professional zoning with the social hierarchy, although he conceded that it would be advisable that 'all the banks and warehouses should be together, and as close as possible to the main city square'.[39]

Francesco Patrizi's ideal republic was one where political harmony and control was imaged in the architectural order of the urban fabric and its constituent parts. Such a model owed much to the *Trecento* ideal expressed by Lorenzetti's frescoes in the 'Sala della Pace', subtly altered to admit nobles back into the ruling group. While this had formed part of Pius II's political agenda for Siena in the 1460s, it was actually realised in the *Novesco* oligarchy from the 1490s. It was during this period that a number of the city's thoroughfares were consciously developed as elite palace streets, home to bankers and wealthy merchants, whose sophisticated palaces expressed membership and alliance with the city oligarchy through an architectural style common to that group. These patronage choices conformed to the theories outlined by Patrizi and Francesco di Giorgio, who also appears to have influenced the architectural style favoured in Siena during these years. As will be discussed further below, Fran-cesco di Giorgio's active role in designing buildings in Siena remains somewhat elusive, although it is evident that he was a central figure in the process that transformed Siena in the years around 1500.

Exclusive Enclaves: the Palace Street and Crony Patronage

In the previous chapter it was shown that through an elaborate process of reinterpretation of the city's recent and remote past, a number of Sienese families constructed myths of lineage that closely paralleled the combined historiographic and architectural process employed by civic and other patrons in their bid to affirm the city's antique Roman origins. Thus, while numerous members of the urban elite associated their family identity with the architectural vestiges of the medieval magnate families' tower-houses, so too these very same monoliths were utilized in the case of S. Ansano in Castelvecchio, to recreate an early Christian martyrdom site at the heart of the city. In both cases, written texts served to support and corroborate the patronage choices that were being made.

A parallel, and at first sight quite distinct, strand in the collective patronage choices of the city's ruling group of families can be identified in the gradual process that saw the creation of exclusive palace–street enclaves from the last decade of the fifteenth century. Such a development is in marked contrast to earlier residential choices of the Sienese elite, which, as has been shown, tended to maintain familial allegiance to clan neighbourhoods.

Following the return of the *Noveschi* to Siena in 1487, a dominant inner circle from among what were called 'quelli dell'impresa' came to control the city government, and from among these Pandolfo Petrucci gradually emerged as a leader.[40] By 1503, Pandolfo was virtual *signore* of the city, supported in his position by a narrow group of followers drawn primarily from the *Nove* but including also other members of Siena's elite, with whom a secret pact of alliance was also signed.[41] This new elite appears rapidly to have marked its importance and identity within the city through group cultural patronage initiatives that transformed many of the city's major monuments and streets. An excellent example of this process appears in the well-documented case of the redevelopment of piazza Postierla and the via del Capitano (fig. 228–9).[42]

Via del Capitano and Postierla form the final approach to the religious precinct at piazza del Duomo. Until 1487, much of the area had belonged to the Spedale di S. Maria della Scala, which owned vast properties in the Sienese *contado* and real estate within the

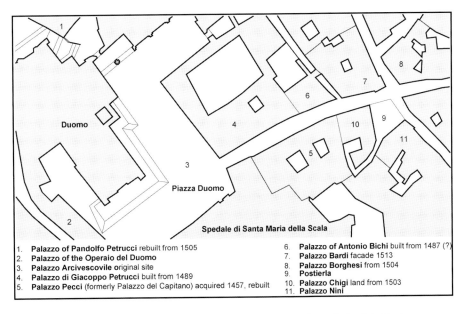

1. **Palazzo of Pandolfo Petrucci** rebuilt from 1505
2. **Palazzo of the Operaio del Duomo**
3. **Palazzo Arcivescovile** original site
4. **Palazzo di Giacoppo Petrucci** built from 1489
5. **Palazzo Pecci** (formerly Palazzo del Capitano) acquired 1457, rebuilt

6. **Palazzo of Antonio Bichi** built from 1487 (?)
7. **Palazzo Bardi** facade 1513
8. **Palazzo Borghesi** from 1504
9. **Postierla**
10. **Palazzo Chigi** land from 1503
11. **Palazzo Nini**

228. Map showing the arrangement of the piazza Postierla and via del Capitano area, *c*.1480–1520.

city walls, including much of the via del Capitano. As is becoming increasingly clear, the Ospedale was one of a number of city institutions to come under the control of the new city elite, and the Petrucci in particular.[43] It is consequently less of a surprise than it might at first sight seem to find almost all the property between the Duomo and Postierla passing into the hands of the

229. The via del Capitano and cathedral precinct, detail from F. Vanni, *Sena Vetus Civitas Virginis*, fig. 10.

Petrucci and their cronies in the decade or so after 1487. As the map shows, the via del Capitano precinct became a palace street, developed exclusively by leading families from the new oligarchy, including Giacoppo Petrucci, Antonio Bichi, Agostino Chigi, the Borghesi, Pecci and Piccolomini (if we include the Archbishop's palace).

How did this come about, and how did the patronage process that led to the development of the street differ from the development of the Strada Romana in the preceding quarter-century? The via del Capitano development serves as the most dramatic example to contrast the collective patronage dynamics that replaced the inclusive *Ornato*-mediated policies of the previous decades. The street was developed as an exclusive enclave reserved for the city's leading families, often at the expense of less wealthy or empowered citizens. Thus, the palace of Giacoppo Petrucci, until 1495 the most influential member of the oligarchy, was 'a fundamenti erectum', using properties which were requisitioned from their life-lessees in order to allow their sale to Petrucci.[44] The site was further expanded through acquisition of the house of the young heirs and widow of the surgeon Alessandro di Giovanni Sermoneta, a sale for which Francesco di Giorgio Martini served as a witness.[45] Another incidental 'victim' of Giacoppo Petrucci's patronage was the artist Neroccio di Bartolomeo de' Landi, whose home and workshop were also requisitioned to make way for the new palace.[46] Neroccio had in fact inherited the usufruct of the property from his master, Lorenzo di Pietro 'il Vec-

ABOVE 230. Plan of the Palazzo del Governatore. Palazzo di Iacoppo Petrucci on the left, Palazzo di Antonio Bichi on the right. Cabreo 5 nr. 40, Habsburg Tuscany, inv. VII.2.A4, fol. 40, State Library, Prague.

BELOW 231. Palazzo del Governatore. Palazzo di Iacoppo Petrucci on the left, Palazzo di Antonio Bichi on right.

RIGHT 232. Palazzo di Iacoppo Petrucci, courtyard.

chietta', who had thus also lived and worked in the immediate proximity of his major employers, the Ospedale di S. Maria della Scala and the Opera del Duomo.[47]

At the time of the palace's construction, Giacoppo Perucci was one of the inner circle of the *Novesco* oligarchy, established after the return of the party exiles in 1487.[48] As Christine Shaw has shown, his power in the city, and influence with the Medici, exceeded that of his younger brother Pandolfo until the winter of 1495.[49] It is thus significant that on his return to Siena from exile, he chose to establish his palace on a different (though nearby) site to his family's enclave around the Baptis-

tery, founding a new palace in the immediate vicinity of the Duomo and, as we shall see, of a number of his closest intimates. The palace that was built is now embedded within the Medicean Palazzo del Governatore, but numerous architectural elements in *pietra serena* document the original ownership of the building by the prominent display of the Petrucci arms that decorate the capitals (figs 230–3).[50] The large palace was arranged symmetrically around a central portal facing the via del Capitano, from which an *andito* led to a courtyard that gave onto a garden and service areas, including stables, byres and cisterns.[51] In itself the symmetrical layout, large scale and classicizing details of the building distinguished it from most contemporary palace projects, signalling perhaps the intention that the palace should be understood as a new focus of political and socio-economic power in the city. Such a focus was not exclusively directed on Giacoppo Petrucci, and indeed his palace was flanked to one side by the Archbishop's palace of Cardinal Francesco Piccolomini, and to the other by the magnificent palace of Antonio Bichi; both the Piccolomini and Bichi were prominent in the new *Novesco* regime.

Antonio Bichi was another leading member of the *Novesco* elite, who had been one of 'quelli dell'impresa'

of 1487 and was one of the four core members of the oligarchy in 1491.[52] Antonio returned to Siena from exile in 1487 and settled in the central district of S. Giovanni, investing in a new palace there from the summer of 1491, when he bought a property there from the heirs of the physician Alessandro Sermoneta.[53] Some considerable amount of pressure was brought to bear by Bichi on Sermoneta's widow and young heirs to ensure that the sale went through, and he was supported in this by powerful figures such as Pandolfo Petrucci and his adviser Antonio del Venafro.[54] The site was rapidly enlarged with a sale of adjacent public land belonging to the *Opera del Duomo*, negotiated in October directly through the *Operaio*, Alberto Aringhieri, at an advantageous price.[55] By November, Antonio had bought the necessary site for the palace, including land bought for 130 florins from the nuns of Sant'Abondio, for which a dispensation had been sought from Pope Innocent VIII.[56]

The palace itself is certainly to be identified with a portion of the present Palazzo del Governatore, which combines the pre-existing palaces of Giacoppo Petrucci and Antonio Bichi (fig. 234–5).[57] The building was originally freestanding, with a main façade onto via del Capitano and had a garden to the rear. Its incorporation into the Medici governor's palace has altered it beyond recognition; the original façade is gone, and the street

ABOVE 233. Palazzo di Iacoppo Petrucci, detail of capital bearing Petrucci arms in the courtyard.

BELOW 234. Palazzo di Antonio Bichi, detail of capital from possible courtyard of original palace.

RIGHT 235. Palazzo di Antonio Bichi, detail of wood and stucco ceiling of original palace.

level was raised in the sixteenth and seventeenth centuries. Internally, however, a highly worked wood-and-stucco beamed ceiling survives with putto and astrological motifs, and a portion of what may have been a courtyard loggia using a refined classical order can be found walled into a landing. The palace had been completed by July 1497, when it is interesting to note that Antonio Bichi was granted the right to build a stone bench along the façade of his palace, constructing this on over two *braccia* of public land.[58]

236. Designs for palace windows from the Trattati of Francesco di Giorgio Martini. MS. Magliabechiano, II.I.141 fol. 44r, Biblioteca Nazionale Centrale, Florence.

The acquisition and construction of the palace was expensive, and part of its costs were passed on in the form of debts to Antonio's heirs, so that in 1509 his son Firmano declared 'numerous debts of 200 *lire* or less to shop-keepers, builders, brick-makers and other sorts of professionals, up to a total of 600 florins'.[59] It seems clear that Antonio's desire to build a new palace in the via del Capitano, somewhat removed from his family's enclave around the church of S. Pietro in Castelvecchio, was dictated by the specific desire to build himself a place at the heart of the new regime enclave. Such indeed is the impression given by Firmano, who stated that the magnificent building was 'finished in a manner and quality above our station, because of its site, and because our father thought he was doing a service to the city'.[60] Firmano's sister, Eustochia, confirms this impression of

Antonio as politically ambitious in her own observations, contained in her 1509 tax return, that her father was 'not very wealthy, not very sensible but ambitious'.[61]

By 1509 Bichi family finances reflected their renewed political activity, with a total of nine households declaring a total taxable wealth of only 20,250 *lire*, and enormous debts amounting to around 100,000 *lire*.[62] These debts were largely to Pandolfo Petrucci, and can be understood as financial underwriting of the *Novesco* regime. Antonio's considerable debts to Pandolfo (2,523 florins – about 10,000 *lire* – of which were passed on to Antonio's heirs), and involvement with him in business interests connected with alum and ore extraction, were combined with his investment in architecture on a prominently placed site near to Pandolfo's palace, and next door to that of Pandolfo's elder brother, Giacoppo.[63] Moreover, it also interesting to note that while no firm attribution can be made for the design of the Palazzo di Antonio Bichi, Francesco di Giorgio Martini was connected to the family in a number of ongoing projects, ranging from partnership in the mining industries of southern Tuscany to the decoration of the Cappella Bichi in Sant'Agostino, commissioned by Eustochia Bichi and her father in the late 1480s.[64]

As has been mentioned, both the palaces of Antonio Bichi and Giacoppo Petrucci are now incorporated within the massive structure of the Medicean Palazzo del Governatore. Some speculation surrounds the original ordering of the façade, but it is significant to note that the present arrangement closely resembles one of the design solutions proposed by Francesco di Giorgio in the Magliabecchiano manuscript of the *Trattati* (fig. 236–8).[65] The design employed a plaster skim that served both to cover all earlier modifications made to the façade, and may also have supported *all'antica* sgraffito designs that were increasingly popular among Siena's late fifteenth-century patrons. Within this regularized façade, windows and doors were given sculptural relief with simple sandstone round-arched frames, while each bay was separated by a simple panel pilaster, similar to those employed at the Villa Chigi 'alle Volte' outside Siena (see fig. 243). As is discussed further below, such elements as these can be understood as defining features of the *Novesco* domestic architecture.

Facing Antonio's palace was the 'the casa grande', the former Palazzo del Capitano, acquired from the Commune by the *Novesco* Tommaso Pecci in 1457, and extensively restored around 1476.[66] Palazzo Pecci was one of the most prestigious palaces of fifteenth-century Siena, and had been used as a temporary residence for honoured guests, such as Pope Pius II in 1460, Ippolita Sforza in 1465 and Eleanor of Aragon in 1473.[67] By the end of the century it had been divided into apartments

237. Designs for palace façade proportions, derived from Francesco di Giorgio Martini. MS. S.IV.6, fol. 27r, Biblioteca Comunale di Siena.

238. Designs for palace façades from the Trattati of Francesco di Giorgio Martini. MS. Asburnham 361, fol. 20r, Biblioteca Medicea Laurenziana, Florence.

and was lived in by Tommaso's numerous heirs.[68] While surprisingly little is known of this wealthy *Novesco* family in the late fifteenth century, Bartolomeo Pecci appears twice on committees established to oversee celebrations of urban significance in the early sixteenth century, in the company of other members of the new oligarchy, while Guido di Bartolomeo became *Operaio del Duomo* in 1517.[69] The palace was heavily restored in Gothic Revival style in the nineteenth century, and no traces survive of the post-1470s classicizing restoration.[70]

In turn, the Pecci palaces flanked a site for which Agostino Chigi 'the Magnificent' asked for a building permit in 1503, which was granted by a committee of three prominent citizens.[71] Agostino Chigi's banking and diplomatic activity in Rome greatly served Sienese interests, while in Siena he and his brothers were important financial backers of the Petrucci regime, as Ingrid Rowland has shown; the planned palace at Postierla was an expression of the family's close relationship with the regime.[72] The Chigi palace was eventually only built in the 1520s, by which time the other palaces around

piazza Postierla had been completely renewed by other members of the ruling group, including the Bardi, Nini and Borghesi.[73] Again, as with the Chigi, Petrucci and Bichi properties, the new Borghesi palace benefited from advantageous concessions of land, this time granted from the *Opera del Duomo*, which was closely controlled by the governing group, and Pandolfo Petrucci in particular.[74] Francesco di Giorgio's assistant, Giacomo Cozzarelli, is named as a witness in the *Opera* concession documents to the Borghesi, a service that Cozzarelli's recently deceased master had provided for other *Noveschi*.[75]

Cozzarelli's presence as a witness is insufficient to identify him as the architect of the Palazzo Borghesi, although there are clear similarities between the rectangular-framed *all'antica* style windows set into a somewhat austere façade and the arrangement of the Palazzo 'del Magnifico', which is traditionally assigned to him.[76] However, it is also important to notice that, as was shown in the previous chapter, the Borghesi and Bardi palaces stood out for the unusual and innovative fresco

façade decorations, which Vasari reports were carried out by Beccafumi and Sodoma respectively.[77] While no traces of these frescoes survive, a well-known drawing in the British Museum records the Borghesi design, which used classical figures and decorative friezes distributed around the stone-framed windows (see fig. 213).[78] No firm date can be given to these designs, although it seems probable that they were executed around 1512 or 1513, by which time a number of other façades in the city were decorated with *all'antica* style frescoes of this sort.[79]

This rapid survey of the means by which property was acquired by patrons involved in the redevelopment of the via del Capitano indicates the somewhat unorthodox practices employed for securing the necessary buildings and sites needed for constructing large new palaces in so central a location. These patrons shared a common strategy for the appropriation of formerly 'institutional' property, and they made architectural choices that collectively introduced new forms of palace architecture to Siena, as is outlined further in the final section of this chapter. Stylistically, as well as in terms of urban placement, the via del Capitano must be understood as a conscious move to develop an exclusive street for the city's new oligarchic group, and the fact that only the Pecci and Borghesi had a known residence in the area before 1487 further supports this suggestion. Such a reading of the area is corroborated by the fact that this alternative *locus* of authority was immediately recognized by the Medici after their conquest of Siena in 1555, when they established their governor's palace near the Duomo, rather than impose their presence on Siena's civic space *par excellence*, the Campo.[80]

If the via del Capitano was the prime residential street for the post-1487 crony-elite, that is not to say that the process of social stratification did not affect other districts and areas in perhaps more subtle ways. An illuminating example of a less polarized process of urban change can be identified in the via del Casato, one of the major 'tributaries' of the piazza del Campo. The Casato constitutes an interesting case of palace–street development, as it is known to have had a concentration of palaces along it from at least the twelfth century.[81] Indeed, it is tempting to think that its very name alludes to the *casati*, the city's magnate families that were excluded from government office in the ban-lists published in 1277, which opened the way for the city's fourteenth- and fifteenth-century republican regimes.[82] For sure, a number of the families known to have had palaces on the street in the thirteenth century were indeed from the *casati*, while the street's importance within the urban fabric was implicitly acknowledged by the fact that it was wider than most others.[83] Moreover,

as Samuel Cohn has recently shown, the Casato was the site of numerous social conflicts during the Trecento, as it was a street closely associated with the Nine, and thus reprisals against that group took place in that street after their disgrace in 1355.[84] While the development of the Casato from the thirteenth century deserves a full treatment elsewhere, it seems likely its precedents as a residential district for the city's nobles were a motivating factor in the way that the street's physiognomy changed during the late fifteenth and early sixteenth centuries.[85]

For tax purposes, the Casato was divided into two residential districts, the Casato di Sotto which is closest to the Campo, and the Casato di Sopra. The Casato di Sotto was regularly among the wealthiest districts in Siena during the period 1453–1509 that have been analysed here, and a number of residents in the district were among the top twenty wealthiest Sienese citizens. This situation was evidently the result of a combination of social and economic factors. On the one hand, the Casato was a residential district favoured by members of the city's socio-political elite as it was in a central location, had prestigious associations and was well maintained. In turn, being adjacent to the Campo, the economic and political centre of Siena, it was a convenient place to live for wealthy merchants and bureaucrats; it is no surprise to find bankers, wool and silk merchants as well as a number of notaries resident on the street. Moreover, a high number of those residents owned commercial properties both on the Casato and around the Campo itself. Shop space around the intersection of the Casato and the Campo – called the 'Bocca del Casato' – commanded premium rent rates, and the notaries' guild was also headquartered there.[86] Among the less wealthy residents of the street in 1481 were minor officials and attendants in the Palazzo Pubblico, such as musicians; a paper-seller called Agostino di Cenni had a shop, which presumably supplied the many notaries of the area, in spite of the fact that he complained of scant business as a result of the closure of the Studium.[87]

However, perhaps the most remarkable feature of the Casato is the degree of mobility of its residents; it is a commonplace that residential strategies in the premodern city were dominated by clan cohesion and ancestrally owned property.[88] Such an argument can certainly also be made in Siena for a number of families, although mobility of house or palace ownership was much more common than has ever been recognized. A number of reasons for the particular mobility of Casato residents can be suggested. One reason that emerges very clearly from the tax records for the Casato is the extraordinary number of exiles that Siena's political wrangling produced in the 1450s and 1480s.[89] For many, exile brought expropriation by the Commune, and the con-

sequence of this was that much property was sold on at auction; in the aftermath of the *Nove*'s return in 1487, at least five individuals resident in the Casato complained about having suffered such penalties.[90] Again, the consequences of exile and expropriation have not been studied from the point of view of the property market, but it seems clear that exiles' properties changed hands rather often during the period, and were only sometimes returned to the original owners.[91] Certainly, a number of the new residents of the via del Casato had been subjected to expropriation of their palaces in the years of their exile, and members of the Pecci, Pasquali and Tommasi families resident in the Casato all mentioned property losses on their return to the city after 1487.[92]

When seeking a pattern for the development of the Casato, however, it is not these dramatic 'surgical' alterations that appear to have made the most decisive impact, but rather it is the slower urban process that altered the social composition and architectural appearance of the street in the early sixteenth century. The Casato was neither an area where magnate clan enclaves (*castellari*) that might have developed during the eleventh and twelfth centuries survived, nor was it a place – with rare exceptions – where extended families took up residence during the fifteenth century. Indeed, evidence from the tax registers of the *Lira* indicate that there are very few cases of families growing in the area, and it is indeed more common to find those residents that could afford to moving to more prestigious locations or returning to the clan base of their already established families elsewhere in the city (see Appendix, table 7). Thus, for example, in 1453 Tommaso di Nanni Pecci, the third wealthiest citizen in Siena, lived in the Casato with other family members nearby; as mentioned earlier, in 1457 Tommaso moved to the more central Palazzo del Capitano, and by 1481 the clan had become firmly established around that palace.[93] Again, Caterina Piccolomini lived in the via del Casato until her brother was named Pope Pius II, at which time she moved away to her prestigious new palace on the via di Città.[94] While never resident in the Casato, as he was principally abroad and his tax returns show him resident in the district of S. Donato, the banker Ambrogio Spannocchi also owned property in the Casato, but nevertheless chose to establish his palace residence at the highly visible Banchi di Sopra location.[95]

These last cases must be considered exceptions, as sites as prominent as those acquired by Pecci, Piccolomini and Spannocchi were rare in the densely packed urban core, and the ability to secure them indicated the wealth and status of the individuals involved. With the possible exception of the Bargagli, Nini and Pasquali, however, the Casato was never chosen as the principal or repre-sentative residence of any one family until sometime after 1488. Thus, we see that the Bindi and Tommasi families, though firmly linked to the Casato, settled in greater numbers elsewhere in the city; even families with major banking interests on the Casato, like Venturini, Ghinucci or the Benassai, expanded as clans elsewhere in the city, while retaining banks and palaces on the Casato. By contrast, the growing number of elite family members on the Casato in the sixteenth century, such as the Piccolomini, Accarigi and Borghesi, can only be explained as being a result of changes to the street itself.

Documentary sources in fact indicate that an alternative to moving out emerged at some time after 1488, as attempts were made to raise the status and appearance of the Casato. Thus, surveying the architectural choices expressed in tax returns submitted by residents in the years up to 1500, the Casato resembles much of the rest of Siena. Complaints are regularly made about the high cost of maintenance, damp basements, prohibitive building costs and so on.[96] During this half-century, some of the wealthier residents of the Casato moved on to more prestigious locations when the opportunity arose. However, it appears that by the sixteenth century, a higher proportion of Casato residents were drawn from the socio-economic elite. This observation correlates closely with the fact that in the years up to 1480 only three *Ornato*-mediated renovations are documented along the Casato, while it is remarkable that tax returns of 1509 indicate that by this date nearly 30 per cent of residents (31 out of 115) were involved in renovating their homes or palaces.[97] The vast majority of these specifically mentioned the demolition of overhangs and that construction of new façades was underway. Thus, as Crescenzio di Bonaventura Borghesi eloquently put it, 'we are in debt for part of the house we have bought in Siena, which has cost us more than it would have repaired war damage, on account of our having to remove an overhang and other matters'.[98] It has not been possible to locate the legislation that enforced these demolitions, but it is nonetheless clear that this resulted from the extension of the *Ornato*'s activities from other important streets to encompass the Casato as well, as one Francesco di Baldassarre de la Seine reports that 'we have removed the overhang on account of the officials in charge of decorum (*quelli de l'onoranza*)'.[99] It is known that in 1507 the city government introduced stringent new measures that regulated trades exercised in the city centre, and required certain overhang-demolitions in the street that led to Pandolfo Petrucci's palace, 'pro maiori ornamento publico', measures that may also have extended to the Casato.[100] It remains, of course, to explain why the *Ornato* turned their attention to the Casato at this particular point in time.

Returning again to the data that can be collected from the *Lira*, it appears that in the period 1453–1509 the number of families resident in the Casato that filed a tax return with a family surname, an indicator of status and lineage, grew far more rapidly than in the rest of the city, rising from 31 per cent in 1453 to 64 per cent in 1509.[101] This can be taken as a gauge for the gradual gentrification of the via del Casato that reinforces the choice made by such neo-residents of the street as the Borghesi and Piccolomini. Furthermore, it seems that throughout the fifteenth century, residents of the Casato were especially involved in banking and merchant business in wool, linen and other cloths, with at least 35 per cent of all declarants stating some business in these sectors in 1453 and 1481.[102] As early as 1453, among those declaring their profession or investments in tax returns, one in three was involved in banking.[103] Both the Spannocchi and Pecci had major banking interests, while other resident bankers, such as the Benassai, were patrons of new palaces along the street.[104]

Tax evidence indicates that this concentration had developed further by 1509, by which time the Casato seems to have emerged as perhaps the main banking district of the city, with the *banchi* of the Chigi, Venturini, Benassai, Ghinucci and probably the Spannocchi operating in the area. Moreover, a remarkable number of residents in the street declared a specific patronage bond to Pandolfo Petrucci, which suggests that the Casato emerged as residential area with close ties to the new oligarchy.[105] Conte di Pietro Bargagli, for example, had recently renewed the façade of his house, and declared a debt of 200 florins with one of Pandolfo's businesses.[106] Less fortunate was Prospero di Niccolò, who had recently had to sell half his house to one Antonio Nuti in order to satisfy a debt with 'il Magnifico'.[107] The heirs of Conte Nini, on the other hand, declared a debt of 100 florins to Pandolfo's preferred religious institution, the nunnery of S. Maria Maddalena, left as testamentary bequest by their father. Connections might pass through other members of the Petrucci clan, so that Giovanni Battista di Francesco Guglielmi lived in a house on the Casato that he had acquired as part of a copious dowry from his father-in-law Petruccio Petrucci (Pandolfo's nephew, the son of Giacoppo) when he married Mariana Petrucci; Guglielmi was evidently a successful haberdasher (*pizzicaiolo*), and also owned a hotel in Pandolfo Petrucci's favourite thermal resort, the Bagni di S. Filippo.[108] Numerous other residents declared debts to the 'ligrittieri di piazza', which might refer to Pandolfo Petrucci's cloth business on the Campo, and others still were bound into the local financial network, through involvement in the activities of the Venturini, Borghesi and Chigi banks.[109]

Such examples as these indicate the variety of forms of patronage that might serve to bind a broad swathe of the city's economic hierarchy to Pandolfo Petrucci; the Casato seems to be a place where such connections were more widespread, but it is important to recognize to what degree such methods of patronage were used throughout the city to bind the quasi-prince to his allies.[110] It is evident that the concentration of merchant and banking wealth among Casato residents is the reason for the high incidence of patronage links with Petrucci, and it is surely for this reason that the Casato was favoured as a street ripe for urban renewal in the early 1500s. Thus can be explained the rehabilitation of the *Ornato*, who appear only rarely in documents after 1480, as the powers of that office were well suited to the rapid execution of a generalized renovation campaign of this sort. It is significant, however, that the *Ornato* now no longer applied rulings enforced in virtue of a shared sense of civic pride, but rather they operated to create a socially stratified enclave for bankers and merchants.

Among the many bankers that lived along the Casato, it is certainly the palace of Sigismondo di Mariano Chigi, brother of the well-known Rome-based banker and patron Agostino, that stands out as the most impressive. Agostino Chigi's recently published correspondence with his brother Sigismondo illustrates the complex political and financial relationship that bound Pandolfo Petrucci to the Chigi family and their bank.[111] The Chigi were prominently placed within the *Novesco* regime, and indeed Sulpicia Petrucci, one of Pandolfo's daughters, was married to Sigismondo Chigi in 1505, which may have provided the occasion for reordering

239. Unknown draughtsman, design for the façade decoration of the Palazzo Chigi al Casato, *c.*1650. Fondo Chigi, P VIII 17, fol. 31, Biblioteca Apostolica Vaticana.

ABOVE 240. Palazzo Chigi al Casato.

ABOVE RIGHT 241. Palazzo Chigi al Casato, detail of the portal.

BELOW RIGHT 242. Palazzo Chigi al Casato, internal courtyard.

the Casato palace (fig. 239–42).[112] For sure, both Agostino's planned palace at Postierla (discussed above) and Sigismondo's marriage alliance and new palace served to underline the prominence of the Chigi in Sienese affairs, while an acquisition campaign of huge proportions assembled a massive rural estate for the family, making them landowners on a scale that rivalled much of the city's nobility within just a few years.[113] Moreover, the architectural choices that were made for the Casato palace also served to reinforce connections between the Chigi and their allies.

The Chigi's property on the Casato had originally been bought by Mariano Chigi from Ambrogio Spannocchi in 1474, while further acquisitions in the 1490s enlarged the available site.[114] Centrally placed, adjacent to the Campo and close to many banking partners, such the Ghinucci, Venturini and Turamini, the site was both practical and magnificent. Moreover, the prominently

243. Villa Chigi alle Volte Basse, near Siena.

placed site would further have been improved if plans
to enlarge towards the Campo had not been thwarted
by city officials in 1504.[115] The site was developed by
Sigismondo and his brother Cristoforo from the early
sixteenth century, with a three-bay façade that was sub-
sequently enlarged by a further three bays by Massimo
Chigi in the seventeenth century.[116] It is not yet clear
when work on the palace was complete, although a tax
report of 1509 indicates that there was still building
work underway on the rear of the building, but that the
façade, which accommodated a number of shops, was
complete.[117]

As with many palaces along the Casato, the Chigi
palace had a double loggia on the upper storeys, facing
both the Casato and the countryside to the rear. In turn,
the façade was decorated with an elaborate sgraffito
design, which may have included scenes from Ovid
executed by Sodoma, who had also been employed for
internal decorations, as well as working at Agostino
Chigi's villa in Rome.[118] Evidence from a seventeenth-
century drawing in the Chigi collection illustrates
Sodoma's elaborate designs, which incorporated fictive

architecture, narrative scenes, family arms and decorative
friezes, marking the conspicuous and central Chigi resi-
dence with an elaborate and sophisticated *all'antica*
design.[119] On the corner between the Bocca del Casato
and the Campo, the palace decoration was easily visible,
while the fresco façade design allowed the patron to
reduce expensive stone detailing to the barest essentials
of the door frames and string-courses.

While it is not yet clear whose hand lies behind the
design of the Chigi palace, it is nonetheless evident that
the Chigi were among the most sophisticated patrons of
art and architecture in early sixteenth-century Siena.
One need only think of the Villa Chigi 'alle Volte Basse',
under construction during these same years and usually
attributed to Francesco di Giorgio Martini, to assess the
high quality, innovation and sophistication of other
family commissions (fig. 243).[120] Meanwhile in Rome,
Agostino Chigi's Villa Farnesina in via della Lungara
serves as a further reminder of Chigi's preference for
high quality and Sienese craftsmanship.[121] As we have
seen, Agostino himself planned to build a palace in
Siena on piazza Postierla, for which the necessary site

188

244. Palazzo Bardi al Casato di Sopra, 33.

245. Palazzo Agazzari al Casato.

had been acquired by 1503. In turn, it is evident that the architectural choices made for the façade – fresco design, rectangular framed windows, *pietra serena* details – were in line with the stylistic choices of the city's elite, such as the Palazzo Borghesi, the palace of Pandolfo Petrucci and the *casamento* of Andrea Piccolomini.

In fact the palace built by Sigismondo di Mariano Chigi participated in the urban process that renewed the palaces and houses that lined the via del Casato during the late fifteenth century and into the sixteenth. The decoration of palaces along the street perhaps had a public as well as a private role, since the Casato was the principal access for processional entries by city officials to the Campo.[122] Indeed, it seems that a number of owners of properties along the street took advantage of favourable locations, which were especially prominent in processions and other public events, by erecting especially visible façades.

Thus, the Late Gothic palace on a bend on the Casato di Sopra follows the curve of the street with a gently concave façade that displayed the family coat of arms, visible from both approaches along the street; the palace

was probably constructed for the Bardi family in the late fifteenth century, and used marble classicizing colonettes and capitals that stand out from Gothic brick-work and acute *bifore*, so as to attract attention to the new building (fig. 244).[123] Likewise, the Palazzo Agazzari, at the corner with the Costa Larga, also fills a corner site and adopted a decorated frescoed façade, which was almost certainly executed in the first quarter of the sixteenth century (fig. 245).[124] Like the Palazzo Chigi, the palace had a large open loggia in the attic storey and a façade decorated with *all'antica* style military trophies.[125] The intriguing Palazzo Ugurgieri (perhaps Benassai) is on a rectilinear stretch of the street, which allowed for a more regular design that adopted round-arched *bifore* with classicizing colonettes, a symmetrical façade arrangement, and also used a sgraffito façade decoration, as well as an open loggia to the rear (fig. 246).[126] The palace design suggests a date in the 1470s, since the arrangement of the façade is clearly derivative of the Palazzo Spannocchi, built during that decade under the supervision of Giuliano da Maiano.[127] To these more readily identifiable palaces must be added the residences of other bankers and merchants that made up the late fifteenth-century socio-economic elite, for whom the adoption of common stylistic solutions served to define the Casato specifically as a residential street for that group.

The via del Casato was developed along similar lines to the Strada Romana, as discussed in chapters Five and Six, that is with the aid of enabling legislative measures, but a more restricted social group had access to its renovation. Thus, if the Strada Romana constitutes an example of inclusive policy strategies that favoured urban renewal through collective patronage, the via del

246. Palazzo Ugurgeri or Benassai al Casato.

this a remarkable example. Furthermore, the urban and political process that brought the collective projects of the via del Capitano and via del Casato to fruition, was part of a more comprehensive transformation of Siena's government institutions, which saw the ascent of a sole leader, a *signore*, whose own strategies pushed these innovations to new ends. Thus, where Lorenzo de' Medici's projects for a grand urban palace were abandoned, in Manfredo Tafuri's words, in favour of the more understated 'humanist leisure and pleasure', Pandolfo Petrucci achieved the architectural expression of his pre-eminence in the city.[129]

Francesco di Giorgio Martini, the *Novesco* Oligarchy and the Architectural Style of Siena's Post-Republican Elite

At the beginning of this chapter we saw how, by the 1480s, Francesco di Giorgio Martini's fortunes had become closely bound to those of the *Novesco* faction, and that his return to Siena from Urbino coincided with that of his political allies. As the previous section has shown, the city's new elite significantly altered the urban fabric, underlining through architecture the status and authority invested in their tight-knit ruling group. While the active role of Francesco di Giorgio and his circle in the buildings discussed above still requires additional documentary support, it is nonetheless evident that he had an unchallenged position in the artistic life of Siena before his death in 1501.

Francesco was an important associate in a consortium established to manage mineral extraction in the southern Tuscan Colline Metallifere; with other specialists, such as Paolo Vannoccio Biringucci (father of the author of the minerology treatise *Pirotechnia*) and Paolo Salvetti (a specialist in iron foundry), but also with major stakes in the hands of such individuals as Pandolfo Petrucci or the banker Angelo Benassai, this partnership cut transversally between the social and cultural elites of the city.[130] Similar economic interests almost certainly lay behind the extraordinary plans for a massive dam in the valley below Montemasi, across the Bruna river, while it seems probable that Francesco's appointment as *podestà* to Porto Ercole (also in southern Tuscany) was related to intelligence and military issues.[131] It is certainly such matters that are best documented for Francesco's late fifteenth-century career in Siena, as he is reported in the company of Paolo Vannoccio Biringucci on a number of site surveys for fortification of the Sienese *contado*, operating as a consultant member of the powerful financial office of the Camera del Comune.[132] Viewed in this context, we can perhaps begin to see that

Capitano exemplifies its opposite, as an exclusive enclave renewed by the crony-patrons of the Petrucci circle. Between these two extremes the case of the via del Casato charts the more gradual process of social stratification and a widespread shift of patronage strategies and social ambitions, as it illustrates the degree to which social hierarchy came to be overlaid on the city fabric through the development of palace streets by the urban elite. Such a process was by no means unique to Siena; the development of the elite residential streets and enclaves in Laurentian Florence and papal Rome, or the somewhat later Strada Nuova in Genoa, illustrate a similar and contemporary process of stratification and segregation in other centres.[128]

Nevertheless, within the context of fifteenth-century Siena's broad-based system of political conflict and consensus, the changes in the patterns of elite architectural patronage, and the means by which these transformed the physical and symbolic essence of the city, makes

Francesco was assigned an important position within the city's government, and supervised such profitable enterprises as mining, military architecture and civil engineering. Francesco's close connections with Biringucci led to his naming him his legal procurator, so that Francesco could leave Biringucci in control while travelling outside Siena.[133]

Evidence of this sort seems to indicate that Francesco may have had an official role as 'architector' within the Camera del Comune, perhaps serving there as a contractor/designer, as he did for the reordering of the cathedral's High Altar.[134] Indeed, it is interesting that Francesco was not made master of the cathedral works, but it was his trusted assistant Cozzarelli that took up the post in 1499, applying his master's project for a number of years after Francesco's death in December 1501.[135] While no documents have yet emerged to link Francesco to any specific architectural project within Siena's city walls, his role as consultant architect has been posited by Mauro Mussolin for the design of the Dominican Observant complex of S. Spirito, and Tafuri also claimed such a role for the initial design of S. Sebastiano in Vallepiatta.[136]

Without attempting to come at the problem from the question of attribution, it is perhaps possible to begin resolving the issue by looking at the structure of patronage within which Francesco seems to have worked in these years in Siena. As has been suggested, Francesco di Giorgio Martini emerges from the documents with a status that sets him as an equal to business and political associates, all of them members of the new oligarchy. Rather than be contacted project by project, Francesco was a part of the decision-making process that resulted in his employment; he was a *member* of the oligarchy. By setting the terms of discussion in this way, it becomes significant that Francesco (and on other occasions his assistant Cozzarelli) is documented as a witness for a number of sales that resulted in the development of via del Capitano palaces by the Bichi and Borghesi. It is not clear precisely what sort of relationship such evidence points to, but it is possible that these architect/contractors were informally providing advice to patrons. In this regard it is worth remembering that in 1508 Cozzarelli appeared as a witness to a document in which Pandolfo Petrucci recognized outstanding debts to Domenico di Bartolo da Piacenza, in connection with building work at S. Spirito, the Palazzo del Magnifico and the Osservanza Sacristy.[137] While this has frequently been cited as conclusive evidence of Cozzarelli's authorship of these buildings, it more likely suggests that he was a contractor, filling a role in Petrucci architectural commissions that had previously been the task of Francesco di Giorgio.

Indeed, in August 1497, a committee made up of Siena's most powerful oligarchs – Pandolfo Petrucci, Iacomo Piccolomini and Antonio Bichi – was responsible for the plans that led to the substitution of Duccio's *Maestà* with a sculpted altar arrangement designed by Francesco di Giorgio Martini, which in part can still be observed.[138] The High Altar project included a number of expensive cast-bronze sculptures of angels (*spiritelli*), and Francesco di Giorgio both masterminded the design and the production of these, with the practical assistance of Giacomo Cozzarelli.[139] Francesco's plans continued to be observed following his death in 1501, and when in 1506 Pandolfo Petrucci took over from Aringhieri as *Operaio*, he ensured that the project was seen through to its conclusion.[140] As such, it would seem that the removal of Duccio's masterpiece should be understood as a politically charged patronage decision, and that the powerful triumvirate that oversaw the plans linked that choice to the governing oligarchy and its emerging leader, Pandolfo Petrucci.

Outside the cathedral, the growing devotional and patronage requirements of the city elite lay behind the construction of a number of churches and the expansion of numerous others, a continuous process through the second part of the fifteenth century, which seems to have been more accentuated in the last quarter-century.[141] Here again, Francesco di Giorgio played an important role. New classicizing portals marked the completion of expansion works on S. Francesco, S. Agostino and S. Spirito between the 1480s and 1516, and as Mussolin has noted, specific governmental *Balìa* committees were elected to oversee construction and restoration of S. Spirito, S. Francesco and S. Maria dei Servi in January 1499, perhaps indicating the elite's particular concern with the renewal of these churches.[142] In addition, S. Sebastiano in Vallepiatta and S. Sebastiano in S. Lorenzo, S. Maria Maddalena at Porta Tufi and S. Maria in Portico were built *ex-novo* between 1479 and 1514. This creation of new ecclesiastical space provided numerous new chapels for pious patrons desirous of self-commemoration, and resulted in the production of many altar panels and fresco cycles.[143]

It is even possible that factional divisions and political allegiances were transferred to such commemorative religious settings, as has been suggested by Mussolin for the church of S. Spirito, whose side chapels, rebuilt from 1499, were largely patronized by *Noveschi*.[144] The Observant Dominican monastery of S. Spirito ai Pispini provides an illuminating example of what might be described as the politicization and factional response to the patronage of sacred spaces (fig. 247–8). Construction of S. Spirito's new monastic buildings was undertaken between 1462 and 1494, and benefited from consider-

247. Church and convent of S. Spirito ai Pispini.

construction of the dome and choir.[147] Pandolfo thus chose to direct his patronage at the highly visible dome, where his coats of arms were prominently displayed, while also exerting some pressure on his peers to assist the project to its completion.

The S. Spirito project can be seen to transfer the dynamics of political patronage to the artistic sphere, as Pandolfo Petrucci's emergent role as leader of the oligarchy permitted him to assume visible control of the church by selecting the dome for his patronage, while a number of the church's chapels were commissioned by his allies. *Novesco* interference with the patronage process seems to have become crucial by the last decade of the fifteenth century, as is shown again in the case of the Arte dei Tessitori Pannilini (Linen-weavers' Guild) church of S. Sebastiano di Vallepiatta (fig. 249).[148] Here, Andrea Piccolomini, Niccolò Borghesi and Luca Vieri were elected as a committee to supervise the construction of a guild church, which was also promoted by Pandolfo Petrucci; again, the committee members were all connected in a network of working relationships with Francesco di Giorgio Martini, to whom the first construction phase for the crypt level is credibly attributed.[149] The S. Sebastiano commission would seem to confirm a growing scholarly consensus that places Francesco di Giorgio in close contact with the *Novesco* oligarchy, as a technical consultant on various engineering and architectural projects, as well as a vital point of reference for artistic commissions.[150] Francesco's close associations with the governing elite are well docu-

able public subsidies. It was not until 1499, however, that the new church was begun, under the supervision of a lay group of *operai* appointed by the government *Balìa*.[145] The close ties between the *operai* and the oligarchy meant that many of the chapels in the new church received the patronage of *Noveschi* and other families from the city's new ruling group.[146] From among these, Pandolfo Petrucci played a prominent role in attracting *Balìa* and elite patronage to the church, and himself provided funds between 1499 and 1500 for the

248. Interior view of S. Spirito ai Pispini, showing Petrucci arms in spandrels of the dome.

249. S. Sebastiano in Vallepiatta.

mented, and were tangibly expressed in his centrally located home, adjacent to Pandolfo Petrucci's palace.

So what was the dominant style of these years in Siena? As we have seen, a somewhat severe *all'antica* palace style was favoured by *Novesco* patrons; simple façades, articulated by *pietra serena* rectangular-framed details predominate, although it is likely that many of these received surface decoration in fresco. As Francesco Paolo Fiore has quite naturally observed, Urbino is the obvious place to look for the origins of this style, within the court setting of Federigo da Montefeltro's architectural patronage of Francesco di Giorgio.[151] His working technique in Urbino can well be compared to the role as contractor/architect described above. The many projects with which he was involved in Urbino and the Marche show that he evidently delegated work to his assistants, many of whom were indeed brought from Siena, and returned with him around 1487.[152] The stylistic debt of Pandolfo Petrucci's palace to the bath complex in Urbino's Palazzo Ducale, for example, is examined in the Conclusion, while numerous scholars have noted the analogies that link Siena's S. Bernardino all'Osservanza to the church of the same name in Urbino.[153] In both secular and religious buildings Francesco di Giorgio drew on his growing knowledge of antique architectural precedents to define a sparse and undecorated *all'antica* style that broke dramatically from the surface decoration with classicizing motifs favoured by Federighi. Thus, the central role that Francesco di Giorgio assumed in the political and artistic patronage network of *Novesco* Siena both served to determine the stylistic coherence of that group's architectural choices, and in turn radically altered the face of the city.

Conclusion

The Prince and the City

PANDOLFO PETRUCCI, 'IL MAGNIFICO'

*After many changes, whereby first the plebs governed, then the nobles, now the
nobles have come out on top: from among these Pandolfo and Iacoppo Petrucci have
acquired more authority than the others, the one on account of his prudence,
the other for his brave spirit, so that they have become like princes of that city.*[1]

Pandolfo di Bartolomeo Petrucci was the first citizen in
Siena's history to rise to a position of virtual supremacy
within the city's republican system of government. He
returned to Siena from exile, with other members of the
Monte dei Nove, on 22 July 1487, and in the admiring
words of Machiavelli, who saw him as an ideal prince,

> He was given the command of the palace guard, as if
> it were a menial task, which others had refused; nev-
> ertheless, with time, those armed men gave him such
> reputation and authority that before long he became
> prince of Siena.[2]

Recent scholarship has conclusively shown and doc-
umented Pandolfo's rise to a position of *primus inter pares*
in Siena by use of existing city institutions and offices,
supported by the military security afforded by control
of the palace guard.[3] The latter was facilitated by his
considerable private wealth, part of which was drawn
from his involvement in the iron ore extraction and
casting industry.[4] By 1496, following Charles VIII's visit
to Siena but before the death of Pandolfo's elder brother
Giacoppo (25 September 1497), the Milanese Ambas-

sador wrote to Lodovico il Moro that 'Pandolfo who,
on account of the fact that he has almost total control
of everything in this city, is thus the individual who has
been and remains the principal leader of all Your Excel-
lency's friends and servants', while in 1498 the Venetian
Marin Sanudo was able to write of him that 'at the
present time he is everything in Siena'.[5]

Pandolfo and his brother Giacoppo were not the first
members of the Petrucci family to aim for power in
Siena during the fifteenth century, for Antonio di Cecco
Rosso Petrucci had led his unsuccessful coup in 1456 and
been exiled as a consequence.[6] It is not clear whether
punitive action was taken against the Petrucci clan as a
whole, although the family's total declared wealth in 1481
was considerably lower than it had been in 1453, sug-
gesting at least some decline in its fortunes.[7] The tradi-
tional properties of the family had clustered around the
baptistery area, in the three neighbouring districts of S.
Giovanni, Porta Salaria and S. Pellegrino; tax returns of
1481 reveal their reduced control over these areas, with
only three families declared resident there, although by
1509 nine Petrucci households were back. It is not clear

FACING PAGE 250. Church of the Osservanza (La
Capriola), rear view showing Petrucci extension to the
monastery on the left.

251. Church of the Osservanza (La Capriola), sacristy with Iacopo Cozzarelli's *Lamentation of the Dead Christ*.

what process was adopted to reclaim control over the clan area, but Giacoppo's acquisition of a nearby site for the construction of a palace on land previously belonging to the Spedale della Scala indicates that their power within the *Novesco* oligarchy combined with increased Petrucci financial fortunes to enable them to renew their base in their traditional area of residence by acquisitions and new constructions.[8]

As we have seen in the previous chapter, Giacoppo's palace was strategically placed on the via del Capitano, and was part of a widespread overhaul of the street at the hands of the new oligarchy. Similarly, the tight-knit group of *Novesco* leaders extended their patronage to major religious architectural projects, which can be understood also to have coalesced the visible presence of the city's new regime in the public space of the city. While patronage at S. Spirito and S. Sebastiano was to an extent collegial, bringing together members of the city's new oligarchy, Pandolfo's strategies for his familial and individual ecclesiastical patronage lend themselves to a sequential treatment that tracks his political ascent in parallel with his growing patronage control over religious institutions.[9]

When Antonio di Cecco Rosso Petrucci died in 1457, he was buried in the suburban monastic church of the Osservanza, founded by S. Bernardino on the hill of La Capriola outside Porta Ovile (fig. 250).[10] The Franciscan Observant monastery was dignified with the construction of a new church, begun in May 1474 and completed by 1488, and considered by numerous scholars to be Francesco di Giorgio Martini's most important Sienese project before he left for Urbino.[11] In 1494 the church of the Osservanza was damaged by lightning, and Pandolfo Petrucci became involved in its restoration. At this time Pandolfo also commissioned the construction of a sacristy with a crypt and new monastic quarters, for which an inscription around the sacristy furniture indicates a completion date of 1497.[12] Patronage at the Osservanza was not exclusive to Petrucci, since other prominent *Novesco* families, such as the Luti and Borghesi, were patrons of chapels there.[13] Indeed, the monastic complex itself may even have served as an informal meeting place for Pandolfo's close circle, since the plot for the assassination of his main rival, Niccolò Borghesi, was hatched there, and it has somewhat fancifully been suggested that the monastery was linked to Pandolfo's palace by an underground tunnel.[14]

By contrast, the sacristy does appear to have been the product of Pandolfo's exclusive patronage; it is a rectangular room with a vaulted ceiling supported on hanging capitals bearing the Petrucci arms (fig. 251–2). The sacristy was commissioned to perform a double function, both as the burial place for Pandolfo, under a simple tomb slab with the inscription 'UT SUA POSTERITAS SECUM REQUIESCERET URNAM. HANC SIBI PANDULPHUS IUSSIT ET

ESSE SUIS', and as a means of preserving the only Sienese relics of S. Bernardino.[15] Thus, already by 1497, Pandolfo was in a sufficiently powerful position to plan a personal burial site associated with one of Siena's most important saints. Beneath the sacristy he built a crypt for use by the Petrucci, thus creating a double-tier family mausoleum, with the upper room clearly devoted to its most prominent member.[16]

Pandolfo's choice of endowing the Osservanza and creating his family mausoleum there may be understood in relation to other examples of burial chapels built for Italian princes during the same period.[17] The sacristy has much in common with another Observant Franciscan church, that of S. Bernardino at Urbino, which had recently been completed for Federico da Montefeltro by Francesco di Giorgio.[18] Both Pandolfo and Federico endowed suburban Observant churches dedicated to poverty, constructing burial sites clearly marked by family arms and *all'antica* inscriptions, and providing also monastic buildings. However, one important difference should be noted, and that is the Petrucci precedent for burial in the Osservanza. While the scale of Pandolfo's patronage marked his growing wealth and power in the city, his patronage at this date remained associated with his family and Antonio di Cecco Rosso's burial choices, although it is not clear to what extent Pandolfo intended consciously to refer to his ancestor, and his ancestor's attempts to assume power in Siena.[19] Nonetheless, viewed through the filter of Francesco Patrizi's projection of *Novesco* ambitions, it is likely that Pandolfo consciously viewed his ancestor as a precursor for his political project.

Certainly, from 1507, Pandolfo Petrucci's patronage at the convent of S. Maria Maddalena, outside Porta Tufi, was far less circumspect, and it reflects the quasi-princely status he had risen to in Siena.[20] Very little is known about this church and convent, primarily because both were demolished in 1526 on account of their strong connections with the deposed Petrucci family and *Nove* regime.[21] Following the *Nove*'s return to Siena in 1487, which had taken place on the feast day of Mary Magdalene (22 July), the saint was given special consideration by the ruling elite; in August 1492 the *Balìa* established that a *palio* should be run in commemoration of their return, while in July 1505 they assigned funds to make a silver statue in honour of Mary Magdalene to be erected in the Duomo.[22]

However, while S. Maria Maddalena may have been honoured as a *Novesco* feast, architectural patronage of the convent appears to have been directly related to Pandolfo, and the chronicler Sigismondo Tizio specified that the convent was 'built by Pandolfo Petrucci'.[23] Vasari attributed the design to Giacomo Cozzarelli, although

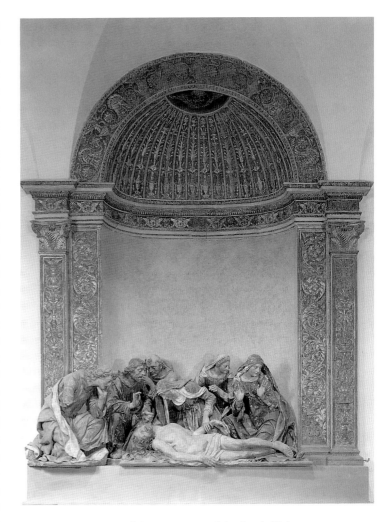

252. Iacopo Cozzarelli's *Lamentation of the Dead Christ*. Note the Petrucci arms in the capitals of the pilasters framing the altar.

this cannot be confirmed from documents, while Tizio further stated that construction began in September 1507, adding that two months later construction was underway in the cloister.[24] In 1507–8 Pandolfo interceded with Pope Julius II for the concession of indulgences to visitors to the convent, which were granted in February 1508.[25] He also decreed the suppression of the nunneries of S. Caterina a Laterino, S. Prospero, S. Mamiliano in Valli, S. Margherita ai Tufi and SS. Trinita d'Alfiano, ordering the relocation of their communities to the convent of S. Maria Maddalena.[26] Finally, Pandolfo left 2,200 gold florins in his will for completion of church and convent, which was drawn up on 2 October 1511, suggesting that work was not yet complete at that time.[27]

In 1526 an anonymous nun described 'our beautiful church, all built of travertine stone, made in a beautiful way at the command and for the devotion of the

Magnificent Pandolfo Petrucci, at his expense and during his lifetime'.[28] At S. Maria Maddalena, Pandolfo personally took over the patronage of a church whose dedicatee was the patron of the political regime of which he had become the leader, and his assumption of patronage there reflected his increased political control of the elite. Pandolfo endowed the convent; his cousin, Girolama di Bartolomeo Petrucci, was Mother Superior.[29] Reflecting his ruthless political choices, Pandolfo even appears to have forced the unfortunate Mariana Bostoli to dissolve her marriage in order to ensure that she could join the monastery and bring it her considerable dowry.[30] In these respects, then, his patronage of the convent marks a decisive step towards the architectural definition of his regime as princely, rather than oligarchic, as is illustrated further by his residential choices.

Pandolfo must originally have lived in his father's house on the via dei Pellegrini, which formed part of a Petrucci property block along that street, terminating on the corner of via di Monna Agnese with a house known as 'Casa Petrucci' (fig. 253).[31] In October 1482 Pandolfo bought his first property in the area, to the east of his father's house, paying 300 florins to Antonia, the widow of Benedetto Petrucci.[32] Soon after this sale went through, Pandolfo was exiled from Siena, returning in 1487 to inherit all or part of his father's house when his father died in 1495.[33] By April 1503, following another brief period of exile forced on him by Cesare Borgia, Pandolfo returned to Siena, and in the

253. Palazzo Petrucci and the piazza S. Giovanni, detail from F. Vanni, *Sena Vetus Civitas Virginis*, fig. 10.

words of the Observant Dominican prior, Roberto Ubaldini, assumed the position of 'urbis primarius'.[34] Subsequently, around 1504, a series of acquisitions from the Accarigi family seem to have allowed Pandolfo to gain control of the entire property block that reached to the corner of via dei Pellegrini on piazza S. Giovanni.[35]

In 1481 Antonio di Bonaventura Accarigi had declared ownership of a 'house in Porta Salaria that is falling apart and is impossible to rent out', worth 2,000 *lire*, as well as 'the house next door that needs to be restored on account of the fact that the tower of the palace has collapsed'.[36] It was these properties that Pandolfo almost certainly bought in 1504, so that by November of that year he owned all the property required for his palace, and construction work probably commenced that same year.[37] The contemporary chronicler Sigismondo Tizio reported that construction of the palace was already underway by January 1505, as Pandolfo used materials from the *Opera* stone workshop, taking advantage of his position as *Operaio*.[38] Additional evidence of Petrucci's use of that public office for private ends comes from a document that lists tools loaned from the *Opera* builders' yard to builders working on the 'house of Pandolfo'.[39] He also appears to have siphoned rainwater from the cathedral and baptistery roofs to fill a private cistern in his palace courtyard, again causing some public outcry.[40] A further privilege was granted two months later, on 20 March 1506, when permission was given for Pandolfo to cut wood in the protected forests of the Monte Amiata, which had in the past been used for the beams of the cathedral roof, 'from which it would be possible to cut 20 *canne* of beams and 200 cross beams for the roof of his house'.[41]

On 14 December 1508 Pandolfo acknowledged a debt of 2,731 *lire* to Domenico di Bartolo da Piacenza for building work at the Osservanza, S. Spirito and at his palace, although this date probably does not mark the completion of his residence.[42] Nonetheless, it is probable that a first construction phase was complete by the end of 1507, as notarized documents were drawn up 'in the room known as the tower room' and 'in the upper room of *domina* Aurelia', which confirm that the two residential *piani nobili* – one inhabited by Pandolfo and the other by his wife – were in use.[43] After this time, additional building work as well as decoration of a suite of rooms to create an additional apartment inside the palace preceded the wedding of Pandolfo's son, Borghese, to Vittoria Piccolomini on 22 September 1509.[44]

The palace in its present form was thus evidently developed for the most part during the first decade of the sixteenth century, by reordering pre-existing buildings, many of which were longstanding Petrucci pro-

254. Palazzo del Magnifico Pandolfo Petrucci, façade.

perties. The Palazzo del Magnifico, as it came to be known, is an unusual residence for a leading citizen and defies easy comparison with other contemporary princely palaces.[45] It is neither freestanding nor was it built from scratch, its façade is not dressed in expensive stone, and the internal arrangement of rooms was largely dictated by pre-existing structures (fig. 254). Its setting

255. Palazzo del Magnifico Pandolfo Petrucci, arms in andito.

was firmly associated with family: its height, and the incorporation of the Accarigi tower as the central block of the palace, and the placement of the portal on this axis, gave Pandolfo's palace a veneer of ancestry, which reinforced the permanent association of the site with the Petrucci family.[46] Furthermore, the need to house an extended family and large household was acknowledged in the complex five-storey plan, which included cellars

256. Palazzo del Magnifico Pandolfo Petrucci, portal.

on the ground floor, a service mezzanine, two *piani nobili* and an attic storey.[47] The palace's placement also reduced its impact on the urban stage, as the via dei Pellegrini is narrow, and thus visibility was a problem that needed to be addressed.

Nonetheless, it is also true to say that the palace's appearance today hides much of what must have been its original magnificence (fig. 255–9). Pandolfo's palace combined traditional Sienese magnate architectural solutions with a contemporary 'courtly' architectural style, most notably that employed in the Palazzo Ducale at Urbino (fig. 260–1).[48] Thus, the centrally positioned

257. Palazzo del Magnifico Pandolfo Petrucci, horse-stay, in a photograph by Paolo Lombardi, *c.*1860.

tower – through which the main portal was cut, and within which Pandolfo's private study was set on the second floor – reinforced the lineage and ancestral presence of the Petrucci at the centre of Siena's urban fabric. While not all the property on the baptistery square belonged to Pandolfo, the long via dei Pellegrini façade suggested his ownership of the entire block, which may also have been accessible from the rear, towards the Duomo and Giacoppo Petrucci's palace.[49] This accent on family and ancestry was updated by stylistic choices that dignified the palace as a princely residence that combined elements from Francesco di Giorgio's architecture for the Montefeltro at Urbino with the most innovative and sophisticated decorative *all'antica* façade solutions that were beginning to be used in early sixteenth-century Rome.[50]

The via dei Pellegrini façade was plausibly decorated with *sgraffito*, as the considerable areas of open wall space are ideally suited to a treatment similar to the fictive sculptural scenes of the palazzo Borghesi, as illustrated in Domenico Beccafumi's design (see fig. 213). With that façade it also shares the simple articulation with *pietra serena* string-courses, rectangular window frames and cornice, a reduced and simplified *all'antica* language of architecture that evokes the order of the 'facciata ad Ali'

of the Ducal palace at Urbino. Perhaps the most original introduction, however, are the strong horizontal bands that underscore the window sills, that seem to create a stripped down frieze element that binds the façade together, in the manner outlined by Francesco di Giorgio in his discussion of 'recinti', string-courses that wrap around buildings like belts.[51] The façade was further enriched by numerous elaborate iron horse-stays and flag brackets cast by Giacomo Cozzarelli, without a doubt the most beautiful of their kind in Siena (fig. 257).[52]

Internally, the palace was arranged around an expanded light well or courtyard, faced on one side by a cantilevered loggia, which is structurally similar to that of the Ducal palace at Gubbio, although much simplified in form (fig. 258).[53] As at Gubbio, where Francesco di Giorgio used contrasting tonalities of building materials to create a simple and legible graphic effect, the architect of Pandolfo's palace employed the contrasting dark *pietra serena* and white stucco to carve out an ordered courtyard from a cramped situation. The loggia, which has since been closed, was the main circulation feature for the building, with the principal staircase rising to its western side and access to the apartments from its various levels.[54] The varying steepness of the flights of stairs suggests that these must have been inserted into the pre-existing building, without adapting the levels of the floors. Thus access to the second *piano nobile* and Pandolfo's apartment was via an unusually steep flight of stairs that rise from a rectangular *salone*, which suggests the integral reuse of an earlier staircase. Throughout the palace, the internal space was articulated by *pietra serena* pilasters and cornices, a number of which bear the Petrucci arms; observation reveals substantial modifica-

258. Palazzo del Magnifico Pandolfo Petrucci, cantilevered loggia.

259. Palazzo del Magnifico Pandolfo Petrucci, façade towards baptistery, showing walled-in loggia on third floor (before restoration).

Cozzarelli assumed control of a number of important Sienese projects, including the reordering of the cathedral High Altar, and was still active defending his master's interests in an inheritance dispute as late as 1513.[57] Furthermore, beyond formal similarities between the architecture of Urbino and the Palazzo 'del Magnifico', it is also evident that the way architecture and internal decoration were coordinated for the Siena project owed much to the managerial skills displayed by Francesco at Urbino, where multiple projects were seen to completion by teams of artists, many of them imported from outside the city.[58] A well-known cycle of frescoes painted by some of the most famous artists working at the time in Italy – including Signorelli, Genga and Pinturicchio – adorned Pandolfo's apartment, while intricately carved wood-work architectural elements, a coffered ceiling and *intarsia* panels were provided by Antonio Barili; the floors were covered with expensive maiolica tiles, richly ornamented with Petrucci arms and *grottesche*.[59] Very little of this magnificent decorative complex survives *in situ*, since the Palazzo 'del Magnifico' was first sacked by an angry rabble in the 1524 and was definitively despoiled by its impoverished aristocratic owners during the nineteenth century, when all

260. Palazzo Ducale, Gubbio, cantilevered loggia in the courtyard.

tion to the original layout, which has resulted in the clumsy superimposition of details. In spite of these alterations, the simple contrast of white walls and grey stonework, as well as the stripped down classicizing architectural detailing, bear a striking comparison to some of the rooms designed by Francesco di Giorgio Martini in the Ducal palace at Urbino (fig. 261). In this regard, the thermal complex at Urbino is most illuminating; broad panel pilasters and narrow pilaster strips modulate the space, while vertical frieze elements intersect these to a form of simplified capital. There are certainly analogies with the treatment of wall surfaces in the Palazzo 'del Magnifico', although it is difficult not to agree with Tafuri's assessment of this architecture as revealing the 'impoverished' use of Francesco di Giorgio's language employed by his assistant, Giacomo Cozzarelli, to whom the palace is traditionally attributed.[55]

Cozzarelli had worked as Francesco's assistant in Urbino, remaining there to continue supervision of projects underway when his master returned to Siena in 1487.[56] Following Francesco's death, late in 1501,

261. Palazzo Ducale, Urbino, bath complex.

the furnishings that could be prised from the walls were sold on the international art market.[60]

If the design and original furnishings of the palace described it as a sophisticated and cosmopolitan residence whose magnificence underlined the position of its owner as a leading figure in Siena, and on the Italian political stage, its urban placement and the manner by which this was enhanced, served further to reinforce Pandolfo's ascendancy in the city. The palace itself had a significant setting, adjacent to the baptistery and piazza S. Giovanni, the public and civic space through which all newborn Sienese passed before joining the citizen body through baptism. The façade of the Palazzo 'del Magnifico' significantly appropriated that space by means of an ample loggia, opened along a room of the second *piano nobile* where Pandolfo lived, which overlooked the piazza.[61] In this way, the loggia subtly reconfigured the civic space to perform also in private or princely occasions, so that, for instance, it is known that in February 1515 Isabella d'Este watched a play, staged

on the piazza S. Giovanni, from the palace loggia.[62] The palace thus took advantage of existing public space, applying to it private functions; Pandolfo Petrucci seems also to have interfered decisively in the definition of the urban context of his palace by means of a series of zoning restrictions, *ballatoio* demolitions and street-straightening policies, enforced from September 1507.[63]

A first zoning provision issued by the *Balìa* established that the area adjacent to the baptistery and leading to it from the piazza del Campo along the via dei Pellegrini should, on aesthetic grounds, no longer contain the workshops of butchers, blacksmiths, linen-makers and a number of other professions.[64] A general ban was subsequently also issued against cobblers and linen-makers along the Strada Romana from the Croce del Travaglio to Porta Camollia.[65] Sigismondo Tizio, whose critical opinion of Pandolfo is well known, recognized that these measures were intended to make the via dei Pellegrini more luminous and less cluttered, so as to improve the visibility of the palaces that lined the street, but also pointed out that the principal beneficiary of the programme was Pandolfo himself.[66] The demolition of overhanging structures, and the removal of professions whose activities invaded the public space of the street, favoured the creation of a visual axis from the Campo to the Palazzo 'del Magnifico', extending further the visual impact of that new seigneurial residence. It is significant that to achieve this, Pandolfo harnessed long-established urban policies for the improvement of streets that had originally been promoted for a collective or civic benefit, as along the Strada Romana during the 1460s and 1470s. Government-enforced zoning procedures thus ensured the dignified access to the building from the Campo, improved its axial alignment to the Palazzo Pubblico, and generally helped to insinuate the Palazzo 'del Magnifico' into the position of the prince's palace and a site of government.

In fact, it seems that the palace served as something more than the residence of Pandolfo and his close family. Pandolfo remained active in business throughout his political career, through a variety of interests that ranged from banking to the wool industry and mining; notarial documents drawn up in the 'camera dicta de la torre' suggest that business and political transactions were in part conducted from his quarters on the second *piano nobile* of the palace.[67] These many interests evidently required the full-time service of two or three secretaries, accountants and scribes, and it seems likely that rooms designated in a 1514 palace inventory as 'cancellaria' and 'scriptoio di Ambrogio Smeraldi' served for government as well as business purposes.[68] Pandolfo's palace may increasingly have been used for government

262. Lorenzo Pomarelli, design for portico around the piazza del Campo (*c.*1547?). Opera Metropolitana di Siena.

business, and certainly lodged a large household, including a tailor and baker and considerable catering facilities.[69] It might thus be proposed that the palace became an alternative *locus* of government to the Campo and the Palazzo Pubblico, whose public and government functions were reduced.

A decision of October 1508 seems to confirm this impression, as Pandolfo was nominated to take charge of a special commission of three citizens elected to supervise a project that was to lead to the construction of a classicizing portico around the piazza del Campo.[70] The wording of the decision pointed to the great honour and decorum that would accrue to the city as a result of the portico, which would have changed the piazza into a 'forum'; funding for the project was immediately made available in the form of 900 florins per year from the salt taxes.[71] Furthermore, the fact that this project was approved about a year following the via dei Pellegrini zoning and street improvement policies seems to argue in favour of the likelihood that these plans were ideally linked, and that they served to define a new relationship between the traditional civic centre at the piazza del Campo and the relocated focus of power in the Palazzo 'del Magnifico'.

Actual construction of the portico appears to have advanced no further than the preparation of a number of columns, which are thought to have been reused during the 1530s for the church of S. Maria dei Servi.[72] Drawings by Baldassarre Peruzzi and a follower of his named Lorenzo Pomarelli suggest that the project would have involved masking the Palazzo Pubblico with a classicizing façade, and encircling the Campo with a continuous

arcade, which might have been intended to support terraces (figs 262–3).[73] Some questions continue to surround the surviving drawings connected to this project: Christoph Frommel argued that both the Peruzzi and Pomarelli drawings are to be related to the 1508 plan, although they were only produced in the second quarter of the sixteenth century.[74] It has been argued, in contrast, that a drawing by Pomarelli in the Museo dell'Opera del Duomo should be connected to an unsuccessful attempt to revive the project in 1546, and it is plausible that it was at that time that a series of drawings now in the Biblioteca Comunale of Siena were produced.[75]

It is thus fair to say that none of the extant visual sources can be dated directly to the 1508 project, although the evidence they provide offers a helpful guide to what was planned. Before 1508, adaptations to the Campo had remained largely traditional in nature and public in patronage. The form of the piazza, and the façades of private and public buildings fronting onto it, continued largely to observe 1297 legislation that offered the Palazzo Pubblico as a model to be imitated by other buildings, although a few buildings were breaking from that rule by the later fifteenth century.[76] Plans to make the Palazzo Pubblico symmetrical by the addition of a second tower were abandoned when funds allocated to the project were rerouted to repair the original 'Torre del Mangia' that had been damaged by lightning in 1463, and even the Piccolomini family had decided that their palace should not invade the civic piazza when they renovated the 'Casamento Vecchio' portion of their palace.[77] The portico project must then be considered

263. Baldassarre Peruzzi(?), design for the portico around the piazza del Campo (*c.*1510?). E I 2, fol. 4r, Biblioteca Comunale degli Intronati, Siena.

264. Baldassarre Peruzzi, design for portico around the Campo and symmetrical ordering of the Palazzo Pubblico. Ecole des Beaux-Arts, Paris (EBA 249).

to have broken drastically from the traditional arrangement of the city centre, and as such can be considered to have had a clear political intent (fig. 264).

The construction of porticoes around the central urban spaces of Italian cities appears to have become quite widespread by the early sixteenth century. One of the most significant examples in this respect is the central piazza at Vigevano, remodelled from 1492 on Lodovico il Moro's orders, with the likely involvement of Leonardo da Vinci and Donato Bramante, which created a porticoed piazza that leads up to the Sforza castle by a triumphal ramp of stairs (fig. 265).[78] The

265. Piazza Ducale, Vigevano.

regular arcading of the portico masked the streets opening onto the piazza as well as the façades of the buildings, including the city hall, thus making the civic piazza into an 'antechamber' to the ducal residence. Both the urban intervention, and the classicizing architectural language of the arcade, served to redefine the small centre around the authority of the Duke of Milan, in contrast to the local communal authorities.[79]

As Wolfgang Lotz first indicated, a similar intention seems to have motivated the construction of porticoes in the central piazza at Ascoli Piceno in 1507–9 for Pope Julius II della Rovere, who had conquered the city for the Papal State in 1506 (fig. 266).[80] While the sixteenth-century reordering of the piazza S. Marco in Republican Venice should caution us from an overhasty reading of the Campo loggia plans in terms of a political masking of the symbols of civic liberty, it is nonetheless also true that the Venetian project unified urban space without effacing the monumental presence of government authorities.[81] Furthermore, Pandolfo is likely to have known the Vigevano example through his extensive diplomatic correspondence with Lodovico il Moro, and this may have inspired the despotic masking and redefining of the central site of Sienese civic government.[82]

It remains unclear why the plans for the portico failed or were abandoned; nonetheless, the fact they were not carried out denotes the final stage in the architectural reflection of Pandolfo's political ascent, marking the survival of Siena's traditional civic space in the face of Petrucci's attempts to establish a princely dynasty. Rather than group all Pandolfo's building patronage together, united by a coherent objective of princely *magnificenza*, each individual project might better be understood as part of a gradual process by which Pandolfo subtly transformed his status within the ruling elite, and with it altered the city fabric accordingly.[83] The Osservanza might thus be seen as his first piece of semi-public patronage, motivated by both dynastic intentions and the more immediate benefits of the suburban site, which perhaps served as a meeting place for Pandolfo's associates. In turn, involvement in the S. Spirito plans reveals Pandolfo as a broker of the power and patronage of the political elite. By 1507, when work was begun on the new convent of S. Maria Maddalena, Pandolfo was able to attach his personal patronage to the monastic complex dedicated to the glory of the political faction he had come to control. By this time he also contemplated reordering the city around the site of his renovated and enlarged palace.

Pandolfo's patronage intentions changed in line with his political fortunes, peaking with the princely redefinition of the urban fabric only in the last years of his life.

266. Piazza S. Francesco, Ascoli Piceno.

While he was ultimately unsuccessful in his bid to reduce the visual significance of the civic centre, he had nonetheless achieved a similar transformation of the Duomo, where the civic icon of Duccio's *Maestà* was definitively removed and replaced with a sophisticated *all'antica* sculptural High Altar, made according to designs left by Francesco di Giorgio. As Machiavelli noted for Pandolfo's political rise to power, so too the means used visually to express this ascent were prudently and gradually increased, revealing Pandolfo's understanding of the political significance of architecture.[84]

Petrucci Hegemony and the Ritual Use of Urban Space

On 21 May 1512, Pandolfo Petrucci died, aged sixty, at S. Quirico d'Orcia on his way back from the thermal baths of Bagni di S. Filippo.[85] The quasi-tyrant of Siena had provided well for his funeral and succession. As early as July 1507, he and other key members of the oligarchy had signed a secret pact of alliance that clearly defined the self-interested nature of their agreement. While paying lip service to Siena's longstanding civic culture and the 'peaceful way of life of the city', they stated:

> those that desire to live well are often prevented from that aim, and have thus come together and agreed to act as a single body, and for the benefit of one another they have pledged their lives and their goods. And if any injury is done against one or more of the group . . . they should consider that it is an action against the group as a whole.[86]

Furthermore, recognizing that any body requires a head, they chose from among their group Pandolfo Petrucci as leader, and established that all members of the group – including Pandolfo in his capacity as leader – should pass on their membership of the group to an heir. Thus, two months after Pandolfo's death, on 21 July the group confirmed their allegiance to Pandolfo's sons, the Cardinal Alfonso and his brother Borghese.

By this time, Pandolfo's will of October 1511 had been carried out, and he had been buried in the elegant but restrained sacristy chapel of S. Bernardino all'Osservanza, which he had commissioned in 1497.[87] The funeral was a lavish affair that went well beyond the sumptuary norms of the period, both for the large quantities of candle wax offered by the civic authorities and urban institutions, and for the rich materials procured for the banners and clothing of the magistracies participating in the funeral ritual and procession. In view of the large number of mourners that could not be accommodated in the deceased's parish church, the funeral mass was held in the cathedral, a fact that undoubtedly also reflected the high status accorded to him. The funeral cortège wound its way through the city, from the southern gate of Porta Tufi, where Pandolfo's body had rested the night before the funeral, at the Olivetan monastery of S. Benedetto a Porta Tufi.[88] As Philippa Jackson has proposed, the cortège from S. Benedetto a Porta Tufi to the deputed tomb at the church of the Osservanza cut through the city, south–north, touching on a number of key locations of Siena's new *Novesco* topography.[89] Almost certainly the procession passed by piazza Postierla, and along the via del Capitano to reach the piazza del Duomo, thus passing through an area whose architectural connotations were absolutely bound to the tight-knit oligarchy. The close association of this urban space to the new regime had been clear as early as 1495, when, as Allegretto Allegretti reported, the anniversary celebrations for the *Nove*'s return to Siena (22 July), were held in the Borghesi palace and on piazza Postierla.[90] Thence the procession proceeded to Pandolfo's palace, where female relatives paid their respects, before continuing to the church of S. Francesco, from which the friars carried Pandolfo's body to its final resting place at the Osservanza.

Such ritual use of the city subtly adjusted the previous ceremonial format observed for the funerals of prominent Sienese figures, according Pandolfo both the honours of a civic funeral while at the same time underlining his personal and familial status, and further legitimizing Petrucci hegemony.[91] With Cardinal Alfonso in Rome, the onus of continuing Petrucci control in Siena fell on Borghese Petrucci, an individual whose political acumen was evidently much less developed than that of

his father, and who found it consequently very difficult to maintain increasingly complex diplomatic relations with neighbouring states and foreign powers.[92] Nevertheless, the degree to which processions and ceremonial functions within the urban setting served to define the changing balance of power in formerly republican Siena can be understood most clearly in a triumphal entry planned for November 1515, on the occasion of the visit of Leo x de' Medici.

The Pope's northward journey to Bologna was undertaken with the objective of meeting François I, King of France, in the aftermath of his victory at Marignano. The events that surround the papal visit to Siena offer various insights into the Petrucci regime and its dependance on the powerful persona of Pandolfo, as it was precisely Borghese's lack of diplomatic *savoir faire* that led to the Pope's decision to bypass Siena on the first part of the journey from Rome to Florence.[93] For behind the architectural and artistic plans for the processional entry of the Pope to Siena lay a complex diplomatic web of favours and alliances that was catalysed around the seeming diplomatic formality of the papal visit. The incident is well described in contemporary sources, which recount how, on 12 November 1515, Borghese Petrucci set out from Siena to meet Leo x at Bolsena, where negotiations between the two occurred on 17 November; the Medici pope sought Petrucci support for his family's ambitions in Tuscany.[94] Evidently failing to comply to Leo's requests, Borghese returned to Siena, while the Pope proceeded to Florence, avoiding Siena on his journey and turning his support to a rival claimant to Petrucci primacy, Borghese's cousin, Cardinal Raffaele Petrucci.[95]

While Leo x's visit to Siena did not take place, preparations for his arrival had almost been completed, with four arches in place along the planned processional route of a sophisticated *all'antica* triumphal entry. Meticulous accounts document the involvement of Siena's principal artists in preparing the ephemeral architecture for the entry, under the direction of Vannoccio di Paolo Biringucci, who was *Operaio* of the influential *Camera del Comune*, joint director of the Sienese mint and a close ally of Borghese Petrucci.[96] Domenico Beccafumi, Sodoma, Giacomo Pacchiarotti and Girolamo di Giovanni all painted arches, while Biringucci appears to have provided inscriptions for them. In view of the south–north routes from Rome towards Florence, two of the arches were located on the city gates of Porta Romana and Porta Camollia, liminal sites that were regularly involved in the ritual transactions that preceded formal entry to the city.[97] What stands out as a novelty in the ritual geography of Siena is the fact that the two other arches were erected at the palaces of Giacoppo and Borghese Petrucci. The decision to forgo any ephemeral embellishments to the civic centre around the Campo, and to concentrate attention on the Petrucci residences, reveals the political and symbolic importance that was attached to them. No longer was Siena a republic whose ritual ceremonial receptions were staged in the shared space of the public weal; rather, the dynastic promotion of the Petrucci centred ritual events around their exclusive private residence. The failure of diplomatic negotiations might be compared to the redundant triumphal arches, as Borghese Petrucci's regime foundered from a lack of strong foreign allies.[98]

FACING PAGE 267. Church of S. Bernardino dell' Osservanza (La Capriola).

Appendix

Table 1: Residence by districts of sample of magnate families with surnames listed in 1277 ban[*]

Family Name	Clan base district	Households in 1453	Households in 1481	Households in 1509
Accarigi	Porta Salaria	3 (2)	8 (1)	6 (2)
Buonsignori	–	2	1	2
Forteguerri	S Pietro di Castelvecchio	2	2	1 (3)
Maconi	–	–	–	–
Malavolti	S Pietro alle Scale	1 (1)	3	2
Minganelli	S Cristoforo	1 (1)	1	2 (2)
Piccolomini	Pantaneto	16 (2)	14 (11)	15 (23)
Ponzi	–	–	–	–
Renaldini	Rialto e Cartagine	1	1	(2)
Rossi	S Donato a Lato Chiesa	–	–	(2)
Salimbeni	S Donato a Lato Chiesa	2 (1)	(2)	1 (1)
Saracini	S Pellegrino	13	10(2)	12 (10)
Scotti	Porta Salaria	2 (2)	3 (2)	1 (5)
Tolomei	S Cristoforo	14 (2)	7 (5)	24 (2)
Ugurgeri	S Pietro alle Scale	4	3	3 (1)

[*] Bracketed figures are for the households recorded as living outside the clan residential area. (For the 1277 magnate ban lists, see D. Waley, *Siena and the Sienese in the Thirteenth Century* (Cambridge 1991), 78).

Table 2: Summary information from ASS, *Ufficiali sopra alle mura*, 5: Taxed foreign building workers 1462–3[1]

Provenance	master	worker	kiln-man	sculptor	quarry–man	ditch digger	other (building)
Lombardy	267	485	50	6	4	418	57
Rest of Italy	32	95	17	35	11	118	90
Outside Italy	–	7	1	–	–	1	
Unknown	16	78	3	3	18	86	–
Total	315	665	71	44	33	623	147

1 G. Pinto, *La Toscana nel Tardo Medioevo* (Florence 1982), Tables 1–4.

Table 3: Summary information from ASS, *Ufficiali sopra alle mura*, 5: Provenance of foreign building workers 1462–3[1]

Provenance	master	worker	kiln-man	sculptor	quarryman
Lugano and Valley	121	141	15	1	1
Como and Lake	94	156	20	2	1
Ticino and Lake	32	98	14	2	2
Valtellina	14	74	–	–	–
North Italy	22	63	3	2	5
Central Italy	10	32	14	33	6
Out of Italy	–	7	1	–	–
Unidentified	16	78	3	3	18
Total	315	665	71	44	33

1 G. Pinto, *La Toscana nel Tardo Medioevo* (Florence 1982), Table 2.

Table 4: Break-down of decisions following from *Ornato* petitions listed in ASS, *Concistoro* 2125 (1428–1480)

Year[1]	Total Petitions	Subsidies awarded	*Ballatoio* demolition	Facade renewal	Street improvement	Land concession	Tax exemption	Average petitions/yr
1428–1449[2]	9	2	2	2	–	–	–	.4
1450–1459[3]	1	–	–	–	1	–	–	.1
1460–1464	24	13	14	10	5	1	1	4.8
1465–1469	72	48	41	17	17	5	7	14.4
1470–1480	41	22	19	13	17	3	4	3.7

Note: categories are not mutually exclusive

1 Archival chance may in part be responsible for the cut-off of records in 1480, as petitions survive in other sources into the sixteenth century.

2 These early documents are quite different in nature to those after 1459 as they do not refer to the *Maestri sopra all'ornato*; they may have been grouped with the *Ornato* petitions during nineteenth-century archival re-arrangements.

3 ASS, *Concistoro* 2125, *f*10 (25 Oct 1459) begins the sequence of *Ornato* petitions, related specifically to "la corte romana" (the papal court) which was coming to the city.

Table 5: Concessions of public land to private patrons identified in public sources

Private Patron	Site	Date	Purpose
Piccolomini	Chiasso Setaiuoli	4 Oct 1460	Palace
Caterina Piccolomini	Piazza Manetti	24 Oct 1460	Palace
Piccolomini	S. M. Maddalena	13 Jan 1463	House
Caterina Piccolomini	Porta Nuova	1463	Palace
Butchers	Fontebranda	24 Aug 1463	House and shop
Cione di Fazino	San Virgilio	9 Oct 1463	House
Meo della Massa	Fonte Nuova a Ovile	8 March 1464	Brick kiln
Cardinal of Pavia	Porta Tufi	10 Sept 1464	Palace
Iacomo Piccolomini	Corner of Campo	28 Oct 1469	Palace
Giovanni Cinughi	Poggio Malavolti	31 May 1470	Church
Mariano di Agostino	Canto Magalotti	20 Jan 1472	House
Lombards	Derelict properties	23 April 1472	Houses
Abbot of S. Galgano	S. M. Maddalena	4 Feb 1474	Palace
Tanner	Fonte Nuova a Ovile	16 Nov 1474	House
Confraternity	Fontegiusta	3 June 1479	Church enlargement
Weavers' guild	Vallepiatta	2 March 1493	San Sebastiano
Weavers' guild	Vallepiatta	12 July 1499	San Sebastiano
A. Chigi	Postierla	28 Sept 1503	Palace
A. Bichi	Fosso di San Sano	4 May 1504	Private well
Servites	Via dei Servi	9 April 1513	Better access

Table 6: Examples of public subsidies for religious architecture

Patron	Work subsidised	Funding	Date
Comune	Cappella di Piazza	330 fl	16 March 1460
Povere di Vallepiatta	Refectory	?	19 Feb 1461
S. M. Servi	Bell tower repairs	600 lire	26 Nov 1465
S. Agsstino	Side chapels	?	14 March 1465
S Spirito	Church	300 fl	12 July 1466
S. Agostino	Church	2000 lire	8 June 1468
S. Francesco	Church	8000 lire	19 June 1468
S. M. Servi	Church	1000 lire	1 July 1468
S. Spirito	Walls	?	19 July 1468
S. Caterina	Tabernacle	100 fl	18 Feb 1470
S. Caterina	Church	300 fl	8 March 1471
S. Francesco	Church work	6000 lire	25 Aug 1472
S. M. Servi	Church work	?	25 Aug 1472
S. Caterina	Doors and steps	300 fl	18 March 1474
Umiliati	Repairs	400 lire	20 Feb 1479
S. Francesco	Completion church	1000 fl/yr for 4 yrs	27 Dec 1478
S. Caterina	Camera acquisition	50 fl	14 Oct 1482
S. Giovanni	?	100 lire	28 Feb 1486
S. Domenico	War damage repairs	40 lire	16 March 1489
S. M. Scala	?	600 fl/yr	11 Oct 1503

Table 7: Families with residence in via del Casato (1453–1509) (figures in brackets are outside Casato)

Family Name	Clan base district	Households 1453	Households 1481	Households 1509
Accarigi	Porta Salaria	– (5)	1 (8)	– (8)
Bargagli	Casato di Sopra	1 (1)	2 (3)	2 (2)
Benassai	Casato di Sotto	2 (1)	3 (3)	3 (5)
Bindi	S. Donato/ Spadaforte	2 (2)	– (2)	– (6)
Borghesi	S. Giovanni/ Pantaneto	– (9)	– (9)	4 (24)
Buzzichelli	Casato di Sotto	1	1	–
Chigi	Porta all'Arco/Casato Sotto	2	1 (1)	1
Ghini	Casato di Sotto	2	1	– (1)
Ghinucci	Casato di Sotto	2 (1)	2 (4)	1 (3)
Lapini	Casato di Sotto	1	1	1 (1)
Mancini	S. Pellegrino	–	1 (2)	– (6)
Mannucci	Stalloreggi di fuori	–	1 (2)	5 (2)
Marsili	Aldobrandino del Mancino	–	1	(1)
Massaini	Pantaneto/ S. Giorgio	– (2)	1 (8)	– (7)
Nini	Casato di Sotto	1	2	5 (4)
Pasquali	Casato di Sotto	4	3 (1)	6
Pecci	S. Giovanni	1	1 (11)	1 (17)
Piccolomini	Pantaneto	1 (17)	– (25)	3 (35)
Ruffaldi	Casato di Sotto	2	–	–
Spannocchi	S. Donato al Lato della Chiesa	– (7)	1 (2)	– (3)
Tommasi	S. Cristoforo/ Pantaneto	– (7)	2 (7)	1 (11)
Turamini	Casato di Sotto	1	3	3 (1)
Venturini	Casato di Sotto	2 (1)	(2)	3 (11)

Notes

Abbreviations used in the Notes and Bibliography

AOMS Archivio dell'Opera Metropolitana di Siena
ASF Archivio di Stato, Firenze
ASM Archivio di Stato, Milan
ASR Archivio di Stato, Rome
ASS Archivio di Stato di Siena
BAV Biblioteca Apostolica Vaticana
BCS Biblioteca Comunale degli Intronati di Siena
BNCF Biblioteca Nazionale Centrale, Florence
BSSP Bullettino Senese di Storia Patria
DBI Dizionario Biografico degli Italiani
MEFR Mélanges de l'École Française de Rome

INTRODUCTION

1 Further detailed bibliographic references appear in the chapters that follow, but studies that have influenced my approach to cities are K. Lynch, *The Image of the City* (Cambridge, MA, and London, 1960); S. Kostof, *The City Shaped: Urban Patterns and Meanings through History* (London, 1991) and *The City Assembled: The Elements of Urban Form through History* (London, 1992); J. Rykwert, *The Seduction of Place: The City in the Twenty-first Century* (New York, 2000).

2 For Sano see G. Freuler, 'Sienese Quattrocento Painting in the Service of Spiritual Propaganda', in *Italian Altarpieces, 1250–1550: Function and Design*, ed. E. Borsook and F. Superbi Gioffredi (Oxford, 1994), pp. 81–116; most recently, see the catalogue entry by V. Cerutti in *Siena e Roma. Raffaello, Caravaggio e i protagonisti di un legame antico*, ed. B. Santi and C. Strinati, exh. cat., S. Maria della Scala, Palazzo Squarcialupi, Siena, 25 November 2005 – 5 March 2006 (Siena, 2005), pp. 86–7, with bibliography. For Neroccio, catalogue entry by V. Cerutti, in *Siena e Roma*, pp. 80–82, with bibliography. For Beccafumi's painting see M. Folchi in *Beccafumi. L'opera completa*, ed. P. Torriti (Milan, 1998), pp. 130–33, and E. Tenducci in *Beccafumi*, pp. 272–3.

3 On the idea of the eye-witness style in painting, an essential starting-point is M. Baxandall, *Painting and Experience in Fifteenth-century Italy: A Primer in the Social History of Pictorial Style* (Oxford, 1972); among many that followed on from this perceptive study, see P. Fortini Brown, *Venetian Narrative Painting in the Age of Carpaccio* (New Haven and London, 1988). On the use of images as historical sources – another complex issue addressed by numerous scholars – see my discussion in the following chapters, although a useful survey is P. Burke, *Eyewitnessing: The Uses of Images as Historical Evidence* (London, 2001).

4 These changes made the image ultimately anachronistic; for an interesting consideration of this problem, see A. Na-

gel and C. S. Wood, 'Interventions: Toward a New Model of Renaissance Anachronism', *Art Bulletin*, LXXVII (2005), pp. 403–15, and discussion in chapter One.

5 For the concept of 'paradigm' see C. Ginzburg, 'Spie. Radici di un paradigma indiziario', in *Miti, emblemi e spie. Morfologia e storia* (Turin, 1986), pp. 158–209 (English translation: 'Clues: Morelli, Freud and Sherlock Holmes', in *The Sign of Three*, ed. U. Eco and T. A. Sebeok, Bloomington, IN, 1983, pp. 81–118), following T. S. Kuhn, *The Structure of Scientific Revolutions* (Chicago, 1962). Central also to my approach is the method expressed in the historical writings of M. Tafuri, for which see the Introduction to *Ricerca del Rinascimento: principi, città, architetti* (Turin, 1992); Tafuri's *Ricerca* is now available in English as *Interpreting the Renaissance: Princes, Cities, Architects* (New Haven and London, 2006).

6 For 'urban process', see the essays in Z. Çelik, D. Favro and R. Ingersoll, eds., *Streets: Critical Perspectives on Public Space* (Berkeley, 1994); described also as 'planning by accretion' in A. Ceen, *The Quartiere dei Banchi: Urban Planning in Early Cinquecento Rome* (New York, 1986), p. 7 (originally Ceen's PhD thesis, University of Pennsylvania, 1977).

7 As argued in relation to architecture in the Renaissance by Tafuri, *Ricerca del Rinascimento*, pp. 23–4, 89–90 and 223–4.

8 Tafuri was evidently much influenced by the historical method of Marc Bloch, *Apologie pour l'histoire ou Métier d'historien* (1949; Paris, 1993), chap. 1, and the concept of 'histoire à rebours', with its implications for a direct relationship between historical enquiry and contemporary discourse. It is this perception of history that caused Tafuri famously to say 'non c'é critica, solo storia' (R. Ingersoll, 'Interview with Manfredo Tafuri', *Casabella*, nos. 619–20, 1995, p. 96, which synthesizes the introduction to *La sfera ed il labirinto*, Turin, 1980), and the comment, when asked what was the secret of the sixteenth-century architects, 'we are their secret' (H. Burns, 'Tafuri e il rinascimento', *Casabella*, nos. 619–20, 1995, p. 121).

CHAPTER ONE

1 Inscription from Ambrogio Lorenzetti's fresco of *The Effects of Good Government*, Palazzo Pubblico, Siena; the texts are transcribed and translated in R. Starn, *Ambrogio Lorenzetti: The Palazzo Pubblico, Siena* (New York, 1994), p. 101: 'Volgete gli occhi a rimirar costei/ vo' che reggete, ch'è qui figurata/ e per su' eccellenzia coronata,/ la qual sempr'a ciascun suo diritto rende./ Guardate quanti ben vengan da lei/ e come è dolce vita riposata/ quella della città du' è servata/ questa virtù che più d'altra risprende.'

2 Bernardino da Siena, *Prediche volgari sul Campo di Siena (1427)*, ed. C. Delcorno (Milan, 1989).

3 Bernardino da Siena, *Le prediche volgari inedite. Firenze 1424, 1425. Siena 1425*, ed. D. Pacetti (Siena, 1935), p. 458 (sermon 41).

4 So described by L. Ghiberti, *I commentarii*, ed. J. von Schlosser (Berlin, 1912), p. 28. For the discussion that follows I will adopt this war–peace distinction as opposed to the more current good–bad. Payments that date the cycle are documented in H.B.J. Maginnis, 'Chiarimenti documentarii: Simone Martini, i Memmi e Ambrogio Lorenzetti', *Rivista d'arte*, 41 (1989), pp. 3–21, appendix nos. 4–17.

5 Bernardino da Siena, *Prediche volgari*, II, p. 1254 (XLII.102): 'Ella è tanto utile cosa questa pace! Ella è tanto dolce cosa pur questa parola 'pace', che dà una dolcezza a le labra! Guarda el suo opposito, a dire 'guerra'! E una cosa ruida tanto, che dà una rusticezza tanto grande, che fa inasprire la bocca. Doh, voi l'avete dipenta di sopra nel vostro palazzo, che a vedere la Pace dipenta è una allegrezza. E così è un scurità a vedere dipenta la Guerra dall'altro lato [. . .]'.

6 In addition to S. Bernardino and L. Ghiberti, public officials referred to these as the 'Guerra' and 'Pace' images; see below.

7 The vast and constantly growing bibliography is recently collected in Q. Skinner, 'Ambrogio Lorenzetti's *Buon Governo* Frescoes: Two Old Questions, Two New Answers', *Journal of the Warburg and Courtauld Institutes*, 62 (1999), pp. 2–28.

8 The role of Lorenzetti's frescoes in urban and architectural history is widely accepted; it is expressed by S. Kostof in *The City Shaped: Urban Patterns and Meanings through History* (London, 1991), p. 306, and in 'Urbanism and Polity; Medieval Siena in Context', *International Laboratory for Architecture and Urban Design Yearbook* (1982), pp. 66–73.

9 This point has been argued effectively by R. Starn, 'The Republican Regime and the "Room of the Peace" in Siena, 1338–40', *Representations*, 18 (1987), pp. 1–31.

10 The Italian original opens this chapter; translation taken from Starn, *Ambrogio Lorenzetti*, p. 101.

11 The issue of who had access to the Sala dei Nove, other than the Nine, is not clear, although S. Bernardino's comments below make sense only in the light of the image being known to a broad section of the community.

12 Bernardino da Siena, *Le prediche volgari inedite*, p. 458 (sermon XLI): 'Io ho considerato, quando so' stato fuore di Siena e ho predicato de la pace et della guerra, che voi avete dipenta, che, per certo, fu bellissima inventiva. Voltandomi a la pace, veggo le mercanzie andare a torno, e veggo balli, veggo racconciare le case, veggo lavorare vigne e terre, seminare, andare a' bagni a cavallo, veggo andare le fanciulle a marito, veggo le gregge de le pecore, ecc. E veggo impiccato l'uomo, per mantenere la giustizia; et per queste cose ognuno sta in santa pace et in concordia.' Lina Bolzoni has effectively considered the relationship between civic images (including the Lorenzetti frescoes) and architecture in the sermons of S. Bernardino in *La rete delle immagini. Predicazione in volgare dalle origini a Bernardino da Siena* (Turin, 2002), pp. 167–90 (English translation now available as *The Web of Images: Vernacular Preaching from its Origins to St Bernardino da Siena*, Aldershot and Burlington, 2004).

13 Starn, *Ambrogio Lorenzetti*, pp. 100–101, 'e questi acciò ricolti, un ben comun per lo signor si fanno [. . .] seguita poi ogni civile effetto, utile necessario e diletto'.

14 Patronage documentation for the frescoes is gathered in E. C. Southard, 'The Frescoes in Siena's Palazzo Pubblico, 1289–1355', PhD thesis, Indiana University, Bloomington, 1979, pp. 271–7.

15 The fundamental studies for the regime of the Nine are W. M. Bowsky, *The Finances of the Commune of Siena, 1287–1355* (Oxford, 1970), and W. M. Bowsky, *A Medieval Italian Commune: Siena Under the Nine, 1287–1355* (Berkeley, 1981).

16 On the Visconti period, see Maria Assunta Ceppari, 'La signoria di Gian Galeazzo Visconti', in *Storia di Siena. Dalle origini alla fine della repubblica*, I, ed. R. Barzanti, G. Catoni and M. De Gregorio (Siena, 1995), pp. 321–6; on merce-

naries and financial strain see W. Caferro, *Mercenary Companies and the Decline of Siena* (Baltimore and London, 1998).

17 Tradition and retrospection will be discussed in chapter Seven. See also my 'Revival or Renewal: Defining Civic Identity in Fifteenth-century Siena', in *Shaping Urban Identity in the Middle Ages*, ed. P. Stabel and M. Boone (Leuven and Apeldoorn, 1999), pp. 111–34, which challenges the one-way arguments of D. L. Kawsky, 'The Survival, Revival and Reappraisal of Artistic Tradition: Civic Art and Civic Identity in Quattrocento Siena', PhD thesis, Princeton University, 1995.

18 In this respect the painted ideal might be compared to a written programme, such as the famous plans of Nicholas V for the Vatican Borgo, whose programmatic functions have been commented on by M. Tafuri, *Ricerca del Rinascimento. Principi, città, architetti* (Turin, 1992), pp. 33–88.

19 G. Poli, 'Schemi grafici dei diversi interventi di restauro e ripresa pittorica', in *Ambrogio Lorenzetti: Il buon governo*, ed. E. Castelnuovo (Milan, 1995), pp. 393–7. R. Gibbs, 'In Search of Ambrogio Lorenzetti's Allegory of Justice in the Good Commune', *Apollo*, CXLIX (May 1999), pp. 11–16, has proposed that Andrea Vanni's interventions went a good deal beyond restoration alone.

20 A. Angelini, 'I restauri di Pietro di Francesco agli affreschi di Ambrogio Lorenzetti nella "Sala della Pace"', *Prospettiva*, 31 (1982), pp. 78–82.

21 *Le Biccherne. Tavole dipinte delle magistrature senesi (secoli XIII–XVIII)*, ed. U. Morandi et al. (Rome, 1984), pp. 96, 116, 178.

22 *Le Biccherne*, p. 116.

23 'Ki ben ministra remgna'. C. Alessi, in *Francesco di Giorgio e il Rinascimento a Siena*, ed. L. Bellosi (Siena and Milan, 1993), pp. 272–3. Echoes of the winged figures from Lorenzetti's landscapes can also be seen in Benvenuto's *biccherna* of 1468; see Alessi in *Francesco di Giorgio*, p. 266.

24 See, ASS *Diplomatico Bichi Borghesi*, Pergamene Bichi, vol. I, n. 81 (27 October 1442: note also ASS, MS. B 25, fol. 32v); also 'ad faciendum et componendum tres pannos de razo [. . .] cum designio et ystoria que sunt in sala Pacis ipsius palatii, et ad similitudinem figuram et picturrarum dicte sale' (26 June 1446), from G. Cecchini, 'L'arazzeria senese', *Archivio Storico Italiano*, CXX (1962), p. 172 [doc. 4]; a number of the documents for this commission are also collected in Kawsky, 'The Survival, Revival and Reappraisal of Artistic Tradition', pp. 206–16 [doc. 5]. See also H. Smit, ' "Ut si bello et ornato mestiero": Flemish Weavers Employed by the City Government of Siena (1438–1480)', in B. W. Meijer et al., *Italy and the Low Countries: Artistic Relations: the Fifteenth Century* (Florence, 1999), pp. 69–78.

25 Cecchini, 'L'arazzeria senese', p. 171 [doc. 2].

26 A summary of Giachetto's works is provided in a late fifteenth-century inventory, 'di tutti i lavori di panni [. . .] che maestro Giachetto à dati al palazzo', transcribed in Cecchini, 'L'arazzeria senese', p. 177 [doc. 7]. A partial set of accounts for work in Siena survives unpublished in ASS *Diplomatico Bichi Borghesi*, Pergamene Bichi, vol. I, n. 81 (note also in ASS, MS. B 25, fol. 32v), lists payments of the salary for 1442–51, as well as accounts for a number of tapestries (sums: 3,362 *lire*, 2,036 *lire*, 4,299 *lire*).

27 'Sia uno dei più famosi mahestri di questa arte', from Cecchini, 'L'arazzeria senese', p. 171 [doc. 2]; petition to remain in Siena in Cecchini, 'L'arazzeria senese', pp. 173–5 [doc. 5]. His fame was indeed reported outside Siena, as

Antonio Averlino, called 'Il Filarete', referred in his architectural treatise to 'Grachetto francioso anchora se vive è buono maestro, maxime a ritrarre del naturale', from J. Lestoquoy, 'Eugène IV, Jean Fouquet et Grachetto', *Journal des Savants* (1976), pp. 141–8; see also Smit, ' "Ut si bello et ornato mestiero" ', pp. 69–78.

28 ASS *Diplomatico Bichi Borghesi*, Pergamene Bichi, vol. I, n. 81, 'Item veduto qunato sarebbe honorevole et utile che quello nobile exercitio del fare e panni di Razzo si piantasse nela nostra città, e che dei cittadini ne imparassero [. . .].' On such incentives, see my ' "Più honorati et suntuosi ala Republica": *Botteghe* and Luxury Retail along Siena's Strada Romana', in *Buyers and Sellers: Retail Circuits and Practices in Medieval and Early Modern Europe*, ed. B. Blondé, P. Stabel, J. Stobbart and I. Van Damme (Turnhout, 2006), pp. 65–78.

29 See the inventory in Cecchini, 'L'arazzeria senese', p. 177 [doc. 7].

30 Kawsky, 'The Survival, Revival and Reappraisal of Artistic Tradition', pp. 133–6, for a reading in relation to the 1447 presence of King Alfonso of Naples in Sienese territories. This reading is evidently inspired by the Baron thesis for 'civic humanism' in Florence: H. Baron, *The Crisis of the Early Italian Renaissance: Civic Humanism and Republican Liberty in an Age of Classicism and Tyranny* (Princeton, NJ, 1955); among many critiques of the thesis see J. Najemy, 'Review Essay', in *Renaissance Quarterly*, 45 (1992), pp. 340–50.

31 G. Pardi, 'La popolazione di Siena attraverso i secoli', *BSSP*, 30 (1923), pp. 85–123, and 32 (1925), pp. 3–62; also D. Ottolenghi, 'Studi demografici sulla popolazione di Siena dal secolo XIV al XIX', *BSSP*, 10 (1903), pp. 297–358. This figure appears to have remained fairly constant throughout the fifteenth century, which made Siena the second largest city in Tuscany after Florence (38,000 in 1427), and about twice the size of the next largest city, Pisa (7,300); see D. Herlihy and C. Klapisch Zuber, *Tuscans and their Families: A Study of the Florentine Catasto of 1427* (New Haven and London, 1985), p. 58.

32 M. Sanudo, *La spedizione di Carlo VIII in Italia*, ed. R. Fulin (Venice, 1873), p. 145; additional fifteenth-century descriptions of the city are to be found in chapter Six.

33 N. Rubinstein, 'Political Ideas in Sienese Art: The Frescoes by Ambrogio Lorenzetti and Taddeo di Bartolo in the Palazzo Pubblico', *Journal of the Warburg and Courtauld Institutes*, 21 (1958), pp. 189–207. Most recently, the cycle has been re-examined by R. Guerrini, '*Dulci pro libertate*. Taddeo di Bartolo: Il ciclo di eroi antichi nel Palazzo Pubblico di Siena (1413–1414). Tradizione classica ed iconografia politica', *Rivista Storica Italiana*, 112 (2000), pp. 510–68. See also chapter Six and M. Caciorgna and R. Guerrini, '*Imago Urbis*. La lupa e l'immagine di Roma nell'arte e nella cultura senese come identità storica e morale', in *Siena e Roma. Raffaello, Caravaggio e i protagonisti di un legame antico*, exh. cat., ed. B. Santi and C. Strinati, S. Maria della Scala, Palazzo Squarcialupi, Siena, 25 November 2005 – 5 March 2006 (Siena, 2005), pp. 99–118.

34 K. Christiansen, 'Mattia di Nanni's Intarsia Bench for the Palazzo Pubblico, Siena', *Burlington Magazine*, 139 (1997), pp. 372–86.

35 J. Beck, *Jacopo della Quercia*, 2 vols. (New York, 1991), I, pp. 81–94; H. Burns, ' "Restaurator de ruyne antiche": tradizione e studio dell'antico nelle attività di Francesco di Giorgio', in *Francesco di Giorgio, architetto*, ed. F. P. Fiore and

M. Tafuri (Milan, 1994), p. 155; see also M. Caciorgna, 'Moduli antichi e tradizione classica nel programma della Fonte Gaja di Jacopo della Quercia', *Fontes. Rivista di filologia, iconografia e storia della tradizione classica*, 7–10 (2001–2002), pp. 71–142.

36 An interesting survey of civic patronage is in D. Balestracci and G. Piccinni, *Siena nel Trecento. Assetto urbano e prassi edilizia* (Florence, 1977); see also the classic W. Braunfels, *Mitteralterliche Stadtbaukunst in der Toskana* (Berlin, 1951), and Bowsky, *A Medieval Italian Commune*, pp. 260–98.

37 The civic patronage of painting has been extensively explored; see, for example, D. Norman, *Siena and the Virgin: Art and Politics in a Late Medieval City* (New Haven and London, 1999). The classic introduction to these issues remains H. Wieruszowski, 'Art and the Commune in the Time of Dante', *Speculum*, 19 (1944), pp. 14–33.

38 There is still some discussion as to whether the Duomo, the most 'real' detail in the fresco, may be a later addition; see Gibbs, 'In Search of Ambrogio', p. 15.

39 See, for example, survey references in S. Kostof, *The City Shaped: Urban Patterns and Meanings through History* (London, 1991), pp. 305–6; J. White, *Art and Architecture in Italy, 1250–1400* (Harmondsworth, 1987), pp. 390–93.

40 M. Baxandall, 'Art, Society and the Bouguer Principle', *Representations*, 12 (1985), p. 40; such themes have recently been addressed by L. Syson, 'Representing Domestic Interiors', in *At Home in Renaissance Italy*, ed. M. Ajmat-Wollheim and F. Dennis (London, 2006), pp. 86–101; also the discussion led by A. Nagel and C. S. Wood, 'Interventions: Toward a New Model of Renaissance Anachronism', *Art Bulletin*, LXXVII (2005), pp. 403–15.

41 W. MacDonald, *The Architecture of the Roman Empire* (London and New Haven, 1986), vol. II, pp. 10–31.

42 No single viewpoint from the Palazzo Pubblico captures Lorenzetti's composition, which indicates the desire to conflate a number of different elements into one complex and comprehensive vision.

43 For Siena as 'daughter of the road', see E. Sestan, 'Siena avanti Montaperti', *BSSP*, 68 (1961), pp. 3–49, reprinted in his *Italia Medievale* (Naples, 1968), pp. 151–92. A rapidly growing bibliography on the Francigena is gathered in a special issue edited by L. Bassini and F. Vanni, *De strata francigena: studi e ricerche sulle vie di pellegrinaggio del Medioevo*, III (Florence, 1995). See also G. Venerosi Pesiolini, 'La Via Francigena nel contado di Siena XIII–XIV', *La Diana*, 8 (1933), pp. 118–55; R. Stopani, *La Via Francigena in Toscana* (Florence, 1984); I. Moretti, 'La Via Francigena', in *Storia di Siena. Dalle origini alla fine della repubblica*, ed. Barzanti, Catoni and De Gregorio, I, pp. 41–54.

44 On Siena's *contado* road network, see D. Ciampoli and T. Szabó, eds., *Viabilità e legislazione di uno stato cittadino del Duecento. Lo Statuto dei Viarii di Siena* (Siena, 1992), pp. 10–13 and 42–6.

45 See especially T. Szabó, 'La rete stradale del comune di Siena. Legislazione statutaria e amministrazione comunale nel Duecento', *Mélanges de l'Ecole Française de Rome*, 87 (1975), pp. 141–86; also Ciampoli and Szabó, *Viabilità e legislazione*.

46 On the *Viarii* and their statutes, see Szabó, 'La rete stradale,' p. 163; Ciampoli and Szabó, *Viabilità e legislazione*, pp. 10–13 and 42–6, which also publishes the statute.

47 ASS, *Statuto di Siena* 47, fol. 140 (23 September 1415) and ASS, *Consiglio Generale* 231, fol. 268 (9 March 1466).

48 Ciampoli and Szabó, *Viabilità e legislazione*, pp. 46–56 has noted the site-specific character of the legislation: of 434 laws in the 1290 *Statutum*, 107 relate to city streets, 107 to *contado* roads, 62 to fountains (inside and outside the city), 45 to bridges and 19 to thermal baths.

49 ASS, *Statuto di Siena* 25, fol. 287 (15 June 1469): 'Conciosia cosa che el rompare delle strade sia gravissima chosa et concernente la perturbatione del pacifico stato della Signoria et vedendosi nel decto errore di trascurarsi iudicasi tali rompitori et commettitori et assaltatori di strade doversi acramente punire acciò che per timore di pena grave li homini si astenghino da tali delicti [. . .] essare incorso nela pena della forca et ciascuno officiale del contado o cittadino come forestiere possa e debba tale delinquente punire.'

50 For example at Arbia and Petroio, ASS *Concistoro* 2123, fol. 40, 62–3, 86 (12 October 1460 and ff.); Buonconvento, ASS *Concistoro* 2118, fol. 194 (15 January 1462); Tressa, ASS *Concistoro* 2124, fol. 139 (4 June 1474); Macereto and Arbia, ASS *Balìa* 253 fol. 100, 248v (5 December 1500, 29 December 1507).

51 ASS *Concistoro* 2125, fol. 121 (10 October 1473); also, P. Pertici, *La città magnificata: interventi edilizi a Siena nel Quattrocento* (Siena, 1995), pp. 126–8, 'atteso quanto comodo et honore si cava d'essa strada'.

52 Ibid.; accounts in ASS *Biccherna* 2, fol. 320–22v.

53 S. Kostof, *The City Assembled: The Elements of Urban Form through History* (London, 1992); D. Balestracci and G. Piccinni, *Siena nel Trecento. Assetto urbano e prassi edilizia* (Florence, 1977), pp. 17–29.

54 N. Adams and S. Pepper, *Firearms and Fortification: Military Architecture and Siege Warfare in Sixteenth-century Siena* (Chicago, 1986), pp. 32–7.

55 P. Turrini, *'Per honore et utile de la città di Siena'. Il comune e l'edilizia nel Quattrocento* (Siena, 1997), pp. 33–40, for walls to *c.* 1450.

56 ASS *Consiglo Generale*, 229, fol. 254 (9 August 1462).

57 ASS *Consiglo Generale*, 229, fol. 255v (9 August 1462); 1,000 fl. assigned in 1471 (ASS *Consiglo Generale*, 233, fol. 263) and 350 fl. in 1478 (ASS *Concistoro* 2117, fol. 185 and 193). Lombard builders and this tax are discussed further in chapter Five.

58 ASS *Biccherna* 1086; entries in 1453, with modifications to 1460. Ordered by *Terzi* and areas. Continued application of this tax is confirmed by the review of the inventory in 1484; see ASS *Consiglo Generale* 239, fol. 191v (4 April 1484): 'hanno visto lo grande disordine che è nella taxa deli orti e vigne che sono in Siena perchè alcuno che ha poco paga tanto e chi ha tanto paga quasi niente: et ancho perche ci'é alcuni che non pagano alcuna cosa'.

59 M. S. Elsheikh, ed., *Il Costituto del Comune di Siena volgarizzato nel MCCCIX–MCCCX* (Città di Castello, 2002), II, p. 10 (Dist. III.20).

60 ASS *Statuti di Siena* 39, fol. 28v (21 March 1412, but valid at least to 1466); BCS, MS. A. VII. 19–22, *Balìa* Spoglio, 27 October 1509.

61 Elsheikh, *Il Costituto*, II, p. 10 (Dist. III.20–21) and p. 27 (Dist. III.60); ASS *Statuti di Siena* 39, fol. 28v (*c.* 1415); M. Ascheri ed., *L'ultimo statuto della Repubblica di Siena (1545)* (Siena, 1993), p. 411, Dist. IV, cap 96 (1545: 'murare omnia et singula foramina'). Bernardo Bellanti was allowed a private door in 1504: BCS, MS. A. VII. fol. 19–22, *Balìa* Spoglio, 10 February).

62 ASS *Concistoro* 2117, fol. 188v (1477), 'grande disagio a molti cittadini in più luoghi e guastamento di molte case [. . .] con bugni forti forti'.

63 Balestracci and Piccinni, *Siena nel Trecento*, map 2.

64 Adams and Pepper, *Firearms and Fortification*, pp. 34–7.

65 For the imagery associated with the city gates, see further discussion in chapter Two, in relation to Porta Camollia.

66 Adams and Pepper, *Firearms and Fortification*, p. 35.

67 Milanesi, *Documenti*, III, pp. 289–90; ASS, *Consiglio Generale* 231, fol. 305v (14 May 1467); see also A. Angelini, 'Le lupe di Porta Romana e Giovanni di Stefano', *Prospettiva*, 65 (1992), pp. 50–55.

68 Angelini, 'Le lupe di Porta Romana'; documents in Milanesi, *Documenti*, II, pp. 242–5, 274–5, 307–8; see also M. Israëls, 'New Documents for Sassetta and Sano di Pietro at the Porta Romana, Siena', *Burlington Magazine*, 140 (1998), pp. 436–43.

69 The arrangement of the Porta Camollia is discussed in chapter Two; see also my '"Ornato della città": Siena's Strada Romana as Focus of Fifteenth-century Urban Renewal', *Art Bulletin*, 82 (2000), pp. 26–50.

70 Discussed below. Szabó, 'La rete stradale', pp. 151–63, reveals large financial problems from the thirteenth century.

71 ASS, *Statuto di Siena* 47, fol. 140 (23 September 1415); also ASS, *Statuto di Siena* 41, 'Tesoretto', fol. 141; ASS, *Statuto di Siena* 47, fol. 141 (26 February 1429); on *Viarii fuori le mura* see ASS, *Statuto di Siena* 41, 'Tesoretto', fol. 38 (undated entry), fol. 38v (27 December 1386), and fol. 57, 'Non sara se no uno viario nel contado e me di Siena dove solevano essere tre [. . .]' (1413).

72 ASS, *Statuto di Siena* 47, fol. 140 (23 September 1415), 'valenti et boni ciptadini [. . .] ignoranti [ch]e non sanno quello che fanno'; also ASS, *Statuto di Siena* 41, 'Tesoretto', fol. 141; ASS *Consiglio Generale* 231, fol. 266 (9 March 1466).

73 ASS, *Statuto di Siena* 47, fol. 140 (23 September 1415); ASS *Consiglio Generale* 231, fol. 266 (9 March 1466).

74 ASS, *Viarii* 3, documents *Viarii civitatis* activity for 1518–24.

75 Szabó, 'La rete stradale', p. 169; funding requests appear in, for example, ASS *Consiglio Generale* 228, fol. 321 (21 December 1460); ASS *Consiglio Generale* 231, fol. 268; ASS *Consiglio Generale* 236, fol. 245v, 265; ASS *Consiglio Generale* 237, fol. 79v, 131v, 261; ASS *Consiglio Generale* 238, fol. 86; ASS *Consiglio Generale* 239, fol. 6, 174v, 204, 224 (21 July 1484). Direct cash payment for the widening of via delle Cerchia is documented, see ASS *Consiglio Generale* 239, fol. 204, 224 (May–July 1484).

76 ASS *Consiglio Generale* 228, fol. 321 (21 December 1460), 'Veduto el grande mancamamento dele strade et vie publiche dela città, le quale non solamente vengono meno per lo continuo uso delli abitanti ma per lo frequente andare delli forestieri, et maxime deli muli, che passano ogni dì per la città'.

77 On gate taxes as sources of communal revenue, see also L. Martines, *Power and Imagination. City States in Renaissance Italy* (Harmondsworth, 1980), pp. 248–51.

78 ASS *Concistoro* 2123, fol. 80 (11 April 1477).

79 ASS *Viarii* 3 (1519–24), entries 'Da la cassettina dei muli ordinata al viatrio dela città . . .'.

80 Balestracci and Piccinni, *Siena nel Trecento*, pp. 41–3.

81 Elsheikh, *Il Costituto*, II, p. 39 (Dist. III.84), 'tutte le vie le quali sono a lato a la strada per li quali s'entra ne la strada, si selicino'; see also D. Friedman, 'Palaces and the Street in Late-Medieval and Renaissance Italy', in *Urban Landscapes,*

International Perspectives, ed. J.W.R. Whitehand and P. J. Larkham (London, 1992), pp. 69–113.

82 The demolition of overhangs (*ballatoi*) is discussed in chapter Five.

83 Elsheikh, *Il Costituto*, II, p. 8 (Dist. III.16), p. 26 (Dist. III.57–8).

84 Balestracci and Piccinni, *Siena nel Trecento*, pp. 45–6.

85 Listed in ASS *Viarii* 3; street widening near S. Spirito is documented in ASS *Balìa* 253, fol. 115 (23 April 1501).

86 ASS *Consiglio Generale* 235, fol. 158 (4 February 1474); Milanesi, *Documenti*, II, p. 353; on the palace, see chapter Six.

87 On Pietro dell'Abaco, see N. Adams, 'The Life and Times of Pietro dell'Abaco, a Renaissance Estimator from Siena (active 1457–86)', *Zeitschrift für Kunstgeschichte*, 48 (1985), pp. 384–95.

88 ASS *Consiglio Generale* 235, fol. 158, 'perchè in esso luogo le strada e le mura de le case da esso lato non vanno a dirictura, ma vanno ad arco e torte; volendo pigliuare la facciata diritta come e giusto e raggionevole'.

89 See, most recently, M. Tuliani, 'Il Campo di Siena: Un mercato cittadino in epoca comunale', *Quaderni medievali*, 46 (1998), pp. 59–100 and 'La dislocazione delle botteghe nel tessuto urbano della Siena medievale (secc. XIII–XIV)', *BSSP*, CIX (2002), pp. 88–116.

90 Starn, *Ambrogio Lorenzetti*, pp. 72–3; for a suggestion that these figures should be understood to be male, see J. Bridgeman, 'Ambrogio Lorenzetti's Dancing "Maidens": A Case of Mistaken Identity', *Apollo*, 133 (1991), pp. 245–50.

91 T. Benton, 'Three Cities Compared: Urbanism', in *Siena, Florence and Padua: Art, Society and Religion, 1280–1400*, ed. D. Norman (New Haven and London, 1995), II, p. 7–27 and C. Cunningham, 'For the Honour and Beauty of the City: The Design of Town Halls', (in the same volume) p. 40; J. Hook, *Siena: A City and its History* (London, 1979), pp. 71–101; L. Franchina, ed., *Piazza del Campo: evoluzione di una imagine* (Siena, 1983); E. Guidoni, *Il Campo di Siena* (Rome, 1971); Tuliani, 'Il Campo di Siena'.

92 Tuliani, 'Il Campo di Siena', pp. 61–3.

93 *Il constituto del comune di Siena dell'anno 1262*, ed. L. Zdekauer (Milan, 1897), Dist. III, rubric 47 (also in Tuliani, 'Il Campo di Siena', p. 65).

94 Legislation in Braunfels, *Mitteralterliche Stadtbaukunst*, p. 41. There are many fifteenth-century modifications, for example the planned Palazzo Piccolomini façade onto the Campo, discussed in chapter Four.

95 Elsheikh, *Il Costituto*, II, pp. 18–23 (Dist. III.37–52), 317, 321–3 (Dist. V.162, 172, 178), except around the Assumption; see also Balestracci and Piccinni, *Siena nel Trecento*, pp. 155–7. Tuliani, 'Il Campo di Siena', pp. 72–7 outlines the trades active in the market until the 1309 legislation.

96 Balestracci and Piccinni, *Siena nel Trecento*, p. 157.

97 On zoning and the creation of a prestigious retail space, see chapter Five.

98 ASS, *Particolari Famiglie Senesi* 82, unfoliated (1506); for the image, see K. Christiansen, *Gentile da Fabriano* (Ithaca, NY, 1982), pp. 50–55, 137.

99 Hook, *Siena: A City and its History*, p. 76; Tuliani, 'Il Campo di Siena', pp. 88–100, records the considerable government income derived from leases to stall-holders on the Campo market.

100 Elsheikh, *Il Costituto*, II, p. 20 (Dist. III.42), 'non lassarò da alcuno essere occupato con sedia o vero deschi o vero meritie'.

101 Elsheikh, *Il Costituto*, II, p. 22 (Dist. III.48–9); Balestracci and Piccinni, *Siena nel Trecento*, p. 47, on fourteenth-century Casato zoning for officials' access to the piazza.

102 Elsheikh, *Il Costituto*, II, p. 321 (Dist. v.172), 'huomini et persone pare et tornare non possono da esso palazzo senza tedio e gravezza loro'.

103 For a symbolic reading of the space, see Guidoni, *Il Campo di Siena*, and E. Guidoni, *Arte e urbanistica in Toscana (1000–1351)* (Rome, 1970), pp. 250–57; also Hook, *Siena: A City and its History*, pp. 71–6. On the Campo's function in civic ritual, see chapter Two.

104 A symbolic reading of the palace has been proposed by C. Cunningham, 'For the Honour and Beauty of the City: The Design of Town Halls', in *Siena, Florence and Padua*, ed. Norman, I, pp. 29–54, although this does not draw parallels with Lorenzetti's frescoes. A vast bibliography addresses the city hall, and is conveniently gathered in *Ambrogio Lorenzetti: il Buon Governo*, ed. E. Castelnuovo (Milan, 1995).

105 With the construction of the new Great Council chamber completed in 1343 (now the Teatro dei Rinnovati), a further symbolic layer was added, as this structure rested on the city dungeons (*Securitas* figured in architecture).

106 The fiscal system is analysed by Bowsky, *The Finances of the Commune of Siena*; the 'open' façade is commented on by most secondary literature, often in comparison with the much more severe and 'closed' aspect of the contemporary Palazzo della Signoria in Florence (see, for example, N. Rubinstein, *The Palazzo Vecchio, 1298–1532: Government, Architecture and Imagery in the Civic Palace of the Florentine Republic*, Oxford, 1995).

107 On the separation of Justice, see Q. Skinner, 'Ambrogio Lorenzetti's *Buon Governo* Frescoes', pp. 4–6, with earlier bibliography.

108 The place of the Virgin Mary in Sienese government is comprehensively addressed in Norman, ed., *Siena and the Virgin*; see also D. Norman, 'Sotto uno baldachino trionfale': The Ritual Significance of the Painted Canopy in Simone Martini's *Maestà*, in *Beyond the Palio: Urban Ritual in Renaissance Siena*, ed. P. Jackson and F. Nevola (Oxford, 2006), pp. 11–24.

109 M. Cordaro, 'Le vicende costruttive', in C. Brandi, ed., *Il Palazzo Pubblico di Siena. Vicende costruttive e decorazione* (Milan, 1983), p. 82.

110 See discussion of the completion of the chapel in chapter Five. Archivio dell'Opera Metropolitana di Siena, Museo, n. 16; discussed by C. Ghisalberti, 'Late Italian Gothic', in *The Renaissance from Brunelleschi to Michelangelo: The Representation of Architecture*, ed. H. Millon and V. Magnago Lampugnani (London, 1994), p. 429; illustrated in T. Benton, 'The Building Trades and Design Methods', in Norman, ed., *Siena, Florence and Padua*, I, p. 122. Recent research has been presented by Andrea Giorgi, Stefano Moscadelli and Wolfgang Loseries in papers soon to be published, '"Fare e' disegniamenti della capella". Nuovi documenti sul progetto della Capella del Campo a Siena', at the Kunsthistorisches Institut in Florenz-Max-Planck-Institut (13 October 2004), and Università degli Studi di Siena (28 February 2005), discussed further in chapter Five.

111 Elsheikh, *Il Costituto*, II, p. 19 (Dist. III.40).

112 R. Mucciarelli, 'Igiene, salute e pubblico decoro nel Medioevo', in *Vergognosa Immunditia: Igiene pubblica e privata a Siena dal medioevo all'età contemporanea* (Siena, 2000), pp. 13–84, for pigs, pp. 44–5.

113 Elsheikh, *Il Costituto*, II, p. 24 (Dist. III.53). There was even a law banning people from defecating in the square, with

114 an exemption for those under fourteen; see Elsheikh, *Il Costituto*, II, p. 23 (Dist. III.52); Hook, *Siena: A City and its History*, pp. 125–47. See also Mucciarelli, 'Igiene, salute', pp. 41–6.

114 D. Alighieri, *The Divine Comedy*, ed. and trans. J. Sinclair, 3 vols. (Oxford and New York, 1939), II, pp. 176–7: 'quella gente vana/ che spera in Talamone, e perdergli/ più di speranza ch'a trovar la Diana.'

115 These have attracted considerable attention: most thorough is F. Bargagli Petrucci, *Le fonti di Siena e il loro acquedotti. Note dalle origini al MDLV* (Siena, Florence and Rome, 1903; repr. Siena, 1992). More recent are Balestracci and Piccinni, *Siena nel Trecento*, pp. 145–9; D. Balestracci ed., *I bottini medievali di Siena* (Siena, 1993), and D. Balestracci, 'L'acqua a Siena nel medioevo', in *Ars et Ratio*, ed. J. Maire Vigueur and A. Paravicini Bagliani (Palermo, 1990), pp. 19–31; P. Galluzzi, ed., *Prima di Leonardo: cultura delle macchine a Siena nel Rinascimento* (Milan, 1991), pp. 273–330.

116 Bargagli Petrucci, *Le fonti*, I, pp. 33–46.

117 *Ibid.*, pp. 63–75 and 77–104. Funding difficulties are discussed in, for example, 'gabella del pane vendareccio' from 1406, capped at 1,200 *lire* in 1462. Bargagli Petrucci, *Le fonti*, I, pp. 127–8; ASS *Biccherna* deliberations are scattered with top-up requests.

118 P. Galluzzi, ed., *Gli ingegneri del Rinascimento da Brunelleschi a Leonardo da Vinci* (Florence, 1996), pp. 117–87 (English version: P. Galluzzi, ed., *Mechanical Marvels: Invention in the Age of Leonardo*, Florence, 1997, pp. 117–87); Balestracci, *I bottini medievali*, pp. 71–2, 153–8.

119 F. Patrizi, *De Institutione Reipublicae* (Paris, 1520), fol. 104v (Bk. VIII, Preface), 'aquae abundantia ad omnium rerum usum [. . .] et fontes plurimos paribus pene spaciiis per urbem emittunt, qui et usui omnibus sunt, et species decoremque ornatus'; P. N. Pagliara, 'Vitruvio: da testo a canone', in *Memoria dell'antico nell'arte italiana*, ed. S. Settis (Turin, 1986), III, p. 29.

120 The most recent survey is V. Serino, ed., *Siena e l'acqua. Storia e immagini della città e delle sue fonti* (Siena, 1997).

121 M. A. Ceppari and P. Turrini, 'Fontenuova, l'acqua dei pellicciai', in *Siena e l'acqua*, ed. Serino, p. 36; Balestracci and Piccinni, *Siena nel Trecento*, p. 164.

122 See also P. Torriti, *Tutta Siena, contrada per contrada* (Florence, 1988), p. 247.

123 On the fountains see Serino, *Siena e l'acqua*, entries for all city fountains, and the introductory essay by D. Balestracci, 'Siena e le sue fonti', pp. 9–18.

124 For the zoning of butchers, see chapter Five.

125 M. A. Ceppari and P. Turrini, 'Fontebranda, l'acqua dell'Oca', in *Siena e l'acqua*, ed. Serino, p. 32.

126 ASS, *Consiglio Generale* 231, fol. 37v–38 (13 September 1465) records plans for a brick-kiln proposed by Meo della Massa; the plan is again discussed by one Stefano di Simone, ASS, *Concistoro* 2158, fol. 160 (17 September 1473).

127 L. B. Alberti, *On the Art of Building in Ten Books*, ed. and trans. J. Rykwert, N. Leach and R. Tavernor (Cambridge, MA, 1991), p. 113 (Bk IV.7).

128 Some general considerations can be found in R. Greci, 'Il problema dello smaltimento dei rifiuti nei centri urbani dell'Italia medievale', in *Città e servizi sociali nell'Italia dei secoli XII–XV* (Centro italiano di studi di storia e d'arte, Pistoia), ed. E. Cristiani (Pistoia, 1990), pp. 439–64

129 Mucciarelli, 'Igiene, salute', pp. 36–40.

130 *Ibid.*, pp. 37–9.

131 ASS, *Concistoro* 2125, fol. 49 (25 February 1466); L. Banchi and S. Borghesi, *Nuovi documenti per la storia dell'arte senese* (Siena, 1898), pp. 222–3, 'la chioca che vada verso Vallerozzi acciò che si possa spesso votiare'.

132 ASS *Balìa* 253, fol. 240v (20 September 1507) refers to refuse ending up in Spedale della Scala 'cloaca'; also Bargagli Petrucci, *Le fonti*, I, p. 69.

133 In addition to these channels, the other destinations for refuse were 'pozzi neri' (black wells or septic tanks) or 'pozzi di butto' (wells for throwing things into), into which refuse of all sorts was cast; many of these have been found in recent restorations around the city, bringing to light diverse archeological artifacts, which range from crockery to organic material; see, for example, M. Bernardi et al., 'Il pozzo di butto nel castellare degli Ugurgeri, nella Contrada della Civetta', in *Contrada Priora della Civetta* (Genoa, 1984), pp. 115–23.

134 C. Frugoni, *A Distant City: Images of Urban Experience in the Medieval World* (Princeton, NJ, 1991), pp. 54–81. Most recently on this theme, see J. Gardner, 'An Introduction to the Iconography of the Medieval Italian City Gate', *Dumbarton Oaks Papers*, 41 (1987), pp. 199–213.

135 E. Cioni, *Museo nazionale del Bargello. Sigilli medievali senesi* (Florence, 1981), pp. 3–4; also A. Cornice in *Iconografia di Siena. Rappresentazione della Città dal XIII al XIX secolo*, ed. R. Barzanti, A. Cornice and E. Pellegrini (Città di Castello, 2006), p. 4, a useful book that assembles and illustrates a rich array of images of the city, including a number discussed below.

136 M. Cristofani, ed, *Siena: le origini. Testimonianze e miti archeologici*, exh. cat. (Florence, 1979), pp. 145–51; the city's Renaissance foundation myth developed the idea that the Castelvecchio had been the original site of a Roman fort, the *Castrum veteris*; see chapter Seven.

137 ASS, *Ufficiali sopra alle mura*, 5; figure in A. Tomei, ed., *Le Biccherne di Siena. Arte e Finanza all'alba dell'economia moderna* (Azzano San Paolo, Bergamo, and Rome, 2002), pp. 184–5.

138 R. Marchionni, *Battaglie Senesi: Montaperti* (Siena, 1996), p. 40; G. Tommasi, *Historia di Siena* (Siena, 1625), pp. 318–19.

139 Numerous cities were dedicated to the Virgin, for example, Venice; see E. Muir, 'The Virgin on the Street Corner: The Place of the Sacred in Italian Cities', in *Religion and Culture in the Renaissance and Reformation*, ed. S. Ozment, *Sixteenth Century Essays and Studies*, XI (Kirksville, MO, 1987), pp. 24–40. F. Glenisson, 'Fête et société: l'Assomption à Sienne et son évolution au cours du XVI siècle', in *Les fêtes urbaines en Italie à l'époque de la Renaissance*, ed. F. Croisette and M. Plaisance (Paris, 1993), pp. 65–129; Norman, *Siena and the Virgin*.

140 ASS *Concistoro* 2375, fol. 1 (1514–1640; Dist. 1, rub. 1), drawn from city Statutes, for example, Elsheikh, *Il Costituto*, I, p. 3 (Dist. 1.1); Ascheri, *L'ultimo statuto*, p. 3.

141 See most recently the essays in *Siena, Florence and Padua*, ed. Norman.

142 B. Benvoglienti, *De urbis Senae origine et incremento* (Siena, 1506), fol. biv2; E. Carli, *Il Duomo di Siena* (Siena, 1979), pp. 9–28; P. A. Riedl and M. Siedel, eds., *Die Kirchen von Siena: Der Dom S. Maria Assunta* (Munich, 2006), III.

143 Carli, *Il Duomo*, pp. 99–124; also G. Aronow, 'A Description of the Altars in Siena Cathedral in the 1420s', in H. van Os, *Sienese Altarpieces, 1215–1460: Form, Content and Function, II: 1344–1460* (Groningen, 1990), pp. 225–42.

144 E. Boldrini and R. Parenti, eds., *Santa Maria della Scala: archeologia e edilizia sulla piazza dello Spedale* (Florence, 1991); R. Parenti, 'Santa Maria della Scala. Lo Spedale in forma di città', in *Storia di Siena. Dalle orgini alla fine della repubblica*, ed. Barzanti, Catoni and De Gregorio, pp. 239–52.

145 H. W. van Os, *Vecchietta and the Sacristy of the Siena Hospital Church: A Study in Renaissance Religious Symbolism* (The Hague, 1974); P. Torriti, 'Gli affreschi del Pellegrinaio', in *Il Santa Maria della Scala: l'Ospedale dai mille anni*, ed. P. Torriti (Genoa, 1991), pp. 71–5; D. Gallavotti Cavallero, ed., *Lo Spedale di Santa Maria delle Scala. Vicende di una committenza artistica* (Pisa, 1985).

146 N. Adams, 'Baldassarre Peruzzi: Architect to the Republic of Siena', PhD thesis, Institute of Fine Arts, New York University, 1977, pp. 211–12; also H. Wurm, *Baldassarre Peruzzi Architekturzeichnungen. Tafelband* (Tübingen, 1984), p. 165.

CHAPTER TWO

1 Aeneas Silvius Piccolomini [Pius II], *The Goodli History of the Lady Lucres of Scene and of her Lover Eurialus*, ed. E. J. Morrall (Oxford, 1996), p. 3 (the first surviving English translation of Piccolomini's *Historia de duobus amantibus*, published *c.* 1553, p. xiii). I have used Aeneas Silvius Piccolomini, *Storia di due amanti e rimedio d'amore* [Latin/Italian edition], ed. and trans. Maria Luisa Doglio (Turin, 1973), p. 28, 'Intranti Sigismondo Cesari quot honores impensi fuerint, iam ubique vulgatum est'.

2 M. Baxandall, 'Art, Society and the Bouguer Principle', *Representations*, 12 (1985), p. 40.

3 Some comments on the possible uses of fiction in Renaissance urban history can be found in L. Martines, 'The Italian Renaissance Tale as History', in *Language and Images of Renaissance Italy*, ed. A. Brown (Oxford, 1995), pp. 322–6.

4 These themes are addressed in my '"Lieto e trionphante per la città": Experiencing a Mid-Fifteenth-century Imperial Triumph along Siena's Strada Romana', *Renaissance Studies*, 17 (2003), pp. 581–606; also in P. Jackson and F. Nevola, 'Introduction', in *Beyond the Palio: Urban Ritual in Renaissance Siena* (Oxford, 2006), pp. 1–10.

5 Cited from R. Trexler, 'Preface' to F. Filarete and A. Manfidi, *The Libro cerimoniale of the Florentine Republic*, ed. R. Trexler (Geneva, 1978), p. 12, from A. Filarete, *Filarete's Treatise on Architecture*, ed. and trans. J. Spencer (New Haven, 1965), p. 44.

6 I have coined the term 'meta-urbanism' to describe this form of layering of usage and meaning; see chapter Four.

7 Tommaso Fecini, 'Cronaca Senese (1431–1479)', in A. Lisini and F. Iacometti, eds., *Cronache Senesi*, in *Rerum Italicarum Scriptores*, vol. 15, part 6 (Bologna 1931–9), p. 872, refers to a visit on 1 April 1474 of 'Cristofano re d'Asia e Svezia con 30 signori e 150 cavagli che va per voto; posossi all'albergo della Corona'; it can only be assumed this is Christian of Denmark (he was indeed in Italy at this time), unless it is an April Fool's Day joke.

8 The events of the Imperial visits of 1355 and 1368 are now discussed in detail in G. J. Schenk, 'Enter the Emperor: Charles IV and Siena between Politics, Diplomacy and Ritual (1355 and 1368)', in Jackson and Nevola, *Beyond the Palio*, pp. 25–43.

9 The process is summarized in M. Ascheri, *Siena nella Storia* (Cinisello Balsamo, Milan, 2000), pp. 88–106. On the eco-

nomic effects of this period, with special reference to military costs, see W. Caferro, *Mercenary Companies and the Decline of Siena* (Baltimore and London, 1998).

10 M. Ascheri and P. Pertici, 'La situazione politica senese del secondo Quattrocento (1456–79)', in *La Toscana ai tempi di Lorenzo il Magnifico: Politica, economia ed arte* (Pisa, 1996), III, pp. 995–8. Specifically on the Piccolomini conflict with government institutions during the thirteenth century, see R. Mucciarelli, *La terra contesa. I Piccolomini contro Santa Maria della Scala, 1277–1280* (Florence, 2001).

11 M. A. Ceppari, 'La signoria di Gian Galeazzo Visconti', in *Storia di Siena. Dalle orgini alla fine della repubblica*, ed. R. Barzanti, G. Catoni and M. De Gregorio (Siena, 1995), I, pp. 321–6.

12 Ascheri and Pertici, 'La situazione politica senese', p. 995; Ascheri, *Siena nella Storia*, pp. 110–18.

13 See W. Brandmüller, *Il concilio di Pavia-Siena, 1423–24. Verso la crisi del conciliarismo* (Siena, 2004); N. Mengozzi, 'Martino v ed il Concilio di Siena (1418–31)', *BSSP*, 25 (1918), pp. 247–314.

14 Comparisons can be drawn with a similar visit to Siena by the Emperor Frederick III (1453), which I have examined in detail in my '"Lieto e trionphante per la città"'.

15 On the success of the novel see E. Morrall, *Aneas Silvius Piccolomini and Niklas von Wyle: The Tale of Two Lovers, Eurialus and Lucretia* (Amsterdam, 1988), p. 35, who claims 73 editions; E. Morrall, 'Introduction', in Piccolomini, *The Goodli History*, p. xv. D. Pirovano, 'Introduzione,' in Aeneas Silvius Piccolomini, *Historia de duobus amantibus*, ed. D. Pirovano (Alessandria, 2001), p. 7, is more cautious and counts 'almeno trenta, stampate prima della fine del secolo xv e più di quaranta nel scolo successivo'. See also E. O'Brien, 'The History of the Two Lovers', in A. S. Piccolomini, *The Two Lovers: The Goodly History of Lady Lucrece and her Lover Eurialus*, ed. E. O'Brien and K. R. Bartlett (Ottawa, 1999), pp. 14–84.

16 The stock elements of the Renaissance tale are summarized effectively in L. Martines, *Strong Words: Writing and Social Strain in the Italian Renaissance* (Baltimore and London, 2001), pp. 199–231.

17 Readings of the tale in relation to classical and contemporary sources can be found in R. Glendenning, 'Love, Death and the Art of Compromise: Aeneas Silvius Piccolomini's *Tale of Two Lovers*', *Fifteenth-Century Studies*, 23 (1996), pp. 101–20; Morrall, *Aneas Silvius Piccolomini and Niklas von Wyle*; E. Morrall, 'Introduction', in Piccolomini, *The Goodli History*, pp. xviii–xxxiii; D. Pirovano, 'Memoria dei classici nell' *Historia de duobus amantibus* di Enea Silvio Piccolomini', *Studi Vari di Lingua e Letteratura Italiana in Onore di Giuseppe Velli* in Quaderni di *ACME*, 41 (2000), I, pp. 255–75. Also A. Frugoni, 'Enea Silvio Piccolomini e l'avventura senese di Gasparre Schlick', *La Rinascita*, 4 (1941), pp. 229–49.

18 The case for and against the likelihood of the story being based on true events is laid out by Morrall in *Aneas Silvius Piccolomini and von Wyle*, and in the 'Introduction' in Piccolomini, *The Goodli History*, pp. xviii–xix.

19 The political circumstances of the visit are described in P. Pertici, '"I sacri splendori": Eugenio IV e Siena in un affresco di Domenico di Bartolo,' *BSSP*, CVI (1999 [2001]), pp. 484–94.

20 The German translation was the first version of the story to be published, and manuscripts circulated from 1444; see Morrall, *Aneas Silvius Piccolomini and Niklas von Wyle*, p. 35.

21 P. Nardi, *Mariano Sozzini: Giuresconsulto senese del Quattrocento* (Milan, 1974), pp. 13–16 and 73–5.

22 ASS, *Concistoro* 1926–7; various letters written in the name of Sigismund all bear the signature of Schlick.

23 Piccolomini, *Storia di due amanti*, pp. 126–9 (letter to Schlick).

24 Piccolomini, *Storia di due amanti*, p. 18. For dating and biographical information, see Glendenning, 'Love, Death and the Art of Compromise', pp. 102 and 114, which proposes a reading of the narrative that retraces the *Tristan* of Gottfried von Strassburg. The work was completed and sent to Sozzini with a letter dated Vienna, 3 July 1444; see E. Morrall, 'Introduction', in Piccolomini, *The Goodli History*, p. ix, and Piccolomini, *Storia di due amanti*, p. 18.

25 Morrall, *Aeneas Silvius Piccolomini and Niklas von Wyle*, cites Aeneas Silvius Piccolominis [Pius II]. *De Gestis Concilii Basilensis Commentariorum Libri II*, ed. D. Hay and W. K. Smith (Oxford, 1967), p. xxivf.; see also M. Simonetta, *Rinascimento segreto. Il mondo del Segretario da Petrarca a Machiavelli* (Milan, 2004), pp. 65–74. Even Mariano Sozzini appears to have been absent, as he was banned from Siena for the period of the visit; see Nardi, *Mariano Sozzini*, pp. 118–19 [doc. 8].

26 Piccolomini, *Storia di due amanti*, p. 128 (letter to Schlick, 'Civitas Veneris est'), p. 86 (flirting with women at Porta Tufi); on Piccolomini's own amorous pursuits, see Glendenning, 'Love, Death and the Art of Compromise', pp. 101 and 115 n. 2, for a letter of 1444 to Pietro da Noceto in which Piccolomini confesses his great love of women and the fact that 'after possessing them, have grown extremely weary of them'.

27 P. Viti, 'I volgarizzamenti di Alessandro Braccesi dell' *Historia de duobus amantibus* di Enea Silvio Piccolomini', *Esperienze Letterarie*, VII/3 (1982), pp. 62–8; MS. in Biblioteca Ricciardiana, Florence (Ricc. 2094), first published in Florence (1481).

28 Siena was traditionally – although not always politically – aligned with the Holy Roman Emperor, and thus Ghibelline; this was particularly a result of the Imperial support that assured the Sienese victory against the Florentines at Montaperti in 1260.

29 A more comprehensive 'experiential' reconstruction of the urban experience of ritual is outlined in my analysis of the triumphal entry of Frederick III and Eleanora of Portugal in February 1452: '"Lieto e trionphante per la città"', pp. 581–606, with bibliography and some methodological discussion, summarized below.

30 K. Lynch, 'Notes on City Satisfaction (1953)', in *City Sense and City Design: Writings and Projects of Kevin Lynch*, ed. T. Banerjee and M. Southworth (Cambridge, MA, and London, 1990), p. 147, and K. Lynch, *The Image of the City* (Cambridge, MA, and London, 1960), pp. 46–90, based on the five typological elements: paths, edges, districts, nodes and landmarks. The visual bias of the application of Lynch's method is clearly expressed by D. Favro, 'Meaning and Experience: Urban History from Antiquity to the Early Modern Period', *Journal of the Society of Architectural Historians*, 58 (1999), p. 367, who states that this is because architectural historians are 'unable to conduct interviews with the original users of historical environments'.

31 R. Finnegan, *Tales of the City: A Study of Narrative and Urban Life* (Cambridge, 1998), offers a stimulating multi-narrative approach to experiencing the contemporary city of Milton

32 In this respect, Sigismund's visit is somewhat different from that of Frederick's, which being brief had a less long-lasting impact. A useful comparison can instead be made to the effects of Pius II's two long stays in 1458–60 (see chapter Four) and my 'Ritual Geography: Housing the Papal Court of Pius II Piccolomini in Siena (1459–60)', in Jackson and Nevola, *Beyond the Palio*, pp. 65–88.

Keynes in England, in which no totalizing discourse or conclusion is proposed by the author.

33 R. Trexler, *Public Life in Renaissance Florence* (New York and London, 1980), pp. 279–90; on purely civic Sienese ritual see my 'Cerimoniali per santi e feste a Siena a metà Quattrocento. Documenti dallo *Statuto di Siena*, 39', in *Siena ed il suo territorio nel Rinascimento*, III, ed. M. Ascheri (Siena, 2001), pp. 171–84; also W. Heywood, *Palio e Ponte* (Siena and London, 1904), continues to be a useful source.

34 Discussed in Trexler, *Public Life*, pp. 290–306; also P. Fortini Brown, 'Measured Friendship, Calculated Pomp: The Ceremonial Welcomes of the Venetian Republic', in *Triumphal Celebrations and the Rituals of Statecraft (Papers in Art History from the Pennsylvania State University, VI, Part 1)* (University Park, PA, 1990), pp. 136–87. A useful summary of ritual entries to Siena is in A. Provedi, *Relazione delle pubbliche feste date in Siena negli ultimi cinque secoli* (Siena, 1791); see the essays in Jackson and Nevola, *Beyond the Palio*.

35 Trexler, *Public Life*, pp. 297–306.

36 Trexler, *Public Life*, p. 297.

37 ASS, *Concistoro* 397, fol. 5 (3 March 1432); Fecini, 'Cronaca Senese', p. 842 (reports the arrival on 2 March, and that they were two noblemen and a bishop). The Albergo della Corona was frequently used for embassies, perhaps on account of its quite central location and large size; see M. Tuliani, *Osti, avventori e malandrini. Alberghi, locande e taverne a Siena e nel contado tra '300 e '400* (Siena, 1994), pp. 171–7, 210.

38 ASS, *Concistoro* 398, fol. 6v (5 May). A cap of 100 *lire* was set on the stay.

39 ASS, *Concistoro* 398, fol. 18–20 (12 May); approved also in ASS, *Consiglio Generale*, 217, fol. 14v (14 May 1432).

40 For a discussion of the political risks of such visits, see C. Shaw, *The Politics of Exile in Renaissance Italy* (Cambridge, 2000), pp. 74–9; the exiles returned within days of the court's departure, see Fecini, 'Cronaca Senese', p. 847. For an early precedent for political change coalescing around an Imperial visit, see Schenk, 'Enter the Emperor'.

41 ASS, *Concistoro* 398, fol. 20, 'tenuti star di dì et di notte ala guardia dello Imperadore et del presente reggimento'; Fecini, 'Cronaca Senese', p. 844 for Colonna and others.

42 That this was acknowledged as being a difficult task is indicated by the fact that they were given no instructions as to how to broach the subject, but were told to choose the right moment, 'come parrà a loro, essendo in sul fatto' (ASS, *Concistoro* 398, fol. 20). The ambassadors were named on 5 May (ASS, *Concistoro* 398, fol. 7): Pietro Pecci, Antonio da Battignano, Pietro Berardi and Pietro di Michele.

43 ASS, *Concistoro* 398, fol. 20, 'sieno la maggiore parte che possino licterati [. . .] almeno due licterati'. For the committee on housing, see ASS, *Concistoro* 398, fol. 56–7v (6–7 June): Meo di Niccolò di Cione, Francesco di Mino del Cicerchia, Ser Chasuccio di Francescho, Mr Marino di Giovanni di Golla, Leonardo di Meo di Niccolò, Iacomo di Agniuolo di Guidoni.

44 ASS, *Concistoro* 399, fol. 12r, 'prestant de ornamentis palatii [. . .] pro honorando imperatore'.

45 ASS, *Concistoro* 399, fol. 13v, 'Pingant arma Imperatoris in facie palatii sub signuo nominis Hiesu in capite armorum comunis'.

46 An unpublished account book records many items of expenditure: ASS, *Concistoro* 2475, 'Per le Stanze de lo'nperadore'.

47 ASS, *Concistoro* 2475, 'Per le Stanze de lo'nperadore', fol. 1: 'Al nome sia dello Omnipotente Glorioso e hetterno et dela sua santissima madre Madonna Santa Maria, sempre Vergine, et dei gloriosi apostoli, Misser Scto Pietro et Misser Scto Pauolo et del glorioso santo Misser Giovanni Battista, et del vangelista et dei gloriosi martiri Ansano, Savino, Crescentio et Vittorio, et generalmente di tutta la celestial chorte di paradiso, ei quali con preghiere devotissime preghiamo che ci concedino gratia di fare tutte quelle cose che sieno laude et riverentia santissima et che noi possiamo provedere chom principio meyo et fine laudevole et perfetto ale stanze da ordinarsi per la Maesta dello Impero a onore e stato del magnifico chomuno di Siena. E chosi piaccia addio che ssia.'

48 The bibliography on Siena's devotion to the Virgin is vast; see most recently, D. Norman, *Siena and the Virgin: Art and Politics in a Late Medieval City* (New Haven and London, 1999).

49 Payments discussed below and are contained in ASS, *Concistoro* 2475, fol. 6–8 (8–23 June).

50 The military functions of this sequence of gates is described in N. Adams and S. Pepper, *Firearms and Fortification: Military Architecture and Siege Warfare in Sixteenth-century Siena* (Chicago, 1986), pp. 34–7. The use of staggered or crooked street alignment to gates appears more regularly in sixteenth-century fortification design, but does not seem to have affected the design of Siena's gates; see, in general, H. de la Croix, 'Military Architecture and the Radial City Plan in Sixteenth-century Italy', *Art Bulletin*, 42 (1960), pp. 263–90.

51 Milanesi, *Documenti*, III, pp. 207–8.

52 Adams and Pepper, *Firearms and Fortification*, pp. 34–5; the Torrione has since been demolished. On these hostels, see Tuliani, *Osti, avventori e malandrini*, pp. 34–41, 209–24.

53 The decoration of Siena's city gates is discussed by Norman, *Siena and the Virgin*, p. 226 n. 56; see also J. Gardner, 'An Introduction to the Iconography of the Medieval Italian City Gate', *Dumbarton Oaks Papers*, 41 (1987), pp. 199–213; M. Israëls, 'New Documents for Sassetta and Sano di Pietro at the Porta Romana, Siena', *Burlington Magazine*, 140 (1998), pp. 436–43.

54 Attribution and dating to the year of Simone's death is in G. Vasari, *Le vite dei più eccellenti pittori, scultori ed architettori*, ed. P. Barocchi (Florence, 1967), II, pp. 198–9; see also M. Israëls, 'Al cospetto della città. Il Sodoma a Porta Pispini, culmine di una tradizione civica', in *Siena nel Rinascimento: l'ultimo secolo della repubblica*, Acts of the International Conference, ed. G. Mazzoni and F. Nevola (Florence, 2007).

55 This was the site traditionally used for these meetings; see the description of the area by the mid-fifteenth-century Sienese historian A. Dati, 'Historiae Senenses', in *Opera* (Siena: Simone di Niccolò Nardi, 1503), p. ccxxviii, 'Extra Camilliam portam ad portam alteram latissima patet area [. . .] Longitudo est paulo minus stadia duo, latitudo maior.'

56 See Fecini, 'Cronaca Senese', pp. 844–5 for a full listing of the leading courtiers and the number of riders in each of their parties.

57 Diana Norman has considered the baldachin in Simone's fresco in direct relation to the entries to Siena of the Angevin princes; see Norman, 'Sotto uno baldachino trionfale'.

58 Fecini, 'Cronaca Senese', p. 844, 'Siate voi proprii guardia della vostra città senese'.

59 ASS, *Concistoro* 399, fol. 16v (12 July), 'Die sabati duodecima Julii. Qua Imperatore Intravit circa horam novam', noting that the Emperor had responded to the governors' offer of the city keys, 'Et ego committo vobis eas'.

60 Fecini, 'Cronaca Senese', p. 845, 'mongioia, o vuoi dire iscudo in terzo con l'armi di'nperio e duca di Milano e di Siena'.

61 No such descriptions survive for Sigismund's entry; for the entry of Frederick III, see my 'Lieto e trionphante per la città'; for Pius II's entry in 1460, see Piccolomini, *I Commentarii*, II, pp. 662–5, and A. Allegretti, *Ephemerides Senenses ab anno MCCCCL usque ad MCCCCXCVI italico sermone scriptae*, in *Rerum Italicarum Scriptores*, ed. L. Muratori, vol. 23 (Milan, 1733), p. 769 (31 January 1460).

62 On the ritual functions of this moment in papal Rome see, for example, Ingersoll, 'Ritual Use of Public Space', pp. 172–4; a useful analysis of the act within the Sienese context can now be found in Schenk, 'Enter the Emperor'.

63 Donusedo Malavolti was Bishop of Siena for 1316–50. The casa di S. Marta was the traditional residence used for housing guests to the city; a foundation document (1348) for the guest house is in ASS, *Spedaletti*, 'Ospizio di Santa Marta', p. 51; there is a brief discussion in G. Cecchini, ed., *Guida inventario dell'archivio di Stato di Siena* (Rome, 1951), II, p. 207. It is referred to in the sale document of 25 October 1458 as 'detta casa che fù di M. Dom. Deo Malavolti', for which see ASS *Diplomatico Bichi Borghesi*, Pergamene Bichi, vol. I, fol. 122 (summarized in ASS MS. B 25, fol. 46v–47v). See also A. Cirier, 'Note sur le monastère de Santa Marta in Siene', *BSSP*, 109 (2002), pp. 497–513 (512).

64 ASS, *Concistoro* 2475, fol. 85 for a full listing of works; Domenico is noted there and at fol. 19v, paid for a minimal sum for unspecified work. See also Piccolomini, *Storia di due amanti*, p. 28, 'Palatium illi apud sacellum sancte Marthe super vicum, qui ad Tophorum ducit portam, structum fuit'.

65 ASS, *Concistoro* 2475, fol. 20–29 (payments to 17 July for all aspects of construction of the kitchens).

66 ASS, *Concistoro* 2475, fol. 18, 'si chontengono nel palazo pigliamo dallui per preparare ale stanze dello Imperadore'.

67 ASS, *Concistoro* 2475, fol. 10–11 (23–26 June) 'uno panno da muro depinto chon fighure grandi' and 'uno tappetto grande ala franciosa di piu cholori'.

68 ASS, *Concistoro* 2475, fol. 11 (26 June), 'panni x da muro grandi fighurati [. . .] iiii banchali e ii panni da muro, luno ala storia di Salamone e latro ala storia d'alessandro', with reference to their acquisition by the Commune.

69 As reported by Fecini, 'Cronaca Senese', p. 845.

70 ASS, *Concistoro* 399–402 make frequent references to the offering of food. For confirmation of provision that the *spenditore di palazzo* was to make sure of daily supplies sent to the Palazzetto, see ASS, *Concistoro* 400, fol. 3 (2 September).

71 ASS, *Consiglio Generale*, p. 217, uses the formula 'Serenissimo Imperatore dno Sigimondo Siena dimorante'.

72 The idea of overlaid multiple webs of use and of temporary use involving the urban fabric is compelling, and I discuss it in relation to the papal court of Pius II in 'Ritual

Geography: Housing the Papal Court of Pius II'. A reading of Marseilles in this light is offered by D. L. Smail, *Imaginary Cartographies: Possession and Identity in Late Medieval Marseilles* (Ithaca, NY, and London, 2000).

73 Documentation of the properties involved, with minimal reference to improvement costs and damage compensation at the end of the stay, is recorded in ASS, *Concistoro* 2475, fol. 34–5, 84–5 and 100–103.

74 Fecini, 'Cronaca Senese', p. 846.

75 ASS, *Concistoro* 399, fol. 63; see also P. Pertici, *Le epistole di Andreoccio Petrucci (1426–1443)* (Siena, 1990), p. 15.

76 Piccolomini, *Storia di due amanti*, p. 36 (and p. 68), 'medias inter Cesaris curiam et Euriali domum Lucretia edes habuit, nec palatium petere Eurialus poterat, quin illam ex altis sese ostentatem fenestris haberet in oculis [. . .] ex sua [Cesare] consuetudine nunc huc nunc equitaret illuc et hac sepe transiret.'

77 Fecini, 'Cronaca Senese', p. 846: 'A dì tre d'agosto si fè uno placo dal sale a la lupa molto largo e bello alto sopra l'uscio di palazo, e in sul paco si ferono e' gradi più alto l'uno che l'altro, e nel più alto e in mezo si fè la sedia imperiale coperta di drappo. E venne lo 'nperadore e posesi nella sedia, di poi al primo grado arcivescovi e signori senesi e altri magiori dell'inperio e gli altri sicondo il grado degli uomini, e cosi erano assettati a sedere.' The scene can be conjured from the Sano di Pietro image of S. Bernardino preaching, where the 'porta del sale' is prominently visible on the Palazzo Pubblico façade, to the left of the saint.

78 Fecini, 'Cronaca Senese', p. 846 'con 200 giovane benissimo ornate, e ballossi con grande onestate, e si tornò poi ciascuno a casa sua'. It is surprising Piccolomini did not hear reports of the ball and incorporate them in the *Historia*, as it would have served well in his narrative.

79 Involvement in foreign affairs is documented in numerous entries in ASS, *Concistoro*, pp. 399–403; for the Piccinino troops, see *Concistoro* 399, fol. 63 (27 August).

80 Piccolomini, *Storia di due amanti*, p. 106, for the investiture of a 'pimp' in the affair: 'In nobilitate multi sunt gradus, mi Mariane [Sozzini], et sane, si cuiuslibet origine queras, sicut mea sententia fert, aut nullas nobilitates invenies aut admodum paucas, que sceleraraum non habuerint ortum.'

81 J. H. Beck, 'The Historical "Taccola" and the Emperor Sigismund in Siena', *Art Bulletin*, 50 (1968), pp. 309–20.

82 On Taccola, see *Prima di Leonardo: cultura delle macchine a Siena nel Rinascimento*, ed. P. Galluzzi (Milan, 1991); also P. Galluzzi, 'Introduction', in *Mechanical Marvels: Invention in the Age of Leonardo*, ed. P. Galluzzi (Florence, 1997), pp. 24–35. On Francesco di Giorgio Martini in Siena, see chapter Nine.

83 Beck, 'The Historical "Taccola" ', pp. 314–16.

84 Captions in Beck, 'The Historical "Taccola" ', p. 315, 'Defende oves meas ex quibus te custodiam elegis'.

85 ASS, *Concistoro* 400, fol. 54 (24 October 1432).

86 Piccolomini, *Storia di due amanti*, p. 86, 'Solent matrone Senenses ad primum lapidem sacellum dive Marie, quod in Betleem nuncupant, sepius visitare [. . .] Solebat hoc hominum [studentes] genus pergratum esse nostre matronis, sed postquam Cesaris curia Senas venit, irrideri, despici et haberi odio cepit, qui plus amorum strepitus quam litterarum lepor nostras feminas oblectabat.'

87 I have not been able to identify the palace, which is described in ASS, *Concistoro* 403, fol. 41 (19 April 1433) as being in the district of S. Giovanni and 'in contrada del

Senatore', having once belonged to the 'Domini de Cortonio'. It may, in fact, be the Palazzo del Capitano (discussed below and in chapter Three).

88 G. Aronow, 'A Documentary History of the Pavement Decoration in Siena Cathedral, 1362 through 1506', PhD thesis, Columbia University, 1985, pp. 113, 125–32; E. Carli, *Il Duomo di Siena* (Siena, 1979), pp. 147–8; R. Hobart Cust, *The Pavement Masters of Siena (1369–1562)* (London, 1901), pp. 76–81, 112–14. See M. Caciorgna, 'Il transetto destro', in *Il pavimento del Duomo di Siena*, ed. M. Caciorgna and R. Guerrini (Siena, 2004), pp. 139–41.

89 Hobart Cust, *The Pavement Masters*, pp. 77–8; P. Pertici, '"I sacri splendori": Eugenio IV e Siena in un affresco di Domenico di Bartolo,' in *BSSP*, CVI (1999 [2001]), pp. 484–5. For Domenico di Bartolo's drawing see Milanesi, *Documenti*, II, p. 161 (30 October 1434); cited Hobart Cust, *The Pavement Masters*, p. 77 n. 2, 'et assai farebbe honore averlo nella mani della decta opera'.

90 The means by which monuments of this sort served to reinforce a governmental or 'civic' memory of the event is discussed in relation to the visit of Frederick III in my '"Lieto e trionphante per la città": Experiencing a Mid-Fifteenth-century Imperial Triumph along Siena's Strada Romana', *Renaissance Studies*, 174 (2003), pp. 581–606, esp. pp. 603–6.

91 Piccolomini, *Storia di due amanti*, p. 128, 'Civitas Veneri est. Aiunt, que te norant, vehementer quod arseristi, quodque nemo te gallior fuerit. [...] Qui numquam sensit amori ignem aut lapis est aut bestia. Isse nanque vel per deorum medullas, non lateat, igneam favillam.'

92 Conversely, it is also an ode of the career exile's love for his home town, the city where Piccolomini spent his youth as a student; in this regard it is worth noting that the other addressee of the tale was Mariano Sozzini, another frequent political exile of the city, in fact banished from Siena for the period of the Imperial visit.

93 See comments in L. Martines, *An Italian Renaissance Sextet: Six Tales in Historical Context* (New York, 1994), pp. 153–7, which interprets Lorenzo de' Medici's story *Giacoppo* as a trick played as much on Siena as on a Sienese man.

94 Piccolomini, *Storia di due amanti*, p. 28, 'non mortales sed deas quisque putavit'; Fecini, 'Cronaca Senese', p. 844. On famous Sienese women, see M. Caciorgna, 'Giovanni Antonio Campano tra filologia a pittura. Dalle *Vitae* di Plutarco alla biografia dipinta di Pio II', *Quaderni dell'Opera*, II (1998), pp. 121–9.

95 Piccolomini, *Storia di due amanti*, p. 66, 'Sene ipse vidue videbantur'. On the reflexive politics and emotions surrounding visits by dignitaries, see Trexler, *Public Life*, pp. 279–90.

96 Piccolomini, *Storia di due amanti*, p. 64, 'Ut turres, que fracta interius inexpugnabilis videtur exterius, si admotus aries fuerit, mox confringitur, Eurali verbis Lucretia victa est'.

97 A full discussion of medieval towers can be found in chapter Three.

98 Piccolomini, *Storia di due amanti*, p. 30; opening description of Lucretia comments on her wearing precious stones in her hair.

99 The urban improvements to the city are discussed in the section that follows.

100 Piccolomini, *The Goodli History*, p. 5.

101 Culminating in the 1446 contract with Giachetto di Benedetto, for which see Introduction, and H. Smit, '"Ut si

bello et ornato mestiero": Flemish Weavers Employed by the City Government of Siena (1438–1480)', in B. W. Meijer et al., *Italy and the Low Countries: Artistic Relations: the Fifteenth Century* (Florence, 1999), pp. 69–78.

CHAPTER THREE

1 Heirs of Niccolò di Iacomo Bichi, from ASS, *Lira* 137, fol. 105 (1453): 'Chostocci detta chasa fl. quattrocento e fella la buona memoria di nostro padre che vi spese più di cento fl. che non valeva per essere presso dei suoi'.

2 Sienese examples of fortified magnate enclaves are explored in E. English, 'Urban Castles in Medieval Siena: The Sources and Images of Power', in *The Medieval Castle: Romance and Reality*, ed. K. Reyerson and F. Powe, *Medieval Studies at Minnesota*, 1 (Dubuque, IA, 1984), pp. 175–98 (thanks to Julian Gardner for this reference). See also C. Lansing, *The Florentine Magnates: Lineage and Faction in a Medieval Commune* (Princeton, NJ, 1991), pp. 84–8.

3 On the anti-magnate laws of 1277, see D. Waley, *Siena and the Sienese in the Thirteenth Century* (Cambridge, 1991), pp. 77–82.

4 On the towers extant in the eighteenth century, see G. A. Pecci, *Nota delle torri e li castellari che esistevano e che esistono in Siena*, ASS, MS. A. 2 bis, 19–20. A useful survey, somewhat dependant on eighteenth-century sources, has recently been published by V. Castelli and S. Bonucci, *Antiche Torri di Siena* (Siena, 2005).

5 There is a general summary of tower architecture in Lansing, *The Florentine Magnates*, pp. 84–8. See also K. Trabgar, 'Il campanile del Duomo di Siena e le torri gentilizie della città', *BSSP*, 102 (1995), pp. 159–86.

6 On materials used in Siena see R. Parenti, 'I materiali del costruire', in *Architettura civile in Toscana: il Medioevo*, ed. A. Restucci (Siena, 1995), pp. 371–99; see also M. Giamello, G. Guasparri, R. Neri and G. Sabatini, 'Building Materials in Siena Architecture: Type, Distribution and State of Conservation', *Science and Technology for Culture Heritage*, 1 (1992), pp. 55–65, with materials map.

7 The limestone blocks can be discerned very clearly from the materials maps drawn up by Giamello et al., 'Building Materials in Siena', pp. 55–65 and M. Giamello, G. Guasparri, R. Neri and G. Sabatini, 'I materiali litoidi nell'architettura senese. Tipologia, distribuzione e stato di conservazione', in *Il colore della città*, ed. M. Boldrini (Siena, 1993), pp. 115–29, esp. 116–20.

8 All these towers are noted in Pecci, *Nota delle torri*, fol. 19v–20.

9 A tentative reconstruction of the palace in the sixteenth century is in L. Franchina, 'I misteri del castellare', in *Contrada Priora della Civetta* (Genoa, 1984), p. 104. The existence of a family tower is reported in Pecci, *Nota delle torri*, fol. 20v ('abbassata nel 1280'). Early legislation on tower building can be found in L. Zdekauer, ed., *Il constituto del comune di Siena dell'anno 1262* (Milan, 1897), Distinction IV.1 and 5.

10 Property owners in the Castellare Ugurgieri: ASS, *Lira* 144, fol. 58, 92, 187.

11 See ASS, *Lira* 194, fol. 3–9 (1481) and 112, fol. 1–6 (1509)

12 A. Carniani, *I Salimbeni, quasi una signoria* (Siena, 1995); F. Guerrieri, 'Vicende architettoniche', in *La sede storica del Monte dei Paschi di Siena*, ed. F. Guerrieri (Siena, 1988), pp. 17–24.

13 V. Lusini, 'Il Castellare dei Salimbeni', *Rassegna dell'arte senese*, 18 (1925), pp. 19–39; also F. Guerrieri et al., 'Vicende architettoniche', pp. 17–24.

14 See G. Morolli, ed., *Giuseppe Partini: architetto del Purismo Senese* (Florence, 1981), esp. pp. 154–6; F. Guerrieri, 'Vicende architettoniche', pp. 129–45.

15 For a discussion of the restoration of the tower in the twentieth century by Pierluigi Spadolini, see F. Guerrieri, 'Restauro, conservazione, riasseto funzionale', in Guerrieri, *La sede storica*, pp. 167–88.

16 The church is discussed in chapter Four. The Poggio Malavolti was reordered in the later nineteenth century to make way for the piazza della Posta, and is described in English, 'Urban Castles in Medieval Siena'; also U. Morandi, 'Il castellare dei Malavolti', in *Quattro Monumenti Italiani (INA)*, ed. M. Salmi (Rome, 1969), pp. 15–37. Brief discussion in P. Torriti, *Tutta Siena, contrada per contrada* (Florence, 1988), pp. 301–2.

17 Morandi, 'Il castellare dei Malavolti', pp. 20–24.

18 G. Prunai, G. Pampaloni and N. Bemporad, eds., *Il Palazzo Tolomei a Siena* (Florence, 1971), pp. 59–86; also T. Benton, 'Three Cities Compared: Urbanism', in *Siena, Florence and Padua: Art, Society and Religion, 1280–1400*, ed. D. Norman (New Haven and London, 1995), II, pp. 13–14.

19 Further discussion of the Tolomei clan in chapter Seven. On the use of family loggias in medieval Siena, see G. Piccinni, 'Modelli di organizzazione dello spazio urbano dei ceti dominanti del Tre e Quattrocento. Considerazioni senesi', in *I ceti dirigenti nella Toscana tardo comunale (Atti del convegno, 5–7 dicembre 1980, Firenze*, ed. D. Rugiadini (Florence, 1983), pp. 230–34.

20 The palace is discussed further in relation to commerce in chapter Five; detailed discussion in F. Toker, 'Gothic Architecture by Remote Control: An Illustrated Building Contract of 1340', *Art Bulletin*, 69 (1985), pp. 67–95. See the essays in *Palazzo Sansedoni*, ed. F. Gabbrielli (Siena, 2004).

21 The emergence of the façade is discussed in detail in chapters Five and Six; see also D. Friedman, 'Palaces and the Street in Late-Medieval and Renaissance Italy', in *Urban Landscapes, International Perspectives*, ed. J. W. R. Whitehand and P. J. Larkham (London, 1992), pp. 69–113, and, somewhat more summarily, H. Saalman, 'The Transformation of the City in the Renaissance: Florence as Model', *Annali di Architettura*, 2 (1990), pp. 73–82.

22 For demographic issues see S. Cohn, *Death and Property in Siena, 1205–1800* (Baltimore, 1988); on economic decline at the end of the fourteenth century see W. Caferro, *Mercenary Companies and the Decline of Siena* (Baltimore and London, 1998) and M. Ascheri, 'Siena. Centro finanziario, gioiello della civiltà comunale italiana', in *Le Biccherne di Siena. Arte e Finanza all'alba dell'economia moderna*, ed. A. Tomei (Azzano San Paolo, Bergamo, and Rome, 2002), pp. 14–21. The classic statement on artistic decline is M. Meiss, *Painting in Florence and Siena After the Black Death* (Princeton, NJ, 1951); useful critiques are offered by H. van Os, 'The Black Death and Sienese Painting', *Art History*, 4 (1981), pp. 237–49 (also in *Sienese Altarpieces: Form, Content and Function*, II: *1344–1460*, Groningen, 1990) and S. Cohn, *The Cult of Remembrance and the Black Death: Six Renaissance Cities in Central Italy* (Baltimore, 1992), pp. 271–80.

23 G. Cecchini, 'Introduzione', in *Archivio di Stato di Siena, Archivio di Biccherna. Inventario*, ed. G. Cecchini (Rome, 1953), pp. xi–xii and III. Cases from 1454 to 1556 are contained in ASS, *Biccherna* 1061; elections in ASS, *Biccherna* 772–814 (1459–1530). ASS, *Statuti di Siena* 25, fol. 127 (1419); M. Ascheri, *Siena nel Rinascimento. Isituzioni e sistema politico* (Siena, 1985), pp. 109–37. Of 228 petitions and arbitrations in ASS, *Biccherna* 1061, only ten predate 1503. More material in ASS, *Notarile Antecosimiano*, 1546, fol. 1–15 (1515–18); on house restorations from 1423 see below and ASS, *Biccherna* 1059, fol. 2 (P. Turrini, *'Per honore et utile de la città di Siena'. Il comune e l'edilizia nel Quattrocento* (Siena, 1997), pp. 43–81). Identification of *Petroni* as professionals from the building trade, from ASS, *Biccherna* 1061, for example: fol. 6 (1469), Guidoccio di Andrea and Francesco di Turrino detto 'el Guasta', fol. 11 (1503), 'Urbano di Pietro [da Cortona] scalpellino, Ventura [Turapilli?] falegname'.

24 Turrini, *'Per honore et utile de la città'*, pp. 33, 43–78.

25 ASS, *Biccherna* 1059, fol. 2; Turrini, *'Per honore et utile de la città'*, pp. 43–81. See also N. Mengozzi, 'Martino V ed il Concilio di Siena (1418–31)', *BSSP*, 25 (1918), pp. 247–314.

26 ASS, *Consiglio Generale* deliberation of 8 April, recorded in ASS, *Biccherna* 1060, fol. 2r–v (18 April 1444).

27 ASS, *Biccherna* 1060 (listed in Turrini, *'Per honore et utile de la città'*, pp. 43–81); Ruffaldo Ruffaldi case in ASS, *Consiglio Generale* 233, fol. 71 (12 December 1469).

28 ASS, *Consiglio Generale* 233, fol. 308–309 (21 June 1471); issues of urban aesthetics and legislative measures for the street's improvement are addressed in detail in chapter Five.

29 *Ibid.* The funding for this massive project was shared between the *Comune* (500 fl.), the Spedale di S. Maria della Scala (400 fl.) and the Savi della Misericordia (100 fl.); it has been pointed out that the Spedale della Misericordia had closed at the end of the fourteenth century, and its property passed to the *Studium* as the Casa della Sapienza; see P. Nardi, 'Origini e sviluppo della Casa della Misericordia nei secoli XIII e XIV', in *La Misericordia di Siena attraverso i secoli*, ed. M. Ascheri and P. Turrini (Siena, 2004), pp. 84–6, and P. Brogini, 'La trasformazione della Casa della Misericordia in Casa della Sapienza', in the same volume, pp. 121–33; the use of 'Misericordia' in this document might be explained by a continued association of the term with the Sapienza.

30 Turrini, *'Per honore et utile de la città'*, pp. 43, 46.

31 ASS, *Consiglio Generale* 233, fol. 308 (21 June 1471), 'considerato che nela nostra Città molte case sono guaste e di continuo ruinano con grande deturpamento della città et vedendo caso che quelli di fuore avessero a tornare dentro non trovarebbero ricepto lo parrebbe non tanto utile quanto necessario ad tale inconveniente obviare'. The situation had clearly been made worse by earthquake damage in 1468, documented in the *Biccherna* cover of that year.

32 Turrini, *'Per honore et utile de la città'*, p. 136.

33 *Ibid.*, pp. 136–7. For Luca di Bartolo, see P. Sanpaolesi, 'Aspetti di architettura del '400 a Siena e Francesco di Giorgio', in *Studi Artistici Urbinati*, I (1959), p. 152; Cecchini, 'Minime di storia dell'arte senese: Un'altro palazzo gotico del Rinascimento', *BSSP*, 68 (1961), pp. 241–50. Siena's complex relationship with Gothic (or traditional fourteenth-century) architectural forms is discussed further in chapter Six, as is the activity of Luca di Bartolo da Bagnocavallo.

34 For the thesis of Siena's continued preference for Gothic, see most recently M. Quast, 'Palace Façades in Late Medieval and Renaissance Siena: Continuity and Change in the Aspect of the City', in *Renaissance Siena: Art in*

Context, ed. A. L. Jenkens (Kirksville, MO, 2005), pp. 55–6; on Palazzo Marsili, see G. Cecchini, 'Minime di storia dell'arte senese', pp. 241–50, and for its nineteenth-century overhaul, see G. Maramai in *Giuseppe Partini*, ed. Morolli, p. 157.

35 Family history in T. Bichi Ruspoli, 'L'archivio privato Bichi Ruspoli', *BSSP*, 77 (1980), pp. 194–225; also G. Cecchini, 'Il Castello delle Quattro Torri e i suoi proprietari', *BSSP*, 55 (1948), pp. 3–32.

36 For the will of Niccolò di Galagano Bichi, rector of S. Maria della Scala, that stipulated burial in S. Agostino, see ASS, *Diplomatico Bichi Borghesi*, Pergamene Bichi, vol. I, doc. 67 (10 November 1437); summarized ASS, MS. B 25, fol. 25–26).

37 ASS, *Lira* 137, fol. 83, 89, 92, 218 and ASS, *Lira* 144, fol. 13. See also Cecchini, 'Il Castello', pp. 6–7; P. A. Riedl and M. Siedel, eds., *Die Kirchen von Siena* (Munich, 1985), I.1, document 13, p. 461.

38 ASS, *Lira* 137, fol. 218.

39 The most useful published account of the Bichi's fifteenth-century influence is in P. Pertici, 'Per la datazione del *Libro d'ore* di Feliziana Bichi', in *Siena ed il suo territorio nel rinascimento*, III, ed. M. Ascheri (Siena, 2001), pp. 161–9.

40 ASS, *Diplomatico Bichi Borghesi*, Pergamene Bichi, vol. I, doc. 60 and 61 (31 May 1433; summarized ASS, MS. B 25, 22), and contains much information showing Giovanni's active involvement in government; also Pertici, 'Per la datazione', p. 164, refers to information from Sigismondo Tizio's chronicles.

41 Pertici, 'Per la datazione', pp. 164–7. On banking ties with Naples, see documents in ASS, *Diplomatico Bichi Borghesi*, Pergamene Bichi, vol. I, for example: documenting a deal with Salerno di Cristofano di Salerno for trade between Naples and Barbary on the ship called *Camugli*, doc. 40 (27 August 1454); Gano di Giovanni di Antonio Bichi gives over his part in banking enterprises in Naples to Giovanni di Guccio Bichi, doc. 73, fol. 34v–5 (5 July 1453).

42 ASS, *Lira* 137, fol. 83, 89, 92, 218; discussed by Cecchini, 'Il Castello', pp. 7–15.

43 ASS, *Lira* 137, fol. 108, 'casa della mia abitazione colle massarizie in essa esistenti, sicondo lo chomputo mio la quale chasa per finirla alla sua perfetione a di bisogno ancora da spendarvi fl 600 come si può vedere'. It is surprising that the rich family archives contain little information for the patronage of the palace.

44 ASS, *Diplomatico Bichi Borghesi*, Pergamene Bichi, vol. I, doc. 97 and 98 (16 January and 16 February 1452). These rights were renewed by Pope Pius II (doc. 132, 49v: 6 Sept 1460) and Sixtus IV.

45 Considerable discussion has surrounded Cosimo de' Medici's inclusion of a private chapel in the new palace on via Larga; see D. Kent, *Cosimo de' Medici and the Florentine Renaissance: The Patron's Oeuvre* (New Haven and London, 2000), pp. 247, 305–28.

46 D. Balestracci, 'From Development to Crisis: Changing Urban Structures in Siena Between the Thirteenth and Fifteenth Centuries', in *The 'Other Tuscany': Essays in the History of Lucca, Pisa and Siena*, ed. T. W. Blomquist and M. F. Mazzaoui (Kalamazoo, 1994), pp. 210–11; Cecchini, 'Minime di storia dell'arte senese', pp. 241–50, and Cecchini, 'Il Castello'.

47 Heavy restorations of the palace in the nineteenth century, and again in the 1960s, make it difficult to date such details,

although it seems probable that they formed part of the original design; see M. Marini, 'Trasformazioni urbane ed architetture a Siena nella seconda metà del XIX secolo', in *Siena tra Purismo e Liberty* (Milan and Rome, 1988), p. 270.

48 For the component parts of the Renaissance palace, see G. Clarke, *Roman House – Renaissance Palaces: Inventing Antiquity in Fifteenth-century Italy* (Cambridge, 2003).

49 The bibliography for the *all'antica* style in architecture is vast and is perhaps best condensed in relation to palace architecture in Clarke, *Roman House – Renaissance Palaces*; see also for the emergence of the style in architecture the seminal essay by H. Burns, 'Quattrocento Architecture and the Antique: Some Problems', in *Classical Influences in European Culture, AD 500–1500*, ed. R. R. Bolgar (Cambridge, 1971), pp. 269–87, and H. Burns, 'Raffaello e "quell'antiqua architectura"', in *Raffaello architetto*, ed. C. L. Frommel, S. Ray and M. Tafuri (Milan, 1984), pp. 381–404.

50 Burns, 'Quattrocento Architecture and the Antique', pp. 273–4; I. Hyman, *Fifteenth Century Florentine Studies: The Palazzo Medici and a Ledger for the Church of San Lorenzo* (New York, 1977), pp. 35–6. A detailed analysis is offered in Clarke, *Roman House – Renaissance Palaces*, pp. 164–79.

51 On the blending forms of the Palazzo della Signoria and the Palazzo Medici, see M. Trachtenberg, 'Archaeology, Merriment and Murder: The First Cortile of the Palazzo Vecchio and its Transformation in the Late Florentine Republic', *Art Bulletin*, 71 (1989), pp. 565–609, followed by Kent, *Cosimo de' Medici and the Florentine Renaissance*, pp. 217–38; also the essays in *Cosimo il Vecchio de' Medici, 1389–1464*, ed. F. Ames-Lewis (Oxford, 1992). Cosimo's political methods are analysed in N. Rubinstein, *The Government of Florence under the Medici (1434–1494)* (Oxford, 1966) and D. V. Kent, *The Rise of the Medici: Faction in Florence, 1426–1434* (Oxford, 1978).

52 The large number of government decisions also documented in the Bichi private archive indicates the degree to which the two were intertwined; see ASS, *Diplomatico Bichi Borghesi*, Pergamene Bichi, vol. I and material in the Archivio Privato Bichi Ruspoli [henceforth APBR].

53 Clarke, *Roman House – Renaissance Palaces*, p. 173, for the podium's late medieval and classical origins.

54 Discussed in my 'Ritual Geography: Housing the Papal Court of Pius II Piccolomini in Siena (1459–60)', in *Beyond the Palio: Urban Ritual in Renaissance Siena*, ed. P. Jackson and F. Nevola (Oxford, 2006), pp. 65–88; ASS, *Concistoro* 1995, fol. 66v (2 October 1459). Cardinal Rodrigo held debauched parties in the palace, and was reprimanded for this by the Pope; see Pertici, 'Per la datazione', p. 161.

55 ASS, *Diplomatico Bichi Borghesi*, Pergamene Bichi, vol. I, doc. 73; also Cecchini, 'Minime di storia dell'arte senese', pp. 247–9.

56 The obvious similarity between the Bichi castle and the castle/villa at Poggio Imperiale in Naples does not appear to have been noted, particularly as regards the plan of the two buildings, though Siena connections are indicated in *La Villa Farnesina a Roma*, ed. C. L. Frommel (Modena, 2003), pp. 56 and 61, as well as C. L. Frommel, *Die Farnesina und Peruzzis architektonisches Frühwerk* (Berlin, 1961), pp. 90–97.

57 The display functions of military architecture in fifteenth-century Italy have rarely been examined, but such an argument might follow similar lines to the thesis outlined in relation to English fifteenth-century castles, for example by

J. Goodall, 'A Medieval Masterpiece: Herstmonceux Castle, Sussex', *Burlington Magazine*, CXLVI (2004), pp. 516–25. See also for some comments in this regard, N. Adams, 'L'architettura militare di Francesco di Giorgio', in *Francesco di Giorgio, architetto*, ed. F. P. Fiore and M. Tafuri (Siena and Milan, 1993), pp. 126–62, esp. 129–39. For the chapel, see ASS, *Diplomatico Bichi Borghesi*, Pergamene Bichi, vol. I, doc. 97–8 (16 February 1452).

58 Pertici, 'Per la datazione', p. 165; this change in policy has often been identified as the reason for Donatello's stated intention to retire to live his final years in Siena.

59 Donatello's plans for Sienese retirement are variously discussed and documented; see F. Caglioti, *Donatello e i Medici. Storia del David e della Giuditta*, Fondazione Carlo Marchi, Studi 14 (Florence, 2000), I, pp. 31–56, and for documents on Giovanni di Guccio Bichi's role as mediator, II, pp. 418–20 (quotation from II, p. 418, doc. 9).

60 The sale of the palace is widely documented in Sienese and Florentine sources, as the Tegliacci were related to the Medici by marriage and resident in the Gianfigliazzi palace, for which see B. Preyer, 'Around and in the Gianfigliazzi Palace in Florence: Developments on Lungarno Corsini in the 15th and 16th Centuries', *Mitteilungen des Kunsthistorischen Instituts in Florenz*, XLVIII (2004), pp. 55–104; Pertici, 'Per la datazione', pp. 164–5. The sale of the palace is recorded in APBR, *Bichi: Galgano Bichi VII* (Gabelle dei Contratti), fol. 325 (n.a. 282, Reg. 41), for a series of sales between October 1458 and February 1460 to Luigi and his brothers Gabriello and Lorenzo. Bichi and Tegliacci were also neighbours at S. Agostino, where they owned patronage rights to adjacent chapels; see ASS, *Diplomatico Bichi Borghesi*, Pergamene Bichi, vol. I, doc. 179 (15 October 1487), for 'una delle cinque cappelle nuove poste nella facciata dell'altar maggiore, cioè la cappella nell'angolo della parte destra di detta facciata, che seguita dopo la cappella dei Tegliacci'.

61 On the Tegliacci in Florence, see B. Preyer, 'Florentine Palaces and Memories of the Past', in *Art, Memory and Family in Renaissance Florence* (Cambridge, 2000), pp. 176–94; see also B. Preyer, 'Around and in the Gianfigliazzi Palace in Florence', pp. 61–6. It is significant that the Gianfigliazzi also invested in property in Siena, and were involved in investment ventures with other Sienese merchants. An example is indicated by ASS, *Diplomatico Bichi Borghesi*, MS. B 76, fol. 105 (13 October 1473), referring to a business partnership of 4 April 1468, between Paolo d'Ercolano Venturini, Cino di Cecco Cinughi, Feliciano Massaini and Luigi di Giovannazzo Gianfigliazzi; Luigi refers to a house in the Terzo di Camollia and district of S. Andrea.

62 ASS, *Diplomatico Bichi Borghesi*, Pergamene Bichi, vol. I, doc. 122 (summarized in ASS MS. B 25, 46v–47v), a papal bull of Pius II facilitating the alienation of Augustinian property, with the approval of Alessandro da Sassoferrato, Vicar General of the Order, 'vendono al sopradetto Giovanni Bichi un orto con casa vicino a S Marta in luogo detto S Marta, posta vicino al Prato della Porta Tufi, del quale cavavano 32 lire l'anno, e fanno tale vendita perchè non potevano riparare un muro che minacciava rovina per il prezzo di 225 lire'. Earlier acquisition of neighbouring properties from Antonio di Goro di Francesco, and notarized by Galganno di Cenni, are documented in APBR, *Bichi: Galgano Bichi VII (Gabelle dei Contratti)* 325 (n.a. 282, Reg. 41), fol. 42 (9 February 1457). A dispute documented on 30 August 1461 suggests that the Augustinians were not satisfied by

the terms of the sale: see ASS, *Diplomatico Bichi Borghesi*, Pergamene Bichi, vol. I, doc. 137 (summarized in ASS MS. B 25, fol. 50). Bichi ownership of the palace is explored further in chapter Eight.

63 See above and for Frederick III (briefly examined in final section of this chapter), see my '"Lieto e trionphante per la città": Experiencing a Mid-Fifteenth-century Imperial Triumph along Siena's Strada Romana', *Renaissance Studies*, 17 (2003), pp. 581–606, nn. 33, 52.

64 Turrini, '*Per honore et utile de la città di Siena*', pp. 151–2; also Pertici, *La città magnificata*, pp. 50–51.

65 The Palazzo del Capitano is discussed in the final section of chapter Five, and the Pecci enclave is examined in chapter Nine. The palace was described in Tommaso's will, ASS *Particolari Famiglie Senesi* 124, fol. 1v (1468), 'cum orto et cisterna retro dicta domus et cum cellario casalone et cantina [. . .]'.

66 Other examples of buildings given to individuals in thanks for their public service are documented in the fifteenth century, for example Palazzo di S. Galgano, to the Commander of the papal forces, Domenico Doria, in 1489 (BCS A VII 18 *Spoglio Biccherna*, August 1489). The same Palazzo del Capitano may well have been the building awarded to Emperor Sigismund in 1433: see above.

67 ASS, *Concistoro* 2482, fol. 2 (2 and 13 June, 8 and 22 July 1465) and A. Allegretti, *Ephemerides Senenses ab anno MCCCCL usque ad MCCCCXCVI italico sermone scriptae*, in *Rerum Italicarum Scriptores*, ed. L. Muratori, vol. 23 (Milan, 1733), pp. 772–3.

68 Allegretti, *Ephemerides Senenses*, in *Rerum Italicarum Scriptores*, vol. 23, p. 772, 'è stata più la roba che sie è gittata, che è appena quella che si è mangiata'; ASS, *Concistoro* 2482 accounts for 132,337 *lire* in taxes and levies to pay for the visit, and expenditure for food, lodging and festivities, a figure that matches Allegretti's estimate of 24,000 florins expenditure.

69 This question is returned to in chapter Four. See also my 'Ritual Geography'. Some comments can also be found in M. A. Ceppari, 'I Papi a Siena', *Istituto Storico Diocesano di Siena: Annuario 1998–1999* (Siena, 1999), pp. 345–54.

70 The housing of guests in private residences is widely attested in this period in a number of cities. Most recently, on the Mantua sojourn of Pius II and the papal court in 1459, R. Signorini, 'Alloggi di sedici cardinali presenti alla Dieta', in *Il sogno di Pio II e il viaggio da Roma a Mantova. Atti del Convegno Internazionale. Mantova: 13–15 aprile 2000* (Centro Studi L. B. Alberti, *Ingenium*, n. 5), ed. A. Calzona, F. P. Fiore, A. Tenenti and C. Vasoli (Florence, 2003), pp. 315–89, with identification of residences in Mantua and bibliography on cardinals present; and D. S. Chambers, 'Spese del soggiorno di Papa Pio II a Mantova', in the same volume, pp. 391–402. For Florence, see Filarete and Manfidi, *The Libro cerimoniale*, pp. 74–8.

CHAPTER FOUR

1 Inscription from the Loggia Piccolomini, Siena: 'Pope Pius II for his Piccolomini kinsmen.'

2 These events are examined in some detail in my '"Lieto e trionphante per la città": Experiencing a Mid-Fifteenth-century Imperial Triumph along Siena's Strada Romana', *Renaissance Studies*, 17 (2003), pp. 581–606.

3 Aeneas Silvius Piccolomini [Pius II], *I Commentarii*, ed. L. Totaro, 2 vols. (Milan, 1984), I, pp. 29–66.

4 Piccolomini, *I Commentarii*, pp. 61–88.

5 The fresco is discussed, with bibliography, in my '"Lieto e trionphante per la città"', pp. 581–3.

6 On Aeneas Silvius's political agenda to have the *nobili* party readmitted to government see I. Polverini Fosi, '"La Comune Dolcissima Patria": Pio II e Siena', in *I ceti dirigenti nella Toscana del Quattrocento (Atti del V et VI convegno: Firenze, 10–11 dicembre 1982; 2–3 dicembre 1983)*, ed. D. Rugiadini (Florence, 1987), pp. 509–21; see also P. Pertici, 'Una "coniuratio" del reggimento di Siena nel 1450', *BSSP*, 99 (1992), pp. 9–47. C. Shaw, 'Pius II and the Government of Siena', in *Pio II Piccolomini: Il papa del rinascimento a Siena*, ed. F. Nevola, Acts of the International Conference, Siena, 5–7 May 2005 (Siena, 2007).

7 For the *Balìa* election, see L. Fumi and A. Lisini, *L'incontro di Federigo III imperatore con Eleonora di Portogallo* (Siena, 1878), doc. 2, p. 39 (28 October 1451). The decisions of this *Balia* are unfortunately lost, but considerable lacunae in the *Concistoro* and *Consiglio Generale* records show that it operated (see especially ASS, *Consiglio Generale* 225); a *Balia* is mentioned in ASS, *Consiglio Generale* 225, fol. 238r (21 November 1451).

8 Fumi and Lisini, *L'incontro di Federigo*, doc. 3, p. 41 (*Concistoro* decision of 31 October 1451).

9 ASS, *Concistoro* 512, fol. 20 (21 November); also Fumi and Lisini, *L'incontro di Federigo*, doc. 2, p. 39 (*Concistoro*, decision, 28 October 1451). Visconti died 3 September 1402, and his family's hold on Siena was lost the following year; see M. A. Ceppari, 'La signoria di Gian Galeazzo Visconti', in R. Barzanti, G. Catoni and M. De Gregorio, eds., *Storia di Siena. Dalle orgini alla fine della repubblica*, I (Siena, 1995), pp. 323–4.

10 ASS, *Concistoro* 512, fol. 20 (21 November); on opposition to the visit of Sigismund in 1432, see chapter One and J. H. Beck, 'The Historical "Taccola" and the Emperor Sigismund in Siena', *Art Bulletin*, 50 (1968), pp. 314–15.

11 Aeneae Silvii [Piccolomini], Episcopi Senensis, qui postea Pius, Papa II fuit, 'Historia Friderici III Imperatoris', in *Voluminis Rerum Germanicarum Novi*, (Argentorati: Josiae Staedelii et Joh. Friderici Spoor, 1685), p. 73, for discussion of the Siena visit; transcribed in my '"Lieto e trionphante per la città"', pp. 598–600.

12 For an assessment of this unique monument, see my '"Lieto e trionphante per la città"', pp. 604–6.

13 Descriptions of the visit can be read in Piccolomini, 'Historia Friderici III Imperatoris', p. 73; Piccolomini, *I Commentarii*, I, p. 122, 'Imperator interea Senas venerat ibique sponsam manebat', and I, p. 125, 'videre videor te cardinalem futurum [. . .] beati Petri te cathedra manet'.

14 I. Polverini Fosi, '"La Comune Dolcissima Patria"', pp. 516–18; Pius summarized the conflict of interests in a reported speech to the *Concistoro*: Piccolomini, *I Commentarii*, I, pp. 111–23 (Bk I, chap. 22); on 1456 see Introduction and below.

15 Specifically on the Piccolomini conflict with government institutions during the thirteenth century, see R. Mucciarelli, *La terra contesa. I Piccolomini contro Santa Maria della Scala, 1277–1280* (Florence, 2001). On the Visconti period, see Ceppari, 'La signoria di Gian Galeazzo Visconti', pp. 321–6; on government, see M. Ascheri and P. Pertici, 'La situazione politica senese del secondo Quattrocento

(1456–79)', in *La Toscana ai tempi di Lorenzo il Magnifico: Politica, economia ed arte* (Pisa, 1996), III, pp. 995–8, excluded were usually the *Dodici* and the *Gentiluomini*.

16 On Antonio see P. Pertici, 'Una "coniuratio" del reggimento di Siena nel 1450', *BSSP*, 99 (1992), pp. 9–47; C. Shaw, 'Politics and Institutional Innovation in Siena (1480–98), I', *BSSP*, 103 (1996), pp. 10–11, and C. Shaw, 'Pius II and the Government of Siena'. On Pius II, see Polverini Fosi, '"La Comune Dolcissima Patria"', p. 510.

17 Polverini Fosi, '"La Comune Dolcissima Patria"', p. 510, cites decision in ASS, *Balìa* 9, fol. 105 (1 September 1458).

18 Shaw, 'Politics and Institutional Innovation', I, p. 16.

19 Polverini Fosi, '"La Comune Dolcissima Patria"', pp. 510–13; Piccolomini, *I Commentarii*, I, pp. 283–9 and 295–7.

20 Polverini Fosi, '"La Comune Dolcissima Patria"', pp. 509–21; O. Malavolti, *Dell'historia di Siena* (Venice, 1599), III, p. 66. Piccolomini, *I Commentarii*, I, pp. 316–25 (Bk II, chap. 21).

21 Polverini Fosi, '"La Comune Dolcissima Patria"', pp. 519–20, on the breakdown of communications after 1462. Letter from Gregorio Lolli describing the benefits of the pontificate in I. Ammannati Piccolomini, *Epistolae et Commentarii Jacobi Piccolomini Cardinalis Papiensis* (Milan, 1506), fol. 49–51 (18 January 1465), also I. Ammannati Piccolomini, *Lettere (1444–79)*, ed. P. Cherubini (*Pubblicazioni degli Archivi di Stato. Fonti 25*) (Rome, 1997), II, pp. 612–22. See also R. B. Hilary, 'The Nepotism of Pope Pius II', *Catholic Historical Review*, 64 (1978), pp. 33–5.

22 Piccolomini, *I Commentarii*, I, pp. 327–31 (II.22), 737–9 (IV.2); G. A. Campano, 'Vita Pii II Pontificis Maximi', in *Rerum Italicarum Scriptores*, vol. 3, part 3, ed. G. Zimolo (Bologna, 1964), pp. 33, 57; D. Ciampoli, 'Abbadia al tempo di Pio II', in *Abbadia San Salvatore: Una comunità autonoma nella Repubblica di Siena*, ed. M. Ascheri and F. Mancuso (Siena, 1994), pp. 51–68; for St Catherine, ASS, *Consiglio Generale* 230, fol. 132 (23 April 1464, for construction of the oratory in Fontebranda).

23 I have published the ceremonial rules and concessions for Easter in F. Nevola, 'Cerimoniali per santi e feste a Siena a metà Quattrocento. Documenti dallo *Statuto di Siena*, 39', in *Siena ed il suo territorio nel Rinascimento*, III, ed. M. Ascheri (Siena, 2001), pp. 182–4 (16 May 1460); N. Adams, 'The Construction of Pienza (1459–64) and the Consequences of *Renovatio*', in *Urban Life in the Renaissance*, ed. S. Zimmerman and R. Weissman (Newark, 1989), pp. 21–46.

24 Malavolti, *Dell'historia*, III, fol. 68r–v; Ammannati Piccolomini, *Lettere*, pp. 487–8. A. Allegretti, *Ephemerides Senenses ab anno MCCCCL usque ad MCCCCXCVI italico sermone scriptae*, in *Rerum Italicarum Scriptores*, ed. L. Muratori, vol. 23 (Milan, 1733), p. 770.

25 The arm and head came from Patras with Thomas Paleologus, despot of Morea; see R. Rubinstein, 'Pius II's Piazza S. Pietro and St Andrew's Head', in *Enea Silvio Piccolomini, Papa Pio II (Atti del Convegno per il quinto centenario della morte e altri scritti)*, ed. D. Maffei (Siena, 1968), pp. 235–43.

26 Thanks to Sally Cornelison for information on Florentine relics, for which see A. Bicchi and A. Ciandella, '*Testimonia Sanctitatis*': le reliquie e i reliquiari del Duomo e del Battistero di Firenze (Florence, 1999); also S. Cornelison, 'Art Imitates Architecture: The St Philip Reliquary in Renaissance Florence', *Art Bulletin*, 86 (2004), pp. 642–58.

27 Named Pienza by a bull of 13 August 1462; see Campano, 'Vita Pii II', p. 70. For a recent account of Pienza, see F.

Nevola, 'L'architettura tra Siena e Pienza: architettura civile', in *Pio II e le arti. La riscoperta dell'antico da Federighi a Michelangelo*, ed. A. Angelini (Cinisello Balsamo, Milan, 2005), pp. 182–213.

28 H. Heydenreich, *Architecture in Italy, 1400–1500*, revised P. Davies (New Haven and London, 1996), p. 50; on the ideal city see P. C. Marani, 'Renaissance Town Planning from Filarete to Palmanova', in *The Renaissance from Brunelleschi to Michelangelo: The Representation of Architecture*, ed. H. Millon and V. Magnago Lampugnani (London, 1994), pp. 540–44, and N. Adams and N. L. Nusssdorfer, 'The Italian City, 1400–1600', in the same volume, pp. 205–11; S. Lang, 'The Ideal City from Plato to Howard', *Architectural Review*, 112 (1952), pp. 90–101; L. Firpo, ed., *La città ideale nel Rinascimento* (Turin, 1975), pp. 7–32. On Pienza see C. R. Mack, *Pienza: The Creation of a Renaissance City* (Ithaca, NY, 1987); the thesis of this book sums this approach up. A critique of this view is to be found in C. Smith, *Architecture in the Culture of Early Humanism* (New York and Oxford, 1992), pp. 98–129; see also below. A monumental, if not altogether convincing, study is J. Pieper, *Pienza. Der Entwurfeiner humanistischen Weltsicht* (Stuttgart and London, 1997), also in an Italian version: *Pienza. Il progetto diuna visione umanistica del mondo* (Baden-Wurttemberg, 2000). See also the recent exhibition catalogue, *Pio II, la citta, le arti. La rifondazione umanistica dell'architettura e del paesaggio*, ed. G. Giorgianni (Siena, 2006).

29 These visits are examined in detail, with specific reference to the lodging of the papal court and cardinals, in my 'Ritual Geography: Housing the Papal Court of Pius II Piccolomini in Siena (1459–60)', in *Beyond the Palio: Urban Ritual in Renaissance Siena*, ed. P. Jackson and F. Nevola (Oxford, 2006), pp. 65–88.

30 Tommaso Fecini, 'Cronaca Senese' *(1431–1479)*, in A. Lisini and F. Iacometti, eds., *Cronache Senesi*, in *Rerum Italicarum Scriptores*, vol. 15, part 6 (Bologna, 1931), p. 868; Allegretti, *Ephemerides Senenses*, in *Rerum Italicarum Scriptores*, vol. 23, p. 770; F. Luti, *Notizie di Papa Pio II e sue lettere a varii potentati*, Biblioteca Comunale di Siena [henceforth BCS], MS. B. V. 40, fol. 3–5; ASS, *Consiglio Generale*, 228, fol. 48v (20 August).

31 Fecini, 'Cronaca Senese', p. 868.

32 Luti, *Notizie di Papa Pio II*, fol. 3–8; authorship attributed by A. Dati, 'Historiae Senenses', in *Opera* (Siena: Simone di Niccolò Nardi, 1503), p. 85ff.

33 On Assumption *sacra rappresentazione* see W. Heywood, *Our Lady of August and the Palio of Siena* (Siena, 1899); also D. Arasse, '*Fervebat Pietate Populus*: Art, dévotion et société autour de la glorification de Saint Bernardin de Sienne', *MEFR*, 89 (1977), pp. 189–263.

34 BCS, S. Tizio, *Historiarum Senensium*, MS. B. III. 9, fol. 507, 'totumque forum arcubus triumphalibus circumcirca est vallatum atque sepitum'.

35 Luti, *Notizie di Papa Pio II*, fol. 6; also in C. Mazzi, *La congrega dei Rozzi di Siena nel secolo XVI* (Florence, 1882), I, pp. 33–6; Tizio, B. III. 9, fol. 507.

36 Luti, *Notizie di Papa Pio II*, fol. 6, 'mirabili artificio [. . .] et humo, aspectantium miraculo, Virginis habitu homo et qui Angelos agebant, assumpti sunt in id coelum'; also in Mazzi, *La congrega*, I, pp. 33–6.

37 Museo delle Biccherne, Archivio di Stato, Siena. See *Le Biccherne. Tavole dipinte delle magistrature senesi (secoli XIII–XVIII)*, ed. U. Morandi et al. (Rome, 1984), p. 166; L. Cavazzini, in *Francesco di Giorgio e il Rinascimento a Siena*, ed. L. Bellosi (Siena and Milan, 1993), p. 114; most recently, *Le Biccherne di Siena. Arte e Finanza all'alba dell'economia moderna*, ed. A. Tomei (Azzano San Paolo, Bergamo, and Rome, 2002), p. 196.

38 Piccolomini, *I Commentarii*, I, pp. 316–17, 'pulcherrime adornatum et festivantem ingressus est patriam, nec usquam maior ostentatio letitiae visa est'.

39 Piccolomini, *I Commentarii*, I, pp. 316–31; Allegretti, *Ephemerides Senenses*, in *Rerum Italicarum Scriptores*, vol. 23, p. 770. The golden rose survives in the Museo Civico of the Palazzo Pubblico, Siena; see Collareta in *Francesco di Giorgio*, pp. 146–7.

40 Fecini, 'Cronaca Senese', p. 869 (28 January 1458[9]).

41 Allegretti, *Ephemerides Senenses*, in *Rerum Italicarum Scriptores*, vol. 23, p. 770 (31 January 1460), 'Ammajosi tutta la strada dal Duomo fino alla porta a Camollia, cioè alla porta depinta, dove fù fatto un bellissimo apparato a guisa di un coro d'angeli, ovvero un Paradiso. E quando Pio giunse in quel luogo, un angiolo discese di quel coro più a basso cantando certe stanze, e voltandosi alla figura di nostra Donna e di poi al papa, raccomandadogli la Sua e la Nostra città di Siena.' Fecini, 'Cronaca Senese', p. 869, is far more summary.

42 R. Trexler, *Public Life in Renaissance Florence* (New York and London, 1980), pp. 306–15; for a Sienese example, see my '"Lieto e trionphante per la città"', pp. 581–606, and Gerrit Schenk, 'Enter the Emperor: Charles IV and Siena between Politics, Diplomacy and Ritual (1355 and 1368)', in *Beyond the Palio*, pp. 25–43.

43 Piccolomini, *I Commentarii*, pp. 663–5; translation from Aeneas Silvius Piccolomini [Pius II], *The Commentaries*, ed. and trans. F. A. Gragg, *Smith College Studies in History*, 22 (1936–7); 25 (1939–40); 30 (1947); 35 (1951); 43 (1957).

44 ASS, *Arti* 4 (1458–9): 'Entrate, uscita e deliberazioni, bastardello', fol. 18r (September 1459), payments for paper and work 'pro pictura plurium armorum' (my thanks to Machtelt Israëls for this reference). See also Luti, *Notizie di Papa Pio II*, fol. 4v, 'conplurium mira celeritate insignia per multa Piccolomine domus exserico et pictura in maiore basilica coniecta pendebant'; A. M. Carapelli, *Notizie delle chiese e cose raggaurdevoli di Siena*, BCS MS. B. VII. 10, fol. 156v, 'L'anno 1459 a 24 di febbraio entrando da questa porta [Romana] in Siena Pio 2. Som. Pont.e con sei cardinali, fuora di questa porta fu con gran Pompa incontrato dalla Signoria e Clero, e numeroso popolo accompagnato fino al Duomo, ed al Palazzo del Vescovado, ed era tutto el corso di questa Strada tutto nobilmente parato e si vedeva per tutte le strade l'arme del Pontefice.'

45 The details of the process of selection of residences for the papal court is not repeated here, as it is analysed in my 'Ritual Geography'. A detailed discussion of the programmatic significance of the papal visit for the enactment of new urban legislation is considered in the last section of this chapter and in chapter Five; see also my '"Ornato della città": Siena's Strada Romana as Focus of Fifteenth-century Urban Renewal', *Art Bulletin*, 82 (2000), pp. 26–50.

46 On Spannocchi, see my 'Ambrogio Spannocchi's "bella casa": Creating Site and Setting in Quattrocento Sienese Architecture', in *Renaissance Siena: Art in Context*, ed. L. A. Jenkens (Kirksville, MO, 2005), pp. 141–56; ASS, *Concistoro*, 2477, fol. 72v; also chapter Six.

47 Pius, his secretaries, treasurer, datary, stable-hands and baker, see my 'Ritual Geography', p. 78–9 (table 3); located in ASS,

Lira, 137, fol. 76, 105, 360 and the house of Tommaso Pecci. Giovanni Saracini's role as paymaster for papal projects in Siena is documented in Archivio di Stato di Roma [henceforth ASR], *Camerale I: Tesoreria Segreta (Entrata e uscita) 1288* and 1289.

48 ASS, *Lira* 140, fol. 216.

49 Nine officials were elected 'sopra le stanze da deputarsi', ASS, *Concistoro*, 2477, fol. 0v (31 January 1459), a volume that lists the properties and their rental costs; for further discussion, see my 'Ritual Geography.'

50 ASS, *Concistoro*, 1995, fol. 56, 66, 78, 88 (September–October 1459); also ASS, MS. B 15: 'Ristretto del contenuto ne' contratti e ne' brevi et bolle pontificie [. . .]'.

51 ASS, *Concistoro*, 1995, fol. 56 (quoted in Polverini Fosi, '"La Comune Dolcissima Patria"', p. 515), 'Mantova hoggi è molto ornata di prelati e signori, di Ambasciatori e di molta corte, et è una bella Mantova ed oltra a questo c'è molte stanze belle e grandi e degne. Ecci habundantissimo di ogni cosa.' This is borne out by R. Signorini, 'Alloggi di sedici cardinali presenti alla Dieta', in *Il sogno di Pio II e il viaggio da Roma a Mantova. Atti del Convegno Internazionale. Mantova: 13–15 aprile 2000* (Centro Studi L. B. Alberti, *Ingenium* n. 5), ed. A. Calzona, F. P. Fiore, A. Tenenti and C. Vasoli (Florence, 2003), pp. 315–89, with identification of residences in Mantua and bibliography on cardinals present; and D. S. Chambers, 'Spese del soggiorno di Papa Pio II a Mantova', in the same volume, pp. 391–402, for discussion of the lavish treatment reserved for the papal court.

52 ASS, *Concistoro*, 1995, fol. 66v (2 October 1459), 'desiderare molto la stanza dove ste e che di questo la Santità di Nostro Signore ne haveva scripto uno breve al Luigi Tegliacci per cagione dela vendita di essa casa.' It is interesting to see this preference of palace-type residence over more spartan monastic arrangements as a precursor to the comments in K. Weil-Garris and J. d'Amico, *The Renaissance Cardinal's Ideal Palace: A Chapter from Cortesi's 'De Cardinalatu'* (Rome, 1980), p. 71.

53 ASS, *Concistoro*, 1995, fol. 66v (2 October 1459), 'non se fermarà in Siena ala tornata ma per rectas vias andarà ad Roma'; rather than the house of Battista Bellanti, he was given a number of neighbouring Luti properties.

54 ASS, MS. B 15: 'Ristretto del contenuto ne' contratti e ne' brevi et bolle pontificie [. . .]', fol. 374 (September 1459), 'per prepararli la consueta casa et addobbarla delle cose necessarie'.

55 The needs of papal ceremonial are discussed in my 'Ritual Geography'.

56 On the concept of civic religion see W. M. Bowsky, *A Medieval Italian Commune: Siena under the Nine, 1287–1355* (Berkeley, 1981), pp. 273–80; D. Webb, *Patrons and Defenders: the Saints in the Italian City States* (London, 1996), pp. 251–316; G. Parsons, *Siena, Civil Religion and the Sienese* (Aldershot and Burlington, VT, 2005), pp. 1–31.

57 Allegretti, *Ephemerides Senenses*, in *Rerum Italicarum Scriptores*, vol. 23, p. 770, 'dè le candele di sua mano a tutti cittadini della città di Siena'.

58 M. Dykmans, *L'Oeuvre de Patrizi Piccolomini ou le ceremonial papal de la première Renaissance* (Vatican City, 1982), II, pp. 332–9, 342–3; the participation of the Pope was so important as to warrant an alternative ceremonial to be observed in his absence (Dykmans, II, pp. 339–42), as for other major feasts.

59 See note 44 above.

60 I. Origo, *The World of Saint Bernardino* (New York, 1962), p. 3.

61 For the identification of cardinals and their residences, see my 'Ritual Geography', tables 1 and 2.

62 P. Pertici, *La città magnificata: interventi edilizi a Siena nel Quattrocento* (Siena, 1995), p. 67 n. 1; secretarial post confirmed in ASS, *Concistoro* 2480, fol. 14 (1460); see also Aeneas Silvius Piccolomini [Pius II], *Selected Letters*, ed. and trans. A. Baca (Northridge, CA, 1969), pp. 23–5 (15 January 1444). M. Pellegrini, 'Un gentiluomo "piesco" tra la patria senese e la corte papale: Goro Lolli Piccolomini', in *Pio II Piccolomini: Il papa del rinascimento a Siena*, ed. F. Nevola, Acts of the International Conference, Siena, 5–7 May 2005 (Siena, 2007).

63 Pertici, *La città magnificata*, p. 67 n. 1, for tax return (*Lira* 156, fol. 84). Pius may even have subsidized the acquisition, see ASR, *Tesoreria Segreta*, 1288, fol. 119v (17 September 1462), 'sua Santità li da per comperare una casa;' on the façade coat of arms, P. Torriti, *Tutta Siena, contrada per contrada* (Florence, 1988), p. 79.

64 For the palace, see chapter Six and my 'Ambrogio Spannocchi's "bella casa"'.

65 For a consideration of the different levels on which heraldry operated, see C. Burroughs, 'Hieroglyphs in the Street: Architectural Emblematics and the Idea of the Façade in the Early Sixteenth-century Palace Design', in *The Emblem and Architecture: Studies in Applied Emblematics from the Sixteenth to the Eighteenth Centuries*, ed. H. J. Boker and P. M. Daly (*Imago Figurata*, 2) (Turnhout, 1999), pp. 57–82; P. Guerrini, 'L'epigrafia sistina come momento della "restauratio urbis"', in *Un pontificato ed una città, Sisto IV (1474–1484)*, ed. M. Miglio (Vatican City, 1986), pp. 453–68.

66 L. Miglio, 'Graffi di storia', in *Visibile parlare: le scritture esposte nei volgari italiani dal medioevo al rinascimento*, ed. C. Ciociola (Naples, 1997), pp. 59–70 (cf. pp. 60–61 and 65). For a subtle consideration of the history of writing on walls, see A. Petrucci, 'Il volgare esposto: problemi e prospettive', in *Visibile parlare*, ed. Ciociola, pp. 45–58; A. Petrucci, 'Potere, spazi urbani, scritture esposte: problemi ed esempi', in *Culture et idéologie dans la genèse de l'état moderne*, ed. S. P. Genet (Rome, 1985), pp. 85–97; and A. Petrucci, *La scrittura. Ideologia e rappresentazione* (Turin, 1986).

67 Miglio, 'Graffi di storia', pp. 65–6 for transcriptions.

68 For the use of inscriptions in the fifteenth century, see R. Weiss, *The Renaissance Discovery of Classical Antiquity* (Oxford, 1988), pp. 145–66; G. Clarke, *Roman House – Renaissance Palaces: Inventing Antiquity in Fifteenth-century Italy* (Cambridge, 2003), pp. 227–32. For the common ground between these and graffiti, see Petrucci, *La scrittura*, pp. 21–33.

69 A precedent for the superimposition of the papal court onto an extant urban fabric can be seen in the case of Avignon; see B. Guillemain, *La cour pontificale d'Avignon, 1309–1376. Étude d'une société* (Paris, 1966), pp. 181–276 and 497–532; more summary is Y. Renouard, *The Avignon Papacy, 1305–1403* (London, 1970); original French edition (Paris, 1954), pp. 80–96. The ceremonial implications of the distribution of cardinals' residences around the city do not seem to have been pursued for Avignon or Rome during the fourteenth and fifteenth centuries.

70 See *Pio II e le arti. La riscoperta dell'antico da Federighi a Michelangelo*, ed. A. Angelini (Cinisello Balsamo, Milan,

2005); also L. Martini, ed., *Pio II, la città, le arti. La rinascita della scultura: ricerca e restauri*, exh. cat., Siena, 23 June – 8 October 2006 (Siena, 2006).

71 ASS, *Consiglio Generale* 228, fol. 168 (4 April 1459), cited in Pertici, *La città magnificata*, p. 66 and quoted in P. Turrini, *'Per honore et utile de la città di Siena'. Il comune e l'edilizia nel Quattrocento* (Siena, 1997), pp. 135–7, 'chi volesse più hedificare in quello luogo [. . .] facendo uno bello acconcime di quella contrada et ripararsi a tanta vergogna della città maxime avendoci ad venire la corte'. The initiative was supported by the *Ufficiali sopra l'ornato*, a specifically founded body charged with urban improvement, for which see chapter Five.

72 See the tax records of 1453: ASS, *Lira* 136, fol. 13 for Caterina and fol. 16 for Francesco di Bartolomeo, who stated, 'Inprima o a pagare infra termine d'uno anno fl cinquecento a Mona Caterina mia matrigna e dona che fu di Bartolomeo mio padre per la dote sua'. Documents and analysis of the palace have recently been published by A. L. Jenkens, 'Caterina Piccolomini and the Palazzo delle Papesse in Siena', in *Beyond Isabella: Secular Women Patrons of Art in Renaissance Italy*, ed. S. Reiss and D. Wilkins (Kirksville, MO, 2001), pp. 77–91. It is important to note that previous biographies have mistakenly considered that Caterina's husband was still alive at the time of the palace's construction; tax records show this was not the case. See C. Ugurgieri della Berardenga, *Pio II Piccolomini, con notizie su Pio II e altri* (Florence, 1973), pp. 135, 220.

73 Caterina declared dowry repayments still owed to her in ASS, *Lira* 136, fol. 13 (1453) and *Lira* 156, fol. 19 (1466).

74 The appointment is reported in ASS, *Consiglio Generale*, 228, fol. 304–304v (29 October 1460); see also Ugurgieri della Berardenga, *Pio II Piccolomini*, p. 220.

75 ASS, *Lira* 156, fol. 19 (1466) is filed as a joint return by Caterina and her son-in-law.

76 Turrini, *'Per honore et utile . . .'*, p. 137; Pertici, *La città magnificata*, p. 120.

77 ASS, *Consiglio Generale* 228, fol. 168 (21 October 1459), 'sarebbe facta la faccia dinanzi'.

78 E. F. Rumhor, *Italienische Forschungen* (Berlin, 1827), II, p. 198; also ASS, *Consiglio Generale* 228, fol. 168, mentions a possible buyer 'el quale non vuole essare nominato'; L. Banchi and S. Borghesi, *Nuovi documenti per la storia dell'arte senese* (Siena, 1898), pp. 201–2 (from ASS, *Consiglio Generale* 228, fol. 300–01, 24 October 1460); later complaints from Giovanni di Rinaldo suggest land concessions may have been forced (ASS, *Concistoro* 2125, fol. 107, 8 May 1469). See also Jenkens, 'Caterina Piccolomini', docs. 1 and 2. Additional acquisition of a site near piazza Manetti from one Bartolomeo Guidoni 'aluptarius' is documented in Archivio Chigi Saracini (Siena), 4629, fasc. 1, fol. 5v–6 (26 August 1460) for 328 florins (my thanks to Laura Bonelli for bringing this archive to my attention).

79 ASS, *Consiglio Generale* 228, fol. 300–01 (24 October 1460; Banchi and Borghesi, *Nuovi documenti*, p. 201).

80 *Ibid.*

81 *Ibid.*, 'fare la detta casa honoratissima, et con grande spesa, ad honore di questa Magnifica Città'.

82 ASR, *Mandati Camerali* 834–6 and *Tesoreria Segreta* 1288–9 document these payments, summarized in tabular form in my 'Urbanism in Siena (*c.* 1450–1512). Policy and Patrons: Interactions Between Public and Private', PhD thesis, Courtauld Institute of Art, University of London, 1998, II,

pp. 454–9; first traced payment is ASR, *Mandati Camerali* 834, fol. 80v (19 January 1459), of 400 florins.

83 ASR, *Tesoreria Segreta*, 1288, fol. 103v (12 June 1462), 'a lei per murare la sua casa' and 'per lo palazo fa fare'.

84 ASR, *Mandati Camerali*; Hilary, 'The Nepotism of Pope Pius II', pp. 33–5.

85 ASS, *Lira* 156, fol. 19 (1466), 'anno paghato da diciotto mesi in qua di debiti per la detta casa fl 4252 et due terzi, et anno speso nela decta casa del loro proprio fl settemila. Et annolo fatto per honore et ornamento dela città. Et per fare questo si sono spogliati di tutti i loro beni mobili: anno abonificata la città per la rata loro quanto nissun altro, come si vede. Furono danificati nela morte di papa pio in ducati tremila in denari che lassarono a Spoleto.' For the issue of Paul II stripping Piccolomini appointments on his accession, see A. de Vincentis, *Battaglie di Memoria. Gruppi, intelletuali, testi e la discontinuità del potere papale alla metà del Quattrocento* (Rome, 2002).

86 ASS, *Lira* 174, fol. 6 (1479); ASS, *Lira* 185, fol. 150 (1481); ASS, *Lira* 235, fol. 463 (1509). The slow progress of the final stages of construction are documented in Jenkens, 'Caterina Piccolomini'.

87 ASS, *Concistoro* 2125, fol. 3 (Pertici, *La città magnificata*, pp. 66, 68); Turrini, *'Per honore et utile . . .'*, pp. 135–42. For another case of Piccolomini patronage working in consort with public policies, see the overhaul of a group of buildings near the southerly Porta Vecchia of Samoreci by Giovanni di Fazio Piccolomini as documented in ASS, *Concistoro* 2125, fol. 13 and 17 (19 December 1463; Pertici, *La città magnificata*, pp. 74–5): 'considerato che le città le quali sono belle sono ornate di casamenti e habitate da uomini da bene infino in su le mura'.

88 For the palace's name, see Jenkens, 'Caterina Piccolomini', n. 1.

89 Ugurgieri della Berardenga, *Pio II Piccolomini*, pp. 28–34.

90 On the psychological effects of exile, see R. Starn, *A Contrary Commonwealth: The Theme of Exile in Medieval and Renaissance Italy* (Berkeley and Los Angeles, 1982); a more technical study, based largely on Sienese examples, can be found in C. Shaw, *The Politics of Exile in Renaissance Italy* (Cambridge, 2000).

91 Ugurgieri della Berardenga, *Pio II Piccolomini*, pp. 504–45; also Campano, 'Vita Pii II', p. 66. Much work remains to be done on these four brothers, who are discussed in greater detail in chapter Eight; see also comments in my 'L'architettura tra Siena e Pienza: architettura civile', in *Pio II e le arti. La riscoperta dell'antico da Federighi a Michelangelo*, ed. A. Angelini (Cinisello Balsamo, Milan, 2005), pp. 183–213.

92 For a family tree, see A. Lisini, 'Notizie genealogiche della famiglia Piccolomini', *Miscellanea Storica Senese*, V (1898), table 6.

93 ASS, *Concistoro* 1992, fol. 77 (27 September 1458). Niccolò was apostolic *cubiculario*, and kept the ASR, *Tesoreria Segreta* accounts, see R. Rubinstein, 'Pius II as Patron of Art', PhD thesis, Courtauld Institute of Art, University of London, 1957, p. 66; also ASS, *Statuti di Siena* 40, fol. 83 (12 May 1459): 'avuta firma fede che in esso luogo si farebbe uno nobilissimo casamento ad grande ornato e bellezza della città'.

94 Interpretations of the piazza Piccolomini project vary. An extreme position that identifies the project as predominantly political, and as a challenge to the civic power

invested in the Palazzo Pubblico, is in A. L. Jenkens, 'Pius II's Nephews and the Politics of Architecture at the End of the Fifteenth Century in Siena', *BSSP*, CVI (1999 [2001]), pp. 68–114; also Jenkens, 'Caterina Piccolomini'. Somewhat more cautious is F. P. Fiore, 'Siena e Urbino', in *Storia dell'architettura italiana: il Quattrocento*, ed. F. P. Fiore (Milan, 1998), pp. 277–9, and 'La Loggia di Pio II per i Piccolomini a Siena', in *Il sogno di Pio II*, pp. 129–42.

95 ASS, *Ufficiali Vino e Terratici* 10, discussed by D. Ciampoli, 'La proprietà del comune di Siena in città e nello stato nella prima metà del Quattrocento, in *Siena e il suo territorio*, vol. II, ed. D. Ciampoli and M. Ascheri (Siena, 1990), p. 12; Turrini, *'Per honore et utile . . .'*, p. 173. A seventeenth-century history of the Piccolomini site can be found in ASS, *Consorteria Piccolomini*, 4 'Ricordi e memorie (1148–1778)', fascicule Y, fol. 14v–16, marked 'Piccolomini danno il nome a più luoghi pubblici'.

96 G. Cantucci, 'Considerazioni sulle trasformazioni urbanistiche nel centro di Siena', *BSSP*, 68 (1961), pp. 251–62; G. Piccinni, 'Modelli di organizzazione dello spazio urbano dei ceti dominanti del Tre e Quattrocento. Considerazioni senesi', in *I ceti dirigenti nella Toscana tardo comunale (Atti del convegno, 5–7 dicembre 1980, Firenze)*, ed. D. Rugiadini (Florence, 1983), p. 230.

97 ASS, *Lira* 144, fol. 61, 69, 80, 81, 105, 107, 111, 119, 121, 126, 133, 143, 144, 147, 155, 166; outside ASS, *Lira* 144, fol. 174 (S. Pietro alle Scale), ASS, *Lira* 138, fol. 263 (Aldobrandino del Mancino) and *Lira* 57, fol. 25r (Casato di Sotto).

98 ASS, *Lira* 192, fol. 40, 51, 54, 62, 73, 76, 80, 86, 88, 96, 98, 102, 108; four bordered the district: ASS, *Lira* 192, 10 (S. Vigilio), ASS, *Lira* 192, fol. 140 (S. Giorgio) and ASS, *Lira* 195, fol. 5, 7 (S. Pietro alle Scale); the others were scattered, and may even be families that acquired the Piccolomini name as privilege: ASS, *Lira* 193, fol. 14 (S. Agnolo a Montone), ASS, *Lira* 193, fol. 187 (Rialto), ASS, *Lira* 185, fol. 76 (Aldobrandino), ASS, *Lira* 186, fol. 25 (S. Pellegrino), ASS, *Lira* 198, fol. 187 (S. Antonio), ASS, *Lira* 200, fol. 226 (La Magione), ASS, *Lira* 198, fol. 121 (S. Pietro Ovile Sotto).

99 G. Cugnoni, 'Aeneæ Silvii Piccolomini Senensis qui postea fuit Piu II Pont. Max.; Opera inedita ex codicibus Chisianis', *Atti della R. Accademia dei Lincei*, ser. 3, 8 (1882–3), p. 356; L. von Pastor, *Storia dei Papi dalla fine del Medio Evo* (Rome, 1961), II, p. 204. The church was rebuilt in the sixteenth century, to a design by G. Pelori; see M. Ricci, *'Fu anco suo creato': l'eredità di Baldassarre Peruzzi in Antonio Maria Lari e nel figlio Sallustio* (Rome, 2002), p. 32, and P. Torriti, *Tutta Siena, contrada per contrada* (Florence, 1988), p. 327.

100 ASS, *Concistoro* 2378 for accounts of 1480, when Andrea Todeschini Piccolomini served as *Gonfaloniere* of the *Terzo* of S. Martino.

101 See A. L. Jenkens, 'Pius II and his Loggia in Siena', in *Sonderdruck aus Pratum Romanum: Richard Krautheimer zum 100. Geburtstag*, ed. R. L. Colella, M. J. Gill, A. L. Jenkens and P. Lamers (Wiesbaden, 1997), pp. 199–214.

102 S. Tizio, *Historiarum Senensium*, BCS, MS, B. III. 14, fol. 17 (1460).

103 ASR, *Tesoreria Segreta*, 1288, fol. 73, 80 and 84 for acquisitions 'per la logia che N s fa fare in Siena'.

104 Allegretti, *Ephemerides Senenses*, in *Rerum Italicarum Scriptores*, vol. 23, p. 770; G. Milanesi, *Documenti per la storia dell'arte senese* (Siena, 1854), II, pp. 321–2; in another document, tentatively dated to late 1463, Federighi asserted 'ò ispac-

ciato tutte le mia faccende della Loggia' (Milanesi, *Documenti*, II, p. 325).

105 ASR, *Tesoreria Segreta*, 1289, fol. 133, 'li quali hanno lavorato alla loggia dei piccolomini'.

106 On this brief visit (31 August to 10 September) see Campano, 'Vita Pii II', p. 70. Previous payment for the loggia, ASR, *Tesoreria Segreta*, 1288, fol. 109 (12 July 1462). See also D. Boisseuil, 'Pie II e les bains siennois', in *Pio II Piccolomini: Il papa del rinascimento a Siena*, ed. F. Nevola, Acts of the International Conference, Siena, 5–7 May 2005 (Siena, 2007).

107 Described with special attention to the formal evocation of the 'triumphal arch' by Jenkens, 'Pius II and His Loggia', pp. 202–3.

108 Ugurgieri della Berardenga, *Pio II Piccolomini*, pp. 221, 504–45; firm identification of these coats of arms remains difficult. See also Jenkens, 'Pius II and his Loggia', p. 204.

109 Ugurgieri della Berardenga, *Pio II Piccolomini*, pp. 504–45; compare to F. W. Kent, 'The Rucellai Family and its Loggia', *Journal of the Warburg and Courtauld Institutes*, 35 (1972), pp. 397–401.

110 Discussed in relation to Palazzo Piccolomini in chapter Eight.

111 ASS, *Lira* 192, fol. 159 (1481), 'Item, sotto la Loggia Piccolomini ci troviamo comuni infra Messer Iacomo e me due bottighe e uno fondacetto, le quali rade volte si appigionano per la humidita grande che in epse surge et il più del tempo stanno serrate come al presente pubblichamente si vede. Et quando depse si traesse alcuno denaio si mete in concime e mantenimento della loggia.'

112 On the *consorteria* see Polverini Fosi, '"La Comune Dolcissima Patria"', p. 520. The Tolomei, on the other hand, did make a *consorteria* declaration: see chapter Eight.

113 Discussion of Andrea and Iacomo, and their completion of Pius II's projects, continues in chapter Eight.

114 ASS, *Consiglio Generale* 228, fol. 291v (18 October 1460; Milanesi, *Documenti*, II, p. 201; Turrini, *'Per honore et utile . . .'*, p. 174); ratification of the request made to the ASS, *Concistoro* 564, fol. 18v–19 (4 October 1460), cited in Turrini, *'Per honore et utile . . .'*, p. 173 n. 6.

115 ASS, *Consiglio Generale* 228, fol. 291v (18 October 1460; Milanesi, *Documenti*, II, p. 201; Turrini, *'Per honore et utile . . .'*, p. 174), 'bonificandosi et magnificandosi di tale acconcio et adorno la città'.

116 ASR, *Tesoreria Segreta* 1288, fol. 74 (8 January 1461) and entries following on fol. 75, 79, 101, 108v, 118.

117 Specific properties are mentioned in ASR, *Tesoreria Segreta* 1288, fol. 101, 108v, 118. ASS, *Consorteria Piccolomini* 17 (Contratti di Andrea di Nanni Piccolomini [1464–1519]) contains a number of sales involved in the creation of the site. A similar volume, relating to Iacomo, patron of the other half of the Palazzo Piccolomini, is probably lost. This material is discussed in chapter Eight.

118 ASS, *Lira* 166, fol. 12–13, cited from Pertici, *La città magnificata*, p. 119, 'fare il casamento'.

119 *Ibid.* ('haviamo il casamento per terra, come si vede, che per honore della città et nostro [. . .] a non farsi [. . .] non potrà essere sença spesa di più migliaia di fiorini'); on Paul II's persecution of Pius's nepotism, see U. Morandi, 'Gli Spannocchi: piccoli proprietari terrieri, artigiani, piccoli, medi e grandi mercanti-banchieri', in *Studi in onore di Federico Melis* (Naples, 1978), III, pp. 91–120, and the thorough study by de Vincentis, *Battaglie di Memoria*.

120 Design described in ASS, *Concistoro* 2125, fol. 106 (28 October 1469); Milanesi, *Documenti*, II, pp. 337–9.

121 Full analysis of the palace as it was built is in chapter Eight; the formal division of the two properties, made by a notarial act drawn up by Bernardino di Pietro Politi, is to be found in ASS, *Consorteria Piccolomini* 19 (9 October 1480); also in ASS, *Consorteria Piccolomini* 17, fol. 53vff. (Contratti di Andrea di Nanni Piccolomini [1464–1519]).

122 Most emphatically expressed in Jenkens, 'Pius II's Nephews'.

123 ASS, *Consorteria Piccolomini* 17, fol. 53vff., lists properties of Niccolò di Minoccio, Francesco and Lorenzo di Mandolo Piccolomini, Guido di Antonio Piccolomini, Antonio di Mandorlo Piccolomini and Iacomo della Piazza.

124 ASS, *Biccherna* 1061, fol. 21 (29 June 1503).

125 The actual *consorteria* was only established after the death of the Pope (thanks to Giuseppe Chironi for this information): see G. Chironi, ed., *L'archivio diocesano di Pienza* (Siena, 2000), pp. 19–25 and G. Chironi, 'Pius II and the Formation of the Ecclesiastical Institutions of Pienza', in *Pius II, 'el più expeditivo pontefice': Selected Studies on Aeneas Silvius Piccolomini, 1405–1464*, ed. Z. von Martels and A. Vanderjagt (Boston and Leiden, 2003), pp. 180–83. By contrast, the Tolomei, for example, filed a joint tax return for their shared palace property; see ASS, *Lira* 146, fol. 46 (1453), discussed in chapter Eight.

126 Kent, 'The Rucellai Family', p. 399.

127 See G. Pecci, *Raccolta Universale di tutte le iscrizioni, arme e altri monumenti si antichi, come moderni, esistenti nella citta di Siena*, MS. D. 5, fol. 124–7, 141.

128 These buildings are examined further in chapter Eight.

129 Any further modifications of this palace were removed in the nineteenth-century neoclassical work on the main staircase (possibly by A. Fantastici; see C. Cresti, ed., *Agostino Fantastici. Architetto senese, 1782–1845*, Turin, 1992).

130 A poor restoration of the building has recently applied a new plaster façade with crass false rustication that resembles a rather unattractive tartan; discussed briefly by G. Fattorini, 'Alcune questioni di ambito beccafumiano: il "Maestro delle Eroine Chigi Saracini" e il "Capanna senese"', in *Beccafumi. L'opera completa*, ed. P. Torriti (Milan, 1998), pp. 45–6.

131 Rubinstein, 'Pius II as Patron', pp. 73–4, also for fifteenth-century dating; N. Rubinstein, 'Political Ideas in Sienese Art: The Frescoes by Ambrogio Lorenzetti and Taddeo di Bartolo in the Palazzo Pubblico', *Journal of the Warburg and Courtauld Institutes*, 21 (1958), pp. 179–207; G. and C. Thiem, *Toskanische Fassaden-Dekoration in Sgraffio und Fresko* (Munich, 1964), p. 128, wrongly calls this Palazzo Turchi, attributing the frescoes to a sixteenth-century artist, Il Capanna (after G. Vasari, *Le vite dei più eccellenti pittori, scultori ed architettori*, ed. G. Milanesi, Florence, 1881, V, pp. 633–54). See also F. Bisogni, 'La nobiltà allo specchio', in *I libri dei leoni. La nobiltà di Siena in età medicea*, ed. M. Ascheri (Siena, 1996), pp. 211–12.

132 Further discussion of the purpose of portrait-bust imagery on façades as providing a sense of the family's ancestry can be found in the discussion of the Palazzo Spannocchi in chapter Six; also in D. Carl, 'Die Büsten im Kranzgesims des Palazzo Spannocchi', *Mitteilungen des Kunsthistorischen Instituts in Florenz*, 43 (1999), pp. 628–38.

133 The tower on piazza Piccolomini was not wholly owned by the Piccolomini, but exclusive ownership was implied by its connection to the numerous other family properties and extensive display of Piccolomini arms on the site (for shared ownership with the Maconi, see G. Pecci, *Notizie su torri ed altre fabriche di Siena*, ASS, MS A. 2 bis, D 131, fol. 19v). Towers and their reuse are discussed in chapters Seven and Eight.

134 From a vast bibliography see the most comprehensive and recent study: Clarke, *Roman House – Renaissance Palaces*.

135 Milanesi, *Documenti*, II, pp. 323–4, claimed to have seen documents in the Archivio del Duomo di Firenze, proving Rossellino's authorship of the palace (no references given). C. R. Mack, 'Studies in the Architectural Career of Bernardo di Matteo Ghamberelli Called Rossellino', PhD thesis, University of North Carolina at Chapel Hill, 1972, p. 351, rightly suggested that it is very unlikely that Rossellino would have arbitrated a salary for a project he was involved with.

136 ASS, *Lira* 156, fol. 19 (1466), Caterina di Silvio Piccolomini.

137 Milanesi, *Documenti*, II, pp. 348–9, 'finestre non fornite di marmo et veduti certi pregi di due Madonne'.

138 H. Burns, 'Quattrocento Architecture and the Antique: Some Problems', in *Classical Influences in European Culture AD 500–1500*, ed. R. R. Bolgar (Cambridge, 1971), pp. 269–87; these acute openings may also have been accentuated or even introduced in a nineteenth-century restoration of the palace; see G. Morolli, ed., *Giuseppe Partini: architetto del Purismo Senese* (Florence, 1981), p. 157. See also F. Gabbrielli, 'Il palazzo delle Papesse', in *Il palazzo delle libertà*, exh. cat., ed. Marco Pierini (Prato and Siena, 2003), pp. 172–80, for sixteenth-century restoration.

139 This is clearly at variance with the Palazzo Medici, where greater innovation and a more accentuated *all'antica* style characterizes the courtyard; nevertheless, it is important to remember that the Palazzo Medici also condensed innovative and traditional features; see the detailed discussion in Clarke, *Roman House – Renaissance Palaces*, pp. 164–79.

140 Milanesi, *Documenti*, II, pp. 308–9 (28 March 1460). Serious doubts must be raised regarding Milanesi's identification of the 'ligneam figuram futuri edifitii' described in this document as the Piccolomini plan, since five days after the submission of the model, Vecchietta was commissioned to produce a sculpture for the Loggia della Mercanzia (Milanesi, *Documenti*, II, pp. 308–10), suggesting that the model was probably for that sculpture, and not for the architecture.

141 Mack, 'Studies in the Architectural Career', p. 340; Rubinstein, 'Pius II as Patron', pp. 69–73; Jenkens, 'Pius II and his Loggia', p. 212, has curiously argued in favour of L. B. Alberti on the grounds that the building was 'so clearly steeped in a knowledge of Roman architecture . . . [and] literary culture of Florentine humanism' as to exclude the hand of Federighi as designer.

142 ASR, *Tesoreria Segreta* 1288, fol. 94 (6 January 1462), and AOMS, 30 (25), fol. 80 (November 1463?; Milanesi, *Documenti*, II, p. 325); see Jenkens, 'Pius II and his Loggia', pp. 208–10.

143 Mack, 'Studies in the Architectural Career', pp. 333–40.

144 Allegretti, *Ephemerides Senenses*, in *Rerum Italicarum Scriptores*, vol. 23, p. 773 (12 September 1469), 'Pietro Paolo detto il Porrina de'Porrini di Casole, Gentiluomo di Siena; e il Capo Maestro de'muratori era il maestro Martino Lombardo'.

145 Piccolomini, *I Commentarii*, II, 1768 (Bk IX, chap. 25).

146 On the issue of Pius's architectural knowledge, see J. Onians, 'Leon Battista Alberti: The Problem of Personal and

Urban Identity', in *La corte a Mantova nell'epoca di Andrea Mantegna*, ed. C. Mozzarelli, R. Oresko and L. Ventura (Rome, 1997), pp. 207–15. The famous case of the Pienza hall-church design is a clear indication of Pius's strong will, and the requirement that architects should synthesize his ideas.

147 B. Mantura, 'Contributo ad Antonio Federighi', *Commentari*, 19 (1968), pp. 98–110; J. T. Paoletti, 'A. Federighi: Documentary Re-evaluation', *Jahrbuch der Berliner Museum* (1975), p. 88, docs. 32 and 145. Further discussion of Federighi can be found in chapter Six. See also the essays contained in *Pio II e le arti*, ed. Angelini, especially A. Angelini, 'Antonio Federighi ed il mito di Ercole', pp. 105–50.

148 For Pienza see C. Smith, *Architecture in the Culture of Early Humanism* (New York and Oxford, 1992), p. 100.

149 Consider in relation of supposed *Comune* sponsorship of Vecchietta for the Loggia, 'tum commodo ipsius civius nostri, tum honore nostre reipublice'; Milanesi, *Documenti*, II, pp. 308–9 (28 March 1460).

150 On the tomb, see R. Bartalini, 'Il tempo di Pio II', in *Francesco di Giorgio e il Rinascimento a Siena*, ed. L. Bellosi (Siena and Milan, 1993), p. 99; also C. Alessi, 'San Francesco a Siena, mausoleo dei Piccolomini', in *Pio II e le arti*, pp. 281–305. Aeneas Silvius would almost certainly already have come into contact with Federighi during his term in office as Bishop of Siena.

151 ASR, *Mandati camerale* 834, fol. 171 (24 July 1460), 'Antonio Federighi Magistro Opere maioris ecclesie senensis [. . .] pro habitatione Sancti Dominus Nostri.'

152 Paoletti, 'A. Federighi', doc. 29 (1450); Mantura, 'Contributo ad Antonio Federighi', p. 102, comments remarkably that 'essendo l'archivio in riordinamento non è possibile dare collocazioni' indicating that a document in AOMS, dated 16 October 1450, records payment to Federighi of 95 fl. 'vinti largi dro disse voleva andare a Roma'.

153 Jenkens, 'Pius II and his Loggia', pp. 208, 212; Milanesi, *Documenti*, II, pp. 323–4.

154 On Pienza, see Onians, 'Leon Battista Alberti', pp. 214–15.

155 Essential studies of Pienza are Mack, *Pienza*; A. Tönnesman, *Pienza. Städtbau und Humanismus* (Munich, 1990); and the work of Nicholas Adams, most recently, 'Pienza', in *Storia dell'architettura italiana: il Quattrocento*, ed. F. P. Fiore (Milan, 1998), pp. 314–29.

156 An oversimplified comparison with Siena can be found in Jenkens, 'Pius II and his Loggia', pp. 199–200, 'as grandiose as his project in Pienza [. . .] not as separate undertakings.'

157 The Palazzo Piccolomini in Siena, and its completion, is discussed further in chapter Eight. See also Jenkens, 'Pius II's Nephews'.

158 R. Mucciarelli, *La terra contesa. I Piccolomini contro Santa Maria della Scala, 1277–1280* (Florence, 2001); see particularly the essay by G. Chironi, 'Un mondo perfetto. Istituzioni e *societas* christiana nella Pienza di Pio II', in *Pio II Piccolomini: Il papa del rinascimento a Siena*, Acts of the International Conference, Siena, 5–7 May 2005, ed. F. Nevola (Siena, 2007).

159 See above for favours, N. Adams, 'The Construction of Pienza (1459–64) and the Consequences of *Renovatio*', in *Urban Life in the Renaissance*, ed. S. Zimmerman and R. Weissman (Newark, 1989), p. 56.

160 For funding see Mack, *Pienza*, p. 41 and Appendix 2, pp. 180ff; on expropriation, N. Adams, 'The Acquisition of Pienza, 1459–1464', *Journal of the Society of Architectural Historians*, 44 (1985), pp. 99–110; on imposed building, D. S.

Chambers, 'The Housing Problems of Cardinal Francesco Gonzaga', *Journal of the Warburg and Courtauld Institutes*, 39 (1976), pp. 30–32. See also my 'Francesco Patrizi: umanista, urbanista e teorico di Pio II', in *Pio II Piccolomini*, ed. Nevola.

161 Piccolomini, *I Commentarii*, II, 1744–71 (Bk IX, chap. 23–6).

162 *Ibid.* (Bk IX, chap. 23–4).

163 *Ibid.* (Bk IX, chap. 25), 'volens quattuor nobilibus aedificiis circundari forum'.

164 *Ibid.*, II, 1770–77 (Bk IX, chap. 26).

165 *Ibid.*, II, 1776 (Bk IX, chap. 26), 'Haec Pontifex ex altissima fenestra cum cardinalibus non sine iocunditate spectavit, quamvis interea e publicis negotiis consultaret.'

166 ASS, *Lira* 161, fol. 200 (1466) Pietro di Bartolomeo di Carlo Piccolomini, 'non ho havuto sussidio alcuno nè dal papa pio, nè da nissuno' and ASS, *Lira* 161, fol. 207 (1466) Enea e Carlo di Arcangelo Piccolomini, 'al tempo di papa pio, benche fussimo picholuomini non fummo però papeschi in guadagnare'.

167 Piccolomini, *I Commentarii*, I, 284, 'multos in hac urbe fuisse nobiles ed admodum potentes, qui palatia sublimia et altas turres templaque nobilissima extruxerunt, rem publicam administrantes' (Bk II, chap. 13: translation Piccolomini [Pius II], *The Commentaries*, ed. and trans. Gragg, p. 135). The passage is echoed closely in Piccolomini, 'Historia Friderici III Imperatoris', p. 64, 'In ea primum Nobiles imperium habuere, quorum adhuc turres extant, atque alta palatia, monumentaque opere sumptuoso constructa'.

168 On the anti-magnate laws of 1277 see D. Waley, *Siena and the Sienese in the Thirteenth Century* (Cambridge, 1991), pp. 77–82; also comments in chapter One.

169 Piccinni, 'Modelli di organizzazione dello spazio urbano', pp. 230–34.

170 L. Lanza, 'Ideologia e politica nei "Commentarii" di Pio II: le descrizioni delle città', in *Studi in onore di Arnaldo d'Addario*, ed. L. Borgia et al. (Lecce, 1995), II, pp. 523–5.

171 See, among others, Polverini Fosi, '"La Comune Dolcissima Patria"'.

172 Patrizi's only published biography is F. Battaglia, *Enea Silvio Piccolomini e Francesco Patrizi, due politici senesi del Quattrocento* (Siena, 1936), a useful text, although much coloured by the political context from which it was written; these views are revised and corrected by P. Benetti Bertoldo, 'Francesco Patrizi the Elder: The Portrait of a Fifteenth-century Humanist', D.Phil., Wolfson College, University of Oxford, 1996.

173 Benetti Bertoldo, 'Francesco Patrizi the Elder', p. 12, lists Barnaba di Nanni, Andreoccio Petrucci, Aeneas Silvius Piccolomini, Goro Lolli, Achille Petrucci, Francesco Patrizi, Francesco Tolomei, Francesco Arringhieri and Agostino Dati. For the anti-governmental stance of the intellectual and *novesco* elite, see also P. Pertici, *Le epistole di Andreoccio Petrucci (1426–1443)* (Siena, 1990), pp. 15–26; also for political unrest among this group, see P. Pertici, 'Una 'coniuratio' del reggimento di Siena nel 1450', *BSSP*, 99 (1992), pp. 9–47.

174 See also Battaglia, *Enea Silvio Piccolomini*, pp. 82–6.

175 P. Pertici, 'La furia delle fazioni', in *Storia di Siena. Dalle origini alla fine della repubblica*, I, ed. R. Barzanti, G. Catoni and M. De Gregorio (Siena, 1995), pp. 390–93.

176 Battaglia, *Enea Silvio Piccolomini*, pp. 93–4; see also M. Faloci Palugnani, 'Siena e Foligno', *Bollettino della Regia Deputazione di Storia Patria per l'Umbria*, XXIII (1918), pp. 115–206.

177 Pertici, *Le epistole*, p. 19; also Benetti Bertoldo, 'Francesco Patrizi the Elder', pp. 166–7.

178 Benetti Bertoldo, 'Francesco Patrizi the Elder', pp. 49–50 for stages of completion; Battaglia, *Enea Silvio Piccolomini*, pp. 101–2 for later date. Further reports of writing phases are collected from correspondence with Agostino Patrizi; see M. Dykmans, *L'Oeuvre de Patrizi Piccolomini ou le ceremonial papal de la première Renaissance* (Vatican City, 1982), I, pp. 3–5.

179 The letter exists in an undated mutilated sheet in a manuscript volume of the work, presumably of the 1470s, which contains Patrizi's own coat of arms. See BAV, MS Chigi F VIII 195, fol. 2. Patrizi specified: 'Avunclus tuus Pius Secundus Pontifex Max. Francisce Car.lis Senen. vir fuit summo ingenio, magna eloquentia, exquisitasque doctrina [. . .] Is est plurimis rationibus sepe me ad hortatus est ut munus scribendi de Institutione civili suscipem, meque facture opere pretium se arbitrare dicebat, si diligenter que huis rei usui sunt'; published in my 'Francesco Patrizi'.

180 Tönnesman, *Pienza*, cites a number of passages from *De Institutione Reipublicae* in the appendix, although his discussion of these excerpts is entirely minimal. Some discussion of the text is to be found in M. Tafuri, *Venezia e il Rinascimento* (Turin, 1985), pp. 159–61, although here it is related exclusively to a Venetian context (summarized also in M. Tafuri, *Ricerca del Rinascimento. Principi, città, architetti*, Turin, 1992, p. 55). For a discussion of the text and its dependence on classical sources, and especially for its use of Vitruvius, see P. N. Pagliara, 'Vitruvio: da testo a canone', in *Memoria dell'antico nell'arte italiana*, ed. S. Settis (Turin, 1986), III, pp. 28–30; followed also by H. Burns, '"Restaurator de ruyne antiche": tradizione e studio dell'antico nelle attività di Francesco di Giorgio', in *Francesco di Giorgio, architetto*, ed. F. P. Fiore and M. Tafuri (Milan, 1994), p. 158. Richard Schofield has recently considered the text in relation to Girolamo Riario's architectural patronage, although his essay does not place the development of Imola in relation to Patrizi's advice, see R. Schofield, 'Girolamo Riario a Imola: ipotesi per una ricerca', in *Francesco di Giorgio alla corte di Federico da Montefeltro: atti del convegno internazionale di studi*, ed. F. P. Fiore (Florence, 2004), II, pp. 600–608.

181 F. Patrizi, *De Institutione Reipublicae libri novem* (Paris, 1534) – I have found no copies of the putative 1494 edition and have used the Paris, 1520 (Galeotto da Prato) edition in the notes below. The letter is also contained in the vellum presentation volume prepared for Sixtus IV, BAV, MS. Vat. Lat. 3084, fol. 4v. The Sienese context of production is noted by Benetti Bertoldo, 'Francesco Patrizi the Elder', pp. 146–61.

182 On the Italian city-state, from a vast bibliography see the useful collection, *City States in Classical Antiquity and Medieval Italy*, ed. A. Molho, K. Raaflaub and J. Emlen (Ann Arbor, 1991).

183 *Novesco* aspects of the Lorenzetti cycle were noted and put in relation to Patrizi's *De gerendu magistratu*, by Pertici, *Le epistole*, p. 19.

184 Patrizi, *De Institutione*, fol. VI verso, 'Civilem societatem quam civitatem appellamus (urbis enim nomen aedificiis tantum ac moenibus continentur) hominum inventum esse utilitatis gratia duce natura nequaquam mihi ambigendum esse videtur. Est enim homo sociale animal longe magis quam apes, formice, grues et eiusmodi genera, que graegatim aluntur, gregantimque se tuentur [. . .].'

185 *Ibid.*, fol. XXXVIII verso (Bk III.1), 'Virtutes imprimis duces habeant, que imperant, sien quibus nihil recte agitur, quarum precipua iustitia est, quequidem humanae societatis fundamenta iacit, et pietatem in se continet [. . .].' Also described are: *fides, fortitudo, prudentia, modestia, temperantia, constantia*.

186 *Ibid.*, fol. xlii verso (Bk. III.4).

187 On the establishment of the *Ufficiali sopra l'ornato* see chapter Five.

188 Patrizi, *De Institutione*, fol. xl recto (Bk. III.2), 'Hoc exemplo complures civitates divisae sunt etiam temporibus nostris ut patria nostra Senensis [. . .] Verum ex inclyta quoque Venetorum Republica, in qua peregrinis nullus est locus, et tamen nec iustitia, nec severitas deest, et ex eiusmodi iudiciis nullae discordie, nullae seditionis, nullaeque inimicitiae oriuntur.'

189 *Ibid.*, fol. lxxxvi verso (Bk. VI.1), 'primum Patricium appellaverunt, secundum equestrem, tertium vero plaebeium.' Discussed without specific reference to Siena in Benetti Bertoldo, 'Francesco Patrizi the Elder', pp. 181–4 and F. Battaglia, *Enea Silvio Piccolomini*, p. 115.

190 *Ibid.*, fol. lxxxvi verso (Bk. VI.1), 'Verum in veteribus documentis pigneribusque domus nostrae scriptum repperi, et signa in vetustissimis marmoribus nostra, ad hanc usque aetatem Romae, pluribus locis cernuntur.'

191 *De Origine et Antiquitate Urbis Senæ* was never published and survives in a number of manuscripts. In Siena: ASS, MS. D 166, ASS, MS. B III 3, and BCS, B III 5; in Rome: BAV, Chigi, G I 9, fol. 134–55. The text is discussed further in chapter Seven. Further discussion of Piccolomini history, with a list of texts dedicated to Pius II, can be found in *Consorteria Piccolomini*, 4 'Ricordi e memorie (1148–1778)', fascicule marked 'Dell'antichità e nobiltà della casa Piccolomini'.

192 F. Patrizi, *De Origine et Antiquitate*, ASS MS. D 166, fol. 13v (for Piccolomini) and fol. 21v (for the Tolomei: 'fugentes enim Cleopatra'). Similar issues of mythical forebears are addressed in I. D. Rowland, 'L'Historia Porsennae e la conoscenza degli Etruschi nel Rinascimento', *Studi umanistici piceni*, 9 (1989), pp. 185–93; see also chapter Seven for discussion.

193 Although Patrizi's text is less sophisticated than is L. B. Alberti's (*On the Art of Building in Ten Books*, ed. and trans. J. Rykwert, N. Leach and R. Tavernor, Cambridge, MA, 1991), the Sienese origins of the work single it out for comment. For considerations of the urban renewal of Siena in relation to Alberti's text, see the discussion in my '"Ornato della città": Siena's Strada Romana'.

194 Patrizi, *De Institutione*, fol. cxxi verso (Bk. IX.11), 'Secundum vias privatae aedes longo ordine ad pares (si fieri potest) dimensiones constituendae sunt, ut speciem urbis ornent [. . .] In privatis tamen aedificiis sancta illa mediocritas servanda est, quae res omnes mirifice commendat, ut peripatetici asserunt.'

195 G. Prunai, G. Pampaloni and N. Bemporad, eds., *Il Palazzo Tolomei a Siena* (Florence, 1971), pp. 59–86; also T. Benton, 'Three Cities Compared: Urbanism', in *Siena, Florence and Padua: Art, Society and Religion, 1280–1400*, ed. D. Norman (New Haven and London, 1995), II, pp. 13–14; for the church, see *Die Kirchen von Siena*, ed. P. A. Riedl and M. Siedel (Munich, 1985), II, pp. 343–426. See also chapter One.

196 F. Guerrieri, ed., *La sede storica del Monte dei Paschi di Siena* (Siena, 1988), pp. 99–100.

CHAPTER FIVE

1 ASS, Concistoro 2125, fol. 39 (18 December, 1465); P. Pertici, *La città magnificata: interventi edilizi a Siena nel Rinascimento*, Siena 1995, 89: 'per ampliare lo honore publico et refare ornata la città di degni et ornati lavori […] et più nella strada […] che negli altri luoghi, perchè chi viene nella città vostra vede più quella strada che l'altre'.

2 F. Sacchetti, *Il Trecentonovelle*, ed. V. Marucci (Rome, 1996), pp. 38–9 [novella XII]: 'accattò da un suo vicino uno ronzino, sul quale salendo suso et andando insino alla porta, come là giunse, il ronzino si cominciò a tirare a dietro, come se della porta aesse auto paura o fosse aombrato o che si fosse posto in cuore di non volere uscire della terra. Alberto, accennandoli cotale alla trista, non lo poteo mai fare andare [. . .] lo volse indietro e cominciollo a rimenare a casa chi gli l'aveva prestato: là dove il ronzino non ch'egli andasse a passo, ma andva sí di trotto che facea ben trottare Alberto. Et cosí arrivò per lo Campo di Siena [. . .]'.

3 For thirteenth- and fourteenth-century legislation, see chapter One.

4 Bernardino da Siena, *Prediche volgari sul Campo di Siena (1427)*, ed. C. Delcorno (Milan, 1989), II, pp. 1040–41 [Sermon XXXV, 217], where the quotation serves as an analogy for 'all paths lead to God'.

5 On pathways and movement in Venice, see P. Fortini Brown, 'Measured Friendship, Calculated Pomp: The Ceremonial Welcomes of the Venetian Republic', in *Triumphal Celebrations and the Rituals of Statecraft (Papers in Art History from the Pennsylvania State University, VI, Part 1)* (University Park, PA, 1990), pp. 136–87; also D. Howard, 'Ritual Space in Renaissance Venice', *Scroope*, 5 (1993–4), pp. 4–11. Further discussion on the traveller's experience of the street is offered in chapter Six.

6 On the Palio see A. Dundes and A. Falassi, *La Terra in Piazza: An Interpretation of the Palio of Siena* (Berkeley and London, 1975) and M. A. Ceppari et al., eds., *L'immagine del Palio: Storia, cultura e rappresentazione del rito di Siena* (Siena, 2001); on the Palio *alla lunga*, W. Heywood, *Palio e Ponte* (Siena and London, 1904), pp. 98–105. For the routes in the fourteenth- to sixteenth-century usage, see D. Balestracci, R. Barzanti and G. Piccinni, 'Il Palio: una festa nella storia', in *Nuovo Corriere Senese* (1978), p. 9. Some comments also in P. Jackson and F. Nevola 'Introduction', in *Beyond the Palio: Urban Ritual in Renaissance Siena* (Oxford, 2006), pp. 1–2. See also G. Parsons, *Siena, Civil Religion and the Sienese* (Aldershot and Burlington, VT, 2005), pp. 43–7.

7 ASS, Concistoro 2111, fol. 197 (27 November 1398), quoted from W. Braunfels, *Mitteralterliche Stadtbaukunst in der Toskana* (Berlin, 1951), p. 254 (doc. 8). On the vital role of the piazza del Campo as a market place, see M. Tuliani, 'La dislocazione delle botteghe nel tessuto urbano della Siena medievale (secc. XIII–XIV)', *BSSP*, CIX (2002), pp. 88–116.

8 The tale recounted is to be found in ASS, Concistoro 2154, fol. 24 (no date, but probably 1460/61). The urban renewal legislation is discussed in chapter Six.

9 This as a result of a package of zoning restrictions enforced to coincide with the visit of Pope Pius II; see ASS, Concistoro 2125, fol. 10.

10 ASS, Concistoro 2154, fol. 24 (no date, but probably 1460/61), 'sí per mutare luogo et peggiorare per esso, et sí per aver trovato essa l'altra buttega et in essa fare le spese necessarie al mestiero mio, della qual cosa sono totalmente disfatto'.

11 ASS, Concistoro 2155, fol. 82 (30 January 1465/6), from Antonio di Chelino di Antonio et compagni barbieri, who promised 'pronto et in ordine essa barbaria di chaldaie, scigatoi, baccini et altre cose pertinenti alla barbaria'.

12 ASS, Concistoro 2111, fol. 197 (27 November 1398), from Braunfels, *Mitteralterliche Stadtbaukunst*, p. 254 (doc. 8), 'in ogni buona città si provede a l'adorno et aconcio de la città'.

13 ASS, Concistoro 2125, fol. 78 (January 1468; Pertici, *La città magnificata*, p. 106), 'grandissimo ornamento a tucta la città et contento di tutti e' cittadini'.

14 ASS, *Statuto di Siena* 40, fol. 83 (12 May 1452).

15 I. Moretti, 'La Via Francigena', in *Storia di Siena. Dalle orgini alla fine della repubblica*, ed. R. Barzanti, G. Catoni and M. De Gregorio (Siena, 1995), I, p. 52; also T. Szabó, 'La rete stradale del comune di Siena. Legislazione statutaria e amministrazione comunale nel Duecento', *MEFR*, 87 (1975), pp. 141–86.

16 M. Ascheri and P. Pertici, 'La situazione politica senese del secondo Quattrocento (1456–79)', in *La Toscana ai tempi di Lorenzo il Magnifico: Politica, economia ed arte* (Pisa, 1996), III, p. 1001.

17 Quoted from Ascheri and Pertici, 'La situazione politica', p. 1001 n.17, 'io mi ricordo che la guerra fra la nostra e la vostra Repubblica ebbe origine pure dalla Strada'.

18 W. Caferro, *Mercenary Companies and the Decline of Siena* (Baltimore and London, 1998), pp. 156–65, for economic decline. See also the essays in A. Tomei, ed., *Le Biccherne di Siena. Arte e Finanza all'alba dell'economia moderna* (Azzano San Paolo, Bergamo, and Rome, 2002). Siena's economic history after 1348 is remarkably understudied; see also the essays in *Siena nel Rinascimento: l'ultimo secolo della repubblica*, Acts of the International Conference, Siena (28–30 September 2003 and 16–18 September 2004), ed. M. Ascheri and F. Nevola (Siena, 2007).

19 It cannot fall within the scope of the present study to offer a thorough assessment of Siena's economy during this period, a study that is nonetheless much needed. For the present purpose, I offer comments based on legislative measures and their practical implementation as assessed through tax records.

20 For decline, see D. Balestracci, 'L'immigrazione di manodopera nella Siena medievale', in *Forestieri e stranieri nelle città basso-medievali (Atti del seminario, Bagno a Ripoli, giugno 1984)*, ed. G. Cherubini and G. Pinto (Florence 1988), pp. 163–80; G. Pinto, *La Toscana nel Tardo Medioevo* (Florence, 1982), pp. 421–49.

21 ASS, *Biccherna* 1058 (1307–54) petitions, discussed by D. Balestracci and G. Piccinni, *Siena nel Trecento. Assetto urbano e prassi edilizia* (Florence, 1977), p. 31.

22 ASS, *Statuti di Siena* 47, fol. 128v (7 June 1398), 'qualunque persona forestiero artista o lavoratore vorrà venire ad abitare nela ciptà o contado di Siena sia exempto da ogni spesa o factione di comune reale o personale per tempo di x anni proximi che seguiranno'.

23 ASS, *Statuti di Siena* 47, fol. 130 (21 November 1404), repeated in ASS, *Statuti di Siena* 41, fol. 129 and 143v (21 November 1404), without exemptions on *gabella del sale*. ASS, *Statuti di Siena* 40, fol. 72 (undated, 1451?), Redi di Salvatore di Lapi in *Concistoro* 2158, fol. 18 (12 July 1470).

24 Exemptions from the obligation to build were given to those already owning property, for example Iacomo da Castro, ASS, *Concistoro* 2156, fol. 75 (5 April 1467); Redi di

Vanni Angeli, freed from building behind payment of 80 ducats, ASS, *Balìa* Spoglio, BCS. A. VII. 19–22 (17 December 1480).

25 Balestracci and Piccinni, *Siena nel Trecento*, pp. 31–3.

26 *Ibid.*, p. 171.

27 Bartolomeo Benvoglienti, *De urbis Senae origine et incremento* (Siena, 1506), pp. civ–civl. Salicotto and S. Salvatore (which cover the area of the Borgo S. Maria), are among the poorest city districts, which may indicate a concentration of immigrants.

28 Names are also used to trace immigration also by S. Cohn, *The Laboring Classes in Renaissance Florence* (New York, 1980), pp. 96–101.

29 D. Herlihy and C. Klapisch Zuber, *Tuscans and their Families: A Study of the Florentine Catasto of 1427* (New Haven and London, 1985), p. 58. Tax-based estimates, derived from the ASS, *Lira* offer tentative population figures for 1453 of 14,047, for 1481 of 11,571 and for 1509 of 12,925. Contrast with G. Pardi, 'La popolazione di Siena attraverso i secoli', *BSSP*, 30 (1923), p. 110; his figures are based on baptismal records and indicate a rather high figure of 15,000.

30 Two late examples are Paolo Teutonico, a printed bookseller, ASS, *Balìa* Spoglio, BCS. A. VII. 19–22 (6 May 1507), and the doctor Mazzino Mazzinghi, ASS, *Balìa* Spoglio, BCS. A. VII. 19–22 (18 March 1512).

31 Cecchini, 'L'arazzeria senese', 171 [doc. 2]; ASS, *Concistoro* 460, fol. 46 (27 October 1442).

32 H. Smit, '"Ut si bello et ornato mestiero": Flemish Weavers Employed by the City Government of Siena (1438–1480)', in *Italy and the Low Countries: Artistic Relations, The Fifteenth Century*, ed. B. W. Meijer et al. (Florence, 1999), p. 71. See also L. Campbell, 'Cosmè Tura and Netherlandish Art', in *Cosmè Tura: Painting and Design in Renaissance Ferrara*, exh. cat., ed. S. Campbell, Isabella Stuart Gardner Museum, Boston (Milan, 2002), pp. 71–105, esp. 71–85 for identification of the masters Jacquet of Arras and Arnold Boteram (with thanks to L. Syson for this reference).

33 ASS, *Statuti di Siena* 40, fol. 93 (10 May 1460), 'far fare nella città di Siena, et durante la detta condotta, tanto savone bianco buono e mercantile che sia bastevole al bisogno et necessita della città di Siena el suo contado'.

34 ASS, *Statuti di Siena* 40, fol. 98 (10 July 1461), described as 'magistro tincte coraminis rubei puliti'.

35 Discussed at length at the end of this chapter.

36 Tax established, 'contra Lombardos et alios peregrinos laboratores', with ASS, *Concistoro* 575, fol. 42r (9 August 1462); ratified in ASS, *Consiglio Generale* 229, fol. 255v (9 August 1462), which specified 'Che tutti li lombardi e altri forestieri cioe muratori, manovali, chiavari, catinari, segatori di legname, lavoratori di scassati e di fosse o di vigne, fornaciari, che facessero mattoni o calcina, o altri lavori a fornare, scarpelliantori e cavatori di marmi o di pietre che vengono in Siena e nel contado distretto o giurisdizione suo'. The list is in ASS, *Ufficiali sopra alle mura*, 5; analysis by Pinto, *La Toscana nel Tardo Medioevo*, pp. 421–9.

37 On Visconti see M. A. Ceppari, 'La signoria di Gian Galeazzo Visconti', in *Storia di Siena*, ed. Barzanti, Catoni and De Gregorio, I, pp. 315–26; on Lombards see Pinto, 'L'immigrazione di manodopera', pp. 421–49 and Balestracci, 'L'immigrazione di manodopera', pp. 163–80.

38 G. Cecchini, 'Maestri luganesi e comaschi a Siena nel XV secolo', in E. Arslan, ed., *Arte e artisti dei laghi lombardi*, I: *Architetti e scultori del Quattrocento* (Como, 1959), p. 131.

39 Collected essays in Arslan, ed., *Arte e artisti dei laghi lombardi*, I, and in E. Arslan, ed., *Arte e artisti dei laghi lombardi*, II: *Gli stuccatori dal Barocco al Rococo* (Como, 1964) and M. L. Gatti Perrer, 'Premesse per un repertorio sistematico delle opere e degli artisti della Valle Intelvi' (Atti del Convegno, Varenna, 1966), *Arte Lombarda*, 11 (1966). See also *Magistri d'Europa: Eventi, relazioni, strutture della migrazione di artisti e costruttori dai laghi lombardi*, ed. S. della Torre, T. Mannoni and V. Pracchi (Como, 1997).

40 Further research is necessary on Lombards. For masters working in Europe, see the essays in Arslan, ed., *Arte e artisti dei laghi lombardi*, I; in general on Lombards see R. Goldthwaite, *The Building of Renaissance Florence* (Baltimore, 1981), pp. 247–8.

41 P. Braunstein, 'Il cantiere del Duomo di Milano alla fine del XIV secolo: lo spazio, gli uomini e l'opera', in *Ars et Ratio*, ed. J. Maire Vigueur and A. Paravicini Bagliani (Palermo, 1990), p. 160.

42 E. Poleggi, 'Il rinnovamento edilizio genovese e i maestri Antelami del secolo XV', in '"Valle Intelvi", Acts of Conference, September 1966', *Arte Lombarda*, XI/2 (1966), pp. 53–68; also 'La condizione sociale dell'architetto e i grandi committenti dell'epoca alessiana', in *Galeazzo Alessi e l'architettura del Cinquecento* (Atti del convegno internazionale di studi: Genova, 16–20 Aprile 1974) (Genoa, 1975), pp. 359–68; also 'Un caso di studio: Genova e le valli d'origine dei magistri d'Antelamo', in *Magistri d'Europa*, ed. Mannoni, pp. 380–492.

43 M. Hollingsworth, *Patronage in Renaissance Italy* (London, 1994), p. 107; also S. M. Connell, 'The Employment of Sculptors and Stone Masons in Venice in the Fifteenth Century', PhD thesis, Warburg Institute, University of London, 1976. The Lombardo family came from Carona, the same town in the lake region from which the Solari master-masons came from.

44 An assessment of the significance of Lombard builders in Siena can be found in the closing section of this chapter.

45 For grouping in threes and fours see ASS, *Mura* 5, fol. 101v; on Milan and Pavia working structures see L. Giordano, 'I maestri muratori lombardi: lavoro e remunerazione', in *Les chantiers de la Renaissance*, ed. A. Chastel and J. Guillaume (Paris, 1991), pp. 165–73.

46 ASS, *Lira* 191, fol. 72 and 81 ('la extensione [ancora] per anni 11 perchè sono anni 14 che venni ad abitare').

47 ASS, *Consiglio Generale* 234, fol. 129 (23 April 1472), 'huomini et maxime Lombardi [. . .] piazze, casellini, case guaste, et altre case che minacciano ruina nela vostra città, per edificare et racconciare esse case et essi luoghi. Et ancho sallirerebbero nella vostra città et conferirebbero alla lira come altri cittadini'.

48 D. Balestracci, 'La corporazione dei muratori dal XIII al XVI secolo', in *Il colore della città*, ed. M. Boldrini (Siena, 1993), pp. 25–34. Published statutes: V. Lusini, 'Dell'Arte del legname dinnazi al suo Statuto del 1426', *BSSP*, 11 (1904), pp. 183–246; Milanesi, *Documenti*, I, pp. 105–35; D. Balestracci, ed., *Statuto dell'Arte dei muratori (1626)* (Siena, 1976). Break-up in Milanesi, *Documenti*, I, pp. 126–9; confirmed in ASS, *Arti* 126, statute of the 'Muratori', ratified by Mercanzia in 1525, fol. 17v–18 (September 1525).

49 ASS, *Arti* 126, fol. 17v–18, 'duas tertias partes magistros habitatores sive habitantium continue civitatis Senarum'.

50 ASS, *Arti* 126, fol. 17v–18.

51 Balestracci, 'La corporazione dei muratori', p. 32.

52 Economic regeneration is addressd in statutes in ASS, *Siena* 40, fol. 68–80 (from 1451), fol. 83 (1452), fol. 89 (1459) and others. Against economic decline, see S. Cohn, *Death and Property in Siena, 1205–1800* (Baltimore, 1988), pp. 122–6.

53 ASS, *Statuti di Siena* 40, fol. 72–4.

54 ASS, *Statuti di Siena* 40, fol. 20 (12 July 1451); for bans on luxury cloth from Perpignan, see ASS, *Siena* 40, fol. 97v (16 June 1461).

55 ASS, *Statuti di Siena* 40, fol. 89, 'si intende le arti e li mestieri sono quelle cose fanno la città ricca e ornata et popolosa'.

56 ASS, *Concistoro* 2156, fol. 29 (18 September 1466).

57 ASS, *Concistoro* 2160, fol. 81 (22 July 1477), 'di fama la citta vostra havendo assai mancamaneto di chi perfectamente exercita tale arte [. . .]'.

58 ASS, *Concistoro* 2117, fol. 198 (24 January 1477/8), 'oltre li denari che rimarebono in Siena si governa e si nutrisca bona parte del vostro popolo [. . .]'.

59 ASS, *Concistoro* 2117, fol. 227 (23 May 1477). Such exemptions were fairly standard while Spain remained the main producer of lustre-ware; see, for example, the recent catalogue *Spanish Pottery, 1248–1898: With a Catalogue of the Collection in the Victoria and Albert Museum*, ed. A. Ray (London, 2000).

60 ASS, *Concistoro* 2117, fol. 267 (1480) for leather, and fol. 275 (27 December 1481) for rope.

61 On shops and the rental market, see chapter Six.

62 ASS, *Concistoro* 2111, fol. 197 (27 November 1398), from Braunfels, *Mitteralterliche Stadtbaukunst*, p. 254 (doc. 8), 'ed abino ad ornarla si che è banchieri stieno insieme dal ta' lato al tale è drapieri e orafi da ta' lato al tale peliciari e armaioli [. . .]'. Some similar objectives of retail clustering can be seen in Tuliani, 'La dislocazione delle botteghe'.

63 That they were not enforced is implicit in later legislation on the same matters, see below.

64 ASS, *Statuti di Siena* 40, fol. 83, 'Per ogni interesse publico o privato provvidero et ordinarono statuto et reformarono che da calende gennaio proximo advenire 1452 inlà, niuno fabbro di ferro o rame, excepto solamente orafi, possi stare e fare exercitare tale mestiere per alcuno modo da la Croce al Travaglio per infino ala cantina di Santo Giorgio sotto la pena di fl 100 d'oro'.

65 For example, zoning restrictions ASS, *Concistoro* 2118, fol. 186 (butchers, August 1463); ASS, *Balìa* 235, fol. 240–41, 290 (linen-makers and others, September–November 1507).

66 See chapter One for discussion of these measures; *Il Costituto*, ed. Elsheikh, pp. 18–23 (Dist. III.37–52), 317, 321–3 (Dist. V.162, 172, 178), except around the Assumption; see also Balestracci and Piccinni, *Siena nel Trecento*, pp. 155–7. Tuliani, 'Il Campo di Siena', pp. 72–7, outlines the trades active in the market until the 1309 legislation.

67 See Balestracci and Piccinni, *Siena nel Trecento*, pp. 151–64; P. Nardi, 'I borghi di San Donato e San Pietro a Ovile. "Populi", contrade e compagnie d'armi nella società senese dei secoli XI–XIII', *BSSP*, 73–5 (1966–68), pp. 7–59.

68 ASS, *Consiglio Generale* 228, fol. 131v (20 July 1460); see also the discussion of zoning in F. Nevola, '"Più honorati et suntuosi ala Republica": *Botteghe* and Luxury Retail along Siena's Strada Romana', in *Buyers and Sellers: Retail Circuits and Practices in Medieval and Early Modern Europe*, ed. B. Blondé, P. Stabel, J. Stobbart and I. Van Damme (Turnhout, 2006), pp. 65–78.

69 ASS, *Consiglio Generale* 228, fol. 131v (20 July 1460), 'per ornamento della città e massimamente della piazza pubblica vulgarmente chiamata champo [. . .]'.

70 ASS, *Concistoro* 2154, fol. 24 (no date, but probably 1460/61), 'nell'arte mia facevo assai bene [. . .] dipoi credendo fare meglio la lassai per un'altra bottega posta insul campo sotto la casa dei giullari'; see also above.

71 ASS, *Concistoro* 2125, fol. 10 (quoted from Pertici, *La città magnificata*, p. 71): 'sarebbe bene e honorevole cosa, et maxime havendoci ad venire la corte romana [. . .] si deliberasse e statuisse e ordinasse che per la strada maestra da la chiesa di San Donato presso a Montanini infino al Duomo e infino alla piazza Piccolomini inclusive non possino stare a buttiga fabbri di veruna ragione per alcuno modo'.

72 On Renaissance zoning see J. Ackerman and M. Rosenfeld, 'Social Stratification in Renaissance Urban Planning', in *Urban Life in the Renaissance*, ed. S. Zimmerman and R. Weissman (Newark, 1989), pp. 21–49; also L. B. Alberti, *On the Art of Building in Ten Books*, ed. and trans. J. Rykwert, N. Leach and R. Tavernor (Cambridge, MA, 1991), pp. 191–2 (VII.1). The visit of Pius II is discussed further in chapter Four and in my 'Ritual Geography: Housing the Papal Court of Pius II Piccolomini in Siena (1459–60)', in *Beyond the Palio*, ed. Jackson and Nevola, pp. 65–88.

73 First legislation against butchers, ASS, *Consiglio Generale* 228, fol. 205r (March 1459), and ASS, *Statuto di Siena* 40, fol. 95 (1460); see also P. Turrini, *'Per honore et utile de la città di Siena'. Il comune e l'edilizia nel Quattrocento* (Siena, 1997), pp. 185–8; on zoning see ASS, *Statuto di Siena* 40, fol. 83 (12 May 1452), ASS, *Consiglio Generale* 228, 131v (20 July 1459), ASS, *Consiglio Generale* 230, fol. 68v (23 December 1463) and ASS, *Concistoro* 2125, fol. 10, 23 (25 October 1459, 18 December 1463; Pertici, *La città magnificata*, pp. 71, 79).

74 Balestracci and Piccinni, *Siena nel Trecento*, p. 163, for a reference to a 1315 case from ASS, *Consiglio Generale* 86, fol. 58 (14 August).

75 ASS *Consiglio Generale* 228, fol. 131v (20 July 1460) and fol. 205 (1459); also in ASS, *Statuto di Siena* 25, fol. 330 (21 March 1460); also ASS, *Statuto di Siena* 40, fol. 89v (25 October 1459).

76 ASS, *Statuto di Siena* 25, fol. 330 (21 March 1460), 'civitas nostra sit multus damnata a cortigianis et allis forensibus existentibus in civitate Senensis' because 'per stratas magistras stent'.

77 Comparison was made to Mantua, for which also see H. Burns, 'The Gonzaga and Renaissance Architecture', in *Splendours of the Gonzaga*, exh. cat., ed. D. Chambers and J. Martineau, Victoria and Albert Museum (London, 1981), pp. 28–9. ASS, *Statuto di Siena* 25, fol. 330 (21 March 1460), 'in contrarium aliarum civitatis que in ordine se gubernant'.

78 ASS, *Concistoro* 2124, fol. 30, 'li vostri antiqui [i.e. medieval *Comune*] istituro et ordinaro le buttighe dell'arte nostra si tenessero insulle strade et in quelle dove al presente esse buttighe sono [. . .] circa hanno usate le dette buttighe fra padri loro et loro maggiori che le parrebbe assai difficile alloro abbandonare'.

79 ASS, *Concistoro* 2118, fol. 186 (24 August 1463).

80 ASS, *Concistoro* 2118, fol. 186 (24 August 1463) again fol. 171 (12 April 1464).

81 ASS, *Concistoro* 2124, fol. 112 (undated, June–September 1464); see also Turrini, *'Per honore et utile'*, pp. 185–8.

82 ASS, *Consiglio Generale* 231, fol. 171 (10 August 1466); response to petition ASS, *Concistoro* 2124, fol. 89 (see also Turrini, *'Per honore et utile'*, p. 187).

83 A. Fiorini, *Siena. Immagini, testimonianze e miti nei toponomi della città* (Siena, 1991), p. 188.

84 Briefly, for the thirteenth century see the editor's 'Intro-
duzione' in G. Cecchini, ed., *Archivio di Stato di Siena,
Archivio di Biccherna. Inventario* (Rome, 1953), pp. XI–XII and
112–13; Pertici, *La città magnificata*, p. 64, describes the *Petroni*
generically, 'vigilavano sulle mura, edifici pubblici, strade
[. . .]'; Turrini, *'Per honore et utile'*, p. 33.

85 ASS, *Consiglio Generale* 233, fol. 308 (21 June 1471), quoted
in chapter Three; M. C. Paoluzzi, in *Le Biccherne di Siena.
Arte e Finanza all'alba dell'economia moderna*, ed. A. Tomei
(Azzano San Paolo, Bergamo, and Rome, 2002), pp.
198–200.

86 Previous analysis of the *Ornato* is limited to Pertici, *La città
magnificata*, pp. 63–4; a consistent number of records docu-
menting their interventions in Siena survive in ASS, *Concis-
toro* 2125 (listed and partially transcribed in Pertici, *La città
magnificata*, pp. 65–141). Legislative origins for the office in
ASS, *Statuto di Siena* 40, fol. 137 (11 October 1458); noted
in E. Brizio, 'Leggi e provvedimenti del Rinascimento
(1400–1542): spoglio di un registro archivistico (Statuto di
Siena 40)', in *Antica legislazione della Repubblica di Siena*, ed.
M. Ascheri (Siena, 1993), p. 193. While Pertici's digest of
ASS, *Concistoro* 2125 covers documents that predate October
1458 (Pertici, *La città magnificata*, pp. 65–70, docs. 1–10),
none of these specifically mentions the *Ufficiali sopra l'or-
nato*, and it is probable these papers have been included in
the archival file by modern archivists.

87 A discussion of the term *ornato* in art-historical literature
can be found in H. Wohl, *The Aesthetics of Italian Renais-
sance Art: A Reconsideration of Style* (Cambridge, 1999),
pp. 54–76; see also his '"Puro senza ornato": Masaccio,
Cristoforo Landino and Leonardo da Vinci', *Journal of the
Warburg and Courtauld Institutes*, LVI (1993), pp. 256–60. This
formulation, however, sees the term in an Albertian sense
as being an added ornament, as opposed to the more func-
tional aesthetic quality proposed here.

88 ASS, *Concistoro* 2125, fol. 39 (18 December 1465; Pertici, *La
città magnificata*, p. 89), 'per ampliare lo honore publico et
fare ornata la città di degni et ornati lavori, et levare via,
maxime nei luoghi più degni li ballatoi, loro adoperano
ogni loro ingegnio, et gravano li cittadini vostri, senza
alcuno riservo, a fare decto effecto, et più nella strada di
Kamollia che in altri luoghi, perché chi viene nella citta
vostra vede piu quella strada che l'altre. Et già si vede per
quelli che sono stati levati quanto n'è divenuta ornatissima'.

89 Pertici, *La città magnificata*, pp. 65–141. I have only identi-
fied one election record for the officials (January 1460 in
ASS, *Concistoro* 320, fol. 38v; thanks to Maria Assunta
Ceppari for this document), and they do not appear in the
ASS, *Elezioni e cerne* lists.

90 ASS, *Statuto di Siena* 40, fol. 137 (11 October 1458); noted
in Brizio, 'Leggi e provvedimenti', p. 193. While M. Ascheri,
Siena nel Rinascimento. Istituzioni e sistema politico (Siena,
1985), p. 14, has shown that the *Consiglio del Popolo* estab-
lished the *Ornato* with a decision of 31 March 1403, their
activity is not documented until 1459 (ASS, *Concistoro* 2125,
fol. 10; Pertici, *La città magnificata*, p. 71); pre-1459 ASS, *Con-
cistoro* 2125 documents do not refer to the *Ornato*.

91 ASS, *Statuto di Siena* 40, fol. 137 (11 October 1458); noted
in Brizio, 'Leggi e provvedimenti', p. 193.

92 In addition to the *Viarii*, *Petroni* and *Ornato*, there was
also the city works department, the *Opera*, which oversaw
publicly funded building projects such as the Loggia della
Mercanzia, church of S. Ansano and S. Caterina in Fonte-

branda, as well as the Cathedral. See summary information
in entries in S. Moscadelli, *Inventario analitico dell'Archivio del-
l'Opera Metropolitana di Siena* (Munich, 1995); also J. Hook,
Siena: A City and its History (London, 1979), pp. 67–70.

93 Terms can be frequently found in the petitions in ASS, *Con-
cistoro* 2125 (partially transcribed in Pertici, *La città magnifi-
cata*, pp. 65–141).

94 ASS, *Concistoro* 2111, fol. 197 (27 November 1398), quoted
from Braunfels, *Mitteralterliche Stadtbaukunst*, p. 254 (doc. 8).
Florence and Venice are mentioned as comparisons in the
quotation itself.

95 Turrini, *'Per honore et utile de la città di Siena'*, p. 26; N. Men-
gozzi, 'Martino V ed il Concilio di Siena (1418–31)', *BSSP*,
25 (1918), pp. 247–314. For the work of the *Petroni*, see
chapter One.

96 ASS, *Concistoro* 1995, fol. 56 (25 September 1459; also in I.
Polverini Fosi, '"La Comune Dolcissima Patria": Pio II
e Siena', in D. Rugiadini, ed., *I ceti dirigenti nella Toscana
del Quattrocento (Atti del V et VI convegno: Firenze, 10–11
dicembre 1982; 2–3 dicembre 1983)* (Florence, 1987), pp. 509–
21, 515) 'warning your Excellencies [the Commune] that
[. . .] Mantua is a beautiful city, filled with many large, dig-
nified and beautiful buildings' as discussed in chapter Four;
for Pius's criticisms of Mantua, see H. Burns, 'The Gonzaga
and Renaissance Architecture', in *Splendours of the Gonzaga*,
ed. Chambers and Martineau, pp. 28–9.

97 Numerous cases listed in ASS, *Concistoro* 2125 (see Pertici,
La città magnificata, pp. 63–142). On overhangs see D. Fried-
man, 'Palaces and the Street in Late-Medieval and Renais-
sance Italy', in *Urban Landscapes, International Perspectives*,
ed. J.W.R. Whitehand and P. J. Larkham (London, 1992),
pp. 74–86.

98 Pertici, *La città magnificata*, p. 7; on these visits and their
impact on the city, see also F. Nevola, 'Ritual Geography:
Housing the Papal Court of Pius II Piccolomini in Siena
(1459–60), in *Beyond the Palio*, ed. Jackson and Nevola,
pp. 65–88.

99 Described in detail in Piccolomini [Pius II], *I Commentarii*,
ed. Totaro, II, 1594–5 (Book VIII.8). For Pius's use of pro-
cessional displays, see R. Rubinstein, 'Pius II's Piazza
S. Pietro and St. Andrew's Head', in *Enea Silvio Piccolomini,
Papa Pio II (Atti del Convegno per il quinto centenario della
morte e altri scritti)*, ed. D. Maffei (Siena, 1968), pp. 235–9.
ASR, *Camerale I: Tesoreria Segreta (Entrata Uscita)*, 1288, fol.
104–106v (15–21 June 1462) for listing of 26 subsidies for
such demolitions (cited, and in part transcribed, in E.
Muntz, *Les arts à la cours des papes pendant le XV et XVI siècles.
Recueil de documents inédites tirés des archives des bibliothèques
romaines*, Paris, 1878, I, p. 300).

100 ASR, *Tesoreria Segreta* 1288, fol. 104 (1461–2), for numerous
payments of 5–8 ducats made to different individuals.

101 Piccolomini [Pius II], *I Commentarii*, ed. Totaro, II, pp. 1594–5
(Bk VIII.8: translation from Piccolomini [Pius II], *The Com-
mentaries*, ed. and trans. F. A. Gragg, *Smith College Studies in
History*, pp. 551–6).

102 ASS, *Concistoro* 2125, fol. 14 and 21 (and reference in *Con-
siglio Generale* 230, fol. 51–2); Pertici, *La città magnificata*, pp.
78–9; 'viri officiales ad ornatum [. . .] numero sex convo-
cati in aule pape in palatio magnificorum dominorum
[. . .] deliberaverunt, quod omnes illi, quibus facta fuerunt
precepta de emovendis ballatoris, habeant terminum usque
ad medium mensem septembris proxime futuri ad illa
levanda et removenda [. . .]'. Geographical limits were set

'a domo Cristofani Bartholomei Vannelli da San Giusto exclusive usque ad domum ser Christofori de Clanciano'.

103 ASS, *Concistoro* 2125, fol. 21; Pertici, *La città magnificata*, p. 78. It is curious that the fine is quantified in ducats, the usual currency of the Roman court, rather than florins or *lira*, which were used in Siena.

104 O. Malavolti, *Dell'historia di Siena* (Venice, 1599), III, p. 68.

105 The Duomo route is mentioned in petitions: e.g. ASS, *Concistoro* 2125, fol. 15 (19 July 1463; Pertici, *La città magnificata*, p. 75); ASS, *Concistoro* 2125, fol. 19 (24 February 1464; Pertici, *La città magnificata*, p. 78); ASS, *Concistoro* 2125, fol. 24 (1463; Pertici, *La città magnificata*, p. 80).

106 ASS, *Consiglio Generale* 228, fol. 300–01 (24 October 1460; and in L. Banchi and S. Borghesi, *Nuovi documenti per la storia dell'arte senese*, Siena, 1898, p. 201).

107 F. Patrizi, *De Institutione Reipublicae libri novem* (Paris, 1520), fol. xlii verso (Bk. III.4; also Bk. VIII).

108 Patrizi, *De Institutione*, fol. xlix (Bk. III.12), 'Ut viae publicae adaequarentur, sternerenturque, ne quid in illi aedificarentur, quod usui ornamentove obesset'.

109 Patrizi, *De Institutione*, fol. cxxi verso (Bk. VIII.10), 'viarum ratio et de porticibus'.

110 P. N. Pagliara, 'Vitruvio: da testo a canone', in *Memoria dell'antico nell'arte italiana*, ed. S. Settis (Turin, 1986), III, pp. 28–30; H. Burns, '"Restaurator de ruyne antiche": tradizione e studio dell'antico nelle attività di Francesco di Giorgio', in *Francesco di Giorgio, architetto*, ed. F. P. Fiore and M. Tafuri (Milan, 1994), p. 158. For the letter requesting the text, see P. Benetti Bertoldo, 'Francesco Patrizi the Elder: The Portrait of a Fifteenth-century Humanist', D.Phil., Wolfson College, University of Oxford, 1996, p. 50 n. 155, 'roga tamen eum ut tibi Vitruvium concedat pro aliquibus diebus, quem ad me mittes et ego ad te remittam'. For a strong endorsement of Patrizi's dependance on Vitruvius, see M. G. Aurigemma, 'Note sulla diffusione del vocabolario architettonico: Francesco Patrizi', in *Le Due Rome del Quattrocento: Melozzo, Antoniazzo e la cultura artistica del '400 Romano*. Acts of the Conference (Rome 1996), ed. S. Rossi and S. Valeri (Rome, 1997), pp. 365–79.

111 Benetti Bertoldo, 'Francesco Patrizi the Elder', p. 172, lists other sources for architectural information: Varro's *De Re Rustica*, Pliny's *Naturalis Historia*, M. Porcius Cato's *De Agri Cultura* and others.

112 Patrizi, *De Institutione Reipublicae libri novem*, fol. cxii verso (Bk. VIII.13), 'forum [. . .] quale est in patria nostra, quod in tota Italia conspicuum habetur'; fol. cxv (Bk VIII.16), 'loco aedito in medio urbis omnes architecti aedificandam censent, ut ex ea maxima moenium pars conspiciatur'.

113 It is worth noting that the *Ornato* may have influenced Sixtus IV's reforms of the 'Maestri di Strada' in Rome, through Patrizi's discussion of the *aediles* (his treatise was dedicated to the Pope). E. Re, 'Maestri di Strada', *Archivio Società Romana di Storia Patria* (1920), pp. 5–102.

114 Conclusions drawn from ASS, *Concistoro* 2125 (summarized in Pertici, *La città magnificata*, pp. 63–142).

115 F. Nevola, '"Ornato della città": Siena's Strada Romana as Focus of Fifteenth-century Urban Renewal', *Art Bulletin*, 82 (2000), p. 46, table presents material extracted from ASS, *Concistoro* 2125, which is entirely made up of *Ornato* petitions. While the office of the *Ornato* remained in place after the last document (ASS, *Concistoro* 2125, fol. 144, 29 June 1480; Pertici, *La città magnificata*, p. 139), their activity was much reduced.

116 Statistics drawn from material contained in ASS, *Concistoro* 2125 (summarized in Pertici, *La città magnificata*, pp. 63–142). Individual cases are mentioned in the text below. Map identifies sites, some of which appear more than once in documents.

117 Pertici, *La città magnificata*, pp. 63–142; Friedman, 'Palaces and the Street', p. 76, discusses some cases.

118 Compare to exclusive developments, such as the Strada Nuova in Genoa: G. L. Gorse, 'A Classical Stage for the Old Nobility: The Strada Nuova and Sixteenth-century Genoa', *Art Bulletin*, 79 (1997), pp. 301–27, or papal interventions in Rome, as discussed by M. Tafuri, '"Roma Instaurata". Strategie urbane e politiche pontificie nella Roma del primo Cinquecento', in *Raffaello architetto*, ed. C. L. Frommel, S. Ray and M. Tafuri (Milan, 1984), pp. 56–106. On the accretive process of urban change, see A. Ceen, *The Quartiere dei Banchi: Urban Planning in Early Cinquecento Rome* (New York, 1986), p. 7 (drawing on Ceen's PhD thesis, University of Pennsylvania, 1977).

119 As in Paolo di Antonio's petition, cited at the outset, ASS, *Concistoro* 2125, fol. 78 (19 January 1468; Pertici, *La città magnificata*, p. 106). It seems probable that many other improvements to buildings were made without the intervention (and documentation) of the *Ornato*.

120 ASS, *Concistoro* 2125, fol. 22 (7 November 1463; Pertici, *La città magnificata*, p. 79); on Giovanni Cinughi, see chapter Six.

121 ASS, *Concistoro* 2125, fol. 94 (17 April 1469; Pertici, *La città magnificata*, p. 112).

122 ASS, *Concistoro* 2125, fol. 4 (n.d.; Pertici, *La città magnificata*, p. 67).

123 ASS, *Concistoro* 2125, fol. 43 (30 January 1466; Pertici, *La città magnificata*, p. 91).

124 *Ibid.*; a fourteenth-century architectural drawing of the palace survives, reproduced in F. Toker, 'Gothic Architecture by Remote Control: An Illustrated Building Contract of 1340', *Art Bulletin*, 69 (1985), pp. 67–95; see also C. Ghisalberti, 'Late Italian Gothic', in *The Renaissance from Brunelleschi to Michelangelo: The Representation of Architecture*, exh. cat., ed. H. Millon and V. Magnago Lampugnani (London, 1994), p. 429.

125 Useful comments, which avoid the all-too-easy Siena–Florence, Gothic–Renaissance polarization, can be found in H. Burns, '"Restaurator de ruyne antiche": tradizione e studio dell'antico nelle attività di Francesco di Giorgio', in *Francesco di Giorgio, architetto*, ed. F. P. Fiore and M. Tafuri (Milan, 1994), pp. 151–8; also F. P. Fiore, 'Siena e Urbino', in *Storia dell'architettura italiana: il Quattrocento*, ed. F. P. Fiore (Milan, 1998), pp. 272–88.

126 'Ornato della città' is cited in almost all the petitions contained in ASS, *Concistoro* 2125. That the *Ornato* officials were unbiased in assignation of funds seems likely from the socio-economic breadth of applicants, although it has been impossible to confirm this through checks on electoral procedures and individual official's connections. Attempts to find election lists have been unsuccessful, with the exception of January 1460 in ASS, *Concistoro* 320, fol. 38v (thanks to Maria Assunta Ceppari for this document). That incentives, as made through *Ornato* intercession, were sometimes not enough to see restorations to completion is evident in tax declarations bemoaning uncompleted building work resulting from required *ballatoio* demolitions (e.g. ASS, *Lira* 193, fol. 6 and 185, fol. 128 (1481) and ASS, *Lira* 234, fol. 15, 16, 28 and 34 (1509)).

127 First mentioned in G. Cecchini, 'Minime di storia dell'arte senese: Un'altro palazzo gotico del Rinascimento', *BSSP*, 68 (1961), pp. 241–50; also Pertici, *La città magnificata*, p. 122.

128 Cecchini, 'Minime di storia', pp. 241–50.

129 ASS, *Lira* 146, fol. 54 (1453) taxed for 1,075 *lira* total wealth.

130 Site shown in BAV, *Archivio Chigi* 25039; a land concession made by the *Comune* to Biagio di Cecco on the corner bounding the Strada and piazza S. Spirito suggests the likelihood of further public property in the area; ASS, *Concistoro* 2125 fol. 114 (Pertici, *La città magnificata*, pp. 122–3).

131 ASS, *Concistoro* 2125 fol. 114 (13 November 1470; Pertici, *La città magnificata*, pp. 122–3), 'vostro servidore molto stimolato e richiesto da detti frati che debbi fare uno muro [. . .]'. A full discussion of S. Spirito can be found in M. Mussolin, 'Il convento di Santo Spirito di Siena e i regolari osservanti di San Domenico', *BSSP*, 104 (1997), pp. 7–193; see also chapter Nine.

132 Petition in ASS, *Concistoro* 2125 fol. 114 (13 November 1470; Pertici, *La città magnificata*, pp. 122–3); castellanship in BCS MS. A.VII.18 *Spoglio Biccherna*, dated 15 July 1470 and 25 May 1473.

133 ASS, *Concistoro* 2125 fol. 114 (Pertici, *La città magnificata*, p. 123), 'accio che si tolga tanta bruttura'.

134 *Ibid.*, 'ad similitudinem unius ex finestris iam completis'.

135 The piazza is discussed further below.

136 ASS, *Concistoro* 2125 fol. 114 (Pertici, *La città magnificata*, p. 123), 'chon beccatelli e cornici due [. . .] et sopra a esso muro fare tante colonne di mattoni [. . .] a sei facce belle'. And of the windows, 'fenestris [. . .] cum columnellis et straforibus'.

137 Analysis of the Palazzo del Capitano in my 'Revival or Renewal: Defining Civic Identity in Fifteenth-century Siena', in *Shaping Urban Identity in the Middle Ages*, ed. P. Stabel and M. Boone (Leuven and Apeldoorn, 1999), pp. 111–34; see also below.

138 For an analysis of the use of plaster in vernacular architecture, see M. Boldrini, ed., *Il colore della città* (Siena, 1993). Plaster was removed as a result of a nineteenth-century neo-Gothic taste for stripping plaster in order to reveal structure and Gothic traces in Siena's medieval fabric.

139 Initial 'stratigraphic' research of this sort is being published by R. Parenti and his team for more major Sienese buildings; see, for example, E. Boldrini and R. Parenti, eds., *Santa Maria della Scala: archeologia e edilizia sulla piazza dello Spedale* (Florence, 1991).

140 A. Filarete, *Filarete's Treatise on Architecture*, ed. and trans. J. Spencer (New Haven, 1965), cited in Burns, 'Quattrocento Architecture and the Antique', p. 272.

141 ASS, *Concistoro* 2125, fol. 92 (14 September 1468; Pertici, *La città magnificata*, p. 112).

142 For popular housing see also G. Giovannoni, 'Case del Quattrocento in Roma', in *Saggi sull'architettura del Rinascimento*, ed. G. Giovannoni (Milan, 1931), pp. 29–47; B. Zevi, 'Dialetti Architettonici', in *Controstoria dell'architettura in Italia* (Rome, 1997); *Edilizia seriale pianificata in Italia 1500–1600*, ed. G. Cataldi, in *Studi e Documenti di Architettura*, 14 (1987); A. Chastel and J. Guillaume, *La maison et la ville à la Renaissance*, Acts of the Conference, Tours, 1977 (Paris, 1983). The house is discussed by M. Quast, 'Palace Façades in Late Medieval and Renaissance Siena: Continuity and Change in the Aspect of the City', in *Renaissance Siena: Art in Context*, ed. A. L. Jenkens (Kirksville, MO, 2005), p. 59.

143 ASS, *Lira* 197, fol. 165 (1481).

144 ASS, *Concistoro* 2125, fol. 31 (7 December 1464; Pertici, *La città magnificata*, p. 84).

145 Pertici, *La città magnificata*, p. 40, is based on R. Goldthwaite, *The Building of Renaissance Florence* (Baltimore, 1981), pp. 13–26.

146 That residence was untaxed is implicit in 7,500 examined from ASS, *Lira: Dichiarazioni dei beni*, tax returns, where residence is never taxed.

147 One of many such comments in ASS, *Concistoro* 2125, fol. 39 (18 December 1465).

148 ASS, *Lira* 229, fol. 431 (1491); the palace is mentioned further below.

149 On formulaic writing techniques, tailored to the intended recipient, see N. Zemon Davis, *Fiction in the Archives: Pardon Tales and their Tellers in Sixteenth-century France* (Stanford, 1987).

150 ASS, *Concistoro* 2125, fol. 31 (7 December 1464; Pertici, *La città magnificata*, p. 84); ASS, *Lira* 229, fol. 431 (1491).

151 Compare to exclusive developments, such as the Strada Nuova in Genoa: Gorse, 'A Classical Stage', and Chapter Nine.

152 One of many such comments in ASS, *Concistoro* 2125, fol. 39 (18 December 1465), 'per ampliare lo honore publico e refare ornata la città di degni et ornati lavori'.

153 M. Cordaro, 'Le vicende costruttive' in *Il Palazzo Pubblico di Siena. Vicende costruttive e decorazione*, ed. C. Brandi (Milan, 1983), pp. 29–145; see also Chapter One.

154 J. Beck, *Jacopo della Quercia* (New York, 1991), I, pp. 81–94; Burns, '"Restaurator de ruyne antiche"', p. 155. A. Lusini, 'I Turrini e l'oreficeria pura', *La Diana* (1929), pp. 62–70; P. Bacci, 'La colonna del Campo, proveniente da avanzi romani presso Orbetello (1428)', *Rassegna dell'arte senese*, n.s. 1 (1927), p. 227. See also M. Caciorgna and R. Guerrini, 'Imago Urbis. La lupa e l'immagine di Roma nell'arte e nella cultura senese come identità storica e morale', in *Siena e Roma. Raffaello, Caravaggio e i protagonisti di un legame antico*, exh. cat., ed. B. Santi and C. Strinati, S. Maria della Scala, Palazzo Squarcialupi, Siena (Siena, 2005), pp. 99–118. A full discussion of Siena's foundation legend can be found in chapters Six and Seven.

155 N. Rubinstein, 'Political Ideas in Sienese Art: The Frescoes by Ambrogio Lorenzetti and Taddeo di Bartolo in the Palazzo Pubblico', *Journal of the Warburg and Courtauld Institutes*, 21 (1958), pp. 179–207; see also K. Christiansen, 'Mattia di Nanni's Intarsia Bench for the Palazzo Pubblico, Siena', *Burlington Magazine*, 139 (1997), pp. 372–86.

156 N. Rubinstein, *The Palazzo Vecchio, 1298–1532: Government, Architecture and Imagery in the Civic Palace of the Florentine Republic* (Oxford, 1995), pp. 60–61.

157 ASS, *Concistoro* 2462, fol. 58 (18 June 1446, in Milanesi, *Documenti*, II, p. 235), 'faciendo eam totam de marmo carrarese; faciendo stipitos, architraves, cornices, cardinales, et quod quodlibet de per se sit de uno pezo; ac etiam faciendum totum politum, straforatum, pomicatum, lustratum, et bene repertum ad usum et dictum cujuslibet boni et intelligentis magistri: cum quatuor mediis figuris virtutum cardinalium'.

158 For documents relating to the new doors see Morandi in *Il Palazzo Pubblico di Siena*, doc. 379 (29 November 1466), which names Urbano di Pietro.

159 On the preference for 'Gothic', see G. Cecchini, 'Minime di storia dell'arte senese: Un'altro palazzo gotico del Rin-

ascimento', *BSSP*, 68 (1961), pp. 241–50; Turrini, *'Per honore et utile de la città di Siena'*, pp. 135–42.

160 D. Balestracci, 'From Development to Crisis: Changing Urban Structures in Siena Between the Thirteenth and Fifteenth Centuries', in *The 'Other Tuscany': Essays in the History of Lucca, Pisa and Siena*, ed. T. W. Blomquist and M. F. Mazzaoui (Kalamazoo, 1994), p. 211. A. L. Jenkens has recently criticized Balestracci's judgement in his 'Introduction: Renaissance Siena, the State of Research', in *Renaissance Siena*, ed. Jenkens, p. 1.

161 On variety of local 'Renaissances', see P. Fortini Brown, '*Renovatio* or *Concilatio*? How Renaissances Happened in Venice', in *Language and Images of Renaissance Italy*, ed. A. Brown (Oxford, 1995), pp. 127–54; see also the collection *Artistic Exchange and Cultural Translation in the Italian Renaissance City*, ed. S. J. Campbell and S. J. Milner (Cambridge, 2004). Stylistic diversity as a feature of Sienese fifteenth-century architecture is examined below.

162 In general, see Balestracci and Piccinni, *Siena nel Trecento*, and the general survey in J. White, *Art and Architecture in Italy, 1250–1400* (Harmondsworth, 1987).

163 *Il Palazzo Tolomei di Siena*, ed. G. Prunai, G. Pampaloni and N. Bemporad (Florence, 1971), p. 83; A. Lisini, 'Palazzo Tolomei', *Miscellanea Storica Senese*, IV (1896), pp. 13–14; Turrini, *'Per honore et utile de la città'*, p. 101. Had such plans been approved, it is possible that the Palazzo Tolomei would have taken on functions similar to Orsanmichele in Florence.

164 ASS, *Consiglio Generale* 235, fol. 230 (14 June 1474); see also Turrini, *'Per honore et utile de la città'*, pp. 129–31. On grain stores see M. A. Ceppari, 'Tra legislazione annonaria e tecnologia: alla ricerca di una Biccherna perduta', in *Antica legislazione della Repubblica di Siena*, ed. M. Ascheri (Siena, 1993), pp. 201–23. For restorations on the eve of the arrival of Pius II, see ASS *Concistoro* 2479, fol. 3v–4, 51, 68, 80, 97, 115, 124 (January 1460).

165 There is also the problem of heavy nineteenth-century restorations in both cases; see M. Marini, 'Trasformazioni urbane ed architetture a Siena nella seconda metà del XIX secolo', in *Siena tra Purismo e Liberty* (Milan and Rome, 1988), pp. 266–86.

166 Turrini, *'Per honore et utile'*, pp. 115–21; ASS *Consiglio Generale* 232, fol. 55 (29 January 1468).

167 Turrini, *'Per honore et utile'*, pp. 151–2.

168 A. Bruno, 'Palazzo del Capitano', in *Università di Siena: 750 anni di storia*, ed. M. Ascheri et al. (Siena, 1991), pp. 407–8; high rental costs are mentioned in ASS *Consiglio Generale* 231, fol. 92v–93 (13 March 1465), fol. 178v (4 September 1466) and *Consiglio Generale* 232, fol. 59 (22 January 1468).

169 The fifth occluded window opening on the first storey may be a later addition.

170 Turrini, *'Per honore et utile'*, pp. 116–19; other documents in Pertici, *La città magnificata*, pp. 101, 104–5.

171 ASS *Concistoro* 2462, fol. 120–122v (30 June 1466; Turrini, *'Per honore et utile'*, p. 116), 'faccia dinanzi [. . .] di mattoni nuovi [. . .] e due filaia di finestre di 4 finestre a filaio a colonelli di macigno bene lavorato'.

172 On the use of double string-courses in Sienese Quattrocento architecture, see Burns, 'Restaurator de ruyne antiche', pp. 155–7.

173 On the segmental arch in Siena, see F. Gabbrielli, 'Stilemi senesi e linguaggi architettonici nella Toscana del Due-Trecento', in *Architettura civile in Toscana: il Medioevo*, ed. A. Restucci (Siena, 1995), pp. 305–68.

174 Turrini, *'Per honore et utile'*, pp. 116–19; 'Gothic' private palaces before 1460 are documented in G. Cecchini, 'Il Castello delle Quattro Torri e i suoi proprietari', *BSSP*, 55 (1948), pp. 3–32.

175 The unity of style for sites of civic authority is little studied; see D. Friedman, *Florentine New Towns: Urban Design in the Late Middle Ages* (Cambridge, MA, 1988), pp. 105–12, 200–11; C. Cunningham, 'For the Honour and Beauty of the City: The Design of Town Halls', in *Siena, Florence and Padua*, II, p. 53.

176 ASS, *Concistoro* 2118, fol. 176–9 (30 October 1463), for a full description of the planned tower; Morandi, in *Il Palazzo Pubblico di Siena*, doc. 376.

177 ASS, *Concistoro* 2125, fol. 12 (7 March 1464); accounts for the restoration can be found in ASS, *Biccherna* 1070, 'Libro della Torre'.

178 M. Cordaro, 'Baldassarre Peruzzi, il Palazzo Pubblico e il Campo di Siena', in *Baldassarre Peruzzi: pittura, scena e architettura*, ed. M. Fagiolo and M. L. Madonna (Rome, 1987), pp. 169–80 and C. L. Frommel, *Die Farnesina und Peruzzis architektonisches Frühwerk* (Berlin, 1961), pp. 129–30. Further discussion in Conclusion.

179 So described in ASS, *Concistoro* 2125, fol. 35 (12 April 1464); though no projects survive for the planned tower, it seems reasonable to assume it would have resembled the Torre del Mangia – thus the innovation would be in the symmetry of the palace façade, rather than the stylistic choices adopted in the tower's design.

180 Cordaro, 'Le vicende costruttive', pp. 20–21, 57.

181 Attribution and dating from S. Tizio, *Historiarum Senensium*, BCS, MS. B.III.10, fol. 61; work began 11 August 1468 (A. Allegretti, *Ephemerides Senenses ab anno MCCCCL usque ad MCCCCXCVI italico sermone scriptae*, in *Rerum Italicarum Scriptores*, ed. L. Muratori, vol. 23 (Milan, 1733), 773) and finished in August 1470 (T. Fecini, 'Cronaca Senese', p. 871). See also R. Bartalini, 'Il tempo di Pio II', in *Francesco di Giorgio e il Rinascimento a Siena*, pp. 92–105, n. 33. For a discussion of Federighi's career see chapter Six; also the essays in *Pio II e le arti. La riscoperta dell'antico da Federighi a Michelangelo*, ed. A. Angelini (Cinisello Balsamo, Milan, 2005). Another possible source for the frieze is in the sarcophagus preserved in the portico of the church of S. Saba in Rome, of which Francesco Todeschini Piccolomini was titular cardinal.

182 A similar case is discussed for Orcagna's Orsanmichele tabernacle by Burns, 'Quattrocento Architecture and the Antique', p. 272; for Lombard sources for the frieze, see P. Sanpaolesi, 'Aspetti di architettura del '400 a Siena e Francesco di Giorgio', in *Studi Artistici Urbinati*, I (1959), pp. 156–8.

183 Illustrations in Cordaro, 'Le vicende costruttive', p. 42.

184 AOMS, Museo, n. 19; discussed by C. Ghisalberti, 'Late Italian Gothic', in *The Renaissance from Brunelleschi to Michelangelo*, ed. Millon and Magnago Lampugnani, p. 429.

185 Sodoma was paid for the painting; see Banchi and Borghesi, *Nuovi documenti*, pp. 470–71 (February 1539).

186 R. Lieberman, 'Real Architecture, Imaginary History: The Arsenale Gate as Venetian Mythology', *Journal of the Warburg and Courtauld Institutes*, 54 (1991), p. 123.

187 Sanpaolesi, 'Aspetti di architettura del '400 a Siena', pp. 139–68, 146–50, although no documentary evidence supports the Pienza proposal. For Vecchietta as architect, see most recently the comments of F. P. Fiore, 'Siena e

188 Urbino', in *Storia dell'architettura italiana: il Quattrocento*, ed. F. P. Fiore (Milan, 1998), pp. 281–2. In both Sanpaolesi and Fiore the suggestion is implicit that Vecchietta's career in some sense laid the foundations for that of Francesco di Giorgio Martini, and that his possible role as architect is auxiliary to such an hypothesis.

188 Sanpaolesi, 'Aspetti di architettura del 400 a Siena', p. 146; also S. Bertelli, 'The Tale of Two Cities: Siena and Venice', in *The Renaissance from Brunelleschi to Michelangelo*, ed. Millon and Magnago Lampugnani, pp. 373–97; A. Bruschi, 'Religious Architecture in Renaissance Italy from Brunelleschi to Michelangelo', in *The Renaissance from Brunelleschi to Michelangelo*, pp. 150–52. For Vecchietta's possible involvement in the Cappella dei Mascoli decoration in S. Marco, Venice, see also Bertelli, 'The Tale of Two Cities', and M. Morresi, 'Venezia e le città del Dominio', in *Storia dell'architettura italiana: il Quattrocento*, ed. F. P. Fiore (Milan, 1998), pp. 208–9.

189 Parenti, 'Santa Maria della Scala', pp. 51–5; L. Cavazzini and A. Galli, 'Biografia di Francesco di Giorgio ricavata dai documenti', in *Francesco di Giorgio e il Rinascimento a Siena*, ed. L. Bellosi (Siena and Milan, 1993), p. 512; F. P. Fiore, 'Giacomo Cozzarelli', in *The Dictionary of Art*, ed. J. Turner (London, 1996), VIII, pp. 100–01. On fortification work with Guidoccio di Andrea, see Sanpaolesi, 'Aspetti di architettura del '400 a Siena', p. 145, and documents in Milanesi, *Documenti*, II, pp. 281–2.

190 See for example the use of estimators and practical mathematicians, as discussed in N. Adams, 'The Life and Times of Pietro dell'Abaco, a Renaissance Estimator from Siena (active 1457–86)', *Zeitschrift für Kunstgeschichte*, 48 (1985), pp. 384–95. As shown in chapter Four, the document dated 28 March 1460, referring to a 'ligneam figuram futuri edifitii' (Milanesi, *Documenti*, II, pp. 308–10), most likely pertains to a statue design for the Loggia della Mercanzia as opposed to a design for the Loggia Piccolomini.

191 For Vecchietta as architect, see H. W. van Os, *Studies in Early Tuscan Painting* (London, 1992), pp. 39–57; as designer of Chiesa di Villa at Castiglione Olona, see A. Natali, 'Il Vecchietta a Castiglione Olona', *Paragone*, 35 (1984), pp. 3–14, although this view has been challenged with documents published by G. Sironi, 'I fratelli Solari, figli di Marco (Solari) da Carona: nuovi documenti', *Arte Lombarda*, 102–3 (1992), pp. 65–9.

192 The classic survey remains L. Ettlinger, 'The Emergence of the Italian Architect During the Fifteenth Century', in *The Architect: Chapters in the History of the Profession*, ed. S. Kostof (New York, 1977), pp. 96–123.

193 Adams, 'The Life and Times of Pietro dell'Abaco'; also M. Trionfi Onorati, 'Antonio e Andrea Barili a Fano', *Antichità Viva*, 6 (1975), pp. 35–42.

194 Adams, 'The Life and Times of Pietro dell'Abaco', pp. 389–90; also S. Moscadelli, 'Maestri d'abaco a Siena tra Medioevo a Rinascimento', in *L'Università di Siena. 750 anni di storia* (Siena, 1991), pp. 207–16.

195 ASS, *Concistoro* 2479 (1459–60), fol. 42 and other entries; ASS, *Archivio Generale dei Contratti*, no. 1340 (27 April 1473); Milanesi, *Documenti*, II, pp. 353–4 (January 1474).

196 P. Galluzzi, 'Le macchine senesi. Ricerca antiquaria, spirito di innovazione e cultura del territorio', in *Prima di Leonardo: cultura delle macchine a Siena nel Rinascimento*, ed. P. Galluzzi (Milan, 1991), pp. 15–44, rightly suggests that it is precisely the practice-based skills developed within the context of Siena's difficult topography that produced the technical qualities of recognized 'architects' such as Francesco di Giorgio and Baldassarre Peruzzi.

197 G. Vasari, *Le vite dei più eccellenti pittori, scultori ed architettori*, ed. P. Barocchi (Florence, 1971), III, p. 174.

198 Allegretti, *Ephemerides Senenses*, in *Rerum Italicarum Scriptores*, vol. 23, p. 776; Milanesi, *Documenti*, II, p. 235. See also V. Lusini, *Storia della Basilica di San Francesco in Siena* (Siena, 1894).

199 Allegretti, *Ephemerides Senenses*, in *Rerum Italicarum Scriptores*, vol. 23, p. 773 (12 September 1469), discussed in chapter Four.

200 P. A. Riedl and M. Siedel, eds., *Die Kirchen von Siena* (Munich, 1985, 1992), II, 1.2, section on 'San Domenico', assembles the documentation; for Pienza, Porrina is documented supervising the Bishop's palace, the construction of fifteen row houses and other sundry tasks; see ASR, *Camerale I: Tesoreria Segreta* (Entrata Uscita) 1288 (1461–2), fol. 122v (28 September 1462) and ASR, *Camerale I: Tesoreria Segreta* (Entrata Uscita) 1289 (1463–4), fol. 78 (28 April and 29 May 1463), fol. 95v (4 August 1463).

201 For instance, Luca di Bartolo, architect of the Palazzo del Capitano, was closely controlled by a detailed contract, as was Francesco di Cristoforo Fedeli from Como, whose S. Maria del Portico is discussed in chapter Six. Fedeli has been connected to various projects, most recently the church of S. Maria degli Angeli in Valli; see T. Kennedy, 'Religious Architecture in Renaissance Siena: The Building of Santa Maria degli Angeli in Valli', in *Siena nel Rinascimento: l'ultimo secolo della repubblica*, Acts of the International Conference, ed. G. Mazzoni and F. Nevola (Florence, 2007), although Kennedy – perhaps mistakenly – does not propose any authorial hand on Fedeli's part in the design and prefers a more nebulous association to Francesco di Giorgio Martini and the Osservanza.

202 J. Pope-Hennessy, *Sienese Quattrocento Painting* (London and Oxford, 1947), p. 23, although he also enjoyed this sport, as did his 'school', represented in many of the exhibition entries for K. Christiansen, L. B. Kanter and C. B. Strehlke, eds., *Painting in Renaissance Siena, 1420–1500* (New York, 1988). A recent, succinct yet useful commentary on Siena's self-definition through art is to be found in Campbell and Milner's 'Art, Identity and Cultural Translation in Renaissance Italy', in their *Artistic Exchange and Cultural Translation in the Italian Renaissance City*, pp. 1–13, esp. p. 5. A useful survey of the period is in D. Norman, *Painting in Late Medieval and Renaissance Siena, 1260–1555* (New Haven and London, 2003), pp. 173–259. See also L. Syson, A. Angelini, P. Jackson and F. Nevola, *Renaissance Siena: Art for a City*, exh. cat., National Gallery, London (London, 2007).

CHAPTER SIX

1 M. Sanudo, *La spedizione di Carlo VIII in Italia*, ed. R. Fulin, Venice 1873, p. 145: 'Siena adoncha è città seconda di Toscana de potentia et richezze... al presente si può numerare fra le altre moderne, perché in quella non è alcun segno di antiquità ma è tutta degnamente rinnovata'.

2 Leandro Alberti, *Descrittione di Tutta Italia di F. Leandro Alberti Bolognese* (Venice: Lodovico degli Avanzi, 1568 [the Latin first edition is 1550]), p. 58, quotes Faccio [sic.], 'Per quella strada, che vi era più piana / Noi ci traemo alla città

di Siena, / La qual è posta in parte forte e sana. / Di leggiadria di bei costumi è piena / Di vaghe donne, e d'Huomini cortesi, / E l'aer dolce, lucida, e serena'. See Fazio degli Uberti, *Il Dittamondo e le Rime*, ed. G. Corsi (Bari, 1952), pp. 207 and 134; also G. Petrella, *L'officina del geografo: La 'Descrittione di tutta Italia' di Leandro Alberti e gli studi geografico-antiquari tra Quattro e Cinquecento* (Milan, 2004), pp. 104, 490.

3 Alberti, *Descrittione*, p. 58, 'Io vidi il Campo suo, ch'è molto bello, / E vidi Fonte Branda e Camelia, / E l'hospedale, del qual'ancor novello. / Vidi la chiesa di Santa Maria, / Con intagli di marmo'.

4 On visiting dignitaries, see chapter Two; also collected essays in *Beyond the Palio: Urban Ritual in Renaissance Siena*, ed. P. Jackson and F. Nevola (Oxford, 2006).

5 Jacopo Foresti, *Supplementum Chronicarum* (Venice, 1483), cited from the later edition (Venice: Bernardino Rizzo, 1490), fol. 76v, 'haec quippe civitas nunc super colle cuiusdam peninsule iacet undique qusi ripas tugolas habens; in superiore tamen urbis parte solus aliquantulum habet multis hortis viridiariisque ornatum, in qua quidem celeberissima et superba extant edificia. Videlicet gymansium perpulchrum, et foro et porticus et regia palatia, hospitaleque sumptuosissimus pientissime gubernatum. Ampla quoque et libera est, cum turribus et propugnaculis, ac optimis instituta moribus'.

6 Iacobi Philippi, *Supplementum Chronicarum* (Venice: Bernardino de Benaliis, 1486), fol. 109v shows Siena, reused in fol. 224. The 1490 edition (Venice: Bernardino Rizzo), seems to have ironed out these illustration inconsistencies. On the illustrations see also C. Sinistri, 'Le vedute di città nelle edizioni incunabole del *Supplementum Chronicarum*', *Esopo*, 56 (1992), pp. 48–69, and G. Ricci, 'Sulla classificazione della città nell'Italia di Foresti', *Storia Urbana*, 17 (1993), pp. 5–17. Little is added by V. Fontana, 'Immagini di città italiane nelle descrizioni del *Supplemento delle croniche* di Giacomo Filippo Foresti da Bergamo', in *Venezia e Venezie: Descrizioni, interpretazioni, immagini. Studi in onore di Massimo Gemin*, ed. F. Bonin and F. Pedrocco (Padua, 2003), pp. 53–60.

7 M. Sanudo, *La spedizione di Carlo VIII in Italia*, ed. Rinaldo Fulin (Venice, 1873), p. 145; see also, for example, A. Reumont, 'Viaggio in Italia nel MCDXCVII del cavaliere Arnaldo di Harff di Colonia sul Reno', *Archivio Veneto*, 11 (1876), p. 124; collected travellers' comments in Attilio Brilli, *Viaggiatori stranieri in terra di Siena* (Rome and Siena, 1984).

8 Sanudo, *La spedizione di Carlo VIII*, p. 145, 'al presente si può numerare fra le altre moderne, perché in quella non é alcun segno di antiquità ma tutta degnamente rinnovata'.

9 Bartolomeo Benvoglienti, *De urbis Senae origine et incremento* (Siena, 1506), p. civ3 (but written 1484–6); Sienese humanist accounts of the city are examined in chapter Seven.

10 Alberti, *Descrittione*, pp. 57–60.

11 *Ibid.*, p. 58, 'Vedesi poi il superbo palagio di pietra quadrata fatto da Pio 2 Pontefice Rom. con molti altri nobili edifici et vaghi palagi, che sarei molto lungo in definirli'.

12 For sure, as was argued in chapter Two, Pius II's patronage agenda was intended to be exemplary, as is suggested in the comments in Aeneas Silvius Piccolomini [Pius II], *I Commentarii*, ed. L. Totaro, 2 vols. (Milan, 1984) I, p. 284 (Bk II, chap. 13).

13 C. von Fabriczy, 'Giuliano da Maiano in Siena', *Jahrbuch der Königlich Preussischen Kunstsammlungen*, 4 (1903), pp. 320–34, from ASF, *Conventi Soppressi*, Badia di Firenze, Familiarum,

VI, no. 317 [nuovo], fol. 245v; Pietro Turamini was a wealthy banker, see ASS, *Lira* 57, fol. 23v (1453) and heirs in ASS, *Lira* 185, fol. 143 (1481). I have discussed the Palazzo Spannocchi in greater detail in 'Ambrogio Spannocchi's "bella casa": Creating Site and Setting in Quattrocento Sienese Architecture', in *Renaissance Siena: Art in Context*, ed. L. A. Jenkens (Kirksville, MO, 2005), pp. 141–56.

14 L. Banchi and S. Borghesi, *Nuovi documenti per la storia dell'arte senese* (Siena, 1898), pp. 242–3 (also in F. Guerrieri, 'Vicende architettoniche', in *La sede storica del Monte dei Paschi*, ed. F. Guerrieri et al., Siena, 1988, p. 64).

15 A full acquisition history for the palace is reconstructed in my 'Ambrogio Spannocchi's "bella casa"'. A less complete survey is Guerrieri, 'Vicende architettoniche'.

16 U. Morandi, 'Gli Spannocchi: piccoli proprietari terrieri, artigiani, piccoli, medi e grandi mercanti-banchieri', in *Studi in onore di Federico Melis* (Naples, 1978), III, pp. 99–108; see J. M. Cruselles Gómez and D. Igual Luis, *El duc Joan de Borja a Gandia. Els comptes de la banca Spannochi (1488-1496)*, (Gandía, 2003). Also, I. Ait, 'Aspetti dell'attività mercantile-finanziaria degli Spannocchi a Roma nel tardo medioevo', in *Siena nel Rinascimento: l'ultimo secolo della repubblica*, ed. M. Ascheri and F. Nevola (Siena, 2007).

17 Morandi, 'Gli Spannocchi', p. 107. ASS, *Lira* 147, fol. 131 for 1453 declaration of a house in 'San Donato al lato della chiesa' by Ambrogio di Iacomo Spannocchi (value 400 fl.; repeated in ASS, *Lira* 173, fol. 11; 1467) and fol. 137 for Bartolomeo di Giorgio Spannocchi (400 fl.). Living outside the neighbourhood in 1453 were Spannocchi households listed in ASS *Lira* 147, fol. 192 and 265 (resident in the district of Porta all'Arco) and fol. 83 (resident in the district of Pantaneto).

18 ASS, *Concistoro* 2185, fol. 146 (21 October 1473; Banchi and Borghesi, *Nuovi documenti*, pp. 242–3; it has unfortunately not been possible to locate the original), 'de la Vostra città tornato, e per grazia di Dio con qualche guadagno, deliberò per gloria della città e suo, intanto, benché sia vecchio, fare una casa bella'.

19 Most recently on the palace's attribution, see F. Quinterio, *Giuliano da Maiano: 'Grandissimo domestico'* (Rome, 1996), pp. 243–58. On the issue of acquisition of the site, and Salimbeni associations, see my 'Ambrogio Spannocchi's "bella casa"'.

20 S. Tizio, *Historiarum Senensium*, B III 10, fol. 72 for start date, 15 March 1472 (Sienese style); date confirmed in ASS, *Spannocchi* A12, fol. 41, 'Relazione del Palazzo Spannocchi' ('Al di 15 di Marzo 1472 [1473] principiò Ambrogio di Nanni Spannocchi un nobile et bello palazzo'), a diary entry published in full by A. Lisini, 'L'architetto di Palazzo Spannocchi', *Miscellanea Storica Senese*, 3 (1895), pp. 59–60. See also A. Allegretti, *Ephemerides Senenses ab anno MCCCCL usque ad MCCCCXCVI italico sermone scriptae*, in *Rerum Italicarum Scriptores*, ed. L. Muratori, vol. 23 (Milan, 1733), p. 775. The palace is discussed in full in Quinterio, *Giuliano da Maiano*, pp. 243–58, and so I have chosen to dwell only on certain façade features.

21 L. B. Alberti, *On the Art of Building in Ten Books*, ed. and trans. J. Rykwert, N. Leach and R. Tavernor (Cambridge, MA, 1991), p. 106 (Bk. IV.5); an obvious Florentine comparison would be the angled site of the Palazzo Boni-Antinori at the end of via Tornabuoni.

22 This, of course, was a common strategy, adopted for the Palazzo Ruccellai and the Palazzo Strozzi sides facing minor streets, to name but two examples.

23 Close similarities in Siena can be seen in the Duomo busts of popes, although these are on the interior of the building (see A. Lisini, *Il Duomo di Siena*, Siena, 1939, pp. 117, 148, and E. Carli, *Il Duomo di Siena*, Siena, 1979, p. 110). For a parallel on a banker's palace, see Filarete's illustration of the Banco Mediceo in his *Trattato* (illustration in L. Giordano, 'Milano e l'Italia nord-occidentale', in *Storia dell'architettura italiana: Il Quattrocento*, ed. F. P. Fiore, Milan, 1998, p. 179). See also D. Carl, 'Die Büsten im Kranzgesims des Palazzo Spannocchi', *Mitteilungen des Kunsthistorischen Instituts in Florenz*, 43 (1999), pp. 628–38.

24 On private piazzas, and particularly the example of the piazza Strozzi, see C. Elam, 'Piazze private nella Firenze del Rinascimento', *Ricerche Storiche*, 16 (1986), pp. 473–80. Renovations to piazza Salimbeni in the nineteenth century are discussed by Marini, 'Trasformazioni urbane', pp. 266–86; Morolli, *Giuseppe Partini*, pp. 154–6; for Ambrogio's death see Morandi, 'Gli Spannocchi', p. 108. That an open, private space was created is indicated in ASS, *Spoglio Balìa*, MS. C 18 fol. 47 (26 April 1480); subsequently walled in 1527, ASS, *Spannocchi* A1 bis, fol. 10, 23 and 24 (Guerrieri, 'Vicende architettoniche', p. 64).

25 I. Ammannati Piccolomini, *Epistolae et Commentarii Jacobi Piccolomini Cardinalis Papiensis* (Milan, 1506), fol. 301v (14 August 1475), misunderstood by Fabriczy, 'Giuliano da Maiano in Siena', as a letter from Gonzaga; Quinterio, *Giuliano da Maiano*, p. 255 n. 17, also misidentified the sender; see I. Ammannati Piccolomini, *Lettere (1444–79)*, ed. P. Cherubini (*Publicazioni degli Archivi di Stato. Fonti 25*), 3 vols. (Rome, 1997, 1989). As for the interior appointment of the palace, considerable speculation has surrounded various secular images produced by the so-called Master of the Griselda Legend for the palace; see most recently, L. Syson in *Siena e Roma. Raffaello, Caravaggio e i protagonisti di un legame antico*, exh. cat., ed. B. Santi and C. Strinati, Siena, S. Maria della Scala, Palazzo Squarcialupi, 25 November 2005–5 March 2006 (Siena, 2005), pp. 199–205.

26 ASS, *Concistoro* 2125, fol. 83 (15 May 1468); P. Pertici, *La città magnificata: interventi edilizi a Siena nel Rinascimento* (Siena, 1995), p. 108.

27 ASS, *Lira* 229, fol. 431 (1491).

28 For an unsubstantiated attribution to Francesco di Giorgio Martini, see P. Torriti, *Tutta Siena, contrada per contrada* (Florence, 1988), p. 300, tacitly confirmed by M. Quast, 'Il linguaggio di Francesco di Giorgio nell'ambito dell'architettura dei palazzi senesi', in *Francesco di Giorgio alla corte di Federico da Montefeltro: atti del convegno internazionale di studi*, ed. F. P. Fiore (Florence, 2004), II, pp. 401–31, esp. 427–8.

29 ASS, *Lira* 229, fol. 431 (1491) for Guglielmo and his shop; ASS, *Lira* 197, fol. 175 (1481) for his brother, who was less wealthy. Sixteenth-century records for the del Ciaia (almost certainly the same as del Taia), indicate substantial investment in the wool industry, cloth production, and sale of finished products; see ASS, *Particolari famiglie senesi*, vols. 47–52, particularly vols. 48 and 51.

30 For the Castellare dei Malavolti, see U. Morandi, 'Il castellare dei Malavolti', in *Quattro Monumenti Italiani (INA)*, ed. M. Salmi (Rome, 1969), pp. 15–37.

31 On medieval tower houses, and their reuse in Renaissance domestic architecture, see chapter Seven.

32 The church is discussed in H. Steinz-Kecks, 'Santa Caterina in Fontebranda: Storia della costruzione', in *L'oratorio di Santa Caterina di Fontebranda*, ed. Contrada dell'Oca (Siena, 1990), pp. 1–5; also *Die Kirchen von Siena*, ed. P. A. Riedl and M. Siedel (Munich, 1992), II, 1.2, pp. 57–304.

33 See most recently, Quast, 'Il linguaggio', pp. 413–20. Quast has also proposed the involvement of the Paltoni as patrons, for which see 'I palazzi del Cinquecento a Siena: il linguaggio delle facciate nel contesto storico-politico', in *Siena nel Rinascimento: l'ultimo secolo della repubblica*, Acts of the International Conference, Siena (28–30 September 2003 and 16–18 September 2004), ed. G. Mazzoni and F. Nevola (Florence, 2007); for an argument against this hypothesis, see my 'L'architettura tra Siena e Pienza: architettura civile', in *Pio II e le arti. La riscoperta dell'antico da Federighi a Michelangelo*, ed. A. Angelini (Cinisello Balsamo, Milan, 2005), pp. 207–10.

34 Numerous references to the S. Vigilio properties appear in the Piccolomini archives, but most useful to the present purpose is the transcription of the items from Francesco Piccolomini's will that divide his estate between his two brothers, Andrea and Iacomo; see ASS, *Consorteria Piccolomini* 17, fol. 96–117 (8 December 1505; notary, Ruffaldo di Paolo Ruffaldi da Sarteano). A less complete, later copy of the will was published by C. Richardson, 'The Lost Will and Testament of Cardinal Francesco Todeschini Piccolomini (1439–1503)', *Papers of the British School at Rome*, LXVI (1998), pp. 193–214. Francesco continued to use the palace throughout his life; see D. Bandini, 'Memorie Piccolominee in Sarteano', *BSSP*, 57 (1950), pp. 111, 115, 126; C. Ugurgeri della Berardenga, *Pio II Piccolomini, con notizie su Pio II e altri* (Florence, 1973), p. 514 (with no references).

35 On Roman brick-laying see P. N. Pagliara, 'Murature laterizie a Roma alla fine del Quattrocento', *Ricerche di storia dell'arte*, 48 (1992), pp. 43–54; F. P. Fiore, 'L'architettura civile di Francesco di Giorgio', in *Francesco di Giorgio, architetto*, ed. F. P. Fiore and M. Tafuri (Siena and Milan, 1993), p. 74.

36 The door-frame, as Quast and Fiore have noted, has close parallels in Naples, and especially in the Miaraballi portal of S. Lorenzo Maggiore; see Quast, 'Il linguaggio', pp. 413, 419 and F. P. Fiore, 'Siena e Urbino', in *Storia dell'architettura italiana: il Quattrocento*, ed. F. P. Fiore (Milan, 1998), p. 281. The links with Naples indicated by Quast do not however contribute to the problem of the building's patron or attribution, nor yet do they point to a connection with Francesco di Giorgio Martini (Quast, 'Il linguaggio', p. 416).

37 Fiore, 'L'architettura civile', p. 74 and n. 13, also Fiore, 'Siena e Urbino', p. 281. For other Federighi attributions, see most recently N. Adams and N. L. Nussdorfer, 'The Italian City, 1400–1600', in *The Renaissance from Brunelleschi to Michelangelo: The Representation of Architecture*, ed. H. Millon and V. Magnago Lampugnani (London, 1994), p. 213, who probably follow B. Mantura, 'Contributo ad Antonio Federighi', *Commentari*, 19 (1968), pp. 98–110.

38 Mantura, 'Contributo ad Antonio Federighi', pp. 98–110; J. T. Paoletti, 'A. Federighi: Documentary Re-evaluation', *Jahrbuch der Berliner Museum*, 88 (1975), docs. 32 and 145. See also E. Richter, *La scultura di Antonio Federighi* (Turin, 2002). One curious feature – the band of *pietra serena* halfway up the ground floor – most closely resembles the 'recinti' that Francesco di Giorgio later used on many of his buildings; see H. Burns, '"Restaurator de ruyne antiche": tradizione e studio dell'antico nelle attività di Francesco di Giorgio', in *Francesco di Giorgio, architetto*, ed. Fiore and Tafuri, pp. 155–7. On Federighi and the Piccolomini, see chapter Four.

39 A survey of materials can be found in the essays contained in M. Boldrini, ed., *Il colore della città* (Siena, 1993); on plaster façades, see M. Giamello, G. Guasparri, R. Neri and G. Sabatini, 'Building Materials in Siena Architecture: Type, Distribution and State of Conservation', *Science and Technology for Culture Heritage*, I (1992), pp. 55–65; brick is examined in G. Bianchi et al., *Fornaci e mattoni a Siena dal 13. secolo all'azienda Cialfi* (Sovicille, 1991).

40 Allegretti, *Ephemerides Senenses*, in *Rerum Italicarum Scriptores*, vol. 23, p. 774, 'pietre bozzate piane'; ASS, *Concistoro* 2125, fol. 124 (3 December 1473; Pertici, *La città magnificata*, pp. 129–30). The palace was attributed to Giuliano da Maiano in Fabriczy, 'Giuliano da Maiano in Siena'; see also Quinterio, *Giuliano da Maiano*, pp. 475–6.

41 That some anti-governmental political agenda lay behind these *all'antica* palaces of the 1460s and 1470s has been proposed by D. Balestracci, 'From Development to Crisis: Changing Urban Structures in Siena Between the Thirteenth and Fifteenth Centuries', in *The 'Other Tuscany': Essays in the History of Lucca, Pisa and Siena*, ed. T. W. Blomquist and M. F. Mazzaoui (Kalamazoo, 1994), p. 211.

42 ASS, *Concistoro* 2125, fol. 124 (3 December 1473; Pertici, *La città magnificata*, p. 129), 'fornire la sua chasa a la piazza Tolomei'; he was awarded the income from a *contado* mill.

43 The completion of the Piccolomini palace is discussed at the end of chapter Eight; for Iacomo Piccolomini, see ASS, *Lira* 192, fol. 202 (1481), 'Item mi trovo la metà per indiviso de la chasa dove habito posta in nel terzo di Città et popolo di San Desiderio in locho detto dei Mareschotti et decto Palazzo Mareschotti de la quale tengo la metà per indiviso con lo Rede di Caterino Marescotti et da esso Rede l'o comperata a fiorni 600; l'altra metà tengo a pigione'.

44 For an analysis of the Strada Romana considered in terms of visual strategies of this sort, see my '"Ornato della città"'. See also comments in F. Gabbrielli, 'Il palazzo delle Papesse', in *Il Palazzo delle Papesse a Siena,* Quaderni della Soprintendenza per il patrimonio storico, artistico ed etnoantropologico di Siena e Grosseto, no. 5 (2006), pp. 14–16.

45 Alberti, *On the Art of Building*, 106 (Bk. IV.5).

46 In this respect they also resemble the Pienza development, which, as Christine Smith has argued, was developed to 'unfold' to a viewer progressing into the town from the Porta Senese; see her *Architecture in the Culture of Early Humanism* (New York and Oxford, 1992), pp. 98–129.

47 Archivio Privato Bichi (Siena), *Galgano Bichi VII (Gabelle dei Contratti)*, 325 (n.a. 282, Reg. 41), fol. 554 (dated 6 October 1518) for acquisition from the Venturi. See also M. Quast, 'Il Palazzo Bichi Ruspoli, già Rossi in Via Banchi di Sopra: indagini per una storia della costruzione tra Duecento e Settecento', *BSSP*, CVI (1999), pp. 156–88.

48 Drawings in the BCS, MS. S.I.8, suggest seventeenth-century modifications; the palace is discussed further in chapter Eight. See also Quast, 'Il Palazzo Bichi Ruspoli', pp. 178–86.

49 J. Hook, *Siena: A City and its History* (London, 1979), p. 164; S. Hansen, *La Loggia della Mercanzia in Siena* (Siena, 1993), pp. 14–15, citing from ASS, *Consiglio Generale* 199, fol. 71v (28 December 1399), 'per cagione della strada maestra capita tutta la foresteria di qualunque parte che viene alla città di Siena'.

50 See M. Ascheri, *Renaissance Siena (1355–1559)* (Siena, 1993), pp. 10, 29.

51 Hansen, *La Loggia*, pp. 64–8, 77–83. See also D. Friedman, 'Monumental Urban Form in the Late Medieval Italian Communes: Loggias and the Mercanzie of Bologna and Siena', *Renaissance Studies*, 12 (1998), pp. 330–31 and 336–7.

52 Hansen, *La Loggia*, pp. 49–60. In this respect the loggia is quite different from Orsanmichele in Florence where each guild commissioned a statue of its patron.

53 On perception theories also, G. Johnson, 'Activating the Effigy: Donatello's Pecci tomb in Siena Cathedral', *Art Bulletin*, 77 (1995), pp. 445–59; to some extent dependant on J. Shearman, *Only Connect: Art and the Spectator in the Italian Renaissance* (Princeton, NJ, 1992).

54 It is likely that Siena's prostitutes and gamblers also thrived on the city's status as entrepôt, for which see comments in my '"Più honorati et suntuosi ala Republica": *Botteghe* and Luxury Retail along Siena's Strada Romana', in *Buyers and Sellers: Retail Circuits and Practices in Medieval and Early Modern Europe*, ed. B. Blondé, P. Stabel, J. Stobart and I. Van Damme (Turnhout, 2006), pp. 65–78.

55 Pertici, *La città magnificata*, p. 27, from S. Tizio, *Historiarum Senensium*, B. III. 8, fol. 184v; on Jubilee years, also M. Tuliani, *Osti, avventori e malandrini. Alberghi, locande e taverne a Siena e nel contado tra '300 e '400* (Siena, 1994), pp. 46–61, 77–83, 119–23, 157–66. G. Piccinni, 'La strada come affare. Sosta, identificazione e depositi di denaro di pellegrini (1382–1446)', in G. Piccinni and L. Travaini, *Il libro del Pellegrino (Siena: 1382–1446). Affari, uomini, monete nell'Ospedale di Santa Maria della Scala* (Naples, 2003), pp. 1–82.

56 D. Balestracci and G. Piccinni, *Siena nel Trecento. Assetto urbano e prassi edilizia* (Florence, 1977), Map 9 (for 1318–20 identifications); Tuliani, *Osti, avventori e malandrini*, pp. 34–41, 209–24; piazza degli Alberghi near the church of S. Maria delle Nevi recalls the presence of hostels there, while the Albergo Cannon d'Oro and Tre Donzelle appear to have retained their functions for around 600 years.

57 ASS, *Lira* 137, fol. 13 (1453), ASS, *Lira* 185, fol. 72 (1481). This is not the place for a survey of the inn-keeping business in Siena, although there is much archival evidence to make such a study possible.

58 ASS, *Lira* 147, fol. 131 (1453; this is a relative of Ambrogio Spannocchi, banker in Rome); ASS, *Lira* 197, fol. 178 (1481).

59 ASS, *Concistoro* 2125, fol. 23, and ASS, *Consiglio Generale* 230, fol. 68–9 (in Pertici, *La città magnificata*, pp. 79–80), 'ricordato che sarebbe ben fatto che le chase venghano dietro a San Cristoforo o ne la sua compagnia, comunemente abitate da meretrici e persone dixoneste [...] sono cagione che tale strada non s'uxa'. BCS *Balia Spoglio* A VII, 19–22 *ad annum* (19 September 1506), for a 1506 fund established to restore the public brothel, using income from a tax levied on builders. Additional discussion of prostitution can be found in my '"Più honorati et suntuosi ala Republica"'.

60 ASS, *Lira* 185, fol. 232 (1481); a similar complaint was made by Alfonso Petroni, ASS, *Lira* 192, fol. 107.

61 ASS, *Lira* 234, fol. 139 (Chimento di Vanni), 116 (Guglielmini: S. Filippo) and 320 (Mannucci: Pantaneto and Merse).

62 Silk and velvet production was supported with ASS, *Statuto di Siena* 40, fol. 72–4 (May 1451); for goldsmiths on the Strada see ASS, *Statuto di Siena* 40, fol. 83.

63 As with hotels (see note above), surviving archival evidence, especially in the *Lira*, would support a comprehensive study of rent values for the period 1453–1509, an issue that cannot be satisfactorily dealt with here.

64 ASS, *Lira* 185, fol. 323, lists two *botteghe* in Porrione (1200), one-third of two *botteghe* in Chiasso Setaioli (360), half of one *bottega* 'posta in Strada sotto chasa di Michelangelo di Nofrio' (360), a *bottega* Porta Salaria (800), a half of one *bottega* 'ai piei di Porta Salaria' (760), 'certe ragioni in due buttighe poste nell'arte della lana [. . .] chiuse da piu di sei anni' and 'una buttiga a piei di Porta Salaria, sotto chasa de figliuoli di Ristoro di Nofrio' (800).

65 ASS, *Lira* 234, fol. 270.

66 ASS, *Lira* 185, fol. 307; the shops were valued a considerable 5,040 *lire*.

67 ASS, *Lira* 193, fol. 76, and ASS, *Lira* 185, fol. 187 (both 1481).

68 ASS, *Lira* 185, fol. 255.

69 ASR, *Camerale I: Tesoreria Segreta (Entrata Uscita)* 1288 (1461–2), fol. 96 (31 March), 'ducati cinquecento trentasei dicamera dicomanadamento di sua S.ta a Misser Giovanni Saracini per comperare in Siena cierte buttighe per la chiesa di Pientia', and fol. 129v (6 November): 'ducati seicentoventi uno e grossi quattro dati di comandamento de Sua S.ta a Misser Giovanni Saracini, li quali sono per conprare due buttighe che danno fl. 20 di lire 4 l'uno l'ano e uno perpetuo che paga'. Further payments are in ASR, *Camerale I: Tesoreria Segreta (Entrata Uscita)* 1289 (1463–4), fol. 60 (17 January 1463).

70 ASS, *Consorteria Piccolomini* 17: Contratti di Andrea di Nanni Piccolomini (1464–1519), fol. 87 and ff. (28 January 1507).

71 *Ibid.*, 'in civitate Sene. pro miliori pretio fieri poterit, quo apotece sint a Platea Ptolomeorum venendo per Stratam usque ad Platea Piccolominorum, voluendo per ipsam plateam vesus Sanctu Martinum, et intrando per Porrionem, et veniendo verso Plateam et Campum fori, et per totum ipsium Campum, et ascendendo per Porta Salariam, et venendo per Stratam et iam que vadit versus Cruce Travagli [. . .]'.

72 An example will have to suffice: in 1481 Anselmo di Antonio Spannocchi, resident Porta all'Arco (ASS, *Lira* 188, fol. 27), recorded ownership of two *botteghe* on the Campo valued at 2,800 *lire*, while a shop under his home was only worth 240 *lire*.

73 It can probably be assumed these were in the same palace; see ASS, *Lira* 186, fol. 1 and ASS, *Lira* 195, fol. 124.

74 ASS, *Lira* 193, fol. 158 (Marco di Niccolò) and ASS, *Lira* 192, fol. 11 (Alessandro).

75 ASS, *Lira* 199 contains most Tolomei tax returns.

76 D. Friedman, 'Palaces and the Street in Late-Medieval and Renaissance Italy', in *Urban Landscapes, International Perspectives*, ed. J. W. R. Whitehand and P. J. Larkham (London, 1992), pp. 69–113, esp. 74–86; see also H. Saalman, 'The Transformation of the City in the Renaissance: Florence as Model', *Annali di Architettura*, 2 (1990), pp. 73–82.

77 It has been widely suggested that the Renaissance palace in Florence was shop-free, also on grounds of decorum. Paradigmatic statements to this effect can be found in B. Preyer, 'The "chasa overo palagio" of Alberto di Zanobi: A Florentine Palace of about 1400 and its Later Remodelling', *Art Bulletin*, 65 (1983), pp. 387–401; also R. Goldthwaite, 'The Economic Value of a Renaissance Palace: Investment, Production, Consumption', in his *Banks, Palaces and Entrepreneurs in Renaissance Florence* (Aldershot, 1995), p. 4; also D. Kent, *Cosimo de' Medici and the Florentine Renaissance: The Patron's Oeuvre* (New Haven and London, 2000), p. 234. It is certainly worth reconsidering this view, as I hope to show in forthcoming publi-

cations. See the comments of F. Franceschi, 'Business Activities', in *At Home in Renaissance Italy*, ed. M. Ajmar-Wollheim and F. Dennis (London, 2006), pp. 166–71, esp. 169.

78 F. Toker, 'Gothic Architecture by Remote Control: An Illustrated Building Contract of 1340', *Art Bulletin*, 69 (1985), pp. 67–95; see also C. Ghisalberti, 'Late Italian Gothic', in *The Renaissance from Brunelleschi to Michelangelo: The Representation of Architecture*, exh. cat., ed. H. Millon and V. Magnago Lampugnani (London, 1994), p. 429.

79 Tofo Sansedoni owned two apartments, one shop, two parts of shops, and one-third of a shop on the Campo side, and another shop (ASS, *Lira* 144, fol. 177); Guccia di Nanni Sansedoni had an apartment, and two-and-a-half shops (ASS, *Lira* 144, fol. 169); Antonio di Nanni Sansedoni had an apartment and an unspecified number of shops (ASS, *Lira* 144, fol. 278).

80 ASS, *Lira* 185, fol. 65.

81 BAV, *Chigi*, P. VII. 11, fol. 101–2; recently published as M. Quast, 'Il Palazzo Chigi al Casato', in *Alessandro VII Chigi (1599–1667): Il Papa Senese di Roma Moderna*, exh. cat., ed. A. Angelini, M. Butzek and B. Sani, Siena, 23 September 2000–10 January 2001 (Siena, 2000), pp. 435–9.

82 ASS, *Lira* 195, fol. 20; for identification of the palace, see Pertici, *La città magnificata*, p. 79 n. 1.

83 ASS, *Lira* 221, fol. 233 (1488), who in fact complained that they hoped for more income.

84 ASS, *Lira* 192, fol. 159 and 202 (1481).

85 ASS, *Lira* 192, fol. 159 (1481).

86 See, for examples that cover the spectrum of urban experience, L. Martines, *Strong Words: Writing and Social Strain in the Italian Renaissance* (Baltimore and London, 2001).

87 Bernardino da Siena, *Le prediche volgari sul Campo di Siena (1427)*, ed. C. Delcorno (Milan, 1989), I, p. 179 (Sermon IV, 15–17).

88 The economic aspects of Siena's vocation as a site of pilgrimage are considered in G. Piccinni and L. Travaini, *Il libro del Pellegrino (Siena: 1382–1446). Affari, uomini, monete nell'Ospedale di Santa Maria della Scala* (Naples, 2003).

89 The point is made well for Venice by P. Fortini Brown, 'Measured Friendship, Calculated Pomp: The Ceremonial Welcomes of the Venetian Republic', in *Triumphal Celebrations and the Rituals of Statecraft (Papers in Art History from the Pennsylvania State University, VI, Part 1)* (University Park, PA, 1990), pp. 136–87.

90 J. Rykwert, 'The Street: The Use of its History', in *On Streets*, ed. S. Anderson (Cambridge, MA, 1978), p. 15; also J. Rykwert, *The Necessity of Artifice* (London, 1982), p. 105. See also S. Kostof, *The City Assembled: The Elements of Urban Form Through History* (London, 1992), pp. 189–213.

91 See G. Fattorini, 'Pio II e la Vergine di Camollia', in *Pio II Piccolomini: Il papa del rinascimento a Siena*, ed. F. Nevola, Acts of the International Conference, Siena, 5–7 May 2005 (Siena, 2007); and G. Cecchini, 'La Cappella di San Sepolcro', *Terra di Siena* (1959), pp. 31–3.

92 Cecchini, 'La Cappella', suggested the chapel was built on land granted by the *Comune* in part reparation for an enormous written-off debt contracted through Miraballi's bank, and is supported by documents now published in Fattorini, 'Pio II e la Vergine'.

93 U. Morandi et al., eds., *Le Bicherne. Tavole dipinte delle magistrature senesi (secoli XIII–XVIII)* (Rome, 1984), pp. 198–9, also 228–9 (c. 1526).

94 N. Adams and S. Pepper, *Firearms and Fortification: Military Architecture and Siege Warfare in Sixteenth-century Siena* (Chicago, 1986), pp. 34–5.

95 Balestracci and Piccinni, *Siena nel Trecento*, Map 9 (for 1318–20 identifications); statute arrangements for the fourteenth century indicate that inns and 'hostels' were confined to main city streets for security reasons also; see Tuliani, *Osti, avventori e malandrini*, pp. 34–41, 209–24.

96 P. Turrini, *'Per honore et utile de la città di Siena'. Il comune e l'edilizia nel Quattrocento* (Siena, 1997), pp. 81–4.

97 *Ibid.*, and my ' "Ornato della città" '.

98 P. Torriti, *Tutta Siena, contrada per contrada* (Florence, 1988), p. 287; see the essays contained in *La chiesa di San Pietro alla Magione nel Terzo di Camollia a Siena*, ed. M. Ascheri (Siena, 2001).

99 H. W. van Os, 'From Rome to Siena. The Altarpiece for Santo Stefano alla Lizza', *Mededelingen van het Nederlands Instituut te Rome*, XLIII, n.s. 8 (1981), pp. 119–28, esp. 120–21; reprinted in H. W. van Os, *Studies in Early Tuscan Painting* (London, 1992), pp. 369–95, esp. 370–71; see also H. W. van Os, *Sienese Altarpieces, 1215–1460: Form, Content and Function*, II, *1344–1460* (Groningen, 1990), pp. 39–42; the altarpiece was updated with the addition of a predella by Giovanni di Paolo in 1450.

100 L. Marri Martini, *La Parrocchia di San Andrea Apostolo* (Siena, 1933), p. 6; Van Os, *Sienese Altarpieces*, pp. 159–61. The altar is no longer visible from the street as the street level has changed, although the painting is still *in situ*.

101 See chapter Two and my ' "Lieto e trionphante per la città": Experiencing a Mid-Fifteenth-century Imperial Triumph along Siena's Strada Romana', *Renaissance Studies*, 17 (2003), pp. 581–606.

102 A. K. Isaacs, *Spedale di Santa Maria della Scala: atti del convegno internazionale di studi, 20, 21, 22 novembre 1986* (Siena, 1988); G. Piccinni, 'L'Ospedale di Santa Maria della Scala di Siena. Note sulle origini dell'assistenza sanitaria in Toscana', in *Città e servizi sociali in Italia dei secoli XII–XV* (Bologna, 1990), pp. 297–324, and 'Linee di storia dell'Ospedale di Santa Maria della Scala e dell'area circostante', in *Santa Maria della Scala: da ospedale a museo* (Siena, 1995), pp. 11–22; D. Gallavotti Cavallero, ed., *Lo Spedale di Santa Maria della Scala. Vicende di una committenza artistica* (Pisa, 1985); E. Boldrini and R. Parenti, eds., *Santa Maria della Scala: archeologia e edilizia sulla piazza dello Spedale* (Florence, 1991).

103 Bernardino da Siena, *Le prediche volgari*, II, p. 1206 (Sermon XLI, 20–21).

104 A. Reumont, 'Viaggio in Italia nel MCDXCVII del cavaliere Arnaldo di Harff di Colonia sul Reno', *Archivio Veneto*, 11 (1876), pp. 124–46.

105 A survey of travellers' accounts can be found in A. Brilli, *Viaggiatori stranieri in terra di Siena* (Rome and Siena, 1984).

106 A. Milani, 'L'attività costruttiva del Quattrocento dalle fonti archivistiche', in Boldrini and Parenti, *Santa Maria della Scala*.

107 *Ibid.*, pp. 117–18, 132, for 'bella, honorevole e magnifica'; a critical opinion of attribution of the hospital church of SS. Annunziata to Francesco di Giorgio Martini is expressed in M. Tafuri, 'Le chiese di Francesco di Giorgio', p. 25.

108 *Ibid.*, pp. 132–4.

109 On financial difficulties in *contado* holdings see A. K. Isaacs, 'Lo Spedale della Scala nell'antico Stato senese', in *Spedale di Santa Maria della Scala*, pp. 19–29. For the medical history of the hospital in the fifteenth century, see A. Whitley, 'Concepts of Ill Health and Pestilence in Fifteenth-century Siena', PhD thesis, Warburg Institute, University of London, 2004. See also, for a broader coverage of hospitals in the period, J. Henderson, *The Renaissance Hospital* (New Haven and London, 2006), with some discussion of the Siena institution.

110 H. W. van Os, *Vecchietta and the Sacristy of the Siena Hospital Church: A Study in Renaissance Religious Symbolism* (The Hague, 1974), p. 8.

111 P. Torriti, 'Gli affreschi del Pellegrinaio', in *Il Santa Maria della Scala: l'Ospedale dai mille anni*, ed. P. Torriti (Genoa, 1991), pp. 71–5; Gallavotti Cavallero, *Lo Spedale di Santa Maria della Scala*, pp. 137–264. C. B. Strehlke, 'Domenico di Bartolo', PhD thesis, Columbia University, 1986. See also E. Costa and L. Ponticelli, 'L'iconografia del Pellegrinaio nello Spedale di Santa Maria della Scala di Siena', *Iconographica*, III (2004), pp. 110–47.

112 Van Os, *Vecchietta and the Sacristy*.

113 E. Welch, *Art and Authority in Renaissance Milan* (New Haven and London, 1995), pp. 149–50; see also F. Leverotti, 'L'ospedale di S. Maria della Scala in una relazione del 1456', *BSSP*, 91 (1984), pp. 276–92.

114 ASS, *Consiglio Generale* 235, fol. 158 (4 February 1474); Milanesi, *Documenti*, II, p. 353; A. Bruno and G. Pin, 'Il Palazzo di San Galgano in Siena', *BSSP*, 88 (1982), pp. 54–70. Discussions with Ludwin Paardekooper, who has studied the altarpiece for S. Maria Maddalena, have been enormously helpful in developing what follows; see L. Paardekooper, 'Het "San Galgano-polyptiek" van Giovanni di Paolo', in *Polyptiek. Een veelluik van Groninger bijdragen aan de kunstgeschiedenis*, ed. H. Th. van Veen, V. M. Schmidt and J. M. Keizer (Zwolle, 2002), pp. 109–18, nn. 230–32.

115 ASS, *Consiglio Generale* 235, fol. 158 (4 February 1474); Milanesi, *Documenti*, II, p. 353; 'e perchè in esso luogo le strada e le mura de le case da esso lato non vanno a diritura, ma vanno ad arco e torte; volendo pigliare la faccia diritta come è giusto e raggionevole [. . .]'.

116 ASS, *Consiglio Generale* 236, fol. 192v (18 December 1475), 'havendo veduto quello bello palazzo che fa lo abate di San Galgano presso ala Madalena nella città nostra; hanno consyderato che potendo adactare che i vicini che vi hanno ballatoio li levassero e pareggiassero le facciate come è facto il disegno, farebbe grande bellezza della vostra città in quella strada Romana'; the drawing mentioned is lost.

117 *Ibid.*, 'fare la faccia bella al pari di quella dell'Abbate honorevole come sono le case d'incontra pure dell'abbate'. 150 fl. were assigned to Guerrino di Iacomo for work.

118 A. Canestrelli, *L'abbazia di San Galgano* (Florence, 1896; repr. Pistoia, 1989).

119 Canestrelli, *L'abbazia*, pp. 19–25; A. Ghidoli, 'Ragionando di camarlenghi e altri *boni homines*', in *Le Biccherne di Siena. Arte e Finanza all'alba dell'economia moderna*, ed. A. Tomei (Azzano S. Paolo, Bergamo, and Rome, 2002), pp. 55–69.

120 A possible local and recent precedent for a palace as abbatial lodgings could be Francesco Todeschini Piccolomini's palace near S. Vigilio, of which he was Abbot from 1460; see above.

121 The palace design is described in ASS, *Consiglio Generale* 235, fol. 158 (4 February 1474; Milanesi, *Documenti*, II, p. 353; A. Bruno and G. Pin, 'Il Palazzo di San Galgano'); materials subsidized by *Comune*, see ASS, *Concistoro* 2125, fol. 129 (31 May 1474; Banchi and Borghesi, *Nuovi documenti*, pp. 245–6).

122 ASS, *Concistoro* 2125, fol. 129 (31 May 1474; Banchi and Borghesi, *Nuovi documenti*, pp. 245–6).

123 Fabriczy, 'Giuliano da Maiano in Siena', pp. 1–14; Quinterio, *Giuliano da Maiano*, pp. 473–8.

124 The Ospedale degli Innocenti in Florence also uses a descriptive symbol (a baby in swaddling clothes) to illustrate the function of the building; for these maiolica decorations, see, for example, F. Gurrieri and A. Amendola, *Il Fregio robbiano dell'Ospedale del Ceppo a Pistoia* (Pontedera, 1982).

125 A. Liberati, 'Chiese, monasteri, oratori e spedali senesi', *BSSP*, 56 (1949), pp. 146–52.

126 ASS, *Concistoro* 2125, fol. 129 (31 May 1474; Banchi and Borghesi, *Nuovi documenti*, pp. 245–6).

127 *Ibid.*

128 Canestrelli, *L'abbazia*, p. 22.

129 ASS, *Concistoro* 2125, fol. 139 (13 April 1477; Pertici, *La città magnificata*, p. 136).

130 A. M. Carapelli, 'Notizie delle chiese e cose raggaurdevoli di Siena [. . .] delle pubbliche feste fatte nella Piazza, e dell'Entrate solenni d'alcuni personaggi [. . .]', BCS B. VII. 10, fol. 115. Canestrelli, *L'abbazia*, p. 22, states that the head was frequently brought to Siena, and usually taken back to S. Galgano. Other processions are reported in ASS, MS. C 11, *Spoglio del Concistoro, ad annum*, 20 and 23 July 1439 (18v, 20). See, most recently, F. Geens, 'Galganus and the Cistercians: Relics, Reliquaries, and the Image of a Saint', in *Images, Relics, and Devotional Practices in Medieval and Renaissance Italy*, ed. S. J. Cornelison and S. B. Montgomery (Tempe, AZ, 2005), pp. 55–76, as well as E. Cioni, *Il reliquiario di San Galgano: contributo alla storia dell'oreficeria e iconografia* (Florence, 2005).

131 ASS, *Concistoro* 2125, fol. 139 (13 April 1477; Pertici, *La città magnificata*, p. 136), 'uno bello tabernacolo per quella sacra reliquia [. . .] uno luogo forte in decta chiesa con uscio ferrato'.

132 A. Angelini, 'Le lupe di Porta Romana e Giovanni di Stefano', *Prospettiva*, 65 (1992), p. 54; see also A. Angelini, 'Il lungo percorso della decorazione all'antica tra Siena e Urbino', in *Pio II e le arti. La riscoperta dell'antico da Federighi a Michelangelo*, ed. A. Angelini (Cinisello Balsamo, Milan, 2005), pp. 321–3.

133 ASS, *Concistoro* 2125, fol. 139 (13 April 1477; Pertici, *La città magnificata*, p. 136); Canestrelli, *L'abbazia*, p. 23, cites ASS, *Concistoro* 238, fol. 135.

134 As proposed by Paardekooper, 'Het "San Galgano-polyptiek" van Giovanni di Paolo', these are now in the Pinacoteca Nazionale di Siena, nos. 198, 199, 201.

135 Van Os, 'From Rome to Siena', pp. 370–71, has suggested that S. Stefano alla Lizza may originally have been oriented to face the Strada, while the church of S. Andrea is also set back from the building line of the Strada.

136 Milanesi, *Documenti*, II, pp. 341–3 (31 May 1470).

137 *Ibid.* Initial plans had been to build an 'utilissimo et bello' fountain there because 'passano ei' forestieri', surmounted with a painting of the Virgin Mary (see, ASS, *Concistoro* 2125, fol. 47; also in Banchi and Borghesi, *Nuovi documenti*, pp. 222–4, 25 February 1466).

138 On the derelict conditions of the site see ASS, *Concistoro* 2125, fol. 47 (25 February 1466; Banchi and Borghesi, *Nuovi documenti*, pp. 222–4; Pertici, *La città magnificata*, p. 93); the Roman arch is described by Benvoglienti, *De urbis Senae*, fol. ciiiii.

139 *Ibid.*

140 Benvoglienti, *De urbis Senae*, fol. civi; he also reports (ciiii) that the Roman arch was demolished in the 1480s, 'dietca fuit facto permissione damnabili'. On Benvoglienti's *De urbis Senae*, see chapter Seven.

141 ASS, *Concistoro* 2125, fol. 16, 39 (8 May 1463, 18 December 1465; Pertici, *La città magnificata*, pp. 76, 89).

142 Construction of the church is thoroughly discussed in M. Mussolin, 'Il convento di Santo Spirito di Siena e i regolari osservanti di San Domenico', *BSSP*, 104 (1997), pp. 7–193.

143 ASS, *Balìa* 45, fol. 43 (21 June 1499); ASS, *Balìa*, 253, fol. 115 (23 April 1501). The gate probably formed part of the twelfth-century fortification of the Samoreci precinct; see the drawing in Biblioteca Apostolica Vaticana, *Archivio Chigi*, 25039.

144 Tafuri, 'Le chiese di Francesco di Giorgio', p. 72 n. 117. The church has also been compared, less convincingly I think, to Orsanmichele in Florence; see C. Cardamone, 'Santa Maria in Portico a Fontegiusta, Siena', in *La chiesa a pianta centrale: tempio civico del Rinascimento*, ed. B. Adorni (Milan, 2002), pp. 97–105, esp. 104.

145 ASS, *Patrimonio Resti Ecclesiastici*, 3525, 'Spoglio Pizzetti', fol. 345–405; A. Marelli, *Santa Maria in Portico a Fontegiusta* (Siena, 1908), pp. 5, 44–5. For a general discussion of Marian devotional images in relation to architecture, see P. Davies, 'Studies in the Quattrocento Centrally Planned Church', PhD thesis, Courtauld Institute of Art, University of London, 1992, pp. 85–133; B. Adorni, ed., *La chiesa a pianta centrale: tempio civico del Rinascimento* (Milan, 2002).

146 ASS, *Patrimonio Resti Ecclesiastici, Diplomatico (compagnie)*, 1353 (3 June 1479), 'in veduta di molti miracoli che Iddio fa per detta immagine'; Marelli, *Santa Maria in Portico*, pp. 6–7, 45–6.

147 Cited from Marelli, *Santa Maria in Portico*, p. 46; the significance of the victory is also recorded in a battle-scene fresco in the Palazzo Pubblico; see G. Borghini, 'La decorazione', in *Il Palazzo Pubblico di Siena*, ed. Brandi, p. 265, and D. L. Kawsky, 'The Survival, Revival and Reappraisal of Artistic Tradition: Civic Art and Civic Identity in Quattrocento Siena', PhD thesis, Princeton University, 1995, p. 203. A recent article addresses the church, without significant additions to what is discussed here: see Cardamone, 'Santa Maria in Portico di Fontegiusta'.

148 ASV, *Chigi*, G. I. 8, fol. 13v–14r, 'Il giorno seguente nella solennità della Natività della Vergine Maria, i Signori con tutto il Clericato e con tutti gli ordini della Città in devotissima processione si condussero con una honorevole offerta alla Madonna della Devotione ad una solenne Messa e quivi lasciarono appese molte spoglie dei nemici, acquistate nella vittoria il giorno precedente, che fù la vigilia di tanta solennità. Questo luogo è in Kamollia accanto alle pubbliche mura nel quale, pochi anni prima, una immagine di detta donna haveva per autorità di Dio cominciato a fare molti miracoli, a pro dei credenti: onde Papa Sisto l'haveva arricchito di gran doni spirituali e domandasi la Madonna di Fontegiusta, ornata di uno nobile tempio dalla pietà dei Sanesi. A memoria dunque di quella felicità fu fatto il voto che fino questi giorni s'adempisce, che i maestrati con la offerta, in tal giorno vadino a visitarlo'.

149 ASS, *Patrimonio Resti Ecclesiastici*, 3525, fol. 345–405, vi and viii; ASS, *Patrimonio Resti, Diplomatico (compagnie): Compagnia di Santa Maria in Portico di Fontegiusta* (18 March 1482 [1359]).

150 ASS, *Patrimonio Resti Ecclesiastici, Diplomatico (compagnie)*, 1353 (3 June 1479); Marelli, *Santa Maria in Portico*, pp. 6–7, 45–6.

151 'OPUS FECIT MAGISTER FRANCISCUS CRISTOPHORI DE FIDELIBUS DE COMO MCCCCLXXXII'.

152 ASS, *Patrimonio Resti, Diplomatico (compagnie): Compagnia di Santa Maria in Portico di Fontegiusta* (18 March 1482 [1359]): 'devotionis magna ad ecclesia sive cappellam inpari confluant ac ad complementum dicti operis et decore ipsius ecclesie sive cappelle augmentum'.

153 Milanesi, *Documenti*, II, p. 407.

154 *Ibid.*

155 *Ibid.*

156 Marelli, *Santa Maria in Portico*, pp. 11–13.

157 *Ibid.*, pp. 51–3; see also Tafuri, 'Le chiese di Francesco di Giorgio', p. 72 n. 117; contract in Milanesi, *Documenti*, II, p. 406.

158 ASS, *Patrimonio Resti, Diplomatico (compagnie): Compagnia di Santa Maria in Portico di Fontegiusta*, 1367 (26 June 1488), 'si hedificherà in grandissimo honore alla città vostra'.

159 Days mentioned include the Nativity of the Virgin, the saints' days of Fabiano, Sebastiano and Rocco, the day of the church's Dedication on the third Sunday of January, the third Sunday of Lent, and Holy Thursday (see ASS, *Patrimonio Resti, Diplomatico (compagnie): Compagnia di Santa Maria in Portico di Fontegiusta* (18 March 1482 [1359]); also ASS, *Patrimonio Resti Ecclesiastici* 3525, fol. 345–405, VI, VIII, XIII).

160 M. Israëls, 'Sassetta's Arte della Lana Altarpiece and the Cult of Corpus Domini in Siena', *Burlington Magazine*, CXLIII (2001), pp. 532–43; also my 'Cerimoniali per santi e feste a Siena a metà Quattrocento. Documenti dallo *Statuto di Siena*, 39', in *Siena ed il suo territorio nel Rinascimento*, III, ed. M. Ascheri (Siena, 2001), pp. 171–84. The recent addition to the study of urban ritual in Siena, *Beyond the Palio: Urban Ritual in Renaissance Siena*, ed. P. Jackson and F. Nevola (Oxford, 2006), includes a more detailed study by M. Israëls of the Corpus Domini in Siena.

161 Civic symbols around the city gates are discussed in chapters One and Two; see also M. Israëls, 'Al cospetto della città. Il Sodoma a Porta Pispini, culmine di una tradizione civica', in *Siena nel Rinascimento: l'ultimo secolo della repubblica*, Acts of the International Conference, Siena (28–30 September 2003 and 16–18 September 2004), ed. G. Mazzoni and F. Nevola (Florence, 2007). On the use of arms in Milan, see E. Welch, *Art and Authority in Renaissance Milan* (New Haven and London, 1995), pp. 31–46.

162 On Marian shrines and churches, see below and A. Leoncini, *I tabernacoli di Siena* (Siena, 1994).

163 'Che per la città in più luoghi sono fatte e si fanno', Porta Romana contract, cited from Milanesi, *Documenti*, III, pp. 289–90; also ASS, *Consiglio Generale* 231, fol. 305v (14 May 1467); on the city's foundation legend, see the opening section of chapter Seven. See also M. Caciorgna and R. Guerrini, 'Imago Urbis. La lupa e l'immagine di Roma nell'arte e nella cultura senese come identità storica e morale', in *Siena e Roma. Raffaello, Caravaggio e i protagonisti di un legame antico*, exh. cat., ed. B. Santi and C. Strinati, S. Maria della Scala and Palazzo Squarcialupi, Siena, 25 November 2005–5 March 2006 (Siena, 2005), pp. 99–118.

164 Cristofani, *Siena: le origini*, pp. 93–7, 117–19; Rubinstein, 'Political Ideas in Sienese Art', p. 202. See also P. Jacks, *The Antiquarian and the Myth of Antiquity: The Origins of Rome in Renaissance Thought* (Cambridge, 1993), pp. 86–9 and 121–3.

165 On early use of the lupa, which appears also in Lorenzetti's *Buon Governo* and on some coins, see B. Paolozzi Strozzi, 'Alcune riflessioni sull'iconografia monetale senese', in *Le monete della Repubblica Senese*, ed. B. Paolozzi Strozzi (Milan, 1992), pp. 73–170; also A. Angelini, 'Le lupe di Porta Romana e Giovanni di Stefano', *Prospettiva*, 65 (1992), p. 50. Kawsky, 'The Survival, Revival', does not discuss the use of the wolf in Sienese art.

166 A. Lusini, 'I Turrini e l'oreficeria pura', *La Diana* (1929), pp. 62–70; P. Bacci, 'La colonna del Campo, proveniente da avanzi romani presso Orbetello (1428)', *Rassegna dell'arte senese*, n.s. I (1927), p. 227; S. Colucci in *Siena e Roma*, ed. B. Santi and C. Strinati, pp. 136–7.

167 Milanesi, *Documenti*, III, pp. 289–90; ASS *Consiglio Generale* 231, fol. 305v (14 May 1467); ASS *Concistoro* 2125, fol. 93 (1 June 1468; Pertici, *La città magnificata*, p. 112).

168 'Facta una colonna con una lupa dorata che sperano porla in essa fonte [. . .] bello et utile', ASS *Consiglio Generale*, 232, fol. 8 and ASS *Concistoro* 2125, fol. 73 (14 July 1467; also in Pertici, *La città magnificata*, p. 103).

169 Torriti, *Tutta Siena*, p. 88. The dating of these two sculptures is disputed, although they were certainly in place in the fifteenth century; see Colucci in *Siena e Roma*, ed. B. Santi and C. Strinati, p. 141.

170 Benvoglienti, *De urbis Senae*, fol. biv3; ASS *Concistoro* 2125, fol. 70 (5 April 1467; Pertici, *La città magnificata*, p. 102). G. A. Pecci, 'Raccolta Universale di tutte le iscrizioni, arme e altri monumenti si antichi, come moderni, esistenti nella citta di Siena. Fino a questo presente anno 1731', ASS, MS. D. 6, fol. 4v, says of the Tolomei lupa that 'fu opera moderna di Domenico scultore Sanese' (i.e., seventeenth century, although it was almost certainly a replacement or restoration of an earlier example, probably of the fifteenth century). See also Colucci in *Siena e Roma*, ed. B. Santi and C. Strinati, pp. 126–7, who dates a she-wolf now in the Museo della Contrada della Civetta from 1620 and suggests that this replaced a fifteenth-century sculpture.

171 'Sedilia lapidea cum erecta columna', S. Tizio, *Historiarum Senensium*, Biblioteca Comunale di Siena, MS B.III.11, fol. 197. The original sculpture – attributed to Neroccio di Bartolomeo de' Landi – was removed in 1996 for conservation reasons and is now in the Museo Civico at the Palazzo Pubblico; see Colucci in *Siena e Roma*, ed. B. Santi and C. Strinati, p. 134.

172 A similar function was assigned to obelisks erected in late sixteenth-century Rome; see C. Burroughs, 'Absolutism and the Rhetoric of Topography: Streets in the Rome of Sixtus V', in *Streets: Critical Perspectives on Public Space*, ed. Z. Çelik, D. Favro and R. Ingersoll (Berkeley, 1994), pp. 189–202.

173 Growing scholarly attention has turned to the definition of alternative routes for the transmission of 'Renaissance' modes of cultural expression to the traditional Florence-centric model. See, for example, the discussion in T. Henry and C. Plazzotta, 'Raphael: From Urbino to Rome', in *Raphael: From Urbino to Rome*, ed. H. Chapman, T. Henry and C. Plazzotta (New Haven and London, 2004), pp. 15–65; also T. Henry, 'Raphael in Siena', *Apollo*, 140 (2004), pp. 50–56.

174 Most recently Quast, 'Il linguaggio', pp. 406–9, in a section entitled 'I palazzi di derivazione fiorentina'. This follows, and cites, previous suggestions in the same vein by A. L. Jenkens, 'Caterina Piccolomini and the Palazzo delle Pa-

pesse in Siena', in *Beyond Isabella: Secular Women Patrons of Art in Renaissance Italy*, ed. S. Reiss and D. Wilkins (Kirksville, MO, 2001), pp. 77–91; also Fiore, 'Siena e Urbino', pp. 280–81.

175 The issue of the transfer of ideas from one centre to another is addressed in a seminal essay by E. Castelnuovo and C. Ginzburg, 'Centro e periferia', in *Storia dell'arte italiana. Questioni e metodi*, ed. G. Previtali, I.1: *Materiali e problemi: Questioni e metodi* (Turin, 1979), pp. 283–352. The degree to which such transfers could be subtly mediated is a theme of the collection *Artistic Exchange and Cultural Translation in the Italian Renaissance City*, ed. S. J. Campbell and S. J. Milner (Cambridge, 2004). See also my 'L'architettura tra Siena e Pienza'.

176 From a rich bibliography, see C. L. Frommel, 'Roma', in *Storia dell'architettura italiana: il Quattrocento*, ed. F. P. Fiore (Milan, 1998), pp. 377–82; C. W. Westfall, *In This Most Perfect Paradise: Alberti, Nicholas V and the Invention of Conscious Urban Planning in Rome, 1447–55* (University Park, PA, and London, 1974); C. Burroughs, *From Signs to Design: Environmental Process and Reform in Early Renaissance Rome* (Cambridge, MA, 1990). For a similar 'Roman' web of interests proposed for the palace of Tommaso Spinelli in Florence by H. Saalman, 'Tommaso Spinelli, Michelozzo, Manetti and Rossellino', *Journal of the Society of Architectural Historians*, 25 (1966), pp. 151–64; and more recently W. Caferro and P. Jacks, *The Spinelli of Florence: Fortunes of a Renaissance Merchant Family* (University Park, PA, 2001), pp. 91–143, for the palace in Florence.

177 F. Quinterio, 'Verso Napoli: come Giuliano e Benedetto da Maiano divennero artisti nella corte aragonese', *Napoli Nobilissima*, 28 (1989), pp. 204–10, names Antonio Piccolomini, Duke of Amalfi, Alfonso, Duke of Calabria and the Strozzi family as other players in this network. That Naples was the probable location of contact between client and architect is further supported by documents regarding the patronage of the church of S. Anna dei Lombardi in Naples, where Spannocchi mediated financial transactions with both the Rossellino and da Maiano workshops; see D. Carl, 'New Documents for Antonio Rossellino's Altar in the Church of S. Anna dei Lombardi, Naples', *Burlington Magazine*, 138 (1996), pp. 318–20.

178 For the variety of Giuliano's palace style, see the essays in D. Lambertini, M. Lotti and R. Lunardi, eds., *Giuliano e la bottega dei Maiano (Atti del Convegno Internazionale di Studi, Fiesole, 13–5 giugno 1991)* (Florence, 1994); on the growing taste for magnificence in palace patronage, see M. Hollingsworth, *Patronage in Renaissance Italy* (London, 1994).

179 All such features are now considered in the comprehensive and incisive study by G. Clarke, *Roman House – Renaissance Palaces: Inventing Antiquity in Fifteenth-century Italy* (Cambridge, 2003).

180 C. L. Frommel, 'Living *all'antica*: Palaces and Villas from Brunelleschi to Palladio', in *The Renaissance from Brunelleschi to Michelangelo: The Representation of Architecture*, ed. H. Millon and V. Magnago Lampugnani (London, 1994), pp. 183–9, and Clarke, *Roman House – Renaissance Palaces*.

181 A growing bibliography follows the initial essay by A. D. Fraser Jenkins, 'Cosimo de' Medici's Patronage of Architecture and the Concept of Magnificence', *Journal of the Warburg and Courtauld Institutes*, 33 (1970), pp. 162–70; M. Hollingsworth, *Patronage in Renaissance Italy* (London, 1994). See also G. Clarke, 'Magnificence and the City: Giovanni

11 Bentivoglio and Architecture in Fifteenth-century Bologna', *Renaissance Studies*, 13 (1999), pp. 397–411.

182 Quast, 'Il linguaggio', pp. 415–16, rightly also includes the now lost Villa 'Il Pavone', illustrated by Ettore Romagnoli before its demolition in 1825, and an obvious affinity in design is to be found with the oratories of S. Maria delle Nevi and S. Caterina in Fontebranda. Another important example is that of the chapel of S. Ansano, discussed in the next chapter.

183 Burns, '"Restaurator de ruyne antiche"', p. 151.

184 *Ibid.*, pp. 155–7.

185 See the discussion in essays and catalogue entries to *Renaissance Siena: Art for a City*, exh. cat., eds. L. Syson, A. Angelini, P. Jackson and F. Nevola, National Gallery, London, October 2007 – January 2008 (London, 2007); also D. Norman, *Painting in Late Medieval and Renaissance Siena, 1260–1555* (New Haven and London, 2003), pp. 221–32.

186 See T. Kennedy, 'Religious Architecture in Renaissance Siena: The Building of Santa Maria degli Angeli in Valli', in *Siena nel Rinascimento: l'ultimo secolo della repubblica*, Acts of the International Conference, ed. G. Mazzoni and F. Nevola (Florence, 2007).

187 The central importance of the church of the Osservanza has long been recognized as key to a proper understanding for the attribution and chronology of churches built in Siena in the last quarter of the fifteenth century; see Tafuri, 'Le chiese di Francesco di Giorgio', pp. 25–6 and n. 117; also Mussolin, 'Il convento di Santo Spirito', pp. 173–91.

188 Tafuri, 'Le chiese do Francesco di Giorgio', illustrates the chapel at Montesiepi; Burns, '"Restaurator de ruyne antiche"', pp. 151–7.

189 I owe much of my understanding of the 'urban process' to conversations with Richard Ingersoll; see also the essays contained in *Streets: Critical Perspectives on Public Space*, ed. Çelik, Favro and Ingersoll; for 'planning by accretion' see A. Ceen, *The 'Quartiere dei Banchi': Urban Planning in Early Cinquecento Rome* (New York, 1986), p. 7 (from Ceen's PhD thesis, University of Pennsylvania 1977).

CHAPTER SEVEN

1 Bartolomeo Benvoglienti, *De urbis Senae origine et incremento* (Siena, 1506), ci: 'Haec est Sena vetera: haec est civitas Virginis'.

2 The Tisbo Colonnese myth is printed in Italian translation as, *Le origini favolose di Siena, secondo una presunta cronica*, ed. L. Banchi, (Siena, 1882). A series of manuscripts survive, see BAV, Chigi, G I 9, fol. 126–33, 'Patritii Patritii de Urbis Senarum origine opusculum', containing 'Ex Tisbi Columnensis R. Cronicis per eundem Patricium transumptis'; also in two seventeenth-century manuscripts in Siena (Biblioteca Comunale di Siena B. III. 5 and ASS, MS. D. 166) 'Senensis Historia manuscripta ab Origine civitatis ad annum MCCCCLXXII'.

3 The authorship remains disputed. Luciano Banchi in Colonnese, *Le origini favolose di Siena*, claimed the author was Agostino Patrizi; A. Lisini and F. Iacometti, eds., *Cronache Senesi*, in *Rerum Italicarum Scriptores*, vol. 15, part 6 (Bologna, 1931–9), pp. x–xii and xxvii, attributed the text to Francesco Patrizi; BAV, Chigi, G I 9, fol. 126–33, on the other hand, indicates the fourteenth-century Patrizio Patrizi as the author.

4 Piccolomini's circle is discussed further below.

5 Lisini and Iacometti, *Cronache Senesi*, pp. xi–xii.

6 For example, BCS, MS, A VI 3, fol. 25–79, 'Patritii senensis ex nobili patritiorum familia, de Origine Urbis Sene, tractatus incipit', and BAV, Chigi, G I 9, fol. 126–33, 'Patritii Patritii de Urbis Senarum origine opusculum', both of which contain 'Ex Tisbi Columnensis R. Cronicis per eundem Patricium transumptis'. The authorship question is addressed in n. 3, above; overlap with Patrizi's Sienese antiquarian research is discussed in chapter Four.

7 P. Jacks, *The Antiquarian and the Myth of Antiquity: The Origins of Rome in Renaissance Thought* (Cambridge, 1993); R. Weiss, *The Renaissance Discovery of Classical Antiquity* (1969; Oxford, 1988), pp. 59–89, 116–30.

8 On the Taddeo di Bartolo cycle, the classic text remains N. Rubinstein, 'Political Ideas in Sienese Art: the Frescoes by Ambrogio Lorenzetti and Taddeo di Bartolo in the Palazzo Pubblico', *Journal of the Warburg and Courtauld Institutes*, 21 (1958), pp. 189–207. Most recently, the cycle has been re-examined by R. Guerrini, '*Dulci pro libertate*. Taddeo di Bartolo: il ciclo di eroi antichi nel Palazzo Pubblico di Siena (1413–1414). Tradizione classica ed iconografia politica', *Rivista Storica Italiana*, 112 (2000), pp. 510–68.

9 Inscriptions are now helpfully transcribed and annotated in R. Funari, *Un ciclo di tradizione repubblicana nel Palazzo Pubblico di Siena. Le iscrizioni degli affreschi di Taddeo di Bartolo (1413–1414)* (Siena, 2002), p. 45: 'nostro de nomine dicta est / Camilla, tue pars urbis terna Senensis'. It is thought that the programme was devised by local humanists Pietro Pecci and Ser Cristoforo di Andrea.

10 Discussed in chapter Six and in my 'Revival or Renewal: Defining Civic Identity in Fifteenth-century Siena', in *Shaping Urban Identity in the Middle Ages*, ed. P. Stabel and M. Boone (Leuven and Apeldoorn, 1999), pp. 111–34; see also M. Caciorgna and R. Guerrini, '*Imago Urbis*. La lupa e l'immagine di Roma nell'arte e nella cultura senese come identità storica e morale', in *Siena e Roma. Raffaello, Caravaggio e i protagonisti di un legame antico*, ed. B. Santi and C. Strinati, exh. cat., S. Maria della Scala. Palazzo Squarcialupi, Siena, 25 November 2005–5 March 2006 (Siena, 2005), pp. 99–118.

11 Biondo Flavio da Forlì, *Italia Illustrata* (Rome: Iohannis Philippi de Lignamine, 1474), fol. 37.

12 M. Martelli, 'Il Rinascimento. L'ambiente e l'influenza di Sigismondo Tizio', in *Siena: le origini. Testimonianze e miti archeologici*, ed. M. Cristofani, exh. cat. (Florence, 1979), p. 122.

13 Bartolomeo Benvoglienti, *De urbis Senae origine et incremento* (Siena, 1506), but written 1484–6; Francesco Patrizi, 'De origine et antiquitate urbis Senae', and Agostino Patrizi, 'De senarum urbis antiquitate', survive in seventeenth-century copies of *Senensis Historia manuscripta ab Origine civitatis ad annum MCCCCLXXII*, in Siena (Biblioteca Comunale di Siena B. III. 5 and B. III. 3; also ASS MS. D. 166) and in the Vatican (BAV, Chigi, G I 9). M. Martelli, 'Il Rinascimento', p. 122, nn.10 and 11 refers to other copies in the Biblioteca Ricciardiana, Florence, MS. Pecci 4, 10 and 11. Martelli suggests that it is on these texts that S. Tizio relied, when he came to write the opening books of the first volume of his *Historiarum Senesium*.

14 See BAV, MS Chigi, F VIII 195, fol. 2 (discussed in chapter Two).

15 Enea Silvio Piccolomini, *Storia di due amanti e rimedio d'amore* [Latin/Italian edition], ed. and trans. Maria Luisa Doglio (Turin, 1973), p. 31.

16 Lisini and Iacometti, *Cronache Senesi*, p. xii n. 2; see also I. D. Rowland, 'L'Historia Porsennae e la conoscenza degli Etruschi nel Rinascimento', *Studi umanistici piceni*, 9 (1989), pp. 185–93.

17 BAV, MS. Chigi, G I 9, fol. 1–117, 'Pius III Pontificis Senensis Annales Senenses in septem partes divisi', indicates a composition date of 1466.

18 Lisini and Iacometti, *Cronache Senesi*, p. xxxi n. 2 (refers to inventory dated 2 April 1481 in ASS, *Concistoro, Deliberazioni*, 687, fol. 20v).

19 See also, Paola Benetti Bertoldo, 'Francesco Patrizi the Elder: The Portrait of a Fifteenth-century Humanist', DPhil., Wolfson College, University of Oxford, 1996, pp. 131–7.

20 Francesco Patrizi, 'De origine et antiquitate urbis Senae', BCS, MS A XI 38, fol. 1–42 (discussion of Camillus from fol. 12).

21 Francesco Patrizi, 'De origine et antiquitate urbis Senae'; fol. 12–22: the remarkable list of etymologies includes the Borghesi ('a Burgis Belgici', fol. 12v), Patrizi ('Patritios nostros [. . .] senatorium fuisse', fol. 13v), Ottolenghi ('opinamus illius Othonis qui deinde Imperavit', fol. 14r), Petrucci ('viris Romanis clarissimi ex ordino senatorio', fol. 14r–v), and more generally, Lolli, Luti, Marsili, Accarigi, Pini and Minucci (all 'genus Romanorum-', fol. 14v).

22 Francesco Patrizi, 'De origine et antiquitate urbis Senae', fol. 30 v ('quatuor lapides turres paris spatio inter se [. . .] in via que a Camilli nomine perpetuis seculis Camillia nuncupatur'). No one bears the surname Camilli in the 1453 *Lira*. The gate is discussed further below.

23 Francesco Patrizi, 'De origine et antiquitate urbis Senae'; fol. 32 ('in homorem Romuli qui etiam Quirinus vocabatur, constitutum fuerat').

24 References are made to Pliny, Livy, Cicero, Tacitus, Ptolomy and others; see also Benetti Bertoldo, 'Francesco Patrizi the Elder', pp. 131–7.

25 Agostino Patrizi, 'De antiquitate civitatis Senensis', in BCS, MS. A VI 3, fol. 83r–89v, ends in letter form ('Vale, Pientie', 9 October 1488). BAV, Chigi, G I 9, fol. 118–25, describes the text as written in the form of a letter ('Augustini Patritii episcopi Pientini epistola ad Franciscum Piccolomineum de Antiquitate Civitas Senarum'). The text is also contained in BCS B. III. 5 and B. III. 3, ASS, MS. D. 166. On authorship, see M. Dykmans, *L'Oeuvre de Patrizi Piccolomini ou le ceremonial papal de la première Renaissance* (Vatican City, 1982), I, p. 20.

26 Agostino Patrizi, 'De antiquitate', fol. 83, for a neat summary of Francesco Patrizi and fol. 84–5 for textual references.

27 *Ibid.*, fol. 89 ('multa sunt in hoc Blondi commento que (pace illius dixerimus) facile reprobari possunt. Sed quas homo est, qui aliquando non fallatur').

28 B. Benvoglienti, *De urbis Senae*; on Benvoglienti see P. Craveri, 'Bartolomeo Benvoglienti', in *DBI* (Rome, 1966), VIII, p. 698.

29 The intention is expressed in the preface, B. Benvoglienti, *De urbis Senae*, fol. aiiiiv.

30 B. Benvoglienti, *De urbis Senae*, fol. biv; it is to be noted, of course, that Benvoglienti's historical method was closest to that of Biondo himself in its desire to conjugate the

written evidence of ancient authors to the physical remains visible in the city, as expressed most clearly in Biondo Flavio da Forlì, *Roma Instaurata* (Verona: Bonino Bonini da Ragusa, 1481), for which see the illuminating comments of Weiss, *The Renaissance Discovery*, pp. 59–89.

31 Biondo Flavio, *Italia Illustrata*, fol. 37: 'Sena vera est interius, urbium Etruriae viribus opibusque nunc fecunda, quae et ipsa inter novas numerari potest, cum nullis in veterum monumentis reperiatur. Suntque qui affirmant, Carolum (cui Malleo fuit cognomentum) eam condidisse'. See also Biondo Flavio, *Italy Illuminated*, ed. and trans., J. A. White (Cambridge, MA, and London, 2005), pp. 86–7.

32 Benvoglienti, *De urbis Senae*, fols. aiv3, biiii2–4, ci.

33 *Ibid.*, fol. ciiii1; the same gate was also referred to by Patrizi, 'De origine et antiquitate urbis Senae', fol. 30v, although the inscription is considered as further *textual* evidence ('et inscriptis nominibus Severi et Valentis, magnis litteris in quodam vetustissimo marmore monumentum').

34 *Ibid.*, fol. biv3.

35 *Ibid.*, fol. cii.

36 *Ibid.*, fol. ciii v.

37 *Ibid.*, fol. ciii v.

38 *Ibid.*, fol. civ1–3.

39 Benvoglienti, *De urbis Senae*, fol. aiiii2r.

40 Benvoglienti, *De urbis Senae*, fol. aiiii2v, 'ascenditur in Castellum Vetus ubi parva quedam vestigia structure veteris apparent'.

41 Benvoglienti, *De urbis Senae*, fol. aiiii2v, 'Una iuxta novum oratorium Sancti Ansani. Quod pretorium fuisse [. . .] Beatum Ansanum in turre que ibi est carceravit'. This identification is followed also by Giovanni Antonio Pecci, in *Raccolta Universale di tutte le iscrizioni, arme e altri monumenti si antichi, come moderni, esistenti nella citta di Siena*, MS D. 6, fol. 253.

42 G. Kaftal, *Saints in Italian Art: Iconography of the Saints in Tuscan Painting* (Florence, 1952), pp. 61–2; also B. Matteucci, 'Ansano da Siena', *Bibliotheca Sanctorum* (Rome, 1961), I, pp. 1324–34. It is significant that this martyrdom site coincided with the site of Siena's victory against the Florentines in 1260, an event of epic importance in Siena's post-Antique history.

43 The increased production of Ansano images in the mid-fifteenth century has also been noted for painting by R. Argenziano and F. Bisogni, 'L'iconografia dei santi patroni Ansano, Crescenzio, Savino e Vittore', *BSSP*, 97 (1990), pp. 109–11. A predella by Giovanni di Paolo is dated to the 1440s; see J. Pope-Hennessy, *Giovanni di Paolo* (London, 1937), pp. 76–7 and 108 (see also Kaftal, *Saints in Italian Art*, pp. 59–61); an *all'antica* relief predella by Giovanni di Meuccio Contadini in the Duomo, of *c.* 1460, see below; a monumental sculpture of the saint was erected on the Loggia della Mercanzia in 1459, for which see A. Angelini, 'Donatello e il suo seguito a Siena', in *Pio II e le arti. La riscoperta dell'antico da Federighi a Michelangelo*, ed. A. Angelini (Cinisello Balsamo, Milan, 2005), p. 71; also E. Richter, *La scultura di Antonio Federighi* (Turin, 2002), pp. 32–3, 37–40.

44 Benvoglienti, *De urbis Senae*, fol. biiii, provides dates for these events, stating that Ansano had been translated to Siena in 1107, that is 368 years previously: these indications also date the laying down of Benvoglienti's text to 1475, which is ten years earlier than had previously been thought; see Craveri, 'Bartolomeo Benvoglienti', p. 698. Reports of the translation are worked into a narrative by G. A. Pecci, *Storia del Vescovado della città di Siena* (Lucca, 1748), pp.

143–9. On the Duomo chapel, see D. Norman, *Siena and the Virgin: Art and Politics in a Late Medieval City* (New Haven and London, 1999), pp. 67–73.

45 Benvoglienti, *De urbis Senae*, fol. biiii1r: 'Igitur de trans Arbiam Senam adlatum fuit Beati Ansani corpus vertice carens qui est Aretii in Ecclesiaque maiore conditum cum Crescentio, Savino et Victorio quorum usque in hodiernus Sena patrocini protecta est'.

46 Agostino Patrizi, 'De antiquitate', fol. 86v, 'Legimus preterea in sacra martir. historia, Ansanum xpi. athleta inclitum, sub Diocleciano Cesare senis martirio coronatum'; B. Benvoglienti, *De urbis Senae*; biiii 1r for story and aiiii2v for the oratory.

47 A. Liberati, 'Chiese, monasteri, oratori e spedali senesi', *BSSP*, 47 (1940), pp. 334–5, for civic commission of 3 December 1441; see also P. A. Riedl and M. Siedel eds., *Die Kirchen von Siena* (Munich, 1985), I.1, p. 323.

48 Original deliberation in ASS, *Concistoro* 453, fol. 29v (10 August 1441): 'Et veduto chel beatissimo martire Sancto Ansano fù quello per le cui mani la città nostra alla Christiana fede fù vertita, meritamente el luogo nel quale di lui debba essere piu spetial memoria et degna cosa sia honorato. Unde provvidero et ordinaro per li presenti quattro di biccherna con quella compagnia vorrano, si debba vedere la torre del Castelvecchio, nella quale Sancto Ansano fù carcerato, e quine divisare et componare una capella, ad honore al detto Sano. La spesa della quale distintmente debbano fare scrittura da ricarsi al consiglio del popolo, dove poi si discuti quanto per honoranza sabbi a fare' (also in ASS, *Consiglio Generale* 221, fol. 40v; in *Die Kirchen von Siena*, I, p. 513). Acquisitions discussed in *Concistoro* 460, fol. 53v (30 October 1442).

49 There is a thorough documentary overview in *Die Kirchen von Siena*, I.1, pp. 322–8 and 513–15; see also K. Trabgar, 'Il campanile del Duomo di Siena e le torri gentilizie della città', *BSSP*, 102 (1995), pp. 159–86.

50 For these modifications, see *Die Kirchen von Siena*, I.1, p. 323 n. 23.

51 On Luca di Bartolo da Bagnocavallo's work on the Palazzo del Capitano, see my 'Revival or Renewal: Defining Civic Identity in Fifteenth-century Siena', in *Shaping Urban Identity in the Middle Ages*, ed. Stabel and Boone, pp. 111–34; also chapter Five.

52 J. T. Paoletti, 'A. Federighi: Documentary Re-evaluation', *Jahrbuch der Berliner Museum* (1975), p. 111, doc. 20; also *Die Kirchen von Siena*, I.1, p. 514, doc. 87 [24]. The payments are small, and no window-frames are mentioned in this long document. On Federighi as architect, see chapter Six.

53 *Die Kirchen von Siena*, I.1, p. 513, doc. 86 (3 December 1441): 'ad fare la cappella de Sancto Ansano [. . .] in Castel Vecchio, nela torre dove esso per fede cristiana stette in pregione perfino che fo menato al sancto martirio'.

54 *Die Kirchen von Siena*, I.1, p. 323 n. 11; the ambassadors sent to request this favour included Leonardo di Bartolomeo Bentivoglienti.

55 For the piazza, see *Die Kirchen von Siena*, I.1, p. 323 n. 12 (March 1449). Processional use and access to the church is recorded for the feast of S. Ansano in 1499, see ASS, *Concistoro*, 799, fol. 13v (1 December 1499), when after kissing the arm of S. Ansano in the Duomo all the orders of the city went 'ad sacellum sue oratorium SanctiAnsani castri veteris iuxta portam priapi et ibi oblatione cereorum factus est consuetum'. Thanks to Philippa Jackson for this reference.

56 See C. Richardson, 'The Housing Opportunities of a Renaissance Cardinal', *Renaissance Studies*, 17 (2003), pp. 607–27, esp. 614–25.

57 G. Gentilini in *Francesco di Giorgio e il Rinascimento a Siena*, ed L. Bellosi (Siena and Milan, 1993), pp. 186–7. It is not clear what function this sculpture served, but it seems possible that it may have served as an architectural frieze, as has recently been suggested for the similar fifteenth-century reframing of the *Madonna del Voto* by M. Butzek, 'La cappella della Madonna dell'Grazie. Una ricostruzione', in *Pio II e le arti. La riscoperta dell'antico da Federighi a Michelangelo*, ed. A. Angelini (Cinisello Balsamo, Milan, 2005), pp. 83–103. That it may have served such a purpose is supported by its current reuse in the cathedral, where it has been reset as the internal framing element of the central door, supported by columns from another fifteenth-century chapel; see A. Angelini, 'Il lungo percorso della decorazione all'antica tra Siena e Urbino', in *Pio II e le arti*, pp. 330–33.

58 *Die Kirchen von Siena*, 1.1, p. 323 and fig. 403; see also A. Angelini, 'Una proposta per la vetrata dell'oratorio di Sant'Ansano in Castelvecchio a Siena', in *Matteo di Giovanni e la pala d'altare nel senese e nell'aretino*, ed. D. Gasparotto and S. Maganini (Siena, 2002), pp. 185–7.

59 In this regard it is interesting to note that Cardinal Francesco altered the dedication of his titular church in Rome, S. Saba on the Aventine, to include the Virgin Mary and S. Ansano; see Richardson, 'The Housing Opportunities', pp. 612–25.

60 Cesare Orlandi, *De Urbis Senae Eiusque Episcopatus Antiquitate* (Siena, 1573), fol. 22 for sources; it is nonetheless curious that this text again concentrates on the city's claims to Antique origins.

61 Benvoglienti was almost certainly commissioned to write *De urbis Senae* by Cardinal Francesco himself (see above and my 'Revival or Renewal', n. 52). Given the Cardinal's patronage of the chapel, this may also partially explain Benvoglienti's remarkable interest in Ansano's life.

62 Benvoglienti, *De urbis Senae*, outlines a Sienese topography for the saint: not only the tower came to take on his name, but a gate in the vicinity of the Croce del Travaglio was called 'Arcum Sancti Ansani Martiris' on account of a rather improbable legend that claimed Ansano had been flogged on the site, while the unbuilt area south of the church of S. Sebastiano was called the 'Fosso di Sant'Ansano'; the Porta di S. Viene was also so named because it was here that the Sienese awaited Ansano's arrival from the *contado* in 1107.

63 On Siena's Roman past, see *Siena: le origini. Testimonianze e miti archeologici*, exh. cat., ed. M. Cristofani (Florence, 1979); most recently, Caciorgna and Guerrini, 'Imago Urbis. La lupa e l'immagine di Roma'. On the broader theme of architectural evidence corroborating urban myths, see G. Clarke, *Roman House – Renaissance Palaces: Inventing Antiquity in Fifteenth-century Italy* (Cambridge, 2003), pp. 8–25.

64 Craveri, 'Bartolomeo Benvoglienti', p. 698 on a speech delivered in Rome.

65 Benvoglienti, *De urbis Senae*, fol. ciiii 3.

CHAPTER EIGHT

1 Lancelotto Politi, *La Sconfitta di Monteaperto*, Siena 1502 (reprinted, Siena 2002), fol. biiii v: 'Siena dalle alte et superbe torri et palazzi eminentissimi'.

2 C. Shaw, 'Politics and Institutional Innovation in Siena (1480–98)', *BSSP*, 103 (1996), pp. 9–102, and 104 (1997), pp. 194–307; more schematic are D. L. Hicks, 'The Rise of Pandolfo Petrucci', PhD thesis, Columbia University, 1959, pp. 7–49, and M. Ascheri and P. Pertici, 'La situazione politica senese del secondo Quattrocento (1456–79)', in *La Toscana ai tempi di Lorenzo il Magnifico: Politica, economia ed arte* (Pisa, 1996), III, pp. 995–1012.

3 The *Monti* were political groups of varying size and social make-up, formed from the original families associated with Siena's fourteenth-century governments, the 'Nove', 'Dodici', 'Popolo', 'Riformatori', as well as the government-excluded 'Gentiluomini'. On Siena's 'broad' government, see C. Shaw, *Popular Government and Oligarchy in Renaissance Italy* (Leiden and Boston, 2006).

4 On Antonio see P. Pertici, 'Una "coniuratio" del reggimento di Siena nel 1450', *BSSP*, 99 (1992), pp. 9–47; Shaw, 'Politics and Institutional Innovation' (part I: 1996), pp. 10–11; on Pius II, I. Polverini Fosi, '"La Comune Dolcissima Patria": Pio II e Siena', in D. Rugiadini, ed., *I ceti dirigenti nella Toscana del Quattrocento (Atti del V et VI convegno: Firenze, 10–11 dicembre 1982; 2–3 dicembre 1983)* (Florence, 1987), p. 510 and chapter 4.

5 Pertici, 'Una "coniuratio" del reggimento'; P. Pertici, *Le epistole di Andreoccio Petrucci (1426–1443)* (Siena, 1990), pp. 167–77; Ascheri and Pertici, 'La situazione politica', pp. 999–1005; P. Pertici, 'La furia delle fazioni', in *Storia di Siena. Dalle orgini alla fine della repubblica*, I, ed. R. Barzanti, G. Catoni and M. De Gregorio (Siena, 1995), pp. 383–94.

6 Ascheri and Pertici, 'La situazione politica', pp. 1012–13. On the economic grounds for conflict, see chapter Five.

7 ASS, *Consiglio Generale* 238, fol. 154 (9 April 1480); the palace became the seat of the Nove-supported rule of Alfonso, and this connection may have caused the sale in the first place; see also O. Malavolti, *Dell'historia di Siena* (Venice, 1599), III, p. 78. Confirmation of the concession of the property, which had previously belonged to Antonio Bichi, is to be found in ASS, *Lira* 190, fol. 63, 'vò per le chase a pigione che non ho chasa et benchè habbi havuti le denari de la chasa di Sancta Marta che si donò al Duca di Calabria, li ho spesi et chonsumati'.

8 A. Allegretti, *Ephemerides Senenses ab anno MCCCCL usque ad MCCCCXCVI italico sermone scriptae*, in *Rerum Italicarum Scriptores*, vol. 23, ed. L. Muratori (Milan, 1733), pp. 808–10, on events for June to August 1482, and C. Cantoni, *Frammento di un diario sanese*, ed. A. Lisini and F. Iacometti, *Cronache Senesi*, in *Rerum Italicarum Scriptores*, vol. 15, part 6.3 (Bologna, 1939), p. 900. Also Malavolti, *Dell'historia*, III, pp. 78–80; Shaw, 'Politics and Institutional Innovation' (part I: 1996), p. 28.

9 Described in great detail by Shaw, 'Politics and Institutional Innovation' (part II: 1997), and C. Shaw, *The Politics of Exile in Renaissance Italy* (Cambridge, 2000), pp. 40–50. Also, A. K. Isaacs, 'Cardinali e "spalagrembi". Sulla vita politica a Siena fra il 1480 e il 1487', in *La Toscana al tempo di Lorenzo il Magnifico: Politica, economia, cultura ed arte* (Pisa, 1996), III, pp. 1018–33; H. Butters, 'The Politics of Protection in Late Fifteenth-century Italy: Florence and the Failed Sienese Exiles' Plot of May 1485', in *The French Descent into Renaissance Italy, 1494–5*, ed. D. Abulafia (Aldershot, 1995), pp. 137–49.

10 On peace-making pacts, see C. Shaw, 'Peace-making Rituals in Fifteenth-century Siena', in *Beyond the Palio: Urban Ritual*

in Renaissance Siena, ed. P. Jackson and F. Nevola (Oxford, 2006), pp. 89–103. Also, W. Heywood, *Palio e Ponte* (Siena and London, 1904), pp. 44–6, and A. Toti, *Atti di votazione della città di Siena e del senese alla SS. Vergine Madre di G. C.* (Siena, 1870).

11 A. Angelini, *Francesco di Giorgio e il Rinascimento a Siena*, ed. L. Bellosi (Siena and Milan, 1993), p. 116; also U. Morandi et al., eds., *Le Biccherne. Tavole dipinte delle magistrature senesi (secoli XIII–XVIII)* (Rome, 1984), pp. 26, 168. A new identification of the subject has been made in Shaw, 'Peacemaking Rituals', pp. 99–103. For an assessment that quantifies 25 per cent of papal appointments as being nepotistic, and 15 per cent assigned to family, see R. B. Hilary, 'The Nepotism of Pope Pius II', *Catholic Historical Review*, 64 (1978), pp. 33–5. On Paul II Barbo's reprisals against Piccolomini nepotism, see A. de Vincentis, *Battaglie di Memoria. Gruppi, intelletuali, testi e la discontinuità del potere papale alla metà del Quattrocento* (Rome, 2002).

12 The significance of this post in relation to Florence has been described by G. Holmes, 'How the Medici Became the Pope's Bankers', in *Florentine Studies: Politics and Society in Renaissance Florence*, ed. N. Rubinstein (London, 1968), pp. 357–80; see also U. Morandi, 'Gli Spannocchi: piccoli proprietari terrieri, artigiani, piccoli, medi e grandi mercanti-banchieri', in *Studi in onore di Federico Melis* (Naples, 1978), III, pp. 91–120. New studies of Sienese banking can be found in *Siena nel Rinascimento: l'ultimo secolo della repubblica*, II, Acts of the International Conference, Siena (28–30 September 2003 and 16–18 September 2004), ed. M. Ascheri and F. Nevola (Siena, 2007), especially essays by S. Tognetti, F. Guidi-Bruscoli and I. Ait.

13 Shaw, 'Politics and Institutional Innovation' (part I: 1996), pp. 10–45, and Shaw, *The Politics of Exile*, pp. 110–42.

14 Shaw, 'Politics and Institutional Innovation' (part II: 1997), and *The Politics of Exile*, pp. 226–33.

15 G. Chironi, 'Nascita della signoria e resistenze oligarchiche a Siena: l'opposizione di Niccolò Borghesi a Pandolfo Petrucci (1498–1500)', in *La Toscana ai tempi di Lorenzo il Magnifico: Politica, economia ed arte* (Pisa, 1996), III, pp. 1173–95.

16 Chironi, 'Nascita della signoria'; P. Jackson, 'Le regole dell'oligarchia al tempo di Pandolfo Petrucci', in *Siena e il suo territorio nel Rinascimento*, ed. M. Ascheri (Siena, 2000), pp. 209–13; also, D. L. Hicks, 'The Sienese Oligarchy and the Rise of Pandolfo Petrucci, 1487–97', in *La Toscana ai tempi di Lorenzo il Magnifico: Politica, economia, cultura ed arte* (Pisa, 1996), III, pp. 1057 and 1068, on the closed elite, cites document transcribed in Hicks, 'The Rise of Pandolfo Petrucci', from BAV, *Chigiana, Codici Chigi*, I. IV. 136, fol. 19: 'Convenzioni tra Pandolfo e altri cittadini', 22 July 1507, in which Pandolfo and fifteen supporters signed this agreement. 'Pandolfo sia capo, e a lui conservato lo stato e la dignità'. See also G. Chironi, 'Politici e ingegneri. I Provveditori della Camera del Comune di Siena negli anni '90 del Quattrocento', *Ricerche Storiche*, 23/2 (1993), pp. 384–95.

17 G. Prunai and S. del Colli, eds., *Archivio di Stato di Siena: Archivio di Balìa* (Rome, 1957), for the fourteenth-century origins of the office.

18 Prunai and del Colli, *Archivio di Balìa*, pp. ix–lxxi, esp. xliv–liv; Chironi, 'La signoria breve', p. 396. M. Ascheri, 'Istituzioni e governo della città', in *Storia di Siena. Dalle origini alla fine della repubblica*, I, ed. R. Barzanti, G. Catoni and M.

De Gregorio (Siena, 1995), p. 335. See Shaw, *Popular Government and Oligarchy*. This process is also the focus of R. Terziani, *Il governo di Siena dal medioevo all'età moderna: la continuità repubblicana al tempo dei Petrucci (1487–1525)* (Siena, 2002).

19 See C. Shaw, 'Popular Government and the Petrucci', in *Siena nel Rinascimento: l'ultimo secolo della repubblica*, Acts of the International Conference, ed. M. Ascheri and F. Nevola (Siena, 2007).

20 The text is examined further in chapter Seven.

21 O. di Simplicio, 'Nobili e sudditi', in *I libri dei leoni. La nobiltà di Siena in età medicea (1557–1737)*, ed. M. Ascheri (Milan, 1996), pp. 74–82; S. Cohn, *Death and Property in Siena, 1205–1800* (Baltimore, 1988), pp. 126, 146–58.

22 Francesco Patrizi, 'De origine et vetustate urbis Senae', fol. 37v–39v, includes Saracini, Malavolti, Salimbeni, Rinaldini, Scotti, Rossi, Ruffoli (all 1277 nobles), who are post-Antique, while fol. 11–16 includes Borghesi, Bellanti, Placidi, Patrizi, Bichi, Petrucci, Lolli, Luti (not in 1277 lists), who are given Antique origins

23 Benvoglienti, *De urbis Senae*, fol. ciii, 'Populo namque coalescente non iam sub urbe tantu quasi circa matre [. . .] aliii casas, alii palatia, turresque [. . .]'; this section of the work, which concentrates on recent architecture, ends 'Siena completa est' [fol. ciiii, 3r].

24 This issue is examined in chapter Three.

25 This issue is amply examined in chapter One; see, for example E. English, 'Urban Castles in Medieval Siena: The Sources and Images of Power', in *The Medieval Castle: Romance and Reality*, ed. K. Reyerson and F. Powe, Medieval Studies at Minnesota, I (Dubuque, IO, 1984), pp. 175–98.

26 On the family clan structure, see C. Lansing, *The Florentine Magnates: Lineage and Faction in a Medieval Commune* (Princeton, NJ, 1991), pp. xi–xiv, 29–45; see also J. Heers, *Le clan familial au Moyen Age. Etude sur les structures politiques et sociales des milieux urbains* (Paris, 1974).

27 D. Waley, *Siena and the Sienese in the Thirteenth Century* (Cambridge, 1991), p. 78; the list was originally published in P. L. Sbaragli, 'I mercanti di mezzana gente al potere di Siena', *BSSP*, 44 (1937), pp. 59–60.

28 In S. Pellegrino were ASS, *Lira* 186, fol. 1, 7, 19, 20, 22, 26, 27, 29, 34, 38, and out were ASS, *Lira* 190, fol. 110 and *Lira* 188, fol. 11.

29 In S. Pellegrino ASS, *Lira* 111, fol. 14, 16, 29, 30, 56 and ASS, *Lira* 253, fol. 1, 8, 15, 16, 17, 22, 23; nearby ASS, *Lira* 111, fol. 83, 117, 200, 262; away ASS, *Lira* 113, fol. 11, 24, 28, 61, 69 and ASS, *Lira* 237, fol. 35, 61.

30 See ASS, *Lira* references above.

31 G. Prunai, G. Pampaloni and N. Bemporad, eds., *Il Palazzo Tolomei a Siena* (Florence, 1971), pp. 59–86; also T. Benton, 'Three Cities Compared: Urbanism', in *Siena, Florence and Padua: Art, Society and Religion, 1280–1400*, ed. D. Norman (New Haven and London, 1995), II, pp. 13–14.

32 D. Balestracci and G. Piccinni, *Siena nel Trecento. Assetto urbano e prassi edilizia* (Florence, 1977), pp. 131, 135.

33 ASS, *Lira* 146, fol. 1 (1453), 'appena basta a mantenere i tetti'; they had reason to complain, as rent brought in only 16 *lira*; also ASS, *Lira* 113, 6r (1509).

34 ASS, *Lira* 146, fol. 46 (1453), 'viene allirato tutto insieme': the joint assessment is in ASS, *Lira* 146, fol. 1, from the 'uomini e consorti' Tolomei. On the role of ancestral property as expression of a link to the clan see G. Piccinni, 'Modelli di organizzazione dello spazio urbano dei ceti

dominanti del Tre e Quattrocento. Considerazioni senesi', in *I ceti dirigenti nella Toscana tardo comunale (Atti del convegno, 5–7 dicembre 1980, Firenze)*, ed. D. Rugiadini (Florence, 1983), pp. 221–36.

35 Material in this discussion from ASS, *Lira* 146, fol. 1, 3, 10, 13, 15, 17, 19, 25, 36, 48–50, 70, 77, ASS, *Lira* 140, fol. 211, and *Lira* 144, fol. 138.

36 S. Cristoforo, ASS, *Lira* 113, fol. 1–10; others in *Lira* 113, fol. 96 (a Tolomei widow) and ASS, *Lira* 234, fol. 5.

37 ASS, *Lira* 137, fol. 105: 'Chostocci detta chasa fl. quattrocento e fella la buona memoria di nostro padre che vi spese più di cento fl. che non valeva per essere presso dei suoi'; the palace is discussed in chapter Three.

38 I have examined the appropriation of lineage (that of the Salimbeni by the Spannocchi) through site in my 'Ambrogio Spannocchi's "bella casa": Creating Site and Setting in Quattrocento Sienese Architecture', in *Renaissance Siena: Art in Context*, ed. L. A. Jenkens (Kirksville, MO, 2005), pp. 141–56. Similar issues are discussed for Florence by B. Preyer, 'Florentine Palaces and Memories of the Past', in *Art, Memory and Family in Renaissance Florence*, ed. G. Ciappelli and P. Rubin (Cambridge, 2000), pp. 176–94.

39 The original palace design is well known, see F. Toker, 'Gothic Architecture by Remote Control: An Illustrated Building Contract of 1340', *Art Bulletin*, 69 (1985), pp. 67–95; see also C. Ghisalberti, 'Late Italian Gothic', in *The Renaissance from Brunelleschi to Michelangelo: The Representation of Architecture*, exh. cat., ed. H. Millon and V. Magnago Lampugnani (London, 1994), p. 429. On fifteenth-century modifications, see my '"Ornato della città": Siena's Strada Romana as Focus of Fifteenth-century Urban Renewal', *Art Bulletin*, 82 (2000), p. 33.

40 ASS, *Lira* 144, fol. 169, 177, 278 (1453); see also Piccinni, 'Modelli di organizzazione', pp. 221–36, 230 n. 27, cites ASS, *Ospedale di Santa Maria della Scala*, 1186, fol. 324–9 (September 1489) for the division of the palace (ASS, *Ospedale di Santa Maria della Scala*, 1186, fol. 324v, 'intrata principale del palazo e riducto e stalla sia comune di tutti e due da usarsi secondo l'uso consueto e similmente sieno comune tutte le scale e le piazuola et anditi per andare alluno e laltro habituro').

41 K. Trabgar, 'Il campanile del Duomo di Siena e le torri gentilizie della città', *BSSP*, 102 (1995), pp. 173–5; also, with reference to the Porieri and Forteguerri, Pecci, *Notizie su torri*, p. 19.

42 ASS, *Lira* 192, fol. 202 (1481), 'Item mi trovo la metà per indivisa de la chasa dove habito posta in nel terzo di Città et popolo di San Desiderio in locho detto dei Marescotti et decto Palazzo Mareschotti'; ASS, *Lira* 112, 22v and 15v for his heirs (1509).

43 Nineteenth-century neo-Gothic restoration has confused stylistic understanding of the palace (see V. Lusini, *Storia del Palazzo Chigi Saracini*, Siena, 1927), although the presence of a tower is reported by documentary sources; see Pecci, *Notizie su torri*, p. 19, 'Marescotti, oggi Piccolomini e Mandoli'.

44 Pecci, *Notizie su torri*, p. 19, 'Forteguerri e Antolini alla Postierla [. . .] gl'Incontri in detto luogo [. . .] ruinò nel 1300'.

45 Further discussion of the via del Capitano development can be found in chapter Nine; for documents and full discussion see my 'Creating a Stage for an Urban Elite: the Redevelopment of the Via del Capitano and Piazza Postierla

in Siena', in *The World of Savonarola: Italian Elites in Crisis*, ed. C. Shaw and S. Fletcher (London, 2000), pp. 182–93.

46 Archio dell'Opera Metropolitana di Siena, *Contratti* 23 (1438–1599), fol. 8, 14 (28 November 1504, 20 March 1506) for leases; ASS, *Lira*, 236, 7 for Girolamo di Bonaventura Borghesi as owner of two-fifths of the palace (1509); ASS, *Lira*, 234, 36 for heirs of Conte Forteguerri, 'item ci troviamo uno credito in sul bancho di bona memoria di nostro padre de la casa vendemmo a Girolamo Borghesi [. . .]' (1509).

47 See, most recently, A. de Marchi, 'Progetto per la decorazione di casa Borghesi', in *Domenico Beccafumi e il suo tempo*, ed. P. Torriti (Milan, 1990), pp. 426–7; also G. Vasari, *Le vite dei più eccellenti pittori, scultori ed architettori*, ed. P. Barocchi (Florence, 1984), v, p. 166.

48 E. Panofsky, 'Excursus on Two Façade Designs by Domenico Beccafumi', in *Meaning in the Visual Arts* (London, 1955), pp. 267–70.

49 It seems that the Forteguerri arms remained on display in the area well into the *Cinquecento*, as the chronicler Tizio comments on them; see A. Fiorini, *Siena. Immagini, testimonianze e miti nei toponomi della città* (Siena, 1991), p. 215.

50 Evidence extracted from ASS, *Lira*, various volumes. The dramatic growth of the Borghesi clan was commented on by contemporaries, who viewed this as a conscious bid for greater influence in the city; see C. Shaw, *L'ascesa al potere di Pandolfo Petrucci il Magnifico. Signore di Siena (1487–1498)* (Siena, 2001), p. 112.

51 See my 'Creating a Stage for an Urban Elite', p. 192; Vasari, *Le vite*, ed. Barocchi, v, pp. 166 and 383; the tower is also reported by Pecci, *Notizie su torri*, p. 19.

52 On the palace, see A. Ferrari, R. Valentini and M. Vivi, 'Il Palazzo del Magnifico a Siena', *BSSP*, 92 (1985), pp. 107–53; G. A. Pecci, *Memorie storico-critiche della città di Siena che servono alla vita civile di Pandolfo Petrucci* (Siena, 1755, repr. Siena, 1988), I, p. 123; S. Tizio, *Historiarum Senensium*, BCS, MS. B. III. 11, fol. 647, discusses supply of marble for the palace walls, January 1505. See also my Conclusion.

53 On Accarigi property: ASS, *Lira* 186, fol. 75 (1481) for Antonio di Bonaventura Accarigi's palace and tower, shared between heirs in 1492, ASS, *Notarile Antecosimiano* 715, fol. 94 (15 November); the incorporation of the tower in Pandolfo's palace is confirmed in, for example, ASS, *Notarile Antecosimiano* 1080, fol. 367 and 368 (12 March 1508). The Accarigi remained resident in the area in 1509, see ASS, *Lira* 111, fol. 69, 82, 84, 149, 150 and *Lira* 239, fol. 9.

54 Ferrari et al., 'Il Palazzo del Magnifico', pp. 109–11, cite ASS, *Notarile Antecosimiano* 1080, fol. 307 (March 1507), also figs. 3–5. The loggia was visible until the recent restoration, which applied a thick taupe *intonaco* entirely hiding the wall-surface texture, which a light plaster skim (*scialbatura*) would instead have left in evidence.

55 M. Quast, 'Il Palazzo Bichi Ruspoli, già Rossi in via Banchi di Sopra: indagini per una storia della costruzione tra Duecento e Settecento', *BSSP*, CVI (1999), pp. 156–88; Alessandro Bichi was in his own right a leader of the oligarchy after the fall of the Petrucci: see Terziani, *Il governo di Siena dal medioevo all'età moderna*, p. 218ff.

56 Alesssandro Bichi was resident in Castelvecchio in 1509, see ASS *Lira*, 234, fol. 4; acquisition in APB, *Spogli* VII, fol. 325 (na 282, Reg 41; 6 October 1518), fol. 554–5; see also M. Quast, 'Il Palazzo Bichi Ruspoli', pp. 161 and 176. The Rossi and Bandinelli towers are noted in Pecci, *Notizie su torri*, p. 20.

57 On the Strada Romana, see my '"Ornato della città"'.

58 S. Tizio, *Historiarum Senensium*, B.III.14, 298b [302], 'Erant, qui Turres Senensis Urbis, tamquam inutiles, et periculosos ratione fulmineo damuarent, quoniam lapidibis indigebant; alii vero decoram urbem illas magni facere, quod et nobis viscum semper fuit et demoliri eas moleste ferebant'. Thanks to Philippa Jackson for this reference.

59 Demolitions approved and recorded in *Spoglio di Balìa*, BCS, MS. A VII, 19–22 *ad annum*, 9 April 1513 and 26 January 1518.

60 M. Scarpini, *Vivat Foelix. Il Palazzo dei Diavoli a Siena: Storia, architettura, civiltà* (Siena, 2002), pp. 64–6 and 95–8.

61 On these intarsia panels, see C. Sensini, 'Fra Giovanni da Verona maestro d'intaglio e d'intarsio', BSSP, 106 (1999), pp. 189–271, esp. 214–18.

62 Politi, *La Sconfitta di Monteaperto*, b.iiii v, 'Siena dalle alte e superbe torri et palazzi eminentissimi'.

63 See the collection in *Art and Architecture in the Service of Politics*, ed. H. A. Millon and L. Nochlin (Cambridge, MA, and London, 1978).

64 ASS, *Lira* 190, fol. 63 (1481).

65 ASS, *Lira* 236, fol. 16 (1509); the palace is discussed in detail, with full documentation, in chapter Nine. Shaw, *The Politics of Exile*, p. 76, records Antonio Bichi's exile (15 July); p. 50 describes him as one of the five figures of 'the innermost circle of the regime' by the early 1490s, together with Giacoppo and Pandolfo Petrucci, Leonardo Bellanti and Niccolò Borghesi.

66 The complex agenda behind these moves challenges the lineage-based model for palace ownership outlined by F. W. Kent, 'Palaces, Politics and Society in Fifteenth-century Florence', *I Tatti studies*, 2 (1987), pp. 41–70, and the conspicuous consumption/magnificence principle favoured by Richard Goldthwaite in important studies such as *Wealth and the Demand for Art in Italy (1300–1600)* (Baltimore, 1993).

67 ASS, *Lira* 166, fol. 12–13, cited from P. Pertici, *La città magnificata: interventi edilizi a Siena nel Rinascimento* (Siena, 1995), p. 119, for funds to 'fare il casamento. For Paul II's persecution of Pius's nepotism, see the thorough study by de Vincentis, *Battaglie di Memoria*.

68 ASS, *Lira* 166, fol. 12–13, from Pertici, *La città magnificata*, p. 119.

69 The story of the patronage of Pius II's nephews, particularly of architecture, remains to be written, and is the subject of a research project I am pursuing; what is impressive is the geographic scope of the Pope's ambitions, that ranged from Rome through the Kingdom of Naples, and included property in Campania, Abruzzo, the Marche and south Tuscany.

70 C. Ugurgieri della Berardenga, *Pio II Piccolomini, con notizie su Pio II e altri* (Florence, 1973), pp. 536–45. See also B. Banks Amendola, *The Mystery of the Duchess of Malfi* (Stroud, 2002), pp. 21, 27–8; after the death of Maria, in 1461 Ferrante arranged for Antonio's wedding to Maria Marzano. See also G. M. Monti, 'I Piccolomini d'Aragona Duchi di Amalfi. Un quadro di Raffaello e la biblioteca di Pio II', in *Studi sulla Repubblica Marinara di Amalfi* (Salerno, 1935), pp. 97–141.

71 The palace in Naples was in the vicinity of S. Domenico Maggiore; see Banks Amendola, *The Mystery*, p. 28; Antonio was also the patron of the magnificent Piccolomini chapels in the nearby church of Monteoliveto (S. Anna dei Lombardi), for which see C. Cundari, ed., *Il complesso di Monteoliveto a Napoli: analisi, rilievi, documenti, informatizzazione*

degli archivi (Rome, 1999), and for documents linking to the Tuscan milieu, D. Carl, 'New Documents for Antonio Rossellino's Altar in the Church of S. Anna dei Lombardi, Naples', *Burlington Magazine*, 138 (1996), pp. 318–20.

72 Ugurgieri della Berardenga, *Pio II Piccolomini*, p. 504ff.; A. A. Strnad, 'Francesco Todeschini Piccolomini. Politik und Mäzenatentum im Quattrocento', *Römische Historische Mitteilungen*, 8–9 (1964–66), pp. 101–425; C. Eubel, *Hierarchia catholica medii aevi sive Summum Pontificorum, 1431–1503* (Münster, 1914), II, pp. 13–14 and n. 3; a useful survey of Francesco's patronage in Rome is now to be found in C. Richardson, 'The Housing Opportunities of a Renaissance Cardinal', *Renaissance Studies,* 17 (2003), pp. 607–27.

73 Richardson, 'The Housing Opportunities', pp. 609–12; see also R. Ciprelli, 'Le costruzioni dei Piccolomini in un manoscritto inedito', *Regnum Dei: Collectanea Theatina*, 110 (1984), pp. 227–56.

74 See previous chapter; also D. Bandini, 'Memorie Piccolominee in Sarteano', BSSP, 57 (1950), pp. 107–30.

75 Shaw *The Politics of Exile*, pp. 75, 102–3.

76 The palace is listed among the Cardinal's property in his will, which made it over to his brothers: see C. Richardson, 'The Lost Will and Testament of Cardinal Francesco Todeschini Piccolomini (1439–1503)', *Papers of the British School at Rome*, LXVI (1998), pp. 193–214. In a division document drawn up between the heirs of his brother, Andrea, the palace is described as 'la casa nuova gia chiamata vulgarmente la casa del Cardinale', from ASS, *Consorteria Piccolomini* 17, fol. 117v–121 (8 December 1505); the other half of the inheritance passed to Iacomo and is recorded in ASS, *Consorteria Piccolomini* 24, doc. 1. These documents confirm that the Cardinal's will was executed by Francesco di Nanni da Sarteano, a canon of Siena cathedral (see also Bandini, 'Memorie Piccolominee').

77 These elements are discussed further in chapter Six.

78 G. Aronow, 'A Description of the Altars in Siena Cathedral in the 1420s', in H. van Os, *Sienese Altarpieces, 1215–1460: Form, Content and Function, II: 1344–1460* (Groningen, 1990), pp. 225–42, 232–3; on privatization of religious space, see Cohn, *Death and Property*, pp. 102–8. D. Toracca, 'La Libreria Piccolomini e il gusto per l'antico a Siena', in *La Libreria Piccolomini nel Duomo di Siena*, ed. S. Settis and D. Toracca (Modena, 1998), pp. 237–42, 257–61. G. Bonsanti in *La giovinezza di Michelangelo*, exh. cat., ed. C. Acidini Luchinat, J. D. Draper, N. Penny and K. Weil-Garris Brandt (Florence and Milan, 1999), pp. 308–11.

79 E. Carli, *Il Duomo di Siena* (Siena, 1979), pp. 120–29; see essays in Settis and Toracca, eds., *La Libreria Piccolomini*. More recent studies have examined the textual basis for the painted biography, for example M. Caciorgna, 'Giovanni Antonio Campano tra filologia a pittura. Dalle *Vitae* di Plutarco alla biografia dipinta di Pio II', *Quaderni dell'Opera*, II (1998), pp. 85–138, and '"Mortalis aemulor arte deos". Umanisti e arti figurative a Siena tra Pio II e Pio III', in *Pio II e le arti. La riscoperta dell'antico da Federighi a Michelangelo*, ed. A. Angelini (Cinisello Balsamo, Milan, 2005), pp. 151–81; also S. May, 'The Piccolomini Library in Siena Cathedral: A New Reading with Particular Reference to Two Compartments of the Vault Decoration', *Renaissance Studies*, 19 (2005), pp. 287–324.

80 Richardson, 'The Lost Will'; ASS, *Consorteria Piccolomini* 17, fol. 117v–121 (8 December 1505), and ASS, *Consorteria Piccolomini* 24, doc. 1.

81 Ugurgieri della Berardenga, *Pio II Piccolomini*, pp. 536–45; the property is listed in Iacomo's will, ASS, *Consorteria Piccolomini* 24, doc. 6 (28 December 1508.) A printed copy of the will is Rome, Ex typographia reverendae Camerae Apostolicae, MDCXI, and includes property in Ancona, Siena, Rome, Sarteano, Camporsevoli, Pienza and Montemarciano. It is likely that the special importance of Montemarciano was its small fortified port, the so-called Mandracchio, which may be represented in Pinturicchio's final scene of the Piccolomini Library frescoes. See also *Atti: Giornata di studi malatestiani a Montemarciano*, Accademia nazionale virgiliana/Centro studi malatestiani (Brescia, 1990).

82 Ugurgieri della Berardenga, *Pio II Piccolomini*, pp. 536–45.

83 A. L. Jenkens, 'Pius II's Nephews and the Politics of Architecture at the End of the Fifteenth Century in Siena', BSSP, CVI (1999), p. 75 for 1509 tax returns. A remarkable archival source survives for Andrea Piccolomini in the form of a volume containing every property transaction undertaken by Andrea, ASS, *Consorteria Piccolomini* 17, with documents from 1464: 'In questo libro saranno scripti tutti li contracti et publicati et parte insinuati col auctorita oportuna et parte di mano de propri notarii che sono o saranno rogati deli contracti apartenenti a me Andrea di msi. Nanni Piccolomini, Cavaliere cittadino di Siena in mia propria particularmente. Et ali miei successori ad perpetua memoria et accioche sempre si possi vedere apertamente e' miei propri facti. Incominciato ad scrivere questo dì xxxi di dicembre MCCCCLXXVI. Laus Deo'.

84 Ugurgieri della Berardenga, *Pio II Piccolomini*, pp. 536, 543; Iacomo first married Camilla Monaldeschi della Cervara (daughter of the Lord of Bolsena), and after her death Cristofora Colonna.

85 Allegretti, *Ephemerides Senenses*, in *Rerum Italicarum Scriptores*, vol. 23, p. 773.

86 ASS, *Concistoro* 2125, fol. 106 (28 October 1469); Milanesi, *Documenti*, II, pp. 337–9, 'opera meravigliosa et nella città vostra dignissimo ornamento [. . .] venghi in quadro'.

87 Allegretti, *Ephemerides Senenses*, in *Rerum Italicarum Scriptores*, vol. 23, p. 773, 'base al piano della strada'.

88 ASS, *Consorteria Piccolomini* 17, fol. 53v (9 October 1480), describes first Andrea's portion of the palace and then Iacomo's; see also ASS, *Consorteria Piccolomini* 19 (9 October 1480; a seventeenth-century copy). I transcribed this document in full in my 'Urbanism in Siena (c. 1450–1512). Policy and Patrons: Interactions Between Public and Private', PhD thesis, Courtauld Institute of Art, London, 1998. Antonio, Duke of Amalfi, had rescinded his right to all family property on 7 February 1464 (ASS, *Consorteria Piccolomini* 17, fol. 4v–6).

89 ASS, *Consorteria Piccolomini* 17, fol. 53v–54r (9 October 1480), while Iacomo's palace is described as 'Palazzo Nuovo' in tax returns, listed in ASS, *Consorteria Piccolomini* 21, fol. 28 (1484).

90 ASS, *Consorteria Piccolomini* 17, fol. 54r defines the boundaries as 'El casamento nuovo murato posto nella città di Siena nel popolo et terzo di San Martino nella compagnia di Pantaneto confina da un lato el chiasso dei setaiuoli, dal'altro lato la Strada Romana, dal'altro lato la casa di Iacomo della Piazza, dal'altro il casamento vecchio'.

91 ASS, *Lira* 192, fol. 202, 'sotto el decto palazzo'.

92 ASS, *Lira* 192, fol. 202, 'el palazzo nuovo principiato [. . .] per volerlo finire al disegno principiato e come è mia intentione sequitando li tempi [. . .] vi sarà spesa di migli-

aia di fiorini'. ASS, *Consorteria Piccolomini* 21, fol. 28 (transcription of 1484 tax return), 'el quale è in termine che non si puo abitare, come ciascheduno puo vedere, ma per volerlo finire al disgno principiato, et come è mia intenzione, seguitando li tempi in tal modo conditionati, che il fabricare si possa fare, vi sarà spesa di migliara di fiorini, et con difficultà ad provedersi in modo che mi da assai pensiero'.

93 ASS, *Consorteria Piccolomini* 17, fol. 54r, 'et murando di nuovo l'entrata principale verso Porrione rimanga comune, et finita quella della casa nuova nella Strada Romana, et simile modo murando si facci una entrata principale et comune in Porrione'.

94 The thesis is mostly clearly expressed in Jenkens, 'Pius II's Nephews', p. 75; the publication in book form of Jenkens's thesis is still awaited, but I have not consulted the thesis for the comments and interpretation presented here (A. L. Jenkens, 'Palazzo Piccolomini in Siena: Pius II's Architectural Patronage and its Afterlife', PhD thesis, New York University, 1995).

95 Jenkens, 'Pius II's Nephews'; the minute detail in the account by Shaw, 'Politics and Institutional Innovation' parts I (1996) and II (1997), reveal both brothers active in the political life of the city.

96 Shaw, 'Politics and Institutional Innovation' (part II: 1997), for institutional reforms of spring 1494.

97 ASS, *Concistoro* 2378 is a fascinating volume compiled by Andrea, that includes full accounts for his term in office as *gonfaloniere* for S. Martino in 1480.

98 F. Fumi, 'Nuovi documenti per gli angeli dell'altar maggiore del Duomo di Siena', *Prospettiva*, 26 (1981), pp. 9–25; see also C. H. Clough, 'Pandolfo Petrucci e il concetto di "Magnificenza"', in *Arte, committenza ed economia a Roma e nelle corti del Rinascimento (1420–1530)*, ed. A. Esch and C. L. Frommel (Turin, 1995), p. 388 for Iacomo; BCS A. VII. 19–22, 'Spoglio di Balia', *ad annum* (2 March 1492/3 [35, 66]) for Andrea. The High Altar was reordered using Vecchietta's Tabernacle from the Spedale di S. Maria della Scala.

99 Jenkens, 'Pius II's Nephews', p. 114, seems to have recognized the difficulty of maintaining such a position, as the final page of this long article that deals principally with the differing political activity of the two brothers is very tentative: 'it is not implausible, however, to suggest that the separate palace projects must, in some way be linked to the diverging paths each brother chose for himself'.

100 ASS, *Consorteria Piccolomini* 17, fol. 54r, mentions property of Niccolò di Minoccio, Francesco and Lorenzo di Mandolo Piccolomini, Guido di Antonio Piccolomini, Antonio di Mandorlo Piccolomini and Iacomo della Piazza; the problem of neighbours was also discussed in chapter Four.

101 Jenkens, 'Pius II's Nephews', p. 111, has made much of this, suggesting that Andrea made this decision from political tact. There can be little doubt that the original 'palace cube' plan had been abandoned, but whether this was politically motivated is open to further debate, see *infra*.

102 ASS, *Consorteria Piccolomini* 17, fol. 71 (9 April 1492), Mandolo di Francesco Mandolo Piccolomini sells a shop in S. Martino in Porrione to Andrea for 50 fl; fol. 82 (6 April 1498), Andrea buys a shop on the corner of the Campo and Chiasso dei Pollaiuoli from the heirs of Marco di Rinaldo Pecci for 71 fl; fol. 83v (27 July 1499), Madonna Elisabetta di Girolamo del Vecchio sells a shop on the corner of the Campo and Chiasso dei Pollaiuoli to Andrea;

fol. 84 (8 January 1499), Andrea buys a house and part of a shop in via del Porrione from Bernardino di Iacomo da Pienza.

103 There was evidently no eminent domain legislation that allowed patrons to buy up property needed for ambitious architectural projects in Siena at this time; early cases of this type of legislation can be seen in the pontificate of Sixtus IV for Rome: see E. Re, 'Maestri di Strada', *Archivio Società Romana di Storia Patria* (1920), pp. 5–102, esp. 32–6 and 46–9.

104 ASS, *Consorteria Piccolomini* 17: Contratti di Andrea di Nanni Piccolomini (1464–1519), fol. 87 and ff. (28 January 1507).

105 See chapter Four, and Iacomo's tax return, ASS, *Consorteria Piccolomini* 21, fol. 28 (1484), 'Item mi truovo sotto la loggia Piccolomini in comunione con M. Andrea mio fratello, due buttighe, et uno fondachetto, le quali rade volte si appigionano, per la umidità che in esse surge, et quando de poche si cava alcuno denaro si mette in acconcime et mantenimento di detta loggia'.

106 ASS, *Consorteria Piccolomini*, 1, insert no. 5, 'Copia del codicillo' (18 December 1507), 'debeant manutenere et reparare logiam Piccolomineorum sita aut Senis et constructa a felice memoria Pii pape II'. For inalienability clauses in wills, see Cohn, *Death and Property*, pp. 126, 146–58.

107 ASS, *Consorteria Piccolomini* 17, fol. 54r; *Lira* 192, fol. 202 (1481), 'Item mi trovo la metà per indivisa de la chasa dove habito posta in nel terzo di Città et popolo di San Desiderio in locho detto dei Marescotti et decto Palazzo Mareschotti'. The building history of the Palazzo Piccolomini deserves a full study, with a thorough archival search; the aim here is circumscribed to considering the distinct directions the two projects took, and their significance.

108 For property transactions, see ASS, *Consorteria Piccolomini* 21, fol. 28 (1484), 'Item mi trovo la metà per indiviso della casa dove al presente abito, posta in nel terzo di Città, et Populo di San Desiderio, in luogo detto da' Marescotti, et detto el Palazzo Marescotti, dela quale tengo la metà per indiviso con Rede di Caterina Marescotti, et da esso Rede la comprai fiorini seicento di lire quattro il fiorino, dela quale hanno scripta da me di mia mano di poterla ricomprare per lo detto prezzo infra li tempo di dieci anni, dei quali n'é passati cinque, l'altra metà di questa casa la tengo a pigione da detto Rede et a loro ne pago fiorini 10 per l'anno di pigione'; fol. 32 (1509), 'Il palazzo detto il Palazzo Marescotti tutto interamente, et con molte casacce intorno, e dietro ruinate, che vanno fino nel Casato, nel quale ancora sono edificare con grandissima spesa'.

109 Jenkens, 'Pius II's Nephews', p. 110, has connected this to the late fifteenth-century Palazzo Strozzi in Florence, and proposes an intervention by Benedetto da Maiano, without providing any evidence for this.

110 G. Agosti and V. Farinella, 'Interni senesi "all'antica"', in *Domenico Beccafumi e il suo tempo*, ed. P. Torriti (Milan, 1990), p. 590; Milanesi, *Documenti*, III, p. 18; D. Bandini, 'Memorie Piccolominee in Sarteano', *BSSP*, 57 (1950), p. 127.

111 D. Toracca, 'La Libreria Piccolomini e il gusto per l'antico a Siena', in Settis and Toracca, eds., *La Libreria Piccolomini*, pp. 239–42; A. Angelini in Settis and Toracca, eds., *La Libreria Piccolomini*, pp. 335–8; also A. Angelini, 'I Marrini e gli inizi di Michele Angelo senese', in *Omaggio a Fiorella Sricchia Santoro*, a special double issue of *Prospettiva*, 91–2 (1998–99), I, pp. 127–38.

112 ASS, *Lira* 238, fol. 11 (1509), 'quale al presente si hedifica con grande spesa come si vede'.

113 ASS, *Consiglio Generale* 233, fol. 58 (29 October 1469), 'ala piazza et alla città nostra renderà tanta dignità'.

114 ASS, *Consorteria Piccolomini* 17, fol. 54r, 'che a Madonna nostra madre le rimanghi tutte le stantie che lei al presente habita, lei vivente'.

115 ASS, *Lira* 192, fol. 159 (1481), 'Mi trovo la meta dei casamenti nostri qui in Siena dove al presente habito colle masserizie ad me bisognevoli, del quale casamento una parte depso e infra, et una altra parte e disabitato et minaccia ruina come pubblicamente si vede'.

116 ASS, *Consorteria Piccolomini* 17, fol. 129v–134v (2 October 1508); a third brother, Giovanni, was excluded from the document as he was Archbishop of Siena.

117 ASS, *Consorteria Piccolomini* 17, fol. 130v, for example, 'lo studio, camere et stanze che al presente si tengono per li forestieri' and 'studio grande sopradetto el quale usava Ms. Andrea loro per lo scrivere'.

118 Brief comments in B. Sani, 'Novità sugli interni senesi all'antica', in *Le dimore di Siena: L'arte dell'abitare nei territori dell'antica Repubblica dal Medioevo all'Unità d'Italia*, ed. G. Morolli (Florence, 2002), pp. 33–4; see also G. Fattorini, 'Alcune questioni di ambito beccafumiano: il "Maestro delle Eroine Chigi Saracini" e il "Capanna senese"', in *Beccafumi. L'opera completa*, ed. P. Torriti (Milan, 1998), pp. 45–6.

119 ASS, *Consorteria Piccolomini* 17, fol. 131v, 'M° Domenico di M° Macteo et Ventura di Ser Giuliano di Tura, maestri di legname et architectori [. . .]'.

120 Turapilli was hired as *operaio* in 1505 with the charge that he teach his art to eight apprentices: see ASS, *Balìa* 254, fol. 210v (11 October 1505; see also Milanesi, 1854, III, p. 29); in 1521 he petitioned for a state pension published by Milanesi (1854), III, p. 75, arguing that 'ha perso la gioventu e quasi tutta la sua eta in ritrovare le cose et intagli antiqui delli quali ha fatta tanta copia a li artefici della Vostra Città che si puo dire che lo antico in decta vostra città si sia ritrovato e si usi per mezzo delle fatiche sue'. Turapilli certainly deserves greater attention from scholars.

121 The role of time in the evolution of slow architectural projects has been considered in a stimulating way by H. Burns, 'Building against Time: Renaissance Strategies to Secure Large Churches against Changes to their Design', in *L'église dans l'architecture de la Renaissance*, ed. J. Guillaume (Paris, 1995), pp. 107–31.

CHAPTER NINE

1 Francesco di Giorgio Martini, *Trattati di Architettura, Ingegneria e Arte Militare*, ed. C. Maltese (Milan 1967), II, 'Settimo Trattato', pp. 492–3: 'et spezialmente questo avviene nelle patrie delli scientifici, perché nissuno profeta è accetto in la patria, non ostante che in questo vizio di ingratitudine non sono incorsi i miei compattrioti'.

2 In the brief biography that follows it will be suggested that Francesco di Giorgio introduced to Siena a patronage model closer to that present in court contexts (such as Urbino, where he had been employed); it is useful to consider the idea of the court artist/architect in a non-courtly context, an issue addressed in relation to Lorenzo de' Medici in Florence. For example see D. Hemsoll, 'Giuliano da Sangallo and the New Renaissance of Lorenzo de' Medici', *The Early Medici and their Artists*, ed. F. Ames-Lewis

(London, 1995), pp. 187–205, and L. Syson, 'Bertoldo di Giovanni: Republican Court Artist', in *Artistic Exchange and Cultural Translation in the Italian Renaissance City*, ed. S. J. Campbell and S. J. Milner (Cambridge, 2004), pp. 96–133.

3 From a vast bibliography, the two exhibition catalogues of 1993 constitute a useful starting-point: F. P. Fiore and M. Tafuri, eds., *Francesco di Giorgio, architetto* (Siena and Milan, 1993), and L. Bellosi, ed., *Francesco di Giorgio e il Rinascimento a Siena* (Siena and Milan, 1993). Some of this material is discussed in my 'Lots of Napkins and a Few Surprises: Francesco di Giorgio Martini's House, Goods and Social Standing in Late-Fifteenth-century Siena', *Annali di Architettura*, 18–19 (2006–7), pp. 71–82.

4 G. Chironi, 'Repertorio dei documenti riguardanti Mariano di Iacopo detto il Taccola e Francesco di Giorgio Martini', in *Prima di Leonardo: cultura delle macchine a Siena nel Rinascimento*, ed. P. Galluzzi (Milan, 1991), p. 474–82, docs. 29–47.

5 *Ibid.*, p. 475, docs 48–53; Milanesi, *Documenti*, II, pp. 400–02; A. S. Weller, *Francesco di Giorgio, 1439–1501* (Chicago, 1943), p. 14, for a loose translation of the letter. On treatment of exiles, see C. Shaw, *The Politics of Exile in Renaissance Italy* (Cambridge, 2000).

6 P. Bacci, 'Commentarii dell'arte senese. I: Il pittore, scultore e architetto Iacopo Cozzarelli e la sua presenza in Urbino con Francesco di Giorgio Martini dal 1478 al 1488', *BSSP*, 39 (1932), pp. 110–11.

7 Chironi, 'Repertorio', p. 475, doc. 64 (26 December 1485) for offer of restitution of confiscated goods if he returned to live and work in Siena; p. 476, doc. 91 (23 January 1488) for credits on 'beni dei ribelli'.

8 This sequence is documented in Milanesi, *Documenti*, II, pp. 413–14.

9 Just as Cozzarelli appears to trace Francesco di Giorgio's residence in Urbino through the *lira*, Antonio Barili seems to have operated on Francesco's behalf on the Macereto project (see Milanesi, *Documenti*, II, p. 411).

10 The most accurate survey of the political developments remains C. Shaw, 'Politics and Institutional Innovation in Siena (1480–98)', *BSSP*, 103 (1996), pp. 91–102, and 104 (1997), pp. 194–307.

11 Milanesi, *Documenti*, II, pp. 416–18.

12 G. Chironi, 'Appendice documentaria', in *Francesco di Giorgio, architetto*, p. 476, doc. 91 (23 January 1488).

13 G. Chironi, 'Politici e ingegneri. I Provveditori della Camera del Comune di Siena negli anni '90 del Quattrocento', *Ricerche Storiche*, 23/2 (1993), pp. 375–95.

14 G. Della Valle, *Lettere sanesi sopra alle belle arti* (Rome, 1786), III, p. 93.

15 Chironi, 'Politici e ingegneri', pp. 385–6.

16 ASS, *Legato Bichi Borghesi*, 33 (5 July 1491), sale witness to Giacoppo.

17 Chironi, 'Repertorio', pp. 476–81, docs. 99–174.

18 *Ibid.*, p. 479, doc. 148.

19 As documented in correspondence published in D. Carl, 'Giuliano da Maiano und Lorenzo de' Medici. Ihre bezeihung im lichte von zwei neaufgefundenen briefen', *Mitteilungen des Kunsthistorisches Instituts in Florenz*, 37 (1993), pp. 235–56; also, M. Tafuri, *Ricerca del Rinascimento. Principi, città, architetti* (Turin, 1992), pp. 94–6; F. W. Kent, *Lorenzo de' Medici and the Art of Magnificence* (Baltimore and London, 2004).

20 For a comprehensive survey of the architect's career and built works, see Fiore and Tafuri, eds., *Francesco di Giorgio,*

architetto. For discussion of Francesco di Giorgio's reputation, see N. Adams, 'Knowing Francesco di Giorgio', in *Francesco di Giorgio alla corte di Federico da Montefeltro: atti del convegno internazionale di studi*, ed. F. P. Fiore (Florence, 2004), I, pp. 305–16.

21 The bibliography on the subject is vast. For the two treatises, see Francesco di Giorgio Martini, *Trattati di Architettura, Ingegneria e Arte Militare*, ed. C. Maltese, 2 vols. (Milan, 1967). On dating issues, see M. Mussini, 'La trattatistica di Francesco di Giorgio: un problema critico aperto', in *Francesco di Giorgio, architetto*, pp. 358–79, with bibliography; see also the extended discussion in M. Mussini, *Francesco di Giorgio e Vitruvio: Le traduzioni del 'De Architectura' nei codici Zichy, Spencer 129 e Maglaibecchiano II.I.141*, 2 vols. (Florence, 2003), summarized I, pp. 223–30, and M. Mussini, 'Siena e Urbino. Origini e sviluppo della trattatistica martiniana', in *Francesco di Giorgio alla corte di Federico da Montefeltro*, I, pp. 317–36.

22 See Mussini, 'La trattatistica di Francesco di Giorgio', pp. 358–9; also C. Maltese, 'Introduzione', in Francesco di Giorgio Martini, *Trattati*, pp. xxxii–lxiv. A useful, if problematic, survey of the copying tradition of the treatises can be found in G. Scaglia, *Francesco di Giorgio: Checklist and History of Manuscripts and Drawings in Autographs and Copies from ca. 1470 to 1687 and Renewed Copies (1764–1839)* (London, 1992); for one of a number of critical voices, see C. H. Clough, 'Francesco di Giorgio: Checklist and History of Manuscripts and Drawings', *Renaissance Studies*, 8 (1994), pp. 95–106.

23 On the use of the *Trattato* as a 'visiting card', see F. Ames-Lewis, *The Intellectual Life of the Early Renaissance Artist* (New Haven and London, 2000), pp. 66–9, 232; also Clough, 'Francesco di Giorgio', p. 101, for a 1479 meeting in Siena between Francesco, Duke Federico da Montefeltro, and Alfonso, Duke of Calabria. On Urbino as the environment for Francesco's treatise production, see Mussini, *Francesco di Giorgio e Vitruvio*; also G. Clarke, *Roman House – Renaissance Palaces: Inventing Antiquity in Fifteenth-century Italy* (Cambridge, 2003), pp. 92–7.

24 Preserved in BCS, S. IV. 4 and Biblioteca Nazionale Centrale, Florence [BNCF], Magliabecchiano II. I. 141 (published as Francesco di Giorgio Martini, *Trattati di Architettura, Ingegneria e Arte Militare*, ed. C. Maltese, Milan, 1967, II).

25 Francesco di Giorgio Martini, *Trattati*, II, 'Primo Trattato', pp. 309–19, 'Secondo Trattato', pp. 343 and 358 ('io vidi nella città mia'). Local stone can be compared to findings in R. Parenti, 'I materiali del costruire', in *Architettura civile in Toscana: il Medioevo*, ed. A. Restucci (Siena, 1995), pp. 371–99. On the grain stores, see M. A. Ceppari, 'Tra legislazione annonaria e tecnologia: alla ricerca di una Biccherna perduta', in *Antica legislazione della Repubblica di Siena*, ed. M. Ascheri (Siena, 1993), pp. 201–23. Francesco had of course been master of the *bottini*, the city's underground aqueduct; see chapter One and P. Galluzzi, 'Le macchine senesi. Ricerca antiquaria, spirito di innovazione e cultura del territorio', in *Prima di Leonardo: cultura delle macchine a Siena nel Rinascimento*, ed. P. Galluzzi (Milan, 1991), pp. 15–44; also P. Galluzzi, ed., *Mechanical Marvels: Invention in the Age of Leonardo* (Florence, 1997), pp. 120–46.

26 Francesco di Giorgio Martini, *Trattati*, II, 'Settimo Trattato', pp. 492–3, 'nissuno profeta è accetto in la patria, non ostante che in questo vizio di ingratitudine non sono incorsi i miei compattrioti'.

27 C. Maltese (Francesco di Giorgio Martini, *Trattati*, II, p. 493 n. 2) indicated specific periods of good relations as 1489–90, 1493 and post-1497; in fact, relations appear to have been good throughout the period from 1487, as discussed above.

28 On the phenomenon of the stratification of urban space, see J. Ackerman and M. Rosenfeld, 'Social Stratification in Renaissance Urban Planning', in *Urban Life in the Renaissance*, ed. S. Zimmerman and R. Weissman (Newark, 1989), pp. 21–49.

29 F. Patrizi, *De Institutione Reipublicae libri novem* (Paris: Galeotto da Prato, 1520), I have found no copies of the putative 1494 edition; the letter is also contained in the vellum presentation volume prepared for Sixtus IV, BAV, MS. Vat. Lat. 3084, fol. 4v. The Sienese context of production is noted by Benetti Bertoldo, 'Francesco Patrizi the Elder', pp. 146–61.

30 For more detailed discussion, see chapter Four.

31 Patrizi, *De Institutione Reipublicae*, fol. lxxxvi verso (Bk VI. 1), 'Proinde populum trifariam distribuendum statuit, ut pars una artifices, altera agricolas, tertio vero belli propulsatores continerent [. . .] primum Patricium appellaverunt, secundum equestrem, tertium vero plaebeium'.

32 Patrizi, *De Institutione Reipublicae*, fol. cxxi verso (Bk VIII. 11), 'ut privata domus descripta sit ad usum, ac comoditate familiae, necque in ea pars vulla sit vacua et inutilis'.

33 Patrizi, *De Institutione Reipublicae*, fol. cxxi verso–cxxii recto (Bk VIII. 11), 'Secundum vias privatae aedes longo ordine ad pares (si fieri potest) dimensiones constituende sunt, ut speciem urbis ornent. Nec quippam exporrectum habeant, quod viis impedimento esse posit [. . .] In privatis tamen aedificiis sancta illa mediocritas servanda est, quae res omnes mirifice commendat, ut peripatetici asserunt'.

34 Patrizi, *De Institutione Reipublicae*, fol. cxv and cxxi (Bk VIII part 1 and 10).

35 On social stratification, see the useful essay by Ackerman and Rosenfeld, 'Social Stratification', pp. 21–49; for the Casato, and more generally the development of elite enclaves in Siena after 1555, see F. Bisogni, 'La nobiltà allo specchio', in *I libri dei leoni. La nobiltà di Siena in età medicea*, ed. M. Ascheri (Siena, 1996), pp. 201–84.

36 Patrizi, *De Institutione Reipublicae*, fol. cxv (Bk VIII.1), 'Architectum optimum ad videndum esse cum urbis statuitur'.

37 Francesco di Giorgio Martini, *Trattati*, II, p. 342.

38 Francesco di Giorgio Martini, *Trattati*, II, pp. 364–5 (Bk III).

39 *Ibid.*, precept 11.

40 C. Shaw, *L'ascesa al potere di Pandolfo Petrucci il Magnifico. Signore di Siena (1487–1498)* (Siena, 2001); Chironi, 'Nascita della signoria e resistenze oligarchiche'.

41 P. Jackson, 'Le regole dell'oligarchia al tempo di Pandolfo Petrucci', in *Siena e il suo territorio nel Rinascimento*, ed. M. Ascheri (Siena, 2000), pp. 209–13.

42 Unless otherwise mentioned, documentary sources for land acquisitions are published in my 'Creating a Stage for an Urban Elite: The Re-development of the Via del Capitano and Piazza Postierla in Siena', in *The World of Savonarola: Italian Elites in Crisis*, ed. C. Shaw and S. Fletcher (London, 2000), pp. 182–93.

43 D. Gallavotti Cavallero, ed., *Lo Spedale di Santa Maria della Scala. Vicende di una committenza artistica* (Pisa, 1985), pp. 265; serious research on this important issue has only recently been undertaken by Philippa Jackson as part of her 'Pan-

dolfo Petrucci: Politics and Patronage in Renaissance Siena', PhD thesis, Warburg Institute, University of London, 2007, which I have not yet been able to consult.

44 ASS *Ospedale Santa Maria della Scala*, 528, fol. 94.

45 ASS *Legato Bichi Borghesi*, 33 (5 July 1491). The heirs of Alessandro Sermoneta owned much property in the via del Capitano area, see the tax report for 1488 (ASS, *Lira 217*, fol. 91), and were the object of Antonio Bichi's acquisition campaign, for which see comments below.

46 ASS, *Ospedale Santa Maria della Scala*, 172, fol. 90 (1489), where Neroccio's and a number of other properties are described as 'Vendessi a Giacoppo Petrucci'. Published in full in my 'Lots of Napkins and a Few Surprises'.

47 There is a rich literature documenting Vecchietta's relations with the Spedale della Scala: see H. W. van Os, *Vecchietta and the Sacristy of the Siena Hospital Church: A Study in Renaissance Religious Symbolism* (The Hague, 1974).

48 Shaw, 'Politics and Institutional Innovation' (part II: 1997), p. 234.

49 *Ibid.*, pp. 243–4; see also R. Terziani, *Il governo di Siena dal medioevo all'età moderna: la continuità repubblicana al tempo dei Petrucci (1487–1525)* (Siena, 2002), pp. 57–62.

50 For the history of the palace under the Medici, see M. Morviducci, 'Dai Petrucci alla Provincia. Il Palazzo del Governatore come sede del potere a Siena', in *Palazzo della Provincia a Siena*, ed. F. Bisogni (Rome, 1990), pp. 55–108. An unpublished record of the palace history, probably made as a report prior to acquisition plans by the Medici, is in Archivio di Stato di Firenze, *Mediceo del Principato*, 2009, fol. 82 [undated; 1568]: 'Iacopo Petrucci fratello di Pandolfo edificò il suo palazzo appresso al Domo poco di poi che entrorno e'nove in Siena che fù l'anno 1490 circa. Spese in detto edifitio fiorini 12 mila nel qual tempo valeva lo scudo d'oro lire sei, di modo che la spesa fù circa di scudi 8 mila ala moneta di presente. Il detto palazzo fù lassato in perfetto dal detto Iacopo il qual morse senza testamento e lassò quattro figli maschi cioè Guaspparre, Giovan Francesco, M. Petruccio et il Cardinal Raffaello [. . .] Il cardinal Raffaello sopravisse a tutti li fratelli e acrebbe il detto palazzo fino al termine si trova di presente, e spese fra la compera della piazza e la fabbrica circa scudi 2 mila, qual compera e spesa fece sempre a nome di detti suoi nipoti, Iacopo e Antonio Maria [. . .] Quanto alla valuta d'esso palazzo il S. Marcello Augustini volse comperarlo per scudi 4500 d'oro, e dicono no seguì la vendita perche tutt'e dua le parti si pentirono per diversi respetti. Informatomi da qualcuno et inteso piu openioni dico che quando si pagassi detto palazzo scudi 4500 insino a scudi 5000 di moneta di lire 7 per scudo a gabella del comperatore, mi parrebbe fussi prezzo ragionevole, e da contentar' sene chi lo vende, rimettendomene sempre a ogni miglior giuditio, questo è quanto mi occorre dire er informatione di questo fatto'.

51 Morviducci, 'Dai Petrucci alla Provincia', p. 59.

52 Shaw, 'Politics and Institutional Innovation' (part II: 1997), pp. 243, 244; Shaw, *The Politics of Exile*, p. 50.

53 The acquisition is documented in ASS *Diplomatico Bichi Borghesi*, Pergamene Bichi, vol. I, doc. 193a–e (summarized in ASS MS. B 25, fol. 79–79v), dated through August–September 1491, for a total cost of 1,200 florins.

54 The intervention of Venafro is documented ASS *Diplomatico Bichi Borghesi*, Pergamene Bichi, vol. I, doc. 193 c (summarized in ASS MS. B 25, fol. 79v; 30 August 1491) and Pan-

dolfo Petrucci, 193 g (ASS MS. B 25, fol. 80v–81v; 24 September 1491).

55 ASS *Diplomatico Bichi Borghesi*, Pergamene Bichi, vol. 1, doc. 193 h–i (summarized in ASS MS. B 25, fol. 82; 13 October 1491), 70 florins to be paid as income from property at the rate of 12 *lire* (approximately 3 florins) per year.

56 ASS *Diplomatico Bichi Borghesi*, Pergamene Bichi, vol. 1, doc. 193 n (summarized in ASS MS. B 25, fol. 83; 28 November 1491); additional properties are documented in the same fascicule, which can be used to reconstruct the full acquisition history of the palace in greater detail than has been attempted here (see, doc. 193 k–m for three smaller transactions).

57 G. A. Pecci, *Memorie storico-critiche della città di Siena che servono alla vita civile di Pandolfo Petrucci*, 2 vols. (Siena, 1755; repr. Siena, 1988), I, p. 161, refers to the Bichi palace; briefly mentioned by R. Terziani, 'Una ipotesi sui palazzi di Iacoppo Petrucci e Antonio Bichi', in *La città magnificata*, ed. Pertici, pp. 143–4. S. Tizio, *Historiae Senenses*, vol. 1.2.1, ed. G. Tomasi Stussi (Rome, 1995), p. 242 describes the palace as 'macineis lapidibus tum pictura et cathenis exornatum'. (The other volumes in the series *Historiae Senenses* are vol. 1.1.1, ed. M. Doni Garfagnani (Rome, 1992), and vol. 3.4, ed. P. Pertici, Rome, 1998.) The site is described effectively in the sale document of Alessandro Sermoneta's home, see ASS *Diplomatico Bichi Borghesi*, Pergamene Bichi, vol. 1, 193 c (summarized in ASS MS. B 25, fol. 79v; 30 August 1491), 'con orto, e cisterna, posta nel Terzo di Città, e popolo di San Giovanni, in luogo detto il Capitano, ovvero alla Postierla, confinante con Giacobbe di Bartolomeo Petrucci e con Pagolo Venturini, e con la strada pubblica'.

58 ASS *Diplomatico Bichi Borghesi*, Pergamene Bichi, vol. 1, doc. 193 o (summarized in ASS MS. B 25, fol. 83v; 14 July 1497), 'ex gratia conceserunt pro edificandi quibus murellis sedilibus ante domum ipsius Domini Antonii, sitam in contrata del Capitano in civitate Senensis, cui ante strata publica comunis et ab uno domus sive palatium Iacoppi de Petruccis, ex ex° heredum Christophori de Gabriellis [. . .] qui murelli pro sedendo sint largi uno brachio ut circa, item murella pro pedibus retinendis sint largi uno brachio et uno quarto alterius brachii'.

59 ASS *Lira* 236, fol. 27, 'più creditori di 200 *lire* in giù tra butigari, muratori, fornaciari e altre simili persone in somma di fl 600'.

60 ASS *Lira* 236, fol. 27; for a full analysis of Bichi property ownership in fifteenth-century Siena, see chapter 2.2.b of my 'Urbanism in Siena (c. 1450–1512). Policy and Patrons: Interactions between Public and Private', PhD thesis, Courtauld Institute of Art, London, 1998.

61 ASS *Lira* 236, fol. 6, 'uomo poco facoltoso, poco assennato ma ambizioso'.

62 ASS *Lire* 234, fol. 4, 26, 50, 53, 97; 236 fol. 6; 111, 274; 122, 15r; on debts to Petrucci see Shaw, 'Politics and Institutional Innovation' (1997), p. 249.

63 On industry and political alliances see Chironi, 'Politici e ingegneri', pp. 375–95.

64 Chironi, 'Politici e ingegneri'; F. Sricchia Santoro in *Francesco di Giorgio e il Rinascimento a Siena*, ed. Bellosi, pp. 444–7. For this earlier dating of the Bichi chapel, see T. Henry, '"magister Lucas de Cortona, famosissimus pictor in tota Italia . . ."', in *Siena nel Rinascimento: l'ultimo secolo della repubblica*, ed. Mazzoni and Nevola. For debts outstanding to the bank of Alessandro Bichi at the time of Francesco's death, see my 'Lots of Napkins and a Few Surprises'.

65 Palace described in Tommaso's will, ASS *Particolari Famiglie Senesi* 124, fol. 1v (1468); restorations mentioned in ASS *CG* 236, fol. 242 (18 April 1476).

66 For Pius II, see letter of request from Mantua, ASS *Concistoro* 1995, fol. 56 (25 September 1459); Ippolita Sforza and Eleanor of Aragon in A. Allegretti, *Ephemerides Senenses ab anno MCCCCL usque ad MCCCCXCVI italico sermone scriptae*, in *Rerum Italicarum Scriptores*, ed. L. Muratori, vol. 23 (Milan, 1733), pp. 772, 775.

67 ASS *Lira* 236, fol. 119, 'al terzo piano', also 1, 17, 20, 35, 36, 49, 50, 65 and ASS *Lira* 111, fol. 265.

68 For *Operaio* see G. Aronow, 'A Documentary History of the Pavement Decoration in Siena Cathedral, 1362 through 1506', PhD thesis, Columbia University, 1985, p. 508; In 1503 Bartolomeo Pecci prepared the city's celebration of the election of Francesco Todeschini Piccolomini as Pope Pius III (see ASS *Balìa* 253, fol. 178 [22 September 1503]), while in 1515 he oversaw preparations for the triumphal entry of Pope Leo X to Siena (see my '"El Papa non verrà": The Failed Triumphal Entry of Leo X de' Medici to Siena (November 1515)', *Mitteilungen des Kunsthistorisches Instituts in Florenz*, forthcoming).

69 A. Lusini, 'Notturno senese: il Palazzo del Capitano', *Terra di Siena*, 9 (1955), pp. 12–14; A. Bruno, 'Palazzo del Capitano', in *Università di Siena: 750 anni di storia*, ed. M. Ascheri et al. (Siena, 1991), pp. 407–9.

70 Plans for the palace were discussed in ASS, *Balìa*, 49, fol. 59v [28 September 1503] for committee of Pietro Borghese, Giacomo di Giunta and Paolo Vannoccio Biringucci and ASS, *Balìa*, 49, fol. 67v–68 (17 October 1503), with a favourable decision that stated, 'non est in alcunis preiuditium in ornamentum civitatis quod nobilis vir Augustinis Marianis de Chisis non possit in illo modo unum muro faciendo sive fundamentibus fiendis apud Postierle TC, [. . .] pro fabricanda domo nova'.

71 On Agostino's relations with Siena see the correspondence with his brother, Sigismondo, in I. D. Rowland, *The Correspondence of Agostino Chigi (1466–1520) in Cod. Chigi R.V.c* (Vatican City, 2001), and 'Agostino Chigi e la politica senese del '500', in *Siena nel Rinascimento: l'ultimo secolo della repubblica*, II, Acts of the International Conference, Siena (28–30 September 2003 and 16–18 September 2004), ed. M. Ascheri and F. Nevola (Siena: Accademia Senese degli Intronati, 2007). On the fortunes of Agostino's palace project for piazza Postierla, see my 'Il palazzo Chigi alla Postierla: sistemazione urbana e genesi del progetto,' in *Il Palazzo Chigi Piccolomini alla Postierla*, ed. N. Fargnoli, *Quaderni della Soprintendenza per il patrimonio storico, artistico e demoetnoantropologico di Siena e Grosseto*, 6 (2007), 26-43. Sigismondo was himself an important patron of architecture in Siena and the countryside, as discussed below.

72 ASS *Particolare Famiglie Senesi* 39, for a copy of Agostino Chigi's will. ASS, *Balìa* 254, fol. lxiv (20 July 1521), for the building permit; also ASS, *Balìa*, 71, fol. 8v (3 July 1521) and fol. 11r–v (11 July 1521).

73 For sales and concessions from the *Opera del Duomo* see my 'Creating a Stage for an Urban Elite'. For the 1506 new *Opera* committee see S. Moscadelli, *Inventario analitico dell'Archivio dell'Opera Metropolitana di Siena* (Munich 1995), p. 148. Aronow, 'A Documentary History', p. 508, states that Petrucci's control of the office began from 1503 (as a *savio*), although his influence on decision-making can be traced as early as his 1497 involvement in the committee for rear-

74 ranging the Duomo altar: see C. Zarrilli, 'Francesco di Giorgio pittore e scultore nelle fonti archivistiche senesi', in *Francesco di Giorgio e il Rinascimento a Siena*, ed. Bellosi, p. 534, doc. 41. Conclusive evidence for Pandolfo's control of the institution is awaited in the forthcoming work of P. Jackson.

74 AOMS, *Contratti* 23 (27; 1438–1599), fol. 14 (20 March 1506). On Cozzarelli's collaboration with Francesco di Giorgio, see Bacci, 'Commentarii dell'arte senese', pp. 110–11.

75 Summarized by F. Cantatore, 'Opere bronzee', in *Francesco di Giorgio, architetto*, pp. 326–7, and M. Tafuri, 'Le chiese di Francesco di Giorgio', in the same volume, p. 64; most recently, F. P. Fiore, 'Siena e Urbino', in *Storia dell'architettura italiana: il Quattrocento*, ed. F. P. Fiore (Milan, 1998), p. 286.

76 G. Vasari, *Le vite*, ed. P. Barocchi, V, p. 166 (for Beccafumi) and p. 383 (for Sodoma); see also the contract between Agostino Bardi and Sodoma, dated 9 November 1513 (with thanks to Carol Plazzotta for bringing this reference to my attention).

77 Most recently discussed in A. de Marchi, 'Progetto per la decorazione di casa Borghesi', in *Domenico Beccafumi e il suo tempo*, ed. Torriti, pp. 426–7; see also the classic essay by E. Panofsky, 'Excursus on Two Façade Designs by Domenico Beccafumi', in *Meaning in the Visual Arts* (London 1955), pp. 266–76, 268–70.

78 Dating of the façade is further supported by a drawing in a sketchbook attributed to the young Beccafumi, sold at auction at Christie's, London, 7 July 1959, fol. 10 (for which see also D. Sanminiatelli, 'The Beginnings of Domenico Beccafumi', *Burlington Magazine*, XCIV, 1957, p. 401).

79 For the Medici Palazzo del Governatore, see F. Bisogni, ed., *Palazzo della Provincia a Siena* (Rome, 1990).

80 V. Lusini, 'Note storiche sulla topografia di Siena nel sec. XIII', *BSSP*, 28 (1921), pp. 311–12.

81 On the anti-magnate laws of 1277 see D. Waley, *Siena and the Sienese in the Thirteenth Century* (Cambridge, 1991), pp. 77–82.

82 V. Lusini, 'Note storiche', p. 312, refers to 'le nuove abitazioni costruitevi da famiglie delle grandi casate', mentioning the names of Gregori, Marescotti, Ranieri, Lambertini, Lombardo, Cerretani, Mattasala, Alessi and Accarigi. For street widths, see D. Balestracci and G. Piccinni, *Siena nel Trecento. Assetto urbano e prassi edilizia* (Florence 1977), pp. 45–6. Statutes also identified it as a major street, see *Il Costituto del Comune di Siena volgarizzato nel MCCCIX–MCCCX*, ed. M. S. Elsheikh (Città di Castello, 2002), II, p. 41 (Dist. III.88) and pp. 309–10 (Dist. V.140).

83 S. Cohn, *Popular Protest in Late-medieval Europe: Italy, France and Flanders* (Manchester, 2004), pp. 17–18, 59.

84 On the Casato and nobles, and later the fourteenth-century *Nine*, see Cohn, *Popular Protest*, p. 59; thanks also to Sam Cohn for helpful comments on this area and references to the Casato as a *Novesco* street in the fourteenth century. Some comments for the sixteenth century are in Bisogni, 'La nobiltà allo specchio', pp. 201–84.

85 Construction of the Loggia dei Banchetti is documented in ASS, *Particolari Famiglie Senesi* 82, unfoliated (1506); for the fresco it protected, see K. Christiansen, *Gentile da Fabriano* (Ithaca, NY, 1982), pp. 50–55, 137.

86 ASS, *Lira* 185, fol. 205 (1481) Giovanni di Battista, detto Malefaccia, servitore di palazzo and Niccolò di Tura (ASS, *Lira* 185, fol. 230), trombetta del comune. Agostino di

Cenni, cartaio (ASS, *Lira* 185, fol. 206), 'ho una povavara buttiga d'arte dei cartai chon pocho chapitale et se non fusse un pocho di credito [. . .] perche se fa pocho per amore dei tempi forti e non v'e studio e quando non ci e studio, l'arte nostra fa debito'.

87 See, for example, on Florence, F. W. Kent, *Household and Lineage in Renaissance Florence: The Family Life of the Capponi, Ginori and Rucellai* (Princeton, NJ, 1971); more recently, from a different angle, see B. Preyer, 'Florentine Palaces and Memories of the Past', in *Art, Memory and Family in Renaissance Florence* (Cambridge, 2000), pp. 176–94.

88 Shaw, *Politics of Exile in Renaissance Italy*, pp. 40–54.

89 From the 1488 tax records, see ASS, *Lira* 215, fol. 209, 232, 286, 329, 354.

90 Implications for property are not addressed by Shaw, *Politics of Exile*, but decisions made in the days after the return of the *Nove* in 1487, indicate that such matters were of pressing concern; see ASS, *Balià* 35, fol. 3v (23 July 1487) and fol. 9 (28 July), when a committee of nine was elected to supervise the process of property restitution. A volume containing a number of property disputes negotiated by the 'Ufficiali delle confische' and recorded as being 'Atti dei commissari deputati alla restituzione dei beni confiscati' can be found in *Notarile Antecosimiano* 1068 (notary, Vincenzo di Matteo Vivi da Siena: 1485–1495).

91 ASS, *Lira* 215, fol. 286 (Vanni di Signorino Pecci), fol. 329 (Girolamo di Niccolò Pasquali) and fol. 232 (Bandino di Francesco Tommasi), all from 1448.

92 ASS, *Lira* 136, fol. 67 and ASS, *Lira* 57 fol. 24r, 25v and 26r for 1453. By 1481, six Pecci lived in the vicinity of the Palazzo del Capitano; by 1509 they were twelve. For a description of the new palace, see Tommaso's will, ASS *Particolari Famiglie Senesi* 124, fol. 1v (1468).

93 See the tax records of 1453: ASS, *Lira* 136, fol. 13 for Caterina and fol. 16 for Francesco di Bartolomeo, who stated, 'Inprima o a pagare infra termine d'uno anno fl cinquecento a Mona Caterina mia matrigna e dona che fu di Bartolomeo mio padre per la dote sua'. Documents and analysis of the palace have been published by A. L. Jenkens, 'Caterina Piccolomini and the Palazzo delle Papesse in Siena', in *Beyond Isabella: Secular Women Patrons of Art in Renaissance Italy*, ed. S. Reiss and D. Wilkins (Kirksville, MO, 2001), pp. 77–91. It is important to note that previous biographies have mistakenly considered Caterina's husband to have still been alive at the time of the palace's construction, but tax records show this not to have been the case. See Ugurgieri della Berardenga, *Pio II Piccolomini*, pp. 135, 220.

94 Documentation provided in my 'Ambrogio Spannocchi's "bella casa": Creating Site and Setting in Quattrocento Sienese Architecture', in *Renaissance Siena: Art in Context*, ed. A. L. Jenkens (Kirksville, MO, 2005), pp. 141–56.

95 Information is drawn from the tax returns for the districts contained in ASS, *Lira* 136 (1453), 185–6 (1481) and 215 (1488). It has proved impossible to tabulate this information adequately.

96 ASS, *Concistoro* 2125, fol. 40 [1466: Pietro di Giovanni di Benedetto], fol. 84 [1468: Pietro di Giovanni di Benedetto] and fol. 133 [1475: Redi di Niccolo di Minuccio]. For 1509, see ASS, *Lira* 234.

97 ASS, *Lira* 234, fol. 274, 'Habiamo debito una partte de la casa di Siena conprammo, che fra balatoi e una cosa e una altra era meglio escirne di guerra'.

98 ASS, *Lira* 234, fol. 263, 'ce si e levato el ballatoio per chomandamento di quelli de l'onoranza'.

99 ASS, *Balià* 253, fol. 240 [16 Sept 1507] and fol. 241 [13 Oct]. Pietro Borghesi, Iacobo di Giunta and Paolo Vannoccio were named to supervise these alterations.

100 On this process, see S. Cohn, *Death and Property in Siena, 1205–1800* (Baltimore, 1988), pp. 146–58; also G. Catoni and G. Piccinni, 'Famiglie e redditi nella Lira senese del 1453', in *Strutture familiari, epidemie e migrazioni*, ed. R. Comba, G. Piccinni and G. Pinto (Naples, 1984), pp. 291–304.

101 The observation is drawn from those declarants for whom sufficient data is available to make such statistics; see ASS, *Lira* 136 (for 1453) and 185 (for 1481).

102 Findings from tax declarations for the Casato di Sotto in ASS, *Lira* 137 (1453), where 9 of 27 mention a banking interest.

103 Some confusion surrounds the identification of the original patron of what is now known as the Palazzo Ugurgieri; it has recently been advanced by Trinita Kennedy that the Benassai may have been the original owner-developers; see note 125 below.

104 In addition to 'powerful' residents, such as Sigismondo Chigi, and members of families that include Bargagli (2), Benassai (3), Borghesi (4), Ghinucci (1), Nini (5), Piccolomini (3), Turamini (1), Pasquali (6), Placidi (4) and Turamini (2) who were connected to the oligarchy, debts, business interests, dowries, etc., are specified by Prospero di Niccolo di Battista (ASS, *Lira* 234, fol. 117), Redi di Francesco Bardi (ASS, *Lira* 234, fol. 121), Antonio di Bernardino Nuto (ASS, *Lira* 234, fol. 147), Conte di Pietro Bargagli (ASS, *Lira* 234, fol. 140), Giovan' Battista di Francesco Guglielmi (ASS, *Lira* 234, fol. 116), Paolo di Cristofano Turmaini (ASS, *Lira* 234, fol. 324), Alessandro Borghese (ASS, *Lira* 234, fol. 219) and Redi di Neri Placidi (ASS, *Lira* 234, fol. 214).

105 ASS, *Lira* 234, fol. 140, 'Ho piu speso a fare quella pocha della faccia che non vala tutto riesto della chasa'.

106 ASS, *Lira* 234, fol. 117, 'per far fede a una promessa al Magnifico Pandolfo'.

107 ASS, *Lira* 234, fol. 116: 'l'altre habbiamo novamente comprata contigua alla nostra habitiamo, da Petroccio Petrocci perche la nostra che al presente habitiamo e di pochissimo recepto. Costo 700 fl, la quale l'ha pagata per noi el sopranominato Petrocci per Cristofano Colombini [. . .] per parte di 1500 fl habbiamo havere da lui per la dote di Mariana nostra donna'. For Petruccio Petrucci, Pandolfo's nephew, see Shaw, *L'ascesa al potere*, pp. 115–17.

108 ASS *Lira* 234, e.g. fol. 116, 120, 121, 191, 214, 219, 238 and numerous other entries.

109 Further research in this direction would be very fruitful; for an isolated example of such extended commercial networks see Chironi, 'Politici e ingegneri'.

110 See I. D. Rowland, *The Correspondence of Agostino Chigi*.

111 R. Bartalini, *Le occasioni del Sodoma. Dalla Milano di Leonardo alla Roma di Raffaello* (Rome, 1996), p. 112.

112 BAV, *Archivio Chigi* R.v.f, 'Acquisti di Sigismondo Chigi', provides a good entry for rural acquisitions. It is these acquisitions that were the basis for much of the seventeenth-century development of family estates.

113 For the acquisition *Spannocchi* A12, Niccolo and Ambrogio Spannocchi sale of a house to Mariano Chigi (undated); also Frittelli (1922). Further acquisitions are recorded in BAV, *Archivio Chigi* 11445, fol. 279r–287r (16 February 1486–14 October 1496), for which references I thank Philippa Jackson.

114 ASS, *Giudice Ordinario (Ruota)*, 5, fol. 293 (doc. 40), 21 February 1504 (1505), outlines plans to acquire the neighbouring property of the Neapolitan banking family, the heirs of Giovanni Mirabilli (reference also in Rowland, *Correspondence of Agostino Chigi*, p. 74).

115 Most recent discussion of the palace is M. Quast, 'Il Palazzo Chigi al Casato', in *Alessandro VII Chigi (1599–1667). Il papa senese di Roma moderna*, exh. cat., ed. A. Angelini, M. Butzek and B. Sani (Siena and Florence, 2000), pp. 435–7. The plans for enlargement were first mooted in 1636, in Agostino Chigi's will; see A. Chigi et al., *Testamentum Augustini, Augusti, Sigismundi de Chigiis* (Siena: Apud Bonettos, 1640), p. 31, which states 'ho pensiero se piacerà a Dio di ridurre la faccia dinanzi di Due case comprate conforme in tutte sue parti, così della altezza, come dell'Ordine, e dell'Ornato, alla faccia della casa nostra Vecchia'.

116 ASS, *Lira* 234, fol. 318, 'casa [. . .] nela quale abbiamo spesi assai et per inchomodita grande bixogniamo ancora rifare li muri di dietro che fara deli spese assai. Sotto la quale casa cie pigioni per circha fl xxv'.

117 F. Sricchia Santoro, 'Il giovane Sodoma', *Prospettiva*, 30 (1982), pp. 50–51; Bartalini, *Le occasioni del Sodoma*, pp. 114–17; see Quast, 'Palazzo Chigi', p. 435.

118 Bartalini, *Le occasioni del Sodoma*, p. 114; Fabio Chigi, 'Chigiae Familiae Commentarii (1618)', in G. Cugnoni, *Agostino Chigi il Magnifico* (Rome 1878), pp. 81–2, cites Fabio Chigi's remarks of 1618: 'omnia eius artificius opera, qui anteriorem quoque domus, faciem pinxit, Iohannes Antonius Vercellensis cognomento Sodoma decreverat Sigismundus Aedes in forum usque perducere nobiliorem sane in speciem'.

119 F. P. Fiore, 'Villa Chigi alle Volte', in *Francesco di Giorgio, architetto*, pp. 318–25.

120 See C. L. Frommel in *La Villa Farnesina a Roma*, ed. C. L. Frommel (Modena, 2003), II, pp. 9–18.

121 See chapter Six; Balestracci and Piccinni, *Siena nel Trecento*, p. 47, discuss Trecento Casato zoning in favour of access to the Campo by officials.

122 The palace is at via del Casato, no. 31, mentioned by M. Quast, 'Palace Façades in Late Medieval and Renaissance Siena: Continuity and Change in the Aspect of the City', in *Renaissance Siena: Art in Context*, ed. Jenkens, p. 59. It bears the Bardi arms, and the family lived in the district in 1509 (ASS, *Lira* 234, fol. 6). An inscription dated 1490 is set into the façade, although this provides no evidence for the date of construction.

123 Bisogni, 'La nobiltà allo specchio', pp. 211–15.

124 G. Fattorini, 'Alcune questioni di ambito beccafumiano: il "Maestro delle Eroine Chigi Saracini" e il "Capanna senese"', in *Beccafumi. L'opera completa*, ed. Torriti, pp. 45–6.

125 There has been some discussion of the ownership and patronage of this palace, as evinced from a verbal communication of Trinita Kennedy to M. Quast, 'Il linguaggio di Francesco di Giorgio nell'ambito dell'architettura dei palazzi senesi', in *Francesco di Giorgio alla corte di Federico da Montefeltro: atti del convegno internazionale di studi,* ed. F. P. Fiore (Florence, 2004), II, pp. 409–11.

126 For the Palazzo Spannocchi, see chapter Six; Torriti, *Tutta Siena, contrada per contrada*, p. 164, suggests a fifteenth-century design. Quast, 'Il linguaggio di Francesco di Giorgio', p. 409, proposes a connection of the window design to Francesco di Giorgio's designs.

127 C. Burroughs, *The Italian Renaissance Palace Façade: Structures of Authority, Surfaces of Sense* (Cambridge, 2002), pp.

151–73; C. Elam, 'Lorenzo's Architectural and Urban Poli-
cies', in *Lorenzo il Magnifico e il suo mondo*, ed. G. C.
Garfagnini (Florence, 1994), pp. 357–82, and M. Tafuri,
Ricerca del Rinascimento. Principi, città, architetti (Turin, 1992),
pp. 90–114, and the excellent essay 'Via Giulia: storia di
una struttura urbana', in *Via Giulia: una utopia urbanistica
del '500*, ed. L. Salerno, L. Spezzaferro and M. Tafuri
(Rome, 1973), pp. 65–152. Sixteenth-century examples are
far more common, see for example, G. L. Gorse, 'A Clas-
sical Stage for the Old Nobility: The Strada Nuova and
Sixteenth-century Genoa', *Art Bulletin*, 79 (1997), pp.
301–27.

128 Tafuri, *Ricerca del Rinascimento*, p. 96.

129 Chironi, 'Politici e ingegneri', pp. 375–95.

130 N. Adams, 'Architecture for Fish: The Sienese Dam on the
Bruna River: Structures and Designs, 1468–ca. 1530', *Tech-
nology and Culture*, 25 (1984), pp. 768–97; for Porto Ercole,
see N. Adams, 'L'architettura militare di Francesco di
Giorgio', in *Francesco di Giorgio, architetto*, p. 152.

131 On expeditions to view military sites in the *contado*, see
documents published by Chironi, 'Repertorio', pp. 470–82,
and supplemented with Chironi, 'Appendice documen-
taria', pp. 400–11.

132 Chironi, 'Repertorio', p. 405. The role of 'architector' to the
Camera del Comune deserves a specialized study. Francesco
may have served in this capacity, and was certainly followed
in it by Vannoccio Biringucci. See G. Chironi, 'Cultura
tecnica e gruppo dirigente: la famiglia Vannocci Biringucci',
in *Una tradizione senese. Dalla 'Pirotechnica' di Vannoccio
Biringucci al Museo del Mercurio*, ed. I. Tognarini (Naples,
2000), pp. 99–130. See also Milanesi, *Documenti*, III, pp.
123–6, for details on Vannoccio's life.

133 See F. Fumi, 'Nuovi documenti per gli angeli dell'altar mag-
giore del Duomo di Siena', *Prospettiva*, 26 (1981), pp. 9–25.

134 Francesco's work for the *Opera* was regular through the
period, as is attested by documents collected in Chironi,
'Repertorio', which include also payments for setting up a
foundry for them (p. 477 [doc. III.100]). Cozzarelli operated
the foundry in the piazza del Duomo, where the angels for
the High Altar were cast to Francesco di Giorgio's designs;
I thank Monica Butzek for this information, published in
Die Kirchen von Siena. Der Dom S. Maria Assunta, ed. P. A.
Riedl and M. Seidel (Munich 2006), vol. III.

135 On S. Spirito: M. Mussolin, 'Il convento di Santo Spirito a
Siena e i regolari osservanti di San Domenico', *BSSP*, 104
(1997), pp. 7–193, and 'The Rebuilding of the Church of
Santo Spirito in the Late Fifteenth Century', in *Renaissance
Siena: Art in Context*, ed. Jenkens, pp. 83–110. For S. Sebast-
iano: M. Tafuri, 'La chiesa di San Sebastiano in Vallepiatta
a Siena', in *Francesco di Giorgio, architetto*, pp. 302–17; Mus-
solin proposes a later dating for the church and attributes
the design to Baldassarre Peruzzi; see M. Mussolin, 'San
Sebastiano in Vallepiatta', in *Baldassarre Peruzzi (1481–1536)*,
Atti del XX seminario internazionale di storia dell'architettura
(Venice, 2005), pp. 95–122.

136 Banchi and Borghesi, *Nuovi documenti*, pp. 382–3; A. Ferrari,
R. Valentini and M. Vivi, 'Il Palazzo del Magnifico a Siena',
BSSP, 92 (1985), p. 110.

137 C. H. Clough, 'Pandolfo Petrucci e il concetto di
"Magnificenza"', in *Arte, committenza ed economia a Roma e
nelle corti del Rinascimento (1420–1530)*, ed. A. Esch and C. L.
Frommel (Turin, 1995), pp. 383–97, 388. From 1506 the
Opera was controlled by Pandolfo Petrucci, Paolo di Van-

noccio Biringucci and Giovanni Guglielmi: see Aronow, 'A
Documentary History', p. 508.

138 F. Fumi, 'Nuovi documenti per gli angeli dell'altar maggiore
del Duomo di Siena', *Prospettiva* 26 (1981), pp. 9–25.

139 Aronow, 'A Documentary History', pp. 353–4, 490, 508;
Clough, 'Pandolfo Petrucci', p. 388.

140 For the space-hungry nature of private patronage, see
Goldthwaite, *Wealth and the Demand for Art*, pp. 129–48.

141 M. Mussolin, 'La chiesa di San Francesco a Siena: impianto
originario e fasi di cantiere', *BSSP*, 106 (1999), pp. 115–55,
and for the traditional attribution of the portal of that
church to Francesco di Giorgio.

142 Many of these churches were damaged by fire in the
seventeenth century and rebuilt; on private chapel patron-
age see Cohn, *Death and Property*, pp. 97–127; more gener-
ally, Goldthwaite, *Wealth and the Demand for Art*, pp. 129–48.
Much work remains to be done on the family patronage
of chapels in Siena; the best-known example, comparable
for scale and quality with better-known Florentine exam-
ples, is the Cappella Bichi in S. Agostino, for which see
most recently Henry, '"magister Lucas de Cortona, famo-
sissimus pictor in tota Italia . . ."', in *Siena nel Rinascimento:
l'ultimo secolo della repubblica*, ed. Mazzoni and Nevola.

143 The church and monastic complex are definitively analysed
by Mussolin, 'Il convento di Santo Spirito', and 'The
Rebuilding of the Church of Santo Spirito'.

144 Mussolin, 'Il convento di Santo Spirito', pp. 78–83; the *operai*
were Niccolò Borghesi, Giovanni di Cecco de' Tommasi,
Bernardino del Golia (Monte dei Nove), Luca Martini,
Vittorio Cecchini, Giovanni Tegliacci (Monte del Popolo),
Francesco Ragnoni, Giulio Spannocchi and Agostino Berti
(Monte dei Gentiluomini).

145 Mussolin, 'Il convento di Santo Spirito', pp. 78–122.

146 *Ibid.*, pp. 65–91.

147 Mussolin, 'San Sebastiano in Vallepiatta', pp. 104–16.

148 *Ibid.*, pp. 117–22, proposes that the church is to be consid-
ered an autonomous work by Baldassarre Peruzzi; the
church has been discussed, within the corpus of Francesco
di Giorgio's works, by M. Tafuri, 'La chiesa di San Sebas-
tiano in Vallepiatta' in *Francesco di Giorgio, architetto*, pp.
58–60, 302–17.

149 On Francesco di Giorgio at the centre of artistic patron-
age, see M. Mussolin, 'Il Beato Bernardo Tolomei e la
fondazione di Monte Oliveto Minore a Siena', in *La Mis-
ericordia di Siena attraverso i secoli*, ed. M. Ascheri and P.
Turrini (Siena, 2004), pp. 494–509, and A. Angelini, 'Resti
di un "Cenacolo" di Pietro Orioli a Monte Oliveto (con
una nota sulla tarsia prospettica a Siena)', *Prospettiva*, 53–6
(1988–89), pp. 290–98; also my my 'Lots of Napkins and a
Few Surprises'.

150 Fiore, 'Siena e Urbino', pp. 305–8; Alessandro Angelini has
similarly underlined that a similar series of connections
bound the two cities' artistic production, see A. Angelini,
'Senesi a Urbino', in *Francesco di Giorgio e il Rinascimento a
Siena*, ed. Bellosi, pp. 332–45.

151 On Francesco di Giorgio's assistants in Urbino, see most
recently the section of the exhibition catalogue and A.
Angelini's introductory essay, 'Senesi a Urbino', in *Francesco
di Giorgio e il Rinascimento a Siena*, pp. 332–45, with
bibliography regarding artists that followed Francesco from
Siena to work for the Duke. Cozzarelli's extended stay in
Urbino, reported at the beginning of this chapter, was in
pursuit of his master's projects, as he recorded in his tax

return of 1488, 'io sto a Urbino chon Francescho di Giorgio di Martino e sono istato già anni dieci, sì che non mi truovo nisuno altro bene'; from Bacci, 'Commentarii dell'arte senese', pp. 110–11.

152 There are similarities in the S. Bernardino projects that in part explain how Gustina Scaglia mistook plans for the Urbino monastic complex to be for Siena, in 'Newly Discovered Drawings of Monasteries by Francesco di Giorgio Martini', *Architectura*, 2 (1974), pp. 112–24, but which were identified as being for Urbino by H. Burns, 'Progetti di Francesco di Giorgio per i conventi di San Bernardino e Santa Chiara di Urbino', in *Studi Bramanteschi* (Rome, 1974), pp. 293–311, and 'San Bernardino a Urbino', in *Francesco di Giorgio, architetto*, pp. 230–43.

CONCLUSION

1 N. Machiavelli, *Opere*, ed. A. Montevecchi et. al., 4 vols. (Turin 1971–89), from *Istorie Fiorentine*, II, p. 747: 'dopo molte variazioni, ché ora dominava la plebe ora i nobili, restorono i nobili superiori: intra i quali presoro più autorità che gli altri Pandolfo e Iacobo Petrucci; i quali, l'uno per prudenza, l'altro per lo animo, diventorono come principi di quella città'.

2 N. Machiavelli, *Il Principe e altre opere politiche*, ed. D. Cantimori (Milan, 1976), pp. 369–70: 'Gli fu data la guardia della piazza con governo, come cosa meccanica, e che gli altri rifiutarono; nondimeno quelli armati con il tempo gli dierono tanta riputazione che in poco tempo ne [of Siena] diventò il principe.' In this context, 'meccanica' means lowly.

3 D. L. Hicks, 'The Rise of Pandolfo Petrucci', PhD thesis, Columbia University, 1959, and D. L. Hicks, 'The Education of a Renaissance Prince: Lodovico il Moro and the Rise of Pandolfo Petrucci', *Studies in the Renaissance*, 8 (1961), pp. 88–102; G. Chironi, 'Nascita della signoria e resistenze oligarchiche a Siena: l'opposizione di Niccolò Borghesi a Pandolfo Petrucci (1498–1500)', in *La Toscana ai tempi di Lorenzo il Magnifico: Politica, economia ed arte* (Pisa, 1996), III, pp. 1173–95. A series of documents record the formal relationship of Pandolfo as *primus*, of which the first was printed by Hicks, 'The Rise of Pandolfo', p. 146 (from Chigiana, Cod. Chigi, I. IV. 136, fol. 19, 'Convenzioni tra Pandolfo e altri cittàdini', 22 July 1507), in which Pandolfo and 15 supporters signed an agreement that 'Pandolfo sia capo, e a lui conservato lo stato e la dignità'; another is in J. S. Stoschek, 'Pandolfo Petrucci als Auftraggeber', MA thesis, University of Cologne, 1991, p. 74; another is in G. Chironi, 'Politici e ingegneri. I Provveditori della Camera del Comune di Siena negli anni '90 del Quattrocento', *Ricerche Storiche*, 23/2 (1993), pp. 384–95. Recently it has been shown how this document was reissued in 1512 at Pandolfo's death, for which see P. Jackson, 'Le regole dell'oligarchia al tempo di Pandolfo Petrucci', in *Siena e il suo territorio nel Rinascimento*, ed. M. Ascheri (Siena, 2000), pp. 209–13.

4 Chironi, 'Politici e ingegneri'.

5 Quoted by Hicks, 'The Rise of Pandolfo', p. 98, from ASM Carteggio Sforzesco, *Estero Siena* 1263: Antonio Stanga to Lodovico il Moro (16 December 1496), 'il quale sì como in questa città ha quasi el manegio del tutto, cossi è quello che è stato et è principal Capo di tutti li amici servatori

et devoti da Vostra Eccellenzia'; M. Sanudo, *Diarii*, ed. F. Stefani, 25 vols. (Venice, 1879), I, p. 1066 (1 September 1498), and II, p. 160 (14 November 1498), 'al presente in Siena è il tutto'. For the death of Giacoppo see G. A. Pecci, *Memorie storico-critiche della città di Siena che servono alla vita civile di Pandolfo Petrucci*, 2 vols. (Siena, 1755, repr., 1988), I, p. 144; on the process of power shifts, see C. Shaw, 'Politics and Institutional Innovation in Siena (1480–98): I', *BSSP*, 103 (1996), pp. 9–102, and 'Politics and Institutional Innovation . . .: II', *BSSP*, 104 (1997), pp. 194–307.

6 P. Pertici, *Le epistole di Andreoccio Petrucci (1426–1443)* (Siena, 1990) and 'Una "coniuratio" del reggimento di Siena nel 1450', *BSSP*, 99 (1992), pp. 9–47; P. Pertici, 'La furia delle fazioni', in *Storia di Siena. Dalle orgini alla fine della repubblica*, I, ed. R. Barzanti, G. Catoni and M. De Gregorio (Siena, 1995), pp. 383–94; M. Ascheri and P. Pertici, 'La situazione politica senese del secondo Quattrocento (1456–79)', in *La Toscana ai tempi di Lorenzo il Magnifico: Politica, economia ed arte* (Pisa, 1996), III, pp. 995–1012.

7 On the exile of the Petrucci, see C. Shaw, *L'ascesa al potere di Pandolfo Petrucci il Magnifico. Signore di Siena (1487–1498)* (Siena, 2001), pp. 5–10. Tax returns for the Petrucci from 1453: ASS, *Lira* 137, fol. 29, 76, 105, 118, 305, 333, 360, 361, ASS, *Lira* 138, fol. 56, ASS, *Lira* 145, fol. 94, ASS, *Lira* 57, fol. 9, for a total wealth of 26,775 *lira*; for 1481: ASS, *Lira* 186, fol. 75, 77, 126, ASS, *Lira* 189, fol. 156, ASS, *Lira* 192, fol. 30, ASS, *Lira* 195, no number, ASS, *Lira* 197, fol. 85, 147, for a total wealth of 15,825 *lire*.

8 Resident Petrucci in 1509, in the district of Porta Salaria: ASS, *Lira* 111, fol. 85, 107, 123, 153, 154; in S. Giovanni: ASS, *Lira* 236, fol. 16, 24, 33, 38; elsewhere, ASS, *Lira* 113, fol. 5v, 69r, 73, 77, 85, 85r.

9 The observations that follow, on Pandolfo Petrucci's religious and secular architectural patronage, are preliminary and cannot take into account the findings of Philippa Jackson, whose PhD thesis on Pandolfo Petrucci and his cultural patronage is keenly awaited. On Pandolfo's growing power see Jackson, 'Le regole dell'oligarchia', pp. 209–13. My remarks seek to contextualize Petrucci's architectural choices, drawing attention to the major changes in strategy that these evidence in relation to earlier practice in Siena.

10 C. Alessi, 'Pandolfo Pertucci e l'Osservanza', in *Restauro di una terracotta del '400: Il 'Compianto' di Giacomo Cozzarelli* (Modena, 1984), p. 147.

11 M. Tafuri, 'Le chiese di Francesco di Giorgio', in F. P. Fiore and M. Tafuri, eds., *Francesco di Giorgio, architetto* (Siena and Milan, 1993), pp. 25–6 and n. 117, and M. Tafuri, 'La chiesa di San Sebastiano in Vallepiatta a Siena', in the same volume, pp. 302–17; M. Bertagna, *L'Osservanza di Siena* (Siena, 1964), III, pp. 4–13; F. P. Fiore, 'Francesco di Giorgio Martini', in *The Dictionary of Art*, ed. J. Turner (New York, 1996), XI, p. 68.

12 Bertagna, *L'Osservanza*, 70; C. H. Clough, 'Pandolfo Petrucci e il concetto di "Magnificenza"', in A. Esch and C. L. Frommel, eds., *Arte, committenza ed economia a Roma e nelle corti del Rinascimento (1420–1530)* (Turin, 1995), p. 386. The inscription reads: 'PANDULFUS PET. HEC CUM OMNIBUS ORNAMENTIS SACRARIA DICAVIT CIVIUS IN HOS SACERDOTES LIBERALITEM SI PIUS ES O DIVES IMITERIS. AN MCCCCLXXXXVII'.

13 C. Alessi, 'Pandolfo Pertucci', pp. 143–7.

14 F. Donati, 'Lettera relativa all'uccisione di Niccolò Borghesi', *Miscellanea Storica Senese*, I (1893), pp. 129–32; Alessi, 'Pandolfo Pertucci', p. 147.

15 Clough, 'Pandolfo Petrucci', p. 386; the function of the Osservanza as the site of the relics of S. Bernardino is the subject of ongoing research by Mauro Mussolin and Machtelt Israëls.

16 M. Cordaro, 'L'architettura della basilica e del convento dell'Osservanza', in *L'Osservanza di Siena* (Milan, 1984), pp. 38–40. There are evident similarities in Petrucci burial strategies – and the growing individual power of the patron – with that of the Medici at S. Lorenzo, for which see the stimulating comments of J. Shearman, *Only Connect: Art and the Spectator in the Italian Renaissance* (Princeton, NJ, 1992), pp. 10–15.

17 Clough, 'Pandolfo Petrucci', p. 386.

18 The similarity between S. Bernardino dell'Osservanza (Urbino) and the Osservanza (Siena) are such as to have led Gustina Scaglia into confusing plans of the former as being for the latter, a misunderstanding which has been clarified by Howard Burns. See chapter Nine, n. 152.

19 Pius II had compared Bernardino, as Sienese exemplar of virtues, to Antonio, as an exemplar of vices; see Aeneas Silvius Piccolomini [Pius II], *I Commentarii*, ed. L. Totaro (Milan, 1984), I, pp. 996–1001 (v. 29).

20 A. Liberati, 'Chiese, monasteri e oratori senesi', *BSSP*, 48 (1941), pp. 73–80.

21 O. Malavolti, *Dell'historia di Siena* (Venice, 1599), III, p. 126, who adduced strategic motivations for the demolition; see also N. Adams and S. Pepper, *Firearms and Fortification: Military Architecture and Siege Warfare in Sixteenth-century Siena* (Chicago, 1986).

22 Malavolti, *Dell'historia di Siena*, III, p. 93; A. Liberati, 'Chiese, monasteri', 75, from ASS, *Balìa* 47, fol. 47 (14 July 1505), 'quod fiat imago argentea et decora Sancte Marie Magdalene'; 300 fl. further 11 August 1510, *Spoglio Balìa*, BCS MS. A. VII, 19–22 *ad annum*. See P. Jackson, 'The Cult of the Magdalen: Politics and Patronage under the Petrucci', in *Siena nel Rinascimento: l'ultimo secolo della repubblica*, Acts of the International Conference, ed. G. Mazzoni and F. Nevola (Florence, 2007).

23 S. Tizio, *Historiarum Senensium*, B. III. 15, fol. 272 (June 1526 – demolition), 'a Pandulphus Petruccius edificatus'.

24 Vasari, *Le vite*, ed. Barocchi, III, p. 385. S. Tizio, *Historiarum Senensium*, B. III. 12, fol. 37; B. III. 12, fol. 46, 'murus alea posite insuper dive marie magdalene monasterium, [mense septembris] pandulphi opera incohatus est [. . .] lapides ad ecclesiam dive marie magdalene, quas pandulphus manda, muro anterioris claustre construere curabat'.

25 S. Tizio, *Historiarum Senensium*, B. III. 12, fol. 77 (20 February 1508).

26 ASS, *Balìa* 54, fol. 113; 56, fol. 133v; 253, fol. 270, 275v; S. Tizio, *Historiarum Senensium*, B. III. 12, fol. 102 (February 1508), and B. III. 15, fol. 274 (3 July 1526), 'publicatus est Pandulphi opera'; see also Liberati, 'Chiese, monasteri', p. 76.

27 Pecci, *Memorie storico-critiche*, I, p. 259.

28 F. Donati, 'Il convento di Santa Maria Maddalena', *Miscellanea Storica Senese*, II (1894), 1a: 'la nostra bella chiesa, tutta di pietra tubertina, fatta di bellissima foggia per ordine et devotione del Magnifico Pandolfo Petrucci a spese sue per mentre che visse'.

29 Girolama di Bartolomeo di Antonio Petrucci was abbess already when work began; see Jackson, 'The Cult of the Magdalen'.

30 Pecci, *Memorie storico-critiche*, I, p. 237, although the motivations for this enforced cloistering are not clear.

31 On Petrucci property along the street in the fifteenth century, see P. Pertici, *La città magnificata: interventi edilizi a Siena nel Quattrocento* (Siena, 1995), pp. 83–4, n. 2.

32 P. Turrini, *'Per honore et utile de la città di Siena'. Il comune e l'edilizia nel Rinascimento* (Siena, 1997), p. 199.

33 That Vittorio di Bartolomeo retained a part of the palace is evident from his ownership of property in the palace inventory, ASS, *Notarile Antecosimiano*, 1268, doc. 516 (23 March 1514); my thanks to Philippa Jackson for showing me this document.

34 ASS, *Patrimonio Resti Ecclesiastici* 2348, fol. 10, quoted from M. Mussolin, 'Il convento di Santo Spirito a Siena e i regolari osservanti di San Domenico', *BSSP*, 104 (1997), p. 81; for the Borgia exile see Shaw, *L'ascesa al potere di Pandolfo Petrucci*, pp. 131–5.

35 Documents in A. Ferrari, R. Valentini and M. Vivi, 'Il Palazzo del Magnifico a Siena', *BSSP*, 92 (1985), p. 109, and most recently in Turrini, *'Per honore et utile'*, pp. 199–203; neither study attempts a chronology of acquisitions.

36 ASS, *Lira* 186, fol. 75, 'casa in Porta Salaria che cade a pezzi, e non è possibile affittarla [. . .] la casa accanto che ha bisogno di restauro perchè danneggiata dalla caduta del torrione del Palazzo'; shared between Accarigi heirs in 1492, see ASS, *Notarile Antecosimiano* 715, fol. 94 (15 November); the incorporation of the tower in Pandolfo's palace is confirmed in, for example, ASS, *Notarile Antecosimiano* 1080, fol. 367 and 368 (12 March 1508). Accarigi remained resident in the area in 1509, see ASS, *Lira* 111, fol. 69, 82, 84, 149, 150 and Lira 239, fol. 9.

37 A. Ferrari, R. Valentini and M. Vivi, 'Il Palazzo del Magnifico', p. 109; G. A. Pecci, *Memorie storico-critiche*, I, p. 123.

38 S. Tizio, *Historiarum Senensium*, B. III. 11, fol. 647, 'His quoque diebus Pandulfus Petruccius sacros marmoreosque maioris edes parietes domui sue servire procuravit . . . plurisque cives sacra profanis servire mirabant, nec non me redarguente ut tacerent murmurabant.' Numerous references to Pandolfo as *Operaio*, for example Archivio dell'Opera Metropolitana di Siena, *Contratti*, 23 (27), fol. 8 (28 November 1504); see also J. Hook, *Siena: A City and its History* (London, 1979), p. 69.

39 Archivio dell'Opera Metropolitana di Siena, 923 (1060), fol. 2ff (1507–), for references to the 'casa di Pandolfo'.

40 Tizio, *Historiarum Senensium*, B. III. 11, fol. 647.

41 BCS, *Spoglio Balìa*, A. VII. 19–22, 'dal quale si potesse cavare venti canne di tavole e duecento correnti per il tetto della di lui casa;' Ferrari, Valentini and Vivi, 'Il Palazzo del Magnifico', p. 110, based on Pecci, *Memorie storico-critiche*, I, p. 206, incorrectly predate this event to 1504. On the special privileges of the Amiata forests, see D. Ciampoli, 'Abbadia al tempo di Pio II', in *Abbadia San Salvatore: Una comunità autonoma nella Repubblica di Siena*, ed. M. Ascheri and F. Mancuso (Siena, 1994), pp. 51–68.

42 L. Banchi and S. Borghesi, *Nuovi documenti per la storia dell'arte senese* (Siena, 1898), pp. 382–3; Ferrari, Valentini and Vivi, 'Il Palazzo del Magnifico', p. 110.

43 ASS, *Notarile Antecosimiano* 1080, fol. 367, 'in camera dicta de la torre', and fol. 368, 'in camera supariori dicta domina aurelia' (12 March 1508); no outstanding debts for construction are declared in the tax return of 1509 (*Lira* 235, fol. 202).

44 Decoration of the palace and adaptations for the wedding are summarized in G. Agosti and V. Farinella, 'Interni senesi "all'antica"', in *Domenico Beccafumi e il suo tempo*, ed. P. Torriti (Milan, 1990), pp. 590–92.

45 Clough, 'Pandolfo Petrucci', p. 390.

46 The role of towers as markers of lineage is addressed in chapter Seven.

47 ASS, *Notarile Antecosimiano*, 1268, doc. 516 (23 March 1514).

48 For a study of quasi-despotic patronage that balances local precedents with princely ambitions, see G. Clarke, 'Magnificence and the City: Giovanni II Bentivoglio and Architecture in Fifteenth-century Bologna', *Renaissance Studies*, 13 (1999), pp. 397–411, and 'Giovanni Il Bentovoglio and the Uses of Chivalry: Creating a Republican Court in Late Fifteenth-century Bologna', in *Artistic Exchange and Cultural Translation in the Italian Renaissance City*, ed. S. J. Campbell and S. J. Milner (Cambridge, 2004), pp. 162–86.

49 Ferrari, Valentini and Vivi, 'Il Palazzo del Magnifico', p. 116.

50 On the early use of *sgraffito* façades in Rome, see G. Clarke, 'Italian Renaissance Urban Domestic Architecture: The Influence of Antiquity', PhD thesis, Courtauld Institute of Art, University of London, 1992, pp. 354–60; also G. Clarke, *Roman House – Renaissance Palaces: Inventing Antiquity in Fifteenth-century Italy* (Cambridge, 2003), pp. 219–21. See also E. Pecchioli, *The Painted Façades of Florence: From the Fifteenth to the Twentieth Century* (Florence, 2006).

51 H. Burns, '"Restaurator de ruyne antiche": tradizione e studio dell'antico nelle attività di Francesco di Giorgio', in *Francesco di Giorgio, architetto*, ed. F. P. Fiore and M. Tafuri (Siena and Milan, 1994), pp. 151, 155–7; also F. P. Fiore, 'L'architettura civile di Francesco di Giorgio', in *Francesco di Giorgio, architetto*, pp. 74–125.

52 F. Cantatore, 'Opere bronzee', in *Francesco di Giorgio, architetto*, pp. 326–7.

53 Similar comparisons can be found in F. P. Fiore, 'Siena e Urbino', in *Storia dell'architettura italiana: il Quattrocento*, ed. F. P. Fiore (Milan, 1998), pp. 286–8.

54 For users of the apartments, see ASS, *Notarile Antecosimiano*, 1268, fol. 516 (23 March 1514).

55 Summarized by F. Cantatore, 'Opere bronzee', pp. 326–7, and Tafuri, 'Le chiese di Francesco di Giorgio', p. 64; most recently, Fiore, 'Siena e Urbino', pp. 100–101.

56 P. Bacci, 'Commentarii dell'arte senese, I: Il pittore, scultore e architetto Iacopo Cozzarelli e la sua presenza in Urbino con Francesco di Giorgio Martini dal 1478 al 1488', *BSSP*, 39 (1932), pp. 110–11, transcribes a document in which Cozzarelli states 'io sto a Urbino chon Francescho di Giorgio di Martino e sono istato già anni dieci, sì che non mi truovo nisuno altro bene' (1488).

57 See my 'Lots of Napkins and a Few Surprises: Francesco di Giorgio Martini's House, Goods and Social Standing in Late-Fifteenth-century Siena', *Annali di Architettura*, 18–19 (2006–7), pp. 71–82, citing ASS, *Curia del Placito 659*, fol. 14v (10 May 1513).

58 Francesco's ability at managing numerous projects spread across a broad geographical area emerges from essays contained in *Francesco di Giorgio alla corte di Federico da Montefeltro: atti del convegno internazionale di studi,* ed. F. P. Fiore, 2 vols. (Florence, 2004).

59 G. Agosti and V. Farinella, 'Interni senesi'; *Giotto to Dürer: Early Renaissance Painting in the National Gallery*, ed. J. Dunkerton, S. Foister, D. Gordon and N. Penny (New Haven and London, 1991), pp. 86–9. For the ceiling, J. B. Holmquist, 'The Iconography of a Ceiling Decoration by Pinturicchio in the Palazzo del Magnifico', PhD thesis, University of North Carolina at Chapel Hill, 1984, pp. 89–187.

60 The documentary evidence for the internal decoration of the Palazzo 'del Magnifico' is considered in Philippa Jackson's PhD thesis; to date, scholars' findings have been largely speculative as regards the objects originally from the palace and their arrangement in it, and their findings can be summarized in Agosti and Farinella, 'Interni senesi', pp. 590–99, with bibliography; see also L. Syson, ed., *Renaissance Siena: Art for a City*, exh. cat., National Gallery, London, October 2007–January 2008 (London, 2007).

61 The loggia is no longer visible as a result of the recent restoration that plastered over the façade, although pre-restoration photographs as well as extant internal architectural detailing confirm the presence of the loggia.

62 S. Tizio, *Historiarum Senensium*, B. III. 12, fol. 562, cited by C. Mazzi, *La congrega dei Rozzi di Siena nel secolo XVI* (Florence, 1882), I, p. 64.

63 Tizio, *Historiarum Senensium*, B. III. 12, fol. 60.

64 ASS, *Balìa 253*, fol. 240 (16 September 1507), 'Considerantes que strata porte Salarie . . . est frequentata pro uso et comoditate civie quam alium strate tendentes ad dictam ecclesiam [cathedral and S. Giovanni] pro maiori etiam ornamento publico deliberaverunt et pro lege sanciverunt que pizzicaioli, linarii, aluptarii, sive ciabattari, planerrai, bechari et fabbri . . . non possint quoquo modo, vel sub aliquo quesito colore, in futuro stare et neque exercere in supradicta strata vel ibidem tenere apothecas supradictorum artium sub pena xxv fl pro qualibet vice solvenda quacunque.'

65 ASS, *Balìa 253*, fol. 240 (16 September 1507) and fol. 241 (13 October).

66 Tizio, *Historiarum Senensium*, B III 12; fol. 60–61 (13 October 1507), 'edes suis liberiores, atque splendiores apparerent [. . .] luminosiores vie et clariora Palatia, et viarum strata latiora scannis abalatis quoque redindabant'.

67 ASS, *Notarile Antecosimiano 1080*, fol. 367 (12 March 1508), and Ferrari, Valentini and Vivi, 'Il Palazzo del Magnifico', pp. 110–12, although he also used a shop in the Campo for commercial transactions; for Pandolfo's business interests, see his post-mortem inventory: ASS, *Notarile Antecosimiano* 1268, doc. 516 (23 March 1514), fol. 13. Additional details for Pandolfo's varied economic activity emerge from the correspondence between Agostino and Sigismondo Chigi published by I. D. Rowland, *The Correspondence of Agostino Chigi (1466–1520) in Cod. Chigi R.V.c.* (Vatican City, 2001) and 'Agostino Chigi e la politica senese del '500', in *Siena nel Rinascimento: l'ultimo secolo della repubblica*, Acts of the International Conference, ed. M. Ascheri and F. Nevola (Siena, 2007), which specifically examines the relations between Pandolfo and Agostino Chigi.

68 ASS, *Notarile Antecosimiano*, 1268, doc. 516 (23 March 1514), fol. 3r–v; named resident 'secretaries' to Borghese Petrucci are Ambrogio Smerladi, 'Paolino', Francesco da Santa Fiora.

69 ASS, *Notarile Antecosimiano*, 1268, doc. 516 (23 March 1514), fol. 6–9 and 10–12 on kitchens and stores. The assemblage of a *quasi*-court around the Petrucci palace is further suggested by the sale of Francesco di Giorgio Martini's house to Bastiano di Domenico da Cortona, one of Pandolfo's *familiares*, as documented in ASS, *Gabelle dei contratti 332* (1508–1509), fol. 119v, and discussed in my 'Lots of Napkins and a Few Surprises'.

70 ASS, *Balìa 54*, fol. 5r–6v.

71 ASS, *Balìa 253*, fol. 265v (30 October 1508; Milanesi, *Documenti*, III, pp. 307–9, doc. 33), 'considerantes et bene adver-

tentes ad maximum honorem et decus civitatis Senarum in ornamentis fiendis et maxime in porticu faciendo circumcirca plateam et in campo fori civitatis Senarum pro constructione et hedeficio huismundi porticus opera'.

72 G. Pecci, 'Raccolta Universale di tutte le iscrizioni, arme e altri monumenti si antichi, come moderni, esistenti nella citta di Siena', MS D. 5, fol. 36v; E. Romagnoli, *Biografia cronologica de' bellartisti senesi, 1200–1800* (Florence, 1976), VI, pp. 669–72; M. Cordaro, 'Baldassarre Peruzzi, il Palazzo Pubblico e il Campo di Siena', in *Baldassrre Peruzzi: pittura, scena e architettura*, ed. M. Fagiolo and M. L. Madonna (Rome, 1987), pp. 171–2.

73 Published in H. Wurm, *Baldassarre Peruzzi Architekturzeichnungen. Tafelband* (Tübingen, 1984), p. 166; C. L. Frommel, *Die Farnesina und Peruzzis Architektonisches Frühwerk* (Berlin, 1961), pp. 129–30; M. Cordaro, 'Baldassarre Peruzzi'; unpublished, possibly also by Pomarelli, is the sketchbook BCS, E. I. 2. fol. 1–6. One of these drawings has recently been attributed to Peruzzi by C. L. Frommel in '"Ala maniera e uso delj bonj antiquj": Baldassarre Peruzzi e la sua quarantennale ricerca dell'antico', in *Baldassarre Peruzzi (1481–1536), Atti del XX seminario internazionale di storia dell'architettura*, ed. C. L. Frommel, A. Bruschi, H. Burns, F. P. Fiore and P. N. Pagliara (Venice, 2005), pp. 19–21, although Frommel does not offer a sure date for the drawing.

74 Frommel, *Die Farnesina*, pp. 129–30; Howard Burns has recently argued that Baldassarre Peruzzi's plans for the Campo may be fitted within the wider context of his activity as city architect for the reinstated Republic of Siena, following his return to the city in 1527; see H. Burns, 'Prima della caduta. Cultura e identità senese nella prima metà del Cinquecento', in *Siena nel Rinascimento: l'ultimo secolo della repubblica*, Acts of the International Conference, ed. G. Mazzoni and F. Nevola (Florence, 2007).

75 M. Cordaro, 'Baldassarre Peruzzi', pp. 171–2; Milanesi, *Documenti*, III, pp. 307–9, doc. 33; F. Donati, 'Il portico del Campo', *Miscellanea Storica Senese*, I (1893), pp. 33–7; BCS, E. I. 2. fol. 1–6.

76 See Chapter I for discussion of the Campo.

77 The second tower is discussed in chapter Five, and the Piccolomini palace in chapters Four and Eight.

78 W. Lotz, 'Sixteenth-century Italian Squares', in W. Lotz, *Studies in the Italian Renaissance* (Cambridge, MA, 1977), pp. 117–39; R. Schofield, 'Lodovico il Moro's Piazzas: New Sources and Observations', *Annali di Architettura*, 4–5 (1992–3), pp. 157–67.

79 On arch-and-column arcades as classicizing and 'ducal', see R. Schofield, 'Lodovico il Moro's Piazzas', p. 164, and H. Burns, 'Quattrocento Architecture and the Antique: Some Problems', in *Classical Influences in European Culture, AD 500–1500*, ed. R. R. Bolgar (Cambridge, 1971), pp. 271–4.

80 Lotz, 'Sixteenth-century Italian Squares', pp. 80–81; the use of loggias as screening devices that reduced the visibility of communal institutions can be traced to numerous other centres, for example in the reordering to the Capitoline hill in Rome.

81 On Venice, see Lotz, 'Sixteenth-century Italian Squares', p. 83, who also noted that loggias existed around the piazza S. Marco from the Duecento; see also D. Calabi, 'Le due piazze di Rialto e San Marco: tra eredità medievali e volontà di rinnovo', *Annali di Architettura*, 4–5 (1992–3), pp. 190–201, and M. Morresi, *Piazza San Marco: Istituzioni, poteri e architettura a Venezia nel Cinquecento* (Milan, 1999).

82 Hicks, 'The Education of a Renaissance Prince'; Francesco di Giorgio Martini also travelled to Lombardy to offer advice on Milan cathedral's crossing, and to Pavia.

83 Clough, 'Pandolfo Petrucci', groups them together.

84 Machiavelli, *Opere*, II, p. 747.

85 Information and analysis of Pandolfo Petrucci's funeral in relation to other funerals in Siena during the same period is to be found in P. Jackson, 'Pomp or Piety? The Funeral of Pandolfo Petrucci', in *Beyond the Palio: Urban Ritual in Renaissance Siena*, ed. P. Jackson and F. Nevola (Oxford, 2006), pp. 104–16.

86 See also note 3 above. Jackson, 'Le regole dell'oligarchia', p. 212: 'perché quelli che vogliono bene vivare molte volte dalli obstaculi sonno convenuti d'essere unitamente tucti uno corpo et ad beneficio l'uno del'altro promettono mettare la roba et la vita et se ad alcuno o più di lorofusse facta iniuria [. . .] si intendi essare facta ad ciascuno'.

87 For Pandolfo's will and provision for burial, as well as the hypothetical route of the funeral cortège, see Jackson, 'Pomp or Piety?', pp. 107–9, 114.

88 Outside Porta Tufi was also the convent of S. Maria Maddalena, which had flourished under Pandolfo's patronage; on S. Benedetto and Francesco di Giorgio and Pietro Orioli's involvement there, see M. Mussolin, 'Il Beato Bernardo Tolomei e la fondazione di Monte Oliveto Minore a Siena', in *La Misericordia di Siena attraverso i secoli*, ed. M. Ascheri and P. Turrini (Siena, 2004), pp. 494–509.

89 The route is traced, with citations from appropriate sources, by Jackson, 'Pomp or Piety?', pp. 112–15.

90 It seems that popular opposition to the regime prevented them from using the Campo that year: A. Allegretti, *Ephemerides Senenses ab anno MCCCCL usque ad MCCCCXCVI italico sermone scriptae*, in *Rerum Italicarum Scriptores*, ed. L. Muratori, vol. 23 (Milan, 1733), 850 (21 July 1487); Pecci, *Memorie storico-critiche*, I , pp. 114–15; also Shaw, 'Politics and Institutional Innovation', II, pp. 288–9.

91 This is a principal conclusion of Jackson, 'Pomp or Piety?', p. 116.

92 Borghese's diplomatic policies are examined by R. Terziani, *Il governo di Siena dal medioevo all'età moderna: la continuità repubblicana al tempo dei Petrucci (1487–1525)* (Siena, 2002), pp. 144–52; M. Gattoni, *Leone X e la geopolitica dello stato pontificio (1513–1521)* (Vatican City, 2000), pp. 13–14; M. Gattoni, 'Siena e i giganti. Lo scontro franco–spagnolo in Lombardia nelle lettere di Aldello Placidi, oratore senese a Roma e la posizione di Siena, fra Francia, Spagna e lo Stato Pontificio', *BSSP*, 104 (1997), pp. 377–402. See also, for what follows, the expanded discussion in my '"El Papa non verrà": The Failed Triumphal Entry of Leo x de' Medici to Siena (November 1515)', *Mitteilungen des Kunsthistorisches Instituts in Florenz* [forthcoming].

93 Borghese Petrucci was indeed reliant on his father's adviser, Antonio del Venafro, whom, it would seem, Leo x wanted out of the way; see Tizio, *Historiarum Senensium*, BCS, B.III.12, fol. 586, 'abicerent, et dimitterent Sena Urbe' (reported also in Pecci, *Memorie storico-critiche*, II, p. 26).

94 Nevola, '"El Papa non verrà"'; on the political consequence of the Battle of Marignano, see M. Mallett, 'Siena e le guerre d'Italia', in *Siena nel Rinascimento: l'ultimo secolo della repubblica*, Acts of the International Conference, ed. M. Ascheri and F. Nevola (Siena, 2007); also M. Gattoni, 'La politica estera e il primato dei Petrucci a Siena, 1498–1524', in *Siena ed il suo territorio nel rinascimento*, ed. M. Ascheri (Siena, 2001), III, pp. 215–22.

95 Borghese was deposed in Siena and fled the city on 9 March 1516 (see Pecci, *Memorie storico-critiche*, II, pp. 36–46) while his brother was murdered in a Rome jail, for which see F. Guicciardini, *Storia d'Italia*, ed. S. Seidel Menchi (Turin, 1971), II, p. 1331 [Bk. 13, chap. 7], 'occultamente nella carcere strangolato'.

96 For a full discussion of the entry see Nevola, ' "El Papa non verrà" '. On Vannoccio Biringucci, a close ally of Pandolfo Petrucci and then of his son Borghese, see G. Chironi, 'Cultura tecnica e gruppo dirigente: la famiglia Vannocci Biringucci', in *Una tradizione senese. Dalla 'Pirotechnica' di Vannoccio Biringucci al Museo del Mercurio*, ed. I. Tognarini (Naples, 2000), pp. 99–130. See also Milanesi, *Documenti*, III, pp. 123–6, for details of Vannoccio's life.

97 On ceremonial at the city gates, see my ' "Lieto e trionphante per la città": Experiencing a Mid-Fifteenth-century Imperial Triumph along Siena's Strada Romana', *Renaissance Studies*, 17 (2003), pp. 581–606; also essays in *Beyond the Palio: Urban Ritual in Renaissance Siena*, ed. P. Jackson and F. Nevola (Oxford, 2006). For the entry of Charles VIII from Porta Camollia in 1494, see M. Sanudo, *La spedizione di Carlo VIII in Italia*, ed. R. Fulin (Venice, 1873), pp. 144–5; also B. Mitchell, *Italian Civic Pageantry in the High Renaissance: A Descriptive Bibliography of the Triumphal Entries and Selected Other Festivals for State Occasions* (Florence, 1979), pp. 135–8.

98 This book ends with Pandolfo Petrucci, but it is important to note how the tide-like process of architectural change to the urban fabric turned again in favour of classicizing plans for the Campo and Duomo precincts under the impetus of the refounded republic, post-1525; the architectural implications of that change are examined by Burns, 'Prima della caduta'.

Bibliography

UNPUBLISHED SOURCES

I have chosen only to list the names of the archival *fondi* consulted for this book, as full references are supplied in the Notes.

ARCHIVIO DI STATO DI SIENA

Archivio Generale dei
 Contratti
Archivio Privato Spannocchi
Arti di Città
Balìa
Biccherna
Concistoro
Consiglio Generale
Consorteria Piccolomini
Conventi Soppressi
Diplomatico Bichi Borghesi
Gabella dei contratti
Lira

Legato Bichi Borghesi
Notarile Antecosimiano
Ospedale Santa Maria della
 Scala
Particolari Famiglie Senesi
Patrimonio Resti
 Ecclesiastici
Statuti di Siena
Ufficiali confische – Beni
 Ribelli
Ufficiali sopra alle mura
Ufficiali vino e terratici
Viarii

ASS MANUSCRIPTS

A. Bardi, *Diario (1512–56)*, MS. D. 50 (also BCS A. VI. 51)
G. Macchi, *L'Ospedale di Santa Maria della Scala e le grancie*, MS.
 D. 103

G. Macchi, *Palazzi di Siena e stemmi di famiglie nobili di Siena
 e dei Luoghi dello Stato*, MS. D. 106
G. Macchi, *Memorie Senesi*, MS. D. 107
G. Macchi, *Memorie delle chiese di Siena*, MS. D. 111
Agostino Patrizi, *De senarum urbis antiquitate*, A VI 3 (also contained in 'Senensis Historia manuscripta ab Origine civitatis ad annum MCCCCLXXII', MS. D. 166; also BCS B. III. 5, seventeenth-century copies of original)
Francesco Patrizi, *De origine et antiquitate urbis Senae*, in 'Senensis Historia manuscripta ab Origine civitatis ad annum MCCCCLXXII', MS. D. 166 (also BCS B. III. 5, seventeenth-century copies of original)
Francesco Patrizi, *De origine et antiquitate urbis Senae*, MS. A XI 38, fol. 1–42
G. Pecci, *Raccolta Universale di tutte le iscrizioni, arme e altri monumenti si antichi, come moderni, esistenti nella citta di Siena*, MS. D. 4–6
G. Pecci, *Notizie su torri ed altre fabriche di Siena*, MS. A. 2 bis, D 131
Spogli degli Archivi del Comune di Siena, MS. C. 2, 7, 12, 18

ARCHIVIO DELL'OPERA METROPOLITANA DI SIENA

Statuti e Regolamenti
Contratti memorie e
 testamenti
Salarii e pagamenti maestranze

Creditori e Debitori
Inventarii dei beni Miscellanea
Pagamenti maestranze

ARCHIVIO DI STATO DI ROMA

Mandati camerale Camerale I: Tesoreria Segreta

BIBLIOTECA APOSTOLICA VATICANA

Archivio Chigi

BAV, Chigi, G I 9: fol. 126–33, 'Patritii Patritii de Urbis Senarum origine opusculum'

MS. Chigi, G I 9, fol. I–117, 'Pius III Pontificis Senensis Annales Senenses in septem partes divisi'

BIBLIOTECA COMUNALE DI SIENA

U. Bentivoglienti, *Notizie diverse*, C. IV. 23

O. V. Biringucci, *Taccuino di disegni*, S. IV. I

A. M. Carapelli, *Notizie delle chiese e cose raggaurdevoli di Siena . . . delle pubbliche feste fatte nella Piazza, e dell'Entrate solenni d'alcuni personaggi . . .* (seventeenth-century account), B. VII. 10

G. B. Cenni, *Le glorie maestose della Vergine Assunta del Prato a Camollia*, MS. A. V. 6.

A. Dati and F. Patrizi (?), *Notizie di Papa Pio II e sue lettere a varii potentati*, BCS. B. V. 40

I. Franchini, *Disegni di Architettura*, (to 1740), S. I. 8

F. Luti, *Notizie di Papa Pio II e sue lettere a varii potentati*, B. V. 40 (fifteenth-century original)

Francesco di Giorgio Martini, *Trattato di Architettura (II)*, (copy c. 1490), L. IV. 10, S. IV. 4

Mariano di Matteo, *Narrazione della venuta a Siena dello Imperatore Federico III*, I. VIII. 39

B. Neroni 'il Riccio' and Anonymous Sienese, *Taccuino di disegni*, S. IV. 6

Niccolò di Giovanni Ventura, *La sconfitta di Montaperto*, A. IV. 5

B. Peruzzi, *Taccuino di disegni*, S. IV. 7

L. Pomarelli (?), *Disegni del Portico del Campo*, E. I. 2

E. Romagnoli, *Vedute dei contorni di Siena*, C. II. 3–4

Giuliano da Sangallo, *Taccuino di disegni*, S. IV. 8

Spogli degli Archivi del Comune di Siena, A. VII. 14–22

S. Tizio, *Historiarum Senensium*, B. III. 10–15

S. Tizio, *Historiarum Senensium*, Indexes, B. III. 14–25, C. V. I

B. III. 5 and ASS, MS. D. 166), 'Senensis Historia manuscripta ab Origine civitatis ad annum MCCCCLXXII'

A VI 3, fol. 25–79, 'Patritii senensis ex nobili patritiorum familia, de Origine Urbis Sene, tractatus incipit'

B. III. 5 and B. III. 3, *Senensis Historia manuscripta ab Origine civitatis ad annum MCCCCLXXII*

BIBLIOTECA LAURENZIANA, FLORENCE

Ashburnham

BIBLIOGRAPHY OF PUBLICATIONS

D. Abulafia, ed., *The French Descent into Renaissance Italy, 1494–5* (Aldershot, 1995)

C. Acidini Luchinat, 'Due episodi della conquista cosimiana di Siena', *Paragone*, 29 (1978), pp. 3–26

C. Acidini Luchinat, J. D. Draper, N. Penny and K. Weil-Garris Brandt, eds., *La giovinezza di Michelangelo*, exh. cat., Florence, 6 October 1999–9 January 2000 (Florence and Milan, 1999)

J. Ackerman and M. Rosenfeld, 'Social Stratification in Renaissance Urban Planning', in *Urban Life in the Renaissance*, ed. S. Zimmerman and R. Weissman (Newark, 1989), pp. 21–49

N. Adams, 'Baldassarre Peruzzi: Architect to the Republic of Siena', PhD thesis, Institute of Fine Arts, New York University, 1977

N. Adams, 'Architecture for Fish: The Sienese Dam on the Bruna River: Structures and Designs, 1468–ca. 1530', *Technology and Culture*, 25 (1984), pp. 768–97

N. Adams, 'The Acquisition of Pienza, 1459–1464', *Journal of the Society of Architectural Historians*, 44 (1985), pp. 99–110

N. Adams, 'The Life and Times of Pietro dell'Abaco, a Renaissance Estimator from Siena (active 1457–86)', *Zeitschrift für Kunstgeschichte*, 48 (1985), pp. 384–95

N. Adams, 'L'architettura militare di Francesco di Giorgio', in *Francesco di Giorgio, architetto*, ed. F. P. Fiore and M. Tafuri (Milan, 1994), p. 152

N. Adams, 'The Construction of Pienza (1459–64) and the Consequences of *Renovatio*', in *Urban Life in the Renaissance*, ed. S. Zimmerman and R. Weissman (Newark, 1989), pp. 21–49, 56

N. Adams, 'Pienza', in *Storia dell'architettura italiana: il Quattrocento*, ed. F. P. Fiore (Milan, 1998), pp. 314–29

N. Adams, 'Knowing Francesco di Giorgio', in *Francesco di Giorgio alla corte di Federico da Montefeltro: atti del convegno internazionale di studi*, ed. F. P. Fiore (Florence, 2004)

N. Adams and N. L. Nussdorfer, 'The Italian City, 1400–1600', in *The Renaissance from Brunelleschi to Michelangelo: The Representation of Architecture*, ed. H. Millon and V. Magnago Lampugnani (London, 1994), pp. 205–31

N. Adams and S. Pepper, *Firearms and Fortification: Military Architecture and Siege Warfare in Sixteenth-century Siena* (Chicago, 1986)

B. Adorni, ed., *La chiesa a pianta centrale: tempio civico del Rinascimento* (Milan, 2002)

G. Agosti and V. Farinella, 'Interni senesi "all'antica"', in *Domenico Beccafumi e il suo tempo*, ed. P. Torriti (Milan, 1990), pp. 578–99

A. Ahlberg, *The Boy, the Wolf, the Sheep and the Lettuce* (London, 2004)

I. Ait, 'Aspetti dell'attività mercantile-finanziaria degli Spannocchi a Roma nel tardo medioevo', in *Siena nel Rinascimento: l'ultimo secolo della repubblica*, Acts of the International Conference, Siena (28–30 September 2003 and 16–18 September 2004), ed. M. Ascheri and F. Nevola (Siena, 2007)

M. Ajmar-Wollheim and F. Dennis, eds., *At Home in Renaissance Italy* (London, 2006)

L. Alberti, *Descrittione di Tutta Italia di F. Leandro Alberti Bolognese* (Venice: Lodovico degli Avanzi, 1568)

L. B. Alberti, *On the Art of Building in Ten Books*, ed. and trans. J. Rykwert, N. Leach and R. Tavernor (Cambridge, MA, 1991)

C. Alessi, 'Pandolfo Pertucci e l'Osservanza', in *Restauro di una terracotta del '400: Il 'Compianto' di Giacomo Cozzarelli* (Modena, 1984), pp. 143–7

D. Alighieri, *The Divine Comedy*, ed. and trans. J. Sinclair, 3 vols. (Oxford and New York, 1939)

270

A. Allegretti, *Ephemerides Senenses ab anno MCCCCL usque ad MCCCCXCVI italico sermone scriptae*, in *Rerum Italicarum Scriptores*, ed. L. Muratori, vol. 23 (Milan, 1733)

F. Ames-Lewis, ed., *Cosimo il Vecchio de' Medici, 1389–1464* (Oxford, 1992)

F. Ames-Lewis, *The Intellectual Life of the Early Renaissance Artist* (New Haven and London, 2000)

I. Ammannati Piccolomini, *Epistolae et Commentarii Jacobi Piccolomini Cardinalis Papiensis* (Milan, 1506)

I. Ammannati Piccolomini, *Lettere (1444–79)*, ed. P. Cherubini (*Publicazioni degli Archivi di Stato. Fonti 25*), 3 vols. (Rome, 1997)

A. Angelini, 'I restauri di Pietro di Francesco agli affreschi di Ambrogio Lorenzetti nella "Sala della Pace" ', *Prospettiva*, 31 (1982), pp. 78–82

A. Angelini, 'Resti di un "Cenacolo" di Pietro Orioli a Monte Oliveto (con una nota sulla tarsia prospettica a Siena)', *Prospettiva*, 53–6 (1988–89), pp. 290–98

A. Angelini, 'Le lupe di Porta Romana e Giovanni di Stefano', *Prospettiva*, 65 (1992), pp. 50–55

A. Angelini, 'Senesi a Urbino', in L. Bellosi ed., *Francesco di Giorgio e il Rinascimento a Siena* (Siena and Milan, 1993), pp. 116, 332–45

A. Angelini, 'Siena 1460: episodi artistici al tempo di Pio II', in *Umanesimo a Siena. Letteratura, arti figurative, musica*, (*Siena, 5–8 giugno 1991: atti del convegno*), ed. E. Cioni and D. Fausti (Siena, 1994), pp. 263–84

A. Angelini, 'I Marrini e gli inizi di Michele Angelo senese', in *Omaggio a Fiorella Sricchia Santoro*, a special double issue of *Prospettiva*, 91–2 (1998–99), I, pp. 127–38

A. Angelini, 'Una proposta per la vetrata dell'oratorio di Sant' Ansano in Castelvecchio a Siena', in *Matteo di Giovanni e la pala d'altare nel senese e nell'aretino*, ed. D. Gasparotto and S. Maganini (Siena, 2002), pp. 185–7

A. Angelini, 'Antonio Federighi ed il mito di Ercole', in *Pio II e le arti. La riscoperta dell'antico da Federighi a Michelangelo*, ed. A. Angelini (Cinisello Balsamo, Milan, 2005), pp. 105–50

A. Angelini, ed., *Pio II e le arti. La riscoperta dell'antico da Federighi a Michelangelo* (Cinisello Balsamo, Milan, 2005)

A. Angelini, 'Il lungo percorso della decorazione all'antica tra Siena e Urbino', in *Pio II e le arti. La riscoperta dell'antico da Federighi a Michelangelo*, ed. A. Angelini (Cinisello Balsamo, Milan, 2005), pp. 307–85

Anon. Florentine, *La festa che si fece in Siena il XV agosto MDVI* (Siena, 1506) (BCS, Rari, VI. 33)

D. Arasse, '*Fervebat Pietate Populus*: Art, dévotion et société autour de la glorification de Saint Bernardin de Sienne', *MEFR*, 89 (1977), pp. 189–263

G. C. Argan and M. Fagiolo, 'Premessa all'arte italiana', in *Storia d'Italia: I caratteri originali*, ed. R. Romano and C. Vivanti (Turin, 1972), pp. 731–90

R. Argenziano and F. Bisogni, 'L'iconografia dei santi patroni Ansano, Crescenzio, Savino e Vittore', *BSSP*, 97 (1990), pp. 84–115

G. Aronow, 'A Documentary History of the Pavement Decoration in Siena Cathedral, 1362 through 1506', PhD thesis, Columbia University, 1985

G. Aronow, 'A Description of the Altars in Siena Cathedral in the 1420s', in H. van Os, *Sienese Altarpieces, 1215–1460: Form, Content and Function, II: 1344–1460* (Groningen 1990), pp. 225–42

E. Arslan, 'L'architettura milanese nella seconda metà del Quattrocento', *Storia di Milano*, vol. 7 (Milan, 1956), pp. 601–92

E. Arslan, ed., *Arte e artisti dei laghi lombardi*, I: *Architetti e scultori del Quattrocento* (Como, 1959)

E. Arslan, ed., *Arte e artisti dei laghi lombardi*, II: *Gli stuccatori dal Barocco al Rococo* (Como, 1964)

M. Ascheri, *Siena nel Rinascimento. Istituzioni e sistema politico* (Siena, 1985)

M. Ascheri, 'Siena nel Quattrocento: una riconsiderazione', in *Pittura del Rinascimento a Siena* (in Italian Monte dei Paschi edition only), ed. K. Christiansen and C. Brandon Strehlke (Milan, 1989), pp. xix–lvi

M. Ascheri, 'Statuti, legislazione e sovranità: il caso di Siena', in *Statuti, città, territori in Italia e Germania tra medioevo ed età moderna*, ed G. Chittolini and D. Willoweit (*Annali dell'Istituto Storico Italo–germanico: Quaderno 30*) (Milan, 1991), pp. 145–94

M. Ascheri, et al., *Università di Siena: 750 anni di storia* (Siena, 1991)

M. Ascheri, ed., *L'ultimo statuto della Repubblica di Siena (1545)* (Siena, 1993)

M. Ascheri, *Renaissance Siena (1355–1559)* (Siena, 1993)

M. Ascheri, 'Per la storia del tessuto a Siena: qualche aspetto', in *Drappi, velluti, taffetta et altre cose: Antichi tessuti a Siena e nel suo territorio*, ed. M. Ciatti (Siena, 1994), pp. 239–44

M. Ascheri, 'Assemblee, democrazia comunale e cultura politica: dal caso della Repubblica di Siena (XIV–XV sec.)', in *Studi in onore di Arnaldo d'Addario* (Lecce, 1995), IV, pp. 1141–55

M. Ascheri, 'Istituzioni e governo della città', in *Storia di Siena. Dalle orgini alla fine della repubblica*, I, ed. R. Barzanti, G. Catoni and M. De Gregorio (Siena, 1995), pp. 327–40

M. Ascheri, *Siena nella Storia* (Cinisello Balsamo, Milan, 2000)

M. Ascheri, ed., *La chiesa di San Pietro alia Magione nel Terzo di Camollia a Siena* (Siena, 2001)

M. Ascheri, 'Siena. Centro finanziario, gioiello della civiltà comunale italiana', in *Le Biccherne di Siena. Arte e Finanza all'alba dell'economia moderna*, ed. A. Tomei (Azzano San Paolo, Bergamo, and Rome, 2002), pp. 14–21

M. Ascheri, 'Le più antiche norme urbanistiche del Comune di Siena', in *La bellezza della città: Stadtrecht und Stadtgestaltung im Italien des Mittelalters und der Renaissance*, ed. M. Stolleis and R. Wolff (Tübingen, 2004), pp. 241–67

M. Ascheri and F. Nevola, eds., *Siena nel Rinascimento: l'ultimo secolo della repubblica*, II, Acts of the International Conference, Siena: 28–30 September 2003 and 16–18 September 2004 (Siena, 2007)

M. Ascheri and P. Pertici, 'La situazione politica senese del secondo Quattrocento (1456–79)', in *La Toscana ai tempi di Lorenzo il Magnifico: Politica, economia, cultura ed arte* (Pisa, 1996), III, pp. 995–1012

M. G. Aurigemma, 'Note sulla diffusione del vocabolario architettonico: Francesco Patrizi', in *Le Due Rome del Quattrocento: Melozzo, Antoniazzo e la cultura artistica del '400 Romano*, Acts of the Conference (Rome, 1996), ed. S. Rossi and S. Valeri (Rome, 1997), pp. 365–79

C. Avetta, 'Il mercato nella Piazza', in *Piazza del Campo*, ed. L. Franchina (Siena, 1983), pp. 25–34

P. Bacci, 'La colonna del Campo, proveniente da avanzi romani presso Orbetello (1428)', *Rassegna dell'arte senese*, n.s. I (1927), pp. 227–31

P. Bacci, 'Commentarii dell'arte senese. I: Il pittore, scultore e architetto Iacopo Cozzarelli e la sua presenza in Urbino con Francesco di Giorgio Martini dal 1478 al 1488', *BSSP*, 39 (1932), pp. 110–11

A. Bagnoli, 'Donatello a Siena', in *Francesco di Giorgio e il Rinascimento a Siena*, ed. L. Bellosi (Siena and Milan, 1993), pp. 162–9

A. Bagnoli, 'Gli angeli dell'altare del Duomo e la scultura a Siena alla fine del secolo', in *Francesco di Giorgio e il Rinascimento a Siena*, ed. L. Bellosi (Siena and Milan, 1993), pp. 382–6

R. Baldwin, 'A Bibliography of the Literature on Triumph', in *Triumphal Celebrations and the Rituals of Statecraft*, (*Papers in Art History from the Pennsylvania State University*, vol VI, Part 1) (University Park, PA, 1990), pp. 358–85

D. Balestracci, ed., *Statuto dell'Arte dei muratori (1626)* (Siena, 1976)

D. Balestracci and G. Piccinni, *Siena nel Trecento. Assetto urbano e prassi edilizia* (Florence, 1977)

D. Balestracci, R. Barzanti and G. Piccinni, 'Il Palio: una festa nella storia', in *Nuovo Corriere Senese* (1978), p. 9

D. Balestracci, 'Il nido dei nobili: Il popolo di S Cristoforo e la famiglia degli Ugurgeri in età comunale', in *Contrada Priora della Civetta* (Genoa, 1984), pp. 97–102

D. Balestracci, 'L'immigrazione di manodopera nella Siena medievale', in *Forestieri e stranieri nelle città basso-medievali (Atti del seminario, Bagno a Ripoli, giugno 1984)*, ed. G. Cherubini and G. Pinto (Florence, 1988), pp. 163–80

D. Balestracci, 'L'acqua a Siena nel medioevo', in *Ars et Ratio*, ed. J. Maire Vigueur and A. Paravicini Bagliani (Palermo, 1990), pp. 19–31

D. Balestracci, 'La corporazione dei muratori dal XIII al XVI secolo', in *Il colore della città*, ed. M. Boldrini (Siena, 1993), pp. 25–34

D. Balestracci, ed., *I bottini medievali di Siena* (Siena, 1993)

D. Balestracci, 'From Development to Crisis: Changing Urban Structures in Siena Between the Thirteenth and Fifteenth Centuries', in *The 'Other Tuscany': Essays in the History of Lucca, Pisa and Siena*, ed. T.W. Blomquist and M. F. Mazzaoui (Kalamazoo, 1994), pp. 199–213

D. Balestracci, 'Il labirinto sotteraneo', in *Storia di Siena. Dalle orgini alla fine della repubblica*, I, ed. R. Barzanti, G. Catoni and M. De Gregorio (Siena, 1995), pp. 155–66

L. Banchi, 'La Lira, la Tavola delle possessioni e le preste della repubblica di Siena', *Archivio Storico Italiano*, ser. III, 7 (1868), pp. 53–86

L. Banchi, ed., *Le origini favolose di Siena, secondo una presunta cronica di Tisbo Colonnese* (Siena, 1882)

L. Banchi and S. Borghesi, *Nuovi documenti per la storia dell'arte senese* (Siena, 1898)

D. Bandini, 'Memorie Piccolominee in Sarteano', *BSSP*, 57 (1950), pp. 107–30

F. Bandini Piccolomini, 'Una corporazione di lavoratori tedeschi a Siena nel secolo XV', *Miscellanea Storica Senese*, I (1893), pp. 215–17

F. Bandini Piccolomini, 'La cappella dei Bichi in San Agostino di Siena e lo spazo in terracotta dei Mazzaburroni', *Miscellanea Storica Senese*, IV (1896), pp. 121–4

F. Bandini Piccolomini, 'Feste senesi per la presa di Colle nel 1479', *Miscellanea Storica Senese*, IV (1896), pp. 129–32

B. Banks Amendola, *The Mystery of the Duchess of Malfi* (Stroud, 2002)

F. Bargagli Petrucci, 'Francesco di Giorgio, operaio dei bottini di Siena', *BSSP*, 9 (1902), pp. 227–36

F. Bargagli Petrucci, *Le fonti di Siena e il loro acquedotti. Note dalle origini al MDLV* (Siena, Florence and Rome, 1903; repr. Siena, 1992)

H. Baron, *The Crisis of the Early Italian Renaissance; Civic Humanism and Republican Liberty in an Age of Classicism and Tyranny* (Princeton, NJ, 1955)

R. Bartalini, 'Il tempo di Pio II', in *Francesco di Giorgio e il Rinascimento a Siena*, ed. L. Bellosi (Siena and Milan, 1993), pp. 92–105

R. Bartalani, *Le occasioni del Sodoma. Dalla Milano di Leonardo alla Roma di Raffaello* (Rome, 1996)

R. Barzanti, G. Catoni and M. De Gregorio, eds., *Storia di Siena*, 3 vols. (Siena, 1995–7)

R. Barzanti, A. Cornice and E. Pellegrini, eds., *Iconografia di Siena. Rappresentazione della Città dal XIII al XIX secolo* (Città di Castello, 2006)

B. Basile, ed., *Bentivolorum Magnificentia: Principe e cultura a Bologna nel Rinascimento* (Rome, 1987)

L. Bassini and F. Vanni, eds., *De strata francigena: studi e ricerche sulle vie di pellegrinaggio del medioevo*, III (Florence, 1995)

F. Battaglia, *Enea Silvio Piccolomini e Francesco Patrizi, due politici senesi del Quattrocento* (Florence, 1936)

M. Baxandall, *Painting and Experience in Fifteenth-century Italy: A Primer in the Social History of Pictorial Style* (Oxford, 1972)

M. Baxandall, 'Art, Society and the Bouguer Principle', *Representations*, 12 (1985), pp. 32–43

M. Baxandall, *Patterns of Intention: On the Historical Explanation of Pictures* (New Haven and London, 1985)

J. H. Beck, 'The Historical "Taccola" and the Emperor Sigismund in Siena', *Art Bulletin*, 50 (1968), pp. 309–20

J. Beck, 'Review of P. A. Riedl and M. Siedel, eds., *Die Kirchen von Siena*', *Renaissance Quarterly*, 42 (1989), pp. 117–18

J. Beck, *Jacopo della Quercia*, 2 vols. (New York, 1991)

L. Bellosi, ed., *Francesco di Giorgio e il Rinascimento a Siena* (Siena and Milan, 1993)

L. Bellosi, ed., *La sede storica della Banca Monte dei Paschi di Siena* (Certaldo, 2002)

G. Bellucci, 'Importanza della Via Francigena nello formazione e sviluppo degli ospedali', in *Il Santa Maria della Scala: l'Ospedale dai mille anni*, ed. P. Torriti (Genoa, 1991), pp. 23–36

P. Benetti Bertoldo, 'Francesco Patrizi the Elder: The Portrait of a Fifteenth-century Humanist', DPhil., Wolfson College, University of Oxford, 1996

L. Benevolo, *The City in the History of Europe* (Oxford, 1993)

T. Benton, 'Three Cities Compared: Urbanism', in *Siena, Florence and Padua: Art, Society and Religion, 1280–1400*, ed. D. Norman (New Haven and London, 1995), II, pp. 7–27

Bartolomeo Benvoglienti, *De urbis Senae origine et incremento* (Siena, 1506)

M. Berengo, *L'Europa delle città: il volto della società urbana europea tra medioevo ed età moderna* (Turin, 1999)

M. Bernardi et al., 'Il pozzo di butto nel castellare degli Ugurgeri, nella Contrada della Civetta', in *Contrada Priora della Civetta* (Genoa, 1984), pp. 115–23

Bernardino da Siena, *Le prediche volgari di S. Bernardino da Siena dette nella Piazza del Campo, l'anno 1427*, ed. L. Banchi, 3 vols. (Siena, 1880)

Bernardino da Siena, *Le prediche volgari inedite. Firenze 1424, 1425. Siena 1425*, ed. Dionisio Pacetti (Siena, 1935)

Bernardino da Siena, *Prediche volgari sul Campo di Siena, 1427*, ed. C. Delcorno, 2 vols. (Milan, 1989)

R. Bernheimer, 'Gothic Survival and Revival in Bologna', *Art Bulletin*, 36 (1954), pp. 263–81

M. Bertagna, *L'Osservanza di Siena*, 3 vols. (Siena, 1964)

C. Bertelli, 'Concezzione lombarda e progetto toscano', in G. H. Smyth and G. C. Garfagnini, *Florence and Milan: Comparisons and Relations* (Florence, 1989), vol. I, pp. 239–56

S. Bertelli, 'The Tale of Two Cities: Siena and Venice', in H. Millon and V. Magnago Lampugnani, eds., *The Renaissance from Brunelleschi to Michelangelo: The Representation of Architecture*, exh. cat. (London, 1994), p. 373–97

R. J. Betts, 'On the Chronology of Francesco di Giorgio's Treatises: New Evidence from an Unpublished Manuscript', *Journal of the Society of Architectural Historians*, 36 (1977), p. 3–14

G. Bianchi et al., *Fornaci e mattoni a Siena dal 13. secolo all'azienda Cialfi* (Soviclle, 1991)

G. Bianchi, 'Il ruolo del mattone a Siena nell'edilizia medievale e moderna', in Bianchi et al. (1991), pp. 11–20

A. Bicchi and A. Ciandella, '*Testimonia Sanctitatis': le reliquie e i reliquiari del Duomo e del Battistero di Firenze* (Florence, 1999)

T. Bichi Ruspoli, 'L'archivio privato Bichi Ruspoli', *BSSP*, 77 (1980), pp. 194–225

F. Bisogni, ed., *Palazzo della Provincia a Siena* (Rome, 1990)

F. Bisogni, 'La nobiltà allo specchio', in *I libri dei leoni. La nobiltà di Siena in età medicea*, ed. M. Ascheri (Siena, 1996), pp. 201–84

M. Bloch, *Apologie pour l'histoire ou Métier d'historien* (1949; Paris, 1993)

F. Bocchi, 'Suburbi e fasce suburbane nelle città dell'Italia medievale', *Storia delle Città*, 5 (1977), pp. 15–33

S. Boesch Gajano, 'Il comune di Siena e il prestito ebraico nei secoli XIV e XV', in *Aspetti e problemi della prestanza ebraica nell'Italia centro-settentrionale*, (*Quaderni dell'Istituto di Scienze Storiche dell'Università di Roma*, 2) (Rome, 1983)

E. Boldrini and R. Parenti, eds., *Santa Maria della Scala: archeologia e edilizia sulla piazza dello Spedale* (Florence, 1991)

M. Boldrini, ed., *Il colore della città* (Siena, 1993)

L. Bolzoni, *La rete delle immagini. Predicazione in volgare dalle origini a Bernardino da Siena* (Turin, 2002); trans. as *The Web of Images: Vernacular Preaching from its Origins to St Bernardino da Siena* (Aldershot, 2004)

G. Borghini, 'La decorazione', in *Il Palazzo Pubblico di Siena. Vicende costruttive e decorazione*, ed. C. Brandi (Milan, 1983), pp. 147–349

M. Borracelli, 'Siderurgia e imprenditori senesi nel '400 fino all'epoca di Lorenzo il Magnifico', *La Toscana ai tempi di Lorenzo il Magnifico: Politica, economia ed arte* (Pisa, 1996), III, pp. 1097–1123

F. Borsi, *Giuliano da Sangallo. I disegni di architettura e dell'antico* (Rome, 1985)

E. Borsook, 'Decor in Florence and the Entry of Charles VIII of France', *Mitteilungen des Kunsthistorisches Instituts in Florenz*, 10 (1961), pp. 106–22; 11 (1962), p. 217

L. Bortolotti, *Le città nella storia d'Italia: Siena* (Bari and Rome, 1983)

R. Bossaglia and G. dell'Acqua, eds., *I maestri campionesi* (Lugano, 1992)

W. M. Bowsky, 'The Impact of the Black Death upon Sienese Government and Society', *Speculum*, 39 (1964), pp. 1–34

W. M. Bowsky, *A Medieval Italian Commune: Siena under the Nine, 1287–1355* (Berkeley, 1981)

W. M. Bowsky, *The Finances of the Commune of Siena, 1287–1355* (Oxford, 1970)

M. Brachtel, *Lucca 1430–1494: The Reconstruction of an Italian City-Republic* (Oxford, 1995)

C. Brandi, ed., *Il Palazzo Pubblico di Siena. Vicende costruttive e decorazione* (Milan, 1983)

W. Brandmüller, *Il concilio di Pavia-Siena 1423–24. Verso la crisi del conciliarismo* (Siena, 2004)

W. Braunfels, *Mittelalterliche Stadtbaukunst in der Toskana* (Berlin, 1951)

W. Braunfels, *Urban Design in Western Europe* (Chicago, 1988)

P. Braunstein, 'Il cantiere del Duomo di Milano alla fine del XIV secolo: lo spazio, gli uomini e l'opera', in *Ars et Ratio*, ed. J. Maire Vigueur and A. Paravicini Bagliani (Palermo, 1990), pp. 147–64

J. Bridgeman, 'Ambrogio Lorenzetti's Dancing "Maidens": A Case of Mistaken Identity', *Apollo*, 133 (1991), pp. 245–50

A. Brilli, *Viaggiatori stranieri in terra di Siena* (Rome and Siena, 1984)

E. Brizio, G. Chironi, L. Nardi and C. Papi, 'Il territorio per la festa dell'Assunta: patti e censi di Signori e Communità dello Stato', in *Siena e il suo territorio nel Rinascimento*, ed. M. Ascheri and D. Ciampoli (Siena, 1986), pp. 81–250

E. Brizio, 'Leggi e provvedimenti del Rinascimento (1400–1542): spoglio di un registro archivistico (Statuto di Siena 40)', in *Antica legislazione della Repubblica di Siena*, ed. M. Ascheri (Siena, 1993), pp. 161–200

P. Brogini, 'La trasformazione della Casa della Misericordia in Casa della Sapienza', in *La Misericordia di Siena attraverso i secoli*, ed. M. Ascheri and P. Turrini (Siena, 2004), pp. 121–33

A. Brown, ed., *Language and Images of Renaissance Italy* (Oxford, 1995)

B. Brown, 'An Enthusiastic Amateur: Lorenzo de' Medici as Architect', *Renaissance Quarterly*, 46 (1993), pp. 1–22

J. Brown, *In the Shadow of Florence: Provincial Society in Renaissance Pescia* (Oxford, 1982)

A. Bruno and G. Pin, 'Il Palazzo di San Galgano in Siena', *BSSP*, 88 (1982), pp. 54–70

A. Bruno, 'Collegio di San Vigilio e Compagnia degli artisti', in *Università di Siena; 750 anni di storia*, ed. M. Ascheri et al. (Siena, 1991), pp. 323–8

A. Bruno, 'Palazzo del Capitano', in *Università di Siena: 750 anni di storia*, ed. M. Ascheri et al. (Siena, 1991), pp. 407–9

A. Bruschi, 'Religious Architecture in Renaissance Italy from Brunelleschi to Michelangelo', in *The Renaissance from Brunelleschi to Michelangelo: The Representation of Architecture*, ed. H. Millon and V. Magnago Lampugnani (London, 1994), pp. 123–81

P. Burke, *Eyewitnessing: The Uses of Images as Historical Evidence* (London, 2001)

H. Burns, 'Quattrocento Architecture and the Antique: Some Problems', in *Classical Influences in European Culture, AD 500–1500*, ed. R. R. Bolgar (Cambridge, 1971), pp. 269–87

H. Burns, 'Progetti di Francesco di Giorgio per i conventi di San Bernardino e Santa Chiara di Urbino', in *Studi Bramanteschi* (Rome, 1974), pp. 293–311

H. Burns, 'Un disegno architettonico di Alberti e la questione del rapporto fra Brunelleschi ed Alberti', in *Filippo Brunelleschi: la sua opera ed il suo tempo*, ed. G. de Angelis d'Ossat et al. (Florence, 1980), pp. 105–23

H. Burns, 'The Gonzaga and Renaissance Architecture', in *Splendours of the Gonzaga*, exh. cat., ed. D. Chambers and J. Martineau (London, 1981), pp. 27–38

H. Burns, 'Raffaello e "quell'antiqua architectura" ', in *Raffaello architetto*, ed. C. L. Frommel, S. Ray and M. Tafuri (Milan, 1984), pp. 381–404

H. Burns, 'Building and Construction in Palladio's Vicenza', in *Les chantiers de la Renaissance*, ed. A. Chastel and J. Guillaume (Paris, 1991), pp. 191–226

H. Burns, 'San Bernardino a Urbino', in *Francesco di Giorgio, architetto*, ed. F. P. Fiore and M. Tafuri (Siena and Milan, 1993), pp. 230–43

H. Burns, 'Progetti per la nuova casa della Sapienza, Siena. 1492 circa', in *Francesco di Giorgio architetto*, ed. F. P. Fiore and M. Tafuri (Siena and Milan, 1993), pp. 296–301

H. Burns 'I disegni di Francesco di Giorgio agli Uffizi di Firenze', in *Francesco di Giorgio architetto*, ed. F. P. Fiore and M. Tafuri (Siena and Milan, 1993), pp. 330–57

H. Burns, ' "Restaurator de ruyne antiche": tradizione e studio dell'antico nelle attività di Francesco di Giorgio', in *Francesco di Giorgio, architetto*, ed. F. P. Fiore and M. Tafuri (Milan, 1994), pp. 151–81

H. Burns, 'Tafuri e il rinascimento', *Casabella*, 619–20 [1995], p. 121

H. Burns, 'Building against Time: Renaissance Strategies to Secure Large Churches against Changes to their Design', in *L'église dans l'architecture de la Renaissance*, ed. J. Guillaume (Paris, 1995), pp. 107–31

H. Burns, 'Leon Battista Alberti', in *Storia dell'architettura italiana: il Quattrocento*, ed. F. P. Fiore (Milan, 1998), pp. 114–65

H. Burns, 'Prima della caduta. Cultura e identità senese nella prima metà del Cinquecento', in *Siena nel Rinascimento: l'ultimo secolo della repubblica*, Acts of the International Conference, ed. G. Mazzoni and F. Nevola (Florence, 2007) [forthcoming]

E. Burrini, 'I cittadini senesi del Terzo di Camollia e il fisco del 1481. Inventario delle denunce della Lira conservate nell'Archivio di Stato di Siena', Tesi di Laurea, Università di Studi di Siena, 1989–90

C. Burroughs, 'Below the Angel: An Urbanistic Project in the Rome of Pope Nicholas V', *Journal of the Warburg and Courtauld Institutes*, 45 (1982), pp. 94–124

C. Burroughs, 'Florentine Palaces: Cubes and Context', *Art History*, 6 (1983), pp. 359–63

C. Burroughs, *From Signs to Design: Environmental Process and Reform in Early Renaissance Rome* (Cambridge, MA, 1990)

C. Burroughs, 'The Building's Face and the Herculean Paradigm: Agendas and Agency in Roman Renaissance Architecture', *Res*, 23 (1993), pp. 7–30

C. Burroughs, 'Absolutism and the Rhetoric of Topography: Streets in the Rome of Sixtus V', in *Streets: Critical Perspectives on Public Space*, ed. Z. Çelik, D. Favro and R. Ingersoll (Berkeley, 1994), pp. 189–202

C. Burroughs, 'Hieroglyphs in the Street: Architectural Emblematics and the Idea of the Façade in the Early Sixteenth-century Palace Design', in *The Emblem and Architecture: Studies in Applied Emblematics from the Sixteenth to the Eighteenth Centuries*, ed. H. J. Boker and P. M. Daly (*Imago Figurata*, 2) (Turnhout, 1999), pp. 57–82

C. Burroughs, *The Italian Renaissance Palace Façade: Structures of Authority, Surfaces of Sense* (Cambridge, 2002)

H. Butters, 'The Politics of Protection in Late Fifteenth-century Italy: Florence and the Failed Sienese Exiles' Plot of May 1485', in *The French Descent into Renaissance Italy, 1494–5*, ed. D. Abulafia (Aldershot, 1995), pp. 137–49

M. Butzek, *Il Duomo di Siena al tempo di Alessandro VII. Carteggio e disegni* (Munich, 1996)

M. Butzek, 'La cappella della Madonna delle Grazie. Una ricostruzione', in *Pio II e le arti. La riscoperta dell'antico da Federighi a Michelangelo*, ed. A. Angelini (Cinisello Balsamo, Milan, 2005), pp. 83–103

M. Caciorgna, 'Giovanni Antonio Campano tra filologia a pittura. Dalle *Vitae* di Plutarco alla biografia dipinta di Pio II', *Quaderni dell'Opera*, II (1998), pp. 85–138

M. Caciorgna, 'Moduli antichi e tradizione classica nel programma della Fonte Gaja di Jacopo della Quercia', *Fontes. Rivista di filologia, iconografia e storia della tradizione classica*, 7–10 [2001–2002], pp. 71–142

M. Caciorgna and R. Guerrini, 'Imago Urbis. La lupa e l'immagine di Roma nell'arte e nella cultura senese come identità storica e morale', in *Siena e Roma. Raffaello, Caravaggio e i protagonisti di un legame antico*, exh. cat., Siena, S. Maria della Scala, Palazzo Squarcialupi, 25 November 2005–5 March 2006, ed. B. Santi and C. Strinati (Siena, 2005), pp. 99–118

M. Caciorgna, ' "Mortalis aemulor arte deos". Umanisti e arti figurative a Siena tra Pio II e Pio III', in *Pio II e le arti. La riscoperta dell'antico da Federighi a Michelangelo*, ed. A. Angelini (Cinisello Balsamo, Milan, 2005), pp. 151–81

M. Caciorgna and R. Guerrini, *Il pavimento del Duomo di Siena* (Siena, 2004)

W. Caferro, *Mercenary Companies and the Decline of Siena* (Baltimore and London, 1998)

W. Caferro and P. Jacks, *The Spinelli of Florence: Fortunes of a Renaissance Merchant Family* (University Park, PA, 2001)

F. Caglioti, *Donatello e i Medici. Storia del David e della Giuditta*, Fondazione Carlo Marchi, Studi 14 (Florence, 2000)

D. Calabi, 'Le due piazze di Rialto e San Marco: tra eredità medievali e volontà di rinnovo', *Annali di Architettura*, 4–5 (1992–3), pp. 190–201

D. Calabi, *Il mercato e la città. Piazze, strade, architetture d'Europa in età moderna* (Venice, 1993)

D. Calabi, ed., *Fabbriche, piazze e mercati. La città italiana nel Rinascimento* (Rome, 1997)

G. Calamari, *Il confidente di Pio II, Cardianle Iacopo Ammannati Piccolomini* (Rome, 1932)

I. Calvino, *Invisible Cities* (London, 1974)

I. Calvino, *Romanzi e racconti*, ed. M. Barenghi and B. Falcetto, 3 vols. (Milan, 1991)

A. Calzona, F. P. Fiore, A. Tenenti and C. Vasoli, eds., *Il sogno di Pio II e il viaggio da Roma a Mantova. Atti del Convegno Internazionale. Mantova: 13–15 aprile 2000*, Centro Studi L. B. Alberti, *Ingenium* no. 5 (Florence, 2003)

P. Cammarosano, *La famiglia dei Berardenghi. Contributo alla storia della società senese dei secoli XI–XIII* (Spoleto, 1974)

G. A. Campano, 'Vita Pii II Pontificis Maximi', in *Rerum Italicarum Scriptores*, vol. 3, part 3, ed. G. Zimolo (Bologna, 1964)

L. Campbell, 'Cosmè Tura and Netherlandish Art', in *Cosmè Tura: Painting and Design in Renaissance Ferrara*, exh. cat., ed. S. Campbell, Isabella Stuart Gardner Museum, Boston (Milan, 2002), pp. 71–105

S. J. Campbell and S. J. Milner, 'Art, Identity and Cultural Translation in Renaissance Italy', in *Artistic Exchange and Cultural Translation in the Italian Renaissance City* (Cambridge, 2004), pp. 1–13

S. J. Campbell and S. J. Milner, eds., *Artistic Exchange and Cultural Translation in the Italian Renaissance City* (Cambridge, 2004)

A. Canestrelli, *L'abbazia di San Galgano* (Florence, 1896; repr. Pistoia, 1989)

F. Cantatore, 'Opere bronzee', in *Francesco di Giorgio, architetto*, ed. F. P. Fiore and M. Tafuri (Siena and Milan, 1993), pp. 326–7

C. Cantoni, *Frammento di un diario sanese*, ed. A. Lisini and F. Iacometti, *Cronache Senesi*, RIS, 15.6.3 (Bologna, 1939), pp. 875–943

G. Cantucci, 'Considerazioni sulle trasformazioni urbanistiche nel centro di Siena', *BSSP*, 68 (1961), pp. 251–62

S. Cappannoli, *I cittadini senesi del Terzo di San Martino e il fisco del 1481. Inventario delle denunce della Lira conservate nell'Archivio di Stato di Siena* (Tesi di Laurea, Università di Studi di Siena, 1989–90)

C. Cardamone, 'Santa Maria in Portico di Fontegiusta, Siena', in *La chiesa a pianta centrale: tempio civico del Rinascimento*, ed. B. Adorni (Milan, 2002), pp. 97–106

D. Carl, 'Il ciborio di Benedetto da Maiano nella cappella maggiore di San Domenico a Siena: un contributo al problema dei cibori quattrocenteschi, con un excursus per la storia architettonica della chiesa', *Rivista dell'Arte*, 42 (1990), pp. 3–74

D. Carl, 'Giuliano da Maiano und Lorenzo de' Medici. Ihre bezeihung im lichte von zwei neaufgefundenen briefen', *Mitteilungen des Kunsthistorisches Instituts in Florenz*, 37 (1993), pp. 235–56

D. Carl, 'New Documents for Antonio Rossellino's Altar in the Church of S. Anna dei Lombardi, Naples', *Burlington Magazine*, 138 (1996), pp. 318–20

D. Carl, 'Die Büsten im Kranzgesims des Palazzo Spannocchi', *Mitteilungen des Kunsthistorischen Instituts in Florenz*, 43 (1999), pp. 628–38

E. Carli, *Il Duomo di Siena* (Siena, 1979)

A. Carniani, *I Salimbeni, quasi una signoria* (Siena, 1995)

E. Casanova, 'Un'anno nella vita privata di Pio II', *BSSP*, 2 (1931), pp. 19–34

L. Castelfranchi and J. Shell, eds., *Giovanni Antonio Amadeo: scultura e architettura del suo tempo* (Milan, 1993)

V. Castelli and S. Bonucci, *Antiche Torri di Siena* (Siena, 2005)

E. Castelnuovo and C. Ginzburg, 'Centro e periferia', in *Storia dell'arte italiana. Questioni e metodi*, ed. G. Previtali, 1.1 *Materiali e problemi: Questioni e metodi* (Turin, 1979), pp. 283–352; trans. E. Bianchini as 'Centre and Periphery' in *History of Italian Art*, ed. E. Bianchini and C. Dorey (Cambridge, 1994), II, pp. 29–113

E. Castelnuovo, 'Introduction to Part I: Dissemination and Assimilation of Style', in *World History of Art: Themes of Unity and Diversity*, Acts of the XXVIth International Conference of History of Art, ed. I. Lavin (University Park, PA, 1989), pp. 43–7

E. Castelnuovo, ed., *Ambrogio Lorenzetti: il Buon Governo* (Milan, 1995)

G. Cataldi, ed., *Edilizia seriale pianificata in Italia 1500–1600*, in *Studi e Documenti di Architettura*, 14 (1987)

G. Catoni, 'La faziosa armonia', in *Palio*, ed. A. Falassi and G. Catoni (Milan, 1982), pp. 225–72

G. Catoni and G. Piccinni, 'Famiglie e redditi nella Lira senese del 1453', in *Strutture familiari, epidemie e migrazioni*, ed. R. Comba, G. Piccinni and G. Pinto (Naples, 1984), pp. 291–304

G. Catoni and G. Piccinni, 'Alliramento e ceto dirigente nella Siena del Quattrocento', in *I ceti dirigenti nella Toscana del Quattrocento*, ed. D. Rugiadini, Atti del V e VI convegno: Firenze, 10–11 dicembre 1982; 2–3 dicembre 1983 (Florence, 1987), pp. 451–61

G. Catoni and A. Leoncini, *Cacce e tatuaggi: Nuovi raguagli sulle contrade di Siena* (Siena, 1993)

L. Cavazzini and A. Galli, 'Biografia di Francesco di Giorgio ricavata dai documenti', in *Francesco di Giorgio e il Rinascimento a Siena*, ed. L. Bellosi (Siena and Milan, 1993), pp. 512–17

D. Cecchini, *Gli oratori delle contrade di Siena* (Siena, 1995)

G. Cecchini, 'Il Castello delle Quattro Torri e i suoi proprietari', *BSSP*, 55 (1948), pp. 3–32

G. Cecchini, ed., *Guida inventario dell'archivio di Stato di Siena*, 2 vols. (Rome 1951)

G. Cecchini, 'Introduzione', in *Archivio di Stato di Siena: Archivio del Concistoro: Inventario*, ed. G. Cecchini (Rome, 1952), pp. ix–xxiv

G. Cecchini, ed., *Archivio di Stato di Siena: Archivio del Concistoro: Inventario* (Rome, 1952)

G. Cecchini, ed., *Archivio di Stato di Siena, Archivio di Biccherna. Inventario* (Rome, 1953)

G. Cecchini, 'Maestri luganesi e comaschi a Siena nel XV secolo', in *Arte e artisti dei laghi lombardi*, I: *Architetti e scultori del Quattrocento*, ed. E. Arslan (Como, 1959), pp. 131–50

G. Cecchini, 'La Cappella di San Sepolcro', *Terra di Siena* (1959), pp. 31–3

G. Cecchini, 'Minime di storia dell'arte senese: Un'altro palazzo gotico del Rinascimento', *BSSP*, 68 (1961), pp. 241–50

G. Cecchini, 'L'arazzeria senese', *Archivio Storico Italiano*, CXX (1962), pp. 149–77

Cecchino Libraio, *La magnifica e honorata festa fatta in Siena per la Madonna d'Agosto l'anno 1546* (Siena, 1546) (BCS, H. XI. 3)

A. Ceen, *The 'Quartiere dei Banchi': Urban Planning in Early Cinquecento Rome* (New York, 1986) (based on A. Ceen's PhD thesis, University of Pennsylvania, 1977)

Z. Çelik, D. Favro and R. Ingersoll, eds., *Streets: Critical Perspectives on Public Space* (Berkeley, 1994)

R. Celli, *Studi sui sistemi normativi delle democrazie comunali. Secoli XII–XV: Siena e Pisa*, 2 vols. (Florence, 1976)

M. A. Ceppari, 'Tra legislazione annonaria e tecnologia: alla ricerca di una Biccherna perduta', in *Antica legislazione della Repubblica di Siena*, ed. M. Ascheri (Siena, 1993), pp. 201–23

M. A. Ceppari, 'La signoria di Gian Galeazzo Visconti', in *Storia di Siena. Dalle orgini alla fine della repubblica*, I, ed. R. Barzanti, G. Catoni and M. De Gregorio (Siena, 1995), pp. 315–26

M. A. Ceppari, S. Massai and P. Turrini, 'I *risieduti* della città di Siena in età medicea', in *I libri dei leoni. La nobiltà di Siena in età medicea*, ed. M. Ascheri (Siena, 1996), pp. 503–28

M. A. Ceppari, 'I Papi a Siena', *Istituto Storico Diocesano di Siena: Annuario 1998–1999* (Siena, 1999), pp. 345–54

M. A. Ceppari et al., eds., *L'immagine del Palio: Storia, cultura e rappresentazione del rito di Siena* (Siena, 2001)

D. S. Chambers, 'The Housing Problems of Cardinal Francesco Gonzaga', *Journal of the Warburg and Courtauld Institutes*, 39 (1976), pp. 21–58

D. S. Chambers, 'Spese del soggiorno di Papa Pio II a Mantova', in A. Calzona, F. P. Fiore, A. Tenenti and C. Vasoli, eds., *Il sogno di Pio II e il viaggio da Roma a Mantova. Atti del Convegno Internazionale. Mantova: 13–15 aprile 2000*, Centro Studi L. B. Alberti, *Ingenium* n. 5 (Florence, 2003), pp. 391–402

H. Chapman, T. Henry and C. Plazzotta, eds. *Raphael: From Urbino to Rome* (London and New Haven, 2004)

A. Chastel and J. Guillaume, *La maison et la ville à la Renaissance*, Acts of the Conference, Tours, 1977 (Paris, 1983)

G. Chelazzi Dini, ed., *Jacopo della Quercia fra gotico e Rinascimento* (Florence, 1977)

M. Chiantini, *La Mercanzia di Siena nel Rinascimento* (Siena, 1996)

G. Chierici, 'La casa senese ai tempi di Dante', *BSSP*, 28 (1921), pp. 343–80

A. Chigi et al., *Testamentum Augustini, Augusti, Sigismundi de Chigiis* (Siena: Apud Bonettos, 1640)

Fabio Chigi, 'Chigiae Familiae Commentarii (1618)', in G. Cugnoni, *Agostino Chigi il Magnifico* (Rome, 1878)

G. Chironi, 'Un mondo perfetto. Istituzioni e societas christiana nella Pienza di Pio II', in *Pio II Piccolomini: Il papa del rinascimento a Siena*, Acts of the International Conference (Siena, 5–7 May 2005), ed. F. Nevola (Siena 2007)

G. Chironi, 'Repertorio dei documenti riguardanti Mariano di Iacopo detto il Taccola e Francesco di Giorgio Martini', in *Prima di Leonardo: cultura delle macchine a Siena nel Rinascimento*, ed, P. Galluzzi (Milan, 1991), pp. 470–82

G. Chironi, 'Politici e ingegneri. I Provveditori della Camera del Comune di Siena negli anni '90 del Quattrocento', *Ricerche Storiche*, 23/2 (1993), pp. 375–95

G. Chironi, 'Appendice documentaria', in *Francesco di Giorgio, architetto*, ed. F. P. Fiore and M. Tafuri (Siena and Milan, 1993), pp. 400–11

G. Chironi, 'La signoria breve di Pandolfo Petrucci', in *Storia di Siena. Dalle orgini alla fine della repubblica*, I, ed., R. Barzanti, G. Catoni and M. De Gregorio (Siena, 1995), pp. 395–406

G. Chironi, 'Nascita della signoria e resistenze oligarchiche a Siena: l'opposizione di Niccolò Borghesi a Pandolfo Petrucci (1498–1500)', in *La Toscana ai tempi di Lorenzo il Magnifico: Politica, economia ed arte* (Pisa, 1996), III, pp. 1173–95

G. Chironi, 'Cultura tecnica e gruppo dirigente: la famiglia Vannocci Biringucci', in *Una tradizione senese. Dalla 'Pirotechnica' di Vannoccio Biringucci al Museo del Mercurio*, ed. I. Tognarini (Naples, 2000), pp. 99–130

G. Chironi, 'Pius II and the Formation of the Ecclesiastical Institutions of Pienza', in *Pius II, 'el più expeditivo pontefice': Selected Studies on Aeneas Silvius Piccolomini, 1405–1464*, ed. Z.

von Martels and A. Vanderjagt (Boston and Leiden, 2003), pp. 171–85

G. Chironi, *L'archivio diocesano di Pienza* (Siena, 2000)

G. Chittolini, 'Civic Religion and the Countryside in Late Medieval Italy', in *City and Countryside in Late Medieval and Renaissance Italy*, ed. T. Dean and C. Wickham (London, 1990), pp. 69–80

F. Choay, *The Invention of the Historic Monument* (Cambridge, 2001)

K. Christiansen, *Gentile da Fabriano* (Ithaca, NY, 1982)

K. Christiansen, L. B. Kanter and C. B. Strehlke, eds., *Painting in Renaissance Siena, 1420–1500* (New York, 1988)

K. Christiansen, 'Painting in Renaissance Siena', in K. Christiansen, L. B. Kanter and C. B. Strehlke, eds., *Painting in Renaissance Siena, 1420–1500* (New York, 1988), pp. 3–32

K. Christiansen, 'Notes on "Painting in Renaissance Siena"', *Burlington Magazine*, 132 (1990), pp. 205–13

K. Christiansen, 'Mattia di Nanni's Intarsia Bench for the Palazzo Pubblico, Siena', *Burlington Magazine*, 139 (1997), pp. 372–86

D. Ciampoli, 'Il rubricario dello Statuto del comune di Siena del 1337', in *Il Capitano del Popolo a Siena nel primo Rinascimento*, ed. D. Ciampoli (Siena, 1984), pp. 59–123

D. Ciampoli and T. Szabó, eds., *Viabilità e legislazione di uno stato cittadino del Duecento. Lo Statuto dei Viarii di Siena* (Siena, 1992)

D. Ciampoli, 'La proprietà del comune di Siena in città e nello stato nella prima metà del Quattrocento', in *Siena e il suo territorio*, vol II, ed. D. Ciampoli and M. Ascheri (Siena, 1990), pp. 1–44

D. Ciampoli, 'Abbadia al tempo di Pio II', in *Abbadia San Salvatore: Una comunità autonoma nella Repubblica di Siena*, ed. M. Ascheri and F. Mancuso (Siena, 1994), pp. 51–68

M. Ciampolini, 'Palazzo Chigi-Zondadari', in *Unversità di Siena; 750 anni di storia*, M. Ascheri et al. (Siena 1991), pp. 413–14

M. G. Ciardi Duprè dal Poggetto, *La bottega di Giuliano e Benedetto da Maiano nel Rinascimento Fiorentino* (Florence, 1994)

E. Cioni, *Museo nazionale del Bargello. Sigilli medievali senesi* (Florence, 1981)

E. Cioni and D. Fausti, eds., *Umanesimo a Siena. Letteratura, arti figurative, musica (Siena, 5–8 giugno 1991: atti del convegno)*, ed. E. Cioni and D. Fausti (Siena, 1994)

E. Cioni, *Il reliquiario di San Galgano: contributo alla storia dell'oreficeria e iconografia* (Florence, 2005)

C. Cipolla, ed., *Banchieri e mercanti a Siena* (Siena and Rome, 1987)

R. Ciprelli, 'Le costruzioni dei Piccolomini in un manoscritto inedito', *Regnum Dei: Collectanea Theatina*, 110 (1984), pp. 227–56

A. Cirier, 'Note sur le monastère de Santa Marta in Siene,' *BSSP*, 109 (2002), pp. 497–513

M. Civai and E. Toti, *Siena: The Gothic Dream* (Siena, 1992)

G. Clarke, 'Paul III and the Façade of the Casa Crivelli in Rome', *Renaissance Studies*, 3 (1989), pp. 252–66

G. Clarke, 'Italian Renaissance Urban Domestic Architecture: The Influence of Antiquity', PhD thesis, Courtauld Institute of Art, University of London, 1992

G. Clarke, 'Magnificence and the City: Giovanni II Bentivoglio and Architecture in Fifteenth-century Bologna', *Renaissance Studies*, 13 (1999), pp. 397–411

G. Clarke, *Roman House – Renaissance Palaces: Inventing Antiquity in Fifteenth-century Italy* (Cambridge, 2003)

G. Clarke, 'Giovanni Il Bentovoglio and the Uses of Chivalry: Creating a Republican Court in Late Fifteenth-century Bologna', in *Artistic Exchange and Cultural Translation in the Italian Renaissance City*, ed. S. J. Campbell and S. J. Milner (Cambridge, 2004), pp. 162–86

C. H. Clough, 'Francesco di Giorgio: Checklist and History of Manuscripts and Drawings', *Renaissance Studies*, 8 (1994), pp. 95–106

C. H. Clough, 'Pandolfo Petrucci e il concetto di "Magnificenza"', in *Arte, committenza ed economia a Roma e nelle corti del Rinascimento (1420–1530)*, ed. A. Esch and C. L. Frommel (Turin, 1995), pp. 383–97

E. Cochrane, *Historians and Historiography in the Italian Renaissance* (Chicago, 1981)

S. Cohn, *The Laboring Classes in Renaissance Florence* (New York, 1980)

S. K. Cohn, 'La "Nuova Storia Sociale" di Firenze', *Studi Storici*, 26 (1985), pp. 353–71

S. Cohn, *Death and Property in Siena, 1205–1800* (Baltimore, 1988)

S. Cohn, *The Cult of Remembrance and the Black Death: Six Renaissance Cities in Central Italy* (Baltimore, 1992)

S. Cohn, 'Burkhardt Revisited from Social History', in *Language and Images of Renaissance Italy*, ed. A. Brown (Oxford, 1995), pp. 217–35

S. Cohn, *Popular Protest in Late-medieval Europe: Italy, France and Flanders* (Manchester, 2004)

B. Cole, *Sienese Painting in the Age of Renaissance* (Bloomington, Indiana, 1985)

Tisbo Colonnese, *Le origini favolose di Siena, secondo una presunta cronica*, ed. L. Banchi (Siena, 1882)

E. Concina, *Venezia nell'età moderna. Struttura e forma* (Milan, 1994)

S. M. Connell, 'The Employment of Sculptors and Stone Masons in Venice in the Fifteenth Century', PhD thesis, Warburg Institute, University of London, 1976

J. Connors, 'Alliance and Enmity in Roman Baroque Urbanism', *Römisches Jahrbuch für Kunstgeschichte*, 25 (1989), pp. 207–94; trans. as *Alleanze e inimicizie: l'urbanistica di Roma barocca* (Bari, 2005)

M. Cordaro, 'Le vicende costruttive', in *Il Palazzo Pubblico di Siena. Vicende costruttive e decorazione*, ed. C. Brandi (Milan, 1983), pp. 29–145

M. Cordaro, 'L'architettura della basilica e del convento dell'Osservanza', in *L'Osservanza di Siena* (Milan, 1984), pp. 21–50

M. Cordaro, 'Baldassarre Peruzzi, il Palazzo Pubblico e il Campo di Siena', in *Baldassarre Peruzzi: pittura, scena e architettura*, ed. M. Fagiolo and M. L. Madonna (Rome, 1987), pp. 169–80

S. Cornelison, 'Art Imitates Architecture: The St Philip Reliquary in Renaissance Florence', *Art Bulletin*, 86 (2004), pp. 642–58

S. Cornelison, 'When an Image is a Relic: The St Zenobius Panel from Florence Cathedral', in *Images, Relics, and Devotional Practices in Late Medieval and Renaissance Italy*, ed. S. Cornelison and S. B. Montgomery (Tempe, AZ, 2005), pp. 95–113

E. Costa and L. Ponticelli, 'L'iconografia del Pellegrinaio nello Spedale di Santa Maria della Scala di Siena', *Iconographica*, III (2004), pp. 110–47

M. N. Covini, 'L'Amadeo e il collettivo degli ingegneri ducali al tempo degli Sforza', in *Giovanni Antonio Amadeo: scultura e architettura del suo tempo*, ed. L. Castelfranchi and J. Shell (Milan, 1993), pp. 59–76

P. Craveri, 'Bartolomeo Benvoglienti', in *DBI* (Rome, 1966), VIII, pp. 697–8

C. Cresti, ed., *Agostino Fantastici. Architetto senese, 1782–1845* (Turin, 1992)

C. Cribaro, 'Urban Planning and Administration in Florence: 1400–1600', PhD thesis, University of Nebraska, 1980

M. Cristofani, ed., *Siena: le origini. Testimonianze e miti archeologici*, exh. cat. (Florence, 1979)

H. de la Croix, 'Military Architecture and the Radial City Plan in Sixteenth-century Italy', *Art Bulletin*, 42 (1960), pp. 263–90

F. Cruciani, *Il teatro del Rinascimento a Roma 1450–1550* (Rome, 1983)

J. M. Cruselles Gómez and D. Igual Luis, *El duc Joan de Borja a Gandia. Els comptes de la banca Spannochi (1488–1496)*, (Gandía, 2003)

G. Cugnoni, 'Aeneæ Silvii Piccolomini Senensis qui postea fuit Piu II Pont. Max.; Opera inedita ex codicibus Chisianis', *Atti della R. Accademia dei Lincei*, ser. 3, 8 (1882–3), pp. 319–686

C. Cundari, ed., *Il complesso di Monteoliveto a Napoli: analisi, rilievi, documenti, informatizzazione degli archivi* (Rome, 1999)

C. Cunningham, 'For the Honour and Beauty of the City: The Design of Town Halls', in *Siena, Florence and Padua: Art, Society and Religion, 1280–1400*, ed. D. Norman (New Haven and London, 1995), II, pp. 29–54

F. A. D'Accone, *The Civic Muse: Music and Musicians in Siena During the Middle Ages and the Renaissance* (Chicago, 1997)

S. Danesi Squarzina, ed., *Roma: centro ideale della cultura dell'antico nei secoli XV e XVI* (Milan, 1989)

A. Dati, 'Historiae Senenses', in *Opera* (Siena: Simone di Niccolò Nardi, 1503)

P. Davies, 'Studies in the Quattrocento Centrally Planned Church', PhD thesis, Courtauld Institute of Art, University of London, 1992

P. Davies, 'The Madonna delle Carceri in Prato and Italian Renaissance Pilgrimage Architecture', *Architectural History*, 36 (1993), pp. 1–18

P. Davies, 'The Early History of Santa Maria delle Carceri', *Journal of the Society of Architectural Historians*, 54 (1995), pp. 326–35

R. C. Davis, *The War of the Fists: Popular Culture and Public Violence in Late Renaissance Venice* (Oxford, 1994)

T. Dean, ed., *Towns of Italy in the later Middle Ages: Selected Sources* (New York and Manchester, 2000)

A. de Vincentis, *Battaglie di Memoria. Gruppi, intelletuali, testi e la discontinuità del potere papale alla metà del Quattrocento* (Rome, 2002)

S. della Torre, T. Mannoni and V. Pracchi, eds., *Magistri d'Europa: Eventi, relazioni, strutture della migrazione di artisti e costruttori dai laghi lombardi* (Como, 1997)

F. Donati, 'Lettera relativa all'uccisione di Niccolò Borghesi', *Miscellanea Storica Senese*, I (1893), pp. 129–32

F. Donati, 'Il portico del Campo', *Miscellanea Storica Senese*, I (1893), pp. 33–7

F. Donati, 'Il convento di Santa Maria Maddalena', *Miscellanea Storica Senese*, II (1894), pp. 8–11

A. Dundes and A. Falassi, *La Terra in Piazza: An Interpretation of the Palio of Siena* (Berkeley and London, 1975)

J. Dunkerton, S. Foister, D. Gordon and N. Penny, eds., *Giotto to Dürer: Early Renaissance Painting in the National Gallery* (New Haven and London, 1991)

M. Dykmans, *L'Oeuvre de Patrizi Piccolomini ou le ceremonial papal de la première Renaissance*, 2 vols. (Vatican City, 1982)

N. Eckstein, *The District of the Green Lion: Neighbourhood Life and Social Change in Renaissance Florence*, Quaderni di 'Rinascimento', XXII (Florence, 1995)

U. Eco and T. A. Sebeok, eds., *The Sign of Three* (Bloomington, IN, 1983)

C. Elam, 'Lorenzo de' Medici and Urban Development in Renaissance Florence', *Art History*, I (1978), pp. 43–66

C. Elam, 'Piazza Strozzi: Two Drawings by Baccio d'Agnolo', *I Tatti Studies*, I (1985), pp. 105–35

C. Elam, 'Piazze private nella Firenze del Rinascimento', *Ricerche Storiche*, 16 (1986), pp. 473–80

C. Elam, 'Lorenzo's Architectural and Urban Policies', in *Lorenzo il Magnifico e il suo mondo*, ed. G. C. Garfagnini (Florence, 1994), pp. 357–82

M. S. Elsheikh, ed., *Il Costituto del Comune di Siena volgarizzato nel MCCCIX–MCCCX* (Città di Castello, 2002)

E. English, *Enterprise and Liability in Sienese Banking, 1230–1350* (Cambridge, MA, 1988)

E. English, 'Urban Castles in Medieval Siena: The Sources and Images of Power', in *The Medieval Castle: Romance and Reality*, ed. K. Reyerson and F. Powe, *Medieval Studies at Minnesota*, I (Dubuque, IA, 1984), pp. 175–98

A. Esposito, *Un'altra Roma: minoranze nazionali e comunità ebraiche tra medioevo e Rinascimento* (Rome, 1995)

L. Ettlinger, 'The Emergence of the Italian Architect During the Fifteenth Century', in *The Architect: Chapters in the History of the Profession*, ed. S. Kostof (New York, 1977), pp. 96–123

C. Eubel, *Hierarchia catholica medii aevi sive Summum Pontificorum, 1431–1503* (Münster, 1914)

C. von Fabriczy, 'Giuliano da Maiano in Siena', *Jahrbuch der Königlich Preussischen Kunstsammlungen*, 4 (1903), pp. 320–34

M. Fagiolo, ed., *La festa a Roma*, 2 vols. (Rome, 1997)

M. Fagiolo and M. L. Madonna, 'Il revival del trionfo classico', in *La festa a Roma*, ed. M. Fagiolo (Rome, 1997), I, pp. 34–41

A. Falassi, 'Le contrade', in *Storia di Siena. Dalle orgini alla fine della repubblica*, ed. R. Barzanti, G. Catoni and M. De Gregorio (Siena, 1996), II, pp. 95–108

M. Faloci Palugnani, 'Siena e Foligno', *Bollettino della Regia Deputazione di Storia Patria per l'Umbria*, XXIII (1918), pp. 115–206

G. Fattorini, 'Alcune questioni di ambito beccafumiano: il "Maestro delle Eroine Chigi Saracini" e il "Capanna senese" ', in *Beccafumi. L'opera completa*, ed. P. Torriti (Milan, 1998), pp. 45–6

G. Fattorini, 'Pio II e la Vergine di Camollia', in *Pio II Piccolomini: Il papa del rinascimento a Siena*, ed. F. Nevola, Acts of the International Conference, Siena, 5–7 May 2005 (Siena, 2007)

D. Favro, 'Meaning and Experience: Urban History from Antiquity to the Early Modern Period', *Journal of the Society of Architectural Historians*, 58 (1999), pp. 364–73

Fazio degli Uberti, *Il Dittamondo e le Rime*, ed. G. Corsi (Bari, 1952)

T. Fecini, 'Cronaca Senese (1431–1479)', in A. Lisini and F. Iacometti, eds., *Cronache Senesi*, in *Rerum Italicarum Scriptores*, vol. 15, part 6 (Bologna, 1931), pp. 837–74

A. Ferrari, R. Valentini and M. Vivi, 'Il Palazzo del Magnifico a Siena', *BSSP*, 92 (1985), pp. 107–53

A. Filarete, *Filarete's Treatise on Architecture*, ed. and trans. J. Spencer (New Haven, 1965)

F. Filarete and A. Manfidi, *The Libro cerimoniale of the Florentine Republic*, ed. R. Trexler (Geneva, 1978)

P. Findlen and K. Gouwens, 'AHR Forum: The Persistence of the Renaissance', *American Historical Review*, 103 (1998), pp. 51–124

R. Finnegan, *Tales of the City: A Study of Narrative and Urban Life* (Cambridge, 1998)

F. P. Fiore and M. Tafuri, eds., *Francesco di Giorgio, architetto* (Siena and Milan, 1993)

F. P. Fiore and M. Tafuri, 'Il monastero e la chiesa di Santa Caterina a Urbino', in *Francesco di Giorgio, architetto*, ed. F. P. Fiore and M. Tafuri (Siena and Milan, 1993), pp. 260–73

F. P. Fiore, 'L'architettura civile di Francesco di Giorgio', in *Francesco di Giorgio, architetto*, ed. F. P. Fiore and M. Tafuri (Siena and Milan, 1993), pp. 74–125

F. P. Fiore, 'Francesco di Giorgio Martini', in *The Dictionary of Art*, ed. J. Turner (New York, 1996), XI, p. 68

F. P. Fiore, 'Giacomo Cozzarelli', in *The Dictionary of Art*, ed. J. Turner (London, 1996), VIII, pp. 100–101

F. P. Fiore, 'Siena e Urbino', in *Storia dell'architettura italiana: il Quattrocento*, ed. F. P. Fiore (Milan, 1998), pp. 272–313

F. P. Fiore, 'La Loggia di Pio II per i Piccolomini a Siena', in A. Calzona, et al. (2003), pp. 129–42

F. P. Fiore ed., *Francesco di Giorgio alla corte di Federico da Montefeltro*, Acts of the International Conference, Urbino, 11–13 October 2001 (Florence, 2004), II, pp. 409–11

F. P. Fiore, *La Roma di Leon Battista Alberti. Umanisti, architetti e artisti alla scoperta dell'antico nella città del Quattrocento*, exh. cat. (Rome and Milan, 2005)

A. Fiorini, *Siena. Immagini, testimonianze e miti nei toponimi della città* (Siena, 1991)

L. Firpo, ed., *La città ideale nel Rinascimento* (Turin, 1975)

Biondo Flavio da Forlì, *Italia Illustrata* (Rome: Iohannis Philippi de Lignamine, 1474)

Biondo Flavio da Forlì, *Roma Instaurata* (Verona: Bonino Bonini da Ragusa, 1481)

Biondo Flavio da Forlì, *Italy Illuminated*, ed. and trans., J. A. White (Cambridge, MA, and London, 2005)

V. Fontana, 'Immagini di città italiane nelle descrizioni del *Supplemento delle croniche* di Giacomo Filippo Foresti da Bergamo', in *Venezia e Venezie: Descrizioni, interpretazioni, immagini. Studi in onore di Massimo Gemin*, ed. F. Bonin and F. Pedrocco (Padua, 2003), pp. 53–60

J. Foresti, *Supplementum Chronicarum* (Venice, 1483; illustrated edition Venice, 1490)

M. Forlani Conti and P. Torriti, eds., *Santa Maria delle Nevi. Restauri, studi e documenti* (Siena, 1988)

F. Formichi, 'Le dodici "case nuove" di Pienza', *Studi e documenti di architettura*, 7 (1978), pp. 117–28

P. Fortini Brown, 'Painting and History in Renaissance Venice', *Art History*, 7 (1984), pp. 263–94

P. Fortini Brown, *Venetian Narrative Painting in the Age of Carpaccio* (London and New Haven, 1988)

P. Fortini Brown, 'The Ritual Conception of History in Venetian Renaissance Art', in *Acts of the XXVIth International Congress of Art*, ed. I. Laving (University Park, PA, 1989), III, pp. 599–604

P. Fortini Brown, 'Measured Friendship, Calculated Pomp: The Ceremonial Welcomes of the Venetian Republic', in *Triumphal Celebrations and the Rituals of Statecraft* (*Papers in Art History from the Pennsylvania State University, VI, Part 1*) (University Park, PA, 1990), pp. 136–87

P. Fortini Brown, 'The Self-Definition of the Venetian Republic', in *City States in Classical Antiquity and Medieval Italy*, ed. A. Molho, K. Raaflaub and J. Emlen (Ann Arbor, 1991), pp. 511–27

P. Fortini Brown, '*Renovatio* or *Concilatio*? How Renaissances Happened in Venice', in *Language and Images of Renaissance Italy*, ed. A. Brown (Oxford, 1995), pp. 127–54

P. Fortini Brown, *Venice and Antiquity: The Venetian Sense of the Past* (New Haven and London, 1997)

P. Fortini Brown, *The Renaissance in Venice: A World Apart* (London, 1997)

F. Franceschi, 'Business Activities', in *At Home in Renaissance Italy*, ed. M. Ajmar-Wollheim and F. Dennis (London, 2006), pp. 166–71

V. Franchetti Pardo, 'Firenze tra Quattrocento e Cinquecento: linee di sviluppo urbanistico', in C. H. Smyth and G. C. Garfagnini, eds., *Florence and Milan, comparisons and relations*, Acts of two conferences at Villa I Tatti in 1982–1983 (Florence, 1989), I, p. 137–62

L. Franchina, ed., *Piazza del Campo: evoluzione di una immagine* (Siena, 1983)

L. Franchina, 'Sviluppo e variazioni delle attribuzioni a Baldassarre Peruzzi con il mutare del gusto dal secolo XVI al XIX (Siena e dintorni)', in *Rilievi di fabbriche attribuite a Baldassarre Peruzzi* (Siena, 1982), pp. 127–68

L. Franchina, 'I misteri del castellare', in *Contrada Priora della Civetta* (Genoa, 1984), pp. 103–8

S. Fraschetti, 'Antonio di Neri Barili', in *Domenico Beccafumi e il suo tempo*, ed. P. Torriti (Milan, 1990), pp. 548–53

A. D. Fraser Jenkins, 'Cosimo de' Medici's Patronage of Architecture and the Concept of Magnificence', *Journal of the Warburg and Courtauld Institutes*, 33 (1970), pp. 162–70

G. Freuler, 'Sienese Quattrocento Painting in the Service of Spiritual Propaganda', in *Italian Altarpieces, 1250–1550: Function and Design*, ed. E. Borsook and F. Superbi Gioffredi (Oxford, 1994), pp. 81–116

D. Friedman, *Florentine New Towns: Urban Design in the Late Middle Ages* (Cambridge, MA, 1988)

D. Friedman, 'Palaces and the Street in Late-Medieval and Renaissance Italy', in *Urban Landscapes, International Perspectives*, ed. J.W.R. Whitehand and P. J. Larkham (London, 1992), pp. 69–113

D. Friedman, 'Monumental Urban Form in the Late Medieval Italian Communes: Loggias and the Mercanzie of Bologna and Siena', *Renaissance Studies*, 12 (1998), pp. 325–40

U. Frittelli, *Genealogia della Casa dei Chigi* (Siena, 1922)

C. L. Frommel, *Die Farnesina und Peruzzis architektonisches Frühwerk* (Berlin, 1961)

C. L. Frommel, 'Reflections on the Early Architectural Drawings', in *The Renaissance from Brunelleschi to Michelangelo: The Representation of Architecture*, ed. H. Millon and V. Magnago Lampugnani (London, 1994), pp. 101–21

C. L. Frommel, 'Living *all'antica*: Palaces and Villas from Brunelleschi to Palladio', in *The Renaissance from Brunelleschi to Michelangelo: The Representation of Architecture*, ed. H. Millon and V. Magnago Lampugnani (London, 1994), pp. 183–203

C. L. Frommel, 'Pio II committente di architettura', in *Il principe architetto: atti del Convegno internazionale*, ed. A. Calzona et al. (Florence, 2002), pp. 327–60

C. L. Frommel, ed., *La Villa Farnesina a Roma*, 2 vols. (Modena, 2003), pp. 9–18

C. L. Frommel, ' "Ala maniera e uso delj bonj antiquj": Baldassarre Peruzzi e la sua quarantennale ricerca dell'antico', in *Baldassarre Peruzzi (1481–1536), Atti del XX seminario internazionale di storia dell'architettura*, ed. C. L. Frommel, A. Bruschi, H. Burns, F. P. Fiore and P. N. Pagliara (Venice, 2005), pp. 3–82

A. Frugoni, 'Enea Silvio Piccolomini e l'avventura senese di Gasparre Schlick', *La Rinascita*, 4 (1941), pp. 229–49

C. Frugoni, 'L'antichità: dai *Mirabilia* alla propaganda politica', in *Memoria dell'antico nell'arte italiana*, ed. S. Settis (Turin, 1984), I, pp. 5–72

C. Frugoni, *A Distant City: Images of Urban Experience in the Medieval World* (Princeton, NJ, 1991)

F. Fumi, 'Nuovi documenti per gli angeli dell'altar maggiore del Duomo di Siena', *Prospettiva*, 26 (1981), pp. 9–25

L. Fumi and A. Lisini, *L'incontro di Federigo III imperatore con Eleonora di Portogallo* (Siena, 1878)

R. Funari, *Un ciclo di tradizione repubblicana nel Palazzo Pubblico di Siena. Le iscrizioni degli affreschi di Taddeo di Bartolo (1413–1414)* (Siena, 2002)

F. Gabbrielli, 'Stilemi senesi e linguaggi architettonici nella Toscana del Due-Trecento', in *Architettura civile in Toscana: il Medioevo*, ed. A. Restucci (Siena, 1995), pp. 305–68

F. Gabbrielli, 'La fortificazione quattrocentesca di Spedaletto: fonti documentarie ed evidenza materiale', unpublished paper delivered at the conference 'Fortilizi e campui di battaglia nel medioevo attorno Siena', 25–26 October 1996, Spedale della Scala, Siena

F. Gabbrielli, 'Il palazzo delle Papesse', in *Il palazzo delle libertà*, exh. cat., ed. Marco Pierini, Prato-Siena, 2003, pp. 172–80; reprinted in *Il Palazzo delle Papesse a Siena*, Quaderni della Soprintendenza per il patrimonio storico, artistico ed etnoantropologico di Siena e Grosseto, no. 5 (2006), pp. 13–36

F. Gabbrielli, ed., *Palazzo Sansedoni* (Siena, 2004)

D. Gallavotti Cavallero, ed., *Lo Spedale di Santa Maria della Scala. Vicende di una committenza artistica* (Pisa, 1985)

P. Galluzzi, ed., *Prima di Leonardo: cultura delle macchine a Siena nel Rinascimento* (Milan, 1991)

P. Galluzzi, 'Le macchine senesi. Ricerca antiquaria, spirito di innovazione e cultura del territorio', in *Prima di Leonardo: cultura delle macchine a Siena nel Rinascimento*, ed. P. Galluzzi (Milan, 1991), pp. 15–44

P. Galluzzi, ed., *Gli ingegneri del Rinascimento da Brunelleschi a Leonardo da Vinci* (Florence, 1996)

P. Galluzzi, ed., *Mechanical Marvels: Invention in the Age of Leonardo* (Florence, 1997)

J. Gardner, 'An Introduction to the Iconography of the Medieval Italian City Gate', *Dumbarton Oaks Papers*, 41 (1987), pp. 199–213

M. Doni Garfagnani, 'Le fonti della storia e delle antichità: Sigismondo Tizio e Annio da Viterbo', *Critica Storica* (1990), pp. 643–712

M. L. Gatti Perrer, 'Premesse per un repertorio sistematico delle opere e degli artisti della Valle Intelvi' (Atti del Convegno, Varenna 1966), *Arte Lombarda*, 11 (1966)

M. Gattoni, 'Siena e i giganti. Lo scontro franco-spagnolo in Lombardia nelle lettere di Aldello Placidi, oratore senese a Roma e la posizione di Siena, fra Francia, Spagna e lo Stato Pontificio', *BSSP*, 104 [1997], pp. 377–402

M. Gattoni, 'La politica estera e il primato dei Petrucci a Siena, 1498–1524', in *Siena e il suo territorio nel Rinascimento*, ed. M. Ascheri (Siena, 2001), III, pp. 215–22

M. Gattoni, *Leone X e la geopolitica dello stato pontificio (1513–1521)* (Vatican City, 2000)

G. Gaye, *Carteggio inedito d'artisti dei secoli XIV, XV, XVI*, 3 vols. (Florence, 1839)

F. Geens, 'Galganus and the Cistercians: Relics, Reliquaries, and the Image of a Saint', in *Images, Relics, and Devotional Practices in Medieval and Renaissance Italy*, ed. S. J. Cornelison and S. B. Montgomery (Tempe, AZ, 2005), pp. 55–76

L. Ghiberti, *I commentarii*, ed. J. von Schlosser (Berlin, 1912)

C. Ghisalberti, 'Late Italian Gothic', in *The Renaissance from Brunelleschi to Michelangelo: The Representation of Architecture*, ed. H. Millon and V. Magnago Lampugnani, exh. cat., Venice, Palazzo Grassi (31 March–6 November 1994, (London, 1994), pp. 427–30

M. Giamello, G. Guasparri, R. Neri and G. Sabatini, 'Building Materials in Siena Architecture: Type, Distribution and State of Conservation', *Science and Technology for Culture Heritage*, 1 (1992), pp. 55–65

M. Giamello, G. Guasparri, R. Neri and G. Sabatini, 'I materiali litoidi nell'architettura senese. Tipologia, distribuzione e stato di conservazione', in *Il colore della città*, ed. M. Boldrini (Siena, 1993), pp. 115–29

R. Gibbs, 'In Search of Ambrogio Lorenzetti's Allegory of Justice in the Good Commune', *Apollo*, CXLIX (May 1999), pp. 11–16

F. Gilbert, *The Pope, His Banker and Venice* (Cambridge, MA, 1980)

M. Ginatempo, 'Per la storia demografica del territorio senese nel Quattrocento: problemi di fonti e di metodo', *Archivio Storico Italiano*, 142 (1984), pp. 521–32, 541–7

M. Ginatempo, *Crisi di un territorio. Il popolamento della Toscana senese alla fine del Medioevo* (Florence, 1988)

C. Ginzburg, *Miti, emblemi e spie. Morfologia e storia* (Turin, 1986)

C. Ginzburg, *Rapporti di forza: storia, retorica, prova* (Milan, 2000)

L. Giordano, 'I maestri muratori lombardi: lavoro e remunerazione', in *Les chantiers de la Renaissance*, ed. A. Chastel and J. Guillaume (Paris, 1991), pp. 165–73

L. Giordano, 'Milano e l'Italia nord-occidentale', in *Storia dell'architettura italiana: Il Quattrocento*, ed. F. P. Fiore (Milan, 1998), pp. 166–99

G. Giorgianni, ed., *Pio II, la città, le arti. La rifondazione umanistica dell'architettura e del paesaggio*, exh. cat., 28 May–8 October 2006, Pienza (Siena, 2006)

G. Giovannoni, 'Case del Quattrocento in Roma', in *Saggi sull'architettura del Rinascimento*, ed. G. Giovannoni (Milan, 1931), pp. 29–47

R. Glendenning, 'Love, Death and the Art of Compromise: Aeneas Silvius Piccolomini's *Tale of Two Lovers*', *Fifteenth-Century Studies*, 23 (1996), pp. 101–20

F. Glenisson, 'Fête et société: l'Assomption à Sienne et son évolution au cours du XVI siècle', in *Les fêtes urbaines en Italie à l'époque de la Renaissance*, ed. F. Croisette and M. Plaisance (Paris, 1993), pp. 65–129

J. Le Goff, 'L'immaginario urbano nell'Italia medievale (secoli X–XV)', in *Storia d'Italia. Annali 5. Il paesaggio*, ed. C. De Seta (Turin, 1982), pp. 5–43

R. Goldthwaite, *Private Wealth in Renaissance Italy: A Study of Four Families* (Princeton, NJ, 1968)

R. Goldthwaite, 'The Florentine Palace as Domestic Architecture', *American Historical Review*, 77 (1972), pp. 977–1012

R. Goldthwaite, *The Building of Renaissance Florence* (Baltimore, 1981)

R. Goldthwaite, 'The Preconditions for a Luxury Economy', in *Aspetti della vita economica medievale*, Convegno Federico Melis, 10 (Florence, 1985), pp. 659–75

R. Goldthwaite, ed., 'Debate. Renaissance Studies: Economic History', *Renaissance Quarterly*, 42 (1989), pp. 760–825

R. Goldthwaite, *Wealth and the Demand for Art in Italy (1300–1600)* (Baltimore, 1993)

R. Goldthwaite, *Banks, Palaces and Entrepreneurs in Renaissance Florence* (Aldershot, 1995)

E. Gombrich, *Norm and Form: Studies in the Art of the Renaissance* (London, 1985)

J. Goodall, 'A Medieval Masterpiece: Herstmonceux Castle, Sussex', *Burlington Magazine*, CXLVI (2004), pp. 516–25

G. L. Gorse, 'A Classical Stage for the Old Nobility: The Strada Nuova and Sixteenth-century Genoa', *Art Bulletin*, 79 (1997), pp. 301–27

R. J. Goy, *The House of Gold: Building a Palace in Medieval Venice* (Cambridge, 1992)

R. J. Goy, *Venice: The City and its Architecture* (London, 2002)

R. Greci, 'Il problema dello smaltimento dei rifiuti nei centri urbani dell'Italia medievale', in *Città e servizi sociali nell'Italia dei secoli XII–XV* (Pistoia, 9–12 ottobre 1987. Centro italiano di studi di storia e d'arte, Pistoia), ed. E. Cristiani (Pistoia, 1990), pp. 439–64

M. Greenlagh, ' "Ipsa ruina docet": l'uso dell'antico nel Medioevo', in *Memoria dell'antico nell'arte italiana*, ed. S. Settis (Turin, 1984), I, pp. 115–70

A.H.V. Grandjean de Montigny and A. Famin, *Architecture toscane; ou, Palais, maisons et autres édifices de la Toscane, mesurés et dessinés par A. Grandjean de Montigny et A. Famin*, reprinted with a preface and description of plates by John V. Van Pelt (New York, 1923)

P. Guerrini, 'L'epigrafia sistina come momento della "restauratio urbis" ', in *Un pontificato ed una città, Sisto IV (1474–1484)*, ed. M. Miglio (Vatican City, 1986), pp. 453–68

R. Guerrini, '*Dulci pro libertate*. Taddeo di Bartolo: il ciclo di eroi antichi nel Palazzo Pubblico di Siena (1413–1414). Tradizione classica ed iconografia politica', *Rivista Storica Italiana*, 112 (2000), pp. 510–68

F. Guerrieri et al., ed., *La sede storica del Monte dei Paschi di Siena* (Siena, 1988)

F. Guerrieri, 'Vicende architettoniche', *La sede storica del Monte dei Paschi di Siena*, ed. F. Guerrieri (Siena, 1988), pp. 9–207

F. Guicciardini, *Storia d'Italia*, ed. S. Seidel Menchi (Turin, 1971)

E. Guidoni, *Arte e urbanistica in Toscana (1000–1351)* (Rome, 1970)

E. Guidoni, *Il Campo di Siena* (Rome, 1971)

E. Guidoni, *La città dal medioevo al Rinascimento* (Bari, 1981)

E. Guidoni, 'L'Addizione Erculea', in *Storia Illustrata di Ferrara*, ed. F. Bocchi (San Marino, 1987)

B. Guillemain, *La cour pontificale d'Avignon, 1309–1376. Étude d'une société* (Paris, 1966)

F. Gurrieri and A. Amendola, *Il Fregio robbiano dell'Ospedale del Ceppo a Pistoia* (Pontedera, 1982)

S. Hansen, *La Loggia della Mercanzia in Siena* (Siena, 1993)

J. Heers, *Genes au XV siècle. Activité économique et problèmes sociaux* (Paris, 1961)

J. Heers, *Le clan familial au Moyen Age. Etude sur les structures politiques et sociales des milieux urbains* (Paris, 1974)

D. Hemsoll, 'Giuliano da Sangallo and the New Renaissance of Lorenzo de' Medici', *The Early Medici and their Artists*, ed. F. Ames-Lewis (London, 1995), pp. 187–205

J. Henderson, *The Renaissance Hospital* (New Haven and London, 2006)

T. Henry and C. Plazzotta, 'Raphael: From Urbino to Rome', in *Raphael: From Urbino to Rome*, ed. H. Chapman, T. Henry and C. Plazzotta (London and New Haven, 2004), pp. 15–65

T. Henry, 'Raphael in Siena,' *Apollo*, 140 (2004), pp. 50–56

T. Henry, ' "magister Lucas de Cortona, famosissimus pictor in tota Italia . . .", in *Siena nel Rinascimento: l'ultimo secolo della repubblica*, Acts of the International Conference, ed. G. Mazzoni and F. Nevola (Florence, 2007)

D. Herlihy, *Pisa in the Early Renaissance* (New Haven, 1958)

D. Herlihy, *Medieval and Renaissance Pistoia: The Social History of an Italian Town, 1200–1430* (New Haven, 1967)

D. Herlihy and C. Klapisch Zuber, *Les Toscans et leurs familles* (Paris, 1978)

D. Herlihy and C. Klapisch Zuber, *Tuscans and their Families: A Study of the Florentine Catasto of 1427* (New Haven and London, 1985)

L. Heydenreich, 'Il bugnato rustico nel '400 e '500', *Bollettino CISA*, 2 (1960), pp. 180–91

L. Heydenreich, *Architecture in Italy, 1400–1500*, revised P. Davies (New Haven and London, 1996)

W. Heywood, *Our Lady of August and the Palio of Siena* (Siena, 1899)

W. Heywood, *Palio e Ponte* (Siena and London, 1904)

D. L. Hicks, 'The Rise of Pandolfo Petrucci', PhD thesis, Columbia University, 1959

D. L. Hicks, 'The Education of a Renaissance Prince: Lodovico il Moro and the Rise of Pandolfo Petrucci', *Studies in the Renaissance*, 8 (1961), pp. 88–102

D. L. Hicks, 'Sources of Wealth in Renaissance Siena: Businessmen and Landowners', *BSSP*, 93 (1986), pp. 9–42

D. L. Hicks, 'The Sienese Oligarchy and the Rise of Pandolfo Petrucci, 1487–97', in *La Toscana ai tempi di Lorenzo il Magnifico: Politica, economia, cultura ed arte* (Pisa, 1996), III, pp. 1051–72

R. B. Hilary, 'The Nepotism of Pope Pius II', *Catholic Historical Review*, 64 (1978), pp. 33–5

R. Hobart Cust, *The Pavement Masters of Siena (1369–1562)* (London, 1901)

Sir Thomas Hoby, *The Life and Travels of Sir Thomas Hoby, of Bisham Abbey, Written by Himself, 1547–1564* (London, 1902)

M. Hollingsworth, *Patronage in Renaissance Italy* (London, 1994)

M. Hollingsworth, 'Alberti: A Courtier and his Patrons', in *La corte a Mantova nell'epoca di Andrea Mantegna*, ed. C. Mozzarelli, R. Oresko and L. Ventura (Rome, 1997), pp. 217–24

G. Holmes, 'How the Medici Became the Pope's Bankers', in *Florentine Studies: Politics and Society in Renaissance Florence*, ed. N. Rubinstein (London, 1968), pp. 357–80

J. B. Holmquist, 'The Iconography of a Ceiling Decoration by Pinturicchio in the Palazzo del Magnifico', PhD thesis, University of North Carolina at Chapel Hill, 1984

W. Hood, 'Creating Memory: Monumental Painting and Cultural Definition', in *Language and Images of Renaissance Italy*, ed. A. Brown (Oxford, 1995), pp. 157–69

J. Hook, *Siena: A City and its History* (London, 1979)

D. Howard, 'Ritual Space in Renaissance Venice', *Scroope*, 5 (1993–4), pp. 4–11

D. Howard, *The Architectural History of Venice* (New Haven and London, 2002)

J. K. Hyde, 'Some Uses of Literacy in Venice and Florence in the Thirteenth and Fourteenth Centuries', *Transactions of the Royal Historical Society*, 29 (1979), pp. 109–28

I. Hyman, *Fifteenth Century Florentine Studies. The Palazzo Medici and a Ledger for the Church of San Lorenzo* (New York, 1977)

R. Ingersoll, 'Ritual Use of Public Space in Renaissance Rome', PhD thesis, University of California, Berkeley, 1985

R. Ingersoll, 'Interview with Manfredo Tafuri', *Casabella*, 619–20 [1995], p. 96

A. K. Isaacs, 'Popolo e Monti nella Siena del Cinquecento', *Rivista Storica Italiana*, 86 (1970), pp. 32–80

A. K. Isaacs 'Lo Spedale della Scala nell'antico Stato senese', in *Spedale di Santa Maria della Scala: atti del convegno internazionale di studi, 20, 21, 22 novembre 1986* (Siena, 1988), pp. 19–29

A. K. Isaacs, 'Cardinali e "spalagrembi". Sulla vita politica a Siena fra il 1480 e il 1487', in *La Toscana ai tempi di Lorenzo il Magnifico: Politica, economia, cultura ed arte* (Pisa, 1996), III, pp. 1013–50

M. Israëls, 'New Documents for Sassetta and Sano di Pietro at the Porta Romana, Siena', *Burlington Magazine*, 140 (1998), pp. 436–43

M. Israëls, 'Sassetta's Arte della Lana Altarpiece and the Cult of Corpus Domini in Siena', *Burlington Magazine*, CXLIII (2001), pp. 532–43

M. Israëls, 'Al cospetto della città. Il Sodoma a Porta Pispini, culmine di una tradizione civica', in *Siena nel Rinascimento: l'ultimo secolo della repubblica*, Acts of the International Conference, Siena (28–30 September 2003 and 16–18 September 2004), ed. G. Mazzoni and F. Nevola (Florence 2007)

P. Jacks, *The Antiquarian and the Myth of Antiquity: The Origins of Rome in Renaissance Thought* (Cambridge, 1993)

P. Jackson and F. Nevola, eds., *Beyond the Palio: Urban Ritual in Renaissance Siena* (Oxford, 2006)

P. Jackson, 'Le regole dell'oligarchia al tempo di Pandolfo Petrucci', in *Siena e il suo territorio nel Rinascimento*, ed. M. Ascheri (Siena, 2000), pp. 209–13

P. Jackson, 'Pomp or Piety? The Funeral of Pandolfo Petrucci', in *Beyond the Palio: Urban Ritual in Renaissance Siena*, ed. P. Jackson and F. Nevola (Oxford, 2006), pp. 104–16

P. Jackson, 'The Cult of the Magdalen: Politics and Patronage under the Petrucci', in *Siena nel Rinascimento: l'ultimo secolo della repubblica*, Acts of the International Conference, ed. G. Mazzoni and F. Nevola (Florence, 2007)

P. Jackson, 'Pandolfo Petrucci: Politics and Patronage in Renaissance Siena', PhD thesis, Warburg Institute, University of London, 2007.

A. L. Jenkens, 'Palazzo Piccolomini in Siena: Pius II's Architectural Patronage and its Afterlife', PhD thesis, New York University, 1995

A. L. Jenkens, 'Pius II and his Loggia in Siena', in *Sonderdruck aus Pratum Romanum: Richard Krautheimer zum 100. Geburtstag*, ed. R. L. Colella, M. J. Gill, A. L. Jenkens and P. Lamers (Wiesbaden, 1997), pp. 199–214

A. L. Jenkens, 'Pius II's Nephews and the Politics of Architecture at the End of the Fifteenth Century in Siena', BSSP, 106 (2001), pp. 58–114

A. L. Jenkens, 'Caterina Piccolomini and the Palazzo delle Papesse in Siena', in *Beyond Isabella: Secular Women Patrons of Art in Renaissance Italy*, ed. S. Reiss and D. Wilkins (Kirksville, MO, 2001), pp. 77–91

A. L. Jenkens, ed., *Renaissance Siena: Art in Context* (Kirksville, MO, 2005)

G. Johnson, 'Activating the Effigy: Donatello's Pecci Tomb in Siena Cathedral', *Art Bulletin*, 77 (1995), pp. 445–59

P. Jones, 'Florentine Families and Florentine Diaries of the Fourteenth Century', *Papers of the British School at Rome*, 24 (1956), pp. 183–205

P. Jones, 'Medieval Agrarian Society in its Prime: Italy', *Cambridge Economic History of Europe*, ed. M. Postan (Cambridge, 1966), I, pp. 340–430

P. Jones, 'From Manor to Mezzadria: A Tuscan Case-study in the Medieval Origins of Modern Agrarian Society', in *Florentine Studies: Politics and Society in Renaissance Florence*, ed. N. Rubinstein (London, 1968), pp. 193–241

P. Jones, *The Italian City-State: From Commune to Signoria* (Oxford, 1997)

G. Kaftal, *Saints in Italian Art: Iconography of the Saints in Tuscan Painting* (Florence, 1952)

D. L. Kawsky, 'The Survival, Revival and Reappraisal of Artistic Tradition: Civic Art and Civic Identity in Quattrocento Siena', PhD thesis, Princeton University, 1995

T. Kennedy, 'Religious Architecture in Renaissance Siena: The Building of Santa Maria degli Angeli in Valli', in *Siena nel Rinascimento: l'ultimo secolo della repubblica*, Acts of the International Conference, ed. G. Mazzoni and F. Nevola (Florence, 2007)

D. V. Kent, *The Rise of the Medici: Faction in Florence, 1426–1434* (Oxford, 1978)

D. V. and F. W. Kent, *Neighbours and Neighbourhood in Renaissance Florence: The District of the Red Lion in the Fifteenth Century* (Locust Valley, New York, 1982)

D. Kent, *Cosimo de' Medici and the Florentine Renaissance: The Patron's Oeuvre* (New Haven and London, 2000)

F. W. Kent, *Household and Lineage in Renaissance Florence: The Family Life of the Capponi, Ginori and Rucellai* (Princeton, NJ, 1971)

F. W. Kent, 'The Rucellai Family and its Loggia', *Journal of the Warburg and Courtauld Institutes*, 35 (1972), pp. 397–401

F. W. Kent, ' "Più superba di quella di Lorenzo": Courtly and Family Interest in the Building of Filippo Strozzi's Palace', *Renaissance Quarterly*, 30 (1977), pp. 311–24

F. W. Kent, 'Palaces, Politics and Society in Fifteenth-century Florence', *I Tatti Studies*, 2 (1987), pp. 41–70

F. W. Kent, 'Individuals and Families as Patrons of Culture in Quattrocento Florence', in *Language and Images of Renaissance Italy*, ed. A. Brown (Oxford, 1995), pp. 171–92

F. W. Kent, *Lorenzo de' Medici and the Art of Magnificence* (Baltimore and London, 2004)

M. Kiene, 'I progetti di Giuliano da Sangallo per l'Università di Siena', in *Università di Siena; 750 anni di storia*, ed. M. Ascheri, et al. (Siena, 1991), pp. 517–37

C. Klapisch Zuber, ' "Parenti amici e vicini". Il territorio urbano di un famiglia mecantile del XV secolo', *Quaderni storici*, 33 (1976), pp. 953–82

F. Klein, 'Ceti dirigenti e controllo dello spazio urbano; legami di vicinato', in *I ceti dirigenti nella Toscana tardo comunale (Atti del convegno, 5–7 dicembre 1980, Florence)*, ed. D. Rugiadini (Florence, 1983), pp. 210–25

S. Kostof, ed., *The Architect: Chapters in the History of the Profession* (New York, 1977)

S. Kostof, 'Urbanism and Polity; Medieval Siena in Context', *International Laboratory for Architecture and Urban Design Yearbook* (1982), pp. 66–73

S. Kostof, *The City Shaped: Urban Patterns and Meanings through History* (London, 1991)

S. Kostof, *The City Assembled: The Elements of Urban Form through History* (London, 1992)

T. Kuehn, *Emancipation in Late Medieval Florence* (New Brunswick, 1982)

T. Kuehn, *Law, Family and Women* (Chicago, 1991)

T. S. Kuhn, *The Structure of Scientific Revolutions* (Chicago, 1962)

M. Laclotte and E. Moench, *Peinture Italienne. Musée du Petit Palais, Avignon* (Paris, 2005)

A. Ladis, 'Sources and Resources: The Lost Sketchbooks of Giovanni di Paolo', in *The Craft of the Art: Originality and Industry in the Italian Renaissance*, ed. A. Ladis and C. Wood (Athens and London, 1995), pp. 48–85

D. Lambertini, M. Lotti and R. Lunardi, eds., *Giuliano e la bottega dei Maiano (Atti del Convegno Internazionale di Studi, Fiesole, 13–5 giugno 1991)* (Florence, 1994)

S. Lang, 'The Ideal City from Plato to Howard', *Architectural Review*, 112 (1952), pp. 90–101

C. Lansing, *The Florentine Magnates: Lineage and Faction in a Medieval Commune* (Princeton, NJ, 1991)

L. Lanza, 'Ideologia e politica nei "Commentarii" di Pio II: le descrizioni delle città', in *Studi in onore di Arnaldo d'Addario*, ed. L. Borgia et al. (Lecce, 1995), II, pp. 521–33

P. Laspeyres, *Die Kirchen der Renaissance in Mittelitalien* (Berlin, 1882)

M. H. Laurent, 'Intorno alla Madonna dell'Antiportico di Camollia', *Bolletino di Studi Bernardiniani*, 5 (1939), pp. 164–7

A. Lecoq, 'La città festeggiante: Les fêtes publiques au XV et XVI siècles', *Revue de l'art*, 33 (1976), pp. 83–100

H. Lefebvre, *The Production of Space* (Oxford, 1991)

H. Lefebvre, *Writings on Cities*, ed. and trans. E. Kofman and E. Lebas (Oxford, 1996)

A. Leoncini, *I tabernacoli di Siena: arte e devozione popolare* (Siena, 1994)

J. Lestocquoy, 'Eugène IV, Jean Fouquet et Grachetto', *Journal des Savants* (1976), pp. 141–8

F. Leverotti, 'L'ospedale di S. Maria della Scala in una relazione del 1456', *BSSP*, 91 (1984), pp. 276–92

A. Liberati, 'Chiese, monasteri, oratori e spedali senesi', *BSSP*, 47 (1940), pp. 334–5

A. Liberati, 'Chiese, monasteri e oratori senesi', *BSSP*, 48 (1941), pp. 73–80

A. Liberati, 'Chiese, monasteri, oratori e spedali senesi', *BSSP*, 56 (1949), pp. 146–52

R. Lieberman, *Renaissance Architecture in Venice* (London, 1982)

R. Lieberman, 'Real Architecture, Imaginary History: The Arsenale Gate as Venetian Mythology', *Journal of the Warburg and Courtauld Institutes*, 54 (1991), pp. 117–26

A. Lisini, 'L'architetto di Palazzo Spannocchi', *Miscellanea Storica Senese*, 3 (1895), pp. 59–60

A. Lisini, 'Palazzo Tolomei', *Miscellanea Storica Senese*, IV (1896), pp. 13–14

A. Lisini, 'Notizie genealogiche della famiglia Piccolomini', *Miscellanea Storica Senese*, V (1898), pp. 38–90, 121–8, 135–56, 159–77

A. Lisini, ed., *Il constituto del comune di Siena volgarizzato nel 1309–10* (Siena, 1903)

A. Lisini, *Il Duomo di Siena* (Siena, 1939)

A. Lisini and F. Iacometti, eds., *Cronache Senesi*, in *Rerum Italicarum Scriptores*, vol. 15, part 6 (Bologna, 1931–9)

W. Lotz, *Studies in the Italian Renaissance* (Cambridge, MA, 1977), pp. 74–139

A. Lusini, 'I Turrini e l'oreficeria pura', *La Diana* (1929), pp. 62–70

A. Lusini, 'Notturno senese: il Palazzo del Capitano', *Terra di Siena*, 9 (1955), pp. 12–14

V. Lusini, 'Il Castellare dei Salimbeni', *Rassegna dell'arte senese*, 18 (1925), pp. 18–40

V. Lusini, *Storia della Basilica di San Francesco in Siena* (Siena, 1894)

V. Lusini, 'Dell'Arte del legname dinnazi al suo Statuto del 1426', *BSSP*, 11 (1904), pp. 183–246

V. Lusini, 'Note storiche sulla topografia di Siena nel sec. XIII', *BSSP*, 28 (1921), pp. 239–341

V. Lusini, *Storia del Palazzo Chigi Saracini* (Siena, 1927)

K. Lynch, *The Image of the City* (Cambridge, MA, and London, 1960)

K. Lynch, *City Sense and City Design. Writings and Projects of Kevin Lynch*, ed. T. Banerjee and M. Southworth (Cambridge, MA, and London, 1990)

W. MacDonald, *The Architecture of the Roman Empire*, 2 vols. (London and New Haven, 1986), vol. II.

N. Machiavelli, *Opere*, ed. A. Montevecchi et al., 4 vols. (Turin 1971–89)

N. Machiavelli, *Il Principe e altre opere politiche*, ed. D. Cantimori (Milan, 1976)

C. R. Mack, 'Studies in the Architectural Career of Bernardo di Matteo Ghamberelli Called Rossellino', PhD thesis, University of North Carolina at Chapel Hill, 1972

C. R. Mack, 'Nicholas the Fifth and the Rebuilding of Rome: Reality and the Legacy', in *Light on the Eternal City*, ed. H. Hager and S. Munshower, Papers in Art History from Penn State University, II (University Park, PA, 1987), pp. 31–55

C. R. Mack, *Pienza: The Creation of a Renaissance City* (Ithaca, NY, 1987)

R. Mackenny, *Tradesmen and Traders: The World of the Guilds of Venice and Europe 1250–1650* (London, 1987)

H.B.J. Maginnis, 'Renaissance Roots: Time, History and Painting', *Gazette des Beaux-Arts*, 114 (1989), pp. 229–41

H.B.J. Maginnis, 'Chiarimenti documentarii: Simone Martini, i Memmi e Ambrogio Lorenzetti', *Rivista d'arte*, 41 (1989), pp. 3–21, appendix nos. 4–17

H.B.J. Maginnis, 'The Craftsman's Genius: Painters, Patrons and Drawings in Trecento Siena', in *The Craft of the Art: Originality and Industry in the Italian Renaissance*, ed. A. Ladis and C. Wood (Athens and London, 1995), pp. 25–47

O. Malavolti, *Dell'historia di Siena* (Venice, 1599)

M. Mallett, 'Horse Racing and Politics in Lorenzo's Florence', in *Lorenzo the Magnificent: Culture and Politics*, ed. M. Mallett and N. Mann (London, 1996), pp. 253–62

M. Mallett, 'Siena e le guerre d'Italia', in *Siena nel Rinascimento: l'ultimo secolo della repubblica*, Acts of the International Conference, ed. M. Ascheri and F. Nevola (Siena, 2007)

J. Manca, 'Masolino architetto: una interpretazione della Sacrestia Vecchia di Brunelleschi a Castiglione Olona', *Bollettino d'Arte*, 18 (1983), pp. 61–6

B. Mantura, 'Contributo ad Antonio Federighi', *Commentari*, 19 (1968), pp. 98–110

P. C. Marani, 'L'Amadeo e Francesco di Giorgio Martini', in *Giovanni Antonio Amadeo: scultura e architettura del suo tempo*, ed. L. Castelfranchi and J. Shell (Milan, 1993), pp. 353–76

P. C. Marani, 'Renaissance Town Planning from Filarete to Palmanova', in *The Renaissance from Brunelleschi to Michelangelo: The Representation of Architecture*, ed. H. Millon and V. Magnago Lampugnani (London, 1994), pp. 539–4

I. Marchetti, 'I Turrini e l'oreficeria pura', *La Diana*, 4 (1929), pp. 62–70

A. de Marchi, 'Progetto per la decorazione di casa Borghesi', in *Domenico Beccafumi e il suo tempo*, ed. P. Torriti (Milan, 1990), pp. 426–7

R. Marchionni, *Battaglie Senesi: Montaperti* (Siena, 1996)

A. Marelli, *Santa Maria in Portico a Fontegiusta* (Siena, 1908)

M. Marini, 'Trasformazioni urbane ed architetture a Siena nella seconda metà del XIX secolo', in *Siena tra Purismo e Liberty* (Milan and Rome, 1988), pp. 266–86

L. Marri Martini, *La Parrocchia di San Andrea Apostolo* (Siena, 1933)

M. Martelli, 'Il Rinascimento. L'ambiente e l'influenza di Sigismondo Tizio', in *Siena: le origini. Testimonianze e miti archeologici*, exh. cat., ed. M. Cristofani (Florence, 1979), pp. 120–23

L. Martines, *Lawyers and Statecraft in Renaissance Florence* (Princeton, NJ, 1968)

L. Martines, *Power and Imagination. City States in Renaissance Italy* (Harmondsworth, 1980)

L. Martines, *An Italian Renaissance Sextet: Six Tales in Historical Context* (New York, 1994)

L. Martines, 'The Italian Renaissance Tale as History', in *Language and Images of Renaissance Italy*, ed. A. Brown (Oxford, 1995), pp. 313–30

L. Martines, *Strong Words: Writing and Social Strain in the Italian Renaissance* (Baltimore and London, 2001)

Francesco di Giorgio Martini, *Trattati di Architettura, Ingegneria e Arte Militare*, 2 vols., ed. C. Maltese (Milan, 1967)

L. Martini, ed., *Pio II, la città, le arti. La rinascita della scultura: ricerca e restauri*, exh. cat., Siena, 23 June – 8 October 2006 (Siena, 2006)

B. Matteucci, 'Ansano da Siena', *Bibliotheca Sanctorum* (Rome, 1961), I, pp. 1324–34

S. May, 'The Piccolomini Library in Siena Cathedral: A New Reading with Particular Reference to Two Compartments of the Vault Decoration', *Renaissance Studies*, 19 (2005), pp. 287–324

C. Mazzi, *La congrega dei Rozzi di Siena nel secolo XVI*, 2 vols. (Florence, 1882)

G. Mazzoni and F. Nevola, eds., *Siena nel Rinascimento: l'ultimo secolo della repubblica*, I, Acts of the International Conference, Siena, 28–30 September 2003 and 16–18 September 2004 (Florence, 2007)

M. Meiss, *Painting in Florence and Siena After the Black Death* (Princeton, NJ, 1951)

N. Mengozzi, 'Martino V ed il Concilio di Siena (1418–31)', *Bullettino Senese di Storia Patria*, 25 (1918), pp. 247–314

L. Miglio, 'Graffi di storia', in *Visibile parlare: le scritture esposte nei volgari italiani dal medioevo al rinascimento*, ed. C. Ciociola (Naples, 1997), pp. 59–70

G. Milanesi, *Documenti per la storia dell'arte senese*, 3 vols. (Siena, 1854)

G. Milanesi, ed., 'Breve dei maestri di pietra senesi dell'anno MCCCCXLI', in Milanesi, *Documenti per la storia dell'arte senese* (Siena, 1854), I, pp. 105–35

A. Milani, 'L'attività costruttiva del Quattrocento dalle fonti archivistiche', in *Santa Maria della Scala: archeologia e edilizia sulla piazza dello Spedale*, ed. E. Boldrini and R. Parenti (Florence, 1991), pp. 115–34

H. A. Millon and L. Nochlin, eds., *Art and Architecture in the Service of Politics* (Cambridge, MA, and London, 1978)

H. Millon and V. Magnago Lampugnani, eds., *The Renaissance from Brunelleschi to Michelangelo: The Representation of Architecture*, exh. cat. (London, 1994)

B. Mitchell, *Italian Civic Pageantry in the High Renaissance: A Descriptive Bibliography of the Triumphal Entries and Selected Other Festivals for State Occasions* (Florence, 1979)

B. Mitchell, *The Majesty of the State: Triumphal Progress of Foreign Sovereigns in Renaissance Italy (1494–1600)* (Florence, 1986)

A. Molho, K. Raaflaub and J. Emlen, eds., *City States in Classical Antiquity and Medieval Italy* (Ann Arbor, 1991)

G. M. Monti, 'I Piccolomini d'Aragona Duchi di Amalfi. Un quadro di Raffaello e la biblioteca di Pio II', in *Studi sulla Repubblica Marinara di Amalfi* (Salerno, 1935)

U. Morandi, 'Il castellare dei Malavolti', in *Quattro Monumenti Italiani (INA)*, ed. M. Salmi (Rome, 1969), pp. 15–37

U. Morandi ed., *Guida-inventario dell'Archivio di Stato di Siena* (Rome, 1977), III

U. Morandi, 'Gli Spannocchi: piccoli proprietari terrieri, artigiani, piccoli, medi e grandi mercanti-banchieri', in *Studi in onore di Federico Melis* (Naples, 1978), III, pp. 91–120

U. Morandi, 'Documenti', in *Il Palazzo Pubblico di Siena. Vicende costruttive e decorazione*, ed. C. Brandi (Milan, 1983), pp. 413–36

U. Morandi et al., eds., *Le Biccherne. Tavole dipinte delle magistrature senesi (secoli XIII–XVIII)* (Rome, 1984)

I. Moretti, 'La Via Francigena', in *Storia di Siena. Dalle orgini alla fine della repubblica*, I, ed. R. Barzanti, G. Catoni and M. De Gregorio (Siena, 1995), pp. 41–54

G. Morolli, ed., *Giuseppe Partini: architetto del Purismo Senese* (Florence, 1981)

G. Morolli, ed., *Le dimore di Siena. L'arte dell'abitare nei territori dell'antica Repubblica dal Medioevo all'Unità d'Italia*, Acts of the Conference, Siena, 27–30 September 2000 (Florence 2002)

E. Morrall, *Aneas Silvius Piccolomini and Niklas von Wyle: The Tale of Two Lovers, Eurialus and Lucretia* (Amsterdam, 1988)

M. Morresi, 'Francesco di Giorgio e Bramante: osservazioni su alcuni disegni degli Uffizi e della Laurenziana', in *Il disegno di architettura*, ed. P. Carpeggiani and L. Patetta (Milan, 1989), pp. 117–24

M. Morresi, 'Venezia e le città del Dominio', in *Storia dell'architettura italiana: il Quattrocento*, ed. F. P. Fiore (Milan, 1998), pp. 208–9

M. Morresi, *Piazza San Marco: Istituzioni, poteri e architettura a Venezia nel Cinquecento* (Milan, 1999)

A.E.J. Morris, *History of Urban Form Before the Industrial Revolution* (London, 1979)

C. R. Morscheck, 'The Profession of Architect in Milan before Bramante: The Example of Guiniforte Solari', *Arte Lombarda*, 78 (1986), pp. 94–100

M. Morviducci, 'Dai Petrucci alla Provincia. Il Palazzo del Governatore come sede del potere a Siena', in *Palazzo della Provincia a Siena*, ed. F. Bisogni (Rome, 1990), pp. 55–108

S. Moscadelli and C. Zarilli, 'Domenico Beccafumi e altri artisti nelle fonti documentarie del primo Cinquecento', in *Domenico Beccafumi e il suo tempo*, ed. P. Torriti (Milan, 1990), pp. 679–715

S. Moscadelli, 'Maestri d'abaco a Siena tra Medioevo a Rinascimento', in *L'Università di Siena. 750 anni di storia*, ed. M. Ascheri et al. (Siena, 1991), pp. 207–16

S. Moscadelli, *Inventario analitico dell'Archivio dell'Opera Metropolitana di Siena* (Munich, 1995)

R. Mucciarelli, 'Igiene, salute e pubblico decoro nel Medioevo', in *Vergognosa Immunditia: Igiene pubblica e privata a Siena dal medioevo all'età contemporanea* (Siena, 2000), pp. 13–84

R. Mucciarelli, *La terra contesa. I Piccolomini contro Santa Maria della Scala, 1277–1280* (Florence, 2001)

E. Muir, 'Images of Power: Art and Pageantry in Renaissance Venice', *American Historical Review*, 84 (1979), pp. 16–52

E. Muir, *Civic Ritual in Renaissance Venice* (Princeton, NJ, 1981)

E. Muir, 'The Virgin on the Street Corner: The Place of the Sacred in Italian Cities', in *Religion and Culture in the Renaissance and Reformation*, ed. S. Ozment, Sixteenth Century Essays and Studies, XI (Kirksville, MO, 1987), pp. 24–40

E. Muir and R. Weissman, 'Social and Symbolic Places in Renaissance Venice and Florence', in *The Power of the Place*, ed. J. Agnew and J. Duncan (Syracuse, 1988)

E. Muir, *Ritual in Early Modern Europe* (Cambridge, 1997)

E. Muntz, *Les arts à la cours des papes pendant le XV et XVI siècles. Recueil de documents inédites tirés des archives des bibliothèques romaines*, 3 vols. (Paris, 1878–82)

A. Murray, *Reason and Society in the Middle Ages* (Oxford, 1979)

M. Mussini, 'La trattatistica di Francesco di Giorgio: un problema critico aperto', in *Francesco di Giorgio, architetto*, ed. F. P. Fiore and M. Tafuri (Siena and Milan, 1993), pp. 358–79

M. Mussini, *Francesco di Giorgio e Vitruvio: Le traduzioni del 'De Architectura' nei codici Zichy, Spencer 129 e Maglaibecchiano II.I.141*, 2 vols. (Florence, 2003)

M. Mussini, 'Siena e Urbino. Origini e sviluppo della tratta-tistica martiniana', in *Francesco di Giorgio alla corte di Federico da Montefeltro: atti del convegno internazionale di studi*, ed. F. P. Fiore (Florence, 2004), I, pp. 317–36

M. Mussolin, *Vicende di un cantiere conventuale senese: I regolari osservanti di San Domenico ed il convento di Santo Spirito ai Pispini*, Tesi di Laurea (Venice: Istituto Universitario di Architettura, 1995)

M. Mussolin, 'Il convento di Santo Spirito di Siena e i rego-lari osservanti di San Domenico', *BSSP*, 104 (1997), pp. 7–193

M. Mussolin, 'La chiesa di San Francesco a Siena', *BSSP*, 106 (1999), pp. 115–55

M. Mussolin, 'Il Beato Bernardo Tolomei e la fondazione di Monte Oliveto Minore a Siena', in *La Misericordia di Siena attraverso i secoli*, ed. M. Ascheri and P. Turrini (Siena, 2004), pp. 494–509

M. Mussolin, 'The Rebuilding of the Church of Santo Spirito in the Late Fifteenth Century', in *Renaissance Siena: Art in Context*, ed. L. A. Jenkens (Kirksville, MO, 2005), pp. 83–110

M. Mussolin, 'San Sebastiano in Vallepiatta', in *Baldassarre Peruzzi (1481–1536), Atti del XX seminario internazionale di storia dell'architettura*, ed. C. L. Frommel, A. Bruschi, H. Burns, F. P. Fiore and P. N. Pagliara (Venice, 2005), pp. 95–122

A. Nagel and C. S. Wood, 'Interventions: Toward a New Model of Renaissance Anachronism', *Art Bulletin*, LXXVII (2005), pp. 403–15

J. Najemy, 'Review Essay', in *Renaissance Quarterly*, 45 (1992), 340–50

P. Nardi, 'I borghi di San Donato e San Pietro a Ovile. "Populi", contrade e compagnie d'armi nella società senese dei secoli XI–XIII', *BSSP*, 73–5 (1966–68), pp. 7–59

P. Nardi, *Mariano Sozzini: Giuresconsulto senese del Quattrocento* (Milan, 1974)

P. Nardi, 'Origini e sviluppo della Casa della Misericordia nei secoli XIII e XIV', in *La Misericordia di Siena attraverso i secoli*, ed. M. Ascheri and P. Turrini (Siena, 2004), pp. 65–93

A. Natali, 'Il Vecchietta a Castiglione Olona', *Paragone*, 35 (1984), pp. 3–14

C. Nepi et al., 'Per lo studio della "facies" rupestre della città di Siena', *Archeologia Medievale*, 3 (1976), pp. 413–28

A. Nesselrath, 'I libri di disegni di antichità; tentativo di una tipologia', in *Memoria dell'antico nell'arte italiana*, ed. S. Settis (Turin, 1986), III, pp. 87–147

F. Nevola, 'Urbanism in Siena (c. 1450–1512). Policy and Patrons: Interactions between Public and Private', PhD thesis, Courtauld Institute of Art, London, 1998

F. Nevola, 'Revival or Renewal: Defining Civic Identity in Fifteenth-century Siena', in *Shaping Urban Identity in the Middle Ages*, ed. P. Stabel and M. Boone (Leuven and Apel-doorn, 1999), pp. 111–34

F. Nevola, ' "Ornato della città": Siena's Strada Romana as Focus of Fifteenth-century Urban Renewal', *Art Bulletin*, 82 (2000), pp. 26–50

F. Nevola, 'Creating a Stage for an Urban Elite: The Re-development of the Via del Capitano and Piazza Postierla in Siena', in *The World of Savonarola: Italian Elites in Crisis*, ed. C. Shaw and S. Fletcher (London, 2000), pp. 182–93

F. Nevola, 'Cerimoniali per santi e feste a Siena a metà Quat-trocento. Documenti dallo *Statuto di Siena, 39*', in *Siena ed il suo territorio nel Rinascimento*, III, ed. M. Ascheri (Siena, 2001), pp. 171–84

F. Nevola, 'Siena nel Rinascimento: sistemi urbanistici e strut-ture istituzionali (c. 1400–1520)', *BSSP*, 106 (1999 [2001]), pp. 44–67

F. Nevola, ' "Lieto e trionphante per la città": Experiencing a Mid-Fifteenth-century Imperial Triumph along Siena's Strada Romana', *Renaissance Studies*, 17 (2003), pp. 581–606

F. Nevola, 'Ambrogio Spannocchi's "bella casa": Creating Site and Setting in Quattrocento Sienese Architecture', in *Renaissance Siena: Art in Context*, ed. L. A. Jenkens (Kirksville, MO, 2005), pp. 141–56

F. Nevola, 'La storia romanzata. La *Historia de Duobus Aman-tibus* di Enea Silvio Piccolomini', in *Nymphilexis: Enea Silvio Piccolomini, l'umanesimo e la geografia*, exh. cat., ed. C. Cres-centini and M. Palumbo (Rome, 2005), pp. 85–91

F. Nevola, 'L'architettura tra Siena e Pienza: architettura civile', in *Pio II e le arti. La riscoperta dell'antico da Federighi a Michelan-gelo*, ed. A. Angelini (Cinisello Balsamo, Milan, 2005), pp. 182–213

F. Nevola, 'Ritual Geography: Housing the Papal Court of Pius II Piccolomini in Siena (1459–60)', in *Beyond the Palio: Urban Ritual in Renaissance Siena*, ed. P. Jackson and F. Nevola (Oxford, 2006), pp. 65–88

F. Nevola, 'Metaurbanistica e cerimoniale: Pio II ed la corte papale in Siena', in *Enea Silvio Piccolomini. Arte, storia e cultura nell'Europa di Pio II*, Acts of the Conference, ed. A. Antoniutti, M. Gallo and R. Di Paola (Rome, 2006), pp. 357–69

F. Nevola, ' "Più honorati et suntuosi ala Republica": Botteghe and Luxury Retail along Siena's Strada Romana', in *Buyers and Sellers: Retail Circuits and Practices in Medieval and Early Modern Europe*, ed. B. Blondé, P. Stabel, J. Stobbart and I. Van Damme (Turnhout, 2006), pp. 65–78

F. Nevola, ed., *Pio II Piccolomini: Il papa del rinascimento a Siena*, Acts of the International Conference, Siena, 5–7 May 2005 (Siena, 2007)

F. Nevola, 'Lots of Napkins and a Few Surprises: Francesco di Giorgio Martini's House, Goods and Social Standing in Late-Fifteenth-century Siena', *Annali di Architettura*, 18–19 (2006–7), pp. 71–82

F. Nevola, ed., 'Francesco Patrizi: umanista, urbanista e teorico di Pio II', in *Pio II Piccolomini: Il papa del rinascimento a Siena*, Acts of the International Conference, Siena 5–7 May 2005 (Siena, 2007)

F. Nevola, 'Il palazzo Chigi alla Postierla: sistemazione urbana e genesi del progetto,' in *Il Palazzo Chigi Piccolomini alla Postierla*, ed. N. Fargnoli, *Quaderni della Soprintendenza per il patrimonio storico, artistico e demoetnoantropologico di Siena e Grosseto*, 6 (2007), 26–43

F. Nevola, ' "El Papa non verrà": The Failed Triumphal Entry of Leo X de' Medici to Siena (November 1515)', *Mitteilungen des Kunsthistorisches Instituts in Florenz* [forthcoming]

Niccolò di Giovanni di Ventura, *La sconfitta di Montaperti* (Siena, 1502)

D. Norman, ed., *Siena, Florence and Padua: Art, Society and Reli-gion, 1280–1400*, 2 vols. (New Haven and London, 1995)

D. Norman, ' "Love Justice You Who Judge the Earth": The Paintings of the Sala dei Nove in the Palazzo Pubblico', in *Siena, Florence and Padua: Art, Society and Religion, 1280–1400*,

ed. D. Norman (New Haven and London, 1995), II, pp. 145–69

D. Norman, *Siena and the Virgin: Art and Politics in a Late Medieval City* (New Haven and London, 1999)

D. Norman, *Painting in Late Medieval and Renaissance Siena, 1260–1555* (New Haven and London, 2003)

D. Norman, 'Sotto uno baldachino trionfale': The Ritual Significance of the Painted Canopy in Simone Martini's *Maestà*, in *Beyond the Palio: Urban Ritual in Renaissance Siena*, ed. P. Jackson and F. Nevola (Oxford, 2006), pp. 11–24

I. Nuovo, 'La *Descriptio Urbis Viennensis* di Enea Silvio Piccolomini', in *Pio II e la cultura del suo tempo*, ed. L. R. Secchi Tarugi (Milan, 1991), pp. 357–72

V. Nuscis, 'Una nuova cronaca senese sulla crisi degli anni ottanta', in *La Toscana ai tempi di Lorenzo il Magnifico: Politica, economia ed arte* (Pisa, 1996), III, pp. 1107–64

E. O'Brien, 'The History of the Two Lovers', in Aeneas Sylvius Piccolomini (Pope Pius II), *The Two Lovers: The Goodly History of Lady Lucrece and her Lover Eurialus*, ed. E. O'Brien and K. R. Bartlett (Ottawa, 1999)

J. Onians, *Bearers of Meaning: The Classical Orders in Antiquity, the Middle Ages and the Renaissance* (Princeton, NJ, 1988)

J. Onians, 'Leon Battista Alberti: The Problem of Personal and Urban Identity', in *La corte a Mantova nell'epoca di Andrea Mantegna*, ed. C. Mozzarelli, R. Oresko and L. Ventura (Rome, 1997), pp. 207–15

I. Origo, *The World of Saint Bernardino* (New York, 1962)

Cesare Orlandi, *De Urbis Senae Eiusque Episcopatus Antiquitate* (Siena, 1573)

H. W. van Os, *Vecchietta and the Sacristy of the Siena Hospital Church: A Study in Renaissance Religious Symbolism* (The Hague, 1974)

H. W. van Os, 'From Rome to Siena. The Altarpiece for Santo Stefano alla Lizza', *Mededelingen van het Nederlands Instituut te Rome*, XLIII, n.s. 8 (1981), pp. 119–28

H. W. van Os, 'The Black Death and Sienese Painting', *Art History*, 4 (1981), pp. 237–49

H. W. van Os, *Sienese Altarpieces, 1215–1460: Form, Content and Function*, II, *1344–1460* (Groningen, 1984, 1990)

H. W. van Os, *Studies in Early Tuscan Painting* (London, 1992)

D. Ottolenghi, 'Studi demografici sulla popolazione di Siena dal secolo XIV al XIX', *BSSP*, 10 (1903), pp. 297–358

D. Owen Hughes, 'Kinsmen and Neighbours in Medieval Genoa', in *The Medieval City*, ed. E. Miskimin and D. Herlihy (London, 1978), pp. 95–111

D. Owen Hughes, 'Urban Growth and Family Structure in Medieval Genoa', *Past and Present*, 66 (1975), pp. 3–29

L. Paardekooper, 'La pala del Vecchietta per Spedaletto: La committenza del rettore e del camerlengo dello Spedale di Santa Maria della Scala e i rapporti con Pio II', *Mededelingen van het Nederlands Instituut te Rome*, 55 (1996), pp. 150–86

L. Paardekooper, 'Het "San Galgano-polyptiek" van Giovanni di Paolo', in *Polyptiek. Een veelluik van Groninger bijdragen aan de kunstgeschiedenis*, ed. H.Th. van Veen, V. M. Schmidt and J. M. Keizer (Zwolle, 2002), 109–18, notes pp. 230–32

P. N. Pagliara, 'Vitruvio: da testo a canone', in *Memoria dell'antico nell'arte italiana*, ed. S. Settis (Turin, 1986), III, pp. 7–88

P. N. Pagliara, 'Raffaello e la rinascita delle tecniche antiche', in *Les chantiers de la Renaissance*, ed. A. Chastel and J. Guillaume (Paris, 1991), pp. 51–69

P. N. Pagliara, 'Murature laterizie a Roma alla fine del Quattrocento', *Ricerche di storia dell'arte*, 48 (1992), pp. 43–54

E. Panofsky, *Meaning in the Visual Arts* (London, 1955), pp. 266–76

J. T. Paoletti, 'A. Federighi: Documentary Re-evaluation', *Jahrbuch der Berliner Museum* (1975), pp. 87–143

J. T. Paoletti, *The Siena Baptismal Font: A Study of an Early Renaissance Collaborative Programme, 1416–34* (New York, 1979)

B. Paolozzi Strozzi, 'Alcune riflessioni sull'iconografia monetale senese', in *Le monete della Repubblica Senese*, ed. B. Paolozzi Strozzi (Milan, 1992), pp. 73–170

G. Pardi, 'La popolazione di Siena attraverso i secoli', *BSSP*, 30 (1923), pp. 85–123; 32 (1925), pp. 3–62

R. Parenti, 'Una parte per il tutto. Le vicende costruttive della facciata dello Spedale e della piazza antistante', in *Santa Maria della Scala: archeologia e edilizia sulla piazza dello Spedale*, ed. E. Boldrini and R. Parenti (Florence, 1991), pp. 20–96

R. Parenti, 'Santa Maria della Scala. Lo Spedale in forma di città', in *Storia di Siena. Dalle orgini alla fine della repubblica*, I, ed. R. Barzanti, G. Catoni and M. De Gregorio (Siena, 1995), pp. 239–52

R. Parenti, 'I materiali del costruire', in *Architettura civile in Toscana: il Medioevo*, ed. A. Restucci (Siena, 1995), pp. 371–99

R. Parenti, 'Approvvigionamento e diffusione dei materiali litici da costruzione di Siena e dintorni', in *Atti della giornata di studi in onore di Francecso Rodolico*, ed. D. Lambertini (Florence, 1995), pp. 87–108

G. Parsons, *Siena, Civil Religion and the Sienese* (Aldershot and Burlington, VT, 2005)

P. Partner, *The Pope's Men: The Papal Civil Service in the Renaissance* (Oxford, 1990)

L. von Pastor, *Storia dei Papi dalla fine del Medio Evo*, 3 vols. (Rome, 1944–66)

F. Patrizi, *De Institutione Reipublicae libri novem* (Paris: Galeotto da Prato, 1520)

F. Patrizi, *De Discorsi sopra alle cose appartenenti ad una città libera e famiglia nobile*, Italian trans. by G. Fabrini (Venice, 1547)

E. Pecchioli, *The Painted Façades of Florence: From the Fifteenth to the Twentieth Century* (Florence, 2006)

G. A. Pecci, *Storia del Vescovado della città di Siena* (Lucca, 1748)

G. A. Pecci, *Memorie storico-critiche della città di Siena che servono alla vita civile di Pandolfo Petrucci*, 2 vols. (Siena, 1755; repr. Siena, 1988)

L. Pellecchia, 'The Patron's Role in the Production of Architecture: Bartolomeo Scala and the Scala Palace', *Renaissance Quarterly*, 42 (1989), pp. 258–91

E. Pellegrini, *L'iconografia di Siena nelle opere a stampa* (Siena, 1986)

E. Pellegrini, *Piazze e vie di Siena nelle opere a stampa* (Siena, 1987)

P. Pertici, *Le epistole di Andreoccio Petrucci (1426–1443)* (Siena, 1990)

P. Pertici, 'Una "coniuratio" del reggimento di Siena nel 1450', *BSSP*, 99 (1992), pp. 9–47

P. Pertici, *La città magnificata: interventi edilizi a Siena nel Rinascimento* (Siena, 1995)

P. Pertici, 'La furia delle fazioni', in *Storia di Siena. Dalle orgini alla fine della repubblica*, I, ed. R. Barzanti, G. Catoni and M. De Gregorio (Siena, 1995), pp. 383–94

P. Pertici, 'Per la datazione del *Libro d'ore* di Feliziana Bichi', in *Siena ed il suo territorio nel rinascimento*, III, ed. M. Ascheri (Siena, 2001), pp. 161–9

P. Pertici, '"I sacri splendori": Eugenio IV e Siena in un affresco di Domenico di Bartolo', *BSSP*, 106 (1999 [2001]), pp. 484–94

G. Petrella, *L'officina del geografo: La 'Descrittione di tutta Italia' di Leandro Alberti e gli studi geografico-antiquari tra Quattro e Cinquecento* (Milan, 2004)

A. Petrucci, 'Potere, spazi urbani, scritture esposte: problemi ed esempi', in *Culture et idéologie dans la genèse de l'état moderne*, ed. S. P. Genet (Rome, 1985), pp. 85–97

A. Petrucci, *La scrittura. Ideologia e rappresentazione* (Turin, 1986)

A. Petrucci, 'Il volgare esposto: problemi e prospettive', in *Visibile parlare: le scritture esposte nei volgari italiani dal medioevo al rinascimento*, ed. C. Ciociola (Naples, 1997) pp. 45–58

G. Piccinni, 'Modelli di organizzazione dello spazio urbano dei ceti dominanti del Tre e Quattrocento. Considerazioni senesi', in *I ceti dirigenti nella Toscana tardo comunale (Atti del convegno, 5–7 dicembre 1980, Firenze)*, ed. D. Rugiadini (Florence, 1983), pp. 221–36

G. Piccinni, 'L'Ospedale di Santa Maria della Scala di Siena. Note sulle origini dell'assistenza sanitaria in Toscana', in *Città e servizi sociali in Italia dei secoli XII–XV* (Bologna, 1990), pp. 297–324

G. Piccinni, 'Il colore della città medievale', in *Il colore della città*, ed. M. Boldrini (Siena, 1993), pp. 35–44

G. Piccinni, 'Linee di storia dell'Ospedale di Santa Maria della Scala e dell'area circostante', in *Santa Maria della Scala: da ospedale a museo* (Siena, 1995), pp. 11–22

G. Piccinni, 'La strada come affare. Sosta, identificazione e depositi di denaro di pellegrini (1382–1446)', in *Il libro del Pellegrino (Siena: 1382–1446). Affari, uomini, monete nell'Ospedale di Santa Maria della Scala*, ed. G. Piccinni and L. Travaini (Naples, 2003), pp. 1–82

G. Piccinni and L. Travaini, *Il libro del Pellegrino (Siena: 1382–1446). Affari, uomini, monete nell'Ospedale di Santa Maria della Scala* (Naples, 2003)

Aeneae Silvii [Piccolomini], Episcopi Senensis, qui postea Pius, Papa II fuit, 'Historia Friderici III Imperatoris', in *Voluminis Rerum Germanicarum Novi* (Argentorati: Josiae Staedelii et Joh. Friderici Spoor, 1685)

Aeneas Silvius Piccolomini [Pius II], *The Commentaries*, ed. and trans. F. A. Gragg, *Smith College Studies in History*, 22 (1936–7); 25 (1939–40); 30 (1947); 35 (1951); 43 (1957)

Aeneas Silvius Piccolomini [Pius II], *Selected Letters*, ed. and trans. A. Baca (Northridge, CA, 1969)

Aeneas Silvius Piccolomini [Pius II], *I Commentarii*, ed. L. Totaro, 2 vols. (Milan, 1984)

Aeneas Silvius Piccolomini [Pius II] *The Goodli History of the Lady Lucres of Scene and of her Lover Eurialus*, ed. E. J. Morrall (Oxford, 1996)

Aeneas Silvius Piccolomini [Pius II], *Storia di due amanti e rimedio d'amore* [Latin/Italian edition], ed. and trans. Maria Luisa Doglio (Turin, 1973)

Aeneas Silvius Piccolomini [Pius II], *De Gestis Concilii Basilensis Commentariorum Libri II*, ed. D. Hay and W. K. Smith (Oxford, 1967)

G. Piccolomini, 'La morte di Pio II', *Miscellanea Storica Senese*, IV (1894), p. 124

P. Piccolomini, *La vita e l'opera di Sigismondo Tizio (1458–1528)* (Siena, 1903)

J. Pieper, *Pienza. Der Entwurfeiner humanistischen Weltsicht* (Stuttgart and London, 1997); Italian version, *Pienza. Il progetto di una visione umanistica del mondo* (Baden-Wurttenberg, 2000)

P. Pierotti, *Prima di Machiavelli: Filarete e Francesco di Giorgio consiglieri del principe* (Pisa, 1995)

G. Pinto, *La Toscana nel Tardo Medioevo* (Florence, 1982), pp. 421–49

G. Pinto, 'L'organizzazione del lavoro nei cantieri edili (Italia centro-settentrionale)', in *Artigiani e salariati. Il mondo del lavoro nell'Italia di secoli XII–XV (Atti del Centro Italiano di Storia e d'Arte, ottobre 1981)*, ed. E. Cristiani (Pistoia, 1984), pp. 69–103

G. Pinto, ' "Honour" and "Profit": Landed Property and Trade in Medieval Siena', in *City and Countryside*, ed. T. Dean and C. Wickham (London, 1990), pp. 81–91

D. Pirovano, 'Memoria dei classici nell' *Historia de duobus amantibus* di Enea Silvio Piccolomini', *Studi Vari di Lingua e Letteratura Italiana in Onore di Giuseppe Velli* (Alessandria, 2001), I, pp. 255–75

K. Van Der Ploeg, *Art, Architecture and Liturgy: Siena Cathedral in the Middle Ages* (Groningen, 1993)

E. Poleggi, 'Il rinnovamento edilizio genovese e i maestri Antelami del secolo XV', in ' "Valle Intelvi", Acts of Conference, September 1966', *Arte Lombarda*, XI/2 (1966), pp. 53–68

E. Poleggi, 'La condizione sociale dell'architetto e i grandi committenti dell'epoca alessiana', in *Galeazzo Alessi e l'architettura del Cinquecento (Atti del convegno internazionale di studi: Genova, 16–20 aprile 1974)* (Genoa, 1975), pp. 359–68

G. Poli, 'Schemi grafici dei diversi interventi di restauro e ripresa pittorica', in *Ambrogio Lorenzetti: Il buon governo*, ed. E. Castelnuovo (Milan, 1995), pp. 393–7

Lancelotto Politi, *La Sconfitta di Monteaperto* (Siena, 1502, repr. Siena, 2002)

I. Polverini Fosi, ' "La Comune Dolcissima Patria": Pio II e Siena', in *I ceti dirigenti nella Toscana del Quattrocento (Atti del V et VI convegno: Firenze, 10–11 dicembre 1982; 2–3 dicembre 1983)*, ed. D. Rugiadini (Florence, 1987), pp. 509–21

J. Pope-Hennessy, *Giovanni di Paolo* (London, 1937)

J. Pope-Hennessy, *Sienese Quattrocento Painting* (London and Oxford, 1947)

B. Preyer, 'The Palazzo Rucellai', in *Giovanni Rucellai ed il suo Zibaldone. II. A Florentine Patrician and his Palace*, ed. Alessandro Perosa (London, 1981), pp. 155–225

B. Preyer, 'The "chasa overo palagio" of Alberto di Zanobi: A Florentine Palace of about 1400 and its Later Remodelling', *Art Bulletin*, 65 (1983), pp. 387–401

B. Preyer, 'Florentine Palaces and Memories of the Past', in *Art, Memory and Family in Renaissance Florence*, ed. G. Ciappelli and P. Rubin (Cambridge, 2000), pp. 176–94

B. Preyer, 'Around and in the Gianfigliazzi Palace in Florence: Developments on Lungarno Corsini in the 15th and 16th centuries', *Mitteilungen des Kunsthistorischen Instituts in Florenz*, XLVIII (2004), pp. 55–104

M. Pritchard, 'The Urban Development of Bologna, 1300–1500', PhD thesis, Courtauld Institute of Art, University of London, 1994

A. Provedi, *Relazione delle pubbliche feste date in Siena negli ultimi cinque secoli* (Siena, 1791)

G. Prunai and S. del Colli, eds., *Archivio di Stato di Siena: Archivio di Balìa* (Rome, 1957)

G. Prunai, G. Pampaloni and N. Bemporad, eds., *Il Palazzo Tolomei a Siena* (Florence, 1971)

M. Putti, *I cittadini senesi del Terzo di Città e il fisco del 1481. Inventario delle denunce della Lira conservate nell'Archivio di Stato di Siena* (Tesi di Laurea, Università di Studi di Siena, 1989–90)

M. Quast, 'Il Palazzo Bichi Ruspoli, già Rossi in via Banchi di Sopra: indagini per una storia della costruzione tra Duecento e Settecento', in *BSSP*, 106 (1999), pp. 156–188

M. Quast, 'Il Palazzo Chigi al Casato', in *Alessandro VII Chigi (1599–1667): Il papa senese di roma moderna*, exh. cat., Siena, 23 September 2000 – 10 January 2001, ed. A. Angelini, M. Butzek and B. Sani (Siena and Florence, 2000), pp. 435–9

M. Quast, 'Il linguaggio di Francesco di Giorgio nell'ambito dell'architettura dei palazzi senesi', in *Francesco di Giorgio alla corte di Federico da Montefeltro*, Acts of the International Conference, Urbino, 11–13 October 2001, ed. F. P. Fiore (Florence, 2004), II, pp. 401–31

M. Quast, 'I palazzi del Cinquecento a Siena: il linguaggio delle facciate nel contesto storico-politico', in *Siena nel Rinascimento: l'ultimo secolo della repubblica*, I, ed. G. Mazzoni and F. Nevola, Acts of the International Conference, Siena, 28–30 September 2003 and 16–18 September 2004 (Florence, 2007)

M. Quast, 'Palace Façades in Late Medieval and Renaissance Siena: Continuity and Change in the Aspect of the City', in *Renaissance Siena: Art in Context*, ed. A. L. Jenkens (Kirksville, MO, 2005), pp. 47–79

F. Quinterio, 'Verso Napoli: come Giuliano e Benedetto da Maiano divennero artisti nella corte aragonese', *Napoli Nobilissima*, 28 (1989), pp. 204–10

F. Quinterio, *Giuliano da Maiano: 'Grandissimo domestico'* (Rome, 1996)

A. Ray, ed., *Spanish Pottery, 1248–1898: With a Catalogue of the Collection in the Victoria and Albert Museum* (London, 2000)

E. Re, 'Maestri di Strada', *Archivio Società Romana di Storia Patria* (1920), pp. 5–102

O. Redon, 'Il Comune e le sue frontiere', in *Storia di Siena. Dalle orgini alla fine della repubblica*, I, ed. R. Barzanti, G. Catoni and M. De Gregorio (Siena, 1995), pp. 27–40

Y. Renouard, *The Avignon Papacy, 1305–1403* (London, 1970); original French edition (Paris, 1954)

A. Reumont, 'Viaggio in Italia nel MCDXCVII del cavaliere Arnaldo di Harff di Colonia sul Reno', *Archivio Veneto*, 11 (1876), pp. 124–46 and 393–407

M. Ricci, *'Fu anco suo creato': l'eredità di Baldassarre Peruzzi in Antonio Maria Lari e nel figlio Sallustio* (Rome, 2002)

C. Richardson, 'The Lost Will and Testament of Cardinal Francesco Todeschini Piccolomini (1439–1503)', *Papers of the British School at Rome*, LXVI (1998), pp. 193–214

C. Richardson, 'The Housing Opportunities of a Reniassance Cardinal', *Renaissance Studies*, 17 (2003), pp. 607–27

E. M. Richter, *La scultura di Antonio Federighi* (Turin, 2002)

G. Ricci, 'Sulla classificazione della città nell'Italia di Foresti', *Storia Urbana*, 17 (1993), pp. 5–17

P. A. Riedl and M. Siedel, eds., *Die Kirchen von Siena*, 3 vols. (Munich, 1985–2006)

D. Robbins, 'A Case Study for Medieval Urban Process: Rome's Trastevere (1250–1450)', PhD thesis, University of California at Berkeley, 1989

D. Robbins, 'Via della Lungaretta. The Making of a Medieval Street', in Z. Çelik, D. Favro and R. Ingersoll, eds., *Streets. Critical Perspectives on Public Space* (Berkeley 1994), pp. 165–76

O. F. Robinson, *Ancient Rome: City Planning and Administration* (London, 1992)

F. Rodolico, *Le pietre delle città d'Italia* (Florence, 1953, repr. Florence, 1995)

E. Romagnoli, *Biografia cronologica de' bellartisti senesi, 1200–1800* (Florence, 1976)

G. C. Romby, *Costruttori e maestranze edilizie della Toscana medievale – i grandi lavori del contado fiorentino (sec XIV)* (Florence, 1995)

G. Roversi, *Palazzi e case nobili del '500 a Bologna* (Bologna, 1986)

A. Rovetta, 'La cultura antiquaria a Milan negli anni settanta del Quattrocento', in *Giovanni Antonio Amadeo: scultura e architettura del suo tempo*, ed. L. Castelfranchi and J. Shell (Milan, 1993), pp. 393–419

I. D. Rowland, 'L'Historia Porsennae e la conoscenza degli Etruschi nel Rinascimento', *Studi umanistici piceni*, 9 (1989), pp. 185–93

I. D. Rowland, *The Correspondence of Agostino Chigi (1466–1520) in Cod. Chigi R.V.c.* (Vatican City, 2001)

I. D. Rowland, 'Agostino Chigi e la politica senese del '500', in *Siena nel Rinascimento: l'ultimo secolo della repubblica*, II, Acts of the International Conference, Siena (28–30 September 2003 and 16–18 September 2004), ed. M. Ascheri and F. Nevola (Siena, 2007)

I. D. Rowland, 'Pio II, l'urbanistica, e gli esordi dell'etruscologia', in *Pio II Piccolomini: Il papa del rinascimento a Siena*, ed. F. Nevola, Acts of the International Conference, Siena, 5–7 May 2005 (Siena, 2007)

M. Rubin, *Corpus Christi: The Eucharist in Late Medieval Culture* (Cambridge, 1992)

P. Rubin and A. Wright, *Renaissance Florence: The Art of the 1470s*, exh. cat., National Gallery, London, 20 October 1999–16 January 2000 (London, 1999)

N. Rubinstein, 'Political Ideas in Sienese Art: The Frescoes by Ambrogio Lorenzetti and Taddeo di Bartolo in the Palazzo Pubblico', *Journal of the Warburg and Courtauld Institutes*, 21 (1958), pp. 179–207

N. Rubinstein, *The Government of Florence under the Medici (1434–1494)* (Oxford, 1966)

N. Rubinstein, ed., *Florentine Studies: Politics and Society in Renaissance Florenece* (London, 1968)

N. Rubinstein, *The Palazzo Vecchio, 1298–1532: Government, Architecture and Imagery in the Civic Palace of the Florentine Republic* (Oxford, 1995)

R. Rubinstein, 'Pius II as Patron of Art', PhD thesis, Courtauld Institute of Art, University of London, 1957

R. Rubinstein, 'Pius II's Piazza S. Pietro and St. Andrew's Head', in *Enea Silvio Piccolomini, Papa Pio II (Atti del Convegno per il quinto centenario della morte e altri scritti)*, ed. D. Maffei (Siena, 1968), pp. 221–43

R. Olitsky Rubinstein, 'Pius II and Roman Ruins', *Renaissance Studies*, 2 (1988), pp. 197–203

D. Rugiadini, ed., *I ceti dirigenti nella Toscana tardo comunale (Atti del convegno, 5–7 dicembre 1980, Firenze)* (Florence, 1983)

D. Rugiadini, ed., *I ceti dirigenti nella Toscana del Quattrocento (Atti del V e VI convegno: Firenze, 10–11 dicembre 1982; 2–3 dicembre 1983)* (Florence, 1987)

E. F. Rumhor, *Italienische Forschungen* (Berlin, 1827)

J. Rykwert, *The Idea of a Town: Anthropology of Urban Form in Rome, Italy and the Ancient World* (London, 1976)

J. Rykwert, 'The Street: The Use of its History', in *On Streets*, ed. S. Anderson (Cambridge, MA, 1978)

J. Rykwert, *The Necessity of Artifice* (London, 1982)

J. Rykwert, *The Seduction of Place: The City in the Twenty-first Century* (New York, 2000)

H. Saalman, 'Early Renaissance Architectural Theory and the Practice of Antonio Filarete's *Trattato d'Architettura*', *Journal of the Society of Architectural Historians*, 41 (1959), pp. 89–106

H. Saalman, 'Tommaso Spinelli, Michelozzo, Manetti and Rossellino', *Journal of the Society of Architectural Historians*, 25 (1966), pp. 151–64

H. Saalman, 'The Transformation of the City in the Renaissance: Florence as Model', *Annali di Architettura*, 2 (1990), pp. 73–82

F. Sacchetti, *Il Trecentonovelle*, ed. V. Marucci (Rome, 1996)

L. Salerno, L. Spezzaferro and M. Tafuri, eds., *Via Giulia: una utopia urbanistica del '500* (Rome, 1973)

M. Salmi, 'La chiesa di Castiglione Olona e le origini del Rinascimento in Lombardia', in *Miscellanea di Studi Lombardi in onore di Ettore Verga* (Milan, 1931), pp. 271–83

M. Salmi, 'La "Renovatio Romae" e Firenze', *Rinascimento*, 1 (1950), pp. 5–24

M. Salmi, *Il Palazzo Chigi Saracini* (Siena, 1967)

B. Sani, 'Artisti e committenti a Siena nell prima metà del Quattrocento', in *I ceti dirigenti nella Toscana del Quattrocento (Atti del V e VI convegno: Firenze, 10–11 dicembre 1982; 2–3 dicembre 1983)*, ed. D. Rugiadini (Florence, 1987), pp. 485–507

B. Sani, 'Novità sugli interni senesi all'antica', in *Le dimore di Siena: L'arte dell'abitare nei territori dell'antica Repubblica dal Medioevo all'Unità d'Italia*, ed. G. Morolli (Florence, 2002), pp. 33–8

D. Sanminiatelli, 'The Beginnings of Domenico Beccafumi', *Burlington Magazine*, XCIV (1957), pp. 401–10

P. Sanpaolesi, 'Aspetti di architettura del '400 a Siena e Francesco di Giorgio', in *Studi Artistici Urbinati*, 1 (1959), pp. 139–68

B. Santi and C. Strinati, eds., *Siena e Roma. Raffaello, Caravaggio e i protagonisti di un legame antico*, exh. cat., Siena, S. Maria della Scala, Palazzo Squarcialupi, 25 November 2005–5 March 2006 (Siena, 2005)

M. Sanudo, *La spedizione di Carlo VIII in Italia*, ed. R. Fulin (Venice, 1873)

M. Sanudo, *Diarii*, ed. F. Stefani, 25 vols. (Venice, 1879)

M. Saura, 'Architecture and the Law in Early Renaissance Urban Life: L. B. Alberti's "De re aedificatoria"', PhD thesis, University of California at Berkeley, 1988

P. L. Sbaragli, 'I mercanti di mezzana gente al potere di Siena', *BSSP*, 44 (1937), pp. 35–63

G. Scaglia, 'An Allegorical Portrait of Emperor Sigismund by Mariano Taccola of Siena', *Journal of the Warburg and Courtauld Institutes*, 31 (1968), pp. 428–34

G. Scaglia, 'Newly Discovered Drawings of Monasteries by Francesco di Giorgio Martini', *Architectura*, 2 (1974), pp. 112–24

G. Scaglia, 'Architectural Drawings by Giovanbattista Alberto in the Circle of Francesco di Giorgio Martini', *Architectura*, 8 (1978), pp. 104–124

G. Scaglia, 'A Vitruvianist's "Thermae" Plan and the Vitruvianists in Rome and Siena', *Arte Lombarda*, 84/5 (1988), pp. 85–101

G. Scaglia, 'The Development of Francesco di Giorgio's Treatises in Siena', in *Les Traités d'Architecture à la Renaissance*, ed. J. Guillaume (Paris, 1988), pp. 91–7

G. Scaglia, *Francesco di Giorgio: Checklist and History of Manuscripts and Drawings in Autographs and Copies from ca. 1470 to 1687 and Renewed Copies (1764–1839)* (London, 1992)

M. Scarpini, *Vivat Foelix. Il Palazzo dei Diavoli a Siena: Storia, architettura, civiltà* (Siena, 2002)

G. Scavizzi, *Arte e architettura sacra* (Reggio Calabria and Rome, 1981)

R. W. Scheller, 'Gallia Cisalpina: Louis XII and Italy, 1499–1508', *Simiolus*, 15 (1985), pp. 5–60

G. J. Schenk, 'Enter the Emperor: Charles IV and Siena between Politics, Diplomacy and Ritual (1355 and 1368)', in *Beyond the Palio: Urban Ritual in Renaissance Siena*, ed. P. Jackson and F. Nevola (Oxford, 2006), pp. 25–43

C. B. Schmitt and Q. Skinner, eds., *The Cambridge History of Renaissance Philosophy* (Cambridge, 1988)

R. Schofield, 'Florentine and Roman Elements in Bramante's Milanese Architecture', in C. H. Smyth and G. C. Garfagnini, eds., *Florence and Milan, comparisons and relations*, Acts of two conferences at Villa I Tatti in 1982–1983 (Florence, 1989), I, pp. 201–2

R. Schofield, 'Amadeo, Bramante and Leonardo and the Tiburio in Milan Cathedral', *Achademia Leonardi Vinci. Journal of the Leonardo Society*, 2 (1989), pp. 68–100

R. Schofield, 'Avoiding Rome: Lombard Sculptors and the Antique', *Arte Lombarda*, 100 (1992), pp. 29–44

P. Schofield, 'Lodovico il Moro's Piazzas: New Sources and Observations', *Annali di Architettura*, 4–5 (1992–3), pp. 157–67

R. Schofield, 'Amadeo's System', in *Giovanni Antonio Amadeo: scultura e architettura del suo tempo*, ed. L. Castelfranchi and J. Shell (Milan, 1993), pp. 125–56

R. Schofield, 'Girolamo Riario a Imola: ipotesi per una ricerca', in *Francesco di Giorgio alla corte di Federico da Montefeltro: atti del convegno internazionale di studi*, ed. F. P. Fiore (Florence, 2004), II, pp. 600–608

La Scultura decorativa del primo Rinascimento: atti del I convegno internazionale di studi, Pavia, 16–18 settembre 1980 / Università di Pavia, AA. VV. (Rome, 1983)

M. Seidel, 'Die Fresken des Francesco di Giorgio in S. Agostino in Siena', *Mitteilungen des Kunsthistorisches Instituts in Florenz*, 23 (1979), pp. 4–118

M. Seidel, 'The Social Status of Patronage and its Impact on Pictorial Language in Fifteenth-Century Siena', in *Italian Altarpieces (1250–1550): Function and Design*, ed. E. Borsook and F. Superbi Gioffredi (Oxford, 1994), pp. 119–37

M. Seidel, 'A colloquio con l'antichità. Il giovane Francesco di Giorgio e la scultura romana', in *Umanesimo a Siena. Letteratura, arti figurative, musica, (Siena, 5–8 giugno 1991: atti del convegno)*, ed. E. Cioni and D. Fausti (Siena, 1994), pp. 285–310

C. Sensini, 'Fra Giovanni da Verona maestro d'intaglio e d'intarsio', *BSSP*, CVI (1999), pp. 189–271

D. Seragnoli, *Il teatro a Siena nel Cinquecento* (Rome, 1980)

V. Serino, ed., *Siena e l'acqua. Storia e immagini della città e delle sue fonti* (Siena, 1997)

E. Sestan, 'Siena avanti Montaperti', *BSSP*, 68 (1961), pp. 3–49 repr. in E. Sestan, *Italia Medievale* (Naples, 1968), pp. 151–92

S. Settis, ed., *Memoria dell'antico nell'arte italiana*, 3 vols. (Turin, 1984–6)

S. Settis, 'Continuità, distanza, conoscenza. Tre usi dell'antico', in *Memoria dell'antico nell'arte italiana*, ed. S. Settis (Turin, 1986), III, pp. 375–486

S. Settis and D. Toracca, eds., *La Libreria Piccolomini nel Duomo di Siena* (Modena, 1998)

S. Settis, *Futuro del 'classico'* (Turin, 2004)

C. Shaw, 'Politics and Institutional Innovation in Siena (1480–98) part I, *BSSP*, 103 (1996), pp. 9–102; part II, *BSSP*, 104 (1997), pp. 194–307

C. Shaw, *The Politics of Exile in Renaissance Italy* (Cambridge, 2000)

C. Shaw, *L'ascesa al potere di Pandolfo Petrucci il Magnifico. Signore di Siena (1487–1498)* (Siena, 2001)

C. Shaw, *Popular Government and Oligarchy in Renaissance Italy* (Leiden and Boston, 2006)

C. Shaw, 'Peace-making Rituals in Fifteenth-century Siena', in *Beyond the Palio: Urban Ritual in Renaissance Siena*, ed. P. Jackson and F. Nevola (Oxford, 2006), pp. 89–103

C. Shaw, 'Pius II and the Government of Siena', in *Pio II Piccolomini: Il papa del rinascimento a Siena*, Acts of the International Conference (Siena, 5–7 May 2005), ed. F. Nevola (Siena 2007)

J. Shearman, *Only Connect: Art and the Spectator in the Italian Renaissance* (Princeton, NJ, 1992)

R. Signorini, 'Alloggi di sedici cardinali presenti alla Dieta', in A. Calzona, F. P. Fiore, A. Tenenti and C. Vasoli, eds., *Il sogno di Pio II e il viaggio da Roma a Mantova. Atti del Convegno Internazionale. Mantova: 13–15 aprile 2000*, Centro Studi L. B. Alberti, *Ingenium* n. 5 (Florence, 2003), pp. 315–89

G. Simoncini, ed., *La tradizione medievale nell'architettura italiana* (Florence, 1992)

G. Simoncini, 'La persistenza del gotico dopo il medioevo. Periodizzazione ed orientamenti figurativi', in *La tradizione medievale nell'architettura italiana*, ed. G. Simoncini (Florence, 1992), pp. 1–50

Simone di Niccolò, ed., *La sancta vita di Beato Ambrosio da Siena* (Siena: Simone di Niccolò Nardi, 1509)

M. Simonetta, *Rinascimento segreto. Il mondo del Segretario da Petrarca a Machiavelli* (Milan, 2004)

O. di Simplicio, 'Nobili e sudditi', in *I libri dei leoni. La nobiltà di Siena in età medicea (1557–1737)*, ed. M. Ascheri (Milan, 1996), pp. 71–130

S. Sinding-Larsen, 'A Tale of Two Cities: Florentine and Roman Visual Contexts for Fifteenth-century Palaces', *Acta Archaeologiam et Artium Historiam Pertinentia*, 6 (1975), pp. 163–212

C. Sinistri, 'Le vedute di città nelle edizioni incunabole del *Supplementum Chronicarum*', *Esopo*, 56 (1992), pp. 48–69

G. Sironi, 'I fratelli Solari, figli di Marco (Solari) da Carona: nuovi documenti', *Arte Lombarda*, 102–3 [1992], pp. 65–9

C. Sisi, 'Giacomo Cozzarelli', in *Domenico Beccafumi e il suo tempo*, ed. P. Torriti (Milan, 1990), pp. 540–47

Q. Skinner, 'Ambrogio Lorenzetti: The Artist as Political Philosopher', *Proceedings of the British Academy*, 72 (1988), pp. 492–510

Q. Skinner, 'Ambrogio Lorenzetti's *Buon Governo* Frescoes: Two Old Questions, Two New Answers', *Journal of the Warburg and Courtauld Institutes*, 62 (1999), pp. 2–28

T. R. Slater, ed., *The Built Form of Western Cities* (London, 1990)

D. L. Smail, *Imaginary Cartographies: Possession and Identity in Late Medieval Marseilles* (Ithaca, NY, and London, 2000)

H. Smit, ' "Ut si bello et ornato mestiero": Flemish Weavers Employed by the City Government of Siena (1438–1480)', in B. W. Meijer et al., *Italy and the Low Countries: Artistic Relations: the Fifteenth Century* (Florence, 1999), pp. 69–78

C. Smith, *Architecture in the Culture of Early Humanism* (New York and Oxford, 1992)

C. H. Smyth and G. C. Garfagnini, *Florence and Milan: Comparisons and Relations* (Florence, 1989)

U. Sorbi, *Aspetti della struttura e principali modalità di stima dei Catasti senesi e fiorentini del XIV e XV secolo* (Florence, 1960)

E. C. Southard, 'The Frescoes in Siena's Palazzo Pubblico, 1289–1355: Studies in Imagery and Relations to Other Communal Palaces in Tuscany', PhD thesis, Indiana University, Bloomington, 1979

B. Sozzini, *Consiliorum seu potius responsorum Mariani Socini ac Bartholomei filii . . .* (Venice, 1571)

P. L. Spilner, ' "Ut civitas amplietur": Studies in Florentine Urbanism', PhD thesis, Columbia University, 1987

F. Sricchia Santoro, 'Il giovane Sodoma', *Prospettiva*, 30 (1982), pp. 43–65

F. Sricchia Santoro, 'Introduzione', in *Da Sodoma a Marco Pino: pittori a Siena nella prima metà del Quattrocento*, ed. F. Sricchia Santoro (Siena, 1988), pp. 3–12

F. Sricchia Santoro, 'Francesco di Giorgio, Signorelli a Siena e la cappella Bichi', in *Francesco di Giorgio e il Rinascimento a Siena*, ed. L. Bellosi (Siena and Milan, 1993), pp. 420–23

R. Starn, *A Contrary Commonwealth: The Theme of Exile in Medieval and Renaissance Italy* (Berkeley and Los Angeles, 1982)

R. Starn, 'Review of R. Goldthwaite, *The Building of Renaissance Florence*', *Art Bulletin*, 65 (1983), pp. 329–35

R. Starn, 'The Republican Regime and the "Room of the Peace" in Siena, 1338–40', *Representations*, 18 (1987), pp. 1–31

R. Starn and L. Partridge, *Arts of Power: Halls of State in Italy, 1300–1600* (Berkeley and Los Angeles, 1992)

R. Starn, *Ambrogio Lorenzetti. The Palazzo Pubblico, Siena* (New York, 1994)

C. von Stegmann, and H. von Geymueller, *The Architecture of the Renaissance in Tuscany*, with a preface by G. Lowell, 2 vols. (New York, 1885)

H. Steinz-Kecks, 'Santa Caterina in Fontebranda: Storia della costruzione', in *L'oratorio di Santa Caterina di Fontebranda*, ed. Contrada dell'Oca (Siena, 1990), pp. 1–28

C. Stinger, ' "Roma Triumphans": Triumphs in the Thought and the Ceremonies of Renaissance Rome', *Medievalia Humanistica*, 10 (1981), pp. 189–201

R. Stopani, *La Via Francigena in Toscana* (Florence, 1984)

J. S. Stoschek, 'Pandolfo Petrucci als Auftraggeber', MA thesis, University of Cologne, 1991

C. B. Strehlke, 'Domenico di Bartolo', PhD thesis, Columbia University, 1986

C. B. Strehlke, 'Art and Culture in Renaissance Siena', in *Painting in Renaissance Siena, 1420–1500*, ed. K. Christiansen, L. B. Kanter and C. B. Strehlke (New York 1988), pp. 33–60

A. Strnad, 'Francesco Todeschini Piccolomini. Politik und Mäzenatentum im Quattrocento', *Römische Historische Mitteilungen*, 8–9 (1964–66), pp. 101–425

L. Syson, 'Bertoldo di Giovanni, Republican Court Artist', in *Artistic Exchange and Cultural Translation in the Italian Renaissance City*, ed. S. J. Campbell and S. J. Milner (Cambridge, 2004), pp. 96–133

L. Syson, 'Representing Domestic Interiors', in *At Home in Renaissance Italy*, ed. M. Ajmar-Wollheim and F. Dennis (London, 2006), pp. 86–101

L. Syson, A. Angelini, P. Jackson and F. Nevola, eds., *Renaissance Siena: Art for a City*, exh. cat., National Gallery, London, October 2007–January 2008 (London, 2007)

T. Szabó 'Introduzione', in D. Ciampoli and T. Szabó, eds., *Viabilità e legislazione di uno stato cittadino del Duecento. Lo Statuto dei Viarii di Siena* (Siena, 1992), pp. 10–56

T. Szabó, 'La rete stradale del comune di Siena. Legislazione statutaria e amministrazione comunale nel Duecento', *Mélanges de l'Ecole Française de Rome*, 87 (1975), pp. 141–86

T. Szabó, 'Ordini mendicanti, pellegrinagi e viabilità', unpublished lecture given at 'Gli ordini mendicanti in Val d'Elsa', 6–8 June 1996, Poggibonsi, Siena

M. Tafuri, 'Via Giulia: storia di una struttura urbana', in *Via Giulia: una utopia urbanistica del '500*, ed. L. Salerno, L. Spezzaferro and M. Tafuri (Rome, 1973), pp. 65–152

M. Tafuri, *La sfera ed il labirinto* (Turin, 1980)

M. Tafuri, ' "Roma Instaurata". Strategie urbane e politiche pontificie nella Roma del primo Cinquecento', in *Raffaello architetto*, ed. C. L. Frommel, S. Ray and M. Tafuri (Milan, 1984), pp. 56–106

M. Tafuri, *Venezia e il Rinascimento* (Turin, 1985)

M. Tafuri, *Ricerca del Rinascimento. Principi, città, architetti* (Turin, 1992)

M. Tafuri, 'La chiesa di San Sebastiano in Vallepiatta a Siena', in *Francesco di Giorgio, architetto*, ed. F. P. Fiore and M. Tafuri (Siena and Milan, 1993), pp. 302–17

M. Tafuri, 'Le chiese di Francesco di Giorgio', in *Francesco di Giorgio, architetto*, ed. F. P. Fiore and M. Tafuri (Siena and Milan, 1993), pp. 21–73

M. Tafuri, 'A Search for Paradigms: Project, Truth, Artifice', *Assemblage*, 28 (1995), pp. 46–69

R. Terziani, 'Una ipotesi sui palazzi di Iacoppo Petrucci e Antonio Bichi', in P. Pertici, *La città magnificata: interventi edilizi a Siena nel Quattrocento* (Siena, 1995), pp. 143–4

R. Terziani, *Il governo di Siena dal medioevo all'età moderna: la continuità repubblicana al tempo dei Petrucci (1487–1525)* (Siena, 2002)

A. M. Testaverde, 'Il "Paradiso" sul Campo di Siena. Tradizione e rapporti con l'arte del visuale', *Quaderni di Teatro*, 25 (1984), pp. 20–30

A. M. Testaverde Matteini, 'Le decorazioni festive e l'itinerario di "rifondazione" della città negli ingressi trionfali a Firenze tra XV e XVI secolo', *Mitteilungen des Kunsthistorisches Instituts in Florenz*, 32 (1988), pp. 323–52

G. and C. Thiem, *Toskanische Fassaden-Dekoration in Sgraffio und Fresko* (Munich, 1964)

D. Thornton and L. Syson, *Objects of Virtue: Art in Renaissance Italy* (London, 2001)

S. Tizio, *Historiae Seneses*, vol. 1.1.1, ed. M. Doni Garfagnani (Rome, 1992)

S. Tizio, *Historiae Seneses*, vol. 1.2.1, ed. G. Tomasi Stussi (Rome, 1995), p. 242

S. Tizio, *Historiae Seneses*, vol. 3.4, ed. P. Pertici, (Rome, 1998)

F. Toker, 'Alberti's Ideal Architect: Renaissance or Gothic', in *Renaissance Studies in Honour of Craig Hugh Smyth*, ed. A. Morrogh et al. (Florence, 1985), pp. 667–74

F. Toker, 'Gothic Architecture by Remote Control: An Illustrated Building Contract of 1340', *Art Bulletin*, 69 (1985), pp. 67–95

R. Toledano, *Francesco di Giorgio Martini: Pittore e scultore* (Milan, 1987)

A. Tomei, ed., *Le Biccherne di Siena. Arte e Finanza all'alba dell'economia moderna* (Azzano San Paolo, Bergamo, and Rome, 2002)

G. Tommasi, *Historia di Siena* (Siena, 1625)

A. Tönnesman, *Pienza. Städtbau und Humanismus* (Munich, 1990)

A. W. Tordi, ' "La festa e storia di Sancta Caterina": A Critical Edition Based on Ms. I. II. 33 of the Biblioteca Comunale of Siena, with an Introductory Essay on the Legend of Saint Catherine of Alexandria in Medieval Literature', PhD thesis, University of North Carolina at Chapel Hill, 1994

P. Torriti, *La basilica di San Francesco e l'oratorio di San Bernardino* (Genoa, 1987)

P. Torriti, *Tutta Siena, contrada per contrada* (Florence, 1988)

P. Torriti, ed., *Domenico Beccafumi e il suo tempo* (Milan, 1990)

P. Torriti, ed., *Beccafumi. L'opera completa* (Milan, 1998)

P. Torriti, 'Gli affreschi del Pellegrinaio', in *Il Santa Maria della Scala: l'Ospedale dai mille anni*, ed. P. Torriti (Genoa, 1991), pp. 71–5

S. Tortoli, 'Per la storia della produzione laniera a Siena nel Trecento e nei primi del Quattrocento', *BSSP*, 82–3 (1975–6), pp. 22–38

L. Totaro, *Pio II nei suoi Commentarii* (Bologna, 1978)

A. Toti, *Atti di votazione della città di Siena e del senese alla SS. Vergine Madre di G. C.* (Siena, 1870)

K. Trabgar, 'Il campanile del Duomo di Siena e le torri gentilizie della città', *BSSP*, 102 (1995), pp. 159–86

M. Trachtenberg, 'Archaeology, Merriment and Murder: The First Cortile of the Palazzo Vecchio and its Transformation in the Late Florentine Republic', *Art Bulletin*, 71 (1989), pp. 565–609

M. Trachtenberg, 'Gothic / Italian Gothic: Towards a Redefinition', *Journal of the Society of Architectural Historians*, 50 (1991), pp. 22–37

M. Trachtenberg, *Dominion of the Eye: Urbanism, Art and Power in Early Modern Florence* (Cambridge, 1997)

R. Trexler, *Public Life in Renaissance Florence* (New York and London, 1980)

M. Trionfi Onorati, 'Antonio e Andrea Barili a Fano', *Antichità Viva*, 6 (1975), pp. 35–42

M. Tuliani, *Osti, avventori e malandrini. Alberghi, locande e taverne a Siena e nel contado tra '300 e '400* (Siena, 1994)

M. Tuliani, 'Il Campo di Siena: Un mercato cittadino in epoca comunale', *Quaderni medievali*, 46 (1998), pp. 59–100

M. Tuliani, 'La dislocazione delle botteghe nel tessuto urbano della Siena medievale (secc. XIII–XIV)', *Bullettino Senese di Storia Patria*, 109 (2002), pp. 88–116

T. J. Tuohy, 'Studies in Domestic Expenditure at the Court of Ferrara (1451–1505): Artistic Patronage and Princely Mag-

nificence', PhD thesis, Warburg Institute, University of London, 1982

T. J. Tuohy, *Herculean Ferrara. Ercole d'Este (1471–1505) and the invention of a ducal capital* (Cambridge, 1996)

P. Turrini, 'Le disavventure senesi delle "Historiae" di Sigismondo Tizio', in *Studi in onore di Arnaldo d'Addario* (Lecce, 1995), II, pp. 645–56

P. Turrini, *'Per honore et utile de la città di Siena'. Il comune e l'edilizia nel Quattrocento* (Siena, 1997)

C. Ugurgieri della Berardenga, *Pio II Piccolomini, con notizie su Pio II e altri* (Florence, 1973)

G. Della Valle, *Lettere sanesi sopra le belle arti*, 3 vols. (Rome, 1786)

G. Vasari, *Le vite dei più eccellenti pittori, scultori ed architettori*, ed. G. Milanesi, 9 vols. (Florence, 1878–85)

G. Vasari, *Le vite dei più eccellenti pittori, scultori ed architettori*, ed. P. Barocchi, 11 vols. (Florence, 1966–97)

A. Vauchez, 'La Commune de Sienne, les Ordres Mendiants et la culte des saints. Histoire et enseignements d'une crise', *Mélanges de l'Ecole Française de Rome*, 89 (1977), pp. 757–67

G. Venerosi Pesiolini, 'La Via Francigena nel contado di Siena XIII–XIV', *La Diana*, 8 (1933), pp. 118–55

P. Viti, 'I volgarizzamenti di Alessandro Braccesi dell'*Historia de duobus amantibus* di Enea Silvio Piccolomini', *Esperienze Lettterarie*, VII/3 (1982), pp. 62–8

Vocabolario degli Accademici della Crusca, 5th edn (Florence, 1863)

D. Waley, *Siena and the Sienese in the Thirteenth Century* (Cambridge, 1991)

D. Webb, *Patrons and Defenders: The Saints in the Italian City States* (London, 1996)

K. Weil-Garris and J. d'Amico, *The Renaissance Cardinal's Ideal Palace: A Chapter from Cortesi's 'De Cardinalatu'* (Rome, 1980)

R. Weiss, *The Renaissance Discovery of Classical Antiquity* (Oxford, 1988)

E. Welch, *Art and Authority in Renaissance Milan* (New Haven and London, 1995)

E. Welch, 'Between Florence and Milan: Ippolita Maria Sforza, Duchess of Calabria', in *The French Descent into Renaissance Italy, 1494–5*, ed. D. Abulafia (Aldershot, 1995), pp. 123–36

E. Welch, *Art and Society in Italy, 1350–1500* (Oxford, 1997)

E. Welch, *Shopping in the Renaissance: Consumer Cultures in Italy, 1400–1600* (New Haven and London, 2005)

A. S. Weller, *Francesco di Giorgio, 1439–1501* (Chicago, 1943)

C. W. Westfall, *In This Most Perfect Paradise. Alberti, Nicholas V and the Invention of Conscious Urban Planning in Rome, 1447–55* (University Park, PA, and London, 1974)

C. W. Westfall, 'Alberti and the Vatican Palace Type', *Journal of the Society of Architectural Historians*, 33 (1974), pp. 101–21

C. W. Westfall, 'Chivalric Declaration: The Palazzo Ducale at Urbino as a Political Statement', in *Art and Architecture in the Service of Politics*, ed. H. A. Millon and L. Nochlin (London and Cambridge, MA, 1978), pp. 20–45

J. White, *Art and Architecture in Italy, 1250–1400* (Harmondsworth, 1987)

J. W. Whitehand, *Making the Urban Landscape* (Oxford, 1992)

A. Whitley, 'Concepts of Ill Health and Pestilence in Fifteenth-century Siena', PhD thesis, Warburg Institute, University of London, 2004

H. Wieruszowski, 'Art and the Commune in the Time of Dante', *Speculum*, 19 (1944), pp. 14–33

D. Wilkins, 'Donatello's Lost *Dovizia* for the Mercato Vecchio: Wealth and Charity as Florentine Civic Virtues', *Art Bulletin*, 65 (1983), pp. 401–23

C. Wilkinson, 'The New Professionalism in the Renaissance', in *The Architect: Chapters in the History of the Profession*, ed. S. Kostof (New York, 1977), pp. 124–60

H. Wohl, ' "Puro senza ornato": Masaccio, Cristoforo Landino and Leonardo da Vinci', *Journal of the Warburg and Courtauld Institutes*, LVI (1993), pp. 256–60

H. Wohl, *The Aesthetics of Italian Renaissance Art: A Reconsideration of Style* (Cambridge, 1999)

J. Woods Marsden, 'Art and Political Identity in Fifteenth-century Naples: Pisanello, Cristoforo di Geremia and King Alfonso's Imperial Fantasies', in *Art and Politics in Late Medieval and Early Renaissance Italy, 1250–1500*, ed. C. M. Rosenberg (Notre-Dame and London, 1990), pp. 11–37

H. Wurm, *Baldassarre Peruzzi Architekturzeichnungen. Tafelband* (Tübingen, 1984)

C. Zarrilli, 'Incoronazione di Papa Pio II. Siena tra due chimere', in *Le Biccherne. Tavole dipinte delle magistrature senesi (secoli XIII–XVIII)*, ed. U. Morandi (Rome, 1984), p. 166

C. Zarrilli, 'Francesco di Giorgio pittore e scultore nelle fonti archivistiche senesi', in *Francesco di Giorgio e il Rinascimento a Siena*, ed. Bellosi, (Siena and Milan, 1993), p. 534

L. Zdekauer, ed., *Il constituto del comune di Siena dell'anno 1262* (Milan, 1897)

L. Zdekauer, *La vita pubblica dei Senesi del Duecento* (Siena, 1897)

C. Zeika, 'Hosts, Processions and Pilgrimages: Controlling the Sacred in Fifteenth Century Germany', *Past and Present*, 118 (1988), pp. 25–64

N. Zemon Davis, 'The Rites of Violence: Religious Riots in Sixteenth Century France', *Past and Present*, 59 (1973), pp. 51–91

N. Zemon Davis, *Fiction in the Archives: Pardon Tales and their Tellers in Sixteenth-century France* (Stanford, 1987)

B. Zevi, *Biagio Rossetti, architetto ferrarese, il primo urbanista moderno europeo* (Turin, 1960)

B. Zevi, *Controstoria dell'architettura in Italia* (Rome, 1997)

Photograph Credits

Index

302

ISOLA DEL GIGLIO

PIAN D AL MA

BATIGNA

SIENA